the Villa of the
Mysteries
in Pompeii
Ancient Ritual ⮞ Modern Muse

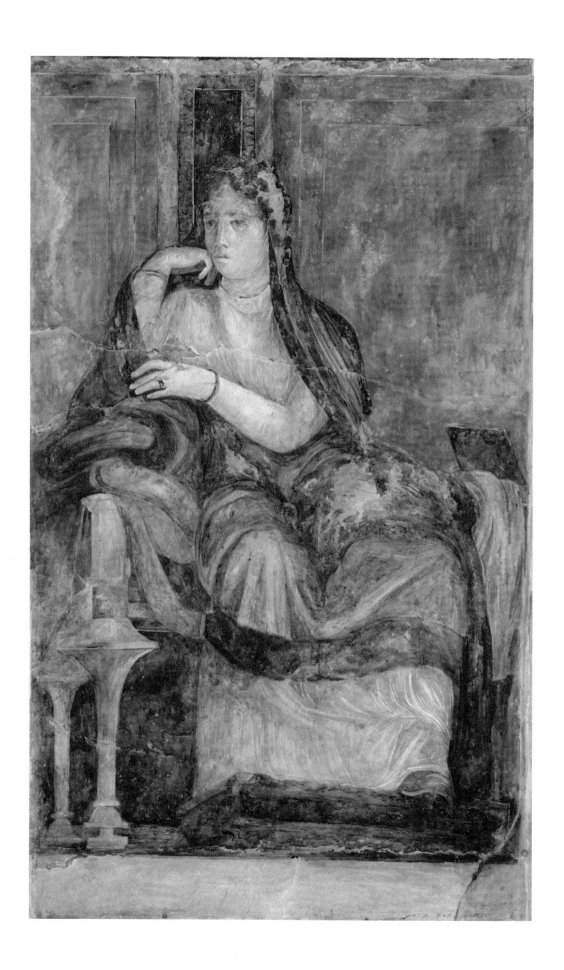

the Villa of the Mysteries
in Pompeii
Ancient Ritual ➢ Modern Muse

Elaine K. Gazda, editor

with the assistance of
Catherine Hammer
Brenda Longfellow
Molly Swetnam-Burland

PUBLISHED BY
The Kelsey Museum of Archaeology and
The University of Michigan Museum of Art
Ann Arbor 2000

Published on the occasion of *The Villa of the Mysteries in Pompeii: Ancient Ritual, Modern Muse*, an exhibition organized by and exhibited at the Kelsey Museum of Archaeology and The University of Michigan Museum of Art, October 1– November 19, 2000.

This exhibition received major funding from the Samuel H. Kress Foundation. Additional funding was generously provided by Helmut Stern, Virginia Patton Moss and Cruse W. Moss, Ann Taylor van Rosevelt, Gregory and Margene Henry, Shiela and Steven Hamp, the Associates of the Kelsey Museum of Archaeology and the Friends of the Museum of Art, and the following University of Michigan units: the Office of the Vice President for Research; College of Literature, Science and the Arts; Horace H. Rackham School of Graduate Studies; Institute for Research on Women and Gender; and the Arts of Citizenship Program.

Front cover: detail of Maria Barosso's watercolor after the scene of the adornment of the bride of the Villa of the Mysteries frieze.
Back cover: detail of Maria Barosso's watercolor after the so-called flagellation scene of the Villa of the Mysteries frieze.
Frontispiece: Maria Barosso's watercolor after the *domina* panel of the Villa of the Mysteries frieze.

ISBN 1-930561-02-4
LIBRARY OF CONGRESS CONTROL NUMBER 00-134412

Distributed by University of Washington Press
P. O. Box 50096
Seattle, WA 98145-5096

Cover design: Steven Hixson, University of Michigan Museum of Art
Interior layout and typesetting: Margaret Lourie, Kelsey Museum of Archaeology
Printed by Colonial Press, Inc., Jackson, Michigan

Contents

Foreword

For many years we at the Kelsey Museum have dreamed of displaying to the public the magnificent watercolor replicas of the frescoes from the Villa of the Mysteries that our founder, Professor F. W. Kelsey, commissioned Maria Barosso to paint shortly after the discovery of the originals at Pompeii. Unhappily, lack of adequate display space in the Kelsey condemned the watercolors to remain rolled up for decades in our attic storeroom. Now, thanks to the vision of Curator Elaine Gazda and the generous collaboration of the Museum of Art, we are proud to be able at last to present these treasures for public viewing in the current exhibition, *The Villa of the Mysteries in Pompeii: Ancient Ritual, Modern Muse*.

As the title suggests, this is an exhibition of multiple dimensions. Not only does it explore the role of women in ancient Rome, in both the domestic and religious spheres; it also brings to the forefront the dynamic role that art can play in society, both ancient and modern. The inspiration that modern artists have drawn from the ancient frescoes, and the ways in which they have chosen to transform and enhance the timeless themes of the frescoes, speak volumes about the power of art to evoke responses far beyond the intent of the original artist.

James Steward's introductory remarks on behalf of the Museum of Art touch upon the key role a university museum can play in connecting its diverse but overlapping communities: students and researchers, artist and public, ancient and modern. The Kelsey Museum since its founding in 1953 has striven to fulfill this demanding role both within the University of Michigan and to the wider public of the state of Michigan. Constraints of time and space and limited resources do not make it always possible to meet this goal fully, but in the current exhibition Professor Gazda, with her first-rate team of students and staff from both museums, has succeeded admirably.

Sharon Herbert
Director
Kelsey Museum of Archaeology

The Museum of Art is pleased to partner with the Kelsey Museum to present *The Villa of the Mysteries in Pompeii: Ancient Ritual, Modern Muse*. This important exhibition exploring the place of women in the ancient Mediterranean and Pompeii's inspiration for artists of our own time is all about connections—between art and life, between past and present. Such connections lend themselves to collaborative programing between the Museum of Art and the Kelsey Museum that will engage a range of University students and faculty, as well as teachers and students in the public schools. Further, they underscore the interdisciplinarity to which this Museum has recommitted itself in recent years, along with a commitment to exhibitions that present fresh scholarship to academic and nonacademic audiences. This exhibition and catalogue succeed on both fronts.

As we enter a new academic year—with the energy of new and returning students and the dedication of inspired faculty—we are reminded of the Museum of Art's complex relationship to the University of Michigan. Since its foundation in 1946, the Museum has derived its central mission from this relationship—one that offers unique opportunities and challenges. What does it mean, after all, to be a museum within one of the world's great public research universities? How can we best serve that quest for excellence? Excellence in our collections and exhibitions is clearly one important way to accomplish this; engagement with students, both in the classroom and out, is another essential component. Collaboration with faculty is a vital avenue for the Museum in both areas, and our work with Professor Elaine Gazda on this project has been a particularly fruitful partnership. Professor Gazda is everything one could hope for in a collaborator, and it has been a great pleasure to work with her. The support and true collegiality we have found with Professor Sharon Herbert and her staff at the Kelsey have also been exemplary.

For all the social and intellectual issues it raises, art is at the core of this exhibition—with its inherent visuality, its varied techniques, its shifting meanings. Projects such as this speak to the Museum of Art's role in the University and the broader community as a vehicle for new scholarship (including fostering and presenting new artmaking) and as a site for the exploration of intersections between the visual arts and other disciplines. While drawing from the talents represented in our University family, a project such as this is not simply for the University. It also reminds us of the way in which art—and this Museum—can provide a public face for the work of brilliant scholars and creative talents, building bridges between the University of Michigan and the people of our broader community.

James Christen Steward
Director
University of Michigan Museum of Art

Preface

The idea for an exhibition on the Villa of the Mysteries in Pompeii at the University of Michigan began to germinate seventy-seven years ago when Francis Willey Kelsey, then Professor of Latin at the University, contracted with Maria Barosso, an artist in Rome, to make a large-scale copy of the fresco cycle in Room 5 of the Villa of the Mysteries in Pompeii. That commission and its consequences for the present exhibition are chronicled in the essays of this volume and in the exhibition itself. My own curiosity about the Barosso copy was piqued during the early years of my curatorship at the Kelsey Museum when each day on the way to my office I passed a stack of rolled up canvases in the Museum's storage area. (At the time I didn't know that the canvas was merely the backing of the watercolor paper on which Barosso had painted her replica.) Over the years, as I and other curators worked our way through the archives of Professor Kelsey and the Kelsey Museum itself, with the expert help of archivist Carol Finerman, we learned more about the "canvases." In the 1980s the Museum engaged conservators Lauren McTavish and Genevieve Baird to document the condition of Barosso's watercolors and recommend treatment or other action that might be required. Their report, in fact, forms the basis of the catalogue entry (no. 69) on the watercolors. It is only now in the process of being superseded as the Kelsey's interim conservator, Brook Bowman, repairs and mounts the watercolors for exhibition. Until now, the large size of several of the watercolors has prohibited our exhibiting them. Consequently, they have remained for the most part invisible to the public and even to students and faculty of the University.

The Barosso watercolors are the centerpiece of the present exhibition, but they do not stand alone, nor do they provide the sole impetus for the exhibition. Since the early 1970s the Kelsey Museum has acquired a number of Roman marble sculptures that relate in style and theme to images on the Villa's painted frieze—a satyr torso, heads of Dionysus/Bacchus, a satyr and Silenus, and a Bacchic sarcophagus (cat. nos. 58, 92–95). Since the 1980s I have planned to combine these sculptures and the Barosso watercolors in an exhibition on Dionysus/Bacchus. In the interim, however, my thinking about the Barosso watercolors and their Roman model has come to focus on the notion of creative reponse to artistic models. During a National Endowment for the Humanities Summer Seminar for College Teachers, *The Roman Art of Emulation*, held at the American Academy in Rome in 1994, I was fortunate to visit the Villa of the Mysteries with the members of the seminar, one of whom was the artist Ruth Weisberg. Inspired by her viewing of the Villa frieze, and later the Barosso watercolors, Ruth created her *Initiation* (cat. no. 111). It was her work that motivated me to expand the concept of the exhibition to include contemporary artistic responses to the frieze. I am grateful to Ruth for her repeated encouragement of this project and for her advice on reaching other artists who have found inspiration in the frieze of the Villa of the Mysteries.

The scope of the exhibition thus expanded, it seemed a project well suited for a collaboration between the Kelsey Museum and the Museum

of Art. James Steward, Director of the Museum of Art, reponded to the idea with enthusiasm, and the exhibition began to take its current shape. The marble head of Dionysus (cat. no. 92), not incidentally acquired by the Kelsey jointly with the Museum of Art, is a tangible sign of the cooperative relations the two museums have long enjoyed. (Most recently, in 1997, the two museums collaborated on the loan exhibition, *Sepphoris in Galilee*.)

The research that underpins the present exhibition grew largely out of a seminar entitled "Women and Cult in the Art of Roman Italy," which I taught in the fall term of 1998. The six graduate students in that seminar—Elizabeth de Grummond, Catherine Hammer, Shoshanna Kirk, Brenda Longfellow, Molly Swetnam-Burland, and Drew Wilburn, as well as Jessica Davis, who joined the project more recently—worked individually and collectively on virtually all interpretive aspects of the exhibition. The exhibition and catalogue owe a great deal to their creativity, scholarship, teamwork, and, not least, their sustaining enthusiasm for the project. They have given of their time and helped me and one another unselfishly throughout. It has been a remarkable privilege to have had this opportunity to work with these gifted young people.

All of the students and I went to Pompeii at different times in the course of our research, and there we were graciously received by Dr. Pietro Giovanni Guzzo, Archaeological Superintendent of Pompeii, and permitted to study at length in the Villa of the Mysteries—its architecture and paintings—as well as related photographic archives. Those of us who went to the Archaeological Museum of Naples were likewise graciously accommodated by Stefano De Caro, Archaeological Superintendent of the Provinces of Naples and Caserta.

In preparing this catalogue, Molly Swetnam-Burland had substantial responsibility for helping me edit the content of the essays, especially in the earlier stages of their development. Brenda Longfellow, as my ever-efficient research assistant, spent many, many hours helping to prepare the essays and catalogue entries for further editing, typesetting, and layout by our editor Margaret Lourie. Over the course of the summer Catherine Hammer joined Brenda in this work and schedule with remarkably good cheer. Melanie Grunow, also a graduate student at Michigan, was in complete charge of putting the footnotes and bibliography into consistent form and tracking down missing references. Jessica Davis assisted in proofreading. Michelle Wallon, my summer office assistant, patiently prepared lists of photographic credits, assisted me in laying out the Kelsey installation, and performed myriad other tasks as required.

Diane Kirkpatrick, Professor of the History of Art, happily undertook the task of contextualizing the works of the six contemporary artists that appear in the exhibition. She, along with Bettina Bergmann, Molly Lindner, James McIntosh, John Pedley, Joan Mickelson, and Anne Haeckl, offered excellent suggestions and criticisms of the essays in the final stages of editing. I and the individual authors are responsible for any errors and shortcomings that may remain.

I am grateful to Lorene Sterner, who produced the plans of Pompeii, the Villa of the Mysteries, and the Villa at Boscoreale as well as computer projections of our installation plans, and to Patrick Young of the Department of History of Art, who photographed and digitized a number of images for the catalogue, including the color photographs of Barosso's watercolors. The University's Photographic Services made

many of the prints for the catalogue. Steven Hixson of the Museum of Art designed the catalogue cover and title. Special thanks are due Margaret Lourie, who not only did the entire layout of the text and illustrations but also went out of her way many times to facilitate and speed the editorial process and the production of this volume.

It has been a great pleasure to work with James Steward and Carole McNamara of the Museum of Art, both of whom contributed in important ways to the conceptual development of the project, the selection of artists' work, and the practical realization of the exhibition. Carole McNamara, Assistant Director for Exhibitions and Collections, was in charge of coordinating the participation of the Museum of Art staff and also acted as liaison to the Kelsey Museum. I am grateful to Sharon Herbert, Director of the Kelsey Museum, for her support of the project as well.

The students, curators, and other members of the staffs of both museums worked collaboratively on numerous facets of the project. Kirsten Neelands, Museum of Art preparator, was responsible along with her colleagues, Kevin Canze and Jaye Schlesinger, for turning my thoughts on the installation at the Museum of Art into reality. Dana Buck played a similar role at the Kelsey. Several students—Jessica Davis, Molly Swetnam-Burland, Brenda Longfellow, Catherine Hammer, Shoshanna Kirk, and Elizabeth de Grummond—participated in designing the arrangements of objects in a number of the individual vitrines and also wrote didactic materials for the installations at both museums. Lori Mott, Museum of Art registrar, worked with Robin Meador-Woodruff of the Kelsey Museum registry to arrange for shipping and receiving the loan objects and paintings, and Kristen Hannold in the Kelsey registry ably filled in for Robin Meador-Woodruff during the summer months. At the Museum of Art Karen Goldbaum and Carol Stein edited all text panels and object labels for the installations, Steven Hixson designed them, Ann Sinfield oversaw new photography, and Whitley Hill, along with Todd Gerring of the Kelsey Museum, handled publicity. Lauren Talalay and Todd Gerring of the Kelsey Museum created an educational kit on Pompeii to be used by area schools and other institutions. Ruth Slavin along with the members of her education staff at the Museum of Art, Debbie Swartz and Pamela Reister, guided the planning of other educational programs. Brenda Longfellow acted as liaison between the two museums in planning public events.

At the Kelsey Museum, Brook Bowman, interim conservator, not only mounted and oversaw the installation of the Barosso watercolors but also treated many of the Kelsey objects. She was assisted by Thyra Throop, Melissa Schaumberg, Phyllis Bowman, and student volunteers Alan J. Campana, Lacy Carra, Amanda Edge, Carolyn Grunst, Brenda Long-fellow, Laura Nicholson, Stephanie Pulaski, and Betsy Wilson. Prior to his departure from the Kelsey, conservator Geoffrey Brown assisted me with planning an installation of the watercolors. Kelsey adminstrator Helen Baker and other members of the office staff, Jackie Monk, Lydia Allison, and Michelle Biggs, cheerfully provided help at every step of the way. At the Museum of Art, administrator Kathryn Huss played an important role in the general management of the project.

This complex undertaking involved the contributions of many other people as well. Drew Wilburn not only produced the maps of Italy and Campania for the catalogue but also designed and produced the QuickTime virtual reality walk-through of the Villa of the Mysteries with the expert

advice and generous assistance of Kelsey curator Terry Wilfong. Drew was assisted in Pompeii by Elizabeth de Grummond. Shoshanna Kirk had the responsibility of helping me, at the early stages of planning, with organizing requests for loans of antiquities and placing advertisements for artists whose work would suit the theme of the show. Sirida Williams Graham helped me organize information on all of the objects and other works in the exhibition in preparation for grant proposal applications.

In addition to those already mentioned, many colleagues, friends, and students at Michigan and elsewhere also offered their help and support: Rebecca Miller Ammerman, Judith Barringer, R. Ward Bissell, Gina Borromeo, Robert Brentano, Richard Brilliant, Dave Burland, Adriana Calinescu, John Clarke, Kevin Clinton, Dorothy Cullman, Lacea Curtis, Paul Denis, Joan Ferrante, Nancy de Grummond, John Dobbins, Lisa Fentress, Kristina Hermann Fiore, Florence Friedman, Biagio Giuliani, Jennifer Johnston, Jeremy Hartnett, Margaret Hiers, Martha Hoppin, Julie Kaufmann-Lloyd, Barbara Kellum, Sandra Knudsen, Christine Kondoleon, Ann Kuttner, Christopher Lightfoot, Joan Mertens, Camilla McKay, David Mitten, Erika Naginski, William Peck, Christopher Philipp, Carlos Picón, Margaret Cool Root, Catherine Sease, Erika Simon, E. Marianne Stern, Nancy Thompson, Christine Verzar, Wendy Watson, and Patricia Whitesides. I am grateful, too, to all the museums, galleries, collectors, and artists who lent their work to the exhibition and to the four teachers at Pioneer High School who agreed to participate in Arts of Citizenship–sponsored interdisciplinary activities related to the exhibition—Karla Hitchcock, Carol Houston, William Johnson, and Debbie Thompson.

The exhibition and catalogue would not have been possible without the generosity of the funders who are acknowledged on the reverse of the title page. In addition to those named there, I want to offer my heartfelt thanks to a number of individuals associated with the funding organizations: Marilyn Perry, President, and Lisa Ackerman, Vice President and Chief Administrative Officer of the Samuel H. Kress Foundation; Associate Dean Anthony Francis and his assistant Peggy Westrick of the College of Literature, Science and the Arts; Julie Ellison, formerly Associate Vice President for Research in Humanities and Arts; Marvin Parnes, Associate Vice President for Research and Executive Director of the Division of Research, Development and Administration; Abby Stewart, Director of the Institute for Research on Women and Gender; David Scobey, Director of the Arts of Citizenship Program, and Thelma Thomas, Associate Dean for the Humanities and Humanistic Social Sciences of the Horace H. Rackham School of Graduate Studies.

The graduate students who worked so long and well to accomplish the goals of this project deserve the highest of praise. I am deeply grateful to them. Not least, I offer warmest thanks to my husband, James McIntosh, and my daughter, Karina McIntosh, for their enduring affection, patience, and support.

Elaine K. Gazda
Curator of Hellenistic and Roman Antiquities
Kelsey Museum of Archaeology

Lenders to the Exhibition

Marsha and Darrel Anderson, Newport Beach, California
Arthur M. Sackler Museum, Harvard University Art Museums
Sarah Belchetz-Swenson
Bentley Historical Collections, University of Michigan
Janis Cline, Boulder City, Neveda
The Detroit Institute of Arts
Everson Museum of Art, Syracuse, New York
The Field Museum of Natural History
Gwenda Jay/Addington Gallery, Chicago
Harlan Hatcher Graduate Library, University of Michigan
Indiana University Art Museum
Jack E. Rutberg Fine Arts, Los Angeles
Kelsey Museum of Archaeology
Koplin Gallery, Los Angeles
Los Angeles County Museum of Art
The Metropolitan Museum of Art
Mount Holyoke College Museum of Art
Museum of Art, Rhode Island School of Design
Patricia Olson
Eleanor Rappe
The Royal Ontario Museum
Gary Ruttenberg, Esq., Los Angeles
Seattle Art Museum
The Toledo Museum of Art
Kat Tomka
Dr. Christine Verzar

Contributors to the Catalogue

JMD	Jessica M. Davis
EdeG	Elizabeth de Grummond
EKG	Elaine K. Gazda
CH	Catherine Hammer
DK	Diane Kirkpatrick
SK	Shoshanna Kirk
BL	Brenda Longfellow
MSB	Molly Swetnam-Burland
DW	Drew Wilburn

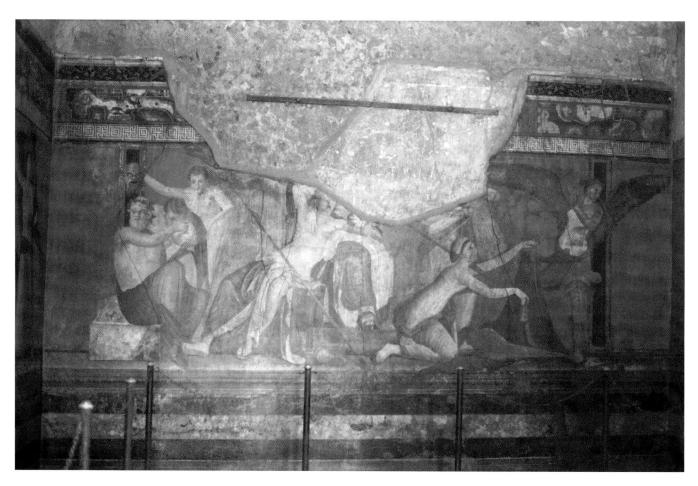

Color plate I. The east wall of Room 5 in the
Villa of the Mysteries. Photo: E. K. Gazda.

1 Introduction: Ancient and Modern Contexts of the Bacchic Murals in the Villa of the Mysteries

Elaine K. Gazda

The Villa of the Mysteries in Pompeii: Ancient Ritual, Modern Muse, centers on an intriguing cycle of frescoes unearthed in 1909 at this well-known villa on the outskirts of the ancient city (figs. 1.1, 1.2).[1] The cycle depicts women engaged in activities that have often been connected with the initiation of one or more young women into the mysteries of the cult of Dionysus, or Bacchus, in preparation for marriage. This exhibition explores ancient and modern contexts for these paintings by bringing together objects from the ancient art and culture of Italy and the Greek world of the eastern Mediterranean as well as a group of works by modern American artists who have been inspired by the ancient cycle.

The Pompeian frescoes (fig. 1.3) display images of rituals performed by statuesque women interspersed with visual references to the immortal realm mostly populated by mythological males, but there is little agreement about its meaning nor even about where the narrative begins and ends.[2] According to one common interpretation, the women first hear sacred readings (fig. 1.4, group A) and prepare a ritual meal (group B).[3] Then follow glimpses into the world of Dionysus. A woman (group C), who seems to have wandered into this divine realm, appears startled, even frightened, either at the sight of the god himself (group D) or by the scenes that follow—the ritual revelation of the phallus (group E) and a demon flagellating a young initiate as a maenad dances (group F). A woman dressing her hair as a bride and flanked by cupids (group G–H) and a seated matron looking on (group I) complete the cycle.

Usually thought to have been painted around 60–40 BC,[4] the fresco cycle has inspired numerous theories about its meaning, function, source of patronage, and design intentions. It decorates what seems to have been the most opulent room of the Villa, presumably one used for special occasions and guests. Yet, because it portrays many women and

Fig. 1.1. Map of Pompeii showing the location of the Villa of the Mysteries.

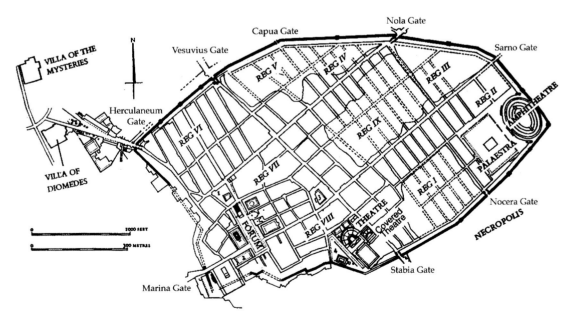

1

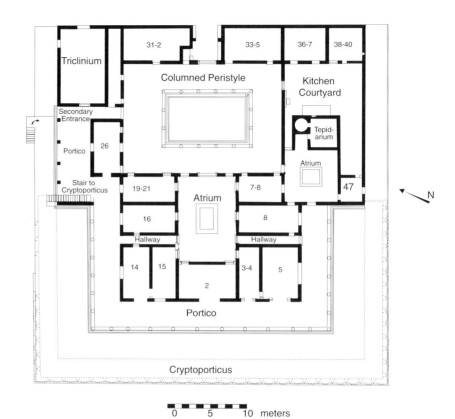

Fig. 1.2. Plan of the Villa of the Mysteries in the second century BC.

Triclinium

31-2 33-5 36-7 38-40

Columned Peristyle

Kitchen Courtyard

Secondary Entrance

Tepid-arium

Portico 26

Atrium

Stair to Cryptoporticus 19-21 7-8 47

Atrium

16 8

Hallway Hallway

14 15 3-4 5

2

Portico

Cryptoporticus

N

0 5 10 meters

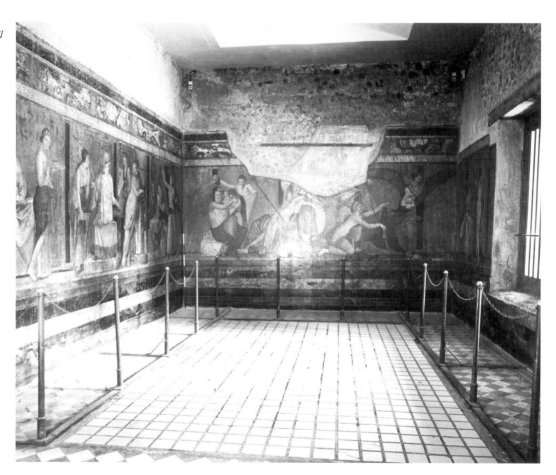

Fig. 1.3. View toward the east wall of Room 5 in the Villa of the Mysteries. Photo: Michael Larvey.

2

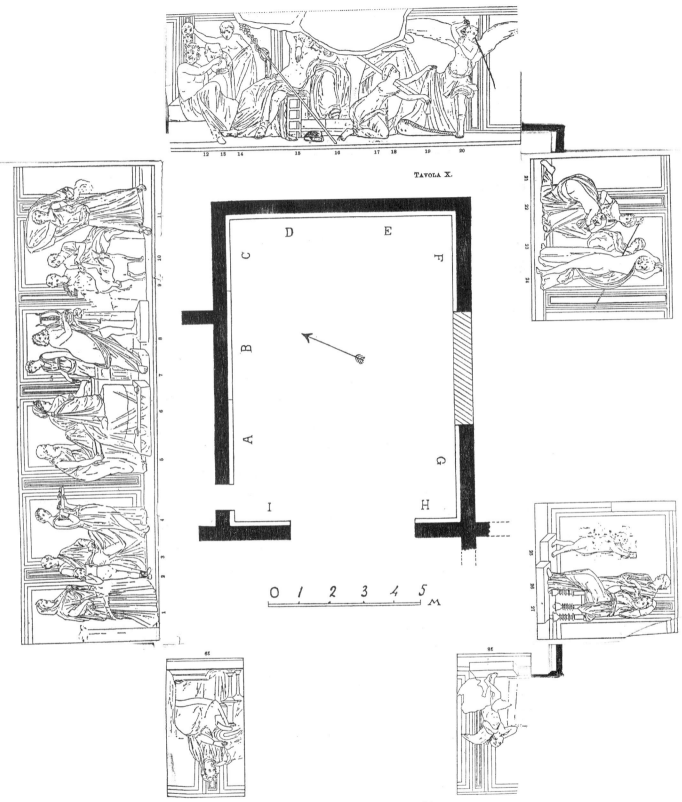

TAVOLA X.

Fig. 1.4. Plan of Room 5 of the Villa of the
Mysteries showing the arrangement of the
mural cycle around the room. The group letters
and figure numbers are referred to by all
authors in this volume.

3

their rituals, some scholars and lay viewers of the cycle have speculated that this room, along with the smaller room adjacent to it (Room 4), may have been the apartment of the *materfamilias*, or *domina* (the woman of the house).[5] Further, according to this and similar theories, the activities depicted on the walls of Room 5, which seem to be related to the cult of the Greek god Dionysus (also known as Bacchus, the Etruscan Fufluns, and the Roman Liber) may indicate that the *domina* was involved in the cult of that god at Pompeii. It has often been imagined that she was a priestess of the cult, that she commissioned the paintings, and that cultic rites took place in this room.[6]

Immediately upon its discovery in 1909, the fresco cycle was widely publicized as a masterpiece and quickly became famous. Fifteen years later, Francis W. Kelsey, Professor of Latin at the University of Michigan, commissioned a large-scale replica in watercolor by an Italian artist, Maria Barosso, with the intent of making a reconstruction of the whole room in the archaeological museum he hoped the University of Michigan would build (cat. no. 69; figs. 12.1–3, frontispiece, and color pls. I–III).[7] Kelsey lived to see most of Barosso's watercolor representation exhibited in 1926 at the Galleria Borghese in Rome (figs. 12.4–5), but he died before the completed work could be sent to Michigan. Since arriving in Ann Arbor, the watercolors have been rolled up and stored at the Kelsey Museum. Only two parts of this replica have ever been shown in this country.[8] In this exhibition, Barosso's watercolors are displayed for the first time as Kelsey had intended—as a reconstruction of Room 5 in the Villa of the Mysteries.

Barosso's watercolor representation of the Pompeian cycle is the immediate source of inspiration for this exhibition. As a work of the twentieth century, which responds in both archaeological and artistic terms to the ancient Villa frieze, it highlights for us a number of questions about the reception of the ancient frieze by scholars, artists, and other viewers since 1909, questions that this exhibition attempts to address. How have scholars throughout the twentieth century responded to the challenge of pursuing the origins, meaning, and function of the fresco cycle? How have artists, including Barosso herself, responded to its enigmatic imagery and sheer aesthetic power? How has the general public responded to the frescoes, to scholarly speculations about their meaning, and to works of art that either appropriate them or draw inspiration from them? The exhibition focuses on the first two of these categories of response. Apart from alluding to the public reception of Barosso's watercolors when they were exhibited in Rome, the third category of response lies beyond the scope of the current project. But we hope that the exhibition and catalogue will encourage others to pursue it as well as the first two. In fact, parts of the cycle have been reproduced in commercial and other popular media, often to pique the viewer's curiosity about the ancient, sensual, and "mysterious." The Roman cycle's familiarity, at least in visual terms, reinforces our sense that it has become a contemporary cultural icon.[9]

The extensive amount of scholarly work on the frescoes in Room 5 of the Villa of the Mysteries requires that we explain our own purposes and position in relation to those of our predecessors. I shall briefly outline the main themes and goals of the exhibition and catalogue in an attempt to clarify the contribution the exhibition seeks to make to our evolving understanding of this ancient work of art and the effect it has had in our own time. One of our key goals is to look more closely at the Italian

contexts of the Villa cycle, especially those of Southern Italy. Such an attempt may throw new light on the meanings the cycle might have held for the women of ancient Campania, especially those of Pompeii. Another goal is to distinguish our own responses to the frescoes from those of viewers of the Roman period.

The exhibition and catalogue essays are concerned with some familiar questions raised by previous scholars—questions that can lead us toward a better understanding of the origins of the frieze, its iconography, and the function of the room that it decorates. But, in keeping with the efforts of current art historical scholarship to understand works of art within their sociohistorical contexts, both the exhibition and the essays in this catalogue attempt to develop a framework of "local" contexts within which to reexamine those questions and to ask some new ones. Those contexts are: geographic (the immediate geographf‡ context of the Villa of the Mysteries in Pompeii, Campania, and Southern Italy in general—ch. 3); cultural (the multicultural character of Campanian and Pompeian society—chs. 3, 6), spatial (the physical and social character of the spaces within the Villa itself and their bearing on our understanding of the frescoes—ch. 4); cultic (the various cults that women in Italy especially patronized and how their participation in multiple cults may affect the reading of the meaning of the frieze—chs. 2, 5–8); iconographic (the multiple meanings that viewers of the Villa frieze might have read into its imagery—chs. 5–6, 10–11); and artistic (the readily available visual repertoire from which the Villa imagery draws—chs. 9–10). Beyond these ancient contexts, the exhibition pursues modern and contemporary ones as well. These concern the circumstances surrounding the commission and execution of the watercolor representation of the Villa cycle by Maria Barosso in Italy of the mid-1920s (ch. 12) as well as the creation of works by artists active at the turn of the twenty-first century who draw inspiration from the ancient imagery and modern interpretations of the Villa cycle (ch. 13). Not least, by juxtaposing ancient and modern in this exhibition, we hope to increase awareness of our contemporary perspectives and how they filter our viewings of the Villa frieze and influence the very questions we ask about it. While endeavoring to understand the ancient contexts of the Villa frieze, it is essential to acknowledge that the questions we ask may well be very different from those that would have concerned ancient viewers.

PART I: WOMEN AND CULT IN ANCIENT ITALY
(CAT. NOS. 1–68)

The exhibition first explores the ancient cults and iconography connected to the Villa of the Mysteries cycle. The works of art and other artifacts shown here are drawn primarily from central and Southern Italy. They bear images symbolic of the cults that women in those regions patronized as well as images of women taking part in cult rituals. The cults they represent include those of the Greek Aphrodite, who in Italy was roughly equated with the Etruscan Turan and Roman Venus; the Greek Eleusinian deities, Demeter and Persephone/Kore, who were roughly equated in Italy with Ceres and Proserpina/Libera; the Egyptian goddess Isis, who had gained great popularity in Italy as throughout the Roman world; and the eastern Dionysus or Bacchus, who was identified in Italy with the Etruscan Fufluns and the Roman Liber.[10]

Because imagery related to the cult of Bacchus/Fufluns/Liber appears so prominent in the Villa cycle, the exhibition places special emphasis on this multicultural fertility god in Italy, especially his presence in Pompeii and the surrounding region of Campania. We explore his importance to the economic and spiritual well-being of the agricultural society of the region and to its female population in particular. Yet the cults of the goddesses just mentioned, which were also heavily patronized by women in Campania and other regions of Italy, offered some of the same benefits to women as the Bacchic cult. Among these were assistance in marriage and procreation, and in some cases the promise of protection or bliss in the afterlife.

The objects in this part of the exhibition not only illustrate that much of the imagery of the Villa of the Mysteries cycle was ubiquitous in the cultic and daily lives, as well as the hoped-for afterlives of the women of ancient Italy but also that some of this imagery could bear meanings pertinent to more than one cult. It was common for women to be active in several cults simultaneously.[11] Such pluralism in religious life and the consequent multivalency of the meaning of religious imagery suggest new approaches to thinking about the ways in which Roman viewers of the mid-first century BC through AD 79, especially women, might have understood the Villa of the Mysteries fresco cycle.

As mentioned above, one theory about the function of Room 5 in the Villa of the Mysteries is that it was a site for the performance of secret Bacchic rites. While this possibility cannot be wholly ruled out, there is a paucity of evidence to support it.[12] By comparison, in Roman Italy, an abundance of evidence shows that religious practice within private dwellings revolved around the household gods, the *lares* and *penates*, coupled with the *genius* of the *paterfamilias* and any other deities the household members particularly favored.[13] In the exhibition, a reconstructed lararium, or shrine of the household gods, serves to focus attention on how simple daily religious ritual was conducted in a Roman house, in contrast to the elaborate rites shown in the Villa of the Mysteries cycle.

Impossible though it may be to "decode" all the details of the Villa's fresco cycle, our abiding curiosity about the meaning of this ancient work does not permit us to abandon efforts to deepen our understanding of it. Nor are those efforts necessarily fruitless. In this part of the exhibition a duplicate detail of Barosso's watercolor representation of the "adornment of the bride" (fig. 1.4, group G, and color pl. III), painted at full scale, calls attention to the importance of female adornment and nuptial preparations, in daily as well as ritual life, and it allows us to offer speculations about the place of such imagery within the Villa's Bacchic cycle and more generally within the artistic and cultic traditions of Southern Italy.[14] Similarly, the central image of Bacchus/Fufluns/Liber on the east wall of Room 5 (color pl. I) is subject to fresh interpretation when considered within the context of Pompeii and the surrounding region.[15] The exhibition's attempt to examine the "local" significance of the Villa cycle suggests that further research along these lines would, indeed, be fruitful.

Women could gain social prestige through the roles they played and offices they held within cults, such as that of priestess. Although the Bacchic mysteries themselves, shrouded in secrecy even in antiquity, elude our full understanding, the organizational structure of the cult may be glimpsed through a fascinating, if partial, lens of an inscription on a

statue base from Rome (figs. 8.9–10). The inscription, which dates to the second century AD, lists the titles and names of what appears to be the full membership of a Bacchic cult. In this Bacchic organization women and men were apparently cast as characters in the drama of the mysteries. Women, of course, played the role of maenad, but there were other roles for them as well, while men played the male characters in the Bacchic entourage and held various offices too. Role-playing of this kind has important implications for the ancient viewers' understanding of images that depict Bacchic characters, implications that we must take into account as we formulate interpretations of imagery associated with the Bacchic cult as well as other cults.[16] The contexts in which those images occur are no less important. They appear not only in wall paintings but also on articles of domestic and cultic use and are often found in connection with burials. The exhibition, accordingly, includes objects that served their owners not only in their daily and religious lives but also in their afterlives.

PART 2: THE VILLA OF THE MYSTERIES FROM ANTIQUITY TO THE PRESENT (CAT. NOS. 69–114)

The first part of the exhibition focuses on the broad social and cultic contexts of the Villa of the Mysteries frescoes primarily in relation to the lives of Roman women. The material presented there prepares visitors to consider the fresco cycle as a product of its time and place and for readings of its imagery and origins that take local cultic, social, and visual traditions into account. The second part of the exhibition builds upon the first by encouraging a conscious awareness of the gap between our modern interpretations of the cycle and the ancient ones whose meanings we can never fully grasp. Modern responses include both scholarly and artistic ones, which, though usually quite different from each other in character and intent, nevertheless when brought together as in this exhibition can be mutually informative. Together, they highlight for us some of the concerns that drive modern inquiry into the nature and meaning of the Roman cycle.

This part of the exhibition focuses on the Villa of the Mysteries cycle itself—as a physical and visual entity (its setting, location, technical character, state of preservation), as a work of art in relation to other works in antiquity (some of its models as well as related contemporary Roman works), and as a source of different forms of inspiration in the present (to scholars and to artists). The Villa cycle, which we can still experience in its Pompeian setting, elicits a host of individual responses. The exhibition touches on those that are suggested by its centerpiece— the watercolor representation of the Villa cycle by Maria Barosso.

A Virtual Visit to the Villa of the Mysteries

Reconstructions of ancient monuments, though often irresistible, are problematic at best, for they cannot fully replicate their models and are, in any case, subject to the limitations of our own knowledge. Yet the terms of Francis Kelsey's commission called for a faithful copy of the fresco cycle in Room 5 that was to be exhibited at the University of Michigan as a replica of the room in the ancient Villa of the Mysteries, a

replica that would make the frescoes' imagery available to scholars for study and to the general public for its enlightenment and enjoyment. The exhibition thus fulfills the intent of the commission by presenting Barosso's watercolors as Kelsey wished them to be seen. This reconstruction can be experienced along with a QuickTime virtual walk-through of the Villa of the Mysteries, which opens the second part of the exhibition. The virtual walk-through enables viewers to orient themselves to the spaces of the actual Villa as they are preserved in Pompeii today and to approximate the way that ancient visitors, who were permitted to enter them, might have navigated through the Villa to arrive at the mural cycle in Room 5. The walk-through culminates in a panoramic viewing of the frescoes of Room 5 in their current state of preservation. Yet, beguiling though a virtual visit may be, it is an experience possible only in our own time. We cannot fully reconstitute the ancient viewers' experience. We can only imagine it. Still more removed from that of the ancient viewer is our encounter of the fresco cycle through the medium of Barosso's watercolors. Although Kelsey in the 1920s might have intended otherwise, the reconstruction presented here, more than seventy years after Kelsey's day, does not presume to recreate the ancient experience but rather to acknowledge our distance from it. The watercolors cannot, for example, inform us about the physical qualities of actual Roman wall paintings. To provide for this dimension, large as well as small fragments of Roman wall paintings of the First, Second, Third, and Fourth Pompeian styles (cat. nos. 99–103) help the viewer gauge the differences between the character of a Roman wall surface and that of Barosso's watercolor replica. They also help to situate the Villa cycle stylistically and chronologically within the Second Pompeian Style. The reconstruction also elicits consideration of ways in which our own viewings of the ancient cycle and Barosso's version of it are conditioned by concerns of our time. Among these is a concern with preservation.

Preservation of the Villa Cycle

One of Francis Kelsey's objectives in commissioning the watercolors by Maria Barosso was to provide an accurate record of the Roman frescoes in the event that they were damaged or destroyed. During his numerous visits to Pompeii Kelsey had witnessed the deterioration of many excavated wall paintings that had lain for years exposed to strong sunlight and inclement weather. The ceiling above Room 5 in the Villa of the Mysteries had fallen at the time of the eruption of Vesuvius in AD 79, so that when the room was excavated its frescoes were likewise exposed to the elements.[17] Photographs taken during and immediately after the excavation of the frescoes (fig.1.5), but before substantial cleaning had taken place, allow visitors to the exhibition to compare the paintings' state of preservation in 1909–10 with their state in the mid-1920s when they were depicted by Barosso. Even after the ceiling of Room 5 was reconstructed, the paintings seem to have suffered some further damage. Photographs, taken for the publication of Amedeo Maiuri's 1929–30 excavation of the Villa, show damage that the cycle sustained not long after the time Barosso painted her watercolors.[18] Still others taken in 1999, along with the images shown in the virtual walk-through of the Villa, document the condition of the paintings at present.

8

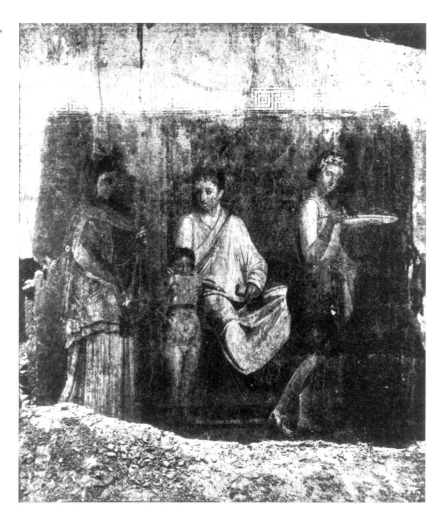

Fig. 1.5. Group A on the north wall of Room 5, as it appeared during the course of excavation in 1905. After Comparetti 1921, frontispiece.

Artistic Sources: Original or Copy?

Another consideration provoked by Barosso's watercolors and our reconstruction of Room 5 has to do with our own concern with originality and authenticity, the values we assume in connection with them, and the degrees of their appropriateness when they are applied to works of times and places other than our own. Barosso's watercolors were commissioned as faithful "copies" of the Roman "originals," and they were executed with that goal in mind. Yet it does not take much reading between the lines of the correspondence between artist and patron to realize that Barosso herself felt her efforts as a copyist were not merely mechanical but ones that required the artist's gift for capturing the likeness of her subject. Though it was an arduous assignment, she felt genuine enthusiasm for the project and was quite aware of its importance to her patron and its potential impact upon the public.[19] Indeed, when Barosso's watercolors were shown in 1926 at the Galleria Borghese in Rome, she became the first living artist to have an exhibition there. Her work was warmly received, and many Italians took a nationalistic pride in it in that it implicitly celebrated their country's ancient Roman glory. How, then, are we to assess Barosso's achievement? Certainly we can admire the faithfulness of her paintings to their model, which can be confirmed by direct comparison with the ancient frescoes. At the same time her watercolors of

9

the Villa frieze were clearly regarded by her contemporaries as more than just documents of an ancient work, to be judged only on the level of their accuracy as archaeological illustrations. The exhibition takes the broader view that, even while their accuracy as copies must be respected, Barosso's watercolors must also be considered as meaningful works in their own right, in light of their own significant history, and according to criteria appropriate to their own purpose, period, and contexts.

Taking the case of Barosso's watercolors as a point of reference, the exhibition asks a similar set of questions in relation to the Roman cycle in the Villa of the Mysteries, which has often been judged to be a faithful copy after a lost Greek model of the Hellenistic period, a model that had once existed in another time, place, and cultural setting.[20] Unlike the case of Barosso's watercolors in which the relation between the earlier model and later version of it can be concretely assessed, the nature of the relation between the frieze in the Villa of the Mysteries and a hypothetical Hellenistic Greek model cannot be determined. Accordingly, the exhibition takes a different approach to this problem. Instead of presuming a single lost model, it presumes that the frieze in Room 5 was created specifically for that room by drawing upon a widely shared repertoire of figural and compositional prototypes. The exhibition presses this line of inquiry further than others have by focusing on those prototypes that would have been available more or less locally to the designer of the frieze. Our "local" range may be described in concentric terms, beginning at Pompeii and moving outward in successive "rings" to the immediately surrounding territory of Campania, the territories of Southern Italy and Sicily, primarily those of Magna Graecia, and central Italy. Our temporal range includes the late fifth century BC to the second century AD, but it concentrates on the years immediately preceding the creation of the frieze in Room 5 up to the time of its burial in AD 79. Although most of the visual prototypes found within these geographic and temporal zones would have been as familiar to artists all around the Mediterranean as they were to Campanian artists in the late Hellenistic period, some of them had acquired a particularly local significance. We proceed from the assumption that the patrons and viewers of the Villa frieze had cultural, aesthetic, and religious needs of their own and that the local Italian context is essential to understanding the place of the frieze in the minds of those who commissioned, painted, and viewed it.

To explore the relations of the Villa cycle to its artistic sources, the exhibition presents primarily South Italian, Etruscan, and Roman works but also some from mainland Greece and the Eastern Mediterranean. These include marble and alabaster sculptures, painted vases, engraved bronzes, wall painting fragments, terracotta figurines, cameos, and fragments of Arretine ware all illustrating styles, motifs, and (in the case of painted objects) colors and techniques similar to those found in the Villa frieze. This rich matrix of images, which also includes those shown in the first part of the exhibition, illuminates for the visitor the visual resources the designer could have drawn upon in creating the cycle for the Villa room. Moreover, it suggests the range of signs and symbols that ancient viewers of the cycle would have been able to draw upon in interpreting its meaning for themselves. This repertoire of readily available imagery and the way the composition of the cycle complements the architecture of the room (as visitors to the exhibition can observe in part from the reconstruction of Room 5) suggest that we should not assess the Villa cycle simply as a copy after a single, now-lost Greek source

monument. Instead, the South Italian, Etruscan, and Roman objects in the exhibition help us to appreciate the Villa cycle as a monument closely tied to its immediate cultural environment. In our exploration of potential visual and iconographic sources for the Villa cycle, the Barosso watercolors serve as a surrogate visual reference for comparing the imagery of the Villa frieze with that of the ancient works on exhibit.

The Question of Authenticity

Not only does the exhibition challenge the theory that the Villa frieze copies a single lost Greek model; it also calls into question some of the values that have led many twentieth-century scholars and other observers of the frieze to adopt the copy-theory in interpreting its origins and meaning. In fact, we cannot easily apply our modern values concerning originality in art, an idea that originates in the Renaissance, to the ancient artists' situation. The artistic as well as social practice in Roman antiquity encouraged building selectively upon the models and lessons of the past in the spirit of improvement and creative emulation. This turn of mind, along with the value Romans placed on *decorum*, or appropriateness, in aesthetic as well as other matters, led to the perpetuation of visual images that artists and viewers would interpret ever anew.

Building upon these considerations of copying and creative reuse of older models, the exhibition includes a few works that are either copies of known ancient prototypes (cat. no. 105) like Barosso's watercolors or are of uncertain authenticity (cat. nos. 63, 79, 104). Such works call attention to the claims we make for the authority of authenticity. They invite viewers to ponder a range of motives for making those claims (e.g., aesthetic and monetary, among others) and how they affect our responses to antiquities. Are these works significantly devalued if they are modern rather than ancient?[21]

Contemporary Artistic Responses to the Villa Frieze

The final part of the exhibition presents a range of very recent artistic response embodied in the work of six artists who have created intensely personal interpretations inspired by the ancient frieze.[22] Interestingly, five of the six artists are female, and four of them chose to work on a monumental scale.[23] Ruth Weisberg's *Initiation* (fig. 13.2; cat. no. 111), one of two versions, is a 28-foot scroll with images that recreate the figural groupings of the Villa frieze but portray herself, her daughter, her son, and their friends enacting a series of contemporary rituals. Her dreamlike interpretation of the frieze effectively connects us to its actors through the layers of intervening history. Patricia Olson's work, *The Mysteries* (color pl. 4; fig. 13.1; cat. no. 108), comprises five triptychs (three of which are in the exhibition), a diptych, and a multimedia piece. Her work recreates some of the figural types and the sequence of their arrangement on the Villa frieze in an exploration of her own creativity as an artist and woman. Sarah Belchetz-Swenson's *Rites* is a work in three parts comprising twenty-two pieces in three media, oil painting, lithography and monoprint. A selection of eight representative pieces is shown here (figs. 13.3–4; cat. no. 106). Belchetz-Swenson, like Weisberg and Olson, appears in her work along with portraits of people close to her—her

11

daughters and an elderly neighbor—each in individual panels that monumentalize them as they are caught in postures reminiscent of those of the women on the Villa frieze. The mother-daughter subjects in this artist's work incorporate an Eleusinian element, which she finds in the ancient frieze. Eleanor Rappe (cat. no. 109; fig. 13.5) has also painted a series of works related to the Villa frieze, three triptychs, one of which, *Rothko in Pompeii: Seeing Red!*, is in the exhibition. The series is in part an homage to Rothko, her teacher, but it also incorporates many personal symbolic references that reveal the artist's individual response to the frieze.

These large works stand in contrast to the small pieces by Kat Tomka (fig. 13.6; cat. no. 110) and Wes Christensen (figs. 13.7; cat. no. 107), which reinterpret particular details of the Villa frieze. Tomka is interested in the idea of time and in how to explore it poetically. *Satyr*, a mixed media piece that draws upon groups C and D of the Villa frieze (fig. 1.4), presents both a blurred vision of its ancient source in the drinking satyr of group D and a binocular vision of time versus eternity in the eyes of the terrified woman in group C. Christensen's allegorical response to the frieze is represented in the exhibition by three miniaturistic works. *Confabulation* reinterprets three satyr and silenus figures of group D and *Turnstile* the winged demon of group E. A third work, *In the Second Style*, shows Ruth Weisberg at work on a version of *Seer* (cat. no. 111), a woman in a posture reminiscent of the terrified woman in group C of the Villa frieze.

Such works, which embrace the art of the past as a source of inspiration, memory, and meaning, are only now being recognized for their importance in the world of contemporary art. These artistic responses to the Villa of the Mysteries cycle remind us of the continuing power of this ancient work to challenge us to determine our position in relation to it.

1 The first official publication of the discovery of the room is that of De Petra 1910. The room containing the figural frieze is designated as no. 5 on the plan in fig. 1.2 in the present volume. The Villa itself is located about a quarter of a mile from the Herculaneum Gate of Pompeii. Situated upon a hill between the Superior (Upper) Road and the Herculaneum Road, and oriented off the Superior Road, it is among a handful of extraurban villas scattered along these roads. The principal east-west orientation of the Villa of the Mysteries both conforms to the irregular terrain of the landscape and takes advantage of the view of the coastline and Bay of Naples to the west. (Comments on the location and orientation of the Villa are contributed by B. Longfellow.)

2 Both the composition and the viewer's attention vacillate between the immediate focal point of the east wall—the god reclining in the lap of his female consort, which is directly opposite the main entrance to Room 5 (see fig. 1.4, group D)—and an implied sequential narrative that either begins on the north wall to the entering viewer's left (fig. 1.4, group A) and proceeds clockwise around the room or combines a clockwise and counterclockwise reading, each beginning at the western entrance and culminating in the middle of the east well. In addition, a number of figures on the frieze appear to be gazing across the room, or across corners of the room, at other figures on the frieze, thus creating yet another set of directional signals for the viewer. See Clarke 1991, fig. 33.

As for the subject of the frieze, most scholars believe it represents the god Dionysus/Bacchus and members of his divine entourage with women enacting rites associated with the Bacchic cult—either a female initiation into the mysteries (first proposed by De Petra 1910) or a revelation of mysteries as part of bridal initiation rites (first articulated by Bieber 1928). Others have opposed the latter interpretation (see, for example, Nilsson 1957; Brendel 1980; Little 1972, and additional scholars mentioned in ch. 6 by D. Wilburn in the present volume). Still other interpretations claim that the frieze represents episodes from myth, perhaps events from the life of Dionysus/Bacchus (Baldwin 1996) or the immortalization of Dionysus and his mother, Semele (Sauron 1984; 1998). Yet others suggests that the frieze was inspired by theatrical performance

and that it represents a Dionysiac pantomime (Bastet 1974; Kuttner 1999). I am grateful to B. Longfellow for her assistance with this bibliography. Further commentary on the historiography of the interpretation of the frieze may be found in Sauron 1998.

3 This plan is based on that of D. Comparetti (1921).

4 Most scholars consider the frescoes to belong to the Second Style of Pompeian wall painting, also known as the "architectural" style, which entered the wall painter's repertoire in the first century BC. See the brief introduction to Roman wall painting styles that precedes cat. no. 99 in the catalogue section of this volume. Some scholars believe the frescoes in Room 5 of the Villa of the Mysteries date to the Augustan period (e.g., Maiuri 1953). In this exhibition we have adopted the majority view. The overall illusion of three-dimensionality in the architectural elements—the pilasters, the blocky podia beneath some of the figures, and the shallow ledge on which all of the figures appear to be placed—although not entirely consistent, seems more like that of Second Style painting than Third or Fourth Styles. The precise dating of the Villa cycle within the decades of the first century BC when the Second Style was most fashionable is difficult to gauge. The exhibition and catalogue adopt the dating of Barbet (1985, 37–40), who proposes the range of 60–40 BC for the second phase of the Second Style. She places the paintings of the Villa of the Mysteries toward the early end of that phase. Kuttner (1999, 107) places them even earlier, around 80 BC.

5 See Sauron 1998 for his theory about the meaning of the cycle to the *domina*, or *materfamilias*, of the Villa. Compare ch. 4 by B. Longfellow in this volume.

6 See ch. 4 by B. Longfellow and ch. 10 by S. Kirk in this volume for further discussion of some of these theories.

7 See ch. 12 by E. de Grummond in this volume for a discussion of the history and intent of this commission.

8 Barosso's work was not yet complete at the time of the exhibition in Rome. As the photograph of the installation shows, the completed sections were hung separately on the gallery walls, not assembled as a replica of the room in the ancient Villa. One of Barosso's versions of the seated "bride" (fig. 1.3, group G) was shown in connection with the exhibition "Pompeii as Source and Inspiration: Reflections in Eighteenth- and Nineteenth-Century Art" (The University of Michigan Museum of Art, Ann Arbor, April 7–May 15, 1977). Barosso's version of the long north wall of Room 5 (groups A–C) was shown in the exhibition, "In Pursuit of Antiquity: Thomas Spencer Jerome and the Bay of Naples (1899–1914)"(Kelsey Museum of Archaeology, Ann Arbor, September 20–December 18, 1983).

9 See the study of J. Henderson 1996. A study by A. J. T. Williams of the Open University, Milton Keynes, on the critical, artistic, and general reception of the Villa frieze since 1909, is in progress (personal communication from the author).

10 See the discussions in chs. 2 and 6 by D. Wilburn and ch. 5 by C. Hammer in this volume.

11 See the discussion in ch. 5 by C. Hammer in this volume.

12 Plutarch's story about the performance of the secret rites of Bona Dea by women in a private house in Rome during the period of Julius Caesar suggests that the performance of Bacchic rites in the Villa of the Mysteries cannot be ruled out entirely (Plut. *Caes.* 9–10). See ch. 4 by B. Longfellow in this volume on the lack of evidence for such a use of Room 5.

13 On the Roman domestic cult, see ch. 7 by M. Swetnam-Burland in this volume.

14 See ch. 10 by S. Kirk and ch. 11 by B. Longfellow in this volume.

15 See esp. ch. 6 by D. Wilburn and ch. 7 by M. Swetnam-Burland in this volume.

16 This theme runs throughout the essays in this volume. See esp. ch. 5 by C. Hammer, ch. 8 by E. de Grummond, and ch. 10 by S. Kirk. See also Kuttner 1999.

17 The frescoes were discovered in April of 1909, but it was not until October of that year that a roof was placed over them. I owe this information to Bettina Bergmann.

18 See Maiuri 1931 and subsequent editions.

19 See ch. 12 by E. de Grummond in this volume for a detailed discussion of the project.

20 See ch. 9 by J. M. Davis in this volume.

21 Another large-scale replica of the Villa of the Mysteries frieze, painted by Eric Hebborn, hung for many years on the walls of a dining room in the Palazzo Guidi on Piazza Paganica in Rome. Hebborn was known as a forger of many different artistic styles. In his version of the frieze he included portraits of people he knew. Unfortunately, the present whereabouts of the panels is unknown. Hebborn eventually removed them from the Palazzo Guidi to Anticoli Corrado, where his studio was located. He was murdered in Rome a few years ago. I am grateful to Robert Brentano, Joan Ferrante, John Clarke, and Richard Brilliant for this information.

22 See ch. 13 by D. Kirkpatrick in this volume.

23 John Clarke has recently brought to my attention a large-scale project by Victoria Star Varner of Southwestern University in Georgetown, Texas.

13

2 The God of the Vine:
A Note on Nomenclature
Drew Wilburn

While this exhibition concerns itself with the Villa of the Mysteries and the ancient as well as modern reception of the megalographic frieze in Room 5, numerous other scholarly issues lie just beneath the surface. One of the many that we as a group encountered seemed, at first, a simple problem: What do we call the god in the frieze? In the ensuing months of research, we considered various possibilities. Much of the previous scholarship on the frieze in Room 5 refers to the god as Dionysus or Bacchus. It is, however, a primary goal of this exhibition to situate the frieze within its many-layered, multicultural context—in Pompeii, in Campania, in Italy, in the classical past, and in the present. The choice of a name for the god, which varied from one period and culture to another, was therefore significant. Ultimately we determined, in both the catalogue and the exhibition, to refer to the divinity by whatever name the context under discussion demanded.[1]

Modern scholarship increasingly recognizes discrepancies between conceptions of the often very similar Greek and Roman divinities and the problems inherent in a simplistic one-to-one correlation between them. The name chosen for a particular divinity carries a meaning beyond merely signifying the general sphere of influence of the god or goddess in question.[2]

In the case of the god of the vine, this problem is further complicated by his multiple personas as the god of the theater, the mask, fertility of the fields, and the Bacchanal. There is also a discrepancy between the names used in the Greek-speaking lands of the eastern Mediterranean and the western Greek colonies, including those in Italy, and the territories of the Latin-speaking west.

In the context of Greek cultures, the god of the vine was known as Dionysus or Bacchus, but judging from the ancient Latin sources, particularly the most prevalent and widely read ancient authors in antiquity, the Romans referred to the deity as Bacchus or Liber. The name Liber is more common in earlier writers such as Plautus. Ennius, writing in the second century BC, however, used both names, Liber and Bacchus. Late Republican and Augustan writers also used both names; a passage from Ovid (*Met.* 4.9–17) is highly instructive:

> Parent matresque nurusque
> Telasque calathosque infectaque pensa reponunt,
> Turaque dant Bacchumque vocant Bromiumque Lyaeumque
> Ignigenamque satumque iterum solumque bimatrem:
> Additur his Nyseus indetonsusque Thyoneus,
> Et cum Lenaeo genialis consitor uvae,
> Nycteliusque Eleleusque parens et Iaccus et Euhan,
> Et quae praeterea per Graias plurima gentes
> Nomina, Liber, habes.

> The matrons and the young wives all obey, put by weaving and work basket, leave their tasks unfinished; they burn incense, calling on Bacchus, naming him also Bromius, Lyaeus, son of the thunderbolt, twice born, child of two mothers, they hail him as Nyseus also, Throneus of the

unshorn locks, Lenaeus, planter of the joy-giving vine, Nyctelius, father Eleleus, Iaccus, and Euhan, and all the names still more by which thou art known, O Liber, throughout the towns of Greece.[3]

Ovid is clearly comfortable using Bacchus and Liber interchangeably. The use of the name Bacchus, however, is more prevalent among the poets, who wrote in a genre in which varied means of expression, references to the Greek literary tradition, and metonomy were prized. Yet Livy, Varro, and Vitruvius, all writing during the first century BC and the first century AD, use the name Liber almost exclusively.

Inscriptional evidence from Italy as well suggests that the god was frequently invoked by the name of Liber. For example, a Republican inscription from Aquinum (*CIL* 10.5422) mentions Aquinas, presumably a local man, as a priest of Liber.[4] The name Liber continues in use well into the Empire, as an inscription from Ostia attests: in the tomb of P. Aelius Maximus, an image of a young god carrying a thyrsus is inscribed above with the words Liber Pater.[5]

In this volume, the name Liber or Bacchus/Liber is used most frequently, as most of the chapters are concerned with the deity as manifested in Campania and Italy under the late Roman Republic and Empire. The name Dionysus, however, is used for discussions of the god in the context of the Greek colonies in Magna Graecia and in other particularly Greek contexts. Although this culture-specific nomenclature may create some confusion for the reader, we believe that it is appropriate to our attempt to understand the imagery of the Villa of the Mysteries cycle and other works in the exhibition in relation to their proper historical contexts.

1 See chs. 3 and 6 by D. Wilburn and ch. 7 by M. Swetnam-Burland in this volume.

2 The Romans, especially, frequently particularized certain aspects of their divinities through a multiplicity of names, so that Jupiter in his triple-*cella* temple on the Capitoline Hill was known as Jupiter Optimus Maximus, Greatest and Best, while Jupiter in another nearby temple was Jupiter Tonans, Jupiter the Thunderer, dedicated by Augustus after he escaped a bolt of lightning, and Jupiter in the temple of Jupiter Feretrius received the spoils of certain wars. (Richardson 1992, 219 and 226. Augustus claimed that Jupiter Optimus Maximus sent a dream in which the god chided the emperor because increased worship at the temple to Jupiter Tonans was reducing the number of suppliants at the central temple on the Capitoline hill.)

3 Trans. Miller 1929, 179.

4 Schur 1926, 73.

5 Calza 1928, 20–21.

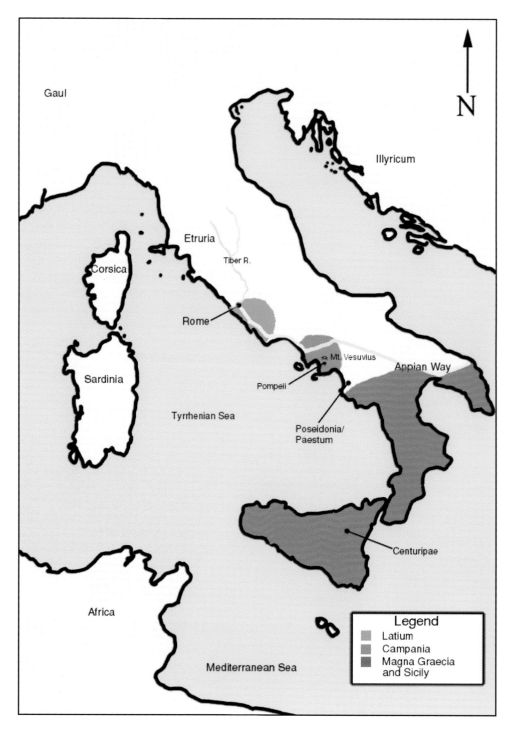

Fig. 3.1. Map of the Italian peninsula showing Latium, Campania, and Magna Graecia.

3 The Geography and History of Campania and Pompeii

Drew Wilburn

> In what terms to describe the coast of Campania . . . with its blissful and
> heavenly loveliness, so as to manifest that there is one region where nature
> has been at work in her joyous mood! And then again all that invigorating
> healthfulness all the year round, the climate so temperate, the plains so
> fertile, the hills so sunny, the glades so secure, the groves so shady! Such
> wealth of various forests, the breezes from so many mountains, the great
> fertility of its wheat and vines and olives, the glorious fleeces of its sheep,
> the sturdy necks of its bulls, the many lakes, the rich supply of rivers and
> springs flowing all over its surface, its many seas and harbors and the
> bosom of its lands offering on all sides a welcome to commerce, the
> country itself eagerly running out into the seas as it were to aid mankind.
> (Pliny *HN* 3.40-41, trans. Rackham 1942, 33)

As Pliny eloquently attests, Campania was an exceptionally fertile region
of Italy (fig. 3.1), which provided an abundance of arable land for its
inhabitants, as well as numerous natural harbors and ports facilitating
trade and transport.[1] Not surprisingly, the region and its fertile soil, rich in
the minerals of volcanic eruptions, attracted many conquerors and
colonizers in antiquity. From a region inhabited by indigenous peoples to
one occupied by a succession of settlers of various ethnic and cultural
backgrounds, the area ultimately fell under Roman rule and was fully
incorporated into the Roman state. Like Campania in general, the city of
Pompeii was subject to a broad range of ethnic and cultural influences,
influences that played an important role in the development of art and
architecture in the city. This chapter provides a brief overview of the
history of Pompeii in the context of Campanian history as background for
other chapters in the volume that address interchanges among the religious
and artistic traditions in the region, for these bear on the problem of reading
the megalographic frieze in Room 5 of the Villa of the Mysteries.

There are no boundary stones to define the region the Romans called
Campania. References by ancient authors can assist in outlining the
approximate extent of the ancient *ager*, but the region cannot be defined
with any precision.[2] In antiquity, all of the cities near the Bay of Naples
were considered part of Campania. Polybius (3.91) suggests that Cales
marked the northern border of the region and Nola the southern border.
The Volturnus River and Mount Tifata formed natural barriers to the
north, the Mediterranean Sea to the west, and the Samnite Mountains to
the east and south.

INDIGENOUS PEOPLES (FIG. 3.2)

Modern archaeological research has shown that the main settlements of
the region were founded in the ninth century BC, probably by peoples
from the region historically known as Etruria. Cremation rites similar to
those of the Villanovan cultures of central and Northern Italy were
practiced in the early Iron Age in Campania.[3] One of the major settle-
ments in Campania was Capua, which was inhabited in this period by a
people known to modern historians as the Opici or the Ausones.[4] These

people traded with the Greek colonists who arrived in Campania. Indeed, Greek products have been found among the grave goods of the Ausones-Opici. But once the Greeks established the colony of Cumae in the seventh century BC (see below), many of the Ausones-Opici and indigenous peoples were displaced from their lands. Most moved inland and established themselves on the western slopes of the Apennine Mountains. They later intermarried with the Samnites resident on the eastern side of the mountains, and the two cultures became fused. On the western coast, the fertile fields of the Campanian plain fell under the sway of the Greek colonizers.

The city of Pompeii may also have been the site of an Iron Age settlement, as has been suggested by recent excavations in the House of Joseph II, located in Regio VIII.[5] It seems likely, in fact, that many of the later Greek, Etruscan, and Roman cities of Campania were initially, because of their strategic locations, inhabited by indigenous peoples of the region. These sites require further excavation, however, before the full sequence of their early histories can be known.

COLONIAL GREEKS (FIG. 3.2)

Greek presence was established in the area in the first half of the eighth century BC, when Greeks from Euboea founded a trading station at Pithecussae on the island of Ischia. A more permanent settlement, the city of Cumae on the coast of the Italian mainland, was founded around 640 BC.[6] The population of Cumae grew in the years following, probably through a combination of new settlers and intermarriage with the indigenous peoples of the region. Greek civic expansion continued throughout the seventh century and well into the sixth, so that by 500 BC, the cities of the Campanian coast each controlled substantial agricultural areas within the indigenous territory.[7] By the end of the sixth century BC, Cumae was an important *polis*, or city-state, in the Campanian region, on a par with the city-states of mainland Greece and other Greek colonies of the region of Southern Italy, known as Magna Graecia.

The swampy basin of the river Sebethus, which lies to the south of Naples, seems to have acted as a natural boundary to Cumae's cultural influence. South of this river basin lies the city of Pompeii, which may or may not have been home to Greek settlers during the period of Greek colonization.[8] Certainly, the Greeks were influential in the city by the sixth century BC, when a city wall and the first temple of Apollo were built in the Greek style.

Herculaneum, located to the northwest of Mount Vesuvius, was probably founded by the Greeks prior to the fifth century BC. The rigidly orthogonal plan of Herculaneum is a hallmark of Greek city planning.[9] Both cities probably acted as independent city-states during the early period of their existence.

ETRUSCANS (FIG. 3.3)

As early as the eighth century BC, Greeks resident in Campania were active trading partners with the Etruscans. By the middle of the seventh century BC, according to Polybius and Strabo, Etruscan control extended over the entire Campanian plain but did not include the territory

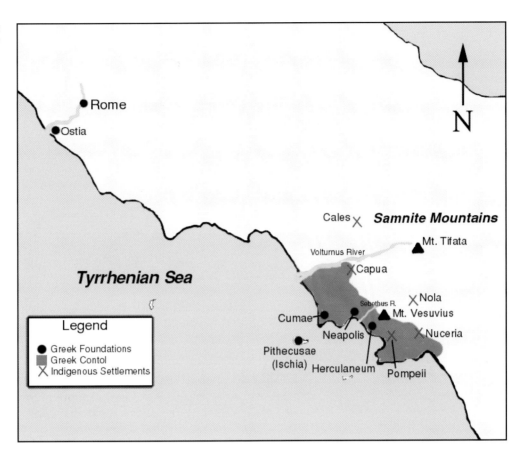

Fig. 3.2. Map of Campania and Rome showing positions of earlier indigenous settlements and the area of Greek colonial control, seventh/sixth centuries BC.

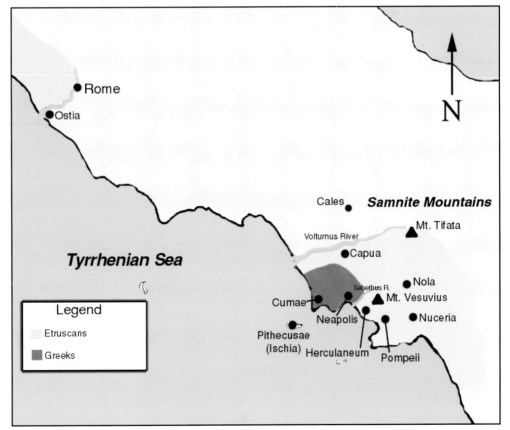

Fig. 3.3. Map of Campania and Rome showing the Etruscan presence in the area, sixth century BC.

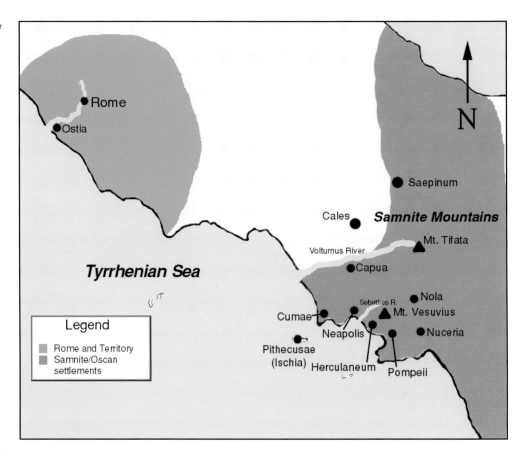

Fig. 3.4. Map of Campania and Rome showing Roman territory and Samnite and Oscan settlements, fifth/ fourth centuries BC.

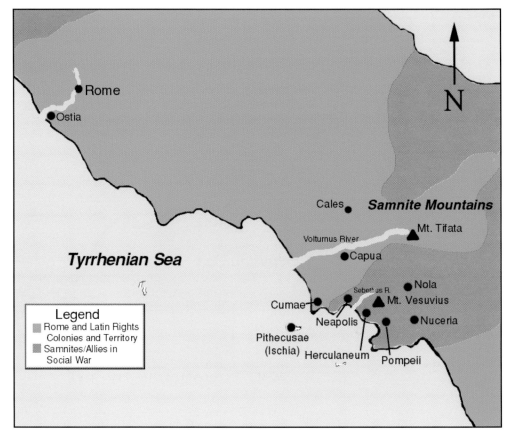

Fig. 3.5. Map of Campania and Rome showing Rome and its allies and the rebellious Italian cities of the Social War, 91–89 BC.

adjacent to Cumae.[10] The bulk of the archaeological evidence for Etruscan domination comes from mortuary remains. A number of very wealthy late seventh-century graves are similar in contents to burials in Etruria proper. The prevalence of Etruscan material, especially black-slipped pottery known as bucchero, in both Greek and indigenous graves from this period onward suggests trade between the Greek colonists and Etruscans. It seems probable that Etruscans and Greeks were living side by side in Campania during the eighth through the sixth centuries BC, and various local communities, including Pompeii, could have been subject to Etruscan rule at this time. Evidence on Etruscan presence in the city of Pompeii in this period is limited. Although Etruscan bucchero pottery has been found at the site, the town plan and architecture remained essentially Greek.[11] Likewise, ancient literary sources do not document any changes. Nonetheless, the presence of both Greeks and Etruscans in the region of Campania suggests that the cultural influences of both groups are likely to have been felt at Pompeii.[12]

An Etruscan presence in the area came to an end with the defeat of the combined forces of the Etruscans and Carthaginians by the Greeks off the coast of Cumae in 496 BC, but nonetheless it seems likely that the inhabitants of the region continued to interact with their northern Etruscan neighbors through trade. Indeed, Etruscan materials are found at numerous archaeological sites during this and later periods.[13]

SAMNITES (FIG. 3.4)

At the end of the fifth century BC, the Samnites, who lived in the eastern part of the Italian peninsula, began to encroach upon Campania. Ethnically and linguistically Oscan, they were Sabine in origin. In 423 BC, the Samnites, who had taken the name Campani, seized the Etruscan city of Capua. Two years later, Greek Cumae fell to the Samnites (421 BC), and soon many other cities came under Samnite control.[14] By the time of the second Samnite War with Rome (343–341 BC), Pompeii was also a Samnite city, apparently in the sphere of influence of nearby Nuceria.[15] During their control of the region, the Samnites were apparently concerned not with destruction of earlier occupied areas but rather with the acquisition of agricultural territories. They controlled Pompeii throughout the Hellenistic period, and many Pompeians seem to have adopted the Hellenistic style in private and public construction, most notably the gymnasium and theater, both built during this period.[16] The city experienced considerable growth at this time, mostly through profitable trade in wine and oil from the region.[17]

Historical sources for the Samnites provide little information about their culture. The most abundant material is archaeological and derives from sites such as Saepinum, which had a long period of Samnite occupation. Often, scholars have relied on epigraphic evidence and cultural analogy with other Italic peoples for constructing models of Samnite culture.[18]

ROME AND CAMPANIA (FIG. 3.5)

Interaction between the areas of Rome and Campania had been long-standing. In the fourth century BC, Campania became involved in

territorial struggles between the Romans and the Samnites. In 326 BC, Rome concluded a treaty with Campania promising military aid and, in doing so, became further embroiled in the conflict. Over the course of the three Samnite Wars, fought for control over the eastern portion of the Italian peninsula, Romans slowly encroached upon Samnite territory in Campania and achieved complete political domination with their victory over the Samnites in 290 BC. The cities of Campania were incorporated into the Roman state as nominally free *municipia*, each city managing its own affairs separately from its Roman conquerors but obligated to provide troops to the Roman state.

Toward the beginning of the second century BC, Livy records that a crisis arose in Campania that required action by the Senate. This was known as the Bacchanalian Conspiracy, which was perceived as a threat by the Roman Senate to Rome's traditional morals.[19] In vigorously suppressing what the Senate judged to be immoral cultic activities, Rome was able to bring the cities of Campania even more firmly under its control and to monitor the local magistrates of the nominally free city-states of Italy. After the suppression of the Bacchic cult, the Campanian region was drawn further and further into the orbit of Rome.

In 91 BC, during what is termed the Social War, a number of Italian cities revolted and demanded the right of Roman citizenship for Italians who met the legal property requirements. Pompeii was among the first to side with those in rebellion.[20] The Roman general Sulla laid siege to Pompeii and after the conflict settled a large number of his veterans in the city.[21] By the end of the Social Wars in 89 BC, Pompeii had become a Roman city, and its citizens were able to vote in Roman affairs. Two years later, in 87 BC, Roman citizenship was extended throughout Campania.

The Roman colonists altered the urban landscape of Pompeii in a number of ways. One of the most significant changes was within the area of the forum, where the Samnite temple of Jupiter was refurbished as a Capitolium, with its three *cellae* dedicated to Jupiter, Juno, and Minerva, analogous to the temple of these deities on the Capitoline Hill in Rome and symbolic of Pompeii's status as a Roman colony.[22] An altar, dedicated to Apollo and installed in his temple, was inscribed in Latin, providing a clear signal of reorientation away from the Samnite past of the city.[23] At this time, a number of other civic structures were completed or constructed in other parts of the town, including the *comitium*, or meeting place, a temple to Venus, the patron goddess of the city, an odeon, or recital hall, and an amphitheater.

Although no study has been undertaken to isolate the houses owned by the new colonists, the new residents do not seem to have made dramatic changes in the placement of residential areas.[24] Decorative motifs used in architecture drew from the Hellenistic repertoire common throughout the Mediterranean, and aesthetic trends built upon those established earlier. About three decades after the Pompeians were enfranchised, Room 5 of the Villa of the Mysteries received its monumental painted décor. The citizens of Pompeii, both the older families and the new Roman colonists, the hellenized Samnites and the veterans of the Roman army, adjusted to a newer way of life within the framework of the recently established Roman colony. A central goal of the present exhibition is to promote readings of the paintings that take into account this diverse background and cosmopolitan cultural milieu.

1 The author would like extend thanks to Catherine Hammer and Brenda Longfellow for their comments on a draft of the text, and special thanks to Molly Swetnam-Burland and Elizabeth de Grummond for their comments, suggestions, additional research, and editing.

2 Pliny the Elder and Polybius each provide geographic markers for the region, but their circumscriptions of Campania seem more based on the amorphous territories of Campanian cities than any lines that can be drawn by modern surveyors. See esp. Pliny *HN* 3.44.41, Pliny *HN* 3.60, and Polybius 3.91.

3 Frederiksen 1984, 135. I follow Frederiksen in referring to these people by the joined term Ausones-Opici.

4 D'Agonisto 1996, 533.

5 Carafa 1997, 16.

6 Coldstream 1994, 54.

7 Frederiksen 1984, 69.

8 Fulford and Wallace-Hadrill 1998, 129. Fulford and Wallace-Hadrill suggest that the settlement of the city was patchy at best, interspersed with a number of periods of abandonment. The entire chronology of the city has been undergoing substantial revision in recent years, based on excavations of structures previously dated to the fifth and sixth centuries BC. These buildings may instead have belonged to the second or third century BC. In addition, excavations undertaken at the edges of the supposed earliest area of the city have traced urbanization in those areas down only to the second or third century BC. Fulford and Wallace-Hadrill 1998, 143.

9 Frederiksen 1984, 88–89. The grid plan, however, was also used by the Etruscans at Marzabotto and other sites, so it is possible that the Etruscans provided the inspiration for the form of this city. On Marzabotto and Etruscan town planning, cf. Mansuelli 1979, 359 ff. and Sassatelli 1992, 38 ff.

10 Frederiksen 1984, 117.

11 The "Greekness" apparent in Pompeii and other cities of this period may reflect a Hellenistic aesthetic. See Pollitt 1986, esp. ch. 7, "Rome as a Center of Hellenistic Art," for the Roman use of Hellenistic formulas.

12 In the settlement of Pompeii in this period, Etruscan bucchero has been excavated in lower levels of I.9.10. Fulford and Wallace-Hadrill 1998 , 143.

13 Cf. Brendel 1995.

14 Based on evidence from Paestum, L. Richardson (1988, 4) suggests that there are no architectural forms at Pompeii that can be securely identified as Lucanian (Samnite).

15 Livy is the first historian to mention Pompeii, in the context of his discussion of the Second Samnite War (9.38.2)

16 Zanker 1998, 37–38, 44.

17 Zanker 1998, 32.

18 For recent work on Samnite towns, see Bispham, Bradley, and Hawthorne 2000, 23–24.

19 I discuss the Bacchanalian Conspiracy and its repercussions in ch. 6 of this volume.

20 For a treatment of the theoretical issues involved in the processes of assimilation and resistance, see Woolf 1998 and Barrett 1997.

21 Zanker (1998, 62) suggests that the colonists numbered at least 2,000 former soldiers and their families. Proscriptions and the seizure of land from residents of the town probably preceded the creation of the colony, although there is no concrete evidence for this supposition.

22 Zanker 1998, 63–64.

23 A number of texts in Latin seem to predate the foundation of the colony (Conway 1967, 1:54–55), but the Latin inscription in the temple of Apollo seems to act as an appropriation of a local shrine. Zanker 1998, 65.

24 Zanker 1998, 74.

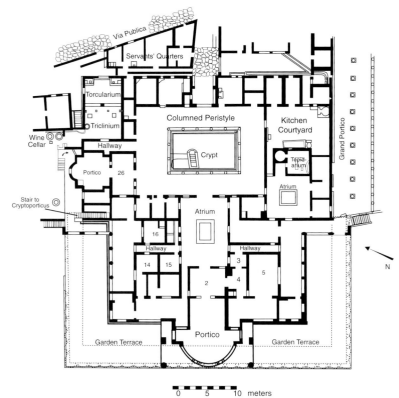

Fig. 4.1. Plan of the Villa of the Mysteries in AD 79.

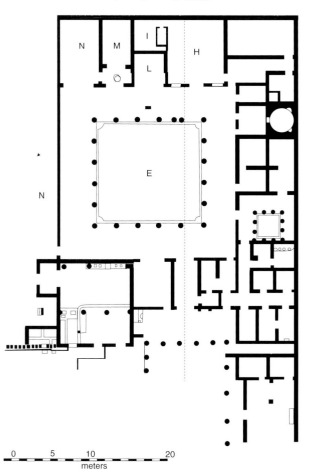

Fig. 4.2. Plan of the Villa of Publius Fannius Synistor at Boscoreale. After Barnabei 1901.

4 A Gendered Space? Location and Function of Room 5 in the Villa of the Mysteries

Brenda Longfellow

The Villa of the Mysteries, one of several known *villae rusticae* in Campania, is most famous for the extraordinary large-scale cycle of paintings located in Room 5, a room of uncertain function. Because the social functions performed in most rooms of Pompeian residences are not easily determined by archaeological remains or literary evidence, the ambiguous character of this room is neither exceptional nor unexpected.

The decoration of Room 5 has, nevertheless, generated an ongoing controversy over its likely function, a controversy driven by the possibility that the overwhelmingly female imagery of its murals echoes the function of the room itself. Thus, it has been suggested that this room, and the adjacent Room 4, were reserved for the mistress of the household and for bridal preparations.[1] Yet this reading is only one among several others, which variously suggest that the room was a nongendered reception room,[2] the main dining room of the Villa,[3] and a dining room for men.[4] In this chapter, I shall investigate the possibility that the Villa owners used Room 5 as a gendered space and consider whether the megalographic murals[5] themselves can help to determine its primary function.

In Campania, megalographic paintings occur both as monumental friezes encompassing entire rooms and as individual panels of large-scale figures within a dominantly architectural wall scheme. Even when the new finds of megalographic murals in a Roman villa at Terzigno are included, examples survive in only seven Campanian dwellings. Among the published examples, two of the best preserved are located in two extraurban villas: Room 5 of the Villa of the Mysteries (c. 60–40 BC) and Room H of the Villa of P. Fannius Synistor at Boscoreale (c. 40 BC).[6] A comparative study of these two Campanian villas suggests that there were some consistent patterns in the use of the rooms containing megalographic paintings.[7]

The absolute location and size of the rooms decorated with megalographic paintings in these two villas are easily determined by examining their floor plans (4.1–2), but to determine the patterns of use and the locations of the megalographic rooms relative to the rest of the spaces within their respective dwellings, it is useful to employ both social and mathematical analyses of the two residences. The social analysis I employ here builds upon recent interpretations of the characteristic spatial organization of the Roman house, which in turn are based on the *Ten Books of Architecture*, written in the Augustan period by the Roman architect Vitruvius. The mathematical analysis I employ is based on a methodology developed by two professors at the Bartlett School of Architecture and Planning, Bill Hillier and Julienne Hanson.[8]

Writing a few decades after the megalographic murals in Room 5 were painted, Vitruvius distinguishes between spaces or areas of a Roman residence into which persons might go uninvited (such as *atria*, *tablina*, and *vestibula*) and areas to which entrance required an invitation (*cubicula*, *triclinia*, and *balnea*).[9] Modern scholars have thus tended to classify the former as public and the latter as private areas of the Roman dwelling. Recent theories about the use of domestic space, however,

suggest that a strict binary distinction between public and private oversimplifies the patterns of room usage in typical Roman dwellings and that we must account for a wider range of gradations. According to one now generally accepted theory, any attempt to distinguish between public and private dwelling spaces must take three factors into account: the relative scale of the room, the degrees to which the architectural appointments of the room allude to those of public architecture, and the character of the room's painted decoration.[10]

Within each Roman dwelling, there were varying degrees of public and private access: typically the most public areas were closest to the main entrance, and the most private were furthest removed. The degree of freedom with which a person was able to move through the house depended on his or her social status and relationship to the head of the household. The farther a visitor was admitted into the inner recesses of the house, the greater his or her status in the eyes of the inhabitants. According to this theory, wall decoration had the role of informing visitors of the functions of various rooms and indicating which rooms were public, private, humble, or grand.[11] According to these criteria, Room 5 of the Villa of the Mysteries and Room H of the Villa at Boscoreale—which are the most elaborately decorated spaces in their respective villas and are located in parts of their respective villas farthest removed from the main entrance—would have been rooms reserved for the owners of the villa and their most important visitors.[12]

This observation can be quantified and expressed concretely by applying the mathematical model developed by Hillier and Hanson, mentioned above. This method maps out the pathways that can be taken through the spaces of a structure, using dots to represent rooms and corridors and lines to represent connections between them (figs. 4.3–4). One advantage of such morphic maps is that they allow us to discern and make direct comparisons among the patterns of movement through the various spaces in houses of different architectural plans, patterns that are not possible to document with floor plans alone. With morphic maps, the relations between spaces within each of the Roman villas can be accounted for and expressed mathematically, and the numerical values that represent the location of the megalographic rooms in relation to the exterior and to other rooms of their respective villas can be compared. This method also accounts for the general types of traffic and kinds of activities that can be expected to have occurred in the megalographic rooms. The quantified results of this type of analysis enable us to describe and interpret the spatial order, including the relative accessibility to, and relative amounts of traffic within and among, particular domestic spaces.[13]

Morphic maps, then, allow us to make direct comparisons between Room 5 in the Villa of the Mysteries and Room H in the Villa at Boscoreale. Through such maps, several overarching similarities in the respective locations of the rooms and their megalographic paintings emerge. The first is that neither of the rooms is in an easily accessible location. Not only are both spaces located toward the back—and thus most private—area of their respective dwellings, but the access routes into the megalographic rooms are limited to one or two paths, indicating that access to these megalographic spaces could easily be controlled.

The locations of these megalographic rooms can be calculated in terms of their relative distance from the entrance by counting the number of boundaries that must be crossed in order to move from the

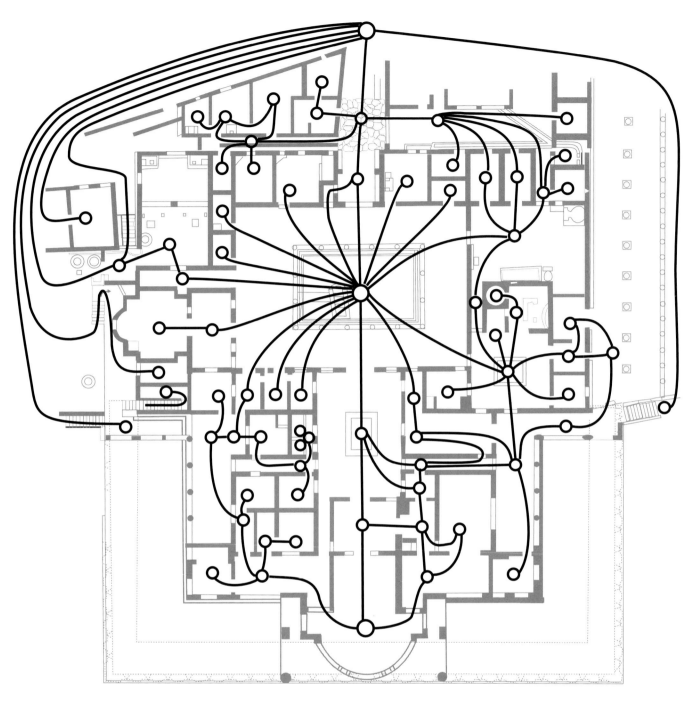

Fig. 4.3. Morphic map of the Villa of the Mysteries.

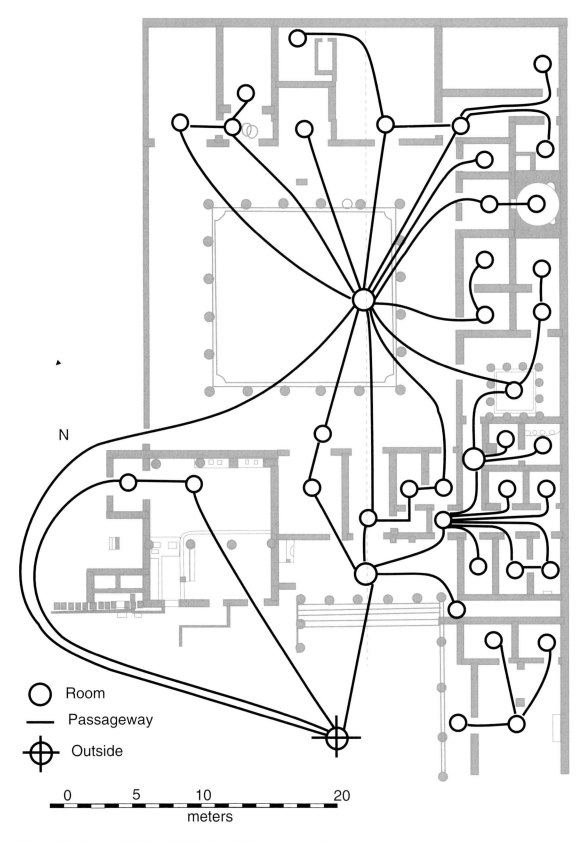

N

Room

Passageway

Outside

0 5 10 20

meters

Fig. 4.4. Morphic map of the Villa of Publius Fannius Synistor at Boscoreale.

28

exteriors of the villas to the megalographic rooms.[14] The mean depths of the megalographic rooms from the rest of the structure, which is the average distance that separates those rooms from all the other known spaces in the dwelling, can also be calculated.[15] The higher the number the more restricted the access. In both villas, the megalographic rooms are among the most restricted spaces.[16]

Thus quantified, several more striking similarities in the placement and relative locations of the two spaces become apparent. In both villas, the distance of the megalographic rooms from the exterior is considerable and confirms the visual impression that both rooms are substantially removed from the entrance. Indeed, Room 5 of the Villa of the Mysteries is one of the farthest spaces from the entrance to that villa and was thus the least accessible to visitors.[17] Furthermore, the mean depths of the two megalographic rooms from the rest of the rooms within their respective structures indicate that these particular spaces were also relatively inaccessible from other spaces within the same structure. Such an internal segregation of these spaces implies that the megalographic rooms were also somewhat inaccessible to members of the two households.[18]

The relative inaccessibility of these rooms strongly suggests that they were used only by certain inhabitants of the residences and by visitors of a sufficient status and relationship to the owner's family to be permitted so great a degree of access to the domestic space. In my opinion, these factors indicate that the megalographic paintings were specifically designed to suit the rooms and their locations and that they mark these rooms as similar in function. Even so, apart from their relatively private and grand character, little can be said with certainty about the purposes these rooms served. Because they received the most complex and opulent decoration in their respective dwellings,[19] it seems reasonable to conclude that they were the most significant rooms in the private zones of these residences.

Using Hillier and Hanson's method, it is possible to determine more precisely the kinds of activities that took place in the megalographic rooms. This can be done by examining the spaces that control access to the other areas in the residence and, in so doing, place certain limitations on the rooms they control. Such spaces are called *nodes*.[20] In the Villa at Boscoreale there are five nodes that control access to various areas, and in the Villa of the Mysteries there are six. In both the Villa of the Mysteries and the Villa at Boscoreale, the node controlling access to the megalographia is the peristyle.[21] In both dwellings, the peristyles rank highest of all the nodes in their *control value*[22] and in the degree of their accessibility.[23] These similarities indicate that the likelihood of encountering an individual in these particular peristyles is very great in the two villas. It also indicates that the same type of traffic and traffic pattern is characteristic of the two peristyles and thus of the megalographic spaces themselves.[24]

According to Mark Grahame, who adapted Hillier and Hanson's method for his own study of the House of the Faun in Pompeii, the kinds of social interaction that would have taken place in nodes such as the peristyles in these two villas probably included two types of activities involving inhabitants of the dwelling: (1) prearranged activities that take place at specific times during the day (*occasions*) and (2) impromptu meetings (*gatherings*). Most of the activities in these nodes were gatherings and, although occasions did occur, they tended to be somewhat informal.[25]

In theory, then, the farther removed a space is from its controlling node, the less accessible it will be both to visitors and to inhabitants and the less likely it is that gatherings will take place in that space. Bearing this principle in mind, we can compare the two megalographic rooms in terms of their accessibility and the categories of social interaction that took place in them. The peristyle in the Villa at Boscoreale, located at a depth of three from the entrance, is one of the nodes farthest from the exterior, a fact suggesting that although the node and its domain are still accessible to visitors, they would not have been highly frequented by people from outside the household. The same is true for the megalographic Room H, which the peristyle node controls. In contrast, the peristyle of the Villa of the Mysteries is located at a depth of only two from the exterior and is thus one of the nodes most accessible to visitors. The relatively frequent traffic of both inhabitants and visitors in the peristyle would, therefore, make it a place where inhabitants and visitors would meet one another with relative frequency. The megalographic Room 5, however, is distanced from the peristyle by four more boundaries, suggesting that it was relatively inaccessible to visitors and inhabitants alike and that even informal meetings between inhabitants in that room would probably have been prearranged.

Applied to Room 5 and Room H, Hillier and Hanson's method underscores not only the fact that these large rooms were among the least accessible to visitors but also that, especially in the Villa of the Mysteries, they were spaces limited in frequency of access by the household members themselves. In short, it clarifies that the two megalographic paintings were similarly located in spaces that functioned primarily as rooms to which only the most prestigious guests were admitted on special occasions and that such occasions most likely did not include the entire household and may have been infrequent.

The conclusion that these spaces were reserved for special prearranged occasions is supported by the character and smaller size of Room I adjacent to Room H in the Villa at Boscoreale and of Room 4 adjacent to Room 5 in the Villa of the Mysteries. In both villas, the large megalographic rooms are visually and structurally associated with the smaller, adjacent rooms by virtue of their decorative schemes, their spatial placement within the villa, and their architecture. These relationships suggest that these paired spaces in each villa should be read together as a suite of rooms that had a functional relationship as well. Storage spaces in the smaller rooms were immediately accessible from the larger ones, which suggests that the primary function of the smaller room was to serve as ancillary support for the activities that took place in the larger room. The presence of the smaller, adjacent rooms, then, supports the hypothesis that the primary function of Room H in the Villa at Boscoreale and Room 5 in the Villa of the Mysteries was for occasions that required planning.

THE FUNCTION OF ROOM 5 IN THE VILLA OF THE MYSTERIES

In the Villa of the Mysteries, the function of Room 5 as one reserved for special occasions and invited guests seems to have been intended from the beginning. Although the Villa complex was renovated several times between the period when the murals were first painted in the mid-first century BC and the eruption of Mt. Vesuvius in AD 79, the spatial

relation of this room to the rest of the Villa remained largely constant. In both c. 60 BC and AD 79, Room 5 was one of the rooms farthest removed from the entrance and least accessible to visitors. In both periods, access to Room 5 was controlled by the peristyle, and in both phases Room 5 was separated from the peristyle by several other rooms, making it unlikely that casual encounters would have taken place in this room. During the mid-first century BC, the peristyle accommodated the same sort of traffic and traffic pattern as it did at the time of the eruption, suggesting that from the mid-first century BC to AD 79 the same types of activities occurred in the peristyle and in the areas it controlled.

The use of Room 5, then, appears to have remained focused on formal occasions. But what sorts of occasions took place here? And for whom and what purposes were they held? Thus far, I have suggested that the primary activities in this room involved only the most prestigious guests, occurred infrequently, required preplanning and an ancillary room with provision for storage, and were segregated from the everyday life of the Villa. With these factors in mind, I shall now evaluate the plausibility of three modern theories regarding the primary function of Room 5: (1) that along with Room 4 it formed the master suite of the Villa, which consisted of a *triclinium* and a bedroom, (2) that it was a dining room for men, and (3) that it was a space for bridal preparations.[26]

Andrew Wallace-Hadrill has suggested that Room 5 formed the master suite of the Villa along with Room 4 and that this suite consisted of a large *triclinium* and a bedroom.[27] He argues that Room 4 functioned as a bedroom because of its proportions and because it contains two rectangular recesses typically associated by modern scholars with bed or couch alcoves. Although their spatial and decorative relationship indicates that these two rooms functioned as a suite, I believe that it is difficult to prove either that Room 4 was a bedroom or that Room 5 was definitively a *triclinium* in any of the Villa's phases.

During the last phase of the Villa, both recesses in Room 4—recesses that most modern scholars tend to read as sleeping alcoves—were pierced with doorways, an architectural change that indicates that the recesses were not demarcated as sleeping alcoves at that time. In addition, no archaeological finds, such as a bed, were associated with this room at the time of the eruption. Moreover, as Penelope Allison has convincingly argued, there is no direct relation between the existence of alcoves in certain rooms and archaeological evidence of bedding.[28] Indeed, not only are there many alcoved rooms entirely lacking any evidence for bedding, such as Room 4 in the Villa of the Mysteries, but there are also many beds found in rooms without alcoves. The only bed in the House of the Prince of Naples, for instance, was found in Room M, a room with megalographic paintings but no alcoves. Thus, the presence of alcoves cannot prove that such a room is a bedroom. When Room 4 in the Villa of the Mysteries was originally decorated with its Second Style paintings in the mid-first century BC, the alcoves of this room were intact and decorated in a manner similar to that of Room 5, with figures against a red background. It is quite possible that during this building phase Room 4 was used as a bedroom, but we do not have any evidence either to prove or disprove that it was. The presence of a cupboard in Room 4 directly opposite the door between Rooms 4 and 5, which was there from the time the walls of Room 4 were painted, suggests to me that the primary function of Room 4 in all its incarnations was to

provide support for and/or coordinate with the activities that occurred in Room 5, whether Room 4 was a bedroom at one time or not.

Wallace-Hadrill's identification of Room 5 as a *triclinium* is also problematic. Lacking any identifying archaeological evidence from this room, it is impossible to distinguish between its social use as either a dining room or a reception room, let alone to distinguish the type of dining room it might have been.[29] Nor is it possible to characterize this particular room as an *ala, exedra, oecus, cubiculum, cenaculum,* or *pinocotheka,* all of which Vitruvius, Varro, and/or Pliny identify as types of rooms within Roman residences.[30] Without specific texts or archaeological finds relating to the spaces in the Villa of the Mysteries, it is possible only to say that the size, placement, and decoration of the room suggest that Room 5 probably served as the most opulent "private" reception room and/or dining room of the Villa.

The use of the iconography of wall paintings to establish the function of a room in a domestic context requires considerable caution, and as a method it has been justly criticized.[31] The interest in the function of Room 5, however, derives primarily from its paintings, so it is necessary to consider how much of a role they might play in ascertaining the activities that occurred in the room. If Wallace-Hadrill is correct that the decoration of a room worked together with its size and its architectural embellishments to signal its function, then the paintings must be taken into account, though they cannot stand alone as evidence for the use of the room. Indeed, it would be unwise to claim that they have no relation at all to the function of the room. At the very least, the paintings must have seemed generally suitable to the primary function of Room 5, just as marine motifs often embellished *balnea* and still lifes of food were sometimes incorporated into Pompeian dining rooms. The Roman concern for decorum, or appropriateness, in aesthetic matters would have dictated as much.[32] The megalographic frieze of Room 5 was an integral part of the room's environment, and as such it must have been deemed appropriate for activities carried out within the room.

Lawrence Richardson, Jr., reads the suite of rooms as a pair of gendered dining rooms, with Room 5 being a larger dining room for men and Room 4 being an adjacent, smaller dining room for women.[33] His theory, however, does not consider the role of the painted decoration in reflecting the function of the room. Although the Bacchic decoration is suitable for a dining room, the overwhelming presence of images of women and female activities in the frieze strongly suggests that Room 5 would not have been wholly restricted to men.

But could it have been limited to women? Alan Little subscribes to this view, arguing that both Rooms 4 and 5 would have been reserved for use by the *domina* and that ceremonies preparing the family's brides for their weddings would have taken place in Room 5.[34] Although Little's theory would account for the use of the room itself for special occasions and the appropriate character of its painted decoration, neither archaeological nor literary sources support the notion that Roman residential spaces were reserved specifically for one gender or the other.[35] Given the prominence—indeed, overwhelming presence—of women in the paintings of Room 5, it is tempting indeed to suggest that women dominated the use of the space. But there is no other evidence, archaeological or architectural, that can confirm this hypothesis. Without the support of ancillary evidence, the frieze alone, in my view, cannot prove

that this room was an exclusively female space. The notion that a Roman household would reserve its most opulent and richly decorated room for occasional use by women seems inconsistent with the dominant role the literary sources claim for the *paterfamilias* within the family and is not supported by the scant literary testimony available to us.[36]

Another possibility is, however, suggested by literary and archaeological evidence—evidence that points away from a binary division of male and female space toward a shared use of space by men and women. In the Roman dwelling, spaces could be diurnally gendered.[37] We know, for instance, from the literary sources and to a certain extent from the archaeological evidence of loom weights, bulk storage units, statuary, tables, fixed bases, and *lararia* that several activities took place in the atrium, including the morning *salutatio* and weaving.[38] Diurnally gendered activities may or may not have occurred in Room 5, but the fact that spaces within the Roman house were shared by both genders suggests that we should consider the possibility that the primary use of the room included both genders, either together or separately, at different times of the day or on different days altogether.[39]

In keeping with what is known about Roman society and rules of decorum in matters of decoration, the murals in Room 5 do suggest that the occasions in the room probably included women. Room 5, although not exclusively reserved for female activities, may well have been deemed an appropriate place for female gatherings, perhaps even for bridal preparations by female members of the household. Indeed, of all the known Campanian paintings, this megalographic frieze, with its seemingly overt references to bridal adornment and preparation, seems one that would most likely have decorated such a space. Yet even if such bridal events took place in this room, they would have been few and far between. The monumental character and mythological content of the mural decoration, however, remained integral to the room and its daily activities for more than a century, and so it must surely have been seen as appropriate to other activities as well. The use of Room 5 presumably varied both diurnally and daily, with one primary function probably being the reception, and perhaps feeding, of prestigious visitors, an activity that, according to the dining habits of wealthy Romans, would have included theatrical entertainment.[40] The Bacchic imagery of Room 5, presented within a shallow, stagelike setting, seems appropriate to such dining and performance activities, which would have been attended by both men and women.

APPENDIX I: ACCESSIBILITY OF SPACES IN THE
VILLA OF THE MYSTERIES (AD 79)

Space Number	Relative Asymmetry	Control Value*	Mean Depth	Depth from Entrance
1	0.1	0.86	4.39	5
2	0.078	1.08	3.67	4
3	0.075	0.75	3.53	4
4	0.104	1.49	4.54	5
5 (megalography)	0.13	0.58	5.35	6
6	0.084	1.15	3.82	4
7	0.072	0.39	3.43	3
8	0.092	0.125	4.14	4
9	0.108	0.2	4.62	5
10	0.127	0.2	5.3	6
11	0.153	0.5	6.19	7
12	0.125	1	5.28	6
13	0.122	1.45	5.07	6
14	0.148	0.33	6.03	7
15	0.107	0.2	4.64	5
16	0.105	0.78	4.58	5
17	0.087	1.25	3.97	4
18	0.107	0.2	4.64	5
19	0.075	0.0625	3.54	3
20	0.075	0.0625	3.54	3
21	0.069	0.39	3.36	3
22	0.127	0.25	5.3	6
23	n/a	1	n/a	2
24	n/a	0.11	n/a	2
25	0.104	0.5	4.49	4
26	0.074	1.0625	3.51	3
27	0.073	0.0625	3.48	3
28	0.075	0.0625	3.54	3
29	0.075	0.0625	3.54	3
30	0.133	0.2	5.54	2
31	0.133	0.2	5.54	2
32	0.075	0.0625	3.54	3
33	0.075	0.0625	3.54	3
34	0.075	0.0625	3.54	3
35	0.13	0.5	5.42	2
36	0.086	0.2	3.91	2
37	0.086	0.2	3.91	2
38	0.084	2.2	3.86	2
39	0.113	0.33	4.84	3
40	0.113	0.33	4.84	3
41	0.075	0.11	3.54	2
42	0.092	0.125	4.14	4
43	0.092	1.125	4.12	4
44	0.121	0.5	5.1	5
45	0.118	0.66	5.03	5
46	0.09	0.955	4.07	4
47	0.092	0.125	4.14	4
48–49	0.101	0.5	4.43	2
50	0.13	1.11	5.41	1
51	n/a	0.22	n/a	1
52	0.108	1.2	4.68	1
53	0.137	0.5	5.65	2
54	0.133	0.83	5.51	2
55	0.132	1.7	5.49	2
56	0.161	0.33	6.46	3
F(1)	0.075	1.31	3.53	4
F(2)	0.078	3	3.65	4
F(3)	0.078	0.53	3.64	4
F(5)	0.084	0.53	3.84	4

Space Number	Relative Asymmetry	Control Value*	Mean Depth	Depth from Entrance
P(1)	0.077	**2.205**	3.37	4
P(2)	0.124	1.08	5.203	6
P(3)	0.098	**2.66**	4.319	5
P(4)	0.098	1.86	4.35	5
P(5)	n/a	0.11	n/a	1
P(6)	0.105	0.66	4.58	4
atrium	0.056	1.173	2.91	3
peristyle	0.046	**11.475**	2.55	2
small peristyle	0.064	**4.59**	3.16	3
entrance	0.079	1.435	3.7	0
kitchen courtyard	0.067	**2.89**	3.28	3
cryptoporticus	n/a	1	n/a	1
P	0.104	**3.03**	4.53	1
R	0.099	1.11	4.36	1
large portico	0.115	1.53	4.9	6

APPENDIX 2: ACCESSIBILITY OF SPACES IN THE VILLA OF P. FANNIUS SYNISTOR AT BOSCOREALE

Space Number	Relative Asymmetry	Control Value*	Mean Depth	Depth from Entrance
1	0.092	**4.83**	2.44	2
2	0.147	0.33	3.28	3
3	0.085	0.7	2.31	3
4	0.119	**2.46**	2.85	3
5	0.157	0.125	3.43	3
6	0.155	0.625	3.41	3
7	0.155	0.625	3.41	3
8	0.157	0.125	3.43	3
9	0.157	0.125	3.43	3
10	0.165	0.25	3.56	4
11	0.227	0.25	4.53	5
12	0.177	0.2	3.75	2
13	n/a	n/a	n/a	n/a
14	n/a	n/a	n/a	n/a
15	0.105	0.827	2.63	4
16	0.119	1.08	2.84	4
17	0.181	0.5	3.81	5
18	0.212	0.5	4.28	6
19	0.147	1.33	3.28	5
20	0.119	1.077	2.84	4
21	0.181	0.5	3.81	5
22	0.125	0.077	2.94	4
23	0.108	**2.41**	2.68	4
24	n/a	0.33	n/a	1
A (outside)	n/a	0.75	n/a	0
B	0.12	**2.625**	2.82	1
C	0.099	0.78	2.53	2
D	0.103	0.28	2.59	2
E (peristyle)	0.057	**6.57**	1.88	3
F	0.173	0.25	3.69	5
G	0.173	0.25	3.69	5
H (megalography)	0.134	1.33	3.08	4
I	0.188	0.33	3.91	5
L	0.125	0.08	2.94	4
M	0.179	0.33	3.78	5
N	0.119	0.41	2.84	4
O	0.117	0.58	2.81	4

* Values in boldface indicate that the space is a node.

1 Little 1972. For a summary of several popular interpretations of Room 5 as a female space, see ch. 13 by D. Kirkpatrick in this volume.

2 There is little agreement on what kind of reception room this may be. Wallace-Hadrill (1994, 113) labels Room 5 a *triclinium* while Ling (1991, 101) and Kuttner (1999, 101) label it an *oecus*.

3 Wallace-Hadrill 1996, 114.

4 Richardson 1988, 175.

5 In his discussion of Roman wall paintings, Vitruvius (*De Arch.* 7.5.2) uses the term *megalographia signorum* to describe monumental representations of statues. According to Little (1972, 9), Vitruvius uses the phrase more specifically in reference to "a traditionally impressive style consisting of figured subjects which were based on well-known sculptural types. . . . By this combination of a technical term drawn from Greek vocabulary of painting, *megalographia*, with the Latin term for statuary, Vitruvius possibly meant to suggest a decorative adaptation to Roman taste of an already established earlier tradition."

6 The Terzigno excavations are not yet published. The four other Campanian dwellings with megalographic paintings are all in Pompeii: the House of the Prince of Naples (VI.15.7/8), the House of the Labyrinth (VI.11.9/10), the House of the Cryptoporticus (I.6.2/4), and the Casa del Sacello Iliaco. Only fragments of the original megalographic paintings remain in the three latter dwellings, and so these are not included in this study. The paintings in the House of the Prince of Naples date to the Augustan/ Tiberian period, and I have chosen not to compare them with the late Republican megalographic murals. Leach (1988, 309–60) describes certain paintings in the Villa Imperiale, the House of the Priest Emandus (I.7.7), and the Villa at Oplontis as megalographic, and there is a painting of similar scale located in Room 14 at the House of the First Floor (I.11.15). None of these paintings, however, is as large as the two dealt with in this paper.

7 This study will compare the floor plans of these two villas as they appeared at the time of the eruption of Mt. Vesuvius.

8 Hillier and Hanson 1984.

9 Vitr. *De Arch.* 6.5.

10 Wallace-Hadrill (1994) proposes a schematic model to account for the gradations of "public and private" and "humble and grand" in Roman domestic spaces.

11 Wallace-Hadrill 1994. In larger houses, the relation of wall paintings to their room functions is most apparent in the service corridors and other servile areas. Such areas tend to be physically inconspicuous; decoration is generally simple and black and white, with the exception of figural paintings in small household shrines (*lararia*) (Wallace-Hadrill 1994, 39).

12 There is no provision in this theory, however, for identifying spaces that served gender-related functions, a deficiency that may be ascribed to the methodology and to the types of evidence available rather than to a lack of gender-specific household activities in Roman life. For instance, ancient literary sources record that certain household tasks, such as weaving, were jobs for women, while other household tasks, such as monitoring the entryway, were jobs assigned to men (see Livy 1.57.9; 6.25.9).

13 The present study was inspired by similar ones including Ray Laurence's analysis of street access in Regio VI and VII in Pompeii (1994, 104–21) and Mark Grahame's analysis of the House of the Faun (1997).

14 For the Villa of the Mysteries, the megalographic Room 5 is separated from the exterior by six boundaries, while the megalographic Room H at the Villa at Boscoreale is separated from the exterior by two or four boundaries, depending on the entrance. The main entrance is located at a remove of four boundaries.

15 The mean depth of the megalographic space in the Villa of the Mysteries is 5.35 and in the Villa at Boscoreale 3.08. Both the Villa of the Mysteries and the Villa at Boscoreale were only partially excavated, so these numbers reflect only what can be ascertained from the known plan. For instance, at the Villa at Boscoreale, this analysis does not take into account Rooms 13 and 14, which were the kitchen, and Room 24, which was equipped for the production of wine and oil. These three rooms have unknown spatial relations to the rest of the villa.

16 See appendixes 1 and 2 for a listing of the mean depths of all the spaces in both villas.

17 The only spaces located farther away from the entrance are Rooms 11 and 14 (see appendix 1).

18 At the Villa of the Mysteries, there is a corridor running around the perimeter of the part of the Villa containing Room 5. Even with this passageway, however, the mean depth of Room 5 compared with the mean depths of the other spaces in the Villa indicates that Room 5 is still one of the most isolated in the Villa (see appendix 1).

19 See Leach 1997.

20 Grahame 1997, 153.

21 In the Villa at Boscoreale, the megalographic room is controlled by two nodes, one with the highest control value (E) and one with the lowest control value (23). From the plan (fig. 4.2), it is clear that E provides the primary access to the room, so this paper will focus on it rather than 23. See appendixes 1 and 2 for a complete listing of the nodes in the two villas.

22 Control value is an index used to describe the local relations of a space, or the degree to which a space may be said to control access to its immediate neighbors. The more neighbors a space has, the greater its degree of control (Hillier and Hanson 1984, 109). In both dwellings, the peristyles have many neighbors and so have very high control values. See appendixes 1 and 2 for a complete listing of the control values in the two dwellings.

23 Highly accessible spaces such as the peristyles in these two dwellings, according to Hillier and Hanson's theory, have a *low relative asymmetry* value. Relative asymmetry is an index used to describe global relations of a space, or the relations a space has with all the other spaces in the dwelling (Hillier and Hanson 1984, 108–40). See appendixes 1 and 2 for a complete listing of the relative asymmetry values in the two dwellings.

24 Grahame 1997, 154.

25 Grahame 1997, 155.

26 These three theories by no means cover all of the modern interpretations of the use of the room. For Jungian adherents, Room 5 is a women's room, reserved for female initiation through self-discovery, and as such it functioned as an Initiation Chamber (Khan 1999, 10; Hall 1988, 10).

27 Wallace-Hadrill 1994, 113.

28 Allison 1992a, 49–56.

29 The one type of reception room that can be ruled out is the *tablinum*, since Vitruvius records that *tablina* were areas that people could enter uninvited and, as such, were public spaces.

30 See Vitr. *De Arch.* 7.5, Varro *Ling.* 5.161–62, and Pliny *Ep.* 2.17.

31 Strocka 1984, 46. Such an approach becomes especially problematic if room function changes over time.

32 Pollitt 1974, 68–69.

33 Richardson 1988, 175.

34 Little 1972. Another room that has been tentatively identified as a women's room based on the iconography of the wall paintings is Room *g* in the Pompeian House of Lucretius Fronto (Clarke 1991, 157).

35 The same holds true for Richardson's theory that the space was reserved for men.

36 This is not to say that some women were not heads of households or powerful or wealthy in their own right. For instance, one Pompeian priestess, Eumachia, demonstrated her position in Pompeian society by building a large porticus in the Roman forum dedicated to Concordia Augusta and Pietas.

37 Laurence 1994, 127–28. "The literary records indicate that for most of the day, the aristocratic male members of the household were outside the house. This masculine absence leads to a temporal division of female and male space in the house. For, if the male member was out from the second to the eighth or ninth hours, as the literary record suggests, then the space was male-dominated at the beginning of the day (salutatio) and end (dinner), whereas the central portion of the day was female-controlled" (Laurence 1994, 127).

38 Allison 1992a, 53; 1993, 5.

39 We do know that exclusively female ceremonies took place in Roman domestic spaces. One example is the Bona Dea ceremony in Rome that Publius Clodius tried to attend (Plut. *Caes.* 9–10).

40 Cf. D'Arms 1991; Jones 1991; Kondoleon 1995, 186; Kuttner 1999, 107–9.

5 Women, Ritual, and Social Standing in Roman Italy

Catherine Hammer

It is virtually impossible to discuss the impressive megalographic frieze in Room 5 of the Villa of the Mysteries without taking into account the fact that both women and Bacchic subjects dominate. From the time the frieze was discovered, the combination of these two elements has produced a wide array of theories, some of which claim that the frieze depicts female participation in Bacchic cultic worship. The basis for such theses, in turn, raises important questions concerning elite Roman women and their religious beliefs and aspirations. I suggest here that a broad awareness of the social standing of Roman women, their rites of passage, and the most prominent cults in women's lives may allow a more nuanced reading of the iconographic references in the frieze from the Villa of the Mysteries, to reflect the complex and interwoven relationships among a number of deities and cultic practices.

ROMAN SOCIETY AND RITES OF PASSAGE

The Roman concept of the ideal aristocratic woman included the virtues of modesty, faithfulness, beauty, and above all devotion to family.[1] Within the patriarchal society of Rome, the identity of a Roman woman—whether as mother, wife, or daughter—was very much tied to that of the men in her life. One indication of her state of dependency was a legal requirement mandating that a woman have a male guardian, be it her father or husband, who possessed *manus* (control) over her.[2] This was not an invariable condition, however. By the first century BC some aristocratic matrons were able to gain control of a considerable amount of wealth and, in doing so, gain a measure of independence and power outside the authority of their fathers or husbands.[3] Yet even exceptional women who attained positions of relative independence had little real power, and certainly no legitimate political power apart from the influence they wielded through men.

Roman society reinforced the expectation that the primary purpose of a woman's life was to marry and produce children, and, perhaps because of this, religious ceremonies and rituals for women centered on two rites of passage—marriage and childbirth. Marriage ceremonies represented public recognition of what were essentially contractual agreements between families,[4] but they were nonetheless accompanied by ritual and symbolic components. The *sponsalia*, or betrothal ceremony, signaled that a woman, although not yet married, was pledged to her future husband. An iron ring was given to the betrothed, which was to be worn on the ring finger of the left hand, the nerve of which was thought to lead directly to the heart.[5] In preparation for marriage a young woman, who could be as young as twelve, would enact a number of rituals, such as dedicating her childhood toys and clothing to the household gods.[6] The bridal toilette was itself part of an elaborate preparatory ritual, which included a specific coiffure and bridal clothes to avoid ill fortune.[7] The scene of the young woman preparing her toilette on the frieze in the Villa of the Mysteries (group G) has been interpreted as such a bridal

ritual (color pl. III).[8] After the ceremony, a procession escorted the bride to her new home, where it ended with the custom of lifting the bride over the threshold.[9] To complete the transfer to her new home, the bride then made offerings to her husband's household gods.[10]

Traditional attitudes and even imperial legislation[11] urged women to produce children. Through various incentives and penalties, the emperor Augustus advocated the remarriage of widows and divorcees as part of his overall program to encourage elite women to bear as many children as possible. One piece of Augustan legislation even exempted women who bore three or more children from the legal requirement of male guardianship. There were, however, many dangers for both mother and child in pregnancy and the birthing process. The mortality rate for women in childbirth was very high and infant mortality even higher. Indeed, nearly half of all children died before the age of ten.[12] Despite the dangers, considerable importance was attached to the continuity of the family line, and a woman who provided heirs for her husband was generally held in greater esteem than one who did not. The desire for children required that women offer supplications to divinities who in return might bestow not only fecundity but an assurance of good health.

Women could call upon the gods to insure their fertility in a number of ways. Both simple rituals and state-sponsored organized cults played a role in marriage and childbirth. Brides might choose, for example, to be married among ripened crops, which were readily associated with fertility and the earth.[13] Women might subscribe to other popular beliefs or use herbs, magic, and spells, but it was in state-sponsored festivals, which were deeply rooted in traditional Roman religion,[14] that they could participate in rituals to aid fertility with the encouragement of the entire community.[15] During the Matralia, the festival of mothers, women would gather to worship at the temple of Mater Matuta, an old Italic goddess concerned with childbirth and child tending, offering the goddess sacred cakes (*testucia*) and decorating her cult statue.[16] During the Lupercalia, an ancient purification rite for the city of Rome, Ovid describes women seeking out ritual flagellation in order to ensure their fertility.[17] The practice of ritual flagellation—as an aid to fertility—has, in fact, been cited in an attempt to interpret the so-called flagellation scene (groups E–F) in the Villa of the Mysteries (color pl. II).[18]

WOMEN'S PARTICIPATION IN CULTS

Roman women were restricted from engaging in most forms of public life. While not as strictly secluded from society as were Greek women, Roman women were typically relegated to social roles in the domestic realm. A woman's place was to be in the home, where as the *materfamilias* she was charged with running the household and raising children.[19] Although discouraged from public life, elite women had a few means by which they could gain social prestige and power outside of marriage. One of the most important of these was participation in religious cults.

Although women were forbidden to make blood sacrifices, which was central to the performance of Roman state religion,[20] they did participate in religious rituals and ceremonies on many levels. While nearly all of the leading officials of the major Roman state deities were men, public priestesses, such as the Vestal Virgins in the important official cult of Vesta, were highly respected and privileged in Roman society.[21] Literary

Fig. 5.1. Coin showing Ceres with a corona spicea *on obverse (a) and a pair of bulls yoked for plowing the earth on reverse (b), Rome, 81 BC. Kelsey Museum of Archaeology, acc. no. 94977.*

and archaeological evidence from as early as the eighth century BC attests to public priestesses of other cults as well as other forms of participation by women in cults, principally those that provided aid in women's rites of passage—especially marriage and childbirth. Among the cults particularly important to Roman women were those of Ceres and Proserpina, Venus, Isis, and Bacchus/Liber. The following discussion sketches the background of these cults in Italy and highlights the ways in which women participated in them.[22]

Ceres/Demeter and Libera/Proserpina/Persephone

Ceres was an ancient Italic goddess of considerable importance in Roman religion.[23] In her most elemental form, she was a goddess of cereal crops and fertility. Women were drawn to the worship of Ceres because of her influence over fertility and also because she was a model for the ideal Roman matron with respect to the virtues of chastity and motherhood.[24]

The very early history of Ceres in Rome is unclear. Epigraphic evidence, however, does attest to the presence of the goddess in Rome as early as 600 BC.[25] There were a number of cults dedicated to Ceres in Rome. Among these was the cult of Ceres, Libera (also known as Proserpina), and Liber. This triadic cult, which had been established by at least the beginning of the fifth century BC,[26] was often identified with the Eleusinian Greek triad of Demeter, Persephone, and Iacchus (sometimes identified with Bacchus/Dionysus).[27] Both men and women participated in this triadic cult of Ceres in contrast to another state cult, which centered on Ceres and Proserpina.

The earliest reference to the cult of Ceres and Proserpina places it in Rome before the end of the third century BC.[28] Participation in the cult of Ceres and Proserpina, unlike the older triadic cult of Ceres, Libera, and Liber, was restricted to women; moreover, women were its chief officials. As Spaeth argues, the importance of the cult of Ceres and Proserpina to women in Rome is underscored by the fact that the priestesses of the cult "were the only women, besides the Vestal Virgins, who had the honor of administering a state cult and of expending public funds."[29] The primacy of women in the cult of Ceres and Proserpina reflects the great influence of South Italian Greek practices in the cults of Demeter and Persephone.[30]

Ceres/Demeter was worshipped individually as well as jointly with Proserpina/ Persephone throughout Magna Graecia, as is attested by the many South Italian votives such as the terracotta head of Demeter (cat. no. 8) and the enthroned figurine of Persephone (cat. no. 7) in this exhibition. It was probably the Greek colonists at Cumae who first introduced the cult of Demeter to the area of Campania.[31] The prestige of the cult of Ceres/Demeter in Campania is suggested by the fact that priestesses of the cult of Demeter in Neapolis (Naples) were specifically summoned to Rome to serve the cult of Ceres and Proserpina there.[32]

By the first century BC, the cults of Ceres in Rome—the triadic cult of Ceres, Libera, and Liber and the cult of Ceres and Proserpina—had been substantially influenced by the Thesmophoria, a Greek festival honoring Demeter,[33] and the Eleusinian Mysteries, one of the most popular of the Greek mystery cults.[34] The growing attraction to these cults in Rome is attested by the increasing number of images in which

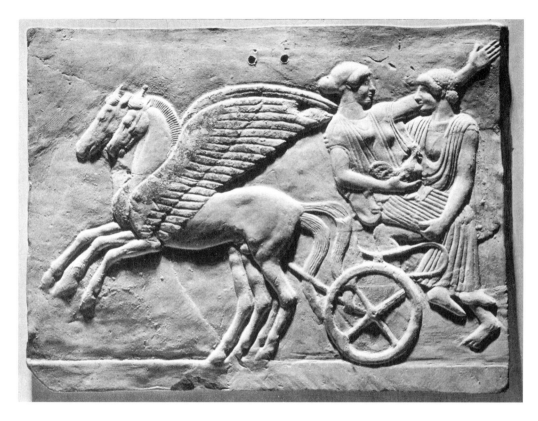

Ceres/Demeter and Libera/Proserpina/Persephone were shown with Thesmophoric or Eleusinian attributes—such as the *corona spicea* (a crown made of wheat stalks), baskets of wheat, torches, snakes, and snake-drawn chariots.[35] These images appeared on a variety of media including coins (fig. 5.1), reliefs, statues, and wall paintings.[36]

At the core of the Greek cults of Demeter was the myth of the abduction of Persephone by Hades, Lord of the Dead. In concert with the natural cycle of death and rebirth, Persephone ascended every spring from the dead to be reunited with her mother Demeter and returned every winter to her husband, Hades, in the Underworld.[37] Devotees believed that, with Persephone, the initiated would descend to the world of the dead and then rise to a richer and better life.

In addition to death and rebirth, Persephone presided over marriage and fertility. Women seemed to identify with the goddess in her role as a divine bride transformed from the status of a young maiden to that of a mature woman through her abduction by Hades (fig. 5.2).[38] Even in death, a woman might be thought of as united in marriage to Hades, Lord of the Dead. This concept is concretely visualized in the nuptial imagery on vases, such as the painted lekanis in this exhibition (cat. no. 73), which were used as grave goods and funerary offerings. The nuptial imagery of the Villa of the Mysteries frieze has sometimes been associated with Ceres and Persephone as well.[39]

Ceres/Demeter and Proserpina/Persephone thus presided over key events in a woman's life—marriage, childbirth, and death. In addition to the Roman ideals they represented for elite women, the roles these goddesses played in relation to the liminal stages of a woman's life[40] may account for their popularity in cult and also for the ways women identified themselves with them.[41]

41

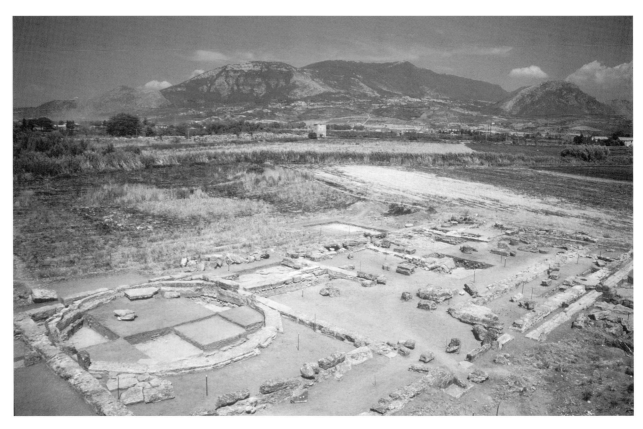

Fig. 5.3. View of the sanctuary of Venus/Aphrodite, Santa Venera, c. sixth century BC–third century AD. Photo: J. G. Pedley.

Venus /Aphrodite/Turan

Venus, the goddess of beauty, love, and sexuality, was originally a minor Italic goddess of fertility who early on was assimilated to the Etruscan goddess Turan[42] and the Greek goddess Aphrodite. Although men did participate in her cult, Venus /Aphrodite was primarily worshipped by women. The importance of the cult of Venus /Aphrodite to women can be readily understood in connection with feminine concerns about marriage as well as fertility.

Cults of Venus /Aphrodite were well established throughout the Graeco-Roman world and are abundantly attested in the Greek sanctuaries of Southern Italy and Sicily. Among the best known of these was the sanctuary of Venus /Aphrodite in Poseidonia (Paestum) in the territory of Lucania, southeast of Campania. Venus /Aphrodite was apparently worshipped by women from the founding of the city through to the Roman period.[43] The early popularity of Venus /Aphrodite among women at Poseidonia is attested by sixth- and fifth-century BC nude female votive figurines, which have been identified as Venus /Aphrodite.[44] The ongoing importance of her cult in Southern Italy is evident in many other votives, which include third- to first-century BC terracotta figurines of Erotes[45] and doves, both common attributes of Venus / Aphrodite, and a first-century BC group of Venus /Aphrodite statuettes dedicated at the extramural sanctuary at Santa Venera, located just south of the city wall of Poseidonia (fig. 5.3).[46] The dedications of votives, however, are not the only form of cultic activity that we may ascribe to women at Poseidonia. A first-century BC inscription found within the

42

sanctuary of Santa Venera commemorates the construction, decoration, and provisioning of that shrine by a woman named Sabina. The inscription makes it clear that Sabina provided funding for the donation with her personal resources.[47] Signs of the cult of Venus /Aphrodite and of the participation in her cult by women such as Sabina are exceptional at Poseidonia. Moreover, the evidence there is also representative of the manner in which women participated in her worship throughout Southern Italy.

In Pompeii, Venus Pompeiana was the patron goddess of the city, and the imposing temple dedicated to her in the heart of the city, near the Forum of Pompeii, reflects her prominent stature.[48] There is documentation from the beginning of the first century AD of a public priestess named Eumachia, who served in the cult of Venus Pompeiana. Several inscriptions identify her specifically not only as a public priestess but also as a daughter, wife, mother, and highly active benefactress within the city.[49] One of her benefactions was the large porticus dedicated to Concordia and Pietas, which opened onto the Forum of Pompeii (fig. 5.4).[50] Eumachia is a notable Roman woman of the early Imperial period who followed the example of the empress Livia in playing an active public role in both religious and secular life.[51]

From the first century BC onward, there were innumerable images of Venus/Aphrodite in Pompeii. Indeed, some scholars have suggested that Venus/Aphrodite is the companion of Bacchus/Liber on the frieze in the Villa of the Mysteries.[52] Images of Venus/Aphrodite in Pompeii may indicate not only a particularly strong devotion to the goddess as patroness of the city but also, during the Roman era of Pompeii, her prominent position within the Roman pantheon as the acclaimed ancestress of the founders of Rome.[53] Toward the end of the Republic, several powerful men took Venus as their personal patroness, making the goddess a political symbol. The Roman dictator Sulla, who founded the Roman colony at Pompeii, took the name Epaphroditus ("favored by Venus").[54] When Julius Caesar dedicated a temple in 46 BC to Venus Genetrix in the Forum Julium in Rome, he was marking the favor shown him by the goddess against his rival Pompey the Great, who had taken Venus Victrix as his patroness. Augustus and the Julio-Claudians,

Fig. 5.5. Portrait statue of Antonia Augusta as Venus Genetrix with a Cupid on her shoulder, c. AD 41–54. Naples, Soprintendenza Archeologica. After Tocco Sciarelli 1983, fig. 122.

following the precedent set by Julius Caesar, claimed Venus as the ancestor of the *gens Julia*, and images of Venus and her attributes became ubiquitous in civic imagery.[55] Women of the Julio-Claudian family followed suit, setting the fashion for other elite women to adopt the guise of Venus in their portraiture in an effort to identify themselves with the goddess in her various personas, particularly that of Venus Genetrix (fig. 5.5).[56] Yet, while the worship of Venus/Aphrodite in the Imperial period became infused with political overtones, the goddess never lost her appeal to women as a divinity with power over sexuality, marriage, and fertility.

Isis

Isis was an ancient Egyptian deity whose worship under Greek influence evolved into a mystery cult with ritual initiation, baptism, and service.[57] Isis particularly appealed to women as a model of womanhood. Her roles as protector and nurturer offered compassion and salvation to her worshippers.[58] The cult of Isis spread quickly to the hellenized world and was brought to Sicily shortly after 214 BC. Soon afterward, the cult was introduced to the Greek cities of Campania and from there to Rome and the rest of Italy.[59] The earliest evidence for the cult of Isis on the mainland of Italy comes from Puteoli (Pozzuoli), the chief commercial port in Campania.[60]

The prevalence the Isaic cult attained in Campania is reflected in Pompeii, which has yielded numerous statues, wall paintings, and frescoes with egyptianizing elements including images of Isis—whether religious, commercial, or purely decorative. Furthermore, fourteen Pompeian inscriptions relate in some way to the cult of Isis and demonstrate that Pompeii was indeed an active center of her cult.[61] Perhaps the best indication of the prominence of the cult of Isis in Pompeii is the temple of Isis itself, located to the southeast of the Forum near the temple of Jupiter Milichius and the city's two theaters (fig. 5.6). Its florescence in the first century AD is attested by the wealth of dedications and statuary discovered within the sanctuary.[62] Moreover, of the public buildings destroyed or damaged by the earthquake of AD 62, the temple of Isis was among the few completely rebuilt and redecorated before the eruption of Vesuvius in AD 79.

Elsewhere in Italy, the cult of Isis was not initially welcomed with open arms. In 54 BC, it was suppressed by a decree from the Roman Senate, which forbade the practice of the cult within Rome. This decree also called for the destruction of the private sanctuaries of Serapis and Isis. Perhaps the most harrowing of the persecutions of the cult, however, were instituted in AD 19 by the emperor Tiberius. The Tiberian persecution, directed against the cult in Rome, was provoked by the seduction of a Roman matron within the temple of Isis by a knight named Decimus Mundus. The deed was accomplished with the supposed aid of the temple priests. Isaic devotees commonly spent the night at the temple, but Mundus evidently took advantage of a more orgiastic element of the cult. When the scandal broke, the temple priests were crucified and Mundus exiled.[63] The cult persisted, however, and after the death of the emperor Tiberius it regained prominence and continued to rise in popularity.

When the cult of Isis was at its height in the second century AD, it enjoyed a huge following all over the Roman empire. The number of

Fig. 5.6. Temple of Isis, Pompeii, AD 62–79. After Zevi 1984, 193.

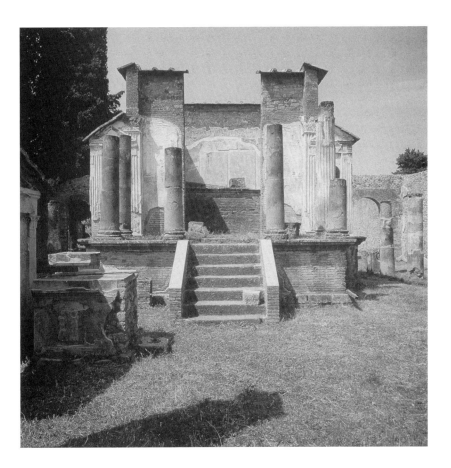

sanctuaries built for the worship of Isis increased dramatically in this period, as witnessed by the archaeological record.[64] The palpable evidence for the rise in Isiac worship during the second century AD appropriately coincides with Apuleius's *Metamorphoses*, which provides an unparalleled insight into the worship of Isis from the viewpoint of devotees.[65]

While the hierarchy within the cult of Isis is not well known, women seem to have enjoyed a higher degree of active participation than in many other Roman state cults. In descriptions or images of festivals and processions, women are well represented. Apart from their roles as priestesses, women could, for example, be bearers of various ceremonial instruments such as sistra (see cat. no. 11), *situlae* (ritual vessels), and censers.[66] In Pompeii, there are numerous depictions of women participating in Isiac ceremonies in just such ways.[67] With regard to inscriptional evidence, Heyob reports that in Vidman's catalogue *Sylloge inscriptionem religionis Isiacae et Sarapiacae* two hundred of the 1099 inscriptions mention women.[68] In Pompeii, two of the fourteen Isiac inscriptions refer to women as well.

Through her manifold associations with other divinities, Isis could be virtually everything to everyone. She was most commonly identified with Ceres/Demeter and Aphrodite, but through syncretism she also took on the aspect of any number of other gods and goddesses.[69] Her essentially limitless powers were attractive to women looking for assurance that the divinity they worshipped would be able to assist them, be it in life or death.[70]

45

Bacchus/Liber/Dionysus

The ancient Italic god Bacchus/Liber was identified early with the Greek god Dionysus.[71] Bacchus/Liber was a multifaceted god, presiding over wine and revelry, ecstasy and madness, sexuality and fertility.[72] But the sexual elements apparent in much of Bacchic imagery, with its emphasis on amorous satyrs and maenads[73] and the overtly sexual symbol of the phallus, do not necessarily reflect an orgiastic element within the cult.[74] In the so-called liknon scene in the Villa of the Mysteries, the kneeling woman (group E, figure 17) has sometimes been interpreted as about to unveil a phallus (color pl. I).[75] This imagery may be read in the context of Jameson's view that the phallus may be understood as "a celebration of the life force, as a charm for fertility, even as a symbol of life after death."[76] Such elements of the cult may explain why among all male deities Bacchus/Liber was the most closely associated with women's rites of passage.[77]

The worship of Bacchus/Liber was unique among the cults of male deities in its inclusion of priestesses.[78] Moreover, in the Greek east there are instances where the priestesses in certain cults of Dionysus had leading roles, taking precedence over the male priests. Two examples of female preeminence in the hierarchy of the cult are attested by inscriptions dating from the third to first centuries BC at Cos and Miletus.[79] These instances, however, may be due to local circumstance; the limited evidence does not allow us to extrapolate such situations universally. What is clear, though, from another monument is that the role of priestess was not the only important one for women in the cult of Bacchus/Liber. The inscriptions on the statue base of Agrippinilla in the Metropolitan Museum record the names of male and female devotees and cultic roles they played in Bacchic ceremonies in Rome in the second century AD.[80] Of the twenty-one different cultic titles recorded, only three were not gender specific. Women held positions under nine titles, six of which were exclusive to them. The latter included *Hiereiai* (priestesses), *Phallophoros* (a phallus bearer), and *Bacchai* (maenads). With more than forty feminine names listed, the role of maenad seems to be the one played by the greatest number of women. This evidence conveys a vivid impression of the very strong presence of women within the hierarchy of the Bacchic cult. Although the inscription dates considerably later than the frieze in Room 5 of the Villa of the Mysteries, it is tempting to draw a general parallel between the two monuments with regard to the prominent role of women in the cult.

CONCLUSION

Religion was an essential element in the lives of Roman women. Participation in state festivals and in cults provided a means of addressing women's fundamental concerns with sexuality, marriage, fertility, childbirth, and death. While appeals to divine intervention may have prompted devotion to deities already important in the lives of women, participation in cults like those discussed above also contributed to women's desire for roles outside the limited ones prescribed for them in Roman society.[81] The significance women placed on their exceptional roles in religion is clear from inscriptions such as the one from a funerary relief from Rome in which a woman named Usia Prima is identified

primarily as a priestess of Isis.[82] In examining the social position of elite Roman women, I have not dealt with examples of how some women deviated from Roman ideals or defied the restrictions that those ideals placed on their sex. Rather I have focused on some of the ways in which cultic participation provided an accepted way for women to lead active and even public lives while attending to their personal concerns.

It is noteworthy that the cults explored in this essay were not isolated from one another. Women participated and had multiple roles in more than one cult, as for instance we are told by a bilingual hexameter text from Rome, which identifies a woman as both a priestess of Dionysus and an attendant of Isis.[83] Roman religion was dynamic and constantly changing to incorporate new influences, new practices, and new deities. Multiple associations of gods and goddesses yielded a complex and overlapping set of identities and interwoven relationships that were expressed in both imagery and cultic practices. An awareness of such complexities furthers our attempts to understand the multiple meanings that may be encoded in the Villa of the Mysteries frieze and its associations with women's cultic activities.

1 These virtues are among the most prevalent within the extensive scholarship dealing with ideal conceptions of Roman women as reflected in literary sources, epigraphical evidence (particularly on funerary monuments), and gendered imagery. For an overview, see Kleiner and Matheson 1996.
2 For the legal status of Roman women, see Pomeroy 1975, 150–55; Hallett 1984; Treggiari 1991.
3 Treggiari 1996, 118.
4 There were three types of marriage ceremonies (*conferreatio, coemptio*, and *usus*), each reflecting ancient Roman laws that treated a woman as property in transferring her from the control of her father to her husband. For nuptial laws see Hallett 1984 and Cantarella 1987, 115–88.
5 Pliny *HN* 37.1–5; Aul. Gell. *NA* 10.10. See also cat. nos. 46–49.
6 See cat. nos. 37–40.
7 An informative and detailed description of Roman nuptial preparations is provided by Balsdon 1983, 181–86. See also La Follette 1994.
8 See ch. 10 by S. Kirk in this volume.
9 Livy's explanation for this tradition is in connection with the legendary story of the Rape of the Sabine Women (Livy 1.9).
10 On domestic cult, see ch. 7 by M. Swetnam-Burland in this volume.
11 See Galinsky 1981, 126–44; Dixon 1988, 71–103.
12 Treggiari 1996, 118.
13 Balsdon 1983, 181.
14 For Roman festivals, see Scullard 1981; Scheid 1992, 377–80.
15 Ov. *Fast.* 2.381–452
16 Ov. *Fast.* 6.475–568
17 Ov. *Fast.* 2.381–452
18 See Toynbee 1929, 67–87.
19 See Williams 1996, 126.
20 Scheid 1992, 377–80.
21 For the Vestal Virgins and the cult of Vesta, see Worsfold 1934; Scheid 1992, 380–84; Beard 1980; 1995; Lindner 1996.
22 This chapter primarily focuses on Roman cultic activity in Campania, which would have pertained to the owners of the Villa of the Mysteries. Although much of our evidence for women's participation in these cults is quite early, we should note that these cultic practices continued into the second century AD.
23 I would like to acknowledge here my debt to Shoshanna S. Kirk for her contributions in researching information on the cult of Demeter in Campania.
24 Spaeth 1996, 113–23.
25 An inscription with the name Ceres was found on a funerary urn dating to c. 600 BC discovered at a necropolis not far from Rome (Spaeth 1996, 1).

26 According to the Greek historian Dionysius of Halicarnassus (6.94.3), the consul Spurius Cassius dedicated a temple on the Aventine to Ceres, Libera, and Liber in 494/ 3 BC. This has remained the traditional date for the foundation of this temple, for which no secure archaeological remains have yet been found (Spaeth 1996, 81–82).

27 For the association of Ceres and Liber/Bacchus/Dionysus, see ch. 6 by D. Wilburn and ch. 7 by M. Swetnam-Burland in this volume.

28 Spaeth 1996, 11–12.

29 Spaeth 1996, 105.

30 Spaeth 1996, 104.

31 Literary sources report the worship of Demeter Thesmophoros at Cumae (Plut. *Mor.* 262; Stat. *Silv.* 4.8.45–51). Archaeological evidence supports the argument for an early introduction of the cult of Demeter into the larger Campanian region from Cumae. See Frederiksen 1984, 32–33, 88–91.

32 Frederiksen 1984, 91, n. 49.

33 For cults of Demeter Thesmophoros, see Lincoln 1979, 221–35; Zeitlin 1982, 129–57.

34 The expansion of the Eleusinian cult was made possible by the fact that as a mystery cult the Eleusinian rites were no longer tied to Eleusis. Despite this, Eleusis, one of the holiest places in Greece as early as the eleventh century BC, remained an important center of cultic activity even in the Roman period (Spaeth 1996, 18). For the Eleusinian Mysteries, see Skov 1975, 136–47; Cole 1994, 201, 212; Meyer and Mirecki 1995, 15–42; Clinton 1993, 110–23.

35 Spaeth 1996, 18.

36 Depictions of Ceres or her attributes were common in wall paintings. One such wall painting from Pompeii depicts a seated Ceres with a *corona spicea* (Naples, Museo Nationale, inv. 9457).

37 See *The Homeric Hymn to Demeter*.

38 See Sourvinou-Inwood 1978, 111–17 and Zeitlin 1982.

39 Brendel 1980, 102–3, 123–29.

40 Spaeth 1996, 52–62.

41 For representations of women in association with Ceres/Demeter and Proserpina/ Persephone, see Wood 2000.

42 Evidence for the worship of Turan in Campania is limited and therefore will not be addressed in this chapter.

43 Pedley 1990, 129–62.

44 Pedley 1990, 162, fig. 122.

45 See cat. no. 76.

46 Pedley 1990, 157–61, figs. 117–21. These include versions of the Venus Anadyomene type, comparable to cat. no. 6. See also Pedley 1993, 227–33, pls. 54–59; 1998, 199–208.

47 M. Torelli's reconstruction of the fragmentary inscription may be read: "Sabina, wife of Flaccus, saw to the construction of the goddess's shrine from the ground up, to the decoration with stucco work, and to the provision of seats and pavements; she paid for it with her own money and approved the work." Pedley 1990, 139 ill. 94, 157, with which cf. 155 fig. 112.

48 For the temple of Venus in Pompeii, see Richardson 1988, 277–81.

49 *CIL* 10.810–12.

50 For the Eumachia Building, see Richardson 1988, 194–98.

51 For the influence of the empress Livia on Roman women in the Augustan period, see Kleiner 1996, 33.

52 For a discussion of the scholarship on the imagery of Venus in the Villa of the Mysteries, see ch. 11 by B. Longfellow in this volume.

53 The connection of Venus to the founding of Rome was emphasized in the literature of the period, including Vergil's epic *The Aeneid*, and in the histories of Livy.

54 *OCD3*, s. v. "Venus."

55 Zanker 1988, *passim*.

56 For women's portrait heads on Venusian bodies, see D'Ambra 1996.

57 While it is debated, the mystery cult of Isis was most likely begun in Egypt under the Ptolemies (Heyob 1975, 7–8).

58 See cat. no. 12.

59 Heyob 1975, 11. Rf. Gallo 1997, 290–96.

60 It is likely that the early date of the cult in Puteoli can be attributed to traders (*negotiatores*) who might have brought the cult to Italy through trading contacts from Alexandria to Puteoli (Grant and Forman 1971, 98).

61 Heyob 1975, 81–87.

62 For the Temple of Isis in Pompeii, see Richardson 1988, 281–85; de Caro 1997a, 338–43; Guzzo 1997, 344–45.

63 Joseph. *AJ* 18.4.73. For the most part the Romans were tolerant of other religions and gods, but suppression or persecution of cults was not unusual. It was perhaps the very nature of the mystery cults that they were often the targets of Roman state action. Mystery cults were often viewed with suspicion because of their secrecy. Also threatening, perhaps, was the highly organized character of the cults and their requirement of allegiance to a single deity, which could have been seen as a threat to an individual's allegiance to both family and state. Accusations of suborning sexual immorality and licentiousness in their temples, which were seen as places of adultery and prostitution, were often made against cults such as that of Isis (North 1979).

64 Wild (1981, 5) comments: "The significantly larger number of sanctuaries from the second century A.D. . . . cannot easily be explained away by appealing to factors such as the chance character of archaeological discoveries. . . . As large scale projects requiring in the normal course of events the cooperation and involvement of fairly large numbers of people, they must represent the culmination of a religious movement rather than its incipience."

65 Apul. *Met.* 11.

66 Heyob 1975, 100.

67 See Tran 1964, *passim*.

68 Heyob 1975, 81–87; Vidman 1969.

69 Apul. *Met.* 11.5.

70 In the second century BC, Romans increasingly began to turn to a new kind of worship—the worship of mystery cults that offered the hope of a life after death. Scholars such as Burkert (1987, 12–29) contend that they flourished because of a greater need for an individualized religious experience, which these mystery religions offered by providing personalized contact with a specific god or goddess.

71 For a discussion of the identification of Liber with Bacchus and Dionysus, see chs. 2 and 6 by D. Wilburn and ch. 7 by M. Swetnam-Burland in this volume.

72 See Henrichs 1979, 1–11; Turcan 1996, 291–315.

73 See cat. nos. 30–33, 58–61.

74 Burkert 1987, 105; Jameson 1993, 44–62.

75 Brendel, 1980, 102–3.

76 Jameson 1993, 57.

77 Kraemer 1979, 55–80.

78 Jameson 1993, 44–62.

79 Burkert 1993, 273–74.

80 For a list of cultic titles and members recorded on the Metropolitan Museum inscription, see ch. 8 by E. de Grummond in this volume.

81 Zeitlin 1982, 134; Kraemer 1979, 80.

82 *CIL* 6.2246. I am grateful to Brenda Longfellow for bringing this example to my attention.

83 *CIL* 14.123 cited by Cole 1993, 283–84, n. 47.

6 The God of Fertility in Room 5 of the Villa of the Mysteries

Drew Wilburn

Virtually all scholarly interpretations of the frieze in Room 5 of the Villa of the Mysteries have proceeded from the assumption that the reclining male figure painted on the east wall of the frieze is the god Dionysus (color pl. I). This widely accepted identity is based in large part on the god's physical appearance. The deity is young, beardless, and loosely draped with clothing that reveals his torso. He wears a wreath woven from leaves, and a thyrsus leans against his seat. The presence of other figures from Dionysus's entourage supports this identification, most importantly the "satyrs" and sileni in groups C and D of the frieze (fig. 1.4). While all of these iconographic elements signified Dionysus as he was known among the Greeks, each element was also associated with the Etruscan Fufluns and the Roman god Liber by means of syncretization. Certainly the reclining figure on the east wall of Room 5 represents a deity with many characteristics of Dionysus, but a closer look at the character of this divinity and his counterparts in ancient Italy reveals that in antiquity the deity portrayed in the Villa of the Mysteries might well have been understood by viewers primarily as an Italo-Campanian one.[1] Such a reading takes into account the connection between the frieze and its local cultural context.

In order to discern the more Italo-Campanian nature of the "Dionysus" in the Pompeian frieze, it is necessary to consider the history of the various manifestations of this deity in the region around the Bay of Naples.[2] By the time the frieze was painted, the native Italian population had been subjected in turn to the domination of Greek, Etruscan, Samnite, and finally Roman colonizers,[3] and all of these peoples had left their marks on the region's artistic and social record. For the sake of clarity, I shall first present the evidence for several manifestations of the deity in this region over time, particularly in the area of Pompeii. I shall then turn to the frieze and comment on the identity of the god it portrays based on his history in Campania and on the iconographic elements of the painting itself.

As the population of Campania became more multicultural and the various peoples intermingled, the religious beliefs of the inhabitants underwent corresponding changes. Much of our evidence for the beliefs of these peoples derives from ancient authors such as Pliny the Elder and Strabo,[4] but archaeological finds also play a substantial role in illuminating the ways in which deities and beliefs manifested themselves over time. The general outline of the cultural changes in this region, which I sketch in chapter 3, provides an armature for examining shifts in the religious realm, which in turn informs my reading of the reclining deity on the east wall of the Villa of the Mysteries frieze.

DIONYSUS

Let us begin with the Greek Dionysus because it is this deity, as expressed in his Bacchic persona, with whom modern scholarship has most often associated the image of the god on the Villa of the Mysteries

frieze. The evidence for this ancient deity is heavily biased toward Attic sources of information, principally literary texts and paintings on Greek vases.

The Greek Dionysus was not only the god of wine but also the patron of the theater in ancient Greece. His most significant festivals celebrated the first tasting of the new vintage in the spring and the grape harvest in the fall. Toward the end of the sixth century BC, both of these Dionysiac festivals, the one celebrated in the city and the other in the countryside, became associated with the theater; thus tragedies and comedies were performed in honor of the god.[5] Some have suggested that the liberating effect of wine through drunkenness parallels an individual's assumption of a new character, an act symbolically represented by donning a theatrical mask.[6] The artistic record indicates that satyrs, maenads, Silenus, and Pan were already associated with Dionysus by this time.[7]

During the sixth and fifth centuries, Dionysus, in his role as the god of wine, played a prominent part in the iconography of the symposium. Symposia in ancient Greece were drinking parties held at the homes of upper-class men for the purpose of discussing art, literature, and society. A similar practice seems to have occurred in the Greek colonies of Southern Italy and Campania, judging by the fact that vessels used in symposia were frequently placed in tombs of the local elite as grave gifts, apparently as markers of social status.[8] On such vessels the wine god is frequently depicted in the midst of a revel, along with satyrs and maenads or with his consort, Ariadne. Although the depictions on these imported vessels represent mainland Greek concepts and practices, the presence in Campania of objects bearing the same iconography suggests that people in that region were exposed to and no doubt influenced by mainland Greek concepts of Dionysus and iconographic motifs that Greeks employed to express them visually.

During the fifth and fourth centuries BC, the Dionysus of the Greek mainland was associated with initiations into a number of different mystic cults in which the worship of him was not tied to any particular locale or *polis*. Dionysus is known from the Eleusinian Mysteries and Orphic rites, and he has been connected to the Pythagoreans.[9] Modern scholarship and the popular imagination, however, have concentrated to a greater degree on orgiastic celebrations of ecstatic union with the god through the media of wine and sexual abandon.[10]

As for Campania, a fifth-century BC inscription, which establishes the geographic boundary for a cemetery exclusively reserved for initiates of the cult, provides early evidence for Bacchic worship in the region.[11] Prior to the time of this inscription, no written texts document the cult of the god in this area, but visual evidence indicates local knowledge of his iconography.[12] As on the Greek mainland, depictions of Dionysus are frequently found in Campania on symposiastic vessels and on personal items. One example, a Corinthian aryballos from Cumae, shows Dionysus dressed in a panther skin in the company of satyrs (fig. 6.1). Although this aryballos was imported, its iconography is similar to that found on items of local manufacture. For example, on the tondo of an Etrusco-Italic kylix of the Vulcian school, the god is shown seated on the back of a panther, holding the thyrsus (fig. 6.2). Certain elements of this motif, which the local artist shared with his mainland Greek counterpart, suggest a common iconographic language for representations of the god. As we shall see, however, similarities among singular elements of iconography may, in fact, create a misleading impression in the way the

51

Fig. 6.1 (left). Corinthian aryballos from Cumae, Dionysus in a revel accompanied by satyrs from the Bacchic entourage. London, British Museum 84.10.II.48. After LIMC, Dionysus 285.

Fig. 6.2 (right). Etrusco-Italic kylix of the Vulcian school, Dionysus/Fufluns riding a panther. Rome, Musei Vaticani. After LIMC, Dionysus/Fufluns 4.

god's full identity was perceived in the two different regions of mainland Greece and Italy. It is necessary to consider the iconographic elements within the context of the beliefs and practices of the particular area under investigation.

FUFLUNS

With the extension of Etruscan influence over a large swath of Campanian territory in the Archaic period, the god Fufluns undoubtedly made his presence known. Fufluns was the name the Etruscans gave the deity who protected the crops and ensured fertility. It is generally believed that prior to contact with the Greeks, the gods of the Etruscans were nameless and without visible form, frequently viewed as councils of threatening spirits who had to be propitiated. Early Etruscan religion is difficult to reconstruct from archaeological evidence, in part because of the paucity of early images of the deities.[13]

One of the earliest artifacts securely attesting the existence of Fufluns

Fig. 6.3. Alabaster cinerary urn from Chiusi showing Fufluns and the sleeping Ariadne flanked by satyrs. Berlin, DDR Staatliche Museum E 39 (SK1287). After LIMC, Dionysus/Fufluns 55.

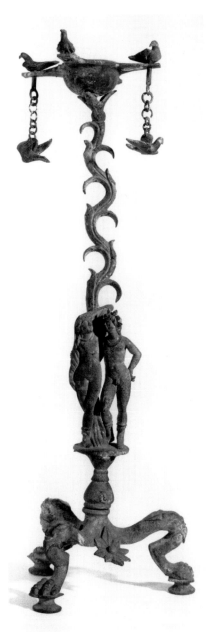

Fig. 6.4. Tondo of a kylix depicting Fufluns in the embrace of a nude young maenad. Philadelphia, University Museum, MS 3444. After LIMC, *Dionysus/Fufluns 34.*

dates to the fifth century BC. A red-figure cup found at Vulci in Etruria is inscribed in Etruscan with the words *Fufluns Pachies*, dedicating the vessel to Fufluns in his Bacchic guise.[14] This inscription suggests that the god Fufluns shared aspects with the Greek Dionysus and was at times associated with Bacchic revelry and with mystic cult practices. Associations between Fufluns and other members of the Bacchic entourage can also be documented for later periods. An alabaster cinerary urn from Chiusi, dated to between 200 and 180 BC, shows Fufluns approaching the sleeping Ariadne (fig. 6.3). The central figures are flanked by two sitting satyrs, identifiable by their cloven hooves and goats' legs. These two pieces suggest that Fufluns was associated with Bacchus in certain circumstances, but other materials suggest that this may not have been the sole manner in which the god manifested himself.

In most fourth- and third-century Etruscan depictions of Fufluns, however, his iconography appears to express a greater concern with fertility and with the god's interaction with other divinities. On the tondo of a kylix of unknown provenance, now in the University of Pennsylvania Museum in Philadelphia (fig. 6.4), a partially draped Fufluns is depicted in the embrace of a young, nude maenad, and the two figures appear to be kissing. Fufluns can be identified by the thyrsus that he is holding, and both individuals wear garlands. There is abundant plant growth in the background, which, along with the intimacy of the scene, is suggestive of fertility. Similar imagery appears on a thymiaterion in the Phoebe Appleton Hearst Museum of Anthropology (fig. 6.5). The floral and avian imagery that dominates the thymiaterion, including the vine that supports the incense bowl, the rosettes on the base, and the birds both resting on the bowl of the thymiaterion and dangling from its four corners all allude to fertility and sexuality. The tendency in artistic depictions of Fufluns and his consort to emphasize themes of fecundity was perhaps inspired by the fertility of Etruria itself, whose land rivaled that of Campania in agricultural productivity.[15] The references to fertility and sexuality evident in the two pieces just mentioned seem similar to other Etruscan representations of Fufluns, which focus on erotic elements in scenes of couples, female divinities, and the deceased.[16]

Fig. 6.5. Ornate thymiaterion showing Fufluns and a maenad, with birds and flowers as further decorative motifs. Phoebe Appleton Hearst Museum 221. Photo: Museum.

The Samnite domination of Campania from the late fifth to the third centuries BC must also have affected religious beliefs and practices in the region, including those concerning the god of the vine, overseer of one of Campania's major crops. An important Samnite document bearing on religion is the Agnone tablet, which names the gods for whom altars were established in a sacred grove. The text, written in Oscan, is inscribed on a small bronze tablet that measures 6.5 by 11 inches.[17] The letter forms and language date the text to the middle of the third century BC, during the period when the Samnites controlled Pompeii.

Among the gods listed is one called Liganacdix Intera, which may be translated as "he who displays the winnowing fan."[18] The winnowing fan, which is associated with the harvest and is typically depicted as containing a number of different fruits, is a frequent attribute of the god Dionysus in Greek iconography, as Dionysus is said to have been cradled by one as an infant.[19] Within the Samnite tradition, the presence of the winnowing fan may also refer to a god of fertility.[20] The deity to whom the epithet refers may be a Samnite god named Loufir, which is Oscan for Liber.[21] If so, Loufir may have followed the Etrusco-Italic model in his concern with the fertility both of the fields and of human beings. Indeed, Samnite (i.e., Sabine) priestesses were known in Rome as ardent proselytizers for Liber/Bacchus, which may suggest that the god was especially popular among women.[22] The scanty evidence for Samnite religion does not permit us to draw conclusions about the god Loufir beyond suggesting analogies with other Italic deities such as Liber. The Samnite people were part of a larger group of cultures native to the Italian peninsula, and for this reason special attention should be paid to the god Liber, the Roman manifestation of a god of fertility in the fields.[23]

LIBER

Festivals of Liber suggest that rites in his honor were celebrated at a very early point in Rome's history. In fact, the Liberalia (March 17) is included in the so-called calendar of Numa, which is thought to reflect festivals from as early as the fifth century BC.[24] Literary evidence records that in Rome in 493 BC, sixteen years after the traditional date for the construction of the temple to Jupiter, Juno, and Minerva on the Capitoline Hill, a temple was dedicated on the nearby Aventine hill to another triad—Ceres, Liber, and Libera. These three deities protected the fields and ensured the fertility of the crops. Ceres, the goddess of agriculture, was assisted by Liber and Libera, who were the male and female aspects of the deity of fertility.[25] Eventually, through contact with the Greeks and Etruscans, the god Liber came to be identified with the Greek Dionysus.[26]

It seems likely, however, that the Roman Liber continued to be regarded primarily as a god concerned with fertility, while the god's relation to wine, acquired through syncretization, was considered a less significant, although still important, aspect. Livy's famous account of the so-called Bacchanalian Conspiracy, which was brought to the attention of the Roman Senate in 186 BC, implies as much. His chronicle of the conspiracy provides one of the most dramatic records of religious practices in Southern Italy during the Roman period. It tells of how the

freedwoman Hispala allegedly made a confession concerning the rites of the Bacchanalia to the consul Postumius:

> From the time that the rites were performed in common, men mingling with women and the freedom of darkness added, no form of crime, no sort of wrongdoing was left untried. There were more lustful practices among men with one another than among women. If any of them was disinclined to endure abuse or reluctant to commit crime, they were sacrificed as victims. To consider nothing wrong . . . was the highest form of religious devotion among them.[27]

Livy's story is partially corroborated by the discovery of a bronze copy of the *Senatus Consultum de Bacchanalibus* at Tiriolo in the northern part of the Italian peninsula. According to this account, the Senate's response was swift and harsh. The Bacchanalian religion was banned throughout Italy, shrines were destroyed, religious leaders were executed, and celebrants of the rites were punished for their criminal acts. Archaeological evidence suggests that the agents of the Senate were thorough in their suppression of the cult. A subterranean chamber excavated at Etruscan Volsinii, for example, shows evidence of deliberate destruction that dates to near the time of the *Senatus Consultum*.[28] Some ancient altars and shrines were allowed to survive, but groups of celebrants were limited to five people, three women and two men. Moreover, celebrants were required to receive permission from the urban praetor in order to participate in the cult or to hold rites.[29]

The reasons for the Senate's suppression of Bacchic rites remain unclear. It has been suggested that the Romans used the worship of Bacchus as a scapegoat in their quest to establish complete hegemony over Italy and to bring the increasingly powerful mystery cult under the control of the state.[30] It seems possible that the suppression of the Bacchic cult was limited in its scope and sought only to remove the orgiastic aspect of the worship of the god of wine from the proper worship of the Roman state god Liber. Most notable, in fact, is Livy's choice of names in the description of the deity and his cult practices. At no point does Livy refer to the god of the condemned cult as Liber, instead calling him Bacchus and his followers Bacchantes.

Despite the senatorial suppression, the god of the Bacchanalia is not absent from the cultural record during the second century BC. Bacchic decoration remained a constant in the theater, and the image of Bacchus, if not his orgiastic rites, was accepted in the context of the state religion.[31] In Pompeii, there is little evidence for suppression of the rites. The temple to the god Bacchus/Liber, located on the outskirts of the city, was founded well before the decree of 186, and archaeological remains document not destruction but rather improvement after the *Senatus Consultum*.[32] A Latin inscription from Cumae (*CIL* 10.3705) names a certain Verrius as the priest of Liber, suggesting that the worship of the god was an acceptable part of the religious practices of this area. Likewise, most domestic representations of Liber, such as the mosaic in the House of the Faun, were not affected by the senatorial decree.[33]

Castriota has aptly commented that "to the Italians, Liber remained the primary male deity of earthly prosperity and regeneration despite the complications that arose periodically from his assimilation to the new Greek Dionysus."[34] It thus seems possible that Romans accepted the traditional identity of Liber but resisted the aspect of his exotic hellenized persona as the god of wine-induced mania. As noted earlier, the worship

of the god continued within a state-sanctioned context and under new senatorial regulations after the Bacchanalian Conspiracy. The imagery of Liber/Bacchus may reflect those circumstances, although in the late second and first centuries BC depictions of this deity, accompanied by other members of the Bacchic entourage, included the drinking of wine. Such depictions, however, often demonstrate special attention to elements of fertility and sexuality, as well as the regenerative powers of the deity, rather than the orgiastic rites associated with Bacchic mania. A glass cameo in the Metropolitan Museum of Art, which dates from the first century BC or AD, depicts the god of wine with a nymph and a satyr playing the *syrinx* (cat. no. 89). The god, who can be identified as Liber, and his consort are shown nude or partially nude, lounging side by side. The scene as a whole suggests their intimacy.

THE GOD OF FERTILITY AND THE VINE
IN THE VILLA OF THE MYSTERIES FRIEZE

The frieze in the Villa of the Mysteries, I would argue, may be read as a product of the environment in which it was created and seen, the elements of its iconography informed by the multicultural history as well as the natural attributes of Campania. By looking at the frieze through this lens, it should be possible to discern some of the associations that visitors to Room 5 in the late Republican or early Imperial period may have brought to their viewing of the figure of the god on the east wall of this room.

One of the most notable aspects of the frieze is the absence of wine implements in the main register. Although Dionysus is typically shown carrying a kantharos, and wine is frequently depicted within scenes of the Bacchanal, in this register all such paraphernalia are absent.[35] The satyrs carry jars, but there is no way to know whether water instead of wine is contained within them. The serving woman (group A, figure 5) appears to be carrying only fruit or cakes on her tray, and there is no wine associated with the seated woman on the long north wall (group A, figure 6) nor with any of the other female figures in the frieze. The sole wine implements appear as decorative elements in the entablature, and, although they refer to the identity of the central figure, they do not necessarily imply that the scene itself depicts an orgiastic rite associated with the mania of drunkenness.

The appearance of the god, as well, gives few if any hints of wine consumption. Although many scholars have insisted that the god is shown in a state of drunkenness, citing the discarded sandal,[36] his pose may merely suggest languor and repose. Rather than drunkenness, I believe the scene focuses on sexuality as it relates to fertility. The female companion of the god cradles him against her breast and embraces his half-naked body.[37] The sexual content is made more explicit by the ribbons on the thyrsus, the dangling ends of which create the outline of a phallus centered on the god's groin.[38] The thyrsus itself, which leans against the leg of the deity, can also be interpreted as a phallic symbol. This symbol may in turn allude to the object that the figure to the right of this scene unveils if, as many scholars have claimed, the concealed object is a phallus.[39] These recurrent phallic references, when combined with other elements of the iconography, strongly suggest a reading of the god that emphasizes fertility.

The fertility of the natural world is suggested by the verdant leaves of the wreaths crowning the heads of certain figures and the prevalence of plant imagery throughout the various scenes. In the entablature above the frieze, ivy and grapevines form tendrils encasing all manner of small animals: grasshoppers, rabbits, snails, and butterflies. This imagery, drawn from the natural world and coupled with Cupids, suggests that the female figure in the main scene could be Venus.[40] Implications of sexuality and fertility may be further underscored by the nudity of some of the figures in the scene, especially the figures 21 and 24 in group F. While neither of these figures is actively involved in an erotic encounter, the nudity of the female body suggests the erotic realm. "Proper" Roman women would have been fully draped, as are the figures in groups A, B, G, and I. The juxtaposition of the concealing drapery of certain women and the partial nudity of others heightens the contrast between modesty and sexuality.

Given the religious and cultural traditions that had shaped the Campanian region by the time of the late Republic, the imagery of Dionysus, Fufluns, and Loufir/Liber and its local associations can inform our interpretation of the frieze in the Villa of the Mysteries. The importance of fertility in depictions of Fufluns and Liber suggests that this aspect of the divinity may have been emphasized above others, such as wine consumption or the Bacchanal. Such an interpretation by no means limits the multivalency of the frieze, for each viewer would have detected a different message in the composition as a whole. For Roman viewers of the frieze, however, as well as those more thoroughly immersed in the regional culture of Campania, the image of the deity and the surrounding scenes of the megalographic painting may have elicited a recognition of the Italo-Campanian Liber and his association with abundance, fertility, and sexuality.

1 Much of the previous scholarship on the frieze has suggested that it depicts some aspect of a mystery cult, and this work often relies on modern interpretation of the Greek mysteries of Dionysus. See Hartwig 1910; Winter 1912; Bieber 1928; Sauron 1984; for a discussion of the frieze as mysteries of Dionysus, Rossbach 1911, 503–4; for the identity of the liknon as a Bacchic offering, Houtzager 1963; Brendel 1980 for an identification of the winged figure as Lyssa, or Boyancé 1966b naming her Ménè Hékate: both delivered Bacchic mania.

2 See also ch. 7 by M. Swetnam-Burland in this volume for an analysis of the frieze with regard to other portrayals of Dionysus in Pompeii, and below for further analysis of the figure of Dionysus.

3 See my ch. 3 in this volume.

4 Pliny *HN* 3.60; Strabo 5.4.3–12.

5 Burkert 1985, 163.

6 See Heinrich 1993, 35–39.

7 Heinrich 1996, 480.

8 Spivey (1997, 15–17, 113–16) suggests that a similar practice was adopted by the Etruscans as well. The symposium is depicted on Etruscan tomb paintings from Tarquinia, such as the Tomb of the Bulls and the Tomb of the Banqueters.

9 See Cole 1980.

10 Euripides' *Bacchae* provides a theatrical portrayal of mania, the state of religious ecstasy achieved by the celebrant of orgiastic Dionysiac rites. Many scholars have regarded this tragedy along with a similar, albeit much later tale in Ovid's *Metamorphoses* as foundational for reconstructing Dionysiac worship and cult ceremonies. These two works must, however, be used cautiously and with due consideration of the fact that they were composed about five hundred years apart in different cultural settings. While portions of these two literary works may reflect actual cult practices, there is little other literary evidence for the mysteries of Dionysus except that which may have filtered through the writings of Christian polemicists of the late Roman empire.

11 Peterson 1919, 70.

12 This issue is further complicated by questions of manufacture and reception. Scholars continue to raise questions concerning the audience for Greek vases found in the west. One major question has to do with whether the iconography of these vessels was created for the Etruscan and western Greek market or, conversely, whether the vessels were merely made for the mainland Greek audience and then sold in the west.

13 See Pallottino 1975. It seems likely, however, that, as in later times, Etruscan cult and ritual centered on determining the will of the gods through reading portents in the weather, the flight of birds, and the entrails of animals. The place of Fufluns within the Etruscan pantheon is suggested by a third-century BC artifact known as the liver of Piacenza. This model of a sheep's liver, which may have been used by *haruspices*, those individuals who divined the will of the gods by reading the livers of sacrificed animals, is divided into various regions that correlate with parts of the sky. Each region is inscribed with the name of a divinity that governed a particular region of the heavens or the earth. An abnormality in one or another part of the liver of the sacrificed animal would suggest an omen from the deity associated with that part of the liver marked with that god's name. The Piacenza model contains an area inscribed with the name of Fufluns, as well as areas reserved for the more obscure gods, such as the formless fates and the Guardians of the Gates. This suggests that Fufluns had a distinct role within Etruscan religion, and the presence of his name alongside more obscure gods such as the formless Guardians, who were peculiar to the Etruscans, suggests that Fufluns was worshipped in Etruria from an early date. The traditional rites of propitiation and divination, such as those suggested by the liver, continued through the third century and were probably practiced during the period in which Etruscans resided in Campania.

14 Bonfante 1993, 222. A number of Etruscan mirrors are inscribed with images of a god named Fufluns who possesses the major attributes of Dionysus/Bacchus. Two significant examples are illustrated in Gerhard 1840, 7, pls. 83, 84; both portray the young god carrying a thyrsus (see also Aigner-Foresti 1998, 4:698).

15 For further depictions of Fufluns, see *LIMC*, s. v. "Dionysos/Fufluns," esp. nos. 66a and 85.

16 Bonfante 1993, 223.

17 The tablet was first published by Cremonese 1848.

18 Salmon (1967, 160) suggests that the original Oscan word should be translated as *liknophoros* (liknon-bearer) as opposed to *legifera* (law-bearing). This reading allows comparison with Dionysus/Bacchus through the iconography of the liknon. For a text of the Agnone tablet, see Conway 1967, 1:191–93.

19 Shapiro et al. 1995, 163.

20 Salmon 1967, 160.

21 Conway 1967, 2:630.

22 Salmon 1967, 172.

23 For a related discussion, see ch. 7 by M. Swetnam-Burland in this volume.

24 Wissowa 1912, 298.

25 Bruhl 1953, 14–15.

26 See Bruhl (1953, 20–24) for a discussion of Liber as a deity independent of Jupiter Liber. See also ch. 5 by C. Hammer in this volume for a discussion of Ceres.

27 Livy 39.13.10–11, translation Sage 1936, 255.

28 Pailler 1988, 5. In Room I, a broken arch and the condition of the central oculus seem to indicate destruction by fire. A number of fragments of an intentionally broken terracotta statuette were interred in the substructures of the peristyle. When reconstructed, this statuette appeared to be a depiction of Dionysus flanked by a panther. It seems likely that the structure of the subterranean rooms, the accompanying finds, and the appearance of large-scale destruction was connected with the *Senatus Consultum*.

29 Livy 29.18.8–9 (*CIL* 1.196).

30 Gruen 1990b, 72–75.

31 Castriota 1995, 91–92.

32 See ch. 7 by M. Swetnam-Burland in this volume for a full discussion and bibliography.

33 See Richardson 1988, 115–16.

34 Castriota 1995, 93.

35 For more on the imagery of Dionysus, see ch. 10 by S. Kirk in this volume.

36 Boyancé 1965–66, 90–92.

37 See ch. 11 by B. Longfellow in this volume for an identification of this figure as Venus based on the correlations with other iconography in the Villa.

38 Henderson 1996, 257.

39 Zuntz 1963, 182.

40 Castriota (1995, 52–53) also suggests that tendril ornamentation on the Villa of the Mysteries frieze may be suggestive of Liber rather than Dionysus. For the use of the entablature to identify the central figure as Venus, see Pappalardo 1982 and ch. 11 by B. Longfellow in this volume.

7 Bacchus/Liber in Pompeii: A Religious Context for the Villa of the Mysteries Frieze
Molly Swetnam-Burland

The image of Bacchus/Liber (color pl. I),[1] leaning against his female companion, is a focal point of the east wall in the frieze in Room 5 of the Villa of the Mysteries. His relaxed body, disheveled clothing, and dreamy expression suggest that he has participated in the activities and celebrations of his followers; his sandal has fallen from his foot, and his head lolls back as if he has had too much to drink.[2] A thyrsus is positioned across his lap, at once suggesting an erect phallus and emphasizing the passive role that the god plays in the rituals taking place before him. He directs his gaze to his companion, ignoring both his followers and the viewer of the frieze. Whether the frieze is read as a portrayal of a bridal drama or Bacchic mystery, Bacchus/Liber is presented as the patron of the event, albeit an inattentive one. An examination of the evidence for the worship of Bacchus/Liber in Pompeii in general suggests that this image of Bacchus/Liber would have particular meaning for a Pompeian audience; images of the deity in domestic shrines and from the extramural public temple show that he was worshipped in similar guise, partly nude and clean shaven, as a deity of fertility and agriculture, especially the vine. This chapter examines the Pompeian contexts associated with the veneration of Bacchus/Liber. I will argue that Room 5 in the Villa of the Mysteries was not a space reserved for religious practice but was instead a space in which the Bacchic imagery was meant to evoke associations of piety and the mythological world.

Numerous scholars have attempted to understand the frieze from the Villa of the Mysteries as a reflection of Bacchic or Dionysiac worship and religion. It has been read as a bridal drama, an initiation ceremony into the worship of Bacchus/Liber or Dionysus, or an initiation into a secret and select woman's cult.[3] Scholars have used evidence of other religious imagery and practice to try to decode the frieze itself, or they have tried to use the frieze as evidence to elucidate the general nature of Graeco-Roman mystery religion.[4] Questions of religion and myth have almost always been central to interpretations of the frieze, but scholars have often looked far afield in searching for comparanda. Much of the early scholarship on the frieze looks to Greek, rather than Roman, textual and visual sources to understand the iconography.[5] Seaford, for example, cites Aristophanes, Aeschylus, Euripides, and anthropological theories about "primitive people," in addition to Livy and Apuleius.[6] Such approaches result in interpretations of the frieze that ignore its Pompeian context and the local traditions associated with the worship of Bacchus/Liber.

THE SANT'ABBONDIO EXTRAMURAL TEMPLE

In fact, the worship of Bacchus/Liber has a documented history in and around Pompeii, and for a community of residents within the city veneration of the deity was an integral part of public and private life. A temple to the deity is located outside the city walls, about a kilometer away from the amphitheater, in what may have been a rural setting. It

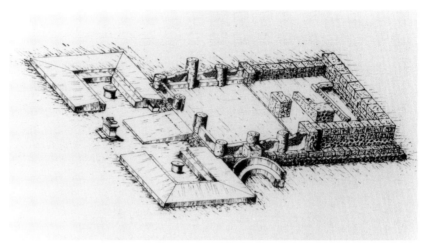

Fig. 7.1. Axonometric drawing of the
Sant'Abbondio temple. Pugliese
Caratelli and Elia 1979, fig. 2.

was not connected to the city by any known roads, and Richardson
suggests that it was surrounded by a grove with a favorable location
overlooking the Sarno River.[7] The temple is a small Doric tetrastyle
building, entered by a ramp (fig. 7.1). A free-standing altar is centered
on the main axis of the temple, and a second altar is located in the *cella* of
the temple. Flanking the first altar are two large red stuccoed *triclinia*,
built in the last phase of habitation of Pompeii, that were originally
covered by a grape arbor.[8] Jashemski thinks that this dining space was
used for the communal enactment of Bacchic rituals of "wine-drinking,
banqueting, and general rejoicing."[9] Along the south side of the temple
is a semicircular *schola*, used as a seating area and possibly also for dining.

The temple itself was built long before Pompeii was made a Roman
colony by Sulla in 80 BC.[10] An Oscan inscription on the altar (fig. 7.2)
declares that it was dedicated by Maras Atinius, an aedile, with his own
money. Another inscription set into the pavement of the *pronaos* bears
the names of two more aediles, Oppius Epidius and Trebius Ulezius.[11]

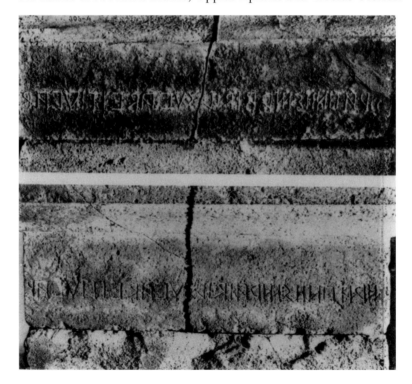

Fig. 7.2. Inscriptions from the altar in the
Sant'Abbondio temple. Pugliese Caratelli and
Elia 1979, fig. 7.

60

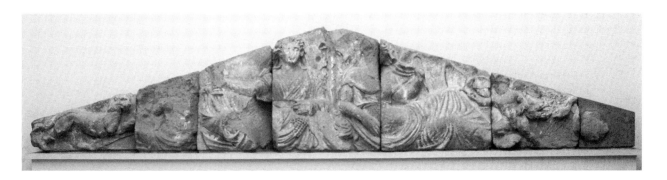

Thus, in its earliest phase, the temple was patronized by the highest class of the city's residents, who made private dedications to show their piety.[12] The pediment of the temple (fig. 7.3) is carved from volcanic tuff and probably dates to the earlier (Samnite) phases of the temple. It presents Bacchus/Liber and a female deity identified as Venus, reclining with their feet pointed toward the corners of the pediment.[13] Each deity is attended by a mythological follower and accompanied by an animal attribute, and each occupies equal space in the badly damaged, but complete, pediment. Most scholars have discussed the temple as belonging to Bacchus/Liber (or Dionysus) alone or have identified him as the primary deity associated with the site. Yet without specific epigraphic evidence identifying him as the sole beneficiary of human attention at the site, it seems rash to ignore the equally prominent iconography pointing to Venus as a co-occupant of this sacred space. [14]

Bacchus/Liber is beardless, veiled, wreathed, and fully clothed. He holds a bunch of grapes in one hand and a kantharos in the other and is attended by a figure alternately identified as Silenus or a satyr.[15] His panther crouches in the corner of the pediment. An upright thyrsus decorated with ribbons separates Bacchus/Liber from Venus, who wears a garment draped below her shoulders, pinned with a brooch or *fibula*, and a necklace. She is attended by a winged Eros offering her an object, perhaps a *flabellum*[16] (a small fan) or a mirror. Partially preserved in the rightmost corner of the pediment is a swan. Venus, like her counterpart, is veiled, and with her left hand she lifts the veil away from her face and body, a gesture that may indicate that this scene depicts the divine marriage of the two deities.[17] An Etruscan tomb from Vulci portrays the deities in an almost identical configuration, again accompanied by the panther and the swan.[18] The imagery on these pediments hints at some of the Etrusco-Campanian traditions and conventions for depicting these deities as a pair. In Greek depictions of this divine couple, the emphasis is placed primarily on Bacchus/Liber, or Dionysus, and his consort plays a secondary role, in some cases acting almost as an attribute.[19] On the pediments from Pompeii and Vulci, however, equal emphasis is placed on Bacchus/Liber and Venus. Both deities seem to be invoked in their roles as protectors of agriculture and fertility, as discussed below.[20]

The Sant'Abbondio temple indicates that Bacchus/Liber was a deity worshipped in the city throughout much of its history. The temple grounds were maintained and even improved despite the *Senatus Consultum* of 186 BC forbidding Bacchanalian rites, the colonization of the city by the Roman dictator Sulla, and the damage to the temple site in the earthquake of AD 62. This does not mean, however, that the cult housed in the temple did not evolve to fit the needs of the new residents

61

of the city or that Bacchus/Liber and Venus were continually worshipped in the same manner. Although the iconography of the pediment suggests that these two deities were originally venerated as fertility gods, the refurbishment of the complex and addition of the two *triclinia* suggest that the Roman-period devotees of the cult tailored the temple to meet the needs of different rituals.

The positions of the *triclinia*, the location of the altar between them, and the deliberate cultivation of plants sacred to Bacchus/Liber attest the importance of communal and ritual dining as cultic activities in the Roman phase of the temple. Near the temple was a pit marked by flat stones and filled with the remnants of sacrificial animals and meals, including bird bones and broken sherds of pottery dining vessels,[21] indicating that even the leftovers and remnants of the shared meals were considered sacred. The importance of ritual dining in cultic practice may suggest that Bacchus/Liber was venerated in the Roman period of the temple as a god associated with agricultural fecundity and cultivation. The position of the temple within a rural, grovelike landscape, too, suggests that Bacchus/Liber was seen as a deity connected to a larger sacred landscape.[22]

There are few other attestations of public worship of Bacchus/Liber within Pompeii. On the doorways and entrances to four *tabernae*[23] in the city there were painted depictions of Bacchus/Liber (often shown with Mercury), two located on the Strada di Nola, one in Regio VII, and one in Regio V.[24] These painted representations of the deity may have functioned as street shrines, places where community members could make offerings as they conducted their daily business, but their close association with particular commercial establishments suggests instead that they functioned as invocations of the gods meant to bring luck and good business.

DOMESTIC RELIGION

Historians and archaeologists are faced with a strange situation when studying Roman domestic cult and its associated shrines. Based on literary evidence, we know that worship played a central role in Roman domestic life and that shrines were spaces that reflected the "relationships of power" of the people dwelling in the house.[25] Yet, at the same time, it is exceedingly difficult to characterize the nature of domestic religion with any specificity; literary sources give tantalizing glimpses into rites of passage and other rituals associated with domestic religion but not into the underlying beliefs.

Roman domestic religion (as evidenced at Pompeii) should not be thought of as standardized or canonical. Different households had different patron deities and probably venerated them in different ways. Not every house or domestic space in Pompeii has a household shrine, suggesting that in addition to the recognized types of household shrines, portable altars could have been used in domestic worship[26] or that domestic worship occurred in archaeologically unattested forms. Similarly, *nymphaea* and other types of fountain shrines are often left out of discussions of "domestic religion"; yet small-scale statuettes similar in guise and form to those from shrines have been found in them.[27] To better understand the role of Bacchus/Liber in domestic religion, it is helpful first to review broadly the practices of domestic religion and the

traditional domestic deities, with the understanding that Roman domestic religion allowed for great diversity and personal adaptation to fit the needs of each family.

The primary deities in Roman domestic cult were the *lares*, *genius*, and *penates* of the family (more specifically of the *paterfamilias*). The *lares* were deities who guarded and protected the home, promoting the welfare of its family members.[28] The *lares* worshipped in the domestic shrines in Pompeii should be understood as domestic incarnations of a general type of beneficent spirit.[29] The *genius* "generally refers to the guiding *numen* of a family, its procreative force, and especially the living spirit of the *paterfamilias*"[30] and is sometimes depicted as a man pouring a libation. Depictions of the *genii* of families are rare, however, and the bearded snakes found commonly in domestic shrines may in fact be symbols of the "religious force" of the *genius*.[31] Of the ancestral deities, the *penates* are the least well understood. They are often equated with *lares* but seem to be more abstract *numina*, linked to the continued nourishment and subsistence of the family.[32]

Family members, including slaves and servants, made offerings of grain, grapes, cakes, wine, and sometimes meat[33] to these deities, on specific days each month and during yearly festivals, such as the *parentalia* and *compitalia*. Cato discusses specifically the duties of the wife of a *villicus* of a farming villa, an esteemed family slave.

> She [the housekeeper] must not engage in religious worship herself, or get others to engage in it for her without the orders of the master or mistress. Let her remember that the master attends to the devotions of the whole household. . . . On the Kalends, Ides, and Nones, she must hang a garland over the hearth and on those days pray to the household gods. Cato *Agr. Orig.* 143 (trans. Hooper and Ash 1934, 125)[34]

Cato treats the housekeeper as the agent of the *paterfamilias*, so that her act of placing garlands and offerings on the shrine benefits him and his household, of which she is a member. Foss has noted that shrines are often located near areas devoted to dining or food preparation, thus allowing the family gods literally to watch over and control the nourishment (and by extension the well-being) of the household. In his view, through the acts of preparing and serving food, the family slaves became living agents of the family gods.[35] In this passage, Cato explains that the female servant should not engage in religious activity except when ordered to do so by the *paterfamilias* or *materfamilias*; nonetheless it is clear that domestic worship was an important part of daily life for both the female servants and family members in the household.

Individual family members, too, gave offerings to the family gods, as during rites of passage. The acts of worshipping Roman ancestral deities, therefore, expressed the piety of individual family members and also reinforced their social bonds with one another. Young boys, for example, donated their *bullae*, symbols of youth and childhood, to the *lares* when they assumed the *toga virilis*,[36] thus establishing themselves as adult members of the households. Newly married women offered coins and grain to the *lares* when they joined their new households.[37] In so doing, a woman would make a statement about her new identity as a *materfamilias*, wife, and potential mother. Just as rites of passage solidified the culturally sanctioned roles of men and women, the duties and sacrifices performed by slaves extended the hierarchical nature of the master/slave relationship into the realm of family religion.[38] Shrines were the physical

Fig. 7.4. Shrine painting from a thermopolium, showing Bacchus/Liber, Mercury, the lares *and* genius. *After Frölich 1991, pl. 2.1.*

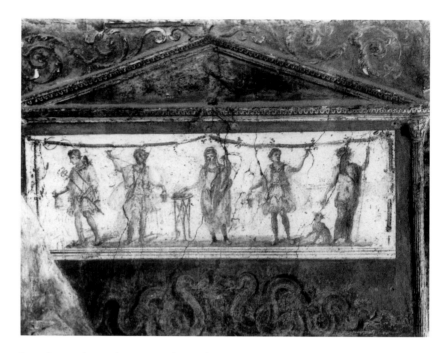

locations where these social rituals were enacted and as such were ideologically significant places where the beliefs shared by the family were made manifest.[39]

Although participation in domestic religion was an important part of daily life for Roman women, it is difficult to determine precisely what their roles in domestic religion were. In most cases women played a secondary role, participating and sharing in the rituals conducted by the *paterfamilias*.[40] In general, depictions of the *materfamilias* in shrine paintings are rare.[41] The shrine painting in this exhibition, from the Piazza del Mercato, Boscoreale (cat. no. 37), is unusual among known shrine paintings in that it depicts a family making a sacrifice and includes the images of the *paterfamilias*, *materfamilias*, and three children or slaves. In this example, the *paterfamilias* and *materfamilias* flank an altar, and each pours a libation to the family gods. This example shows one way in which the *materfamilias* played an explicit role in family ritual.

BACCHUS/LIBER IN DOMESTIC RELIGION

On first inspection, the veneration of Bacchus/Liber seems most at home in environments like *tabernae* and *cauponae*, where wine was sold and the well-being of the owner and his or her family depended on the revenue produced.[42] A shrine in I.8.8 (fig. 7.4), a *thermopolium*, depicts two *lares*, a *genius* performing a sacrifice, Mercury holding a money purse, and Bacchus/Liber offering wine to his panther from a kantharos. The purse held by Mercury seems to be a symbol for commercial prosperity, and Bacchus/Liber's wine seems an apt reference in an establishment devoted to its sale. It is simplistic, however, to say that this was the only aspect of Bacchus/Liber worshipped or that he was mainly associated with the sale or purchase of wine. Bacchus/Liber was just as commonly venerated in more traditional domestic settings, such as the family shrines discussed above.

Grapes (and therefore wine) were the most important crop in the

Campanian region,[43] and evidence for vineyards has been found in public and private parts of Pompeii and its environs. Grape arbors surrounded the two *triclinia* in front of the Sant'Abbondio temple, and there were vineyards of varying sizes in privately owned homes, taverns, and inns, often associated with *triclinia*.[44] Pliny, a native of the region, describes Campania as a territory filled with "vine-clad hills with their glorious wine, famous all the world over" (*HN* 3.60). Clearly, depictions of grapes, wine, and Bacchus/Liber in a Pompeian context could refer not just to the refreshments served in commercial establishments but also to the broader local economy, which sustained families of all classes.

A primary purpose of household shrines was to ensure the welfare of the family, and the *lares* themselves were the guardians of the supply, preparation, and consumption of food. Invocations of Bacchus/Liber as the protector of agricultural fertility, then, fit well with the purposes of the other deities in household shrines. In the context of these shrines, images of Bacchus/Liber and wine-drinking should not be thought of as references solely to "Bacchic" revelry but also, and as importantly, to the well-being and fertility of the household, its landholdings, and all family members.

Orr states that Bacchus/Liber is the third most common nonancestral deity found in the house shrines of Pompeii,[45] but this estimate exaggerates his popularity.[46] In Regio I, for instance, there are roughly 122 house shrines.[47] Of the shrines in Regio I that include depictions of nonancestral deities, five have images of Bacchus/Liber, three have images of Mercury, three have images of Venus, and three have images of Minerva. Therefore, images of Bacchus/Liber are not much more common than those of other nonancestral deities; only about 3 percent of all shrines in Regio I provide evidence of Bacchic worship. In the entire city only fifteen shrines indicate worship of Bacchus/Liber. In Ostia, by contrast, there is no evidence that Bacchus/Liber was worshipped in conjunction with the ancestral deities, though these deities take the same form and guise that they do in Pompeian and Campanian shrines.[48] So while it is not possible to say that Bacchus/Liber was an integral part of *all* domestic religion in Pompeii, there nonetheless does seem to be an interest in the deity in the Campanian region that is not attested elsewhere.

ICONOGRAPHY OF BACCHUS/LIBER IN SHRINE PAINTINGS

In Pompeian art generally, Bacchus/Liber is sometimes depicted as youthful and sometimes as mature; in fact, in both wall paintings and statuary there were several conventions for depicting the god.[49] In Pompeian religious contexts, namely domestic shrines and temples, only the youthful Bacchus/Liber appears. Diodorus Siculus, writing in the first century BC, discusses the young and mature versions of the deity, referring specifically to Greek traditions and myths: "He was thought to have two forms, men say, because there were two Dionysioi, the ancient one having a long beard, because in ancient times all men wore long beards, the younger one being youthful and effeminate and young" (Diod. Sic. 4.5.2, trans. Oldfather 1935, 355). It is an image apparently consistent with this younger, more effeminate version of Bacchus/Liber that the Pompeian shrines and the pediment from the extramural temple depict. Carpenter argues, with reference to images of the god Dionysus

65

Fig. 7.5. Shrine painting from the House of the Centenary, depicting Bacchus/Liber as a cluster of grapes. After Frölich 1991, pl. 11.

on Attic vase painting, that a youthful image of the god is meant to recall certain episodes in the history of his life, specifically a period in his youth when he was driven mad by Hera and as a result roamed the countryside hunting animals in a wild frenzy.[50] The wildness associated with the youthful god has, in turn, influenced scholars' discussion of the frieze in the Villa of the Mysteries, even though these associations are Greek rather than Roman.[51]

Relying on Greek visual and textual sources to explain the nature of Bacchic worship as portrayed in the frieze from Room 5 in the Villa of the Mysteries may lead to a misunderstanding of Bacchus/Liber as worshipped in Pompeii and Campania. It is unlikely that in the Roman period the youthful image was meant to conjure associations of dementia. In the pediment of the extramural temple, the young Bacchus/Liber wears a wreath and is associated with his panther and a satyr or Silenus. Most depictions of Bacchus/Liber from Pompeian shrines conform to this type;[52] he is generally shown as a young, clean-shaven deity, nude or partially nude (with a *chlamys* draped around his shoulders or hips), holding a thyrsus in one hand and a kantharos (or more rarely grapes) in

66

the other.[53] In the shrine paintings, as in the example from I.8.8 discussed above (fig. 7.4), Bacchus/Liber is depicted with his panther, and in most cases he pours a stream of wine from his kantharos into the panther's mouth. This action emphasizes the god's connection with the cultivation of grapes and the production of wine, a connection made even more explicit by the shrine painting from the House of the Centenary (fig. 7.5). In this instance, Bacchus/Liber's body is composed of a cluster of grapes, and, as is usual, he leans upon his thyrsus and pours wine into his panther's mouth. Behind him, on the slopes of Mount Vesuvius, are rows of cultivated grapevines. These depictions of Bacchus/Liber stress that he is a protective and kindly deity who watches over and provides for his followers; they invoke him as a deity closely tied to agricultural fertility and the vine. In other words, depictions of Bacchus/Liber in Pompeian religious contexts do not stress his connections with wild behavior and ecstatic revelry.

This manner of depicting Bacchus/Liber is not unique to shrine paintings but is based on Roman and Hellenistic prototypes and was employed throughout the Roman empire in a variety of media. Richter argues that the type is based on a fourth-century Greek statue prototype.[54] The type itself is so common in a variety of media (marble, bronze, terracotta, and painting) and has so many variations[55] that it should not be thought of as a mere "copy" of a Greek masterwork prototype but rather as a popular way of portraying Bacchus/Liber in the Roman period in a wide range of contexts.

An excellent example of the type in marble comes from the Temple of Isis in Pompeii (fig. 7.6). As in the shrine paintings, Bacchus/Liber is partly nude and clean shaven. In his right hand he would originally have held a thyrsus, and with the left he would have held a kantharos, tipped to pour wine into his panther's mouth. The statue of Bacchus/Liber was appropriate in this setting because the deity was assimilated to the Egyptian god Osiris in the Roman period. On a miniature scale, a Roman signet ring from the Metropolitan Museum of Art (cat. no. 45) features the same combination of seminude deity and panther carved into a carnelian gemstone.[56] The Kelsey sarcophagus (cat. no. 58), dating to the second century AD, also has a depiction of Bacchus/Liber in a similar guise, holding a down-turned kantharos; elsewhere in the frieze the ubiquitous panther frolics between the dancing maenad and satyr.[57] In the shrine paintings, the images of Bacchus/Liber acted as focal points for worship, but this same type and presentation of the deity could be employed in a number of other contexts to different effect. The ring could have been used as the personal emblem of its owner (male or female), as a signet ring to mark documents, or as a magical amulet,[58] whereas the sarcophagus was intended to commemorate the life and religious beliefs of its owner. Thus, this general type and manner of depicting Bacchus/Liber should not be thought of as having an inherently cultic meaning but rather as a generic image of the god suitable for various social and religious purposes.

Nonetheless, the attributes associated with the type do have specific meanings. An inscription from Ariminum records a dedication of a wealthy individual to Liber Pater: *Tullius | Zoticus VI | vir Aug. ad | Liberum patrem | cum redimiculo | auri III et thyrso | et cantaro arg. p. IIS | testamento . . . (CIL* 9.358) The inscription is now incomplete, but it is clear from what survives that Tullius Zoticus set aside money in his will to purchase three golden headbands (*redimiculum*), a silver kantharos,

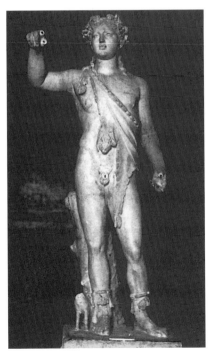

Fig. 7.6. Statue of Bacchus/Liber from the Temple of Isis in Pompeii. DAIR 39.999.

and a silver thyrsus as gifts for the god, probably meant to accompany a statue. It is not incidental that these are the attributes with which Bacchus/Liber is most commonly depicted. The *redimiculum*, or *mitra*, is the Bacchic headband thought to ward off headaches caused by excessive drinking.[59] The thyrsus is the special staff of Bacchus/Liber, often decorated with fillets or ribbons and sometimes depicted with a bushy pineconelike tip. The kantharos is a drinking cup with high, rounded handles. These attributes all make reference to Bacchus/Liber as the god responsible for giving wine to humanity, showing at the same time that he partakes of wine, participates in his own celebrations, and in essence makes himself accessible to the humans that venerate him.

BACCHUS/LIBER AND THE VILLA OF THE MYSTERIES

In the frieze from the Villa of the Mysteries, Bacchus/Liber's participation in his own rites and rituals has been carried to an extreme. His body, bearing, and countenance suggest that he is inebriated. For the most part, this image of Bacchus/Liber conforms to that found in the extramural temple and shrines. He is youthful, partially nude, clean shaven, and wreathed. Yet the panther and kantharos are missing, integral elements of the presentation of the deity in explicitly religious contexts in Pompeii. In the shrine paintings (and to a lesser extent in the pediment from the Sant'Abbondio temple), the interaction between the god and the panther stands symbolically for the nature of the deity and his invocation by the citizens of Pompeii. The gesture is one of sharing, nurturing, and caring and epitomizes the gifts of the gods to his followers. In the shrine paintings, Bacchus/Liber is the agent in this interaction, whereas the panther looks passively to him for guidance and nourishment. In the frieze from the Villa of the Mysteries, by contrast, the god looks to *his* female companion, ignoring both his followers and the viewer of the painting. A Pompeian viewer of the frieze would probably understand the importance of the deity to many inhabitants of the city. Yet this same viewer would also recognize that the image in the frieze is not a standard cult image, in that it does not stand in for the god, inviting the viewer to make dedications or sacrifices to it.

The domestic shrines in the Villa of the Mysteries offer no evidence that Bacchus/Liber was actually worshipped in the villa. In the kitchen and courtyard areas of the villa there are two shrines. The first, on the north side of the court, consists of a tufa altar, a wall painting, and a niche articulated with a stuccoed pediment. The excavators found small statuettes of Hercules and an unidentified goddess in the niche.[60] In the east wall of the courtyard, located near the hearth area, was another niche with painted images of Minerva and Vulcan.[61] In addition, a tile found in the villa has a partially preserved stamp that reads, "Cerer(i) sac(ra) scapula . . . ,"[62] perhaps indicating that Ceres, too, was worshipped by the inhabitants of the villa. There is evidence in the Villa of the Mysteries, therefore, for the domestic worship of the ancestral deities and of Minerva, Hercules, and perhaps Ceres, but not of Bacchus/Liber. Toynbee has argued that Room 5 itself is an "initiation chamber,"[63] a view that suggests the physical space of the room was used to enact rituals for the worship of the deity—in essence, that Room 5 was itself a kind of grandiose shrine. This view has, however, not been accepted by subsequent scholars. Most scholars designate it rather as an

oecus or a *triclinium*,[64] but an exact determination of the function of Room 5 is not possible.[65] As the image of Bacchus/Liber does not correspond to those from shrine paintings in Pompeii and as no portable altars (indicating the presence of religious activity) were found in the room, it seems unlikely that the room did function as an "initiation chamber" or shrine room. The image of Bacchus/Liber in this context is not a cultic one but rather an image inviting reflection and contemplation of the nature of the god, his retinue, and local religious practices associated with worship of the deity.

Bacchus/Liber was a deity of special importance within the city of Pompeii. Although he was not venerated by all residents, a community of followers incorporated worship of the god in their public and private lives. This worship stressed the god's connection to the landscape around the city, a landscape that provided nutritional and economic sustenance for all residents. He was depicted not as wild and dangerous but rather as a kindly deity providing for his followers. It is probably these associations with fertility and fecundity that would have informed a Pompeian viewer's understanding of the depiction of Bacchus/Liber in Room 5 of the Villa of Mysteries.

APPENDIX: SHRINES WITH BACCHUS/BACCHIC IMAGERY

Regio I
- I.2.20–21 (*caupona*): in garden, painted depiction of Bacchus/Liber holding thyrsus and kantharos, pouring wine into mouth of panther at his side. Marble Bacchic head from a herm found in associated niche.
- I.8.8 (*taberna*): on wall behind *thermopolium*, painting associated with *aediculum*. Bacchus/Liber is depicted offering wine to his panther.
- I.12.16 (house): in atrium, niche with aedicular façade and painting, Bacchus/Liber stands with thyrsus and panther, surrounded by grape arbor. Ceiling of niche also painted with grapes.
- I.11.1 (*caupona*): in front room, painting with Bacchus/Liber and panther, Venus and mirror.
- I.3.20 (house): in garden peristyle, niche and altar, decorated with painted theatrical masks.

Regio II, III, IV (no shrines with evidence of Bacchus as focus of worship)

Regio V
- V.4.3 (house): vaulted niche and aedicular façade, surrounded by painted depictions of deities. Directly flanking niche, and inside façade, are Venus Pompeiana and Fortuna. Jupiter stands to right of aediculum and Bacchus/Liber to left. Painting of the god badly damaged, with head and shoulder missing. He stands with a red cloak draped around him, pouring wine into mouth of panther at his side. In register below the niche are depictions of Mercury, Victoria, Minerva, and Hercules.
- V.1, southwest corner (exterior of *taberna*): on pilaster of doorway, depiction of Bacchus/Liber leaning on a satyr and Mercury with omphalos and snake.

Regio VI
- VI.8.20 (*fullonica*): a fountain flanked by depictions of Bacchus/Liber, the river Sarnus, Apollo, and Venus.
- VI.9.6/7 (house/Casa dei Dioscuri): *aediculum*, attached to wall, with free-standing altar in front. The shrine seems to have been meant to house a

single large metal statue; at time of excavation, rivets were found embedded in a small base inside the shrine. Painted on base is a panther raising its head toward a cluster of grapes, indicating that the statue was probably Bacchus/ Liber.

Regio VII
- VII.1.36/37 (*pistrinum*): shrine painting with *lares* and serpents. Bacchus/ Liber stands to left of the painted altar, wearing red *chlamys* and holding thyrsus and grapes. Vesta stands to right of same altar.
- VII.6.34/35 (exterior *tabernae*): Mercury and Bacchus/Liber on pilasters of entrance.

Regio VIII (no shrines with Bacchus)

Regio IX
- IX.8.3/6 (house/Casa del Centenario): small precinct enclosed by two walls off atrium, with free-standing altar in front of paintings and niche. *Lares* flank niche, and on adjoining wall Bacchus/Liber is depicted holding a thyrsus and pouring wine into mouth of panther at his side. His body is composed of a large cluster of grapes.
- IX11.11 (house): free-standing altar in garden, with accompanying painting. Figure of Bacchus/Liber poorly preserved, but thyrsus and panther visible. Figures of Silenus, Bacchantes also visible.
- by Nola Gate (exterior of *taberna*): pilasters with figures of Mercury, Bacchus/ Liber and Ariadne (?) and Hercules.
- by Nola Gate (exterior of *taberna*): Mercury and Bacchus/Liber on a pilaster, under vines and grapes.

1 There is a terminological problem inherent in the study of Bacchus/Dionysus/Liber in the Roman world, as the Roman deity was a syncretized version of similar Italic, Greek, Etruscan, and Samnite deities (see ch. 6 by D. Wilburn in this volume). It is not clear under what name this deity was worshipped in Pompeii, either in the Samnite phases of occupation of the city or the period in which the Villa of the Mysteries was constructed; there are no inscriptions associated with the Sant'Abbondio temple that name the deity. Two graffiti, however, probably dating to the years just prior to the eruption of Mt. Vesuvius, name the god. The first, located "inter decimum et indecimum ostium a vicolette delle terme," reads LIB / LIBER and is placed under an image that the editor identified as "Bacchus." This graffito provides evidence, therefore, that the deity commonly known to scholars as "Bacchus" or "Dionysus" was also known as "Liber" in Pompeii (*CIL* 4.1626). Another graffito, from Regio VI, insula 15, invokes the deity as Bacchus (*CIL* 4.3508), suggesting that this name was also used by residents of the city. It should be noted that both names for the deity were used by the Romans interchangeably and also that most scholars choose to call the deity Dionysus. The use of any of these terms is not improper, so long as it remains clear that the Roman and Greek incarnations of the deity are not necessarily identical. For the purposes of this chapter, I have chosen to refer to the deity as Bacchus/Liber, to indicate that both names were used in Pompeii.
2 See ch. 6 by D. Wilburn in this volume for an alternative interpretation of Bacchus/ Liber in this frieze. Wilburn argues that there are no images of wine *per se* in the frieze and points out that the contents of the bowl held by the satyrs and Silenus may instead be water. He suggests that, as there is no wine depicted in the frieze, the participants in the ritual are not drunk and thus are indulging not in the "Bacchanalia" but rather in fertility rites associated with the Roman deity Liber.
3 See esp. Toynbee 1929, Brendel 1980, Bieber 1928, Herbig 1958, and Sauron 1998. For more detailed discussion of these themes in the present volume, see ch. 1 by E. Gazda (for an introduction to the frieze and interpretations), ch. 5 by C. Hammer (for a discussion of bridal and marital themes), and ch. 11 by B. Longfellow (for a discussion of Venus and marriage within the frieze).
4 See esp. Seaford 1981.
5 Underlying this trend is the assumption, in many cases, that the frieze is a copy of an

original Greek artwork, thus reflecting Greek cultural and religious practices. For a discussion of this issue, see ch. 9 by J. Davis in this volume. This trend has also fostered interpretations of the frieze that rely on Greek rather than Roman mythology.

6 Seaford 1981, 52–67.

7 Richardson 1988, 105.

8 Jashemski (1979–93, 1:157–58) found root cavities and post holes consistent with a grape arbor or pergola.

9 Jashemski 1979–93, 1:158.

10 Richardson (1988, 106) suggests that both temple and pediment date to the second century BC.

11 Mr atiniis mr aidil suvaad eituvad ('Maras Antinius Marae f. aedilis sua pecunia'); u epidiis u tr meziis tr aidilis ('Oppius Epidius Oppi f. Trebius Mezius f. aediles'). Text and Latin translations, Pugliese Carratelli and Elia 1979, 448–49.

12 The altar was dedicated by Maras Atinius in his capacity as a private individual, as he paid for it with his own money. The placement of the names of the two other aediles also might imply that they had donated money to the god and his temple but could indicate that construction of the temple was completed as a public work during their tenure in office. It is not possible to say, therefore, whether the temple was built with public or private funds; it is noteworthy, however, that private individuals made expensive dedications.

13 Richardson (1988, 106) has identified the female deity as Ariadne, but Pugliese Caratelli and Elia (1979, 457 ff.) have suggested that the deity may rather by Venus.

14 Similarly, there are numerous iconographic references to Venus in the frieze from the Villa of the Mysteries, including rabbits and Cupids in the vines and scrollwork that frame the frieze and Cupids in the main frieze itself. See ch. 11 by B. Longfellow in this volume and Castriota 1995, 47–53, 76–77.

15 Richardson 1988, 105; Pugliese Carratelli and Elia 1979, 456–60.

16 Pugliese Carratelli and Elia 1979, 460.

17 Pugliese Carratelli and Elia 1979, 446.

18 Pugliese Carratelli and Elia 1979, 466, fig 15.

19 In Greek and South Italian art, Dionysus is frequently accompanied by a variety of female companions, ranging from his mother, Semele, to Aphrodite and Ariadne. For discussion of Greek and South Italian depictions of Dionysus and his companions, see ch. 10 by S. Kirk in this volume.

20 The swan is a well-attested symbol of Venus, especially connected to her aspects as a fertility goddess. Castriota 1995, 63–68. Bonfante (1993, 221–35) argues that Etruscan and Italic versions of the god (Fufluns) stress his roles as a god of vegetation and fertility.

21 Pugliese Carratelli and Elia 1979, 445.

22 Aspects of the Pompeian landscape were literally venerated within some households in Pompeii. Personifications of the river Sarnus (located near the Sant'Abbondio temple) are included in the family shrines of numerous houses: V.1.23, V.2.4, VI.7.8, IX.3.20, and the Casa del Larario del Sarno. The imagery from this last shrine connects the personified river with agriculture and commerce. It is also interesting to note that statues of Bacchus/Liber and members of his retinue are common in the domestic gardens of Pompeii, and painted representations of Bacchic themes are often present in garden paintings. (See, for example, the sculptural assemblage from the House of the Golden Cupids and the paintings from the House of the Fruit Orchard.) The popularity of Bacchic themes in these settings may also reflect the god's connection to agricultural fertility and the local landscape.

23 By "public," I mean merely shrines or temples not located within the boundaries of a house or villa, areas where the general population would not have access. As discussed below, Bacchus/Liber was a deity worshipped in domestic cult as well.

24 See Boyce (1937, catalogue entries in appendix 2: 6, 17, 19, 30). In addition, there was a painting of a child Bacchus/Liber driving a *biga* outside the entrance to a *fullonica* (Boyce 1937, appendix 2, cat. 2).

25 Wallace-Hadrill 1996, 114.

26 For a discussion of these altars, see esp. Orr 1972, 94–95. For general discussions of domestic religion and shrines, see esp. Boyce 1937, Orr 1972, and Frölich 1991.

27 For example, a bronze statuette of Venus was found in an aedicular fountain in I.7.11 (Casa dell'Efebo), but neither Boyce 1937, Orr 1972, nor Frölich 1991 considers this to be a "lararium," though it is possible that it was a shrine of some sort. It is important to realize that certain features of households that are often assumed to be merely decorative, such as fountains, could also have had religious significance.

28 In fact, these deities should most properly be referred to as the *lares familiares* or *domesticii*, as there were also *lares* who protected Roman travelers, soldiers, athletes, and even crossroads. For the *lares* of travelers and crossroads, see *CIL* 2.4320, *CIL* 2.4217.

71

For the *lares* of soldiers, see Ovid *Tr.* 4.8.22. Orr 1978, 1565–69. Laurence (1996, 39–43) has used street shrines to identify neighborhood communities, whose members would have used the same altar.

29 Orr 1978, 1565–69.

30 Orr 1978, 1569–70.

31 Orr 1978, 1573.

32 Orr 1978, 1562–63. Orr also suggests that they were originally linked with the pantry in a house, because the word *penates* may be etymologically linked to the word *penus*, for storage area.

33 Juv. 9.183, Tib. 1.10.21–24, Hor. *Car.* 3.23.3–4, Hor. *Sat.* 2.3.164. As mentioned in the selection from Cato quoted below, garlands and fragrant plants were also common offerings to the *lares*, *penates*, and *genius*. Propertius mentions flowers, vervain, and marjoram draped or burnt as offerings (Prop. 4.3.53), and Juvenal states that the images housed in the shrines were also draped with flowers and wreaths (Juv. *Sat.* 12.85). According to Orr (1978, 1567 n. 58), many household shrines were equipped with pegs or nails meant to support wreaths and garlands. Thus, there may be a connection between family shrines and the gardens that produced such religious offerings.

34 Though writing in the second century BC, Cato nonetheless remains one of the most informative sources for Roman domestic religion, a topic rarely discussed by Roman authors.

35 Foss 1997, 196 ff.

36 Pet. *Sat.* 60.8.

37 Plat. *Aul.* 23–27, 382–87. See also Macr. *Sat.* 1.15, 22.

38 See Turner 1969, 94–95 and Van Gennep 1960, 1–11 for discussion of rites of passage.

39 Indeed, the entire Roman house can be seen as a physical space that "reflects, constructs, and reproduces relationships of power" (Wallace-Hadrill 1996, 114), shrines being particularly important focal points within any given house.

40 Charles (1998, 511) points out that the *materfamilias* played an important role in family rituals but that she functioned primarily as the auxiliary to the *paterfamilas*, who had the primary responsibility for representing the family to the ancestral gods.

41 Charles 1998, 511.

42 For example, painted representations of the god on the exterior façade of buildings are most commonly associated with *tabernae*.

43 Jashemski 1979–93, 1:220.

44 Jashemski 1979–93, 1:157–58, 221–24.

45 Orr 1978, 1581.

46 See also Charles (1998, 470), who notes that only two statuettes of Bacchus/Liber were found in shrines at Pompeii.

47 Boyce (1937) and Orr (1972) discuss 112 house shrines in Regio I, but (following their typology), I have identified ten additional shrines: I.3.2, I.7.18, I.7.11 (House of the Efebe), I.8.8, I.8.10, I.8.17, I.9.3, I.11.1, I.11.2, and I.13.2 (*triclinium* in House of Suetoria Primigenia). It is difficult to determine in many cases whether a niche in the wall is a shrine or merely a shelf. They are sometimes elaborated with paint, stucco, or a piece of tile intended to function as an offering receptacle but often are plain and undecorated. Allison (1997, 333) points out that, in the latter case, the identification of such niches as *shrines* is problematic: "It has yet to be demonstrated that they *all* had a religious purpose." Of the shrines in Regio I, 27 (or 22 percent) fall into this suspect category. Following Boyce and Orr, I have treated these niches as shrines, but it must be noted that in such cases it is impossible to tell which deities, if any, were venerated.

48 The evidence for domestic religion at Ostia, of course, is much scarcer than at Pompeii and is later in date. Nonetheless, painted and bronze depictions of the *lares*, *genii*, and other deities (such as Hercules, Diana, and Fortuna, among others) take almost exactly the same form as they do at Pompeii. See Bakker 1994. Thus, even given the disparity in evidence, the practice of domestic religion in Ostia seems comparable to that in Pompeii. There was a cult of Liber Pater associated with the public temple of Hercules in the city, though the evidence for the cult consists of one altar with a relief of a thyrsus and one dedicatory inscription, *CIL* 14.4299. Bakker 1994, 201–2.

49 For example, in the sculptural assemblage from the House of the Golden Cupids, there are herms that depict the god in both his youthful and older incarnations.

50 Carpenter (1993, 185–96) traces the chronology of different depictions of the Greek god Dionysus. In the Greek archaic period Dionysus was generally depicted as an older, bearded deity, but by the 420s the new "young" image of Dionysus was in vogue. Carpenter argues that the youthful image of Dionysus was a reference to the frenzied period in his life only in specific historical and political contexts (the 470s).

51 See nn. 3, 4, 5, and 6 above.

52 In only one instance (I.3.20) does Bacchus/Liber seem to be particularly invoked through the symbol of a theatrical mask.

53 These are observations based on the corpus of fifteen shrines with images of Bacchus/Liber in Pompeii. See appendix for a list of the shrines and their locations.

54 Richter 1956, 317.

55 I.e., Bacchus/Liber leaning on a column or satyr in place of the thyrsus, as in the shrine paintings from I.2.20–21; V.1, southwest corner, and—notably—in the antechamber to Room 5 in the Villa of the Mysteries. See also cat. no. 105, a modern replica of a bronze statuette of Bacchus/Liber. In this example, the thyrsus, panther, and kantharos are missing.

56 Compare this depiction, with Bacchus/Liber leaning on a column in place of a thyrsus, to the versions of the type seen in the shrine paintings from I.2.20–21, and V.1, southwest corner, mentioned above.

57 See ch. 8 by E. de Grummond in this volume for a discussion of the Kelsey sarcophagus and its relation to Bacchic cult.

58 Pliny (*HN* 33, 34) discusses gemstones used as seals and signets, as well as the amuletic properties of certain stones and gems. For more specific discussion, see also the introduction to the gems and cameos in the catalogue.

59 Diod. Sic. 4.4.4.

60 Boyce 1937, cat. 481. The paintings seem to depict a *lar* figure and garlands. In addition, at the time of excavation an earlier layer of plaster depicting a processional ceremony was visible.

61 Boyce 1937, cat. 482. Boyce considers a niche in the "rustic" quarters of the villa and a room with four niches to be shrines as well, but nothing indicates which deities, if any, were venerated in these spaces. It is possible that these niches were not shrines, but utilitarian shelves. Boyce 1937, cat. 483 and 484.

62 Maiuri 1947, 241. "Tiles (or machinery) sacred to Ceres" (my translation). The last word, *scapula*, which is partially broken, may refer to a certain type of vine (Pliny *HN* 14.34) but more commonly refers to either shoulder blades or the "shoulder" part of machinery (*OLD* 1AB).

63 Toynbee 1929, 67, 86. There are, however, no niches or altars in the room that would indicate that it was used for religious purposes.

64 Little 1972, 3–4; Ling 1991, 101; Mudie Cooke 1913, 159; Richardson 1988, 175.

65 Wallace-Hadrill 1994, 54. See also ch. 4 by B. Longfellow in this volume for a discussion of the possible use of the space in Room 5.

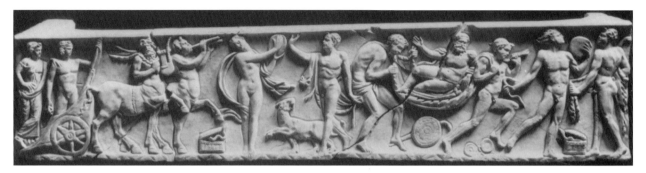

Fig. 8.1. Sarcophagus depicting a Bacchic procession. Kelsey Museum of Archaeology. Photo: Museum.

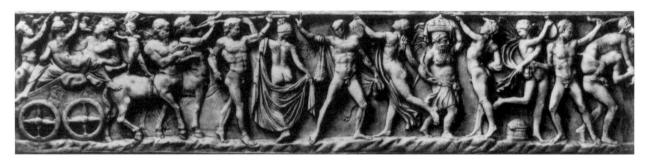

Fig. 8.2. Sarcophagus depicting Bacchus in a chariot pulled by centaurs. Munich, Glyptothek. After Turcan 1966, pl. 10a.

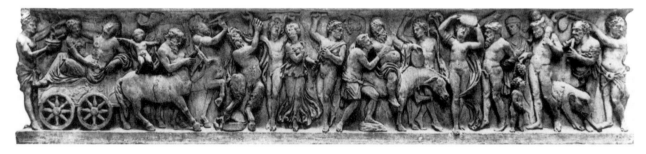

Fig. 8.3. Sarcophagus depicting Bacchus in a chariot pulled by centaurs. London, British Museum. After Turcan 1966, pl. 12a.

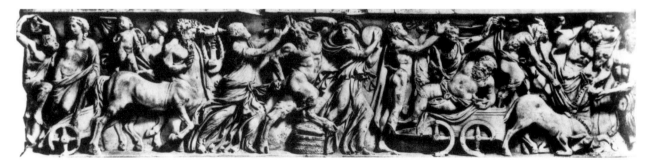

Fig. 8.4. Sarcophagus depicting Bacchus in a chariot pulled by centaurs and Silenus carried by fauns. Naples, National Museum. After Turcan 1966, pl. 18c.

8 Bacchic Imagery and Cult Practice in Roman Italy

Elizabeth de Grummond

Many tantalizing references to and evidence of Italian Bacchic cult activity have been handed down to us from antiquity, yet modern scholars can say frustratingly little in concrete terms about what such cultic activity would have included and hence about works of art that seem to pertain to the cult of Bacchus/Liber and his Greek counterpart Dionysus. Although we possess some literary and epigraphic attestations of Bacchic ritual in Italy, our chief sources of information are the artistic representations themselves. Without explicit knowledge of the rituals actually involved in such cultic activity, we often can do little more than identify visual representations, such as those on the Villa of the Mysteries frieze, on sarcophagi, and on many other works of the Roman period, as simply "Bacchic scenes" that include "Bacchic revelry" or a "Bacchic procession." Typical of these "Bacchic scenes" is the one depicted on the main panel of a marble sarcophagus now in the collection of the Kelsey Museum of Archaeology at the University of Michigan (fig. 8.1).[1] Less typical of our sources of information on Bacchic rituals is a second-century AD Roman inscription, now in the Metropolitan Museum of Art, which records the titles of the cultic offices that existed in at least one manifestation of such cults (fig. 8.9). Comparison of the contents of the Metropolitan inscription with the nearly contemporary images on the Kelsey sarcophagus—and with the earlier images in the Villa of the Mysteries at Pompeii—may allow us some understanding of the functioning of Bacchic cults and of the meaning that artistic representations of Bacchic scenes held for Roman viewers.

Like many other Bacchic scenes, the relief on the Kelsey sarcophagus presents a number of stock figures and motifs. These include Bacchus riding in a chariot pulled by a centaur, a dancing maenad, Silenus being assisted by fauns, and a dancing faun with streaming hair on the right margin of the scene, as well as, of course, such Bacchic symbols and instruments as tympana, or drums; shepherds' staffs known as *lagoboloi*; *cistae mysticae*, baskets that had cultic significance; castanets; a panther; and a snake. Comparable examples of these stock motifs can easily be found on other Bacchic sarcophagi (Bacchus in a chariot pulled by centaurs: figs. 8.2–4; dancing maenad: figs. 8.3 and 8.5; Silenus carried by fauns: figs. 8.4 and 8.6; dancing faun: fig. 8.7).

Ariadne, the wife of Bacchus, is also a recurring figure in Bacchic scenes, but the Ariadne on the Kelsey sarcophagus is, as Michael Behen notes,[2] exceptional (fig. 8.8). When Ariadne is depicted riding in a chariot with her husband—and she often is—she usually lies in Bacchus's lap, the crossing bodies of the couple resulting in a decorative chiasmus. When Bacchus stands in his chariot, as he does in the Kelsey relief, he is usually accompanied by a satyr rather than by Ariadne. In only one instance[3]—on a sarcophagus in the Vatican Museum—does the god appear in his chariot with a woman: here Dionysus is seated, while a woman stands behind him with her hand on the arm of the god in a gesture similar to that seen on the Kelsey sarcophagus.[4] Matz does not identify this woman as Ariadne but instead simply describes her as a generic "Frau."[5] Turcan suggests that the woman *could* be Ariadne but

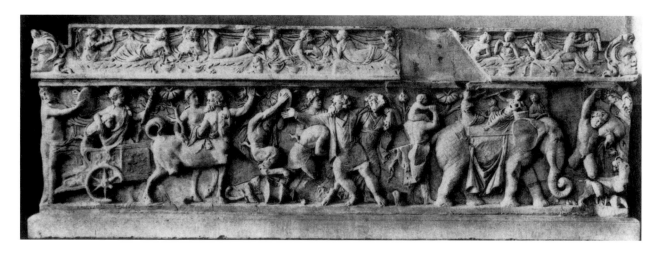

Fig. 8.5. Sarcophagus depicting a dancing maenad. Cambridge, Fitzwilliam Museum. After Turcan 1966, pl. 5a.

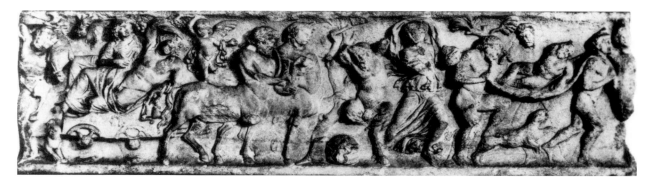

Fig. 8.6. Sarcophagus depicting Silenus carried by fauns. Copenhagen, Ny Carlsberg Glyptotek. After Turcan 1966, pl. 15a.

Fig. 8.7. Detail of a dancing faun on a sarcophagus. After Matz 1968–76, 2:pl. 115.

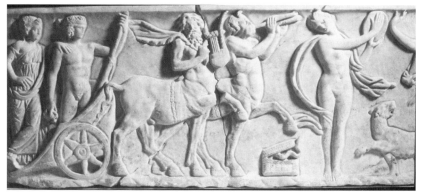

Fig. 8.8. Detail of fig. 8.1, showing Ariadne and Bacchus riding in a chariot. Photo: E. K. Gazda.

prefers to call her Macris, a nurse of Dionysus. There is no compelling reason to suppose that the woman is *not* Ariadne, and Turcan's interpretation seems improbable. Indeed, the young woman shown on the Vatican sarcophagus appears to be roughly the same age as the youthful Dionysus, rather than older, as we would expect of a nurse. Furthermore, the placement of the woman's hand on the arm of Dionysus shows a tenderness that is most easily interpreted as that of a wife toward her husband. (See, for instance, Ariadne depicted with her hand lovingly placed on her husband's shoulder, on the Creusa Painter's fourth-century BC South Italian volute krater, now in the collection of the Toledo

Museum of Art; cat. no. 72.) Bacchus's female companion on the Kelsey sarcophagus shares these characteristics, and Behen does not hesitate to refer to the woman as Ariadne.[6] Although the representation is unusual, the identification of the figure as Ariadne seems justified.

On sarcophagi, Ariadne, a mortal made divine and given eternal life, was often chosen as the figure to be given the portrait features of the deceased woman.[7] And, indeed, Behen argues that the Ariadne on the Kelsey sarcophagus bears portrait features.[8] Henning Wrede, in his catalogue of the use of human portrait features on divine figures, lists fourteen instances of representations of Ariadne with portrait features, although these are all of the "sleeping Ariadne" type.[9] Because the Kelsey representation of Ariadne is unusual, the giving of portrait features to this figure would also, necessarily, be unusual. Indeed, here Ariadne is shown not at the moment in which she typically begins her ascent to divinity and eternal life, a sleeping mortal discovered by a god who becomes enamored, but rather as the already immortal wife. If some logical meaning can be attributed to the choice of this image, portrait features on the Kelsey Ariadne would suggest either a deceased woman who was admired in her lifetime as a loving wife or, perhaps, a woman who had a particular personal devotion to the god Bacchus—or perhaps both.

The dancing maenad on the Kelsey relief, however, seems more prominent in the composition as a whole than the Ariadne figure. The central position that this maenad occupies suggests that she might represent the owner of the sarcophagus. Indeed, the central portion of marble sarcophagus panels was often devoted to a portrait of the deceased.[10] Although Wrede records only two examples of maenads who are depicted with portrait features,[11] the seemingly individualized facial features of the Kelsey dancing maenad and the contemporary hairstyle are particularly striking and strongly suggestive of a portrait.

Both the Ariadne figure and the dancing maenad would be unusual choices for a personal representation of the deceased, but both also have characteristics that make such an identification compelling. These two possibilities are not incompatible with each other, as more than one image of the person being honored did sometimes appear in the same funerary scene.[12] Furthermore, the faces of both Ariadne and the maenad are characterized by distinctly large eyes, and Ariadne's hair, although slightly obscured by a Bacchic wreath, seems to be pulled back in the same general style that the maenad wears.

Now, finally, we must ask what the scene on the Kelsey sarcophagus seems to depict as a whole. At the crux of this question is the issue of whether the scene alludes to real events or is instead intended only as a symbolic or mythological representation. In order to seek answers to these questions, we shall now turn to the so-called Bacchic Inscription of the Metropolitan Museum (fig. 8.9),[13] which offers one of the few concrete insights that we have into the organization of Bacchic congregations in Roman Italy.

The inscription, which appears on a marble statue base, seems to record the dedication of a statue erected in honor of one Pompeia Agrippinilla, who was of a fairly well-known Roman family that was ultimately Greek in origin.[14] Agrippinilla was apparently a priestess of the Bacchic cult, and the statue seems to have been erected and dedicated by other members of her Bacchic circle. The exact provenance of the statue dedication is unknown. The marble base was found near Rome, either along Via Tusculana, near Frascati, or at Torre Nova,

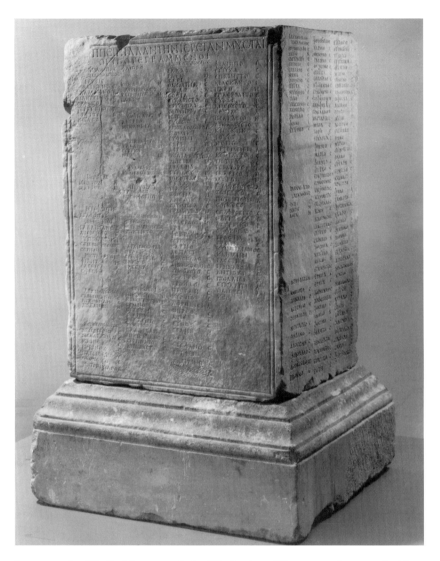

Fig. 8.9. Bacchic inscription recording cultic titles. Metropolitan Museum of Art. Photo: Museum.

between the Via Labicana and the Via Latina. The statue base probably comes from the site of the house of Gallicanus, as this house is near both of the purported findspots, and the name Gallicanus appears more than once on the inscription.

Although the dedicatory inscription is in Greek, Achilles Vogliano believes, for epigraphical reasons, that the piece was carved by a Roman.[15] The names of members of two Roman families, the Pompeii Macrini and the Gauii, figure prominently in the dedication. Because several of the names listed in the inscription are known to us from other sources, Vogliano is able to establish that the inscription belongs to the mid-second century AD; he argues that the paleographic features of the inscription accord with this date.[16] Citing prosopographical evidence, John Scheid suggests more specifically that the dedication was set up between AD 160 and 165, although a slightly later date of AD 165 to 170 has also been proposed.[17]

In all, the inscription, which lists the cultic titles as well as personal names of the dedicants, records more than three hundred Greek names, fewer than seventy Romans names, and a smattering of other names. Approximately one-third of the names are feminine. The Greek names are generally listed without patronymic, and the Latin names are simple

78

cognomina, which are roughly equivalent to modern nicknames. This nomenclature leads Franz Cumont to suggest that the social distinctions of ordinary life had disappeared for the cult members and were replaced by the distinctions of a religious hierarchy.[18] Scheid, however, argues convincingly that only *cognomina* were used in order to avoid repetition, as nearly all the individuals listed seem to have been members or dependents of the same two *gentes*, or clans, who, consequently, would have had the same last name and often the same first name as well.[19] Many of the names are of servile origin, and Scheid, like Vogliano, suggests that the names in the inscription pertain to an entire *familia*, or household, including slaves.[20] Scheid also points out that social status was not, as Cumont supposes, irrelevant within the Bacchic fraternity: the cult members of senatorial rank held the highest offices, while those with names of servile origin occupied the lower rungs of the cult hierarchy.[21]

Figure 8.10 lists the titles that appear in the dedication, along with a short description of the cultic offices to which, according to Cumont,[22] the titles referred.

The titles on the dedication are probably listed in order of their precedence in the sacred Bacchic procession, the importance of which is shown by the number of titles composed in *–phoros*, meaning "–bearer"

Fig. 8.10. Cultic titles appearing on the Bacchic inscription in the Metropolitan Museum of Art. After Cumont 1933; Vogliano 1933; Alexander 1933.

Cultic title (number of names and surmised sex of individuals listed after each title)	Brief description of the offices to which, according to Cumont, the titles may refer
Heros (1 masculine name)	hero
Daidouxos (1 feminine name)	torch bearer
Hiereis (7 masculine names)	priests
Hiereiai (2 feminine names)	priestesses
Hierophantes (1 masculine name)	hierophant, concerned with initiation
Theophoros (2 masculine names)	god bearers
Hypourgos kai Seilenokosmos (1 masculine name)	acolyte who seconded the priest at sacrifices and maintained order during rituals; according to Cumont, he may have worn a Silenus costume
Kistaphoroi (3 feminine names)	*cistae* bearers
Archibassaroi, Archibassarai (2 masculine and 4 feminine names)	those in charge of the Bacchai and Bacchoi
Archiboukoloi (3 masculine names), *Boukoloi Hieroi* (7 masculine names), *Boukoloi* (11 masculine names)	chief neatherds, holy neatherds, and neatherds
Amphithaleis (2 masculine names)	child whose parents were both living
Liknaphoroi (3 feminine names)	liknon bearers
Phallophoros (1 feminine name)	phallus bearer
Pyrphoros (1 masculine name)	flame bearer
Hieromnemon (1 masculine name)	financial administrator of the cult
Arkineaniskoi (1 masculine name)	instructor of the adolescent members
Apo Katazoseos (89 masculine and feminine names), *Bacchoi Apo Katazoseos* (15 masculine names), *Bacchai Apo Katazoseos* (3 feminine names)	those who girded themselves with the skin of a newly sacrificed animal
Hieroi Bacchoi (more than 100 names)	holy Bacchoi
Antrophylakes (2 masculine names)	those who guarded the sacred cave
Bacchai (more than 40 feminine names)	maenads
Seigetai (23 masculine and feminine names)	those who are silent

79

in Greek.[23] Indeed, it is noteworthy that none of the titles seems to refer to the banqueting and drinking that one commonly associates with Bacchanalia. Furthermore, the cultic titles suggest that the wearing of costumes and role-playing may have been important parts of the ritual.

Many of the titles listed, such as torch bearer, phallus bearer, and flame bearer, clearly do not pertain to the figures depicted on the Kelsey sarcophagus. Several titles, however, bear closer consideration. These include: the *heros*, the acolyte who may have dressed up as Silenus (*hypourgos kai seilenokosmos*), those who girded themselves with the skin of a newly sacrificed animal (*apo katazoseos, bacchoi apo katazoseos*, and *bacchai apo katazoseos*) as well as, of course, the *bacchai*.

Cumont proposes that the title *heros* refers to the leader of the cult rather than to a deceased and deified individual associated with the cult.[24] Scheid argues in favor of this second definition but fails to explain how a dead hero might have contributed to the dedication of the statue of Agrippinilla.[25] Indeed, given the context in which the title is used, Cumont's argument seems more plausible. Cumont also notes that Dionysus himself (and Bacchus?) was sometimes referred to as "hero" and furthermore that cult leaders were sometimes named after the god whom they served.[26] This last suggestion, coupled with the apparently theatrical aspect of the cult, has interesting implications for depictions of Dionysus and Bacchus amongst worshippers: such a figure might not represent the god himself but rather the cult member assigned the role of outfitting himself as Dionysus or Bacchus.[27] The consistently ideal-ized representation of Bacchus, on sarcophagi as well as elsewhere, would tend to discount the value of this proposition, but the possibility remains that such representations might be idealized versions of real people and events. Although there is no particular reason to suppose that the Bacchus on the Kelsey sarcophagus is in fact a costumed mortal "hero," the idea that a Bacchic cult member would, in her lifetime, have interacted personally with "Bacchus" adds a certain immediacy and realistic dimension to the scene.

There is nothing in the Metropolitan inscription to suggest that the *hypourgos kai seilenokosmos*, whom Cumont identifies as an acolyte, would have dressed as Silenus. Nonetheless, Cumont argues, through literary evidence and Greek parallels, that this office did include such theatrical-ity.[28] As with the Bacchus figure on the Kelsey relief, there is little reason to suppose that the Silenus is, in fact, a disguised cult member. Further-more, neither the Kelsey Silenus nor images of the Silenus on other sarcophagi present an individual who seeks to maintain order, as Cumont claims the *hypourgos kai seilenokosmos* would have done. On the contrary, Silenus is often shown on sarcophagus reliefs as inebriated and in need of assistance. This discrepancy either suggests that such depictions of Silenus could have had no real (theatrical) basis or that Cumont's description of the duties of the acolyte is flawed.

The *apo katazoseos, bacchoi apo katazoseos*, and *bacchai apo katazoseos*, or those who girded themselves with the skin of a newly sacrificed animal, are perhaps embodied on the Kelsey sarcophagus by the dancing satyr in the center of the relief who seems to be draped in an animal skin. The head of the animal, which hangs down from the satyr's right arm, is only summarily indicated, but comparison with other, similar images on Bacchic sarcophagi (fig. 8.2, central male figure) confirms that the drapery is in fact a roughly portrayed animal skin. Although the other satyrs on the Kelsey sarcophagus do not seem to sport animal skins, it is

not difficult to group these similar figures in a class with the first satyr. Thus, these figures represent a category of revelers that seems to have a parallel, if not a directly reenacted theatrical role, in the Bacchic organization of Agrippinilla.

Finally, *bacchai*, or maenads, are obviously quite important in Bacchic representations such as that on the Kelsey sarcophagus. The forty feminine names that follow this title on the Metropolitan inscription clearly indicate that Roman women associated themselves with this position and that depictions of such women must have had at least some basis in reality, if only on a purely nominal level. Thus, although these women may or may not have danced nude while thumping tympana, the immediately recognizable stock figure of a maenad would serve well to associate a woman with the position of maenad in an actual cultic group.

The only figures on the Kelsey sarcophagus that are not accounted for in some manner by the cultic offices listed on the Metropolitan inscription are Ariadne, who has been discussed at length above, and the two centaurs. These latter figures, half human and half beast, are clearly mythical creatures, whose presence would seem to minimize the possibility that we are faced with a scene from an actual ritual. Yet, given the Roman penchant for including otherworldly creatures in depictions of historical events, the presence of centaurs does not altogether obviate the possibility that the sarcophagus alludes to an actual Bacchic event.[29]

Considered together, the Metropolitan inscription and the Kelsey sarcophagus provide us with a glimpse of the organization and the appearance of members of a Bacchic cult in the second half of the second century AD. Although there were surely changes over time in the organization and functioning of Bacchic cults, many of the elements that are represented in the Kelsey relief and alluded to in the Metropolitan inscription are consistent with early aspects of the worship of Dionysus and Bacchus.[30] Given the continuities through time, the Metropolitan inscription might also be profitably compared with the fresco cycle in the Villa of the Mysteries, often thought to represent elements of a Bacchic ritual. Indeed, a number of the cultic titles given in the Metropolitan inscription might plausibly be used to describe figures in the Pompeian painting. Thus, the reading of the child on the north wall (group A, figure 2) might be an *amphithaleis*; the "priestess" (group B, figure 6), a *hiereia*; the satyrs with goats (group C, figures 9 and 10), *boukoloi*; one of the sileni (group B, figure 8 or group D, figure 12), *a hypourgos kai seileno kosmos*; the Bacchus/Liber figure (group D, figure 15), the *heros*; the woman with the veiled phallus (group E, figure 17), a *liknaphoros* or a *phalophoros*; and the flagellant and dancer on the south wall (group F, figures 21 and 24), *bacchai*.

Certainly these suggestions are tentative. Nonetheless, the possibility of such a correspondence between image and text supports the idea that Bacchic scenes in Roman art—rather than simply imaginary or mythical—had some basis in reality. In the case of the Kelsey sarcophagus, the relief scene seems to present both elements that could have been experienced in the lifetime of the deceased and elements that, in all likelihood, represent an idealized and mythical version of a Bacchic procession or ritual. Although the Kelsey relief may not depict an actual moment—or even simply an idealized version of an actual moment—in a Bacchic ritual, the cultic titles presented to us on the Metropolitan Museum inscription indicate that Romans did have real, firsthand associations with a number of the figural types that appear on the Kelsey

sarcophagus as well as in other Roman art works, such as the murals in Room 5 of the Villa of the Mysteries. Certainly, stock figures often occur in Roman art, but if one accepts Cumont's reading of the Metropolitan inscription, real maenads and men draped in animal skins *did* exist in the second century AD. Although elusive today, a relief like that on the Kelsey sarcophagus and by extension the murals in the Villa of the Mysteries must have reminded initiated Roman viewers of their own experiences within the Bacchic cult.

1 For a description of the sarcophagus and relevant bibliography, see cat. no. 58.
2 Behen 1996.
3 Matz (1968–75) seems to include only one such instance. Turcan (1966, 475) describes (but does not include images of) two sarcophagi that feature a woman standing in the background alongside Dionysus, who stands in a chariot. At any rate, the sixteen examples of a reclining Ariadne and the twenty-odd scenes of Dionysus standing with individuals other than Ariadne (as recorded by Matz) are still far greater in number than three examples of Dionysus standing beside a woman who might be identified as Ariadne.
4 Matz 1968–75, 2:cat. no. 154.
5 Matz (1968–75, 2:296) does not argue that the woman is *not* Ariadne; rather he simply does not discuss the possibility.
6 Behen 1996.
7 Walker 1985, 36.
8 Behen 1996.
9 Wrede 1981, 209–12.
10 Walker 1985, 36.
11 Wrede 1981, 267–68.
12 This representational technique was, however, more common on biographical reliefs depicting different events in the life of the deceased. See, for instance, Koch and Sichtermann 1982, 99–100.
13 The fundamental publication on this inscription appears as a pair of articles (Vogliano 1933, 215–31; Cumont 1933, 232–63) along with a short summary (Alexander 1933, 264–70) in the *American Journal of Archaeology*.
14 Vogliano 1933, 219–24; see also Scheid 1984, 275–90.
15 Vogliano 1933, 218.
16 Vogliano 1933, 224.
17 Scheid 1984, 24 (after G. Alföldy).
18 Cumont 1933, 234.
19 Scheid 1984.
20 Scheid 1984; Vogliano 1933, 224.
21 Scheid 1984.
22 Cumont 1933.
23 Cumont 1933, 233.
24 Cumont 1933, 237–39.
25 Scheid 1984.
26 Cumont 1933, 238–39.
27 A strigilated sarcophagus from the Praetexta catacombs in Rome offers a portrait of a man in the guise of Dionysus (Koortbojian 1995, 8, fig. 3). Priestesses of Isis were also known to have dressed themselves to appear as the deity they served. See ch. 5 by C. Hammer in this volume.
28 Cumont 1933, 245–46.
29 I am grateful to Bettina Bergmann for pointing this out to me.
30 See ch. 6 by D. Wilburn in this volume.

9 The Search for the Origins of the Villa of the Mysteries Frieze

Jessica M. Davis

The watercolors of the Villa of the Mysteries frieze by Maria Barosso and the other twentieth-century artwork inspired by the ancient painting that form part of this exhibition embody their artists' interpretations of and responses to the Pompeian mural. Other essays in this volume examine the way these works as products of their own time incorporate and react to elements of the Villa of the Mysteries frieze.[1] Like the later images, the Villa painting itself is not an isolated creation but rather includes figures and motifs also known from other works. Since the earliest publications of the frieze, scholars have debated the relation between its images and similar scenes found on other objects, some calling it a copy of a Greek painting, others, an original composition. Often, however, the matter of whether the painting is a "copy" or an "original" receives only brief attention in a longer discussion concerning the interpretation of the frieze as a whole. This chapter addresses the problem of the origins of the frieze composition and outlines the general trends of past scholarship on this issue. Following this overview of the debate, I present elements of the visual repertoire on which the murals' artists seem to have drawn and discuss the consequences for the copy theory of the existence of this shared vocabulary of images.

THE COPY HYPOTHESIS

A number of scholars have claimed that the Villa frieze is a copy after a Classical Greek or Hellenistic painting. At the heart of this assertion lies an aesthetic judgment about the relative merits of Greek and Roman art. The notion that Greek art is superior to that of the Romans has been a pervasive theme in the scholarship on classical works since the writings of J. J. Winckelmann in the second half of the eighteenth century. According to Winckelmann, who was strongly influenced by the views of Pliny the Elder and other Roman authors, art after Alexander the Great showed evidence of a decline from the heights achieved by Greek artists of the fifth and fourth centuries BC.[2] Winckelmann recognized the survival of certain images in multiple replicas and identified these as Roman copies. Guided by Winckelmann's work, scholars of the nineteenth and early twentieth centuries expended much effort on identifying sculptures they regarded as Roman copies and attempting to reconstruct the Greek originals on which they were presumably based. This approach, known as *Kopienkritik* or copy criticism, depends heavily on the descriptions of famous Greek works of art in classical literature and particularly in Pliny's *Naturalis Historia*.[3] Although the identification of works from the Roman period as copies after Greek originals has been particularly dominant in studies of sculpture, this methodology has also been applied to research on other media, including painting and mosaic, and has affected the study of the Villa of the Mysteries frieze. In the past twenty-five years many scholars have turned away from this approach; however, it still appears regularly in the literature on Roman art.[4] Some of the problems with copy criticism will be addressed below after a survey of its application to the Villa painting.

Since its discovery during excavations in 1909–10, the Villa of the Mysteries frieze has often been studied through the lens of Greek originals. G. de Petra, who published this phase of the excavations at the Villa in 1910, described the frieze as "without doubt a pale reflection of the original composition from which it derives; and it shows an artistic merit not superior to the average of that which is found on the walls of Pompeii."[5] P. B. Mudie Cooke, writing in 1913, found the image "beyond the capacity of a provincial artist" and added that "the superiority of design to execution" also supports the identification of the painting as a copy.[6] Similar opinions were expressed by commentators on the frieze who wrote in the later 1910s and early 1920s, including E. Pottier and Vittorio Macchioro.[7]

The first disagreements with the theory that the frieze is a copy appeared in the 1920s and early 1930s in works by Ernst Pfuhl, Margarete Bieber, and Amedeo Maiuri.[8] During the same period, however, the treatment of the frieze as a copy was strongly advocated by Ludwig Curtius, who, like Mudie Cooke, viewed it as an imitation of a fourth- or third-century BC painting from Smyrna.[9] In the eyes of later scholars, both those who agreed and those who disagreed with him, Curtius was one of the main proponents of the copy hypothesis.[10] Following these publications, the Villa did not receive major scholarly attention again until after the Second World War.

In the second half of the twentieth century, as the number of publications on the Villa frieze grew rapidly, the identification of the composition as a strict copy after a Greek prototype gradually lost its earlier dominance among scholarly opinions on the cycle's origins. From the 1940s to the 1960s the copy hypothesis still appeared regularly. G. Méautis, writing in 1945, described the mural in critical terms: "All these scenes are of an extreme incoherence, and the conclusion imposes itself that they must have been extracted from an ensemble [that was] much better organized and [that had] a more logical construction."[11] The frieze was identified as based on Pergamene models by Erika Simon in 1961.[12] Two years later G. Zuntz explained his views on the composition's origins in terms similar to those used by Mudie Cooke earlier in the century:

> the frieze makes a whole too meaningful, balanced, and coherent to have originated from the mere juxtaposition [by a local artist] of ready types: it bespeaks the inspiration of a creative genius, and this genius can only have been Greek. For I may as well here confess that the much vaunted "great Italo-Campanian school of painting," which some authorities would credit with the creation of the fresco, seems a phantom to me; still less can I see any evidence for the existence in Republican Rome of so creative a school of painting.[13]

G. Bendinelli, who wrote an article on the frieze in 1968, likewise called it a copy after an earlier original.[14] In the past three decades, however, assertions that the entire frieze is a copy after a prototype of the Classical or Hellenistic periods have appeared less frequently. The view that the frieze is a copy was espoused by Robert Turcan in a 1982 article but later rejected in his 1995 monograph on Roman art.[15] As recently as 1998, Paul Veyne argued that the frieze "is only a copy, skillful and even talented, not unworthy of the original, and, in my opinion, very faithful. Like the majority of the paintings at Pompeii, our fresco is the copy of a lost Greek original, of a century or two earlier."[16]

The conclusion that the Villa frieze is a copy has often been accompanied by a discussion of the changes to the original—sometimes described as "mistakes"—made by the copyist.[17] De Petra, for example, argued that the proportions of the Villa figures are incorrect, that the artist's color choices are poor, and that the movement of the figures is unnatural.[18] In a similar vein, Mudie Cooke wrote that "the artist does not seem to have fully understood the scene."[19] Alongside this development scholars have felt free to describe as Roman interpolations figures and motifs that do not accord with their conception of the presumed original. Zuntz argued that the winged demon was copied from a different Hellenistic painting than the rest of the frieze and that the wedding rings worn by many of the women were a Roman addition, as such rings were not customary in Greece.[20] Interestingly, the two scenes depicting the toilette of the bride and the seated *domina* have sometimes been treated as the biggest additions of all: a number of scholars have considered these images completely unrelated to the rest of the frieze, invented by the copyist or borrowed from another source to fill the space between the window and the doors.[21]

The relation between the frieze and the room that it decorates has been cited as further proof that the original painting was designed for a different space. The Villa of the Mysteries *oecus*, it has been alleged, is too small for the whole frieze, with the result that the copyist had to crowd the figures, or rearrange them to fit on the wall, or omit some scenes altogether.[22] To this litany Curtius added the complaints that the light provided by the large window in the south wall is insufficient to light the frieze properly and that the room's corners interrupt the flow of the composition.[23] Indeed, a reconstruction of the original order of the figures is central to a number of interpretations of the frieze. Curtius, for example, changed the positions of the lyre-playing Silenus, the pair of satyrs with goats, and the scene usually identified as the revelation of the phallus: Silenus and the satyrs next to him, he argued, belong to the right of Dionysus and Ariadne as a parallel for the group of Silenus and satyrs to their left, while the liknon group belongs on the north wall with the fleeing woman. Only after putting the frieze back in order, Curtius wrote, could he begin to address questions of its interpretation.[24]

A few possibilities have been suggested for the location of the frieze's presumed prototype. Mudie Cooke proposed that the original was in the assembly place of the cult of Dionysus in Smyrna. As evidence, she offered two coins from Smyrna, one of Domitianic (fig. 9.1) and one of Severan date, that show Dionysus and Ariadne seated in a pose similar to that of the divine couple at the Villa. Mudie Cooke argued that the Villa image and the coins both replicate the painting in the cult's hall.[25] Curtius likewise espoused the view that the frieze copies an original from Smyrna. He identified the winged woman in the Villa painting, as well as similar figures on a Campana relief in the Louvre (fig. 9.2) and on an Attic vase by Phintias, as the virgin goddess Artemis averting her eyes from the sexual symbol of the phallus. Combining this evidence with that of the coins cited by Mudie Cooke, he concluded that the frieze's model may have decorated the walls of a temple of Artemis in Smyrna.[26] These arguments for a prototype in Smyrna are weakened by their dependence on the two coins, both of which were minted more than a century after the creation of the Villa composition.

Erika Simon, as mentioned earlier, proposed Pergamene origins for the frieze. Simon based her conclusions on a number of stylistic

Fig. 9.1. Coin from Smyrna showing Dionysus and Ariadne. British Museum, London. After Sauron 1998, fig. 6.

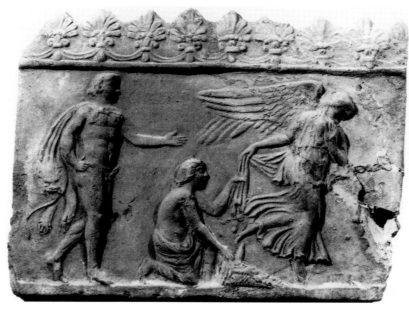

Fig. 9.2. Campana relief with uncovering of phallus. Louvre, Paris. After Sauron 1998, fig. 20.

comparisons with the Gigantomachy and Telemachos friezes from the Great Altar of Pergamon.[27] She suggested that the Villa's owners consciously emulated the decoration and function of a room in the area of the Pergamene palace that has been identified as a space used by the royal family for the worship of Dionysus.[28] Simon was followed in this interpretation by Zuntz, who added to her list of Pergamene features in the Villa frieze.[29] Veyne, who argued that the mural portrays nuptial rather than mystical events, proposed that its prototype decorated not a sanctuary but the home of a Hellenistic ruler, for whose wedding it was commissioned.[30]

As was noted earlier, there are numerous problems with the assertion that the Villa frieze is a copy after a Greek or Hellenistic original, not least of which is the fact that few examples of painting from this period have survived to the present. The walls of Greek public buildings were decorated with frescoes, but over time these have disappeared. Paintings on perishable wooden panels were also popular in Classical Greece, but these too are lost to us. Greek painting is now known almost exclusively from other media, including paintings on vases and in tombs, and from descriptions in later Latin literature.[31] The absence of large-scale Greek painting today does not, of course, negate the possibility that Greek works were copied by Roman painters: the practice of copying paintings is in fact mentioned by Quintilian, among others.[32] Since, however, it is no longer possible to make visual comparisons between copy and model (assuming one existed), and since the textual descriptions of Greek paintings are too brief to allow conclusive identification of Greek prototypes for surviving Roman paintings, the term "copy" must be used with great care.[33]

Equally problematically, the assertion that the Villa cycle is a derivative work is often made without explanation of the means of transmission between the purported original, in Greece or Asia Minor, and the copy in Pompeii. Simon suggested that the reason for copying the prototype was rooted in the desire on the part of the Villa's owner to emulate the private rooms of the Pergamene royal family. She did not explain, however, how an inhabitant of Pompeii might have seen this building.[34] Likewise, neither Mudie Cooke, Curtius, nor Veyne, whose

contexts for the presumed original are mentioned above, gave an explanation of the means by which this model might have been transmitted. More to the point, the issue of how a local Campanian artist would have had sufficient access to such spaces to allow the precise copying, or even free-hand sketching, of the images there has not been addressed by these scholars.[35]

The binary treatment of the Villa frieze as a copy of a Greek model is also flawed in its oversimplification of cultural designations. Often in discussions of the painting's origins "Greek" is used to describe an original that is clearly conceived of as a product of the Hellenistic period and sometimes of an area outside of Greece proper, as in the case of Pergamon. It is also misleading to equate "Pompeian" with "Roman" and to assume as a result that the desire to acquire Greek works of art, attributed to elite Romans of the late Republic by contemporary authors, was shared by the Villa's owners. The Villa of the Mysteries itself was constructed in the period before the Social War when Pompeii was a Samnite city. The inhabitants of Campania at that time included Romans and Greeks as well as Etruscans and members of other indigenous Italic groups.[36] The Villa frieze was probably painted after the Romans took control of Pompeii, and considering that in this period many members of the upper class at Rome owned luxury villas around the Bay of Naples, Roman patronage for the painting seems likely.[37] Even so, there is no way to know with any certainty either the ethnic identity or the political and cultural sympathies of the frieze's patron or artists, much less the influence these factors may have had on their aesthetic choices.[38]

ARGUMENTS AGAINST THE GREEK ORIGINAL

In theory, at least, it is not impossible that the Villa of the Mysteries painting imitates a Greek or Hellenistic original. The problems outlined above, however, substantially weaken this hellenocentric position. Since the 1920s a number of alternatives to this hypothesis have been proposed. A few scholars have instead conjectured an Italian prototype for the frieze. Karl Schefold argued that it copies not a Greek but an urban Roman original of the first century BC: "The frieze of the Villa of the Mysteries was copied in the sixties after a model that must have been created in Rome soon after the turn of the century."[39] Alan Little later suggested a variant on this theme: finding the composition of the east wall unbalanced, he concluded that the frieze was based on a cartoon that did not account for the corners, doors, and window of the Villa's *oecus*. Little did not make clear the source of this cartoon, but since he agreed with the arguments for Italian origins for the frieze, it seems that he conceived of the cartoon as an Italian or even a Campanian creation.[40]

As mentioned earlier, Ernst Pfuhl, Margarete Bieber, and Amedeo Maiuri were among the first to challenge the treatment of the Villa composition as a copy. Pfuhl, in his 1923 work on Greek painting, described the cycle as an Italian product of the Hellenistic period.[41] Bieber, writing in 1928, argued that the frieze is a creation of Southern Italy and that, although the artist drew on material from other cultures, the composition stands alone.[42] In his monograph on the Villa, which was published in 1931 following the excavations of 1929–30, Maiuri likewise acknowledged the frieze's debt to Greek paintings while seeking to place its origins in first-century BC Southern Italy. He wrote that in

its individualization of the figures and in the use of figure types not known from Greek precedents it participates in the process of differentiation that took place in this period between South Italian and Roman art on the one hand and Greek art on the other.[43] Bieber and Maiuri both based their statements about the frieze's origins on comparisons with South Italian material—vases, in the case of Bieber, and sculpture as well as pottery for Maiuri—but introduced parallels from a wider range of sources in their discussions of the mural's iconography.[44]

The trend away from identifying the frieze as a copy gained further momentum in the late 1950s and 1960s from the works of Reinhard Herbig, Jacobus Houtzager, and Otto Brendel. In his monograph on the mural published in 1958, Herbig criticized the application of the evidence of the images of Dionysus and Ariadne, including the coins referred to by Mudie Cooke and Curtius, to the whole frieze:

> The divine group to be sure appears again unmistakably on certain objects of the minor arts, on gems and coins, and also in terracotta groups, which point toward Asia Minor as perhaps the original site of the installation of the work of art. However this is by no means sufficient to risk the assertion that the Pompeian frieze is in its entirety the copy of a great painted or sculpted original composition from the Greek East.[45]

Similarly, Houtzager and Brendel both argued that the Villa artist drew on a variety of models to create an original composition.[46] In a noteworthy combination of approaches, these two scholars as well as Pierre Boyancé have identified the image of Dionysus and his consort alone as a copy after a Greek prototype. Brendel cited as a possible source for this image a painting of Dionysus and Ariadne by Aristeides of Thebes, an artist of the early Hellenistic period, that was set up in the Temple of Ceres at Rome, where it was probably on display at the time of the creation of the Villa frieze.[47]

In more recent years the acceptance of the frieze as a unique work that draws on many sources has come to dominate scholarly opinion on the matter. Such a view was expressed in a 1979 article by Gennaro Grieco, who referred to the composition as a blend of Greek, Roman, and Italian elements: "This Dionysiac frieze is the reflection of the social, artistic, and spiritual eclecticism of Pompeii."[48] In 1991 this position was endorsed separately by Roger Ling and John Clarke, both of whom recognized the frieze as a new creation that includes a number of figures based on previously existing stock types.[49] Their discussions of the painting were followed in 1995 by Robert Turcan's shift away from his earlier statements on this issue, mentioned above, in favor of a similar stance.[50] In one of the most recent publications on the cycle, Gilles Sauron has expressed a similar position, anticipated in an earlier article on the Villa painting, in treating the frieze as an eclectic composition.[51]

Contrary to the opinions on this issue held by Curtius and others, several scholars have used the relation of the frieze to the room it decorates to support arguments against the possibility that it is a direct copy of another work. The scenes, they have argued, accommodate both the door in the east wall and the large window in the south wall. More telling, perhaps, is the treatment of the corners. On each wall, as Bieber noted, the figures stop before the corner, a feature that prevents the image from being obscured. Thus, as Maiuri and Clarke have observed, the last figure on each wall is placed at a point aligned with the borders of both the marble floor pattern and the semivaulted ceiling.[52] A number

of scholars have also commented on the unifying effect on the composition of the interaction of the figures across three of the room's four corners.[53] The overlapping of the figures has been interpreted not as a result of the small size of the room but instead as a compositional device that encourages the viewer's eye to follow the action from one scene to the next.[54] Moreover, as Herbig demonstrated, the shape of the room also allows for an interlocking pattern of glances among figures that are not next to each other.[55] These elements speak strongly in favor of the creation of the frieze specifically for this room.

In the first two sections of this chapter I have presented a selective overview of scholarly opinions on the nature of the origins of the Villa of the Mysteries frieze. Early in the twentieth century the mural was widely assumed to be a copy after a Greek or Hellenistic painting. More recently, following broader trends in the study of Roman art, the copy hypothesis has been rejected by a number of scholars, although it still appears on occasion. The following section examines in greater detail some of the evidence that argues against the identification of the Villa frieze as an exact copy of an earlier prototype.

THE IMAGERY OF THE FRIEZE

Since the discovery of the Villa painting its individual scenes and figures have been compared to numerous works of art to support arguments relating both to the origins of the composition and, more frequently, to its meaning. Comparisons have been made not only with works from Southern Italy but also with objects from all over the Mediterranean world, dating from before and after the creation of the mural, that display elements of the same visual repertoire. Few scholars who have argued that the frieze is a copy have made a connection, however, between their statements about its origins and the variety of objects that the mural has been compared to for the purpose of interpretation. The intent of the following paragraphs is, therefore, to give a sense of the range of comparable works that have been proposed for several of the scenes in the Villa painting by scholars on both sides of the copy issue and to bring this evidence to bear on the problem of the originality of the frieze.

Parallels have most frequently been identified for the figures along the east, south, and west walls of the Villa *oecus*.[56] A number of scholars have recognized the affinities between, on the one hand, the scenes of the bride at her toilette (fig. 1.4, group G, figures 26–27) and the seated *domina* (group I, figure 29) and, on the other, traditional Greek and Roman representations of brides.[57] Bieber compared the Villa figures to the images on two Greek vases, from Attica and Eretria, and on an Apulian vase, all of which depict the preparation of a bride.[58] Brendel also noted the similarity of the *domina* to the seated bride in the painting from Rome known as the Aldobrandini Wedding (fig. 9.3).[59] The *domina* has been likened to women on Greek funerary monuments, such as the stele of Demetria and Pamphilos in Athens.[60] In addition Houtzager pointed to several Tanagra figurines that depict a seated woman who is similar in pose and expression to the *domina*.[61]

The figure of the dancing woman on the south wall of the Villa of the Mysteries frieze (group F, figure 24) has been compared to Neo-Attic maenads, figures drawn from a set of stock types that frequently occur on reliefs of the first century BC.[62] Both Mudie Cooke and Herbig,

Fig. 9.3. Aldobrandini Wedding. Vatican Museums. After Müller 1994, pl. 1.

among others, noted that a close parallel to the Villa figure appears on a Neo-Attic relief now in Berlin (fig. 9.4). This relief is particularly interesting because it includes not only the dancer in a pose nearly identical to that of the woman in the Villa frieze but also the woman behind her who holds a torch or staff.[63] Curtius and Clarke have pointed to a similar figure who appears in a painting of the triumphal procession of Dionysus and Ariadne in the *tablinum* of the House of Lucretius Fronto at Pompeii (fig. 9.5). This painting, part of a Third Style ensemble, was created in the first half of the first century. The two scholars, however, have treated this comparison very differently: Curtius suggested that either the painting in the House of Lucretius Fronto copies that of the Villa or that both are copies of the same original, while Clarke proposed that the similarity of the two images reflects the Villa painter's use of a variety of readily available visual sources.[64]

The winged demon brandishing a whip (group E, figure 20) has been the focus of a number of interpretations of the Villa cycle.[65] In the quest to identify her, many parallel images have been suggested, of which only a few will be discussed here. Karl Lehmann, for example, compared her to a winged figure labeled "ΑΓΝΥΑ" (Ignorance) who appears in a painting from a Hadrianic tomb in Hermoupolis, Egypt. Basing his argument on this identification, Lehmann interpreted the Villa's winged woman as Ignorance rejecting the knowledge to be revealed by the uncovering of the phallus.[66] In addition to the Egyptian painting, the Villa image has been likened to figures on a terracotta Campana relief (fig. 9.2), a third-century mosaic from Djemila, Algeria (fig. 9.6), and a Roman cameo (fig. 9.7).[67] Each of these three works portrays a draped woman who turns away from and raises her hands to reject an object unveiled by a woman who kneels on the ground. In the relief and the mosaic, the object revealed is clearly a phallus, as has been claimed to be the case in the Villa frieze. Here the cameo differs, however: its kneeling woman uncovers a mask, perhaps of Silenus.[68] Unlike the Villa image, the Djemila figure has no wings, and none of these three figures carries a whip.[69] These images, with both their similarities to and differences from the winged woman in the Villa of the Mysteries frieze, have helped to spawn a wide array of identifications and interpretations of this figure: according to Sauron some twenty names, ranging from Artemis to Telete, have been given to her.[70]

The depiction of Dionysus and his companion, often identified as Ariadne, on the east wall of the Villa *oecus* (group D, figures 15–16) is the

Fig. 9.4. Relief with dancing maenad. Formerly Staatliche Museen, Berlin. After Herbig 1958, fig. 34.

Fig. 9.5. Wall painting with procession of
Dionysus and Ariadne. House of Lucretius
Fronto, Pompeii. DAIR neg. 39.958.

Fig. 9.6. Mosaic with uncovering of phallus.
Djemila Museum, Djemila. DAIR neg.
77.2041.

Fig. 9.7. Cameo with uncovering of mask.
Bibliothèque Nationale, Paris. After Bieber
1928, fig. 8.

part of the frieze that, as noted previously, has most frequently been
considered to have been copied from a Greek original, even by scholars
who have not identified the rest of the frieze as a copy.[71] Images from the
story of Dionysus and Ariadne appear frequently in ancient art: thus
representations of the two of them seated after Ariadne's deification
make up only one part of their presence in the artistic record. As with

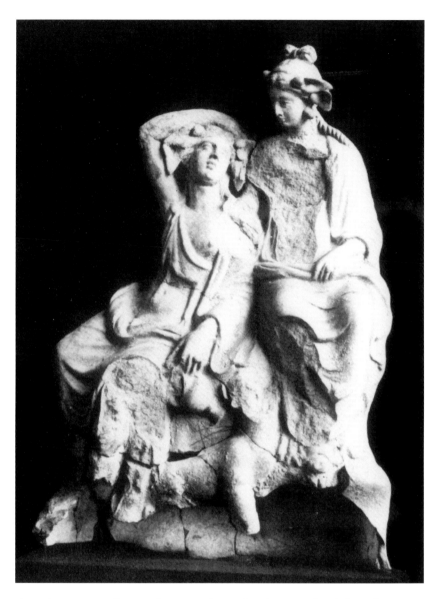

the other scenes discussed, comparisons for the seated pair have been
drawn both from the Greek East and from Italy. In addition to the
previously mentioned coins from Smyrna that show them (fig. 9.1),
Herbig compared the couple to two Hellenistic terracotta figurines from
Myrina, a town in Asia Minor (fig. 9.8).[72] Dionysus and his companion
have also often been compared to the similarly posed figures on a cameo
now in Vienna.[73] Mudie Cooke noted a parallel for the divine couple in a
fresco from one of the *triclinia* of the House of the Vettii in Pompeii. In
this wall painting, from the mid-first century AD, Dionysus and Ariadne,
seated, observe a wrestling match between Pan and Eros (fig. 9.9).[74]

The objects mentioned here reflect the variety of visual sources that
have been used in attempting to identify the origins and determine the
meaning of the Villa of the Mysteries frieze. The comparisons cited
range in date from the fifth century BC to the third century AD and
originate in Italy, Greece, Asia Minor, Egypt, and North Africa. While
the Villa painting clearly draws on a visual repertoire that was available
throughout the ancient Mediterranean world, the very fact that this
imagery appears in such a variety of media, periods, and locations erodes

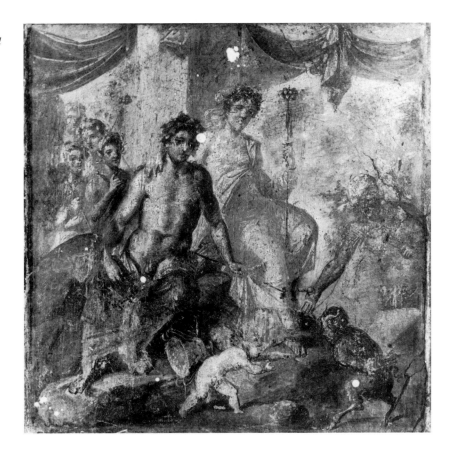

Fig. 9.9. Wall painting of Dionysus and Ariadne watching wrestling match of Pan and Eros. House of the Vettii, Pompeii. DAIR neg. 31.2497.

the foundations of the theory that the mural is strictly a copy after one particular earlier work of art. The ubiquity of Dionysiac motifs in particular from the Classical period to Late Antiquity reinforces the possibility that the Campanian painter of the Villa frieze adapted a number of well-known compositional types for the scenes in the mural rather than copying all of them from a single prototype.

CONCLUSION

From its discovery commentators on the famous mural in the Villa of the Mysteries considered it a copy of an earlier masterpiece. Opposition to the identification of the frieze as a copy, which began with the publications by Pfuhl, Bieber, and Maiuri, has gained greater prominence among scholars in recent years, as evidenced for example by the works of Ling, Clarke, and Sauron. As these authors have noted, the mural's artist drew on a visual vocabulary familiar throughout the Graeco-Roman world. The geographical extent and lengthy duration of the use of this repertoire, attested by the objects and paintings presented here, argue against the identification of the Villa painting as an imitation of a single earlier Greek or Hellenistic source and suggest that it should instead be viewed as a product of first-century BC Southern Italy. Building on the growing appreciation of the whole painting as an "original" composition, this exhibition attempts to ground the study of the Villa of the Mysteries frieze in the artistic, religious, and social practices of the region and period in which it was created.

93

1 See ch. 12 by E. de Grummond and ch. 13 by D. Kirkpatrick in this volume on the other modern images.

2 Winckelmann 1968, 2:153. On Winckelmann's writings and his effect on later scholars, see Gazda 1995, 124–26; Brendel 1979, 19–24.

3 Gazda 1995, 126–28; Bergmann 1995, 83, 85–87.

4 For a recent example, see Cohen 1997, 51–82. Cohen, after reviewing the arguments for and against the identification of the Alexander Mosaic as a copy after a Greek painting, concluded that it is an accurate copy of a fourth-century BC work.

5 "Questa pittura . . . è senza dubbio un pallido riflesso della composizione originale, da cui deriva; e dimostra un valore artistico non superiore alla media di quello che si trova su le pareti di Pompei." De Petra 1910, 144, my translation.

6 Mudie Cooke 1913, 173.

7 Pottier 1915, 324, 333; Macchioro 1920, 12.

8 Pfuhl 1923, 2:876; Bieber 1928; Maiuri 1947.

9 Curtius 1929, 369–70.

10 On Curtius's role in the debate see, for example, Simon 1961, 111; Houtzager 1963, 118; Little 1972, 7.

11 "Toutes ces scènes sont d'une extrême incohérence et la conclusion s'impose qu'elles ont dû être arrachées à un ensemble beaucoup mieux ordonné et d'une construction plus logique." Méautis 1945, 260, my translation.

12 Simon 1961, 112.

13 Zuntz 1963, 198 n. 1.

14 Bendinelli 1968, 824.

15 Turcan 1982, 291–302. Turcan's arguments in this article were based on Simon 1961 and Zuntz 1963. Very different views about the Villa frieze, noted below, were expressed in Turcan 1995, 79–81.

16 "Ce n'est qu'une copie, habile et même talentueuse, non indigne de l'original, et, à mon sens, très fidèle. Comme la majorité des peintures de Pompéi, notre fresque est la copie d'un original grec disparu, antérieur d'un siècle ou deux." Veyne 1998, 17, my translation.

17 The assumption of errors on the part of the copyist has long been a standard element of copy criticism. See Gazda 1995, 127.

18 De Petra 1910, 145.

19 Mudie Cooke 1913, 164.

20 Zuntz 1963, 193–96.

21 Pottier 1915, 345–46; Curtius 1929, 361; Zuntz 1963, 193. Others who shared this view were cited by Mudie Cooke 1913, 167 n. 1. These scenes were ignored completely by Méautis 1945.

22 On crowding, see Curtius 1929, 363 and Bendinelli 1968, 824. On omitted scenes, see Zuntz 1963, 188–89. On the pervasiveness of these assertions in the literature on the frieze, see the comments by Ling 1991, 102–3.

23 Curtius 1929, 346.

24 Curtius 1929, 363–64.

25 Mudie Cooke 1913, 173–74.

26 Curtius 1929, 368–69.

27 Simon 1961, 160–66.

28 Simon 1961, 166.

29 Zuntz 1963, 190.

30 Veyne 1998, 18, 21.

31 Ling 1991, 5. Paintings on vases like the Centuripe-ware (cat. no. 73) and Hadra-ware (cat. no. 97) vessels in this exhibition have been used in reconstructing themes and stylistic trends in Greek wall painting. The painted decoration of a number of Macedonian tombs from the early Hellenistic period has also been studied as evidence for contemporary painting techniques. See Pollitt 1986, 188–92.

32 Quint. *Inst.* 10.2.6–7; Bergmann 1995, 92.

33 For an early discussion of the pitfalls of identifying Roman paintings as copies of Greek works, see Brendel 1979, 180–81. More recently, a thorough treatment of these issues can be found in Bergmann 1995.

34 Simon 1961, 166. In 133 BC Pergamon was bequeathed to Rome, and thus it is not inconceivable that a wealthy Roman traveler (perhaps a diplomat or military officer?) of the late Republic might have gained access to the former palace; Simon, however, did not clarify whether she thought the transmission occurred by this means or by another.

35 Even though solutions to this problem, such as the existence of pattern books, have been proposed in relation to other Roman paintings. See Ling 1991, 128, 218–19.

36 For a more detailed look at the multicultural history of Pompeii up to the time of the creation of the Villa of the Mysteries frieze, see ch. 3 by D. Wilburn in this volume.

37 On the dating of the frieze, see Clarke 1991, 80, 94.

38 A statue of Livia found in the Villa indicates that in the first century AD the house's occupants felt some connection to the imperial family, but it offers no insight into the political views of the frieze's patron a half-century or more earlier. Maiuri 1947, 225–35.

39 "Der Fries der Mysterienvilla ist in den sechziger Jahren nach einem Vorbild kopiert worden, das bald nach der Jahrhundertwende in Rom geschaffen worden sein dürfte." Schefold 1952, 57, my translation.

40 Little 1972, 7–8, 14.

41 Pfuhl 1923, 2:876.

42 Bieber 1928, 326, 330.

43 Maiuri 1947, 174–75.

44 Bieber 1928, 301, 307, 313, 326; Maiuri 1947, 152, 156, 174–75.

45 "Die Göttergruppe erscheint allerdings auf gewissen Monumenten der Kleinkunst unverkennbar wieder, auf Gemmen und Münzstempeln, aber auch Terrakotta-Gruppen, die nach Kleinasien als dem vielleicht ursprünglichen Aufstellungsort des Bildwerkes weisen. Aber das genügt keinesfalls, um die Behauptung zu wagen, der pompejanische Fries sei in extenso die Kopie einer großen malerischen oder plastischen Originalkomposition aus dem griechischen Osten." Herbig 1958, 55, my translation.

46 Houtzager 1963, 20; Brendel 1980, 123, 125.

47 Houtzager 1963, 40; Boyancé 1965–66, 80, 88; Brendel 1980, 123, 137 nn. 77–78.

48 "Cette frise dionysiaque est le reflet de l'éclectisme social, artistique et spirituel de Pompéi." Grieco 1979, 439–41, my translation.

49 Ling 1991, 102–3; Clarke 1991, 99–102, 105.

50 Turcan 1995, 79.

51 Sauron 1984, 174; 1998, 150.

52 Bieber 1928, 323. On the coordination of pavement, painting, and vault, see Maiuri 1947, 125 and Clarke 1991, 100–101.

53 Bieber 1928, 323; Clarke 1991, 99; Andersen 1993, 187.

54 Ling 1991, 103.

55 Herbig 1958, 22, foldout.

56 Houtzager (1963), going even further, devoted nearly half of his monograph to identifying prototypes for each figure in the frieze. His comparisons focus on formal similarities rather than on the actual activity performed by each figure, an approach that weakens some of his selections. For example, he has compared both the fleeing woman and the winged demon of the Villa frieze to dancing maenads (34–35, 45) while likening the dancing woman on the south wall to a fleeing Nereid (50).

57 For example, Brendel 1980, 115, 119.

58 Bieber 1928, 313–14, figs. 10–12. For a discussion of similarities between the iconography of the frieze and the images on South Italian pottery, see ch. 10 by S. Kirk in this volume.

59 Brendel 1980, 119. This painting, like the Villa of the Mysteries frieze, has often been claimed to be a copy after a Greek or Hellenistic original.

60 Houtzager 1963, 56; Sauron 1998, 74, fig. 10.

61 Houtzager 1963, 56–57.

62 For a description and illustrations of Neo-Attic maenads, see Pollitt 1986, 169–72, figs. 174–77.

63 Mudie Cooke 1913, 166; Herbig 1958, 59; Houtzager 1963, 50.

64 Curtius 1929, 298; Clarke 1991, 104–5.

65 See, for example, Simon 1961, 136–47; Brendel 1980, 91; and Sauron 1998, 102–5. She is in addition the subject of several entire articles, including Lehmann 1962, Boyancé 1966b, and Turcan 1969.

66 The painting at Hermoupolis, from the first half of the second century, shows part of the legend of Oedipus. Lehmann 1962, 63–65, pl. 10.1.

67 On the relief, see Pottier 1915, 341; Bieber 1928, 308; Brendel 1980, 132 n. 29. On the mosaic, see Herbig 1958, 59; Lehmann 1962, 63; Brendel 1980, 132 n. 33. On the cameo, see Bieber 1928, 309; Maiuri 1947, 156; Lehmann 1962, 64.

68 Lehmann 1962, 66.

69 These differences have led some scholars to reject these objects as comparisons for the Villa's winged woman. Grieco (1979, 430) and Sauron (1998, 100–102), for example, have both argued that she cannot be given the same identification as the figure in the mosaic and the Campana plaque.

70 Sauron 1998, 94.

71 For example, Houtzager 1963, 40; Brendel 1980, 123.

72 Herbig 1958, 59. The Smyrna coins have been mentioned by many scholars, including Bieber 1928, 301; Maiuri 1947, 152; and Grieco 1979, 439. The Myrina terracottas have also been cited by Pottier 1915, 334–35 and Houtzager 1963, 41.

73 Pottier 1915, 333; Bieber 1928, 301, fig. 4; Boyancé 1965–66, 85.

74 Mudie Cooke 1913, 161. This comparison was also made by Boyancé 1965–66, 85.

95

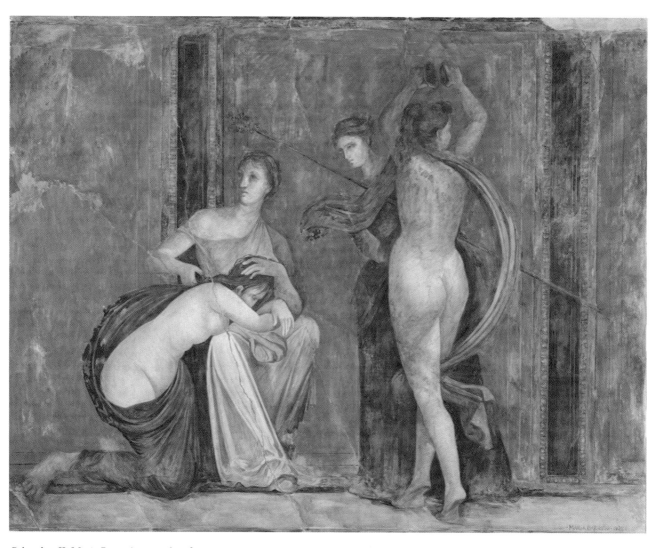

Color plate II. Maria Barosso's watercolor after the flagellation (fig. 1.4, group F) scene of the Villa of the Mysteries frieze.

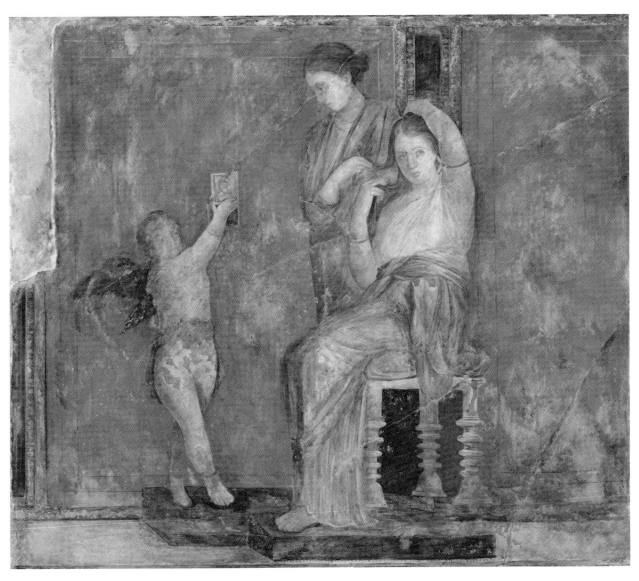

Color plate III. Maria Barosso's watercolor after the adornment of the bride (fig. 1.4, group G) scene of the Villa of the Mysteries frieze.

10 Nuptial Imagery in the Villa of the Mysteries Frieze: South Italian and Sicilian Precedents

Shoshanna S. Kirk

The enigmatic frieze in Room 5 of the Villa of the Mysteries has often been considered an artistic anomaly, for while other Second Style megalographic paintings appear to depict strictly mythological subjects, this one presents a mélange of subjects derived from both myth and reality.[1] Frequent efforts have been made, with varying success, to make logical sense of the frieze's iconography by attempting to identify each figure and by constructing overarching narratives that weave the seemingly disparate elements of the painting into a cohesive whole.[2] Often underlying such efforts is an assumption that the Pompeian frieze is a copy of an earlier Greek original.[3] Such an understanding, however, leaves much to be desired. It does not explain what seems apparent—that the Villa frieze was planned and executed with the unique format of the room in mind.[4] Nor does it account for the fact that, although the frieze does draw upon a repertoire of well-established figure types, those types were integrated into a composition designed specifically for the Pompeian setting.[5]

It is an assumption of the present chapter, as of the exhibition as a whole, that any attempt to understand the frieze in the Villa of the Mysteries must acknowledge the complex interactions among cultural and visual traditions that occurred within Pompeii and its environs.[6] My study will focus particularly on vase paintings of Magna Graecia (fig. 3.1), which include an extensive repertoire of images of women engaging in activities similar in appearance to those depicted on the Villa frieze. This repertoire includes images pertaining not only to the cult of Dionysus but to other cults as well. Viewed in conjunction with the imagery of the Villa frieze, these South Italian and Sicilian vase paintings encourage the reading of the Villa's imagery from a multivalent, possibly a multicultic, point of view.[7] For although in the Villa frieze the imagery of Dionysus/Bacchus seems clear, the range of visual sources upon which the frieze apparently draws includes some that could also refer to the cults of other deities. If we can assume that the designer, patron, and other ancient viewers of the frieze were familiar with an array of such signs, and in some cases perhaps even their ideological associations, we might conclude that they were able to derive meanings quite different from our modern readings of the frieze as categorically "Bacchic/Dionysiac."

Drawing upon the repertoire of South Italian and Sicilian vase paintings, I shall focus in this chapter on one of the many valences of the frieze: the allusion to the imagery associated with marriage, a rite of passage presided over by Aphrodite and, in Southern Italy, Persephone and Dionysus as well. This imagery occurs on red-figure vases of South Italian workshops active from the late fifth to the end of the fourth century BC and on Centuripe vases from Sicily, which were made sometime between the third and the first centuries BC.[8] Although the Villa of the Mysteries frieze was painted more than three hundred years after the painted vases of Magna Graecia began to be produced, the vase paintings form an important component of the visual culture and iconographic tradition from which the Villa frieze later emerged.[9]

A number of scholars have noted a nuptial theme in the Pompeian frieze, mostly focusing their attention on four vignettes: the adornment of the bride (group G; color pl. III), the woman folding a "nuptial peplos" (group B), the seated matron (group I), and the central couple (group D; color pl. I). Following Giulio de Petra's seminal interpretation in 1910 of the frieze as an initiation of women into the mysteries of Dionysus, Margarete Bieber argued in 1928 that the frieze depicted a specifically prenuptial initiation.[10] Domenico Comparetti had, on the other hand, argued in 1921 that the frieze did not depict an initiation but rather the nuptial cortege of Bacchus and Ariadne.[11] In 1929, Jocelyn Toynbee arrived at a conclusion similar to Bieber's, but she understood the frieze as a continuous narrative, depicting a single woman's passage through the stages of the prenuptial initiation, whereas Bieber had assumed multiple female initiates.[12] In 1980 Otto Brendel concurred with an overall nuptial theme but modified details of its interpretation.[13] Recently, however, Gilles Sauron (1998) has challenged the traditional nuptial theory by proposing that Dionysus's companion is not his wife, Ariadne, but his mother, Semele, and thus understanding the frieze to center on the mythology of Semele and the participation of the *domina* in the Dionysiac cult.[14] I do not agree with Sauron's interpretation but will instead build upon the foundations laid by Bieber, Toynbee, Brendel, and others in further exploring the likelihood of a nuptial element on the Villa frieze.

Unlike previous scholars, most of whom looked far afield for source imagery for the frieze, citing images in a variety of media throughout the Mediterranean basin and from a wide range of historical periods,[15] I shall consider the nuptial imagery on the frieze exclusively within the context of ancient Southern Italy and Sicily. In particular, I shall consider the painted vases produced there from the fourth to the first centuries BC in relation to two key images on the Villa frieze, the reclining Dionysus with female companion (the central couple, group D) and the adornment of the bride (group G), in both formal and thematic terms. The vase paintings can, I believe, help to explain the apparent schism in the frieze between representations of myth and those of reality as well as the simultaneous presence of signifiers of the cults of Dionysus and Aphrodite.

Although the frieze in the Villa of the Mysteries participates in the visual culture of the late Hellenistic Mediterranean at large, it was nonetheless a product of first-century BC Pompeii, painted for the private residence of a specific Pompeian patron.[16] An exploration of the imagery from which selected portions of the Villa of the Mysteries frieze springs thus serves a double purpose. First, it may improve our understanding of certain associations that viewers of the frieze between 60 BC and AD 79 might well have made with it. Second, it may serve to clarify the visual and thematic sources—especially those associated with marriage in this part of the ancient world—from which the designer of the frieze drew inspiration.

SOUTH ITALIAN AND SICILIAN VISUAL PRECEDENTS

A. D. Trendall has successfully demonstrated that the often magnificent and ornate vase paintings from Southern Italy and Sicily are distinct in both style and subject from those of earlier as well as contemporary Attic

vases.[17] Common subjects and motifs of the South Italian vase painting repertoire are theatrical performances (both tragedies and phylax plays), funerary references, cultic activities, mythological scenes, lush vegetation often incorporating female heads, and ubiquitous Dionysiac images.[18] The Dionysiac and nuptial vase paintings of Southern Italy and Sicily do, however, appropriate a longstanding Attic visual repertoire composed of stock imagery, which had begun to appear in a variety of Attic media as early as the Archaic period. The Dionysiac repertoire in both mainland and colonial Greek contexts comprises a cast of characters including Dionysus himself, his female companions (Ariadne and/or Semele), satyrs, silens, maenads, nymphs, and theatrical performers. Moreover, certain figural postures and compositions on Attic vases are repeated in the Magna Graecian vase paintings, such as the reclining Dionysus or enthroned Dionysus with a female companion. Cult objects also form a component of this shared Dionysiac repertoire, comprising wine-related imagery such as grapes, ivy, kantharoi, and wine amphorae; vegetal imagery such as thyrsi; animal imagery such as fawns, panthers, goats, and animal skins; and theatrical imagery, such as masks and stage platforms; items associated with the Dionysiac mysteries such as likna, *cistae*, thymiateria; and, finally, musical instruments such as cymbals, tympana, and lyres. The nuptial cast of characters includes Aphrodite, Eros, Peitho (the personification of persuasion), and of course the bride herself. The iconographic repertoire comprises items related to adornment (and thus seduction) including jewelry, *cistae* (jewelry boxes), alabastra (for perfume), lavers, and mirrors; vases associated with the wedding, such as loutrophoroi or *lebetes gamikoi*; and vegetal imagery such as myrtle branches.[19]

This visual repertoire can be understood in semiotic terms as a system of signs. Often signifiers overlap with respect to what is signified, so that a single object may carry multiple meanings and have various functions: the knee-raised posture, a woman with a phiale, or a mirror might appear in a variety of scenes.[20] These visual elements, or signifiers, could be used as the patron and/or painter saw fit and combined in an infinite number of variations to form an image relaying to the viewer an ideological message charged with multiple associations. As François Lissarrague has articulated this process, "None of these images is reproduced. There is no model; each object offers a new combination from a restricted number of elements."[21] A similar principle might be applied to interpreting the Villa of the Mysteries frieze, informed by the imagery most commonly found on South Italian and Sicilian vases.

DIONYSUS AND HIS COMPANION: A *HIEROS GAMOS*?

Entering Room 5 of the Villa of the Mysteries from the main doorway, the viewer immediately confronts the nearly life-sized image of Dionysus (Liber/Bacchus) (group D, figure 15; color pl. I) appearing on the wall opposite. The god is youthful and partly clad, reclining languidly on a *klismos*, with a female companion seated beside him. The couple is accompanied by a retinue of "real" and "mythological" figures who appear on the north, west, and south walls of the room. The abundance of South Italian representations of Dionysus demonstrates that this image of the god, portrayed reclining with a female companion and in the company of attendants, enjoyed a long history of popularity in the region prior to the painting of the Villa of the Mysteries frieze.

100

Fig. 10.1. Detail of Centuripe krater, 300–100 BC. New York, Metropolitan Museum of Art 29.131.2, Fletcher Fund, 1929. Photo: Museum.

On the Villa of the Mysteries frieze, Dionysus is easily identified by his thyrsus, but the extensive damage to the female figure makes the task of identifying her difficult. She is most commonly said to be Dionysus's wife Ariadne, and together they have often been thought to represent a *hieros gamos*, a paradigmatic sacred marriage, a theory first proposed by Amedeo Maiuri.[22] According to this reading, the sacred couple acts as a symbol of the culminating act of initiation—the female initiate's "mystic wedlock" with the god.[23] For just as Dionysus had provided salvation to his mortal bride Ariadne, he would bestow a blessed afterlife upon the female initiate. This interpretation has been challenged by Pierre Boyancé and more recently by Giles Sauron. The latter argues that because only married women were initiated, initiates would associate themselves with Semele, the mother of Dionysus, whom, as mentioned above, he identifies as the enthroned female companion of Dionysus.[24] Yet other scholars prefer to identify the companion as Aphrodite/Venus or Kore/Persephone, whose connection to the realm of marriage is clear.[25]

A similar couple appears on a polychrome-painted Centuripe krater in New York (fig. 10.1). This vase presents the single most striking visual precedent to the Pompeian frieze: on a faded red background, the handsome body of a half-draped, youthful Dionysus can just be discerned.[26] He wears white fillets, which hang down to his shoulders, and he leans back on his right elbow and casts his eyes over his right shoulder. A round object (a shield or a tympanum) rests on the ground at his left, and he holds a thyrsus in his right hand. His left hand gently grasps the hand of a female figure standing behind him, now barely visible. She wears a himation, pulled over her head as a veil. This bridal veil, together with the hand-holding gesture, identifies the figure as Dionysus's wife, Ariadne. The brushwork, palette (particularly the red background), and monumental scale of the figures on the vase also find notable parallels in the Villa of the Mysteries frieze.[27]

Of the polychrome vases, those of the Centuripe type, in fact, bear

101

the greatest number of formal and technical similarities to the Villa frieze. Two explanations have frequently been offered regarding both these similarities and the obvious thematic connections: either the vases and the Villa of the Mysteries frieze must both be based upon some unknown Hellenistic prototype (mural painting), or else Centuripe ware must be rooted in Second Style megalographic Pompeian wall painting. Although a number of characteristics—such as architectural ornaments, megalographic figures in a shallow stagelike setting, the use of light and shadow to create figural modeling, and the use of richly hued tempera paint—suggest that Centuripe ware may have been influenced by wall painting, a causal relation, which postulates a now-lost wall painting as the prototype for the Centuripe vases as well as the Villa of the Mysteries frieze, should not necessarily be inferred. The fact that there are stylistic, technical, and iconographic similarities between Centuripe vases and the Villa frieze, and, further, that the vases and the frieze are from the same general region of the Mediterranean, suggest that painters in both media drew upon a visual and iconographic tradition that was well known in Southern Italy and Sicily. The Centuripe vases clearly indicate that this tradition incorporated nuptial and Dionysiac themes, among which was the *hieros gamos*.

Red-figure vases, though neither coloristically nor technically similar to wall painting, also illustrate important iconographic parallels to the Villa frieze. A reclining Dionysus appears in a bucolic context on the body of a red-figure Lucanian volute krater of early fourth-century date by the Creusa Painter in Toledo (cat. no. 72). Here Dionysus, holding a thyrsus and a kantharos, sits in a chair next to a female companion who places a wreath atop his head.[28] At left a satyr carries a flute-playing nymph/maenad, and a maenad—clad in a chiton and animal skin and holding a kottabos stand and a situla—approaches the couple.[29] Pan and a satyr pick the grapes that hang above. At right, a nymph/maenad hands over a small fawn to a seated woman as a satyr approaches. A rabbit and another fawn appear below them. The thin, ribbonlike band that frames the couple may represent the mouth of a grotto. Thus, the divine couple seems to be surrounded by images that recall cultic activities, here carried out by satyrs and nymphs or maenads.[30] This pastoral setting, populated by woodland creatures and presided over by the god of wine and abundance, is echoed in the proliferation of vegetal motifs on the neck, lip, and handles of the vase. The imagery and atmosphere recall the scenes of the silen with a lyre, satyr with flute, and satyress with a baby goat (group C) on the Villa of the Mysteries frieze.

Sauron argues for identifying Semele as Dionysus's companion in the Villa frieze on the basis of examples that depict her as seated frontally on a throne behind the young god and on a higher level than he.[31] I, however, do not believe this hieratic composition can be used definitively to identify the female companion of Dionysus as his mother, for similar poses and types were used to portray different characters. Rather, the identification of the god's companion on the Villa frieze as Ariadne is supported by the Centuripe vase discussed above (fig. 10.1) as well as by many other South Italian vase paintings in which Dionysus and a female companion are shown in more overtly erotic postures—for instance, as entwined in an amorous embrace in the presence of Eros.[32] It is nevertheless possible that the designer of the frieze may have alluded intentionally to multiple female consorts of Dionysus, including Ariadne, Aphrodite/Venus, Semele, and Persephone/Proserpina/Libera. The connections between Dionysus/Liber and Aphrodite/Venus argued elsewhere in this volume would support the figure's identification as Aphrodite/Venus.[33] Except for

102

Semele, all the goddesses potentially alluded to are connected with marriage. But because the figure of the god's companion is fragmentary and the attributes she may once have had are lost, and because there appear to be no overtly amorous signals between her and Dionysus/Liber, the question of her identity must remain open. On balance, however, a nuptial interpretation of this scene seems the most compelling.

THE ADORNMENT OF THE BRIDE

Another vignette frequently associated with marriage is group G in the southwest corner of Room 5 (color pl. III). On the south wall, a woman (the "bride") seated on a *klismos* facing left looks out at the viewer as a female attendant, standing to the right, coifs her hair. An Eros on the left of the pair holds up a mirror in which a reflection of the seated woman appears. Another Eros on the west wall (group H) looks on, leaning on his bow. This composition is almost unanimously identified as a bridal adornment scene, and it is often discussed in tandem with the seated matron (group I) on the other side of the doorway. Following Bieber's suggestion of 1929, it is generally believed that group G depicts the bride's hair being coifed into a six-lock arrangement unique to the Roman wedding.[34]

A compelling visual parallel to the Villa of the Mysteries scene of bridal adornment occurs on a Centuripe krater in the collection of Emory University's Michael C. Carlos Museum (fig 10.2).[35] A woman

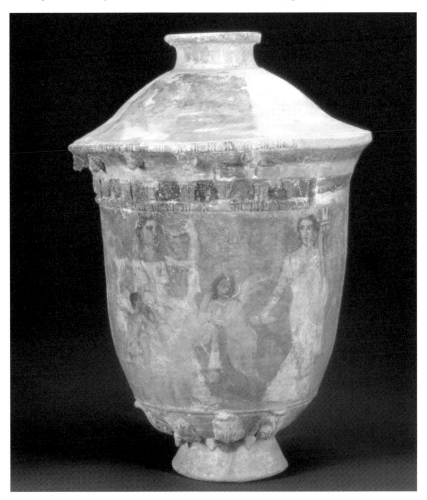

Fig. 10.2. Centuripe krater, mid-third century BC. Emory University. Photo courtesy of Christie's and the Michael C. Carlos Museum.

103

Fig. 10.3. Paestan lebes gamikos, mid-fourth century. Paestum 20296. After Trendall 1987, 2/965, pl. 147.

seated on a *klismos* facing right lifts her veil in a gesture of *anakalypsis*, the unveiling performed by the bride in the wedding ceremony. Two Erotes flank her, leaning their elbows on her knees. The representation of a seated bride with attendants is strongly reminiscent of group G on the Villa frieze, and both cross-legged Erotes and the hand-to-chin gesture of one are strikingly like those of the Erotes on the frieze. On either side of this group stands a woman holding a phiale with offerings, recalling the woman with an offering tray on the Villa frieze (group A, figure 4). Like the Centuripe krater in New York, this vase shares some formal characteristics with the Villa frieze: illusionistically modeled monumental figures using rich, polychrome hues and outlining, a red background, and a shallow stage. The composition of a seated woman with attendants and Eros draws upon a long tradition of Attic images of bridal preparation scenes. The similarity in iconography and composition of nuptial scenes on fifth-century Attic vases would also support the reading of a nuptial theme in the Villa frieze. The iconography does not vary greatly from fifth-century Attic to fourth-century South Italian and Sicilian vases, although there is perhaps a larger body of Attic imagery, and often mythological names are inscribed to situate the scene in the context of a specific tale of marriage. Attic red-figure vase painting is the medium *par excellence* for scenes related to the wedding, often images that veil an ideological agenda.[36]

Also inviting comparison is a bridal scene on the body of a mid-fourth-century *lebes gamikos* from Paestum (fig. 10.3), a type of vase associated with weddings and often found in female graves.[37] A female figure sits on a *klismos* while being crowned with a wreath by Eros, who stands on her thigh. At the left of the scene is a half-draped figure holding a staff and a mirror, and standing to the right of this figure is a woman who leans on a pillar in a posture of conversation facing the central figure. Behind the seated figure and holding her hand is a nude male figure wearing a diadem. At the far right is a woman with a phiale and a branch, probably myrtle. Yet in this image, the bride and youth hold hands and wear rings, suggesting this may be a conflation of images of a *hieros gamos* and bridal adornment. On the finial of the vase (in the shape of a *lebes*) is a female head of a type ubiquitous in South Italian vase painting and often identified as Aphrodite or as a bride. The seated female in the main scene may be intentionally ambiguous—again, she could be a bride or Aphrodite. The vase, its shape associated with wedding rites, may have been given as a wedding gift. In this case, the recipient of the gift (a young bride) probably identified with and sought to emulate the goddess of love. As with Dionysus's female companion on the Villa frieze, a degree of ambiguity in the identity of these figures may have been intentional, enabling the viewer to recognize herself as the bride, who is in turn associated with Aphrodite/Venus.

Similar elements appear in a delicately painted tondo of a mid-fourth-century drinking cup from Paestum (fig. 10.4).[38] A female figure seated facing left on a *klismos* gazes at her reflection in a mirror, which she holds in her right hand while clutching a fillet in her left. To the left stands a tiny Eros with enormous wings holding a wreath and fillets as well as balancing a tall stack of small cakes (or a "skewer of fruit").[39] To the right a small female figure holding a second stack of cakes and a mirror leans against a laver. A fillet, a garland, and a grape cluster hang above the figures' heads. Both of the attendant figures stand on small platforms, similar to the blocky plinths that appear beneath several

figures in the Villa of the Mysteries frieze. Once more, although an apparent hierarchical scale encourages identification of the larger, central figure as Aphrodite, it is difficult to tell whether she is meant to portray a bride or a goddess.[40]

BLURRING BOUNDARIES: MYTH AND REALITY

The Villa of the Mysteries frieze is, in my opinion, far from a documentary account of a wedding or, as many have claimed, a female initiation into the mysteries of Dionysus (or Liber or Bacchus). Rather, it presents a loosely interwoven tapestry of mythological imagery (groups C, D) and what may be idealized scenes of women engaging in or identifying with familiar cultic activities, some (groups A, B, G, I) associated with the wedding. The apparent tension between representations of "myth" versus those of "reality" occurs in South Italian vase paintings as well. Brendel attempted to resolve this tension by segregating the scenes of the Villa frieze into two very different spheres—one comprising "inhabitants of the realm of our common human reality" and the other comprising beings (silens, satyrs, and gods) who are "part of an otherworldly reality, fictitious, mythological, or poetic."[41] According to him, Dionysus himself is "present" at the rites of his own mystery cult, together with his companion. Although Brendel astutely observes the coexistence of mythical and real elements, he sees them as distinct realms that are intertwined, a characteristic of so much Roman art and literature:

> Only in art, which itself is invention, can the representatives of these two worlds meet so easily, without reservations. . . . In the frieze of the Villa of the Mysteries, men and mythological beings associate on equal footing without any hesitation, even with a degree of naturalness.[42]

But the perception of a separation between myth and reality, which Brendel and many other modern scholars have noted in the Villa frieze, may be anachronistic. In reference to Attic vase painting, at least, Mary

105

Fig. 10.5. Polychrome lidded skyphoid pyxis by the Falcone Painter. Palermo GE 4730. After Trendall 1967b, frontispiece.

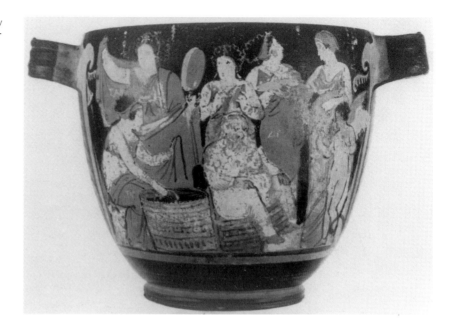

Beard has argued that the traditional scholarly division between mythological scenes and scenes of "everyday life" is a false dichotomy. In Beard's opinion, the divide between the "'imaginary' world of the gods and the 'real' world of human experience" simply did not exist in the mind of the ancient viewer.[43] In other words, the gods and other mythological characters "did not inhabit a separate world" but were themselves components of human experience.[44] Each painted figure may thus have possessed an individual human identity and at the same time played an anonymous suprahuman role. Beard's concept is applicable to both the South Italian vase paintings and the Villa of the Mysteries frieze. For instance, in the case of the Paestan *lebes gamikos* discussed above, the seated female is both a bride *and* Aphrodite. A similar fusion of identities, which transcend boundaries, may be embedded in the Villa frieze as well; Dionysus's female companion, as noted earlier, particularly invites speculation. Not only may she represent such mythological figures as Ariadne and Aphrodite; she may also have a human identity in the eyes of her viewers. In Dionysiac cults, role-playing was apparently common. This practice might well have encouraged readings of cultic imagery that blurred the boundaries that modern viewers perceive between the realms of myth and reality.[45]

Such a "mixing" of realms had been occurring for centuries in Greek visual contexts, including that of the vases of Magna Graecia. A lidded skyphoid pyxis in Palermo, unusual in its polychrome decoration and painterly style (fig. 10.5), provides an instance.[46] In the foreground at the left a seated female figure draws fillets from a large *cista*, to the right of which sits a bearded silen. In the background at the left, a woman holds up her himation with her right hand as if to prevent onlookers from seeing the contents of the basket; with her left hand she holds what appears to be a mirror. Next to her stands a woman with cymbals, and to the right of her a woman holding a phiale engages in conversation with another woman in front of whom stands a small Eros. Garlands hang in the background. The scene appears to represent women preparing for the mysteries of Dionysus, in the company of Eros and a silen. Perhaps the women also played mythological or fictional roles appropriate to

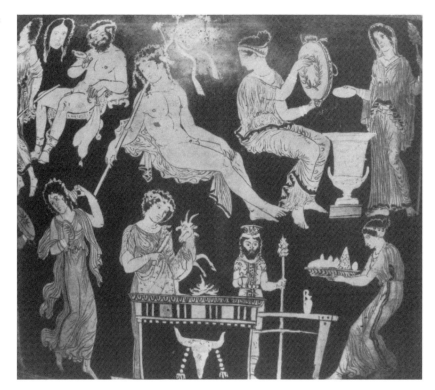

Fig. 10.6. Detail of Apulian volute krater from Ruvo. Naples 2411 (82922). AfterBieber 1917, fig. 16.°

those mysteries. As in the Villa frieze, "real" participants appear comfortable engaging in religious acts in the presence of constituents of the divine and mythological realms.

Beard also notes that a major problem of differentiating mythological from genre scenes relates to conceptions of representation and narrative in Attic vase painting:

> the term "everyday life" implies that we can read these images as documents of social history; it implies that they are evidence for 'what actually happened' at an Athenian banquet or behind the closed doors of the women's quarters, almost as if they are photographs. In fact, these images cannot be simple replicas of reality. They may draw on and select elements from the world round about—for that is how they are "recognizable". But the very process of selection and juxtaposition within the restricted frame of the pot necessarily converts the reality of everyday life into something very different: an *image*, a *representation*, an *intellectual construct*.[47]

The scene on an Apulian volute krater from Ruvo (c. 400 BC) (fig. 10.6) well illustrates Beard's point.[48] A nude Dionysus reposes in the center of the upper register, seated on a himation-draped rock and leaning against a pithy reed, or narthex.[49] At the left are a satyr (seated on a leopard skin holding a wineskin and playing the game of kottabos), a mask, and a dancing nymph/maenad with a thyrsus and a torch. To the right of Dionysus two nymphs/maenads flank a calyx krater, one seated holding a tympanum, the other holding a thyrsus and pouring a libation from a phiale into the krater; a thymiaterion appears at the far right. On the bottom register at left one maenad dances with a tympanum, another with cymbals; in the center a woman wearing a wreath stands behind an altar (beneath which is a picture of a bucranium) preparing to sacrifice a baby goat; to the right is an Archaistic statue of a bearded Dionysus standing and holding a thyrsus, while a maenad bearing a platter of

107

offerings approaches from the right. The altar and statue fix the location as a sanctuary of Dionysus.[50]

The painting appears to depict two distinct realms of activity: a mythological world on the upper register (Dionysus, satyr, and nymphs—or are they, in fact, maenads?) and a scene of "real women" (maenads) performing cultic activities on the bottom register. Yet according to Beard's reading of such mixed-reality representations, the registers would not represent different temporal or spatial realms but rather would depict the god and his retinue as an integral part of the rites accorded to him. The lower register is not a documentary of cultic activity, nor does it necessarily illuminate our understanding of cultic practice. This is rather a representation of worship in general terms; as in any image, the artist has concocted a mixture of visual referents, a "visual shorthand" to relay an idea.[51] It is less a "picture of" than it is a "statement about" Dionysiac cult,[52] in that it provides a prescriptive program for the viewer—that by behaving piously the worshipper may attain union with the god.

The Ruvo vase is one of many images of Dionysus accompanied by female attendants that may be read alternatively as the god with members of his mythical entourage or as a symbolic representation of female initiates with the god, as the Villa of the Mysteries frieze is often understood. These female figures may be simultaneously "real women" (maenads) engaging in the worship of Dionysus *and* mythological nymphs consorting with the god. Likewise, representations of satyrs performing cultic acts may be both mythological creatures and men dressed as satyrs, who through their mimetic endeavor have reached an ecstatic communion with Dionysus.

CONFLATING DIVINE REALMS

On a hydria from Paestum (340–330 BC) a scantily draped Dionysus is flanked by two bejeweled women, the one on the right leaning on a laver while the one on the left stands facing the god in knee-raised posture. A small Eros holding a wreath and an alabastron hovers above the seated god (fig. 10.7).[53] On either side of the scene beneath the horizontal handles is painted a large female head in profile. The "typical" Dionysiac imagery of grapevines, thyrsi, animal skins, as well as the usual members of the Dionysiac entourage (satyrs, silens, and dancing maenads) are absent. One set of visual "signs" has been replaced by another: signs of the nuptial realm, presided over by Aphrodite. This latter set includes the objects held by Eros, a wreath and alabastron (a perfume container, perfume being an essential element in a woman's toilette, guaranteed to enhance seductive appeal), the mirrors held by the two women, and a laurel branch held by the woman on the right, and, of course, Eros himself. Where the bride is usually seated, an effeminate seminude Dionysus appears instead, adorned with jewelry like a bride. The presence of a laver draws attention to the function of the vase itself, a container for water, perhaps used for prenuptial lustration by the bride. The visual mélange of nuptial and Dionysiac elements, in view of the function of the vase, points to the merging of the roles played by the two divinities in marriage.

As with the Paestan hydria, the decoration of Centuripe vases bears on our reading of other painted images. The nuptial and Dionysiac

iconography of many Centuripe vases suggests a function parallel to Attic white-ground loutrophoroi, vases that served alternately a nuptial or a funerary purpose, being both given to brides and buried with unwed young women.[54] Such vases and their accompanying decoration bear witness to two key transforming events in the life of a woman, marriage and death, inextricably linked in the Greek psyche.

The body of a Centuripe krater in New York displays another intriguing image of women engaged in ritual activity (fig. 10.8).[55] Four women move toward the right against a dark rose-colored ground. At left, a woman wearing an ivy wreath beats a tympanum, preceded by a veiled woman to whom another woman offers a light pink folded cloth, resembling a nuptial peplos. This scene adopts the composition of a wedding procession and appears to include some nuptial signifiers (a veiled female being led and a nuptial peplos) as well as Dionysiac ones, such as the ivy and tympanum. Although this scene has been identified as a bridal procession,[56] the presence of ivy and tympanum may also refer to the processions that formed one component of the mysteries. As with the Centuripe krater discussed above (fig. 10.2), the red background, rich palette, use of tempera, and illustionistic modeling are strongly reminiscent of the Villa frieze. More importantly, the intermingling of

Fig. 10.8. Centuripe krater, 300–100 BC. New York, Metropolitan Museum of Art, 53.11.5, Purchase, Joseph Pulitzer Bequest, 1953. Photo: Museum.

signs of both the nuptial and Dionysiac realms in this vase painting appears again in the Villa of the Mysteries frieze.

The symbols appearing in these three vase paintings refer simultaneously to more than one divinity or cult—they are neither strictly Dionsyiac nor Aphrodisiac. The presence of Eros undoubtedly alludes to the sexual aspect of marriage and may in some cases refer to the persuasion of the bride to engage in sexual relations or may symbolize the imminent consummation of the marriage. The presence of Dionysus in a nuptial scene may even refer to a bride's or an initiate's "mystic union" with Dionysus.[57] I do not believe, however, that a unitary reading of these images is necessary or even desirable, but rather that their different layers of meaning should be appreciated. Likewise, the "meaning" of the Villa frieze may have been, and remains, open to the individual viewer's interpretation.

CONCLUSIONS

One of the many levels of imagery belonging to the Villa of the Mysteries painting cycle is its nuptial iconography. Two key images, the central

couple and the bridal adornment scene, appear to resonate more or less directly with the visual legacy of nuptial iconography in South Italian and Sicilian vase painting. The connection between Dionysus (Liber) and marriage may be better understood by his appearance with a female companion as a *hieros gamos*, a divine couple (Dionysus and Ariadne) to be idealized and idolized by mortals. The nuptial theme of the frieze is further reinforced by identifying the central couple either as a *hieros gamos* of Dionysus and Ariadne or as Dionysus and Aphrodite (Liber and Venus). The integration of the divine realms of the latter two deities that occurs in the Villa frieze is also a common feature in the vase painting of Southern Italy and Sicily. The appearance of Dionysus and Aphrodite together elsewhere in Campanian art further reinforces their regional connection.[58] This association serves to illustrate both the complex nature of women's conceptualization of the erotic, marital realm and the overlapping of the roles of deities in that realm.[59]

The pictorial convergence of the realms of Dionysus and Aphrodite (Liber and Venus) in both the Villa frieze and the vase paintings demonstrates a common visual means of expressing certain cultic beliefs. The individual vignettes, figural types, and cult objects in the frieze strongly suggest that both its maker(s) and viewers were familiar with the pictorial legacy of South Italian and Sicilian vase painting. Thus the Villa of the Mysteries frieze can be said to appropriate a pictorial system of signs used by regional artists. Exactly how such a visual corpus may have been transmitted from generation to generation may not be precisely determined, although the availability of visual elements was probably aided by the use of copy-books,[60] portable wooden panel paintings, and vases. The inclusion of figural and compositional elements belonging to earlier traditions of representation does not indicate that the work, as a whole and in its unique context, is derivative.[61] Rather, the frieze is the product of a creative artistic endeavor, which, like many such endeavors of the first century BC, appropriates imagery from the Classical and Hellenistic past. The Villa of the Mysteries frieze and its Magna Graecian precedents share a common means of visual expression, a conclusion that is particularly well supported by the strikingly similar formal and iconographic traits of many Centuripe vase paintings, which appear again in the megalographic frieze, reinterpreted to suit its Pompeian context.

Just as the designer of the frieze was aware of and influenced by these visual predecessors, the Pompeian viewer came to the Villa frieze with a certain visual repertoire already in mind. She or he could well have perceived associations and levels of meaning in the frieze by drawing consciously or unconsciously from a pool of familiar images that made use of a similar vocabulary of signs. This visual corpus comprised images that referred not only to the cult of Dionysus/Liber/Bacchus but to other cults as well. Complex works comprising a variety of symbols to create a "plurality of meanings" were nothing new.[62] The above examples of signifiers conflating the Dionysiac and Aphrodisiac realms in South Italian and Sicilian vase paintings encourage a similarly multivalent reading of the Villa of the Mysteries frieze. Moreover, at least two of the modes of viewing Room 5 imply that the viewer was not meant to have a single visual experience of the frieze. Standing in the main doorway, the viewer is simultaneously compelled to view the central couple (creating a vertical axis through the room) and to view the frieze clockwise from the left.[63] Rather than attempt to create an all-encompassing narrative structure to explain the frieze, it seems more prudent to embrace the

multiple modes of viewing it demands and the many levels of meaning encoded in it, including references to the cults of more than one deity.[64]

Although the creator of the Villa frieze may have adopted many of the pictorial signifiers that were common in the vase paintings of Magna Graecia, what was being signified was inevitably dependent on the particular physical and social context of the frieze. While many of the visual cues that occur in both the Villa of the Mysteries frieze and in its South Italian and Sicilian predecessors appear to have remained the same, the nuptial ceremony and the ideology of marriage in Magna Graecia in the fourth to third centuries BC were not identical to those of first-century BC Pompeii. The visual traditions of South Italian and Sicilian vase painting may reinforce the reading of a nuptial element in the Villa frieze, even though these vase images do not reflect the specific details of Roman custom as the frieze apparently does. While the adornment of the bride on the Villa frieze depicts a woman whose hair is being arranged in the traditional six-plait coiffure of a Roman wedding, in the vase paintings the bride is being adorned in other ways, bedecked with jewelry or perfume. Yet, regardless of specific details of the wedding rituals, the overall *concept*—a prenuptial adorning of the bride by attendant women and Erotes—remains constant. The vases demonstrate a longstanding pictorial tradition incorporating specific symbols such as *objets de toilette*, jewelry, the presence of Eros or Aphrodite, vases connected with the wedding ceremony such as *lebetes gamikoi* or loutrophoroi, myrtle branches and wedding garb including nuptial peploi. A nuptial reading of the Villa frieze in light of these vase paintings cannot be denied, despite a changed cultural climate. The Pompeian viewers of the Villa frieze were offered images related to a long visual tradition of nuptial imagery from their environs, images connected to their own, personal experience.

The South Italian vase paintings discussed here are not strictly narrative but are constructed representations of cultic beliefs and statements about cultic practice. If we apply this idea to the Villa frieze, it may be understood as *visually allusive* but not *illustrative*.[65] That is, the frieze appears to allude to the beliefs and activities of the local cults of Liber/Bacchus and Venus of the first century BC. The vase paintings, however, allude to cults of Dionysus or Aphrodite and represent beliefs endemic to the fourth and third centuries BC. This discontinuity may make a reading of the Villa frieze even more difficult for a modern scholar, but to the ancient viewer, possessed of a framework of cultural markers, the associations between the visual imageries of these cults in different periods might well have been clear.

This approach to the Villa frieze and to associated vase paintings discourages a single definitive reading of them, an approach that accommodates both further study of the frieze and our responses to it. If "the activity of interpretation is endless," then we may always be in pursuit of the meaning(s) of the frieze.[66]

First and foremost, I would like to thank Dr. Elaine K. Gazda for her assistance and encouragement through all stages of this project, which began as a seminar in the graduate program of the History of Art during my first semester at the University of Michigan. Thanks also to Dr. Rebecca Ammerman, Dr. Judith Barringer, and Dr. John G. Pedley for their patient and critical readings of my drafts. I would also like to thank Dr. Elizabeth Fentress and Dott. Pietro Guzzo for their kind assistance in my research in Southern Italy

and Sicily. Fellow contributors to this exhibition Brenda Longfellow, Molly Swetnam-Burland, and Jessica Davis also deserve recognition for reading drafts of my essay, as do my colleagues in the History of Art department, Noel Schiller and Lisa Chan.

1 There is an immense body of literature on the painting cycle at the Villa of the Mysteries. Grieco (1979) provides bibliography and a good overview of the state of scholarship in 1979. For a more recent survey of the literature, see Sauron 1998.

2 An idea against which Clarke has argued (1991, 104): "All strict readings that attempt to pin down the meaning(s) of the mysteries frieze ignore both its sources and its purposes."

3 See ch. 9 by J. Davis in this volume for a more detailed discussion of this issue. Although the copy hypothesis is outdated, it is still upheld by some modern scholars. Veyne (1998, 17), for example, notes, "It is only a copy . . . not undeserving of the original, and, in my opinion, quite faithful" (my translation).

4 Recent scholarship on the composition of the frieze indicates that it was designed for the room. Clarke (1991, 94 ff.) makes a strong case, following Herbig 1958, noting that the gazes of the figures interact with one another (for instance, the gaze of the "fleeing girl" is directed toward one of three vignettes—the unveiling of the phallus, the lecanomancy scene, or the flagellation—creating an interaction between different sections of the frieze). See also Ling 1991, 103 and Andersen 1993, 187. For the unity of composition and symmetry in the frieze, see Grieco 1979, 421–24; for relation to Second Style Wall painting, see Lehmann 1953, 142.

5 See Maiuri 1947; Herbig 1958, esp. plan at back of book; and Ling 1991. Clarke (1991, 100, 104–5, fig. 33) argues, following Herbig, that the frieze exhibits a "complex interplay of gazes" between figures on opposing walls.

6 This approach is aptly summarized by Grieco (1979, 441) as follows: "A synthesis of Italic, Greek, and Roman traditions, the megalography of the Villa of the Mysteries could not thus be, as one formerly believed, a copy of a Hellenistic original. A unique work of its kind, this Dionysiac frieze is the reflection of the social, artistic, and spiritual eclecticism of Pompeii, simultaneously an Oscan, Greek, and Roman city" (my translation).

7 For associations of the frieze with the cult of Ceres, see Brendel 1980, 123–30.

8 A group of more than one hundred vases from Sicily is known as Centuripe ware. Although most scholars believe these vases were fabricated in the town of Centuripe, the majority of extant vases lack provenance. For bibliography on Centuripe ware, see cat. no. 73.

9 Many of the red-figure vases were found in graves, including those of women; some Centuripe vases also were associated with female graves.

10 See de Petra 1910; Mudie Cooke 1913; Bieber 1928.

11 Comparetti 1921.

12 Toynbee 1929.

13 Brendel 1980. See also Little 1964.

14 Sauron 1998. I discuss Sauron's theory and my disagreements below.

15 See ch. 9 by J. Davis in this volume for further bibliography and illustrations of frequently cited visual comparisons to the Villa frieze.

16 Because the patron of the Villa of the Mysteries frieze is unknown, it is not possible to determine whether s/he was a longstanding local resident or a newcomer from Rome.

17 See Schmidt 1996. The imagery of South Italian and Sicilian vases is a product of Greek culture transposed, and eventually responsive, to a foreign environment. A number of cities in mainland Greece exported their pottery to Magna Graecia from as early as the eighth century BC, but soon similar wares were produced by the colonies themselves. As Margot Schmidt (1996, 443) notes, "This kind of artistic production developed therefore in the cultural climate of the cities founded by the Greek colonists, in specific milieux that differed to a greater or lesser extent from those of mainland Greece."

18 For an overview, see Trendall 1982. See also cat. no. 1 in this volume.

19 For the prevalence of myrtle in the Villa of the Mysteries frieze, see Toynbee 1929, 74.

20 Smith (1976, *passim*) argues that mirrors have an Orphic significance.

21 Lissarrague 1998, 192. Lissarrague (1998, 179) notes, "in scenes of marriage as in scenes of the gynaceum, this closed space is marked by the multiplication of coffers, chests, boxes or baskets. These are not only simple utilitarian objects but signs that metaphorically express a point of view about women" (my translation).

22 As proposed by Maiuri 1947, 58 and Herbig 1958, 23. See also Veyne 1998, 58-62. See ch. 11 by B. Longfellow in this volume for further discussion of the female companion.

23 Maiuri 1947, 62.

24 His case is founded upon the scholarship of Pierre Boyancé (1965–66). Boyancé uses as

113

evidence for the identification of Semele an Etruscan mirror in which a couple, clearly engaged in an erotic embrace, are inscribed as Dionysus and Semele. However, information from Greek myth, delivered via word or image, may not necessarily be correctly transmitted. On more than one occasion, Etruscan art demonstrates the adaptation of Greek myth. It is entirely possible that the figures were misidentified or that the myth was adapted here to suit an incestuous legend. To my knowledge, an erotic relationship did not exist between Dionysus and his mother in any Greek source, written or visual, and thus this Etruscan image may not be applied definitively to identify couples in non-Etruscan circumstances.

25 For identification of the figure as Kore, see Pottier 1915, 335; Maiuri 1947, 154. For the identification as Aphrodite/Venus, see ch. 11 by B. Longfellow in this volume. See also ch. 5 by C. Hammer.

26 New York, Metropolitan Museum of Art, 29.131.2. Similarly, in the "Hall of Aphrodite" at the Villa of P. Fannius Synistor, a partly draped male figure reclines in his chair, holding a staff. Seated to his right is a heavily draped female figure. Among the various identifications of this couple are Aphrodite and Adonis, a Macedonian king and queen, or Dionysus and Ariadne. Regardless, the repetition of the motif of a languid, bare-chested, delicately muscled, youthful male figure (Dionysus on two occasions) accompanied by a female figure is striking. For this image at Boscoreale, see Richter 1930, 202; Lehmann 1953, *passim*; Ling 1991, 105, fig. 106; ch. 11 by B. Longfellow in this volume.

27 Richter (1930, 196–98, 203 and figs. 7, 9, 10) and Lehmann (1953, 142) note that the bust of a woman on the finial of this vase resembles the Shieldbearer in the Hall of Aphrodite of the Villa of P. Fannius Synnister at Boscoreale (60–50 BC), with respect to facial features and hairstyle as well as the artist's use of shadow and cross-hatching to create modeled effects.

28 Toledo Museum of Art, 81.110; Trendall 1989, fig. 72; *CVA* USA 20, Toledo 2:pl. 91–93. For an example of a similar image on an Attic red-figure vase, see cat. no. 70.

29 According to Hedreen (1994), nymphs are the mythological members of the Dionysiac *thiasos*, whereas maenads are mortal women induced into mania by Dionysus. For more bibliography, see cat. no. 35.

30 Veyne (1998, 102) remarks on the idyllic quality of this vignette in the Villa frieze, calling it a "Midsummer Night's Dream." The proliferation of wine imagery on this vase draws attention to its relative absence on the Villa of the Mysteries frieze, although the Villa itself was involved in the viticultural industry of Campania, for which see ch. 3 by D. Wilburn in this volume.

31 Sauron 1998, 59–72.

32 See, for example, an Apulian calyx krater by the Hippolyte Painter in Basel (Antiken-museum BS 468; Trendall 1989, fig. 194; Trendall and Cambitoglou 1978–82, 2:18/13) and an Apulian pelike by the Salting Painter in London (Victoria and Albert Museum 2493-1910; Trendall 1989, fig. 145; Trendall and Cambitoglou 1978–82, 1:15/6).

33 See chs. 6 by D. Wilburn and 11 by B. Longfellow in this volume; also ch. 7 by M. Swetnam-Burland.

34 Bieber 1928, 313; Brendel (1980, 119) follows suit.

35 Christie's New York, *Ancient Greek Vases Formerly in the Collection of Dr. Elie Borowski*, sale 9448, June 12, 2000, lot 126; Leipen et al. 1984, 25–26, no. 19.

36 See Oakley and Sinos 1993, *passim*.

37 Paestum, Museo Archeologico, 20296, 340–330 BC, from tomb 13, attributed to the Aphrodite Painter (Trendall 1987, 2/965, pl. 147).

38 Paestum, Museo Archeologico, 4807, from C. Gaudo, mid-fourth century (Trendall 1987, 2/158, pl. 68,d).

39 The exact nature of this object is not known. See Trendall (1987, 14) for a discussion of the scant scholarship. He suggests that they are probably stacks of cakes.

40 Trendall (1987, 119) suggests that the three figures are Aphrodite, Eros, and Peitho (the personification of persuasion).

41 Brendel 1980, 92.

42 Brendel 1980, 92.

43 Beard 1991, 20.

44 Beard 1991, 21.

45 See ch. 5 by C. Hammer and ch. 8 by E. de Grummand in this volume for discussions of the Metropolitan Museum inscription and its relevance for understanding the imagery of the Bacchic cult.

46 Palermo, Museo Archeologico Regionale, GE 4730, from Falcone (Trendall 1967b, 625, no. 1/278, frontispiece; 1989, fig. 440; Houtzager 1963, fig. 32).

47 Beard 1991, 20.

48 Naples, Museo Archeologico Nazionale, 2411 (82922); Trendall and Cambitoglou 1978–82, 1:2/8.

49 A stalk of giant fennel, as identified by Tzannes 1997, 151.

50 Tzannes 1997, 151.

51 Beard 1991, 23.

52 Beard 1991, 20.

53 Paestum, Museo Archeologico, 26605, by the Aphrodite Painter. Trendall 1987, 2/978, pl. 154 a–c.

54 Although few Centuripe vases have been properly excavated, they probably served a funerary purpose—either as cinerary urns, grave markers, or gifts for the deceased—as noted by both Trendall (1955, 165) and Holloway (1991, 163). For more on this issue, see Reilly 1989 and Seaford 1987.

55 New York, Metropolitan Museum of Art, 53.11.5. See Mayo 1982, cat. 143 and Trendall 1955.

56 Deussen 1971, 139 ff. However, close observation indicates that there are no torches, typically held by members of the procession (including the mother of the groom), in Attic red-figure vase painting, nor does an essential element of the wedding, the groom himself, appear (as seen in Attic red-figure depictions of wedding processions and attested in literary sources; see Oakley and Sinos 1993, *passim*). It is unlikely that the absence of the groom can be attributed to regional variants in the wedding ceremony, as Deussen (1971, 148–49) argues, concluding that the Sicilian wedding must have taken place during the day and that the procession only included the bride.

57 Schmidt 1982, 32.

58 For instance in the pedimental sculpture on the temple of Bacchus in Pompeii, as discussed in ch. 7 by M. Swetnam-Burland in this volume. Also see ch. 11 by B. Longfellow in this volume.

59 For an exploration of the overlapping roles of deities, see Sourvinou-Inwood 1978.

60 Ling 1991, 218 ff.

61 Ling 1991, 103.

62 See Sarup 1993, 54.

63 See Clarke 1991, 99.

64 Along these lines, Veyne (1998, 65) notes, "Initiation was an individual choice; it did not hinder one from venerating other divinities: Plutarch, a Dionysiac initiate, was the priest of Apollo at Delphi. The Greek gods were not 'jealous gods'" (my translation).

65 An observation concerning the frieze made by Clarke 1991, 116. Veyne (1998, 72) astutely observes that, "The mysteries were not explained: they were acted out during the course of the initiation, they were not painted on walls because they were secret: our fresco cannot be the exact image of an initiation" (my translation).

66 Sarup (1993, 54) quotes Jacques Derrida: "No border is guaranteed, inside or out," adding that, "Applied to texts, this finding becomes 'no meaning can be fixed or decided upon.' According to deconstructionists there is nothing other than interpretation. As there is neither an undifferentiated nor a literal bottom or ground, the activity of interpretation is endless."

11 Liber and Venus in the Villa of the Mysteries
Brenda Longfellow

The monumental decoration in Room 5 of the Villa of the Mysteries is typically treated as a self-contained entity or as part of an ensemble with the related paintings in the adjacent Room 4. This essay instead examines the megalographic frieze in Room 5 within the larger Villa context and considers its iconographic and thematic relations to the other extant figural, floral, and faunal paintings scattered throughout the Villa. This approach throws new light on the iconography of the frieze, in that the thematic connections among the paintings throughout the Villa suggest a celebration of Venus and her relationship to Liber.[1] The presence of Venusian themes in the later décor of the Villa indicates that subsequent occupants perpetuated the first owners' tastes and that the megalographic frieze provided an ongoing source of inspiration up until the time of the Villa's burial in AD 79.

On the east wall of Room 5, directly opposite the main entrance, is the centerpiece of the monumental frieze. The god Liber, identified by his thyrsus, reclines against a heavily draped seated female figure. The woman has been interpreted variously as Ariadne (Libera), the wife of Dionysus (Liber);[2] Semele, the mother of Dionysus;[3] and Venus, who is closely associated with Liber in Pompeii.[4] The identity of this figure is generally believed to be key to understanding the content of the frieze itself. In my view it is important even beyond that: the woman casts light on the iconographic and thematic relation between the megalographic frieze and the rest of the wall paintings in the Villa. Iconographic evidence from the Villa of the Mysteries and from other megalographic paintings in Campania suggests that the god's companion is Venus and that allusions to both Venus and Liber run throughout the known figural paintings from the Villa of the Mysteries.

Literary sources record that by the fourth century AD, Venus was worshiped in close connection with Liber and often replaced Libera (Ariadne) as his divine consort.[5] Archaeological remains, however, indicate that the Italic coupling of Venus and the god of wine was well established in Pompeii during the Republican period, as the most explicit visual evidence for the Campanian connection between Liber and Venus comes from the Hellenistic pediment of Sant'Abbondio, an extramural Pompeian temple. Liber, recognizable by the panther at his side, and Venus, recognizable by her accompanying swan and Cupid, share the pedimental space equally, suggesting that the two deities likewise shared the Pompeian temple.[6]

The Pompeian connection between Liber and Venus exemplified in the Sant'Abbondio pedimental relief may well be echoed in Room 5 of the Villa of the Mysteries. Here, as U. Pappalardo was the first to point out,[7] one of the strongest visual indicators of the presence of Venus is found in the small vegetal frieze located in the orthostat above the main frieze zone (fig. 11.1). This frieze, which originally extended around the entire room, consists of a scene of acanthus calyces that emit ivy clusters and an occasional pomegranate. Amidst the vegetation are various animals, including rabbits, dogs, birds, butterflies, grasshoppers, and lizards. The birds and butterflies are often associated with Liber, while

Fig. 11.1. Line drawing of the small frieze located above the megalographic painting in Room 5 of the Villa of the Mysteries, detail from north wall. Adapted from Pappalardo 1982a, fig. 2.

the rabbits are linked with Venus as symbols of sexual arousal and procreation.[8] Cupids also inhabit the frieze, and many carry implements of Liber's cult, such as wine vessels, tympana, and double flutes, while a few carry torches and *cistae mysticae*. In addition, one of the Cupids carries an incense burner in the shape of a temple (thymiaterion), an object often associated with Venus.[9] The prominence of references to Liber and Venus in this vegetal frieze, which culminates above the heads of the divine couple, may indicate that the female figure across whose lap Liber reclines is to be read as Venus.

Pappalardo, a strong proponent of the identification of the divine companion as Venus, argues that this frieze of Cupids in the orthostat zone verifies Pompeian interest in both gods and suggests that the megalographic frieze belonged to a priestess of Venus Pompeiana. Although his attempt to connect the Villa to a specific patron has been justifiably criticized, his attention to the details in the orthostat frieze is of crucial importance for identifying the companion of Liber and understanding the strong Venusian iconography of the megalographic frieze.[10] This idea can be taken further, for, although Pappalardo considers the frieze of Cupids sufficient evidence for identifying the god's companion as Venus, numerous other examples of Venusian imagery can be cited, both in the megalographic frieze itself and throughout the Villa.

Within Room 5 itself, in addition to the vegetal frieze, the toiletry scene on the south wall (fig. 1.4; group G) emphasizes the thematic presence of Venus in the décor. Often associated with the bridal toilette, this scene consists of a woman seated on a chair and resting her feet on a podium while dressing her hair, a pose with Venusian connotations, especially in the Campanian context.[11] This scene is similar to the megalographic panel paintings decorating Room M in the House of the Prince of Naples (c. 27 BC–AD 37) in which Venus figures prominently (fig. 11.2). In the House of the Prince of Naples, each of the three walls of Room M contains a central panel set off by elaborate frames from the surrounding Third Style fantastic architecture. The panel on the west wall portrays a large-scale nude Venus standing on a small segment of ground and raising her arms. She wears necklaces, bracelets, and anklets and holds up a lock of her hair. This pose is comparable to the one in the toilette scene at the Villa of the Mysteries,[12] where the seated woman holds her hair in a similar fashion, signaling to the viewer an association with Venus. The Venusian content of the two toilette scenes is underscored by the presence of Cupids. The central panel on the east wall at the House of the Prince of Naples contains a small rectangular panel representing two Cupids, one of whom is retrieving an object from a *cista* while the other gazes at himself in a mirror. The iconography of this imagery relates to the figure of Venus on the opposite wall of Room M.[13]

At the Villa of the Mysteries, two Cupids are more fully integrated into the toilette scene. Here, both Cupids stand on podia: the one to the right of the seated woman leans on a pillar as he gazes at her, and the one to the left of the woman holds up a mirror to reflect her image, an

117

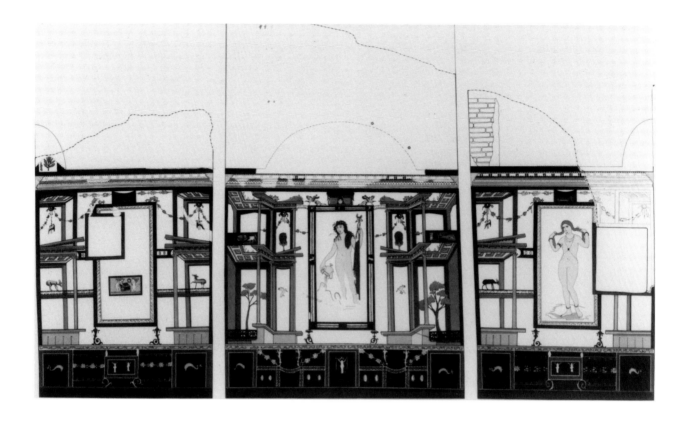

Fig. 11.2. Line drawing of Room M of the Pompeian House of the Prince of Naples, 27 BC–AD 37. After Strocka 1984, fig. 106–8.

accessory also used by one of the Cupids in the House of the Prince of Naples. In addition to the presence of Cupids, the scene of a seated woman with attendants indicates a Venusian content. This image is one commonly used in South Italian vase painting to represent both brides and Aphrodite, and sometimes the identification of such seated figures on vase paintings as women or goddesses is ambiguous for the modern viewer.[14] On such vases, if the woman is not Venus herself, then she can be identified as a mortal partaking of the realm of Venus. The representation of the seated woman with attendants on the Villa of the Mysteries frieze can be understood as functioning in a manner similar to such ubiquitous South Italian images, as it portrays a presumably mortal woman in the guise of Venus Anadyomene. At the Villa of the Mysteries, the strong identification of the bride with Venus further suggests that the multiple readings of the companion of Liber in the central composition of the frieze were probably intended to invoke Venus.

Additional evidence from the House of the Prince of Naples strengthens the possibility that Liber's companion in the Villa of the Mysteries is Venus herself. In Room M, the scenes of Venus dressing her hair and of two Cupids flank a third scene located on the south wall (fig. 11.2). Here the central frame encloses the nude figure of a youthful Liber who wears a purple cloak draped over his left shoulder. He holds a thyrsus in his left hand, and with his right he pours liquid—presumably wine—from a kantharos or rhyton onto the ground where a panther once stood.[15] This deliberate pairing of Venus and Liber and the similar use of imagery in the megalographic paintings at the House of the Prince of Naples suggest that Venus is also Liber's companion in Room 5 of the Villa of the Mysteries.

118

Fig. 11.3. Line drawing of the frieze in Room
H of the Villa of Publius Fannius Synistor at
Boscoreale, c. 40 BC. After Little 1964, pl. 25.

Fig. 11.4. Satyr or pan located on the north
wall above the frieze in Room H of the Villa of
Publius Fannius Synistor at Boscoreale, c. 40
BC. After Lehmann 1955, fig. 23.

VILLA OF PUBLIUS FANNIUS SYNISTOR AT BOSCOREALE

The figures of Venus and Liber appear also to dominate the megalo-
graphic frieze at the Villa of P. Fannius Synistor at Boscoreale (fig.
11.3).[16] In Room H, virtually life-size figures are set within a Corinthian
colonnade and arranged on a narrow ledge. Above the main frieze is a
painted entablature, which has been destroyed except for two masks, a
satyr (or Pan) on the architrave over the center of the entrance (fig. 11.4)
and a bearded Silenus on the architrave over the center of the rear, or
north, wall.[17] The Silenus hangs over the only scene in the room that
illusionistically opens up the wall so that the painted figures appear to be
located in the open air among buildings.[18] This illusionistic scene
portrays Venus, now missing most of her upper body, dressed in a yellow
mantle lined with purple, standing with her right foot propped on a

119

block of stone and a small Cupid perched on her raised knee. This Cupid is about to hurl a dart or arrow at Psyche, who is flanked by two fishing Cupids. Psyche stands in front of a tholos located on the right side of the scene.[19] On the left side of the scene is a second temple, which is square and has caryatid columns. The scene originally to the right of the Venus panel depicted the Three Graces, whom Pausanias describes as the deities most closely related to Aphrodite (Venus).[20]

According to excavation notes, the panel originally to the left of the central scene of Venus portrayed a youthful Dionysus (Liber) with a thyrsus propped against his left leg as he reclined across the lap of a heavily draped female companion. His right foot was bare and his shoe lay abandoned in front of the stone block that held his companion. This image, then, was practically identical to the central image of Liber with a female companion on the back wall of the large-scale frieze in Room 5 at the Villa of the Mysteries, suggesting that the same companion is portrayed in both scenes.[21] While it may seem odd that Venus would appear twice on the same wall at Boscoreale, it is possible that the various aspects of Venus are being portrayed, as in the Villa of the Mysteries frieze, where Venusian elements are present in both the orthostat frieze and the bridal adornment scene. Furthermore, the strong presence of Venus on this wall at Boscoreale does not preclude the possibility that the companion of Liber was a multivalent image for the visitor to Boscoreale—just as the companion of Liber may have been for a visitor to the Villa of the Mysteries—and thus perhaps understood not only as an image of Venus as herself but also as an image of Venus as Ariadne/Libera or even as a mortal woman in the guise of Venus. Lehmann suggests that the juxtaposition of the scene of Liber and his companion at Boscoreale with the scenes of Venus and the Three Graces may be explained by Servius's comment that the Three Graces are the daughters of Aphrodite and Dionysus.[22] Thus, not only may Venus and Liber both be physically present in the panels, but also they would serve thematically to link the other deities portrayed on this wall.

Roger Ling believes that these three scenes at Boscoreale were not intended to be read as a unit but instead are simply close copies of Greek prototypes put together from different sources.[23] The preponderance of the evidence, however, favors reading these three images as a cohesive unit: the literary sources point out the familial connections among Venus, Liber, and the Three Graces,[24] and the location of Venus directly beneath the Silenus in the architrave suggests that the visual connection between the scenes of Venus and Liber on this wall was deliberate. Thus, I would agree with Lehmann's assessment that the Roman viewer would probably have related these scenes to each other. The possibility of a connected reading of these images as "one indivisible whole" increases in light of the compositional norms of Pompeian wall painting. As Lehmann argues, "the independent, framed pictures set in a loose association or juxtaposition within a given room characteristic of the Third and Fourth Styles of Pompeian painting did not appear until relatively late in the Second Style, until the time of the House of Livia or the Farnesina, for example."[25] Many iconographic and thematic elements in each of the megalographic paintings in the villa at Boscoreale, the House of the Prince of Naples, and the Villa of the Mysteries are closely parallel. Most conspicuous among these elements are the recurring figure of Liber and the repeated references to Venus and her retinue.

The visual and iconographic similarities among the images of Liber and Venus in the megalographic wall paintings of the three Campanian residences discussed above seem more than mere coincidence. These decorative correspondences strongly suggest that these paintings had similar purposes in the overall decorative schemes of each of the dwellings. This impression is borne out by similarities in the placement of the three megalographs within their respective residences.[26] Taken together, the decorative and locational similarities suggest that in each case an effort was made to coordinate the decorative schemes within each of these domestic spaces and that the monumental paintings were chosen specifically for their intended visual effect, taking into consideration the overall decorative and spatial configuration of each structure.[27] Rather than standing apart from the smaller figural paintings scattered throughout the residences, the megalographic paintings may have influenced the iconography of the painted décor throughout these dwellings.

In the Villa of the Mysteries, thematic allusions to Venus and Liber occur throughout the Villa. Foremost among these are those in Room 4 (fig. 11.5), adjacent to and contemporary with Room 5. As Room 4 is connected to Room 5 by a doorway and as Room 4 is the only other room in the Villa with monumental figures, albeit of a much smaller scale, Room 4 seems to form a suite with Room 5. The painted decoration of Room 4 represents two architectural levels separated by a molded cornice. On the south wall, the bottom architectural level is embellished with faux marble revetments and the intercolumniations of the top level are enlivened with vessels of a variety of shapes.

In the two alcoves of Room 4, the faux marble revetment decorating most of the south wall is replaced on the east, north, and the rest of the south wall by shallow friezes supporting figures that stand against red backgrounds. The statuesque figures include Liber leaning on a satyr, a dancing maenad, a dancing satyr, Silenus, and a woman who perhaps is a priestess. Unlike the contemporary frieze in the adjoining Room 5, these

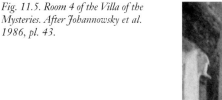

Fig. 11.5. Room 4 of the Villa of the Mysteries. After Johannowsky et al. 1986, pl. 43.

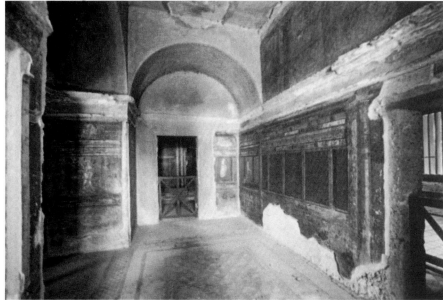

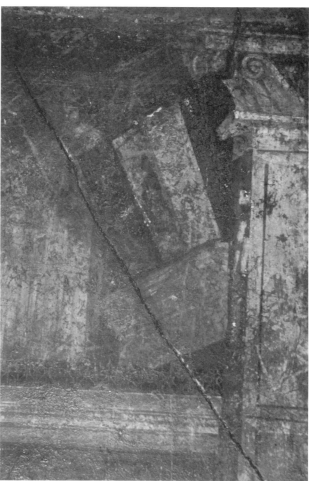

Fig. 11.6 (left). "Priestess" in Room 4 of the Villa of the Mysteries. Photo: B. Longfellow.

Fig. 11.7 (right). Mirror located above the "priestess" in Room 4 of the Villa of the Mysteries. Photo: B. Longfellow.

figures stand isolated within their own panels and do not appear to narrate a story or relate to one another other than in terms of their cultic content. Most of these figures can be directly linked to Liber and a few to Venus. For instance, the "priestess" in Room 4 stands on the east wall to the right of the entrance into Room 3 (fig. 11.6). Her garment has fallen off her right shoulder, alluding to her sexuality and indicating that she is either a Bacchante and/or associated with Venus. Above her is an architectural vista, and in the right-hand corner of this vista is a small, rectangular compact mirror (fig. 11.7).[28] The mirror rests on a painted cornice and is open and tilted so that the reflection of a red-skinned figure is partially visible. Standing on the threshold between Room 4 and Room 5, a viewer can see this mirror at the same time as the mirror in the bridal adornment scene in Room 5. Held by a Cupid, the square compact mirror in Room 5 is likewise open and reflects the head of the seated woman. Mirrors are closely associated with the realm of Venus, and the placement of the only painted images of mirrors in the Villa so that they are simultaneously visible seems to indicate that the two images were deliberately linked.

Allusions to Venus and Liber also occur in the other second stories of the alcoves. An architectural vista similar to that above the "priestess" opens up the south wall above the dancing satyr. Here two masks resting on a cornice associate the satyr below with Liber, who in his Dionysiac guise is the god of theatrical performance. Above the figures on the north wall instead of architectural vistas there are painted pinakes. The two

122

surviving ones portray a woman offering cakes to Liber and a man offering a pig to the god Priapus, the parents of whom are Aphrodite (Venus) and Dionysus (Liber).[29] Contemporary with and adjacent to Room 5, then, the wall paintings throughout Room 4 demonstrate that the realms of Venus and Liber are important and interrelated for the mid-first-century BC patron of the Villa and/or the designer of the wall paintings.

Other references to Venus and Liber in the Villa date to the same phase of the Villa as the wall paintings in Rooms 4 and 5. Of the extant Second Style wall paintings, most portray architectural vistas, and of these, several include figural, floral, and faunal elements. The architectural vistas on the side walls of Room 6, for instance, shift from regularly spaced columns overlying marble panels to a colonnade of black, dark yellow, and porphyry orthostats festooned with garlands consisting solely of ivy (fig. 11.8). During both the Hellenistic and Roman periods, various floral and vegetal motifs were associated with deities.[30] Ivy was particularly associated with Liber, and the presence of ivy as the only nonarchitectural embellishment in Room 6 must have signaled this association. In addition, the ivy in Room 6 recalls both the vegetal frieze in Room 5 and the ivy wreaths worn by at least five figures in the monumental frieze and by the "priestess" in Room 4.

Ivy also occurs in the Third Style decoration of Room 2 (fig. 11.9), which postdates the megalographic frieze of Room 5. Here, in each

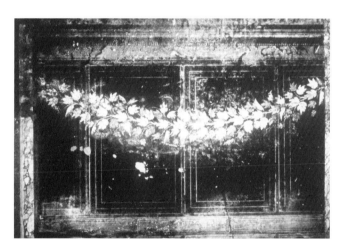

Fig. 11.8. Ivy in Room 6 of the Villa of the Mysteries. After Maiuri 1960, fig. 61.

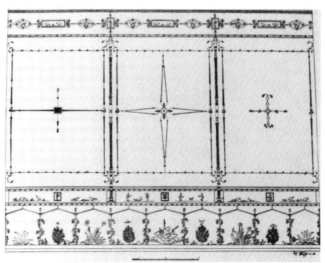

Fig. 11.9. Line drawing of the Third Style decoration in Room 2 of the Villa of the Mysteries. After Maiuri 1947, fig. 86.

123

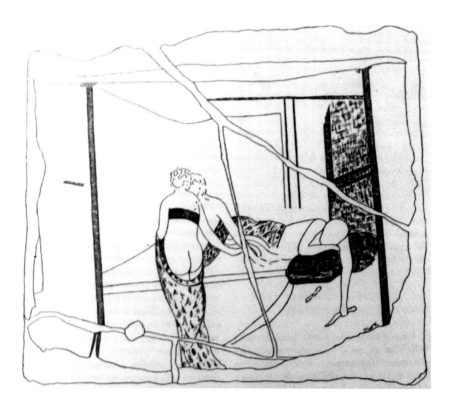

Fig. 11.10. Line drawing of a pinax in Room 32 of the Villa of the Mysteries. After Maiuri 1947, fig. 89.

section of the dado, ivy climbs up fanciful slender columns alongside reeds, poppies, and a central acanthus calyx, all of which seem to symbolize regeneration. Indeed, the individual vegetal motifs refer to divinities who control earthly wealth and fertility, Liber being one of the most important among them.[31] The poppy is an attribute of Ceres, but it is also associated with Aphrodite, the Seasons, and Cybele.[32] The acanthus is an Apolline symbol of renewal, while reeds are symbols of both fertility and the proverbially fertile land of Egypt.[33]

The fauna found among the vegetation of Room 2 and throughout the Villa of the Mysteries may also serve to signify the manifold powers of the fertility deities, including, but not limited to, Liber. The fauna among the plants in Room 2 consist of birds and butterflies, both of which are found in the acanthus frieze in Room 5 and are often associated with Dionysus in the Hellenistic world.[34] The egyptianizing frieze in the upper portion of the wall of Room 2 consists of birds, Egyptians, cats, and griffins,[35] the latter of which are associated with Dionysus and his conquering of the East.[36]

In addition to the egyptianizing frieze in Room 2, there is also one above the colonnade in the atrium. This frieze shows the scenery of the Nile valley in a continuous horizonal format, with Egyptian buildings and palm trees set amid a broad expanse of water.[37] The connections between Dionysus and the East make the egyptianizing elements of both the atrium and Room 2 an interesting study in the longevity of references to this god in the Villa of the Mysteries. For the atrium frieze was painted no later than the megalographe, while the Third Style decoration of Room 2 was painted in a later decorative phase. The continued use of Egyptian motifs over a long period of time suggests the owners of the Villa were interested in maintaining the same thematic elements in their wall paintings. Thus, the multiple inclusions of Dionysiac imagery in the Second Style decoration of the atrium and the Third Style decoration of

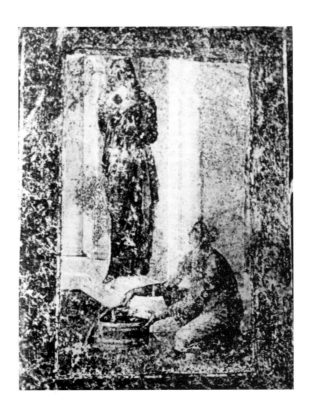

Fig. 11.11. Pinax in Room 32 of the Villa of the Mysteries. After Maiuri 1947, fig. 88.

Room 2 confirm that associations with Dionysus (Liber) were important thematic elements not only in the Second Style paintings but also in paintings added during later decorating phases of the Villa.[38]

The same can be said of Venus. The few known paintings from the rooms around the peristyle contain references to both Liber and Venus. Room 32, the only room in the public part of the house whose figural wall paintings remain *in situ*, is located off the peristyle and next to the vestibule. Its red Third Style paintings include many small panels decorated with figures of various genres and sizes, including pinakes, three of which are extant.

The continued meaning and value of the megalographic frieze and its Venusian imagery for the owners and visitors are highlighted in at least one of these pinakes. The extant pinax on the southern wall depicts what Maiuri calls a scene of *convivio* (fig. 11.10). Here a man sprawls on a couch in the deep sleep of exhaustion. He cradles his head in his right arm, and his left arm hangs off the couch, clutching an unidentifiable object. Two women are also present. One stands with her back to the viewer in front of an apparently naked woman who sits on the bed. The standing woman wears a chest band and drapery that seductively frames her buttocks. Both women reach toward the sleeping man, investing the scene with erotic tension. This image of pleasure in the realm of Venus may have been echoed in the ambulatory of the peristyle directly opposite Room 32, where Maiuri recorded a now-lost scene of Helen and Paris.[39]

Alongside the references to Venus and Liber are other types of references to the themes and iconography of the megalographic frieze, providing tantalizing evidence that the multivalency of the frieze was much more encompassing for the ancient viewer than the modern one can ever reconstruct. One example of the numerous layers of viewing in this residence comes from the extant panel painting from the western wall of Room 32 (fig. 11.11). This pinax consists of a woman kneeling

125

and opening a *cista mystica*, revealing the snake contained within while looking at a woman standing above her. The standing woman is positioned between columns suggestive of a public, presumably religious, building. The standing woman wears a purple chiton and covers her head with a yellow mantle, a color combination worn by several of the women in the megalographic frieze.[40] In addition, the kneeling woman in the pinax closely resembles the one in the megalographic frieze in Room 5 who is unveiling the object in the liknon (group E, figure 17). The woman in Room 32 provides one of the most direct references in the known paintings to the megalographic frieze.

In addition to explicit iconographic and thematic links to Room 5, the extant pinakes in Room 32 also can be obliquely linked iconographically to Room 5 by references to paintings in other rooms of the Villa. For instance, the pinax on the northern wall of Room 32 is relatively small and contains the winged head of Medusa on a red background. This Medusa can be linked to another Medusa that is perched in the architrave of the ressaults of Room 16,[41] a room located off the atrium and toward the back of the house. Other decoration in Room 16 includes a small frieze of figures in the larger architrave, tiny bearded heads in the composite capitals, and red silhouettes dancing along the arch.[42] The only other figural friezes and bearded and dancing figures in the Villa are found in Rooms 4 and 5. The iconographic connections between Room 32 and Room 16, and between Room 16 and Rooms 4 and 5, indicate that at the time of the eruption, the decorative and thematic elements in the Villa of the Mysteries may have been organized around and/or inspired by the carefully preserved monumental frieze in Room 5.

The only extant figural scenes from the rooms around the peristyle make reference to decoration in the more private part of the Villa, and specifically to the monumental frieze in Room 5. Such references as those in Room 32 may have acted as "teasers," as they hint at the overarching themes of the Villa decoration that can only be ascertained by those visitors privileged enough to visit the megalographic frieze. Although subsidiary themes are presumably also embedded in these paintings, the dominant iconographic themes running throughout the floral, faunal, and figural paintings in the Villa of the Mysteries emphasize Venus and Liber, and especially the various forms of fertility associated with each.

In the local context of Pompeii, a city whose patroness was Venus Pompeiana, it is not surprising that the owners of a wine-producing villa would choose to celebrate the presence of both Venus and Liber in their household. The prevalence of the Venusian themes throughout the Villa by no means limits the multivalency of the powerful imagery of the frieze itself, for either the Roman or the modern viewer. But it does suggest that it is important to consider the frieze within its spatial and decorative context and to attempt to understand the effect these contexts would have had on the ancient viewer.

1 See ch. 2 by D. Wilburn in this volume for the appropriateness of the name Liber for this god in Campania, rather than Bacchus, Dionysus, or Fufluns.

2 See Bieber 1928; Toynbee 1929; Bruhl 1953; Herbig 1958; Maiuri 1960; Lehmann 1962; Zuntz 1963; Little 1972; Brendel 1980; and Kuttner 1999, 108.

3 See Boyancé 1965–66; Kerényi 1976; and Sauron 1998.

4 See Pugliese Carratelli and Elia 1979, 480 and Pappalardo 1982a.

5 Castriota 1995, 76, 89. The central Italians called the consort of Dionysus (Liber) Libera rather than Ariadne (Bruhl 1953, 120, 216, 219). For the identity of Libera with Venus, see August. *De civ. D.* 6.9, 7.2–3. On Venus and Dionysus or Liber in Campania, see Schilling 1954.

6 For more information on Sant'Abbondio, see ch. 7 by M. Swetnam-Burland in this volume. Outside of Campania, the prevalence of this Italic coupling is likewise evidenced by the Etruscan tomb pediment from Vulci now in the Villa Giulia, where Fufluns holds a thyrsus and is accompanied by his panther and Turan/Venus is accompanied by a Cupid and a swan.

7 Pappalardo 1982a, 251–58.

8 Pappalardo 1982a, 257.

9 Castriota 1995, 53.

10 Kockel (1986) argues that a major problem with this publication is that Pappalardo associates a certain Istacidia Rufilla, an Augustan priestess of Venus, with the last owner of the Villa, Istacidius Zosimus. In doing so, Pappalardo draws into question the chronological basis for his theory, as the frieze dates earlier than both Istacidia Rufilla and Istacidius Zosimus.

11 Kuttner 1999, 101. For information on the long history of this bridal imagery in the regions of Southern Italy and Sicily, see ch. 10 by S. Kirk in this volume.

12 There are only two other known Campanian paintings of a nude Venus Anadyomene, or "Venus dressing her hair." One, now destroyed, is from Pompeii (VII.15.3), and the other is from Herculaneum and now in the Naples Museum. Three other Campanian paintings also depict Venus as naked but with her right hand holding her hair and her left hand holding a mirror. These examples come from Pompeii (I.13.16; VI.5.3) and one from an unknown house in Pompeii that is now in the Naples Museum (Strocka 1984, 45).

13 A niche cuts into the panel with the Cupids, recalling the niche from Pompeian house I.11.1, which portrays a youthful Dionysus holding a thyrsus in his left hand and pouring wine over a panther with his right. In this scene, he is accompanied by a nude woman, presumably Venus.

14 For an exploration of the ambiguous nature of these images, see ch. 10 by S. Kirk in this volume.

15 For an analysis of when and where this portrayal of Liber is used in Pompeii, see ch. 7 by M. Swetnam-Burland in this volume. The bronze statuette of Liber from the Verzar collection in this exhibition (cat. no. 105) provides one example of the Pompeian portrayal of Liber.

16 Like the iconography of the frieze at the Villa of the Mysteries, the iconography at Boscoreale has fostered debate over its meaning and interpretation. It is important to note that in the uncertainty surrounding the iconography of the room, the only scenes that have *not* been hotly debated are the three scenes on the north wall, which consist of Liber (although his companion is open to interpretation), Venus, and the Three Graces.

17 P. Lehmann (1953, 27–28) calls this room the "Hall of Aphrodite."

18 The rear wall was so badly damaged that only one of its major panels, the central field, could be removed to the National Museum in Naples; the other two have faded away and now are known only from notes made by Antonio Sogliano during excavation (Lehmann 1953, 28).

19 Andreae 1975, 72.

20 Paus. 6.24.7.

21 In both villas, the heavy drapery worn by Liber's companion is in keeping with her identity as Venus in Pompeii. For instance, a fully clothed, heavily draped Venus is the companion of Mars in the tablinum of the House of M. Lucretius Fronto, and another heavily draped Venus is scolding a Cupid in the House of Punished Love. Lehmann (1953, 38) notes that such portrayals of Venus are common throughout Italy and Greece. "The overwhelming majority of ancient representations of Aphrodite and Adonis show the goddess as a heavily draped woman and her lover as a nude young man. Again and again, they appear together in this guise, on Roman sarcophagi, on Etruscan mirrors, in Pompeian paintings, on Greek vases, on miscellaneous minor objects."

22 Servius on the *Aeneid* 1.720; Lehmann 1953, 68.

23 Ling 1991, 105–6.

24 See Paus. 6.24.7, Servius on the *Aeneid* 1.720. Lehmann (1953, 55) points to an explicit connection between the two deities in the Orphic Hymn to Aphrodite: "the One worshipped with Dionysos . . . Mother of the Erotes . . . grace-giving Lady."

25 Lehmann (1953, 37). I believe that the three scenes on the north wall should be used as a key to what is happening on the other two walls of the room for the following three reasons: (1) the figures on the north wall are iconographically recognizable; (2) rooms in this time period typically relate scenes to one another; and (3) the other known megalographic paintings tend decidedly to link various scenes within a room to one another.

In addition, Lehmann observed that the possibility that the patron and/or painter was making a deliberate connection between the various panels on the three walls is reinforced by the three pinakes centered over each of the three large-scale scenes on the back wall, as each of the pinakes is stylistically and visually related to other monumental scenes in the room. The pinax above Liber and his companion depicts a round shield flanked by a seated and standing woman (cat. no. 100), echoing the panel located in the central intercolumniation on the nearby west wall, which portrays a shield between two women seated on rocks. The pinax over the Three Graces portrays a woman seated on a rock with a youth at her side. Once again, the central intercolumniation of the wall nearest to this panel—the east wall—presents a similar scene of a man and a woman. The central pinax located over the scene of Venus and beneath the Silenus head portrays a half-nude seated female figure, probably a depiction of Venus herself and so iconographically related to the back wall (Lehmann 1953, 28–38). Thus, any interpretation must not only relate all three walls to one another but must consider the back wall of primary importance in informing what is represented.

26 See my ch. 4 in this volume for an analysis of the similarities in the room locations and functions of the megalographic paintings in the Villa of the Mysteries and the Villa at Boscoreale.

27 For two different approaches to decorative hierarchies in wall paintings, see Barbet 1985 and Tybout 1993.

28 On the south wall above the dancing satyr is a similar architectural vista. Instead of a mirror, however, two masks are portrayed up in the cornice.

29 Diod. 4.6.

30 Castriota 1995, 55–86.

31 Castriota (1995, 74). Vegetation is used in a similar manner in the Villa of Publius Fannius Synistor at Boscoreale. For instance, Room I originally was decorated with five large red panels on the main part of the walls. Each wall included bucrania hung with garlands, which included figs, grapes, pomegranates, pears, pinecones, acorns, and grain. In the center of each red panel sat a symbol of Dionysus (Liber), including masks, cymbals, and a Silenus (Lehmann 1953, 16–17). Room D, known as the Room of the Musical Instruments, was also festooned with garlands from which various Dionysiac instruments hung, including double flutes, cymbals, castanets, and a Pan pipe (See Lehmann 1953, 14).

32 As a symbol of Demeter/Ceres, the poppies allude both to fertility and to the myth of her nocturnal quest for the lost Persephone, a quest that is central to the Eleusian Mysteries (Castriota 1995, 14–15).

33 According to Castriota, such vegetal motifs may be read as "metonymic symbols capable of evoking the benefits and pacific blessings of the leading fertility deities" (Castriota 1995, 51).

34 Castriota 1995, 52.

35 For a detailed analysis of the decoration in Room 2, see de Vos 1980, 9–12.

36 Castriota 1995, 120.

37 The only other extant decoration in the peristyle is a frieze of weapons located beneath the Nilotic frieze and above the doorframes. Although the relation of weapons to the rest of the Villa decoration is unclear, it is important to note that the atrium of the Villa at Boscoreale also included weapons. Here an intercolumniation in the vestibule contains a great amphora and shield (Lehmann 1953, 7). In addition, both depictions center on shields, calling to mind the solitary woman holding a shield in the megalographic frieze at Boscoreale and the shield in the pinax from the same room (cat. no. 100).

38 Because the famous monumental frieze was carefully preserved for over a century, it may have served as the cornerstone of subsequent decorative phases and even represent the stylistic and thematic culmination of the overall decorative scheme in the Villa. For, if the paintings from different phases of the Villa make reference to the same themes, then the iconographic similarities may suggest that these themes were deliberately preserved over time.

39 The same thematic unity can be established for both the House of the Prince of Naples and the Villa at Boscoreale. For instance, at the House of the Prince of Naples, each wall in Room K is broken up into three large panels. On the north, east, and south walls, two of the three panels depict individual Cupids, and the central panel on the east wall originally portrayed a Cupid standing between a now-lost Venus and her male companion. In the Villa at Boscoreale, Cupids decorate Room O. The use of Venusian imagery not only in the megalographic rooms of each of these households but in other rooms as well suggests that Venus and her domain were of special interest to the inhabitants of these dwellings.

40 Sauron (1998, 74) suggests that these garments identify all the figures who wear them as *dominae*.

41 Ling 1991, 111.

42 Ling 1991, 111.

12 Maria Barosso, Francis Kelsey, and the Modern Representation of an Ancient Masterpiece

Elizabeth de Grummond

The centerpiece of the present exhibition is a series of twentieth-century watercolor panels that represent the famous ancient fresco from the house at Pompeii now known as the Villa of the Mysteries (figs. 12.1–3; color pls. I–III).[1] These invaluable copies of the Pompeian painting were commissioned and brought to the University of Michigan through the resourcefulness and foresight of Francis Willey Kelsey, Professor of Latin Language and Literature at the University of Michigan from 1889 until 1927.[2] Kelsey's accomplishment was only possible, however, through the agency of the artist he hired to create the replica of the ancient painting. This artist, an Italian woman by the name of Maria Barosso, was, as Kelsey realized, uniquely suited to the task of understanding and reproducing an ancient painting for modern scholarly as well as aesthetic purposes.

Born on August 21, 1879, Maria Barosso was a native of Turin in Northern Italy.[3] She was trained as an artist at the prestigious Accademia Albertina in that city, from which she received her degree with honors. For a time after that she was appointed instructor of drawing in the public schools. Moving to Rome, she became the head of drawings for the Super-intendency of Monuments for Rome and Lazio. She spent the remainder of her life as a resident of the city of Rome, living at first with her mother and then, after her mother passed away, residing alone until her own death in 1960. In that time, she adopted the city of Rome as her own, and her legacy as an artist is closely linked with her adopted Roman heritage.[4]

Barosso devoted much of her professional energy to archaeological work in the Roman Forum, the marketplace and city center of ancient Rome. Indeed, she was the first woman to work at the archaeological excavations in the Roman Forum as an employee of the Italian govern-ment.[5] Here she collaborated with the celebrated archaeologist Giacomo Boni, longtime director of excavations in the Roman Forum, and pro-duced numerous archaeological drawings, sketches, and reconstructed views of the remains uncovered in the Forum.[6] In addition to her work recording Boni's findings, Barosso directed her own excavations in the Forum and also wrote numerous reports and communications on archaeo-logical projects that were being carried out in the city of Rome.[7]

Although most of Barosso's art was a direct reflection of her Roman surroundings, she did occasionally work outside her adopted city.[8] She executed a number of drawings and paintings of historical sites in the region around Rome as well as of the Italian city of Assisi.[9] She also worked for brief periods in central Italy[10] and on the island of Crete. Her most substantial undertaking that did not pertain to the city of Rome was, however, her watercolor copy of the paintings in the Villa of the Mysteries at Pompeii (cat. no. 69). Barosso's focus on the city of Rome and on ancient and medieval Italian art and architecture seems to have stemmed from the joy she derived from these subjects and from a strong personal desire to record Italian cultural resources for posterity.[11]

Maria Barosso first met Francis W. Kelsey through Esther B. Van Deman, an archaeologist and graduate of the University of Michigan who frequented Boni's excavations in the Roman Forum in the course of her own research on Roman construction and the House of the Vestal Virgins (Atrium Vestae) in the Forum.[12] Knowing of Kelsey's desire for a

reliable copy of the Pompeian frescoes, Van Deman introduced Kelsey to Barosso in October of 1924 and subsequently served as go-between for artist and patron, impressing on Barosso Kelsey's wish for faithful copies of the paintings, to be used for scholarly purposes in the United States.[13] In late 1924, Kelsey and Barosso began a written correspondence that lasted until Kelsey's death in 1927. Although Kelsey and Barosso were able to meet in person on several occasions, much of their patron-artist relationship developed in writing, and much of their correspondence is now archived at the Bentley Historical Library at the University of Michigan.

Kelsey seems to have had a number of motives for commissioning the Barosso copies of the paintings in the Villa of the Mysteries. The ancient frescoes, which had been uncovered only some fifteen years prior to Kelsey's commission, gained almost instant fame in archaeological and art historical circles and were likewise fairly well known to the general public. Kelsey apparently wished to have faithful copies of the frescoes in order to make them available for study in the United States. Moreover, he saw the copies as a means to ensure the preservation of this famous work, for unlike the frescoes, they would not be imminently subject to deterioration.[14] Furthermore, Kelsey requested that Barosso take note of any technical details that came to her attention in the course of her careful study of the Pompeian paintings and that she produce a manuscript recounting her findings.[15] Barosso, for her part, apparently accepted Kelsey's commission because she appreciated his archaeological concerns for and interest in the Villa of the Mysteries. Although her decision to work with Kelsey put her government job at risk,[16] Barosso devoted herself to the work and focused on making the copies as accurate as possible. Indeed, she "sought, as always in such endeavors, complete faithfulness in form and an objective interpretation, without any preconceived notions as to the appearance of any areas [of the paintings] now ambiguous because of deterioration, and the accentuation of the colors in their proper tones."[17]

Barosso began work for Kelsey in the spring of 1925 by painting a sample copy of one scene from the Villa of the Mysteries fresco to be sent to the University of Michigan.[18] This sample, a full-scale replica of the seated "bride" figure on the south wall of the room (fig. 1.4, group G), was received by Kelsey in Michigan in October of that same year.[19] As Barosso was preparing the sample work, Kelsey lobbied the authorities in charge of overseeing the archaeological remains at Pompeii, asking that the University of Michigan might have copies made of the entire fresco cycle and that Barosso be able to spend the time necessary in the Villa to carry out such work. On June 22, 1925, Kelsey received official permission from the Superintendent of Antiquities at Pompeii, Amedeo Maiuri, to have copies made of the frescoes.[20] Maiuri, however, would only allow the replica to be made at a reduced scale.[21] Furthermore, Kelsey agreed that the watercolors would remain in Italy for one year after their completion, during which time the Italian government would have the right to display and to publish them.[22]

With permission granted, Barosso recommenced work at the Villa of the Mysteries. Although she had already painted a full-scale replica of the scene of the seated "bride" figure on the south wall of the painted room, she had to begin anew, this time creating somewhat less than life-size copies. Before the official permission had been given for her stay at Pompeii, Barosso had worked in Rome, calculating the proportions for a reduced version of the Pompeian frieze.[23] The copies, painted at five-

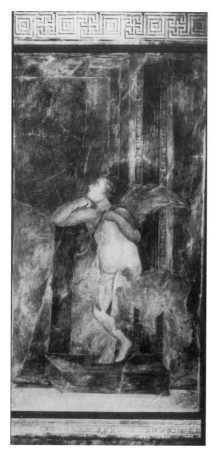

Fig. 12.1. Maria Barosso's watercolor after the Eros figure (fig. 1.4, group H) of the Villa of the Mysteries frieze.

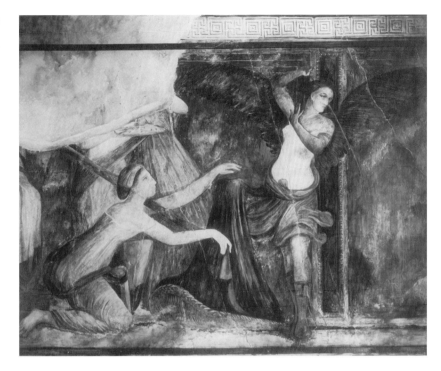

Fig. 12.2. Maria Barosso's watercolor after the unveiling of the phallus and flagellation scene (fig. 1.4, group F) of the Villa of the Mysteries frieze.

sixths of the original size,[24] were made on separate sheets of paper in three registers that were in turn subdivided into smaller panels of manageable size. Once she had relocated to Pompeii, probably in July 1925,[25] Barosso began painting the central register, which consisted of the main figural scene. She saved the less complicated work of copying the upper and lower registers—both decorative borders—for last, not finishing these until her return to Rome the following year.[26] Thus, Barosso first painted the "priestess" on the north wall (group B), the "seated initiate" or matron (group I) flanking the doorway on the west wall, and the Eros figure (group H; fig. 12.1) on the south side of the western doorway.[27] Other sections of the figural portions of the frieze followed: the flagellation and dancing scene (groups E–F; fig. 12.2; color pl. II);[28] the central image of Bacchus on the eastern wall (group D);[29] and the Silenus figure and accompanying fauns, also on the eastern wall (group D; fig. 12.3).[30] After a respite in Rome in the winter of 1925–26, Barosso painted the remaining images on the north wall[31] and, finally, made a reduced-scale copy of the "bride" figure (group G; color pl. III) that she had already replicated in a life-size version.[32]

By the time she completed her watercolors of the Villa of the Mysteries fresco, Barosso had created eighteen[33] panels totaling, in her estimation, over fifty square meters of painting.[34] Spending nearly fifteen months in Pompeii, Barosso worked primarily on site. Her schedule was intense, and, although she clearly relished the project, the magnitude of the task did at times weigh on her. In a letter to Kelsey she remarked that "[The] work [is] unending, every day for the whole day, every day of the week, in that oppressive house, far away and deserted. But the work has turned out splendidly."[35]

Barosso used the finest materials that she could acquire to produce the copies: Winsor & Newton® watercolor paints from England[36] and a paper lined with fine linen canvas, probably from Germany.[37] Barosso chose watercolor as her medium both because this was an art form with which she was familiar and because she felt that only watercolor paints

131

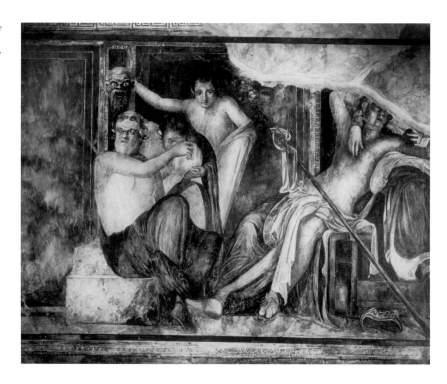

could capture the delicate yet intense colors of the ancient fresco painting.[38] One panel—that depicting the seated matron—was executed on a backing different from the paper-linen canvas (fig. 12.1). Made from a lower quality cardboard, this panel was perhaps painted before Barosso was able to obtain the finer materials.[39]

Barosso based each image on preliminary sketches, and penciled notes and drawings can been seen on her watercolors. The watercolor paint itself was laid down in thick layers, and Barosso seems to have attempted to copy the brushstrokes evident on the Pompeian original. She also carefully imitated in watercolor any corrosion or cracks that could be seen on the ancient fresco. Indeed, her depictions of the fractures in the walls are so well rendered that, without close inspection of the painting, the viewer is easily fooled into believing that the cracks in Barosso's version are real (see, for example, figs. 12.1–3).

Because Barosso's primary goal in creating her version of the fresco cycle in the Villa of the Mysteries was accuracy in copying, a stylistic assessment of Barosso's—rather than the ancient artist's—work is perhaps not appropriate. Nonetheless, Barosso's accomplishments should be framed within the artistic milieu of Italy in the 1920s. During this period, the Fascist government and its leader, Benito Mussolini, encouraged the study and recording—such as that by Maria Barosso—of ancient Roman history, archaeology, and art. Indeed, one archaeologist estimates that, in fourteen years (1924–38) of Fascist-sponsored archaeology in the city of Rome, scholars added more to our knowledge of early imperial Rome than had been gleaned in the entire fourteen previous centuries since the collapse of the Roman empire.[40] Noteworthy projects from this period include the study and excavation of the mausoleum of the first Roman emperor, Augustus, and of the nearby Ara Pacis, or Altar of Peace, which was built by Augustus in the last quarter of the first century BC;[41] the rapid excavation of the various fora, or public marketplaces, erected by a succession of Roman emperors;[42] and the installation of an extensive museum display—the Mostra Augustea

della Romanità, or Augustan Exhibit on Roman Values[43]—an initiative dedicated to the greatness of the Roman empire and overseen by Giulio Giglioli, a respected professor of Classical Studies at the University of Rome.[44] Likewise, the years in which Barosso painted her version of the Pompeian frieze predated the period of the Fascists' Axis link with Nazi Germany, a time when art was used deliberately by Fascist governments for strictly propagandistic purposes. Instead, in the 1920s the Fascist Party limited its influence in the contemporary Italian art world to patronage and sponsorship of exhibitions of a wide variety of artists.[45] Thus, artistic tendencies in Italy followed a number of dynamic yet divergent and competing paths. Art of the Futurist style had ended with World War I, largely to be succeeded in the twenties by the more serene work derived from Synthetic Cubism and Metaphysical painting, as well as the various realistic forms devised by the artists of the Novecento group.[46]

In Barosso's case, because her work beyond the archaeological copies is not well known, it is difficult to categorize her artistic production as a whole. That she was seen as a contemporary artist rather than simply a copyist or an archaeological illustrator is suggested by the success of the government-sponsored exhibition of her paintings that took place in November and December of 1926.[47] This show, which was held at the Borghese Gallery at the Villa of Umberto I in Rome (fig. 12.4), was the result of the government's exercising of its one year of rights to Barosso's Villa of the Mysteries materials (fig. 12.5). The exhibition, a showcase of Barosso's work with the Pompeian paintings as the centerpiece, marked

Fig. 12.4. The Galleria Borghese in Rome. Maria Barosso's handwritten remarks along the top margin note that the three central windows on the second floor correspond to the rooms in which her paintings were displayed.

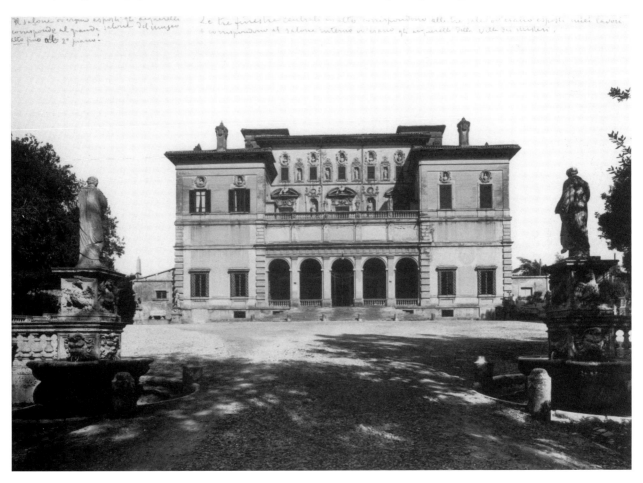

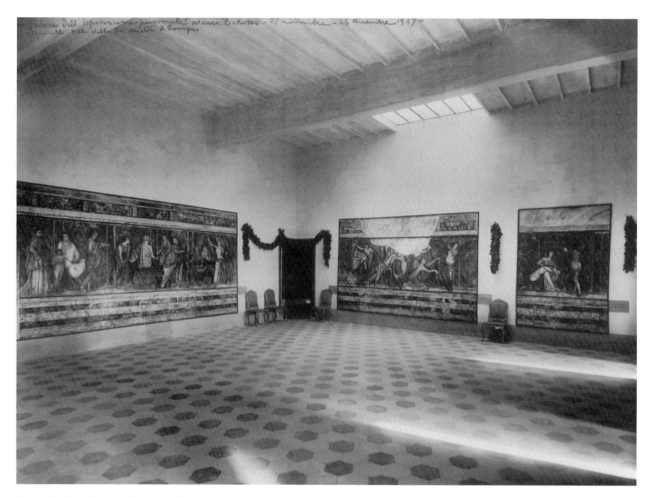

her as the first living artist to be the focus of a show at the Borghese Gallery, a distinction that attracted no little attention at the time. The Villa of the Mysteries paintings were installed on the third floor of the gallery, in an area well lit by a skylight, while a number of Barosso's other paintings and etchings were displayed in a side room. The exhibition was visited by numerous dignitaries, including the king and queen of Italy, as well as many respected scholars. It received a notable amount of press in Italian newspapers.[48] Barosso's achievement was likewise celebrated by the Fascist government.[49]

At the time of the exhibition at the Borghese Gallery, the Villa of the Mysteries copy was not entirely finished: part of the top border of the frieze remained to be painted.[50] In May of 1927—by which time Barosso seems to have completed the project—Francis Kelsey, after a period in the hospital, passed away. At this same time, the Italian government declined, for murky political reasons, to produce the planned monograph of the paintings and of Barosso's observations on the work.[51] The monograph was then offered to a private press, but the project seems never to have reached fruition. The paintings were apparently held by the Italian government until the end of 1927 and subsequently delivered to the University of Michigan at Ann Arbor.[52] Barosso's manuscript of observations on the Villa of the Mysteries paintings does not, however, seem to have reached Ann Arbor.[53]

Kelsey had clearly intended to place Barosso's replica of the Villa of the Mysteries on display at the University of Michigan. His wish,

however, was never fulfilled. The paintings instead remained rolled up and in storage at the University of Michigan's Museum of Archaeology, which now bears Kelsey's name. Since the arrival of the paintings in Ann Arbor, only two panels have ever been exhibited for the public; some have also been used occasionally for teaching purposes at the University. Thus, mounted some seventy years after Kelsey's death, the present exhibition finally achieves Kelsey's purpose in commissioning the production of accurate copies of the ancient frescoes in the Villa of the Mysteries. The images and iconography of the frescoes can be experienced firsthand by students, scholars, and the general public at the University of Michigan in a setting that simulates the Pompeian room. The exhibition likewise offers a testament to the success of Maria Barosso as an artist and as a scholar enamored of antiquity. Barosso's paintings not only provide us with a valuable record of the frescoes; with the present installation, her paintings also serve to increase modern awareness and appreciation of an ancient masterpiece.

1 See cat. no. 69 for further illustrations and a description of the condition of the watercolors as well as the introduction and other essays in this volume for a description of their content. I am grateful to Joan Mickelson for her careful editing of this chapter and for suggesting helpful bibliographic sources on art in Italy of the Fascist period. I am also grateful to Diane Kirkpatrick and Brook Bowman for their thoughtful criticisms. All translations in this chapter are my own. Thanks is, however, owed to Nicola Aravecchia for his assistance in editing Italian translations.

2 For information on other scholarly projects undertaken by Kelsey, see Thomas 1990.

3 For a biographical essay on Barosso, see Margarucci Italiani 1978.

4 Thus, a large collection of Barosso's works is held by the Museo di Roma, a museum devoted to the history of the city of Rome. For an inventory of the Museo di Roma's Barosso paintings, see Margarucci Italiani 1978, 343–47.

5 Margarucci Italiani 1978, 317.

6 For an account of Barosso's introduction to Boni, see the biography of Boni by Tea 1932, 2:156.

7 For example, see Barosso 1940a; 1940b.

8 See Margarucci Italiani 1978, 334 ff.

9 Barosso seems to have had a particular fondness for Assisi and, indeed, sent Kelsey an "artistic calendar" of Assisi—"a work of art in itself" according to Kelsey—at Christmas time in 1925 ("un piccolo calendario artistico"). Maria Barosso to Francis W. Kelsey, 21 December 1925; Francis W. Kelsey to Maria Barosso, 11 January 1926, Archives of the Kelsey Museum of Ancient and Mediaeval Archaeology, Papers of the Kelsey Museum of Ancient and Mediaeval Archaeology and Francis W. Kelsey, Bentley Historical Library, University of Michigan (abbreviated as Papers).

10 "[S]ull'altipiano sannitico" (Margarucci Italiani 1978, 337).

11 Thus, for instance, Margarucci Italiani (1978, 329) reports that Barosso would, on her own time and at her own expense, create images of old buildings in the city of Rome that were being destroyed in the course of urban renewal and that at times, in order to gain the best view of such buildings, Barosso would take the risk of climbing partially demolished and unstable walls.

12 Memorandum no. 16, 1 October to 31 December 1926, Papers. For a biographical account of Van Deman's work in the Roman Forum and in the city of Rome, see Einaudi 1983, 41–47.

13 Francis W. Kelsey diary, 8 October 1924; Esther B. Van Deman to Francis W. Kelsey, 21 October 1924, Papers.

14 Thus Kelsey planned to have the copies on permanent display in a museum at the University of Michigan (Francis W. Kelsey to Maria Barosso, 21 March 1927, Papers). Since Barosso completed her project, the ancient paintings have in fact suffered further damage.

15 Francis W. Kelsey to Maria Barosso, 11 January 1926; Maria Barosso to Francis W. Kelsey, 1 February 1926, Papers.

16 "[Barosso] has refused some very flattering appeals for her work from government

leaders and I trust all way [sic] turn out well in the work for the U. of M., which has an element of danger for her popularity in certain quarters—and important ones, since she is near her next promotion period [as a government employee] and must provoke no criticism." Esther B. Van Deman to Francis W. Kelsey, 8 March 1925, Papers.

17 "Ho cercato, come sempre, in tali lavori, la fedeltà assoluta nella forma e l'interpretazione serena, senza preconcetti di quanto può apparire ora incerto per il deperimento e l'intonazione dei colori nel loro giusto valore" (Maria Barosso to Francis W. Kelsey, 1 February 1926, Papers).

18 Maria Barosso to Francis W. Kelsey, 23 June 1925, Papers.

19 Francis W. Kelsey to Maria Barosso, 16 October 1925, Papers.

20 Amedeo Maiuri to Francis W. Kelsey, 22 June 1925, Papers.

21 Maiuri's concern may be surmised from Barosso's statement that "With regard to the dimensions, in dealing with reproducing a fresco painting on paper with watercolor, I would not have thought that there would be any restrictions, since it is clear that the work will never be thought the original wall painting. I have always made watercolor copies the same size as the original." ("Riguardo alle dimensioni, trattandosi di riprodurre un affresco, su carta con acquarello, non pensavo vi fossero proibizioni, perchè è evidente mai che il lavoro non potrà mai essere creduto l'opera originale eseguito su muro. Sempre ho fatto copie all'acquarello grandi al vero." Maria Barosso to Francis W. Kelsey, 30 April 1925, Papers.) The decision to create less than full-scale copies seems also to have been influenced by the size of paper available for the project (Francis W. Kelsey diary, 23 May 1925, Papers).

22 Francis W. Kelsey to Amedeo Maiuri, 26 May 1925, Papers.

23 Barosso says, "While I am waiting for the official permission to go to Pompeii, I am preparing drawings in proportions slightly less than life size." Barosso's statement suggests that she may have already made sketches of the frieze in the course of her initial visit to the Villa of the Mysteries or perhaps worked from photographs. ("Intanto che attendo il permesso ufficiale per recarmi a Pompeii, preparo dei desegni nelle proporzioni di poco inferiori al vero." Maria Barosso to Francis W. Kelsey, 23 June 1925, Papers.)

24 "One-sixth less than the original." ("1/6 di meno dell'originale." Maria Barosso to Francis W. Kelsey, 22 August 1926, Papers.)

25 By 1 August 1925, Barosso was writing to Kelsey to report that she had transferred to Pompeii and begun work there. (Maria Barosso to Francis W. Kelsey, 1 August 1925, Papers.)

26 Maria Barosso to Francis W. Kelsey, 12 November 1926, Papers.

27 Maria Barosso to Francis W. Kelsey, 1 August 1925, Papers.

28 Maria Barosso to Francis W. Kelsey, 21 September 1925, Papers.

29 Maria Barosso to Francis W. Kelsey, 18 October 1925, Papers.

30 Maria Barosso to Francis W. Kelsey, 15 November 1925, Papers.

31 Maria Barosso to Francis W. Kelsey, 21 March 1926, Papers.

32 Maria Barosso to Francis W. Kelsey, 8 August 1926, Papers.

33 Not including the initial life-size "sample" painting of the "bride" figure.

34 Maria Barosso to Orma F. Butler, 18 September 1927, Papers.

35 "[L]avoro quotidiano incessante per l'intera giornata, in tutti i giorni della settimana, entro quell'opprimente villa, lontana, deserta. Ma il lavoro è riuscito splendido." (Maria Barosso to Francis W. Kelsey, 2 July 1926, Papers).

36 Maria Barosso to Francis W. Kelsey, 18 October 1924, Papers.

37 Maria Barosso to Francis W. Kelsey, 18 October 1924, Papers. Although Barosso states that she is using German paper, the paper is embossed with the logo "Superior Standard Paper," a mark unlikely on German materials of the time (Brook Bowman, personal communication, June 2000).

38 Maria Barosso to Francis W. Kelsey, 18 October 1924, Papers.

39 Brook Bowman, personal communication, June 2000. There is no mention or explanation in Barosso's writings of her use of the lower quality cardboard.

40 MacKendrick 1960, 143.

41 See MacKendrick 1960, 149 ff.

42 This project was undertaken in order to permit the construction of a grand avenue that ran from Mussolini's headquarters in the Palazzo Venezia to the ancient Roman Colosseum. Barosso herself was apparently active in this archaeological campaign (Margarucci 1978, 327).

43 The Italian word *Romanità*—literally "Romanness"—is difficult to translate because it, like its Latin antecedent *Romanitas*, has connotations of Roman imperialism and cultural superiority.

44 This undertaking ultimately resulted in the establishment in Rome of the Museo della Civiltà Romana, or Museum of Roman Civilization, where much of the Fascist exhibition—primarily plaster models of Roman monuments from throughout the Roman empire—can still be viewed today (Bondanella 1987, 189–91).

45 Cannistraro 1989, 150.

46 For an overview of Italian art in this period, see Braun 1989.

47 Memorandum no. 16, 1 October to 31 December 1926, Papers.

48 Memorandum no. 16, 1 October to 31 December 1926, Papers. Additional archival research may further illuminate the reaction of the Italian press to the exhibition.

49 A Fascist newsletter of the period characterized Barosso's Pompeian work as "a superb Fascist victory in the field of art." ("Superba vittoria fascista nel campo dell'Arte," *Roma Fascista*, 4 December 1926, as cited in Memorandum no. 16, 1 October to 31 December 1926, Papers.)

50 A postcard written by Barosso and dated 1 January 1927 indicates that she was still working on the borders of the painting at this time. (Maria Barosso to Francis W. Kelsey, 1 January 1927, Papers.)

51 "The government, owing to some 'dirty politics' will not publish them." (Esther B. Van Deman to Mr. Sanders [?], 18 June 1927, Papers.)

52 A letter written by Barosso in 1927 states that the Italian government would retain the paintings until December of that year. (Maria Barosso to Orma F. Butler, 18 September 1927, Papers.)

53 Kelsey had originally requested that Barosso submit this manuscript to Amedeo Maiuri, the director of the site of Pompeii, presumably in compliance with the agreement that Barosso's materials would remain in the care of the Italian government for one year after their completion. (Francis W. Kelsey diary, 21 August 1926, Papers.) The ultimate fate of the manuscript is at present unknown.

54 See n. 8 of ch. 1 by E. Gazda in this volume.

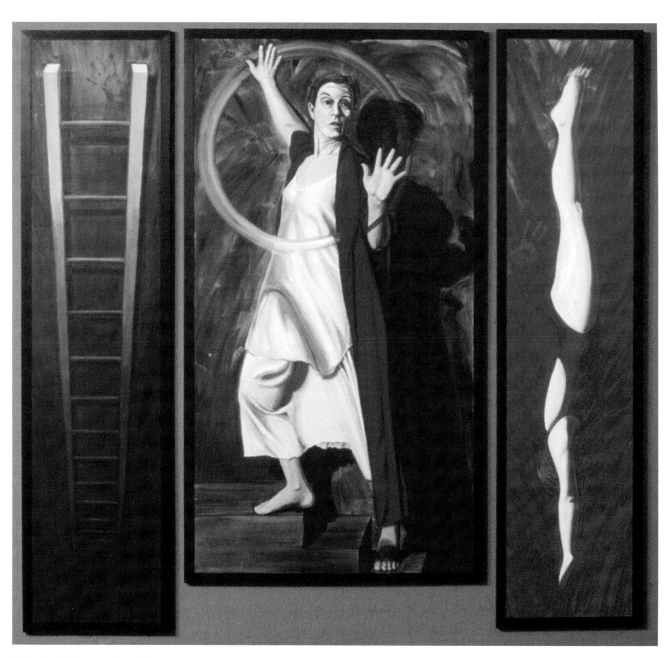

Color plate IV. Patricia Olson, The Descent.

13 Ancient Mysteries, Modern Meanings
Diane Kirkpatrick

Undeniably, the Roman figural frieze that circles the walls of a room in the Villa of the Mysteries near Pompeii haunts the imaginations of many contemporary scholars and artists. What is it about this complex of painted figures that calls so strongly across the centuries to those alive at the transition from the twentieth century to the twenty-first?

Those who know most about the ancient world seem to agree that the scenes in the Roman mural are linked in some way with the "mysteries" or rites connected with a cult of Dionysus. Virtually everybody names the central male figure on the east wall opposite the main room entrance as the god Dionysus, sprawled drunkenly across the lap of a seated female. In part because wall damage has erased the upper part of this female figure, interpreters disagree as to whether she represents Ariadne (Dionysus's bride), Semele (Dionysus's mother), Venus (associated with Dionysus in some mythic versions), the initiate in the Dionysiac rites, or some other woman.

Dionysus himself seems a particularly unknowable god. In scholarly studies describing him, he slides from guise to guise, quality to quality, and even place to place, granted shared identity with numbers of other gods from across the Mediterranean.[1] In the words of Walter Otto, Dionysus was "the god of ecstasy and terror, of wildness and of the most blessed deliverance—the mad god whose appearance sends mankind into madness."[2] As the god is elusive, his mysteries are equally unknowable to the modern viewer. The rites were secret, with initiates sworn to secrecy about details. Yet the haunting quality of the mural seems to intrigue everybody who sees it. Its potency lies partially in the fact that its subject is tantalizingly unclear. As John Clarke says: "The magic of the frieze, both in antiquity and today, lies in its very multivalence."[3]

An Illusionistically painted stone ledge runs round the room at waist level. At its back is a red wall, divided into panels by pilasters containing dark narrow bands. Human and mythic figures occupy the ledge, singly and in groups. The figures are roughly life-size. Although the ledge seems narrow, it miraculously accommodates the different groupings. Some figures are placed directly on the ledge. Others are supported on raised geometric platforms. A few sit on hillocks. The panels and pilasters of the back wall provide a steady spatial "beat" against which the figures, with their varied poses and heights, form a measured, complex, rhythmic chain that draws one around the length of the work. The visual coherence and illusion of the figures is strengthened by the fact that they seem to be modeled by a single light source, from the main entrance in the center of the west wall.[4]

The figures are arranged in a series of tableaux, some overlapping. The female figures vary in age and dress. The nature of some is inconclusive. Are they human or part of the Dionysian entourage? Throughout, the poses seem deliberate, slow-motion and exaggerated, like those in a mimed ritual scene. The faces have quiet, abstracted expressions that seem outside the hurly-burly of everyday life. Absent here are the extreme emotional contortions that Charles Le Brun adapted from late Hellenistic art for the expression of emotion in academic history painting

to assure that details of the narrative could be read by educated viewers through careful attention to the poses and facial expression of the figures.[5]

The actors in the mural in the Villa of the Mysteries do not signal so baldly to us their inner life and their exact role in the story they seem to tell. Western viewing habits urge that we find the meaning here. Yet both our place in history and the content of the mural conspire against finding a definitive answer, and the layered mysteries of the work gain renewed power with each attempt. These qualities feed the contemporary imagination.

At the beginning of the twenty-first century, we have become used to the fact that works of art, like all other things we meet, are interpreted by each of us through the filter of our own matrix of knowledge, experience, and social/cultural background. For us it is axiomatic that in our postmodern age there is no single truth or belief accepted by all. Instead, we find a multitude of truths, beliefs, religions, histories, each with an equal claim to acceptance as correct or right. The speed of life keeps increasing, bringing with it cascades of information and stimuli from the whole world's history and background. Mass media shower us with data and vicarious experience constantly. More and more we have learned to respond to fragments, constructing comprehension from a mosaic of bits and shaping understanding through what Lázsló Moholy-Nagy called "vision in motion," the ability to see things in ever-changing dynamic relationship rather than as static or unchanging.

In the arts, each viewer is expected to "complete" a work of art through her or his perception and interpretation. Gradually, the sketch came to be considered more "alive" than a fully thought-out work of art, because the viewer could experience something of the process of creation. We learned to assemble meaning from Cubist fragmentation, Dada disjunction, Surrealist dream collages, and the conceptual visual montages of Eisenstein. Today, more and more artists require that we be able to decipher a diverse array of references to art and ideas from throughout history.

In 1955, Rudolf Wittkower published a wise essay that outlined the processes we follow in deciphering meaning in the visual arts.[6] Beyond the fact that any act of perception involves interpretation to decode shapes and colors into something with meaning, works of art add layers of symbolic meanings that we must interpret. These include the thing or things that are represented, the theme of the work expressed through symbols whose meanings we must know, and the way the artist has expressed all of this. The combination affects our emotional response or lack of response to an artwork. This response is shaped not only by personal and sociocultural forces but also by any art criticism and aesthetic theory we favor. All of this means that, in the words of Wittkower, "Each generation not only interprets its own meaning into those older symbols to which it is drawn by affinity, but also creates new symbols by using, modifying and transforming those of the past."[7]

Postmodern artists borrow more widely and more personally than ever before. The contemporary viewer has a challenging task. Craig Owens imaginatively identified the strategy favored by today's artists as the use of allegory to construct narrative images that express the multi-layered allusiveness of the modern experience.[8] The six artists in the present exhibition extend these practices to elements of the figural frieze in the Villa of the Mysteries.

Three of the artists find a connection through an interpretation of the

Roman painting as a rite with special meaning to women. C. G. Jung spoke of the collective unconscious through which each of us touches and knows universal symbols or archetypes. It is perhaps not surprising that Jung was interested in the frieze in the Villa of the Mysteries or that some of his women followers, such as Nor Hall, interpreted it as a rite of passage connected with the inner life and growth of women.[9] This reading follows the mural scenes from left to right, beginning on the north wall with the figure of a mature woman in profile, identified as the initiate. Fully dressed with her head cloaked, she steps toward the right, away from a small door that leads to an adjoining bedchamber. She approaches a seated and bare-headed woman (a priestess), who turns her head to watch the approach of the "initiate," at the same time placing one hand protectively on the shoulder of a booted and otherwise naked boy who reads from a scroll. Hall follows the initiate through five to seven further appearances within the mural, each time wearing different clothes and hairdo.

Pat Olson (cat. no. 108) was inspired by Hall's ideas, "In reflecting on the reproductions printed in *Those Women*, I resolved to follow this ritual inner journey myself, by retelling my story as a contemporary woman, using the murals at the Villa of the Mysteries as touchstone and guide."[10] Rather than creating a continuous line of figures and groups as in the Villa frieze, Olson breaks her work into seven groups, six of which are triptychs. In each, she combines direct reference to poses and other details from the Roman wall painting with invented symbols that represent her personal experience. Throughout, Olson is the initiate. Her action takes place on a narrow ledge before a wall reminiscent of the space in the Villa. But Olson's wall and ledge seem constructed of a pink marble, and the more vibrant red of the Pompeian painting has been displaced into the robelike outer garment that the artist wears through-out her *Mysteries*. Most of her figures cast shadows on the back wall, unlike the figures in the Villa paintings, which exist mysteriously in a space that contains the solidly modeled figures yet remains unaffected by the light that illuminates them.

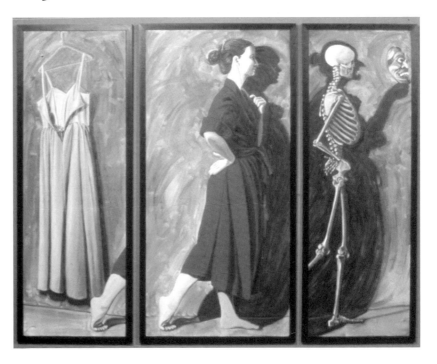

Fig. 13.1. Patricia Olson, The Presentation.

Olson's *Mysteries* begin with *The Presentation* (fig. 13.1), in which she becomes the approaching woman who presents herself to undergo the rite of initiation. The seated woman and the reading boy from Pompeii are not here. "Because the priestly and mythological figures don't resonate with me, I add other elements that do hold meaning." In *The Presentation*'s left panel is "a dress on a hanger representing what I am leaving behind." To the right is "a skeleton that represents the experience that I am approaching."[11] The skeleton reflects Hall's words about the darker sides of the rite, and also Dionysus's connection with the Underworld. At this beginning moment, the three parts of Olson's triptych are equal in height.

The Offering (cat. no. 108) comes next, with Olson adopting the next pose of the Villa initiate who, dressed partly in a purple lower garment, wearing a crown of leaves, and apparently pregnant, carries a plate of cakes toward a group in which two standing women attend a third who sits with her back to the viewer, engaged in what may be ritual cleansing. Olson's initiate carries a birthday cake, rather than the Villa's offering cakes, as a symbol of the newborn self, following an idea of Mircea Eliade that "ritual initiation . . . is the experience of death to the old self, then rebirth of the new."[12] The side panels, shorter than the initiate's central one, hold Olson's grandmothers. The pelvic birthing area of both grandmothers is visible through their clothing, marking their generational creativity, while an exposed fetus replaces the bulge of pregnancy in Olson's initiate, perhaps pointing both to physical and painted offspring.

The third of Olson's *Mysteries* is *The Descent* (color pl. 000), where the initiate distantly echoes the pose of the last figure on the Villa's north wall. The Roman woman's pose is full of contradiction. Her right foot is planted frontally on the stone ledge, yet her left leg and foot are far back, as if she might push off toward her right. Her torso turns toward the right, and her right arm is raised, creating a billowing hood around her upper body. Within the hollow of this space, her head turns sharply toward her left to peer in that direction, although the cloak seems to block what she might see. Her left hand appears outside the left part of her outer garment, upraised with fingers outstretched as if in astonishment or to ward off something. It has been suggested that she is afraid of something she sees, either in the group of Silenus attended by two young satyrs (who are separated from her by the corner but linked by the red panel of the back wall, which wraps around the turn) or by the sight of the winged figure preparing to strike the bare back of the kneeling young woman across the room. Olson finds the Villa figure filled with "sheer terror"[13] and intensifies the body language of herself as initiate to reflect more clearly these strong emotions. This time the initiate's panel is shorter than either of the flanking panels that hold Olson's symbols for the descent into the crucial dark passage through the unknown.

Even without the key to Olson's personal symbols and knowledge of some interpretations of the frescoes in the Villa of the Mysteries, the stately gestures and familiar "props" in these modern *Mysteries* should produce an irresistible urge to probe them for understanding. To paraphrase the words of Jung, when we find ourselves in a world we do not understand, we try to interpret it.[14]

Ruth Weisberg's (cat. no. 111) *Initiation* (fig. 13.2), like Olson's *Mysteries*, reimagines the Villa of the Mysteries painting as a ritual connected with the deep life of contemporary women. Unlike Olson, Weisberg echoes the continuous sequence of figures in the Villa fresco, recreating

it in the form of a scroll. *Initiation* is one of a number of works inspired by the artist's research on the Great Frieze in Pompeii. Barefoot, and dressed in generalized drapery or simple costumes, Weisberg's almost life-size figures assume the poses in the Roman fresco. Her models are herself, her son, her daughter, and their friends. The figures are painted with a delicate touch and elegantly modeled light and shadow. Nothing has the color of full realism. Rather, the figures emerge in shades of browns and grays. They reenact the ancient scenes against an organic, fluid background of abstract watercolor patterning that carries multiple suggestions of landscape, caverns, and inner parts of the human body. The effect heightens the sense that we participate in a vision or dream. As we focus on each group, its figures shift from semitransparency to solid form. Then, when our eye moves on, that group once again drops back into the miasmic whole.

Initiation is made with watercolor and Prismacolor on paper. This medium perfectly suits Weisberg's artistic vision: "I love paper. . . I am interested in elements of transparency and in a layered reality."[15] That layered reality often reaches back to ancient or Renaissance art sources and the artist's dialogue with her earlier model: "I am an artist who feels very deeply committed to attaching myself to history, not rupturing history . . . I am attached to those sources, but I also have a very powerful impulse to extend and to elaborate and to reenact."[16]

For Weisberg, this process of reinterpretation is related to "the midrashic approach to subject matter, a Jewish tradition of exegesis, which validates the artist as an interpreter of a story, allowing the narrative to be reinterpreted and layered . . . so that the artist is revealing new insights or truths about what may be a timeless or archetypal story."[17] These insights for the artist are always as much intuitive as they are based on conscious

Fig. 13.2. Ruth Weisberg, Initiation, *detail.*

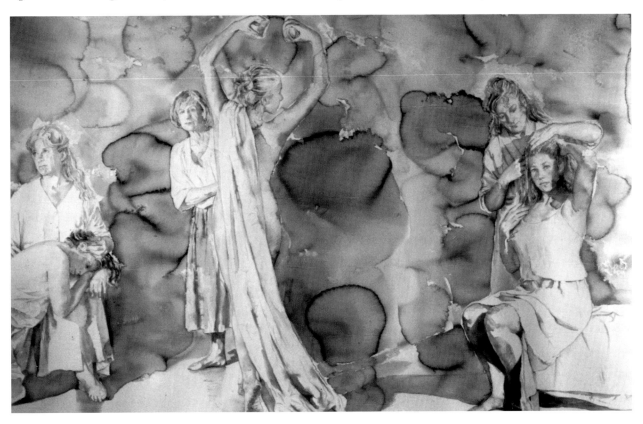

143

study or choice. In *Initiation*, the artist stands behind the figure twirling in ecstatic reenactment of the dancing maenad at the Villa of the Mysteries. The artist seems simultaneously to touch the dancing figure and to look calmly at us as if to draw us into her artistic consciousness.

The relationship between contemporary artistic consciousness and the intuitive vision of a seer or oracle is the subject of a series of smaller works by Weisberg, which depict a woman in the throes of reverie, sleep, or trance. *Seer* (cat. no. 111) is one of this series. Wes Cristensen's *In the Second Style (RW)* (cat. no. 107) shows Weisberg at work on an almost completed variant of *Seer*. In each of these works, a female figure, dressed in a loose white blouse and dark straight skirt, floats within a cloudy red and black ground. She raises her arms and hands near and around her head. Her eyes are closed. Her hair spreads out around her skull. The quality of weightless suspension, appropriate to the consciousness of trance or sleep, may arise from transferring to the vertical plane the pose of a model lying on her back. Whatever the method, the result is an intriguing expression of that inner state in which one may receive inspiration.

Sarah Belchetz-Swenson (cat. no. 106), like Olson and Weisberg, used the figural fresco in the Villa of the Mysteries as inspiration for a series of works that translate the power of the ancient work into modern guise. Each painting in Belchetz-Swenson's *Rites* (cat. no. 106) contains a single figure floating within an undefined space in frozen poses. The oil painting

Rites IV is one of several based on poses taken by an older friend of the artist as she did housework. Stripped of the everyday implements of her tasks and boldly illuminated within a pitch-black space, her figure recalls one in the Roman mural. Though seen from a three-quarter front view, the modern woman sits on a low stool and reaches out her arms in a gesture that seems a variant of the "priestess" on the north wall of the Pompeii painting, seated with her back to us and her arms raised to be served by her attendants on either side. Similarly, the younger woman in *Rites VI* (fig. 13.3), although she looks toward the viewer with a smile, raises her arms in a gesture dealing with an outer garment in a way that recalls the startled figure within the billowing in the Villa fresco. Belchetz-Swenson's final painting, *Rites XIV*, is a standing self-portrait in which the artist displays a smaller painting of her dog, which "partly serves to represent the large-eared silen and satyr contingent."[18] Artist and dog both regard the viewer with steady gaze.

After finishing the first four paintings in *Rites*, those based on the figure of the artist's older friend, Belchetz-Swenson began reading about the Eleusinian Mysteries, "which I assumed to be the origin of the Great Frieze."[19] Although not directly connected with the cult of Dionysus, the Eleusinian Mysteries were connected with the myth of Demeter and her daughter Persephone, who resided part of each year in the Underworld. Parts of the ancient world celebrated the sacred marriage between Iacchos (Dionysus) and Demeter in the upper world as a parallel with that of Persephone and Hades in the Underworld.[20] So although Belchetz-Swenson's understanding of the deeper meaning of the Great Frieze in the Villa of the Mysteries differed from that of most scholars, it inspired her to expand the actors in the remaining *Rites* to include "a girl, a young woman, a mother, an older woman and myself as artist-observer in our common enterprise."[21]

Belchetz-Swenson also added two series of *Rites* prints. The first set are black-and-white lithographs *(Opus II)*. The second set are sepia monoprints *(Opus III)*. The figures in the lithographs are carefully shaded with crayon; those in the monoprints are constructed with wonderful free color wash. Some of the poses in the prints are variants of activities in the paintings. Compare, for example, the hair-fixing in Belchetz-Swenson's painted *Rites VII* with that in the lithograph *Rites II, Opus II* (fig. 13.4). Then compare these with the detail in the Barosso copy of the scene in the Villa mural in which a seated woman arranges her hair, helped by a second woman who stands behind her.[22]

Olson, Weisberg, and Belchetz-Swenson reinvent the theme of the figural fresco in the Villa of the Mysteries, in terms of initiation and transformation in the lives of modern Western women. The other three contemporary artists whose works are included in the exhibition find more intuitive links to the ancient painting.

Eleanor Rappe (cat. no. 109) has been inspired by the Villa of the Mysteries since her first visit to Pompeii and Rome in the early 1960s. In the fall of 1999, she began a series of works inspired especially by the red wall and ordering pilasters that run behind the figures in the Pompeian fresco. Rappe began her series in homage to the American painter Mark Rothko (who had been her undergraduate painting teacher) after reading an article by Vincent Bruno, which mentioned that Rothko felt a "deep affinity . . . between his own work and the ancient style" of the Villa of the Mysteries when he visited the site in 1959.[23]

Bruno draws many comparisons between the fields of color that fill

Fig. 13.5. Eleanor Rappe, Rothko in Pompeii: Seeing Red!

the canvases of Rothko's mature work and the way in which Roman painters of the Second Style used sheets of color on the walls of many rooms in Pompeii. Although the deep red on the walls of the figural frieze in the Villa of the Mysteries is eerily similar to hues used in many Rothko canvases, the solidly modeled figures around the ancient wall diminish any resonance with Rothko's mature work. In fact, Bruno notes more striking parallels between Rothko's paintings and other sites in the Villa of Mysteries, where the walls have only color panels contained by painted architectural elements.

Rappe emphasizes the color field relationship between Rothko and ancient Rome in other works in the series. In *Rothko in Pompeii: Seeing Red!* (fig. 13.5), she combines her interest in the Villa's figural fresco and her admiration for Rothko. This work is a collection of fragments, painted on five canvases and grouped into a collage whole. Rough plaster and uneven, reworked surfaces exude an air of something old, recently recovered and reassembled. At the left a tall vertical panel bears a large upraised hand emerging from the folds of a cloak. Someone familiar with the figures in the Villa mural will recognize the detail of the left shoulder and hand from the startled woman with the billowing cloak. For Rappe, the upraised hand with its palm toward the viewer becomes "a 'stop' sign that says wait, look at what's happening here. It also signifies a kind of openness, a willingness to attend to something new that is being revealed" and "what is both concealed and revealed."[24]

At the middle bottom of the central panel a door opens in a red wall with painted pilasters similar to those in the chamber of the Mysteries. Inside the entrance to the door is a cloaked female figure. She appears to be a reversed frontal view of the "entering" woman at the west end of the north wall in the Villa fresco. A slender rod with feathery arrow tips slants down toward the right above the door. For the artist, "The doorway represents the liminal state of those undergoing the initiation, . . . [while] the figure in the doorway is approaching the initiation with some fear . . . a desire to go forward yet a certain hesitancy about the unknown. . . . The arrow might be the pain she faces—the arrow that pierces and kills—perhaps the death of the ego."[25]

The right "wing" of *Rothko in Pompeii: Seeing Red!* is composed of three smaller panels, each containing a single object. At the top is a

Fig. 13.6. Kat Tomka, Satyr, *front view.*

wing, in the middle is a pomegranate, and at the bottom is a scroll. Each panel is backed by a section of red wall with a segment of painted pilaster. However, in each panel the pilaster is in a different position and is of a different scale, so the viewer seems to stand at different distances from the back plane of each of these small panels. In addition, the pomegranate casts a strange shadow on its background, as if what is wall in the other two panels is here a horizontal surface.

The wing in the top panel resembles one from the flagellator from the east wall in the Villa frieze. Rappe writes that this wing "reminds us that these paintings refer to the sacred and the erotic" but adds that "a wing also refers to transcendence—a heavenly symbol as in flying above the spatio-temporal domain."[26]

The scroll in the bottom panel resembles the one from which the young boy on the Villa's north wall reads. Rappe seems to have made this association for she notes, "a scroll . . . may contain the hermetic formula for the initiation rites and ceremonies . . . it manifests and hides all at once—the word, or the Mysteries, are exposed and then rolled in again. But we, as spectators can never see the writing."[27]

The pomegranate in the middle panel appears nowhere in the Roman cycle. Rappe acknowledges this yet links the fruit to one theme associated with the Pompeian fresco, saying, "While there is no specific reference to a pomegranate in the Villa fresco it seemed to belong here, both as a symbol of eternal life and as a symbol of the unity that contains the multiplicity."[28]

Rappe infuses her work with personal symbols. Having their key helps us to respond more deeply to the psychic montage she has created to link the ancient and the modern. Kat Tomka (cat. no. 110) tantalizes our deductive abilities through different means. In *Satyr* (fig. 13.6), Tomka invents a tiny "architectural altarpiece" that belongs equally to the modern and the ancient world. For her, "[A]rt history is not a stagnant discipline of names, places and dates but a lively resource of ideas waiting to be rediscovered. Reconfigured to aid in my own poetic investigation and interest in time."[29]

In *Satyr,* an elegant standing frame of bent metal, fastened to a wooden base, holds a metal-framed painted panel. The front of the painted panel is filled with a detail of the young satyr who peers into a cup held by Silenus on the east wall in the Villa of the Mysteries. Tomka's cropping makes the satyr hold the cup, and the artist interprets his action as drinking wine. For her, this signifies that "as drinking blurs the senses, the image is not clearly defined but echoes the source of inspiration."[30]

The back of the painted panel in Tomka's *Satyr* has a band containing a pair of eyes inset in a field of alternating bright red-orange and tan. Tomka identifies these as the eyes of the startled woman who is just around the corner in the Villa from the group with the young satyr. A small mirror in Tomka's installation reflects these eyes back to the viewer. The eyes are painted in monochrome shades of black and white. The gaze is reversed from the direction of that in the Pompeii mural. The mirror, of course, turns the eyes back into their original orientation. Removed from their face, the intensity of the isolated eyes suggests the traditional meaning of binocular vision, in which "the soul . . . has two eyes, one fixed on time, the other on eternity."[31]

The fabrication and details of the tiny *Satyr* heighten its expressiveness. Tomka trained as a metalsmith, a craft reflected in the precision of the details here and in the artist's ability to handle vast themes on an intimate scale. Tomka speaks of mixing techniques and materials to

147

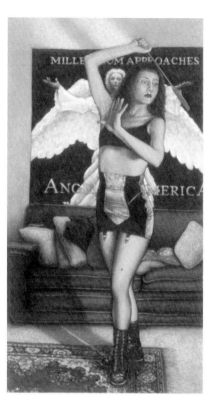

Fig. 13.7. Wes Christensen, Turnstile.

create the look of antiquity in her pieces. Here the design of the lower bracket also suggests the kind of display found in museum exhibits of fragments uncovered in archaeological digs. As the artist writes, "My work employs a feeling of cultural record, artifact or historical fragment; their physicality, emphasis on collaged time and historical referencing work together to form life icons of memory."[32]

Links with the fresco from the Villa of the Mysteries are less immediately apparent in Wes Christensen's *Confabulation* (cat. no. 107) and *Turnstile* (fig. 13.7) than in the other contemporary works in the exhibition. Christensen is especially attracted to the "elusive meaning" of the ancient painting, which "plays right into our contemporary concerns with 'implied narrative' imagery, which purposely presents ambiguous scenarios to our audience in an attempt to engage the viewer in a sort of conversation about what the meaning actually is."[33] For Christensen, this opens the way to translating ancient motifs into personal modern fables. *Confabulation* and *Turnstile* are works in which Christensen drew inspiration from details of the Great Frieze at Pompeii.

The source for *Turnstile* is easily traced. Although dressed in an outfit suggestive of contemporary S & M, Christensen's woman takes the pose of the figure raising the rod/whip at the south end of the east wall in Pompeii. This chastiser performs within a middle-class living room, with oriental carpet on the floor and a pillow-piled soft green couch at the back. Red-haired and wild-eyed, this fury is lit by a raking light that comes from the direction of the invisible object of her attention. Behind her on the wall is a poster invented by Christensen to provide "a visual pun for the missing wings" with the "well known angel figure from Tony Kushner's *Angels in America*, which was playing on Broadway when this piece was painted."[34] Interestingly, the definition of "turnstile" adds another metaphorical layer to the figure of the chastising woman in both Pompeii and Christensen's work. As a turnstile, she is, "a mechanical gate or barrier with metal arms that are turned to admit one person at a time, usually in one direction only."[35]

Confabulation continues Christensen's practice of superimposing an eerie morality drama over memories of the frieze in the Villa of the Mysteries. One finds almost subliminal transfer here of elements from the group of Silenus with the two satyrs at the left side of the east wall at Pompeii. The balding and paunchy Roman Silenus is now seated facing left instead of right and has become a young man with a full head of curly hair and a neat mustache. The young satyr who peers into the cup at Pompeii is here a décolleté young woman who looks into an elaborate hand mirror, which the modern Silenus holds in his right hand. Silenus's second satyr attendant, who holds a theater mask aloft in the Villa of the Mysteries, is now completely reversed in position and metamorphosed into a figure of somewhat indeterminate sex who holds a skull at arm's length, like a modern-day Hamlet considering the remains of Yorick. Multiple necklaces, earrings, and an ample hip suggest that this figure, too, is a woman.

Christensen clearly enjoys playing with symbols, and he seems to have read widely concerning myth and meaning. Like *Turnstile*, *Confabulation* is set in a modern interior. But this setting is filled with esoteric emblems, including the statue of an owl, a candelabra with lighted black candles, a glowing figure, and patterned shapes, plus what appears to be a pierced heart on the central male figure's tee shirt. Christensen admires the malleability of meaning in ancient works, and clearly he enjoys using the nourishment of his sources to create mysterious allegories for the

complexities and practices of contemporary life. With the other five contemporary artists in the exhibition, Christensen's works both stretch and reward the interpretive powers of their viewers.

1 See, for example, the discussions of Dionysus in Otto 1981 and Baring and Cashford 1991 as well as those of Dionysus/Liber in Southern Italy in chs. 6, 7, 10, and 11 of this volume.
2 Otto 1981, 65.
3 Clarke 1991, 105.
4 This calls to mind Roger Ling's mention of "the normal Second Style rule that shadows fall away from the principal entrance of a room" (Ling 1991, 104). Interestingly, John Clarke links the effects of the Villa figures with Vitruvius's (*De Arch.* 7.5.2) *megalographia signorum*, which Clarke translates as "monumental painted representations of statues." Clarke 1991, 98.
5 For Le Brun and the academic conventions of expression, see Montagu 1994.
6 Wittkower 1977, 173–87.
7 Wittkower 1977, 181.
8 Owens 1984
9 See Hall 1988, *passim*; 1999, 2–5.
10 Olson 1999, 6.
11 Olson 1999, 8
12 Olson 1999, 10.
13 Olson 1999, 12.
14 Jung's words were, "Man woke up in a world he did not understand, and that is why he tries to interpret it." C. G. Jung, "The Archetypes and the Collective Unconscious," quoted in Saxon 1986, 3–4.
15 Ruth Weisberg, interviewed by Nygren (1999, 14).
16 Nygren 1999, 8.
17 Nygren 1999, 15.
18 Sarah Belchetz-Swenson, fax to Elaine Gazda, August 1, 2000.
19 Swenson 1986, 2. Since the creation of the cycle and the publication of this museum brochure, the artist has assumed the hyphenated form of her name, which she uses today.
20 Baring and Cashford 1991, 378–79.
21 Swenson 1986, 2.
22 Interestingly, despite the implication of assigning Roman numerals to each of her *Rites*, Belchetz-Swenson does not seem to match the number of the painted version with those in the prints. Perhaps the Roman numerals follow the order of creation in each suite.
23 Bruno 1993, 235.
24 Eleanor Rappe, e-mails to Elaine Gazda, December 12, 1999, and to Diane Kirkpatrick, June 22, 2000.
25 Rappe's, e-mails, December 12, 1999, and June 22, 2000. It is interesting to compare Rappe's interpretation of the doorway with one from a dictionary of symbols where a gate(way) or door(way) "symbolizes the sense of passing from one state to another, from one world to another, from the known to the unknown, and from light to darkness . . . an invitation onto a voyage into the beyond." Chevalier and Gheerbrant 1994, 422, 424.
26 Rappe, e-mails, December 12, 1999 and June 22, 2000.
27 Rappe, e-mails, December 12, 1999 and June 22, 2000.
28 Rappe, e-mail, June 22, 2000.
29 Kat Tomka, "History, Motif, Time, Media," in the Artist's Statement sent to the author.
30 Kat Tomka, letter to Elaine Gazda, October 12, 1999. Not all scholars see the young satyr as drinking. For example, Roger Ling (1991, 104) writes, "it has been suggested that the satyr looking into the bowl or jug is practising 'lecanomancy' (divination from images in a vessel containing liquid) and that what he sees is the reflection of the Silenus mask held up by his companion; . . . it is doubtful whether the mask could have been reflected in the bowl when the satyr's own head was in the way. It is more likely that the satyr is looking at images unrelated to the mask, or alternately he is watching the bowl fill miraculously with wine."
31 Chevalier and Gheerbrant 1994, 363.
32 Tomka, Artist's Statement.
33 Wes Christensen, e-mail to Elaine Gazda, October 22, 1999.
34 Christensen, letter to Elaine Gazda, October 1, 1999.
35 *Collins English Dictionary*, 4th ed.

Catalogue

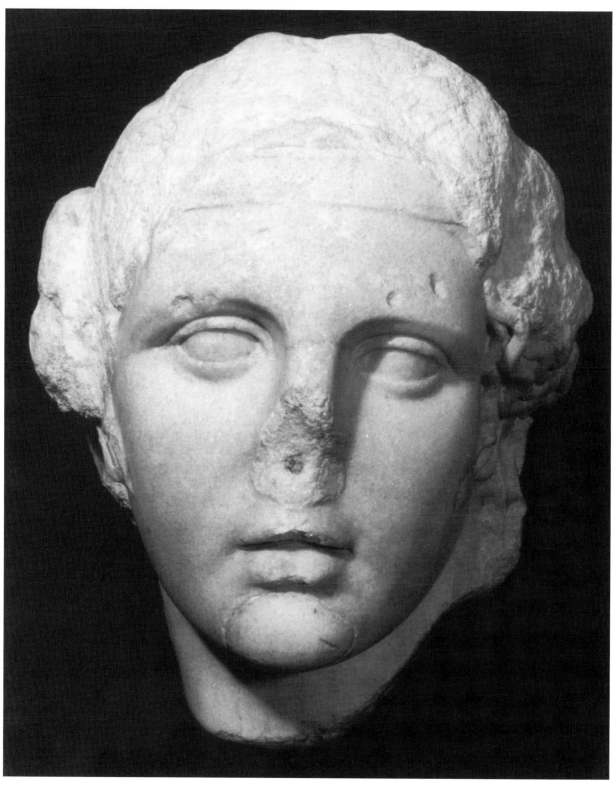

Head of Dionysus/Liber, cat. no. 92

Women and Cult in Ancient Italy

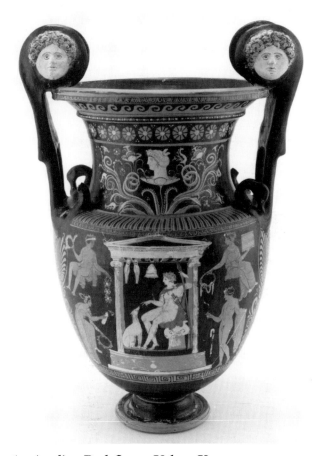

1 Apulian Red-figure Volute Krater

Gioia del Colle Painter
Fired clay with added white paint
H. 23½; Diam. 13¼ in.
(59.8; 33.8 cm)
Apulia, Italy
Kelsey Museum of Archaeology, acc. no. 82.2.1
The vase has abrasions and scratches on its surface and has suffered significant losses of paint. There are hairline cracks in the glaze. Two swan finials, broken at their bases, are now missing. One broken figural finial has been restored.

The two mascaroon handles terminate in gorgoneia on either side. Four sculpted swan-head finials originally sprouted from the base of the handles. The decorative motifs encircling the lip and neck of the vase comprise, in descending order, an egg-and-dart, wave-and-band, and bead-and-reel. Side A of the neck of the vase is decorated with a band of rosettes beneath which a female head in a cap emerges from a floral formation, surrounded by floral ornamentation and tendrils. Side B of the neck displays a band of laurel leaves below which is an abundance of stylized palmettes. The shoulder of the vase is decorated on side A with a band of vertical stripes and an egg-and-dart frieze; side B has only the band of stripes.

Side A of the body of the vase depicts a nude male youth inside an Ionic naiskos. He is seated atop an Ionic pillar and attended by a dog. He wears only a cape over his shoulders, sports a dagger, and holds a spear in his left hand. His helmet and greaves hang from the ceiling of the naiskos. Four attendants appear outside the naiskos. Counterclockwise from top left are a nude man seated on a cloak, wearing a diadem and holding a three-tiered garland in his left hand, a wreath in his right; a peplos-clad female figure in knee-raised position facing the naiskos holding an alabastron and a wreath; a nude standing man in a diadem with a garment draped over his arm holding a spear and a strigil; and a seated peplos-clad woman holding a *cista* and a wreath around which hangs a fillet.

Side B of the body of the vase depicts four figures around a grave stele. The stele supports a kantharos and is tied with a fillet; an ivy motif decorates its base.[1] Counterclockwise from top left the figures include: a seated woman clad in a peplos holding a mirror and a spoked *patera*; a nude man in knee-raised posture wearing a diadem and a cloak draped over his knee and holding a large mirror and a small unidentifiable object; a woman who leans toward the stele wearing a peplos and items of jewelry and holding a "xylophone" and a *cista*; and a nude man seated on a himation holding a phiale and an oinochoe.

Stylized palmettes and floral ornamentation fill the space under the handles. A meander-and-St.-Andrew's-cross frieze runs beneath the figural scenes. The foot is covered with a rich, black glaze.

The female head is a common feature of South Italian vase painting, and of Apulian volute kraters in particular. It is most often identified as the head of Aphrodite, the goddess of fertility, symbolized by elaborate vegetation.[2] The swan-head finials may also be associated with the erotic realm of Aphrodite.[3] The youth inside the naiskos with his dog may signify the "generosity of spirit" and loyalty of the dead person.[4] The stele scene refers to the funerary rites performed at the grave of the deceased. Although the findspot of the krater is unknown, it undoubtedly served in a funerary context, probably as a grave offering interred with the deceased, and perhaps even as a "symbolic effigy" of the deceased.[5] The gorgoneia on the handles may have performed an apotropaic function for the deceased. Its ornate decoration comprises a complex system of signs of erotic, regenerative, and apotropaic images responding to eschatological beliefs, which simultaneously complement the function of the vase itself within a social context.

DATE: c. 340 BC.

BIBLIOGRAPHY: Sotheby & Co. (London) 1968, sale catalogue 18 June, 63–64, no. 111; Sotheby & Co. (London) 1970, sale catalogue 8 December, 39–40, no. 292; Trendall and Cambitoglou

1978–82, 2:458, no. 17/9, pl. 162, 1–2; Christie, Manson & Woods, Ltd. (London) 1982, sale catalogue 6 May, 29, no. 213; Root 1984–85, 1–25.

SK

1 Root (1984–85, 3) notes that the kantharos is now difficult to see because of misfiring.
2 See Root 1984–85, 11.
3 Root 1984–85, 11.
4 Root 1984–85, 9.
5 Root 1984–85, 10; see also Smith 1976.

2 Statuette of Venus and Cupid

Bronze
H. 3¹/₄; W. 1¹/₄; W. at base 1¹/₁₆; D. at base ¹/₂ in.
(8.2; 3.2; 2.7; 1.2 cm)
Fayoum, Egypt
Purchased from D. L. Askren, 1925
Kelsey Museum of Archaeology, acc. no. 3090
The face and hair of Venus are abraded and the surface of the upper body and face of Cupid virtually obliterated. Signs of restoration are evident on the left leg of Venus and between Venus and the pillar on the back of the statuette. There are spots of a whitish incrustation, corrosion above Venus's left buttock, and scattered brown incrustation on the back of the statuette.

The goddess stands on her right leg with her left leg bent.

She rests her left elbow on a pillar and holds her right arm akimbo. She wears a himation, perhaps with a chiton beneath, although the worn surface makes it difficult to be sure. A bracelet is on her right wrist. The details of her face are almost indistinguishable. Her hair rises up from her forehead, with the sides plaited back. She does not appear to be wearing a headdress. A Cupid sits on Venus's right shoulder, his right leg dangling down alongside her right breast and his left leg bent, and he holds an unidentifiable object in his right hand. His left wing overlaps the goddess's hair in back.

Because this object was found in Egypt, it has been assumed that the statuette represents Isis and her son, Harpocrates, in the guise of Venus and Cupid. The main cults of Harpocrates were at Pelusium in the Delta and in the Fayoum, where he was worshipped in several guises, the most common of which outside of Egypt was as the nursing child of Isis. Isis was identified with a wide variety of Hellenic deities, including Artemis, Demeter, and Aphrodite, and her appearance was often hellenized during the Graeco-Roman period. Combinations of Aphrodite/Venus and Isis are fairly common in the art of the Graeco-Roman period, especially in Graeco-Egyptian terracotta or bronze statuettes like this Kelsey figurine.

Even with the common association of Isis and Aphrodite in Egypt, however, this particular statue lacks certain attributes that would have readily identified the goddess and godchild with Isis and Harpocrates. To begin with, when the maternal aspect of Isis is emphasized, the goddess is most commonly portrayed seated and suckling her son. This makes the placement of the boy god on the shoulder of the standing goddess an unusual choice for this statuette. In addition, the goddess does not appear to be wearing a headdress that would distinguish her as Isis. Finally, the identification of the boy as Harpocrates rather than Cupid is difficult to justify because the winged god is not represented with any of the traditional features of Harpocrates: he wears neither the royal crown and *uraeus* nor the sun disk between two horns, he does not suck his thumb, and he does not wear his hair in a sidelock. Without a known archaeological context for the Kelsey Museum piece, it is only possible to identify this Venus and Cupid with Isis and Harpocrates in very general syncretic terms.

The figural type of the Kelsey Venus is one that was well known in Roman Italy. It is reminiscent of representations of Julio-Claudian empresses in the guise of Venus Genetrix. Examples include Livia on a relief in Ravenna and the statue of Antonia Minor from Punta Epitaffio.[1] A draped Venus from Paestum provides a comparable Italic example of this figural grouping of Venus and Cupid.[2] Dating to the first century BC and now in the Paestum Museum, this Venus also has a small figure, possibly a Cupid, perched on her right shoulder.

DATE: Graeco-Roman.

Unpublished.

BL

1 For the Ravenna relief, see Kleiner 1992, 146, fig. 121. For the statue of Antonia Minor, see Zevi 1983, 54–56, fig. 122.
2 Pedley 1990, 159, fig. 119.

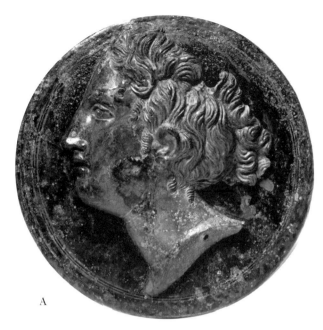

A

B

3 Covered Mirror with Images of Aphrodite

Bronze with tin
Diam. mirror disk 5⁷/₁₆; Diam. cover 5³/₈ in.
(13.8; 13.6 cm)
Southern Italy
Lent by the Toledo Museum of Art
Purchased with funds from the Libbey Endowment,
 Gift of Edward Drummond Libbey
Acc. nos. 1966.111A and 1966.111B

The mirror has undergone restoration, and fragments from the
edge of the mirror cover have been rejoined. The upper edge of
the hair of the repoussé image on the lid has broken off and is now
missing. The mirror's hinge is no longer extant. The piece may
have had a handle for removing the lid, but any such handle is now
also missing. The mirror's reflecting surface shows signs of corro-
sion, as does the lower cheek area of the repoussé head on the
mirror lid.

Somewhat like a modern compact, this cosmetic accessory
consists of a mirror with a protective cover. The mirror
itself is the round, slightly convex upper surface of a metal
disk. This surface would have been highly polished in an-
tiquity and thus able to give a reflected image of the viewer.
The underside of the mirror features a series of raised con-
centric circles that, although adding a decorative touch, may
be the result of the manufacturing process. Mirrors such as
this were apparently cast in a mold and then smoothed on a
wheel to remove any surface irregularities.[1] The concentric
rings would have been created as the disk was turned on the
wheel.

The cover of the mirror is embellished on both sides
with images of female figures. The top of the cover (A)
bears a bust of a woman, crafted in the repoussé metalwork-
ing technique, whereby the bronze was hammered to create
a raised, three-dimensional image.[2] The facial features and
hair of the bust have been enhanced with engraved detail.
The woman is shown in profile as she looks to the viewer's
left with an intent expression on her face, her mouth slightly
open. Her profile is long and straight, and there is little
distinction between the figure's forehead and the bridge of
her nose. Her neck is fleshy and features a series of small
rings or folds. The woman's hair is pulled loosely back from
her face, and her exposed ear is perhaps decorated with a
disk-shaped earring. At the base of the repoussé relief is a
small perforation, apparently made in antiquity, that may
have served as the point of attachment for a handle. The
image of the woman is framed by a border of two low-
relief, concentric circles.

The underside of the mirror cover (B) is decorated with
an engraved image of a female figure crouching inside a
cave as she prepares for her bath. The figure is shown in
profile, turned to the viewer's left, and is nude except for a
band of cloth that covers her breast. She also wears a small
bracelet. Her left arm raised to her side, the woman stretches
out her right hand toward the bath basin that sits before
her. She is posed with one knee almost touching the ground
and the other raised, as it is bent at a right angle. The ren-
dering here of the figure's face bears a strong resemblance
to that on the other side of the mirror lid: the crouching
woman has a strong profile with a long, straight nose, wavy
hair swept loosely back from her face, and a slightly opened
mouth. The cave that shelters the woman is indicated by
means of schematically drawn rocks that encircle and frame
the crouching figure. Remnants of tin on the underside of
the mirror cover indicate that parts of the bronze mirror
were originally sheathed in this lighter-colored metal, prob-
ably in imitation of silver plating.

Covered mirrors such as this one first appeared in the
Greek world in the late fifth century BC.[3] Similar mirrors
were also being made in Etruria in central Italy by the end
of the fourth century BC.[4] Greek covered mirrors are often
difficult to distinguish from Etruscan specimens, although
differences in craftsmanship as well as in subject matter and
composition of decorative images do sometimes allow dis-
tinctions to be made.[5] The Toledo mirror seems, on the
basis of these criteria, to parallel known Greek rather than
Etruscan examples.

The motif of a female figure—usually a goddess—at her
bath was common in ancient Greek art. Here the figure
depicted seems to be Aphrodite, the Greek goddess of love

153

and beauty and a suitable personality to appear on a woman's toilet item. (Like their Latin and Etruscan counterparts in central Italy, Greek mirrors apparently served both as feminine objects of everyday use and as grave goods for deceased women.) Although the repoussé head on the lid may be intended to depict the mirror's owner,[6] the resemblance that this image bears to the engraved portrayal of Aphrodite on the bottom of the lid suggests that the repoussé head may represent Aphrodite as well.

This mirror appears to have been made in the same workshop as a number of other ancient Greek mirrors, as it shares with these mirrors the use of certain stock motifs and figural elements that have been recombined in the engraved images on the various mirrors to create different scenes.[7] A number of the motifs on the mirrors that have been attributed to this workshop appear on South Italian vases produced in the Greek city of Taras in the late fourth century BC; the Toledo mirror, apparently also South Italian Greek in manufacture, seems to date to c. 320 BC.[8]

DATE: c. 320 BC.

BIBLIOGRAPHY: Toledo Museum of Art 1969, *Museum News* 12:89; Cooney 1973, 219–21; Schwarzmaier 1997, 15, 46–47, 132, 135–36, 156, 191, 195, 212, 279, 300, 331, tables 64.1, 82.2.

EdeG

1 Cooney 1973, 216.
2 For an overview of the metalworking techniques used to create such repoussé images, see Stewart 1980, 25.
3 Schwarzmaier 1997, 60 ff.
4 Richardson 1982, 14.
5 Schwarzmaier 1997, 207 ff.
6 Cooney 1973, 220.
7 Schwarzmaier 1997, 191 ff. Perhaps the closest in style to the Toledo mirror is a piece now in the British Museum: Schwarzmaier 1997, 300, cat. no. 162.
8 Schwarzmaier 1997, 331.

4 Mirror with an Engraved Image of Three Women

Bronze
H. 12; Horizontal Diam. 6⁷/₈; Vertical Diam. 7¹/₈; L. handle 4⁷/₈ in. (30.6; 17.5; 18.0; 12.3 cm)
Italy
The Detroit Institute of Arts, Founders Society Purchase,
 Laura H. Murphy Fund
Acc. no. 47.399
The mirror is in good condition. Some patina and corrosion have, however, developed on the piece, notably along the upper right edge, lower center, and left portions of the reflecting surface and on the lower half of the engraved side of the mirror disk.

The disk and handle of this pyriform, or pear-shaped, bronze mirror were cast as a single piece. The juncture of the disk and handle is accentuated by a pair of small points, or tangs, that extend from the sides of the handle.

On the reflecting side of the disk, an engraved palmette motif embellishes the area just above the disk-handle juncture. The edges of this side of the mirror, along both the disk

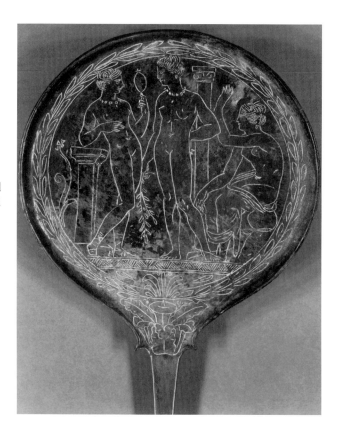

and the handle, are decorated with small, engraved tick marks. At the base of the handle, these tick marks give way to a terminal molded in the form of a deer's head.

The nonreflecting side of the disk features an engraved scene depicting three women. The scene is framed, just inside the raised lip of the mirror disk, by a wreath composed of a vine with sets of paired leaves. The wreath terminates just below the base of the figural scene, where it fuses with a palmette motif similar to that seen on the other side of the mirror. Here, however, the palmette pattern caps a trumpet-shaped flower that sits in a bed of acanthus leaves. This area, known as the exergue, is marked off from the figural scene by a bar decorated with geometric hatching.

Above the hatched bar stand two women, flanked by a third woman, who sits. The scene opens to the left with a shoot of vegetation and a short pilaster. Next to the pilaster stands one of the women, who, throwing her weight on her left leg, admires herself in the mirror that she holds up in her left hand. Unlike the mirror on which this scene is engraved, the mirror that the woman holds features a small cross, perhaps a hook, at its apex. The woman who holds the mirror is nude, wearing only a beaded necklace and a pair of sandals. Her body is shown in three-quarters view, while her head is turned to her left in profile. Her hair is pulled back from her face and gathered on her head. She faces a companion, who stands with her body toward the viewer and her head turned in the direction of the woman holding the mirror. This second woman is also nude but wears a beaded necklace and, perhaps, earrings. Her hair is likewise pulled back from her face into a bun. She has her left hand on her hip and holds in her right hand a sprig of vegetation not unlike that of the wreath that encircles the scene. Behind the woman is a small Ionic column. The third figure, a seated, partially draped female, is shown in

profile, turned toward the other two women. She sits with her left arm raised in the air and her right arm resting on her lap. Although a cloth wrap covers the lower portion of her body, her upper body is exposed. She too has her hair pulled back and perhaps wears small, triangular earrings. The seat on which she is perched appears to be composed of rocks or small boulders.

The pyriform shape of this piece is typical of mirrors from the central Italian city of Praeneste (modern Palestrina). Although pyriform mirrors appear as early as the fifth century BC,[1] they were most common in the third century BC,[2] the period in which the present mirror seems to have been made. While the Detroit mirror itself is ancient, the engraved scene on it has once been said to be a modern forgery, because the hooked mirror that the leftmost figure holds is unlike the mirrors that were actually used in Praeneste.[3] Hooked mirrors were, however, a common enough presence in South Italian vase painting, which seems to have served as a source of influence for Praenestine artisans.[4] The depiction of these mirrors in South Italian vase paintings does not entirely eliminate the possibility of forgery, inasmuch as the source of the iconography used in spurious mirror engravings is often genuine ancient artworks.[5] Stereomicroscopic examination of the piece, however, suggests that the engraving is genuine. The results of that study revealed that the mirror's patina does not seem to be interrupted by the lines of the engraving.[6] In addition, the chemical composition of the bronze suggests that the mirror was intended to be engraved from the start.[7]

The subject of the engraved scene as a whole is unclear. Perhaps a generic women's toilet scene, fairly common on ancient Italian mirrors, is intended. The goddess of love and beauty—whether Greek Aphrodite, Roman Venus, or Etruscan Turan—often appeared in such scenes. Perhaps the figure holding the mirror here is a representation of this goddess. Mirrors were closely associated with both feminine beauty and its divine protector Aphrodite/Venus/Turan in antiquity, and the present example, regardless of the subject matter of the engraved scene, is probably no exception.

Stylistic elements of the engraved scene compare closely to those of other bronzes from Praeneste that are products of the first quarter of the third century BC. Consequently, that date has also been proposed for the present piece.[8]

DATE: First quarter of the third century BC.

BIBLIOGRAPHY: Christie's sale catalogue 1920, 19 April, no. 4; Spink and Son, Ltd. 1920, advertisement in the *Burlington Magazine* for May; Robinson 1948, 67–68; Cummings and Elam 1971, 36; de Grummond 1982, 8, 49, 51, 62, 66, 197, figs. 7, 64; de Puma 1987, 38–39, figs. 21a–d; de Puma 1989, 695–711.

EdeG

1 De Grummond 1982, 9.
2 De Grummond 1982, 162–63.
3 De Grummond 1982, 66.
4 De Puma 1987, 39; see also Cristofani 1967.
5 De Grummond 1982, 63–64.
6 De Puma 1987, 39. It is possible, although unlikely, that the patina itself is modern.
7 De Puma 1989, 703–9.
8 De Puma 1987, 39.

5 Lid of an Apulian Red-figure Lekanis

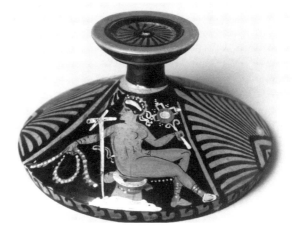

Side A

Side B

Fired clay
H. 3³/₄; Diam. 7¹/₈ in.
(9.5; 19 cm)
Apulia, Italy
Purchased from the Marburg Collection, 1923
Kelsey Museum of Archaeology, acc. no. 2612
There is a large pit in the painted, stylized palmette decoration, but otherwise the lid is in good condition, except for chips on the rim, scratches and hairline cracks in the glaze, and some losses of paint.

The rim of the lid is painted with a wave pattern and the top of the finial with black spokes radiating from the center. The decoration of the body consists of two large stylized palmettes between two figural representations.

Side A depicts a figure seated to the right on what appears to be an Ionic column. The head is turned around to look over the left shoulder. The figure holds a fan and a mirror in its left hand. A crossed staff leans at its side, a fillet dangles behind its back, and a long string of beads or a garland is held in its right hand. The figure wears a diadem in its hair and on its feet short boots of South Italian type. Two curved lines on the chest define the silhouette of either well-developed pectorals or breasts. Male genitalia are also depicted.

On side B is painted a large female head in profile. Her features, which lack detail, suggest rapid execution. One long tendril of hair hangs down by the ear, and she wears a

necklace, an earring, and a diadem. Her bound hair is held in a rayed cap tied at the back with ribbons.

The hastily executed painting of this lid makes identification of the seated figure on side A difficult. It may be either Eros or Hermaphroditos, depending on whether the curved lines on the chest are understood as male pectorals or female breasts. Both Eros and Hermaphroditos are conventionally shown with fleshy, feminine physiognomy,[1] but Eros frequently appears on South Italian pottery, whereas Hermaphroditos does not. The mirror that the figure holds also supports an identification as Eros.

The female head on side B is a type that frequently appears on South Italian pottery. She is often identified as Aphrodite or as a portrait of a deceased woman or a bride. In some cases the painter may have intentionally conflated these identities. In this case, however, it is likely that the head represents Aphrodite, paired with her consort Eros. Thus the images together can be read as a reference to the divine realm of the erotic, and of the magic involved in seduction and sexuality.

DATE: Fourth century BC.

BIBLIOGRAPHY: *CVA* USA 3, University of Michigan 1:pl. 29, 1.

SK

1 See *LIMC* s.v. "Hermaphroditos" for misidentifications of figures of Eros or Attis appearing to be Hermaphroditos.

6 Torso of Aphrodite Anadyomene

Fine-grained white marble
H. 7⁷/₈; W. 3¹/₁₆; D. 2³/₈ in.
(20.0; 8.4; 6.0 cm)
Karanis, Egypt
University of Michigan Excavation, 1935
Kelsey Museum of Archaeology, acc. no. 10726
The head, most of the neck, arms, and lower legs are missing. Both breasts and the broken right buttock are chipped and worn. Chips and abrasions dot the entire surface, which nevertheless preserves a smooth polish.

This delicately carved and subtly modeled figure stands with its weight on the left leg and the right leg relaxed. The upper torso bends sharply to the left, creating an S-curve through the body. A rectangular slot on the upper left hip may have braced the elbow of a separately worked arm, or it may have supported an attribute.

The right arm was raised high, perhaps in the pose of Aphrodite binding her hair, a sculptural type known as Aphrodite Anadyomene. This Aphrodite/Venus type was common throughout the Hellenistic and Roman worlds in a

wide variety of media. A half-draped marble statuette of Venus Anadyomene from Paestum dates to the first century BC.[1] In Campanian wall painting, three examples are known of the nude Venus Anadyomene: one, now destroyed from Pompeii, VII.15.3, another from the House of the Prince of Naples in Pompeii (VI.15.7,8), and a third, from Herculaneum, now in the Naples Museum.[2]

Roman women were often portrayed in the guise of Venus.[3] An adaptation of the Anadyomene pose occurs in the "bridal preparation" scene on the Villa of the Mysteries frieze (group G), where the seated woman holds out a lock of her hair in her right hand.

DATE: Second century BC or later.

BIBLIOGRAPHY: University of Michigan Museum of Art 1965, Ie; Gazda 1978, 30, no. 18.

BL

1 Pedley 1990, 158, fig. 117.
2 Strocka 1984, 45.
3 See Kleiner 1992, 178, fig. 146. See also cat. no. 2.

7 Figurine of Persephone Enthroned

Fired clay
H. 16¹/₂ in.
(42 cm)
Southern Italy, possibly Locri or Hipponion[1]
Everson Museum of Art, Syracuse, New York, Museum purchase
Acc. no. 70.2
Although the figurine was broken and repaired, and restorations have been made to the left shoulder, it is in good condition overall. One palmette is missing from the throne. The figurine was made from a mold; its flat back is pierced by a vent hole. The polos and wreath were hand-molded separately and applied.[2]

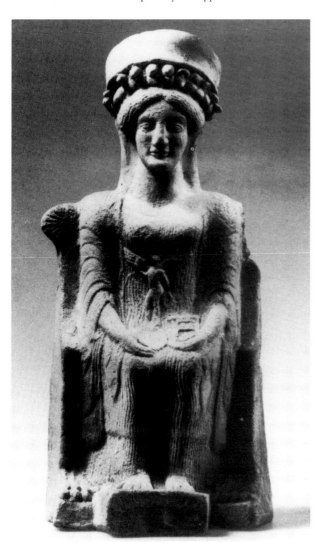

A female figure sits on a throne in a rigid frontal posture, her feet resting on a small pedestal in a static, blocklike

composition. The throne is studded with palmettes at the corners, and its legs terminate in lion's-paw feet. The figure herself wears a himation draped over her shoulders and a chiton rendered in wavy folds tied at the waist by an *apoptygma*. A wreath of small orbs and a polos grace her head. She holds in her right hand a small phiale, in her left a kibotos (small chest). A tiny winged figure stands atop the phiale facing left.

Among the plentiful votive terracottas of Southern Italy, the enthroned female type is the most common.[3] The generic quality and lack of naturalism in the facial features of this and many other enthroned female figures suggests that they were not intended as portraits. Furthermore, the throne identifies the figure not as a mortal woman but as a divinity.[4] Neither the shape of the throne nor the figure's attributes or garments, however, identify her positively as any specific goddess, but the veil and kibotos allude to marriage.[5] The small winged figure on the phiale is most likely a statuette of Eros.[6] Similar figurines often bear one or more of a number of other items such as a lotus flower, a dove, or a pomegranate,[7] items signifying either Aphrodite or Persephone. These probably represent actual votive offerings.[8] In some cases, the enthroned figure is accompanied by a winged female figure, identifiable as Nike.[9]

Both Aphrodite and Persephone, whose cults were popular in Southern Italy, were associated with the nuptial realm. The wreath of the Everson figurine appears to be composed of pomegranates, a fruit most commonly associated with Persephone. This and the similarity of the figure to representations of Persephone as the Bride of Hades in *pinakes* from Locri argue for an identification as Persephone.[10] This goddess may be understood as the bride par excellence, her role in a woman's rite of passage of marriage being both paradigmatic (meant to encapsulate the behaviors of the ideal bride) and symbolic of beliefs about marriage.[11] The Everson figurine functioned as an *anathema*, or a ritual dedication to the goddess whom it represents.[12] Itself a votive offering, it self-reflexively portrays not only the goddess of the cult but also the actual votive offerings (phiale, kibotos, and statuette of Eros) that would have been made by a bride to the goddess.[13]

This image of Persephone draws attention to the practice of representing women's religious activity in Hellenistic Southern Italy. Representations of an enthroned female figure were not confined to terracotta *anathemata* but were popular in a variety of South Italian media, particularly vase painting.[14] Such images anticipate two of the female figures of the later painting cycle at the Villa of the Mysteries: the enthroned goddess type appears both as the female companion of Liber (group D, figure 16) and as the matron on the west wall (group I, figure 29).

DATE: Fifth–third century BC.

BIBLIOGRAPHY: Cahn 1970, 38, fig. 54.

SK

1 The tentative attribution of manufacture to these locales is based on visual inspection of the clay fabric by Rebecca Miller Ammerman. Personal communication, June 12, 2000.
2 The mold created only the front of the figurine; the back was covered with a sheet of clay, pierced to allow steam to escape during firing. See Uhlenbrock (1990a, 16–17) for a description of the process of molding terracotta figurines. She notes that hand-molded appliqué was a common technique for Hellenistic terracottas.
3 Miller 1983, 203.
4 Miller 1983, 203.
5 Miller 1983, 205, 208.
6 Miller 1983, 209.
7 Miller 1983, 206 ff. The variety of other cultic objects occurring in Locrian *pinakes* is considered by Sourvinou-Inwood (1978).
8 According to myth, Hades abducted the young Persephone while she was picking flowers; after bringing her to the Underworld he tricked her into staying and eating the seeds of a pomegranate. Thus, both items possess connotations of fertility, rebirth, and the funerary sphere. See Sourvinou-Inwood 1978, 110.
9 Sourvinou-Inwood 1978, 208 ff.
10 See Sourvinou-Inwood 1978.
11 Sourvinou-Inwood (1978, 106) remarks about representations of Persephone alone (without Hades) on the Locrian *pinakes*, "at the conceptual level Persephone the divine bride expressed and 'symbolized' the concept of marriage."
12 Miller (1983, 204) suggests that the enthroned female types "probably represent the patron goddess of the cult."
13 Miller 1983, 210.
14 See, for instance, two pyxides by the Lipari Painter: one depicting Hera (Trendall 1989, Lipari 745 A, fig. 448) and the other Aphrodite (Trendall 1989, Lipari 276 L, fig. 449).

8 Head of Demeter

Fired clay
H. 2¹/₂; W. 1³/₈; D. 1¹/₂ in.
(6.4; 3.6; 4.0 cm)
Tarentum (?), Italy; purchased at Pompeii
Kelsey Museum of Archaeology, acc. no. 25461

The condition of this small head is generally good, although the body to which it was presumably once attached is missing. Some dirt and other small accretions cling to the top of the hair and to the neck. A section of the hair is unnaturally truncated along the upper right side of the head. The head was apparently originally painted, although very little of this decoration—only small traces of white pigment—remains.

The head is composed of solid terracotta, embellished with hand-modeled hair and facial features. The woman portrayed wears her hair parted down the middle and pulled back from her face. On top of her head she wears a crown that features sets of small, round decorative indentations. The woman has a full face and chin, as well as small rings or folds of flesh along her neck. Her face is oval in shape, with a small, triangular forehead. Her lips are full and curving; her nose, triangular; her eyes, almond-shaped. Her hair—or perhaps

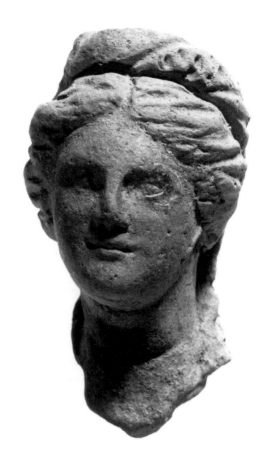

a veil or other form of drapery—frames the back edges of her neck. There is a hint of an earring on her right ear. The back and top of the head are not modeled and bear no decorative detail.

The figure's crown is suggestive of the *corona spicea*, or wreath of wheat stalks, that was characteristic of the Greek goddess Demeter and her Roman counterpart Ceres.[1] Thus the head seems originally to have been part of a figurine—undoubtedly of the so-called Tanagra style (see cat. nos. 77, 78, 79)—of Demeter or Ceres. The dedication of terracotta votive objects to Demeter was particularly prevalent in Southern Italy,[2] and, indeed, this head is thought to have originated in the South Italian Greek colony of Taras (Latin Tarentum, modern Taranto). Demeter—and by association, Ceres too—was particularly revered by women, as Demeter held sway over marriage vows, motherhood, and female chastity. Thus a woman who enjoyed a successful marriage or who had lived through childbirth might offer a votive figurine such as the one to which the Kelsey head once belonged to show her gratitude to the goddess.

Many features of the head—the oval shape of the face, the triangular forehead, and the rings of flesh on the neck—are characteristic of artworks influenced by the oeuvre of the mid-fourth-century Greek sculptor Praxiteles.[3] Because Greek Sicily and Southern Italy experienced decline and periods of unproductiveness in terracotta manufacturing at the end of the third century BC, if not sooner,[4] the Kelsey head was probably made sometime between the middle of the fourth century BC and the end of the third century BC.

The face of the goddess does not exhibit the plumpness that was popular for late third-century figurines from Taras;[5] consequently, a date of mid-third century BC is perhaps most likely for the piece.

DATE: Mid-third century BC.

Unpublished.

EdeG

1 Spaeth 1996, 11.
2 Bell 1990, 65.
3 Uhlenbrock 1990b, 50.
4 Bell 1990, 64.
5 Uhlenbrock 1990, 155, cat. no. 42.

Antefixes with Female Heads

9
Fired clay with painted stucco
H. 9½; W. 9; D. 6⅞ in.
(24.1; 22.9; 17.4 cm)
Etruria, Italy
Frothingham Collection
Kelsey Museum of Archaeology, acc. no. 29113

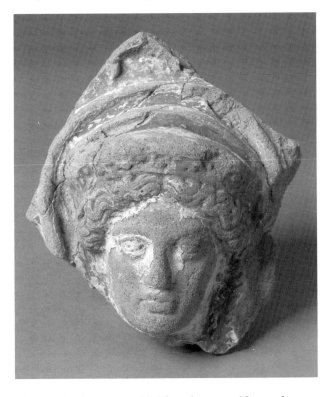

This piece has been reassembled from fragments. No complete edge is intact. The paint and stucco are fading and chipped. In many places—most notably on the face—the polychrome decoration is missing. Dirt and other small incrustations cling to the surface. A hole has been drilled through the underside of the piece.

10
Fired clay with painted stucco
H. 8; W. 8¼; D. 5½ in.
(20.3; 20.8; 14.0 cm)
Etruria, Italy
Frothingham Collection
Kelsey Museum of Archaeology, acc. no. 29114
No complete edge is intact. The back support is missing. The nose and chin are chipped, and the left side of the face is gashed. The paint and stucco are fading and chipped. Some minor dirt incrustations cling to the surface.

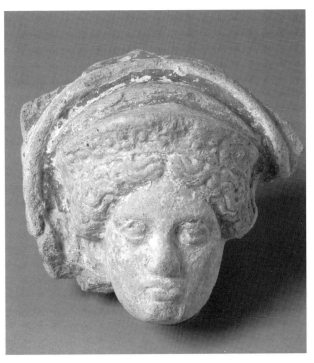

These two virtually identical pieces of terracotta sculpture were presumably made from the same mold. The coarse-tempered, grayish-yellow clay is slightly lighter in the cat. no. 10 specimen. Each depicts a crowned female head with an oval face, triangular forehead and nose, and almond-shaped eyes. The eyes have prominent lids; the lips and chin are full. The hair is parted in the middle and pulled back in wavy bands that frame the face. The hair would have continued in tresses down the sides of the neck, although evidence for this element of the hairstyle is extant on only one of the pieces (cat. no. 9). Both heads are topped by a diadem covered in part by a veil with two folds. The diadem may be embellished with flowers. The ridges of the folded veil merge above the head with the plaque that surrounded the decorative image. In both instances, the face was probably originally painted white and the hair red-brown. The headpiece on one (cat. no. 9) is decorated with a series of bands of red, white, and red-brown paint, while that on the other (cat. no. 10) features yellow (?), black, red, red-brown, and tan (?).

These are antefixes, an architectural element that served as both protective covering and decorative embellishment on the eaves of ancient temples. Like modern roofs of "Spanish tiles," ancient roofs were often composed of horizontal rows of flat tiles with raised edges, the joins between which were covered by superimposed vertical rows of curved "cover" tiles. An antefix was attached to the end of each row of cover tiles in order to close the otherwise open end of the half-cylindrical curved tile. Lining the roof eaves, a string of antefixes would thus protect the underlying wooden roof beams from rainwater and subsequent wood rot. These protective elements, as with the present examples, were usually endowed with sculpted faces that added a decorative touch to the building and that also inspired religious sentiment in the worshipper. The present pieces probably portray maenads, a common motif on Etrusco-Italic antefixes, but the floral motif on the headdresses may also allude to

Persephone, both associated with agriculture and fertility.[1]

The Kelsey examples bear a striking resemblance to an antefix type found at the Etruscan city of Tarquinia. Indeed, the Kelsey pieces were probably cast from the same mold as at least one of the Tarquinia specimens.[2] These were apparently made sometime in the fourth or third century BC.

DATE: Fourth or third century BC.

Unpublished.

EdeG

1 See cat. no. 7, n. 8.
2 The most closely comparable example is in the University Museum in Philadelphia: see Andrén 1940, 69–70, type II:5, pl. 23.

ISIS

11 Sistrum

Bronze, cast and pieced together
Diam. of body 2⁷/₁₆; L. 8⁷/₈; D. 1¹/₁₆; L. of longest rattle 4¹/₂ in. (6.0; 22.4; 2.7; 11.6 cm)
Italy
Bequest of Esther B. Van Deman, 1938
Kelsey Museum of Archaeology, acc. no. 6671
There is some corrosion on the body, especially on the rattles. A green patina covers the entire surface. The metal of the handle has separated slightly at the join after casting. There is a small gouge near the point where the handle meets the upper part of the sistrum. The head of the small feline on the top shows signs of breakage and repair.

The head of the sistrum is roughly rectangular in shape, with an arched top and two upright sides that bend slightly outward from the straight line of the bottom edge. The sistrum has three rattles, each of varying length and made of a thin bar of metal with the ends bent inward to prevent the rattle from falling out when the instrument is shaken. The rattles are not perfectly straight, nor are the three holes in the sides of the sistrum level, so that the rattles lie at a slight angle. The handle of the sistrum, apparently cast in a single piece, has a complex curvilinear profile.

Perched on the top of the sistrum is a feline, perhaps a panther or leopard, with its legs bent beneath its body. It sits with its head raised, gazing at the holder through two small eyes. The animal has a snubbed nose, incised brows, and two ears laid back against the head. The mouth is indicated by a small, thin incised line that ends in two small holes, one on each side of the face. The neck is slightly thick but long and graceful. The body of the animal is somewhat elongated and terminates in a tail, which curves over the back and comes to rest on the animal's right shoulder. The end of the tail is incised to give the appearance of hair.

The sistrum was widely used in the rites of Egyptian deities. Since Pharaonic times, the instrument had been closely associated with the goddess Hathor. Arched sistra

were in use as early as the Middle Kingdom. In the Late Period, cats, kittens, and other animals were added to them. Examples dating to the Ptolemaic and/or Roman period, which are similar to the Kelsey sistrum, include two in the British Museum (acc. nos. 6365 and 25098). In the first, a cat and three kittens crown the arch and in the second, a model, a single recumbent cat.[1]

The sistrum came to be regarded as a symbol of life and adoration. As expressed by L. Manniche, by the time "Plutarch wrote his treatise on Isis and Osiris in the first or second century AD, the arch of the sistrum was seen as the lunar cycle; the transverse bars were the elements; the twin Hathor head depicted Isis and Nephthys, signifying life and death; the cat was the moon; and the act of wielding this complexity of signs was a symbol of the perpetual movement of all beings."[2] Outside of Egypt the sistrum came to be associated with the goddess Isis, the Egyptian deity par excellence, and playing the sistrum in processions formed part of the rites celebrated in her honor (Apul. *Met.* 11.4). The Kelsey sistrum, which comes from Italy and dates to the Roman period, may well have had an equally complex significance. Similar ones must have been used, perhaps by temple songstresses, in rites honoring Isis in her temple in Pompeii.[3]

DATE: Roman.

Unpublished.

DW/EKG

1 Anderson 1976.
2 Manniche 1991, 63.
3 Manniche (1991, 63) discusses the role of songstresses.

12 Statuette of Isis and Horus

Bronze
H. 3⅞; W. 1⅛; D. 1¾ in.
(9.9; 2.8; 3.9 cm)
Egypt
Bequest from Mr. H. C. Hoskier, 1925
Kelsey Museum of Archaeology, acc. no. 4674
There is some green crystalline corrosion and incrusted dirt, particularly at the base.

Isis is seated with Horus on her lap. She wears a traditional Egyptian breast-length wig with a *uraeus* just above her forehead and is crowned by a headdress consisting of a solar disk framed by the cow's horns often found as an attribute of Isis. She has her right hand placed under her left breast and her left arm supports Horus, who lies stiffly across her lap. Horus is nude, his facial features indistinct, and his hair gathered to the right into a sidelock with a *uraeus* above his forehead.[1]

This depiction of Isis nursing the infant Horus conforms to an ancient prototype in Egyptian art. In Egyptian hieroglyphic script, the concept of nursing and rearing a child is related to this motif.[2] Although there are some exceptions in Egyptian art, it is almost invariably Isis and Horus who are portrayed in this manner. This traditional iconographic

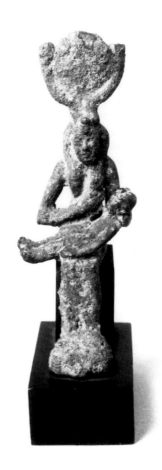

type, which extends into the third century AD, was popular at the end of the Republic and the early part of the empire, when Romans enthusiastically embraced Egyptian symbols and motifs.[3]

This composition of Isis and Horus occurs in a variety of materials and media, such as in gems,[4] statuary both monumental and miniature,[5] and paintings.[6] These numerous representations demonstrate the popularity during the Graeco-Roman period of the goddess's most dominant trait—maternal devotion to her child Horus.[7] The dangers of pregnancy and childbirth, as well as the high infant mortality rate in the ancient world, necessitated invocations to protective deities; Isis was prominent among these dieties.[8] She was a model of womanhood in her roles as protector and nurturer; moreover, this maternal aspect alluded to the compassion and salvation offered to her worshippers.

DATE: 332 BC–AD 200.

BIBLIOGRAPHY: Richards and Wilfong 1995, 16, no. 1.8.

CH

1 Haeckl and Spelman 1977, 22, no. 2.
2 Wilkinson 1992, 33.
3 Symbols such as the lotus, scorpion, crocodile, ibis, sistrum, and pyramid, often associated with Isis, were put on official coins issued in the 80s BC, and in 70 BC Isis herself appeared on Roman coins (Heyob 1975, 96). In the private sphere, decorative schemes also reflected this Egyptianizing trend. One example of this is in the Villa of the Mysteries itself. The Third Style wall painting in Room 2 was filled with Egyptian motifs,

including the depiction of various Egyptian gods and goddesses.

4 Gems and other personal items often acted as protective charms, particularly when images of divinities were placed on them. For an example of such a gem with a traditional Egyptian depiction of Isis and Horus, see Wiegandt 1998, 33, no. 45.

5 For other examples of traditional Egyptian statuettes of Isis and Horus in bronze, see Richards and Wilfong 1995, 16, no. 1.8; Boucher 1983, 47–49, nos. 17–19.

6 For example, a wall painting from a private house in Karanis depicts Isis and Harpocrates (Horus) in such a pose (Gazda 1983b, 39, fig. 68).

7 Tran 1973.

8 Wilfong 1997, 28.

13 Lamp Handle Attachment

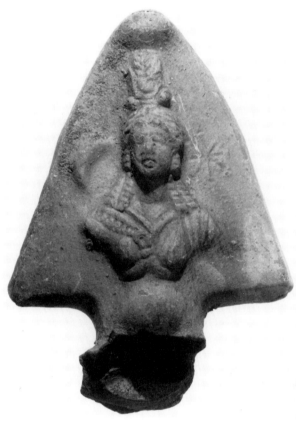

Fired clay
H. 4¹/₈; W. 2¹⁵/₁₆; D. 1¹/₄ in.
(10.5; 7.4; 3.1 cm)
Fayoum, Egypt
Askren Purchase, 1925
Kelsey Museum of Archaeology, acc. no. 3305
The triangular attachment and part of the handle are preserved. The micaceous clay is dark red. The red glaze is especially worn at the top right and on the face. Details of the face are indistinct.

The triangular lamp handle attachment is decorated with a relief bust of Isis, who wears an Egyptian headdress of feathers and a small solar disk between cow's horns. Her hair is Hellenistic in style, falling to the shoulder in two long curls on either side of her neck. Her chiton is fastened

in front by the *nodus Isiacus*. Isis is flanked by a crescent moon in relief at the left and an incised star at the right.

By the Graeco-Roman period, Isis was no longer only an Egyptian deity and was often depicted in hellenized dress. Yet it is within an Egyptian context that one must seek the meaning of the crescent moon and star that flank her here. In Egyptian cosmology, stars are associated with immortality; the moon and star on this lamp may thus be understood as representing Isis's cosmic powers and her mastery over death.[1]

Images of the gods, particularly popular ones like Isis, were regularly used as decorative motifs on even mundane objects. However, the placement of Isis's image on a lamp perhaps carries a significance beyond that of a purely decorative device. Lamps were used as part of funerary assemblages and in connection with household shrines. A letter from Egypt during the Ptolemaic period attests to the use of lamps in ritual practice within the household: "Apollonia and Eupons to Rhasion and Demarion their sisters, greeting. If you are well it is good, we too are well. Please light a lamp for the shrines."[2] Placed before the household shrine, lamps were lit and offerings made to the household gods who protected the family.[3] Isis, who became the personal divinity of many individuals, was often incorporated within domestic religion.[4] Her image on a lamp most likely illustrates such an incorporation.

DATE: Second half of first century BC–early fourth century AD.[5]

Unpublished.

CH

1 Wilkinson 1992, 131.
2 P. Athens 60 (Bell 1948, 94).
3 Gazda 1983b, 31.
4 See cat. no. 41.
5 The uncertain provenance of this piece makes it difficult to date with any precision. It parallels lamps of Broneer Type XXI, which have been dated to the second half of the first century BC through the first century AD (Broneer 1930, 73–76). L. Shier, however, having classified examples of this lamp type from Karanis as B 2.1, which corresponds in general to Broneer's Type XXI, has dated them to as late as the early fourth century AD (Shier 1978, 33–34, cat. nos. 304–38).

14 Lamp Fragment with Bust of Isis

Fired clay
H. 4¹⁵/₁₆; W. 4; D. 1¹⁵/₁₆ in.
(12.5; 10.2; 4.9 cm)
Karanis, Egypt
University of Michigan Excavation, 1931.
Kelsey Museum of Archaeology, acc. no. 22256
The triangular attachment and part of the ring handle are preserved. The fine, micaceous clay is a reddish color. The red glaze is fairly even, except for some wear on Isis's nose and chin. Details of the relief are faded, and there is a crack across Isis's headdress.

Like cat. no. 13, the triangular lamp handle attachment is decorated with a relief bust of Isis in Graeco-Roman style.[1] She wears a feathered headdress with a small solar disk between cow's horns; and her chiton is fastened with a *nodus*

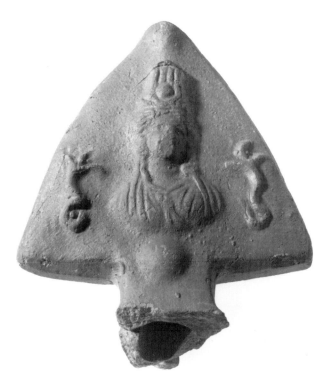

15 Lamp Handle

Fired clay
H. 1⁷/₈; W. 1¹/₄; D. ³/₄ in.
(4.7; 3.2; 2.0 cm)
Karanis, Egypt
University of Michigan Excavation, 1925
Kelsey Museum of Archaeology, acc. no. 6492
The micaceous clay is a pale, slightly reddish color. On the surface are small chips and patchy remains of a dilute red glaze.

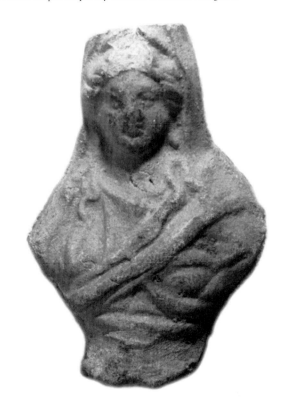

Isaiacus. Her hair falls in ringlets past her shoulders. Curving lotus plants are located to either side.²

The lotus motifs on this lamp fragment had previously been identified as "serpentine forms,"³ but while there are clear examples of serpents associated with Isis,⁴ on the Kelsey lamp handle these curvilinear forms bear a more marked resemblance to the pointed petals and stem of the lotus plant. When meant to convey the symbolism of "creation and rebirth," the lotus in Egyptian art was conventionally depicted in a "floating, upright position."⁵ A similar meaning may have been intended in the case of the lotuses on this lamp.

DATE: Late first century AD.

BIBLIOGRAPHY: Haeckl and Spelman 1977, 28, cat. no. 13.

CH

1 See Broneer 1930, 73–76.
2 The suggestion for the identification of these motifs as lotus buds came from a personal communication with Prof. Janet E. Richards, University of Michigan, May 2000.
3 Haeckl and Spelman 1977, 28, cat. no. 13.
4 See Haeckl and Spelman 1977, 27–28, cat. no. 12.
5 Wilkinson 1992, 121. This is opposed to a depiction of the lotus in which the flower head droops and hangs to one side and is used more simply as a decorative element.

The bust of Isis, with the top of the headdress missing, has a band ring on the back. Isis, represented in Graeco-Roman style, wears a chiton and a himation draped over her left shoulder; long curls extend to her shoulders.

This bust of Isis formed part of one of the most ornate types of Egypto-Roman terracotta lamps.¹ As was standard for this rather uncommon lamp type, the bust was made separately and then attached to the lamp.² This distinctive ornamentation carries the same significance as the images discussed in cat. nos. 13 and 14.

DATE: Late third–early fourth century AD.

BIBLIOGRAPHY: Shier 1978, cat. no. 370, pl. 40.

CH

1 Shier (1978, 35–41, 130) has categorized this piece as a Type B2.5e lamp fragment, corresponding to Broneer's Types XXV and XXVII (see Broneer 1930).
2 For a compilation of other examples of this type, see Shier 1978, 41, n. 385.

16 Head and Torso of Isis

Marble
H. 23⁵/₈; W. 8¹¹/₁₆; D. 5¹/₂ in.
(60.0; 22.0; 14.0 cm)
Karanis, Egypt
University of Michigan Excavation, 1935.
Kelsey Museum of Archaeology,
 acc. nos. 8196 (head) and 25941 (torso)

The face and left ear are missing. The head, severed at the base of the neck, was reattached to the torso in 1978. The right arm below the elbow, the left arm below the forearm, and the legs below the knees are missing. There is a significant amount of wear over the entire surface of the statue. Heavy abrasions and large chips mar the breasts, the left side of wig, and the garment. There are black and yellow incrustations on both front and back and the remains of a round attachment strut on the right shoulder.

This small statue of Isis stands in a traditionally stiff Egyptian pose with the left leg extended forward; however, the body revealed beneath the clinging folds of her long Greek chiton and the fringed shawl tied between her breasts in a *nodus Isiacus* are naturalistically portrayed in Hellenistic fashion.[1] Little remains of the head, except the delicately modeled right ear, the long wing feathers of the vulture headdress on the back and right side of her head, and the ends of the breast-length wig. Her polished ear is pierced by a small drill hole for adorning the statue with earrings.

The head of the statuette was found in the Fayoum district of Egypt at Karanis next to a large state granary in the northeast part of the site (Granary 64, late level C). The body was recovered from the inner court of the North Temple.[2] One explanation for the condition of the head and its separation from the torso proposes that the statue was deliberately destroyed when the North Temple was vandalized by the Christian residents of Karanis sometime in the late third century AD.[3] It is possible that this piece had been an official cult statue of Isis at Karanis. The fact that the statue is made of marble, which is not native to the Fayoum, suggests that it was imported from Alexandria, the center of Graeco-Roman art in Egypt.[4]

A comparison can be drawn to a larger marble statue of Isis found in the northwest corner of the colonnade in the Temple of Isis at Pompeii (Naples Museum, inv. no. 976).[5] The dedicatory inscription on the base of the Pompeian statue attests to the municipal ownership of the sanctuary of Isis.[6] The prominence of the cult of Isis in Pompeii may be judged by the wealth of dedications in the sanctuary and by the fact that of the public buildings destroyed or damaged by the earthquake of AD 62, the temple of Isis was among those completely rebuilt before the eruption of Vesuvius in AD 79.

DATE: Second century AD.

BIBLIOGRAPHY: Boak 1933, 9; Haeckl and Spelman 1977, 24–25, no. 7 (torso only); Gazda 1978, 34, no. 24; Gazda 1983b, 31; Giovino 1992, 3.

CH

1 Gazda 1978, 34.
2 Gazda 1978, 34. See also Boak 1933, 9.
3 Boak 1933, 9–13.
4 Giovino 1992, 3.
5 See Ward-Perkins and Claridge 1978, 2:182, no. 191.
6 The inscription reads: *L. Caecilius Phoebus posuit l[oco] d[ato] d[ecurionem] d[ecreto]*. "Lucius Caecilius Phoebus set [this statue] up in a place granted by decree of the town council." Translation from Ward-Perkins and Claridge 1978, 2:182.

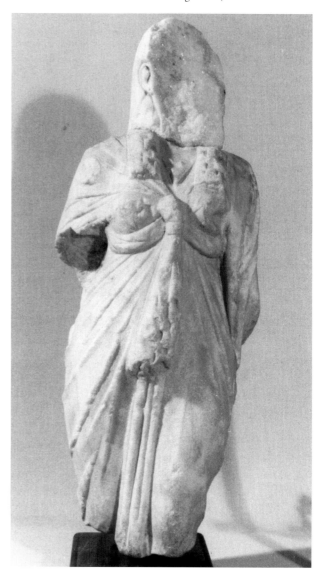

ANATOMICAL VOTIVES

Terracotta votives, including heads, busts, statuettes, and miscellaneous body parts, were offered in sanctuaries throughout the Mediterranean world. In Southern Italy and Sicily such sanctuaries belonged primarily to Demeter and Persephone, but votives were offered to other deities as well.[1] The abundance of terracotta votives from archaeological excavations indicates that their dedication was probably an integral part of a longstanding religious practice, which lasted from the Archaic period until the Roman conquest.[2]

Votive heads first appear in the late sixth century BC at cult sites of west-central Italy, including Campania, and were among the most common body parts found in healing sanctuaries. These votives are believed to represent the part of the body the deity was being asked to heal or thanked for healing. The area of Baiae, which is near the city of Pozzuoli where some of the heads and body parts in this exhibition are believed to have been found, was famous for the medicinal powers of its natural hot springs and the vapors of its volcanic terrain.[3] Female votive body parts such as the Kelsey breast offer us evidence of an active and personal participation of women in ancient Italian religion.

Serial production of such votive terracotta pieces suggests that religious participation was not limited to the upper classes of society. The simple mold technique yielded a votive that most people could afford. Terracotta votives were produced by humble craftsmen, known as *plastes* or *factores*, who worked in the courtyards of their houses with their families, a few apprentices, and the occasional slave.[4] The traces of red paint on some of the votives provide some notion of the bright colors that were applied to enhance the lifelike quality of the dedications after firing.

SK/BL/EdeG

1 Bell 1990, 65.
2 Bell 1990, 65.
3 See Frederiksen 1984, 1–30.
4 Higgins 1976, 105.

17 Votive Head and Neck

Fired clay
H. 8; W. 6¹/₂; D. 3¹/₂ in.
(20.3; 16.6; 9.0 cm)
Pozzuoli, Italy
Purchased from Giuseppe De Criscio, 1923
Kelsey Museum of Archaeology, acc. no. 2797
The surface of the head is a little worn, especially at the edges and on the chin. There are no visible cracks or repairs. Dirt clings to all recessed areas. A red-pink slip covers the entire head and neck.

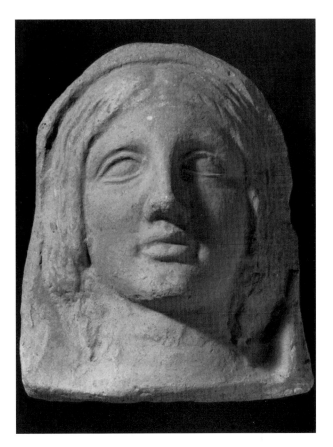

The hollow mold-made votive represents a woman's head and neck framed by a veil. The hair is parted in the middle and falls to either side of the broad face in four wavy strands that end below the ears and above the neck. The facial features are plastically modeled, with lips slightly parted, and almond-shaped eyes strongly outlined and angled downward at the outer corners. Large earrings fall along either side of the neck. The back of the head is flat and pierced by a vent hole 1.8 cm in diameter.

The archaeological context of this head is uncertain. It is said to have been found by one of Giuseppe De Criscio's parishioners. Based on the documented contexts of other terracotta mold-made heads, it was probably an offering dedicated and displayed at a sanctuary in or near Pozzuoli.

This particular votive is part of a mold series that began at Tarquinia in the fourth century BC and then spread throughout Etruria, Latium, and Campania. The votive heads in this mold series are recognizable by their broad, almost square faces, unusual hairstyles, and certain generic facial details, including a depression midway down the front of the neck and a dimple on the chin that is created by a large depression.[1]

The hairstyle of this piece—parted, waved, and falling to the shoulders—is rather unusual but is comparable to two

early-fifth-century BC votives found in Magna Graecia now in the British Museum, one of a standing woman from Locri (BM 1905.3-14.3)[2] and the other of a seated woman from the Temple of Dionysus at Taras (BM 82.2.3.2).[3] Another votive, from Capua and now in the Museo Provinciale Campano (acc. no. 2587), is comparable to the Kelsey example in the treatment of the eyes and the use of the veil.[4]

DATE: Third–second century BC.

BIBLIOGRAPHY: Gazda 1983a, fig. 18; Smithers 1992–93, 48–62, cat. no. 2, fig. 4.

BL

1 Smithers 1992–93, 53.
2 Higgins 1954–59, 1:no. 1235, pl. 170.
3 Higgins 1954–59, 1:no. 1090, pl. 151.
4 Bonghi Jovino 1965, pl. 42, no. 2.

18 Female Votive Head

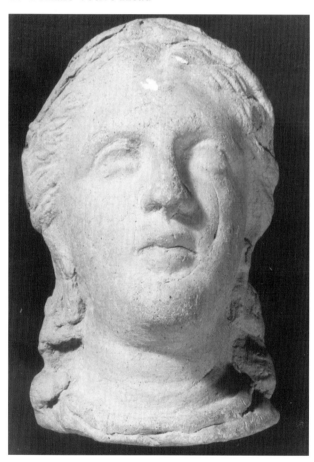

Fired clay with many flecks of black and white mica
H. 7½; W. 4⅞; D. 3¹¹/₁₆ in.
(19.2; 12.4; 9.5 cm)
Pozzuoli, Italy
Purchased from Giuseppe De Criscio, 1923
Kelsey Museum of Archaeology, acc. no. 2798
There are fine surface cracks all over the face; the right cheek has a

deeper vertical scratch. A crescent-shaped crack on the left cheek runs from under the eyelid to the chin. Traces of white pigment remain on the forehead and in the hair above it. The tip of the nose is chipped. The back has several areas of incrustation. There is an uneven vent hole, approximately 2 cm in diameter, at the back of the head.

The female head is hollow, and its neck is oval in cross-section. The woman has full cheeks and a heavy chin. A roll of flesh is indicated on the neck just below the chin. The small mouth with its bowed lips was perhaps intended to be slightly open. The upper and lower eyelids are raised, and the eyeballs are concave. The brows (eyebrows are not represented) continue in a single sweep the arc of the nose. The woman's hair is parted at the center. Above the hair rises an uneven veil.

DATE: 300–250 BC.

BIBLIOGRAPHY: Smithers 1992–93, 54–55, fig. 6.

JMD

19 Female Votive Head

Fired clay with scattered mica flecks
H. 9⁵/₁₆; W. 7½; D. 4¹³/₁₆ in.
(23.7; 19.0; 12.3 cm)
Pozzuoli, Italy
Purchased from Giuseppe De Criscio, 1923
Kelsey Museum of Archaeology, acc. no. 2834
The edge of the veil is chipped, especially at the top above the left eye and on each side at eye level. Two curls have been chipped out of the hair above the left eye. There are small pits and areas of incrustation all over the surface of the face and hair. A large chip is missing along the bottom edge on the proper right side. There is a scratch under the left side of the chin. The area on the right side of the neck just below the chin is chipped and pitted. The forehead and right cheek, the area below the left corner of the mouth, and the neck and shoulders have areas of dark brown spotting. Salts are present on the chin and between the lips. There are some chips and pits in the back. The back has a vent hole, approximately 2 cm in diameter.

This terracotta portrays the head, neck, and bust of a woman to just below the collarbone. A veil stands straight out from the head and projects more at the top than at the sides of the face. On the top of the head is a smooth area of hair between the veil and the curls. This part of the hair is decorated with a pair of raised arcs, which curve out from the veil, and a short line between them. These elements may represent a bow. The hair, parted at the center, is dressed in tight curls on the upper part of the head, with two rows of curls on top and three at the sides of the forehead. Below eye level the hair falls in ringlets half way down the woman's neck. The brows and eyes are not symmetrical: the right eye and brow are lower than the left and are angled slightly downward at the outer corner. The protruding eyelids frame convex eyeballs. The nostrils are not represented. The mouth, slightly to the left of the centerline of nose and chin, is perhaps partly open; the upper lip is larger than the

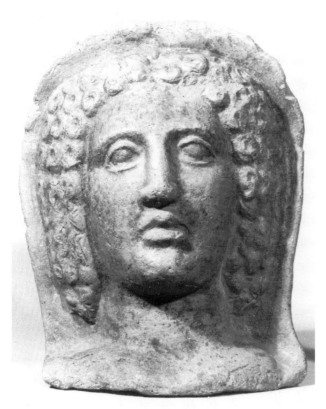

lower. The slight vertical ridges on the back of the piece may be part of the veil.

DATE: c. 300–150 BC.

BIBLIOGRAPHY: Smithers 1992–93, 51–52, fig. 1.

JMD

20 Female Votive Head

Fired clay
H. 9$^{1}/_2$; W. 6$^{3}/_4$; D. 3$^{1}/_2$ in.
(24.3; 17.2; 8.9 cm)
Veii, Italy
Purchased by F. W. Kelsey
Kelsey Museum of Archaeology, acc. no. 1760
The surface is moderately worn overall. A small crack, beginning beneath the chin, extends from the neck to above the eyebrows on the right side of the face, diminishing toward the top. The tip of the nose is broken off, and a large section of the right side of the neck is missing. There are traces of red paint on the locks of hair.

This hollow, mold-made votive portrays a frontal female head with a long, oval face framed by a broad, high veil. The hair is parted at the center, wavy on top, and falls in two rows of globular curls on each side of the face. The facial features—the eyelids, eyes, thin nose, broad cheeks, full lips, and cleft chin—are plastically modeled. The reverse side is

flat and pierced by a small hole (2.9 cm in diameter).

This votive head is identical to one attributed to a deposit from the Temple of Minerva Medica in Rome (no. 2567).[1] The similarities in shape, facial features, and hairstyle suggest the use of the same mold, or mold series, in their production. This votive head corresponds to cat. nos. 17–19 and 21, a broad group distinguished by a veil framing a frontal head.[2] Worn in Roman and Etruscan religious rites, the veil symbolizes piety as well as protection.[3]

DATE: Second half of the third century BC.

BIBLIOGRAPHY: Smithers, 1992–93, 52, fig. 3.

CH

1 Gatti Lo Guzzo 1978, 88, pl. 34, G II, 1.
2 Bonghi Jovino 1965, 88–90.
3 Smithers 1992–93, 50.

21 Female Votive Head

Fired clay
H. 10$^{7}/_{16}$; W. 6$^{1}/_4$; D. 5 in.
(26.5; 15.8; 12.7 cm)
Veii, Italy
Purchased by F. W. Kelsey
Kelsey Museum of Archaeology, acc. no. 1762
The edge of the veil is chipped in several areas, particularly at the

top and lower left. The base of the neck is uneven and has a large chip on the right side. There are minor chips on the nose, chin, and rolls of hair, as well as slight abrasions on the right side of the head. The granular clay is a distinctive deep brownish-orange color.

The female head is hollow but has extremely thick walls (up to 4.5 cm thick) and a very narrow cavity. Like cat. nos. 17–20, this votive head is covered by a veil.[1] Here, however, the veil is narrow, forming a tight curving frame for the oval face and long slender neck. The hair is arranged in short parallel curls above the forehead, extending from ear to ear. One loose wavy strand of hair hangs over each barely discernible ear. The slightly tilted eyes, thin nose, full lips, and chin are plastically modeled. The reverse side is rounded.

DATE: Third–second century BC.

Unpublished.

CH

1 See Bonghi Jovino 1965, 88–90, pl. 42, no. 2.

22 Votive Head of a Child

Fired clay
H. 9$^{1}/_{8}$; W. 7$^{1}/_{8}$; D. 4$^{1}/_{4}$ in.
(23.2; 18; 10.9 cm)
Pozzuoli, Italy

Purchased from Giuseppe De Criscio, 1923
Kelsey Museum of Archaeology, acc. no. 2841
The nose is broken and partly restored. A large crack in the neck is restored. There are incisions on the right cheek. The clay bears inclusions throughout. A vent hole in the back of the head and open bottom reveal a hollow interior and hollow neck.

The crisply delineated features indicate that this may have been an early impression from the mold. The hair is arranged in a series of waves pulled back slightly from the forehead in a classicizing manner, resembling portraits of Julio-Claudian women.

Participation in cultic activity and votive dedication extended to a variety of members of society. That children partook in Dionysiac/Bacchic ritual is attested on the Villa of the Mysteries frieze, where a small boy reads a scroll (group A, figure 2). Another source for possible cultic participation by children comes from an inscription on a statue base in the Metropolitan Museum of Art, which records the names and appellations of various participants in a particular sect of the Bacchic cult. Two masculine names are each labeled *Amphithalei*, or a child whose parents are both living.[1] The dedication of this votive head may have been intended to aid in healing from a physical ailment or in the guidance of a child through a rite of passage, including death.[2] Alternatively, it may have acted as a memorial to a deceased child.

DATE: 300–250 BC.

BIBLIOGRAPHY: Smithers 1992–93, 48–64, cat. no. 5, fig. 8.

SK

1 For more information on the Metropolitan inscription, see ch. 8 by E. de Grummond in this volume.
2 See Ammerman (1990, 39) for votive dedications of body parts as an effort to heal the ailing.

23 Votive Head of a Man

Fired clay with traces of black and white pigment
H. 10¹/₄; W. 6³/₄; D. 5¹/₂ in.
(26; 17.3; 13.9 cm)
Artena, Italy
Purchased by F. W. Kelsey, 1901
Kelsey Museum of Archaeology, acc. no. 2457
There are inclusions, chips, abrasions, and scratches in the clay. The tip of the nose is broken. There is a diagonal break from the left ear to the neck and a crack on the back of the head. The open bottom and vent hole in the back of the head reveal a hollow interior.

The features, which are not sharp, indicate that the head was a late impression from a worn mold. The face has almond-shaped eyes, sharply delineated eyelids, a thick-bridged nose, and a small, pouting mouth. The hair frames the face in a series of loose curls, which are in turn framed by a veil.[1]

 The plasticity of this piece is striking in comparison to other more "masklike" votive heads from Magna Graecia. The youthful features, slight tilt of the head, and treatment of the hair recall the portraits of Alexander the Great.[2] In the context of this exhibition, this male votive head serves as a reminder that participation in this form of cultic activity extended not only to women but to men as well.

DATE: 300–250 BC.

BIBLIOGRAPHY: Smithers 1992–93, 57–59, cat. no. 6, fig. 9.

SK

1 For a similar votive head, see Bonghi Jovino 1965, pl. 42, no. 1.
2 Smithers 1992–93, 58–59. For comparanda, see a marble head of Alexander from Pella, c. 200–150 BC (Pella, Archaeological Museum) and a marble head of Alexander from Kos, second century BC (Istanbul, Archaeological Museum).

24 Votive Breast

Fired clay
H. 2¹/₄; Diam. 3¹/₂ in.
(5.5; 8.8 cm)
Veii, Italy
Kelsey Museum of Archaeology, acc. no. 1776
Some small scratches mar the surface. A chip of terracotta has been removed from the back margin.

This hollow, mold-made terracotta object was fashioned from a buff-colored clay with coarse tempering inclusions. The piece consists of a breast, slightly smaller than life size, resting on a disk-shaped base that extends just beyond the

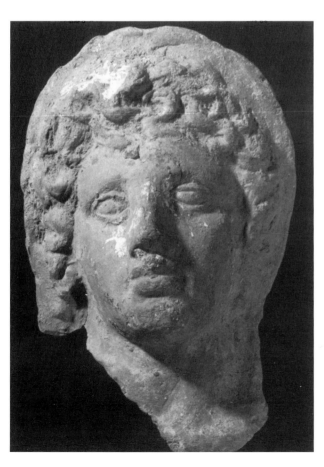

edge of the breast itself. An indication of a nipple appears at the apex of the breast. The base of the object is pierced by a relatively small (1–2 cm), intentionally cut, round hole that would have allowed air to escape when the piece was being fired. The hole may also have served as a point of suspension, as in antiquity votive objects were often mounted along the walls of religious buildings.

Unpublished.

EdeG

tomical detail is rendered only approximately. The leg has a notably bulging calf muscle, while the ankles and toes are summarily indicated. The foot has no toenails, and the toes have a webbed appearance. The underside of the foot is flat rather than arched. The piece can stand upright on its own but tends to rest in a somewhat unstable position.

Unpublished.

EdeG

25 Votive Right Leg and Foot

Fired clay
H. 15$^{1}/_{2}$; W. 3$^{3}/_{8}$; D. 9$^{3}/_{4}$; Diam. 4$^{1}/_{2}$ in.
(39.2; 8.7; 24.5; 11.6 cm)
Veii, Italy
Kelsey Museum of Archaeology, acc. no. 1767
There are scattered small, superficial scrapes as well as chips along the back and side of the ankle, on top of the foot, and in the mid-calf area. The red pigment that coats the piece is deteriorating. Some dirt clings to the surface.

This life-size right foot with lower leg is composed of a tan to pinkish clay with coarse tempering. The entire piece except the underside of the foot is painted a reddish-brown color. The object is hollow, terminating at the top of the calf in a flat surface with a wide, round perforation. Ana-

26 Votive Left Foot

Fired clay
H. 7$^{1}/_{4}$; W. 3$^{1}/_{2}$; D. 10 in.
(18.3; 8.9; 25.5 cm)
Pozzuoli, Italy
Kelsey Museum of Archaeology, acc. no. 2799
This piece is well preserved. There is a small fracture on the underside of the foot. A brown substance—either paint or perhaps a thick dirt incrustation—appears in several crevices. Some dirt clings to other areas, most notably between the toes.

This realistically rendered left foot sits on a thick sandal-like plinth. Fashioned from a dark yellowish-brown terracotta with a coarse, micaceous tempering agent, the piece is mold-made, with a hollow interior. The life-size foot has clearly indicated ankle bones, a slightly exaggerated curve to the instep, and bony, arched toes. The piece terminates

just above the ankle, with a sloped edge that tapers up to a round hole. The sandal-like plinth on which the foot sits follows the contours of the ankles and toes. The plinth is open underneath, except for a strip of terracotta that crosses its width.

BIBLIOGRAPHY: Gazda 1983a, 16.

EdeG

27 Votive Right Hand and Wrist

Fired clay
W. 3^1/$_8$; L. 7^1/$_2$; D. 1^7/$_8$ in.
(8.0; 18.9; 4.8 cm)
Veii, Italy
Kelsey Museum of Archaeology, acc. no. 1773
The ends of three fingers—the little finger in particular—are chipped, as is the underside of the wrist. The tips of the fingers are blackened and may have been burnt. There are clumps of dirt in the interior of the piece.

This right hand and associated wrist, perhaps slightly smaller than life size, were mold-made with a light to deep orange-colored clay that features fairly coarse, micaceous tempering agents. Open at the end of the wrist, the piece has a hollow interior. The anatomy is schematic, particularly along the top of the hand. The fingers are not discrete, and no fingernails are indicated. The underside of the hand

is modeled with more detail: the palm has realistically rounded surfaces and a suggestion of skin creases. A pin-sized, perfectly round perforation—probably used when the object was hung for display—appears on the top of the wrist.

Unpublished.

EdeG

28 Votive Eyes and Nose

Fired clay
H. 2^3/$_4$; W. 4^3/$_8$; 1^3/$_8$ in.
(7.0; 11.0; 3.5 cm)
Veii, Italy
Kelsey Museum of Archaeology, acc. no. 1774
The surface of the nose is scratched, and there is some minor dirt incrustation.

This small, rectangular, slightly convex slab of buff-colored terracotta is embellished with a pair of eyes and a nose. The eyes are almond-shaped, with thick lids. Eyebrows and lashes are lacking. The eyes are close-set on either side of the small, triangular nose, which has no nostrils. The back of the piece is undecorated.

Unpublished.

EdeG

THE MAJORITY OF THESE VOTIVE BODY PARTS are thought to have come from the ancient Etruscan city of Veii in central Italy. Indeed, excavations at Veii have yielded other, similar breasts,[1] legs,[2] hands,[3] and plaques depicting eyes and a nose.[4] Analogy with other artifacts from Veii suggests that cat. nos. 24, 25, 27, and 28 were made sometime between the third and first centuries BC. A more refined date cannot be established for these pieces, as such votive body parts were made with little variation in style or manufacturing technique over the span of these three centuries.[5] The votive foot (cat. no. 26), from Pozzuoli (ancient Puteoli) on the Bay of Naples, may be later in date than the Veientine

pieces. It was probably made in the Roman period (first century BC or later), although, as with the Etruscan votives, a precise date cannot be established.

EdeG

1 Perhaps the most comparable example of a votive breast from Veii is that presented by Vagnetti (1971, 95, pl. 53 T 6). Another breast from Veii is reported by Comella and Stefani (1990, 107, pl. 34a). G. Bartoloni has also published three votive breasts thought to be from Veii (1970, 266, pl. 23a). (The provenience of the collection of votive objects that Bartoloni discusses is unknown, but Bartoloni surmises that the objects were originally from Veii.)
2 Bartoloni 1970, 264–65, pl. 21a.
3 Bartoloni 1970, 265, pl. 20b; Vagnetti 1971, 95, pl. 52 T 4; Comella and Stefani 1990, 105–6, pl. 33a–b.
4 Vagnetti 1971, 95, pl. 53 T 2; Comella and Stefani 1990, 105, pl. 32d.
5 Bartoloni 1970, 269.

29 Votive Statue

Fired clay
H. 7¹⁄₈; W. 6⁵⁄₈; D. 5¹⁄₂ in.
(18.2; 16.7; 13.8 cm)
Veii, Italy
Kelsey Museum of Archaeology, acc. no. 1758

The statue is broken at mid-calf, and only the lower legs and feet remain. Some terracotta has been chipped away from the surface of the statue pedestal just beneath the outer part of the right foot. The first toe on the right foot is also chipped, as is the fourth toe of the left foot. Some dirt clings to the surface and the hollow interior of the piece.

This fragmentary, less than life-size statue appears to have been mold made, although hand modeling is evident in a number of places, for example, along the terracotta slab between the two feet. The piece is of a solid, heavy construction but has a hollow core. It is fashioned from a light pink to gray terracotta with frequent coarse tempering agents, most notably mica.

This pair of slightly out-turned feet probably belonged to a statue of a standing figure. The feet rest on a thick pedestal that, from the side, resembles the soles of shoes. This pedestal, however, extends between the feet and up between the figure's legs. There is minimal anatomical detail: toes and toenails have been incised, but the ankle bones are not differentiated from the rest of the ankle area. The lower hem of a swath of drapery extends just below the upper margin of the broken piece. Three folds and a simple border characterize the drapery, which rises at a slight angle from the wearer's right to left calf. The back of the statue is undecorated. The base is perforated with two holes, one under each foot, that would have allowed air to escape while the statue was being fired.

The vowing of statues to deities as a thanks offering or to increase the efficacy of a prayer was a common practice in the ancient world. Such statues were often images either of the god addressed or of the worshipper himself. In the present case, the image seems to be of the worshipper, as the sloping hem of the drapery suggests a toga—usually human rather than divine attire. Other fragments of comparable statues have been found in deposits of votive goods at Veii, the Etruscan site from which the Kelsey piece comes.[1] Like many industrial-quality votive items, these statues are difficult to date. The present piece may belong to the third or second century BC.

DATE: Third or second century BC.

Unpublished.

EdeG

1 Comella and Stefani 1990, 39–40, pl. 10b–d. See also Gatti Lo Guzzo 1978, 143, pl. 54v, 2.

30 Head of a Figurine (Possibly a Maenad)

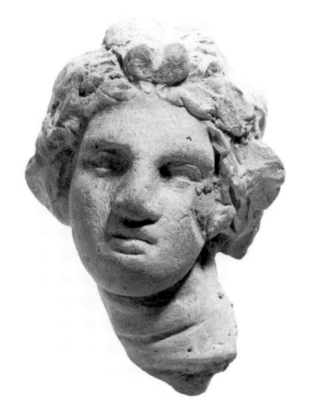

Fired clay
H. 1¹/₃ in.
(3.3 cm)
Taranto, Italy
Purchased by F. W. Kelsey, 1893
Kelsey Museum of Archaeology, acc. no. 25460
The head is a fragment of a larger terracotta figurine. It is broken at the base of the neck and is chipped on the right side of the face. Other chips are missing from the base of the hairline on the left and right sides.

The head and neck are slightly turned, suggesting motion in the pose of the body of the figurine, no longer preserved. There is a prominent fold in the neck. The melon coiffure is composed of six large sections pulled back into a bun at the nape of the neck. There are two small pinched pieces of clay at the crown of the head, hand modeled rather than cast in the mold used to produce the figurine. In addition, two flat, roughly circular hand-modeled pieces of clay added to the hair on the right side of the head may suggest a leafy wreath with berry clusters.

This head is probably from a Tanagra-style figurine. This example comes from Taras, a Spartan colony located on the southern coast of Italy. Taras (Latin Tarentum, modern Taranto) was an important center of production for such figurines within Southern Italy, and the influence of the style of Tarantine figurines was pronounced in other regions of Magna Graecia, including Campania.[1] Tanagra-style figurines were suited to numerous purposes. They were used as votive dedications, grave goods, and possibly dolls. Tanagra figurines, subsequently, display a range of subject matters and poses. They often depict women engaged in daily life activities or women as worshippers. Hand-modeled clay could be added to a more generic type to make it more suitable for a given context or to change the subject matter. This example features a hand-modeled wreath or crown, which may suggest that this figure was a maenad or other sort of follower of the Greek god Dionysus. Maenad figurines in Tanagra style have been found at other sites in Southern Italy, notably Locri.[2] The hairstyle and wreath on an example from Locri are different from those on the Kelsey example, taking the form of spiky additions to the mold-made hairstyle, but the head of the figurine is turned slightly to one side, as in the Kelsey example.

DATE: Fourth–second century BC.

Unpublished.

MSB

1 Bell 1990, 65.
2 Bell 1990, fig. 53.

31 Figurine of Dancer (Possibly a Maenad)

Bronze
H. 2³/₄ in.
(7.0 cm)
Italy
Bequest of Esther B. Van Deman, 1938
Kelsey Museum of Archaeology, acc. no. 6709
The figurine is in excellent condition. There are traces of green-colored deposits in the recesses of the drapery. There is a remnant of a support for the figurine under its feet, but the metal is of a different color from the rest of the figurine, more heavily rusted, and may be modern.

The figurine depicts a dancing woman, with hands held away from her body. Her clothing, which consists of a tunic over a longer robe, is propelled away from her body by her movement.

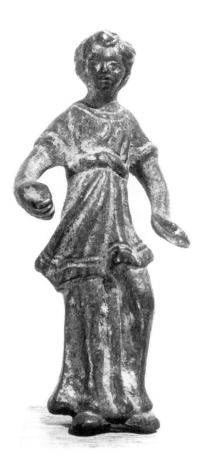

32 Cymbals

Bronze
Cymbal A: Diam. 4⁵/₈; Th. ⁵/₁₆; L. of preserved chain 1¹/₁₆ in. (9.5; 0.7; 2.2 cm)
Cymbal B: Diam. 4⁵/₈; Th. ⁵/₁₆; L. of preserved chain 7⁵/₈ in. (9.5; 0.7; 19.6 cm)
Rome
Bequest of Esther B. Van Deman, 1938
Kelsey Museum of Archaeology, acc. no. 6672
There is corrosion over the whole surface of both cymbals, with flaking at some points and cracking on the outer edges. On cymbal B, the rim is broken off for a length of 3 cm. The chain is broken into two pieces.

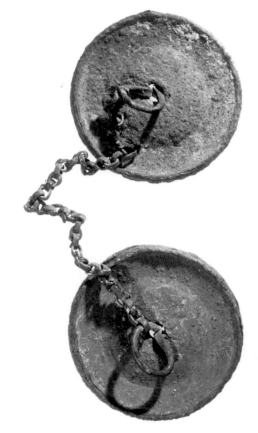

Etruscan and Italic bronze figurines, similar to this one, are found in a variety of contexts, including tombs, sanctuaries, and even houses.[1] They are small in scale and were used as freestanding votive dedications or as decorative applications to furniture or other items such as *cistae* or bronze vessels. This example probably belongs to the latter category of statuette, both because it is smaller in scale than most statuettes and because of the subject matter. Dancers, athletes, and warriors were popular motifs in applied statuettes.[2] In the Hellenistic period, Dionysiac subjects also became popular for such applied bronzes,[3] and it is possible that this dancer is a maenad or a woman engaged in religious activity. The hairstyle and dress of the figurine suggest a date in the third or second century BC, nearing the end of the period in which such figurines were produced.

DATE: Third or second century BC.

Unpublished.

MSB

1 See Cristofani 1985; Richardson 1983.
2 Galestin 1987, xii.
3 Galestin 1987, 155.

Both cymbals are circular, though there is a slight variation in the shapes of the circles. On both obverses, a raised outer rim dips inward toward the center, creating a slight furrow around the perimeter. The center is raised in a secondary circle 6.3 cm in diameter. A small, round hole in the center of each cymbal contains an oval ring, which was made by bending a thin strip of bronze into a circle and folding back the two ends to affix the ring. The chain connecting the cymbals is composed of small bronze links. The reverses of the cymbals have interior circular depressions with slightly raised edges. The edges slope downward to form the rim of the cymbal.

The shape of the cymbals can be compared to that of two examples in the British Museum (acc. nos. 6373 and 6710). All have similarly curving rims and circular depressions. No exact parallels have been found for the means by which the chain was attached to the body of the cymbal. However, a pair of crotals, similar to modern castanets (such as British Museum 26260), demonstrates a similar

means of affixing a cord to join the two parts of the instrument.[1] This piece employs a bent length of flat metal to which a leather band is joined.

Cymbals were frequently used in religious rituals and processions. The *rhoptra*, instruments used in Bacchic worship and rites, were cymbals joined together to create a percussive sound.[2] The maenad in the frieze of the Villa of the Mysteries holds cymbals similar in form to those in the Kelsey Museum and illustrates how such instruments were played.

DATE: Roman.

Unpublished.

DW

1 Anderson 1976.
2 See West 1992, 125–26.

33 Lamp with Dancing Maenad

Fired clay
Diam. 3¹/₈; Diam. at base 1³/₄; H. 1¹/₈ in.
(8.0; 4.4; 3.0 cm)
Purchased by F. W. Kelsey on Capri[1]
Kelsey Museum of Archaeology, acc. no. 418
Part of the top of the lamp has been broken off, and there is a repair in the center. Approximately one half of the lamp is missing—the spout and a portion of the side with the spout. The surface bears evidence of poor glazing or firing.

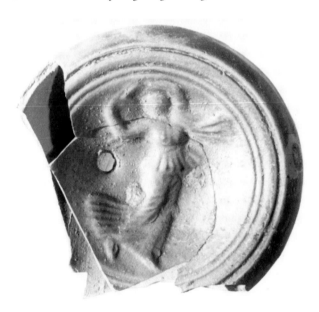

The mold-made lamp is of a reddish-buff clay, with a light reddish-brown glaze, traces of which are evident on the body of the lamp. The lamp, originally circular in shape with a plain rim containing three grooves, is of Loeschcke type VIIa.[2] The discus contains an image of a maenad wearing a flowing chiton, which is belted at the waist. A mantle flows over her left arm and flies above her head. The maenad's head is turned to the side, and she holds an object, perhaps a

tympanum, in her hands, raising it above her head. Her left leg is placed slightly behind her, and she lifts her right foot off of the ground. The maenad does not correspond precisely to any known Neo-Attic maenad type, but it does resemble a number of maenads in the Neo-Attic repertoire.[3]

The lamp is difficult to date, as it lacks both spout and part of one side. However, a date of the Roman period can be suggested based on the popularity of Neo-Attic maenads in decorative schemes of the empire.

DATE: Roman.

Unpublished.

DW

1 The Object Registry indicates that this item was purchased by Kelsey from an artist who was residing at the Villa Chambimi, located at the time near the Hotel du Louvre. The lamp was said to have been found on the land owned by the villa.
2 For lamp typology, see Loeschcke (1919, 25, fig. 2, 49, fig. 7) and Bailey (1980, vii–xii).
3 See Touchette 1995.

34 Head of a Woman from a Votive Statuette

Fired clay
H. 2¹/₄; W. 1³/₈; W. at base 1; D. at forehead 1¹/₄;
 D. at base ¹³/₁₆ in.
(5.7; 3.5; 2.55; 3.15; 2.0 cm)

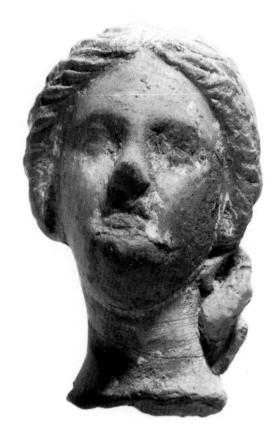

Said to have been found at Taranto, Italy
Purchased by F. W. Kelsey in Pompeii, 1893
Kelsey Museum of Archaeology, acc. no. 25456
The head is broken at the neck. The face is slightly weathered and pock-marked, and there is a gouge in the back of the head. There are red paint traces on the hair and either white paint or an incrustation in three areas: the hair, the bottom of the neck, and the left side of the face. A crack is visible across the tip of the chin, and another diagonal crack runs across the front of the neck. Restoration is visible under the right side of the hair, and the hair has apparently been reattached to the neck.

The line from the mold used to make this terracotta head is visible down the right side of the neck. The hair is parted in the middle and loosely pulled back away from either side of the face. The two sides meet at the base of the head and are again separated into two curls that were added on to either side of the neck. The long curl is still in place along the right side of the neck, while the one that originally lay against the left side of the neck is now missing. The folds of the neck are demarcated as Praxitilean "rings of Venus." The face, tilted upward, has a triangular forehead, blurred eyelids, and a full chin. The head may have belonged to the Tanagra type of statuette found in Southern Italy at sanctuary sites and in women's graves (see cat. nos. 77–79).

DATE: Late first century BC–first century AD.

Unpublished.

BL

35 Red-figure Skyphos

Attributed to the Fignano Painter
Fired clay
H. 6^1/$_2$; D. 5^{15}/$_{16}$; D. foot 3^{15}/$_{16}$ in.
(16.5; 15.0; 9.9 cm)
Campania, Italy
Arthur M. Sackler Museum, Harvard University Art Museums,
 Bequest of Dr. Harris Kennedy, Class of 1894
Acc. no. 1932.56.39

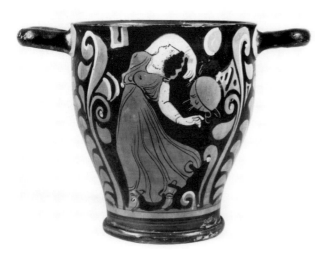

Side A depicts a woman in three-quarter profile dancing on tiptoe, clad in necklace and bracelets, with her chiton billowing out behind her. She throws back her head and her arms, holding a tympanum behind her arching back. Stylized vegetal decoration appears on both sides of her body and continues beneath the two horizontal handles. Side B depicts a man in profile wearing a cloak and a diadem.[1]

The tympanum allows the woman to be identified as a maenad; the male figure on the reverse of the vase may be Bacchus (Dionysus) himself, as indicated by the diadem. A maenad, literally a "mad or raving woman," is a mortal female induced into a temporary state of ecstasy by Bacchus (Dionysus).[2] The uncontrolled frenzy of Euripides' maenads (in his late-fifth-century BC play, *The Bacchae*) includes handling snakes, ripping apart wild animals and eating the raw meat, and, finally, dismembering Pentheus. The behavior of real women in Bacchic cults was probably much more subdued, involving dancing and music-making, as represented here.[3] One scholar has argued for the connection in the Greek world between maenadism and female rites of passage such as marriage and motherhood.[4]

In Attic vase painting, maenads appear in a variety of poses and activities, always clad, and are often found in the company of satyrs. The image of the dancing maenad, both clothed and nude, becomes a visual trope in Roman art and is ubiquitous in Neo-Attic relief sculpture.[5] A nude dancing maenad often appears on Bacchic sarcophagi, such as the one in the Kelsey Museum (cat. no. 58). She also appears in the Villa of the Mysteries frieze, her cymbals raised high above her head and her garment billowing out behind her (group F, figure 24).[6]

DATE: 350–325 BC.

BIBLIOGRAPHY: Houser 1979, no. 16; Mayo 1982, no. 87.

SK

1 Houser 1979, cat. no. 16.
2 As opposed to a nymph, who is a mythological member of the Dionysiac *thiasos*. For more on the distinction between maenads and nymphs, see Hedreen 1994. See also Benson 1995, 381–83. For a general overview on maenads, see *OCD*3 s.v. "maenads"; for maenadism in Greek religion, see Henrichs 1978; 1982, 137–60, 213–36; Bremmer 1984; 1994, 78–80.
3 See Benson 1995, 382.
4 Benson 1995, 382.
5 For extensive bibliography and a comprehensive survey of representations of maenads in Greek and Roman art, consult *LIMC* s.v. "mainades." For Neo-Attic reliefs, see Touchette 1995.
6 For visual prototypes of the dancing woman on the Villa of the Mysteries frieze, see Houtzager 1963, 50–51, 113, figs. 50–51, 60, 62, 64.

36 Campanian Red-figure Bell Krater

Attributed to the Boston Ready Painter
Fired clay with added white and yellow paint
H. 13; W. 12^1/$_4$; D. 12^1/$_8$ in.
(33; 31.4; 31 cm)

176

Fabric from Cumae, Italy
Gift of Mrs. Francis W. Kelsey
Kelsey Museum of Archaeology, acc. no. 28809
The vase was broken into many fragments and has been restored.
There are few inclusions and some losses to the painted decoration.

Beneath each handle is painted a stylized palmette and foliate design, and beneath the lip a stylized band of laurel leaves. A band-and-wave motif encircles the vase beneath the figural frieze.

Side A: The seated central figure is flanked by two attendant females, both wearing peploi and with hair tied in a bun. The details of the central figure, whose body is rendered in applied white, have disappeared. The figure's right arm is visible, held out to the side, but the right arm and details of musculature cannot be differentiated from the blurry torso. The figure is half-draped, seated on a *klismos*, and holds an unidentifiable, small round object in his or her right hand. A female in profile faces the central figure in knee-raised position, placing one foot on a stool. She holds a mirror in both hands. A stylized rosette between the figures may represent another mirror. The woman at the right of the composition is in three-quarters view. She approaches the central figure while holding a situla in her left hand, fillets in her right. Behind her head hangs a bunch of grapes tied with fillets. Between her and the central figure is a lyre, below which is painted a thymiaterion (incense burner).

Side B: Three rapidly sketched youths wear himatia. The figure on the left and in the center face each other; the figure on the right observes. Between the youths are painted rectangular *cistae* decorated with an X, and on either side of the scene are crossed tondi. The composition of three standing youths on side B is ubiquitous in South Italian vase painting. Sometimes the youths wear diadems. In comparison with other examples, the drapery and features of these figures are notably generalized.

The rapid execution of the painting and the subsequent losses of paint make it difficult to determine the gender of the central figure on side A.[1] The curve of the chest seems to indicate the silhouette of breasts, and the figure is rendered in applied white, a convention used for female figures. Although women, with the exception of hetairai, do not normally appear nude in Attic vase painting, half-draped, bare-chested female figures do frequently appear in South Italian red-figure vase paintings, particularly those of Campania and Sicily.[2] The other personage to appear half-draped, seated on a *klismos* and in the company of attendants, is the effeminate god Dionysus.

One scholar identifies the scene as women making offerings to a victorious citharoedeus.[3] Indeed, this subject appears on another vase by the Boston Ready Painter in Naples,[4] but as an interpretation for the Kelsey vase it is problematic, since the central figure appears to be female. The composition of a seated woman with attendants appears on the painter's name vase.[5] On this vase, the figures hold a mirror, situla, *cista*, and a fan. A bird sits on the seated figure's lap, and a thymiaterion rests on the groundline. Such scenes, taken together, are surely references to cultic activity. Mirrors may signify the realm of Aphrodite and Eros (adornment and attraction) or of Orpheus; the bird (perhaps a swan) may signify Apollo or Aphrodite; the lyre

Apollo or Orpheus; grapes the realm of Dionysus. Situlae, used for libation or ablution, and thymiateria may refer to a number of cults.[6] Thus, the Kelsey scene is imbued with symbols of a variety of cultic activities and religious beliefs.

This vase attests to the longstanding representation of "female space"—of women engaged in cultic activity, the precise nature of which cannot be determined. The painting is part of a Magna Graecian visual corpus comprising representations of female participation in cult, imagery that reappears in the painted frieze in the Villa of the Mysteries.

DATE: Fourth century BC.

BIBLIOGRAPHY: *CVA* USA 3, University of Michigan 1, pl. 31.2a–b; Trendall 1967b, 516, no. 4/609, pl. 201.3–4.

SK

1 Trendall (1967b, 516, no. 4/609) identifies the central figure as female. Wilhelmina van Ingen (*CVA* USA 3, University of Michigan 1, pl. 31.2a) identifies the figure as male.
2 Compare the clearly delineated breast of figures on Göttingen J 51 and Syracuse 43011 in Trendall 1967b, 555, no. 4/987, pl. 217.3–4; 585, no. 4/6, pl. 226.1–2. The white semi-nude male figure on the Kelsey volute krater (cat. no. 1) probably represents a sculpted image. See Root 1984–85, 3.
3 *CVA* USA 3, University of Michigan 1, pl. 31.2a–b.
4 Naples 808 in Trendall 1967b, 516, no. 4/608, pl. 202.1.
5 Boston 63.3 in Trendall 1967b, 516, no. 4/607, pl. 201.1–2.
6 As suggested in an unpublished essay by Felicity Devlin on file in the Kelsey Museum.

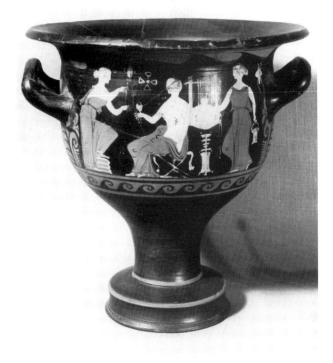

DOMESTIC CULT AND SHRINES

Room 5 in the Villa of the Mysteries has sometimes been thought of as a place where the rites of Dionysus/Bacchus/Liber were perfomed, but there is no direct evidence to support this claim. The only archaeological trace of cultic activity within the Villa of the Mysteries are shrines of the household gods, located in the kitchens and productive areas of the villa complex.

The objects in this section of the exhibition are associated with the rituals and cultic practices of Roman domestic religion and come from shrines within the home. There are four different types of house shrine, known generally as *lararia*.[1] The simplest is a niche or rectangular recess in the wall. Niche shrines were sometimes elaborated with paint, added stucco, or a piece of tile intended to function as an offering receptacle, but often they were plain and undecorated. The second type of house shrine is a niche elaborated by a relief stucco aedicular façade. The third type is a small architectural *aediculum* standing atop a podium attached to a wall. The fourth is the painted type of house shrine, often (but not always) including depictions of the family *lares*, *penates*, and *genius*, combined with snakes eating offerings.[2]

Regardless of type, each shrine performed the same function within a home, as the site for domestic worship, and could be personalized according to the taste of the owner. Even the small niches, which are generally assumed to be the least expensive and lowest quality, could contain statuettes in precious metals of the same deities found in paintings, including *lares*, *penates*, or deities such as Venus or Liber. For example, the small bust of Isis from Mount Holyoke (cat. no. 41) is thought to have been found in a shrine, indicating that the family living in that house venerated Isis.

The word that most scholars use to refer to household shrines, *lararia*, is etymologically linked to *lares*, whose images are the most common found in Roman domestic shrines. Nevertheless, the use of this term and the stress it places on the *lares* as the primary deities in domestic cult might imply that domestic cult existed as a uniform belief system in which *other* deities were peripheral, even if their images are frequently included in family shrines. Worship of the *lares*, *penates*, and *genius* was a large component of domestic religion, yet the addition of small statuettes of other deities or painted figures allowed each family to personalize not only its shrine but its form of domestic worship to suit its particular needs and beliefs.

MSB

1 Known generally, that is, to modern scholars. The word *lararium* itself first appears in the *Historia Augusta*, written in the late third and early fourth centuries AD. A Roman living in the first century AD would not have been familiar with this word and probably would not have used it to refer to any of the shrines found in Pompeii. Modern scholars use this word to refer to any household shrine, not just ones with depictions of the family *lares*. See Boyce 1937, 1–18, and Orr 1978, 1575–78.

2 See following entries for more discussion of the *lares* and *genius*. See also ch. 7 by M. Swetnam-Burland in this volume for a more in-depth discussion of the practices and deities involved in domestic cult.

37 Shrine Painting

Painted plaster
H. 31; W. 61³⁄₄ in.
(78.7; 157 cm)
Villa found in Piazza del Mercato, Boscoreale, Italy
Field Museum Purchase
Field Museum of Natural History, acc. no. 24658
The right side and corners of the fresco are heavily restored with modern plaster. The white ground of the painting is stained in the upper zones with streaks of yellow and brown, and in the lower right corner with a dark smoky color; these marks are not pigments but perhaps mineral deposit or smoke stains.[1] The surface of the fragment is pitted and cracked. A chip of plaster is missing at the feet of the *paterfamilias*. The left hand and arm of the child at the far right of the sacrifice scene are covered by the modern plaster. The child's legs and knees are faintly marked and may have been drawn in at the time of restoration.[2] Chips and faded pigment obscure the features and left arm of the woman to the left of the altar.

The fresco is divided roughly in half by a groundline; above the groundline is a scene of sacrifice and below it a large crested serpent. The sacrificial scene is composed of five figures. To the far left is a musician playing an *aulos*, or double flute. He wears a whitish togalike garment and a green wreath. The musician's skin is light brown, and the features of his face are articulated with black paint. To his right stands a small child or *camillus*, carrying a platter of offerings in his right hand and two garlands in his left. He wears a white garment and has brown hair and light brown skin. To the right of a child stands a woman with whitish skin and brown hair, wearing a toga or *palla capite velato*, covering her head in a manner appropriate to sacrifice. Under the veil the figure wears a wreath, but her facial features and left arm, probably making a libation or sacrificing something on the altar, are rendered indistinct by damage to the surface of the fresco. A remnant of pink pigment on her right arm may represent a metal bracelet or other item of jewelry.[3] To the right is an altar with a fire, painted with red and yellow veining that imitates marble. Two small green trees flank the altar. To the right of the altar stands the father of the family. He is the tallest of the figures, wears his toga drawn over his head and wreath, and extends his right hand over the fire, making a sacrifice. He has light brown skin and brown hair. To his right stands a second child or *camillus*, holding ribbons in his right hand. Below the groundline is an undulating crested snake with an open

mouth and extended tongue. The underside of the snake is painted yellow with brown stripes, and the back is brownish red. The crest of the snake is bright red.

This painting was probably associated with a domestic shrine, in the form of a niche or *aediculum*, where the family members could make offerings. Because the painting does not feature the *lares*, it is likely that statuettes of them were placed in the shrine niche, along with the patron gods of the family members.[4] The scene features family members sacrificing to the household gods, including the mother (*materfamilias*) and father (*paterfamilias*), two children or slaves, and a youth. The snake represents a protective spirit, sometimes thought to be a manifestation of the *penates*. In Pompeian shrines, snakes are frequently shown eating offerings left for them by the family. These snakes were thought to be chthonic deities, living under the ground. In this example the snake is literally beneath the ground level.

DATE: First century AD.

BIBLIOGRAPHY: de Cou 1912, 171–73, no. 24658; Winkes 1982, 23.

MSB

1 De Cou 1912, 173.
2 De Cou 1912, 172.
3 De Cou 1912, 172.
4 For examples of figurines of the *lares*, see cat. nos. 39, 40.

38 *Togatus* or *Genius*

Bronze
H. 5¹/₈ in.
(13.0 cm)
Provenance unknown
Museum Purchase
Royal Ontario Museum, acc. no. 956.7

The statuette has a dark green-brown patina and is in good condition. Its left foot is missing, as well as the eyes and a stripe on the right sleeve, originally inlaid in another material. A crack in the back of the statuette was repaired in antiquity. The surface is chipped on the forehead and right hand.

The statuette depicts a man, probably the *paterfamilias*, wearing a toga and holding an incense burner in his right hand. His left leg is bent, and his outstretched left hand originally probably held a *patera* or lump of incense.

Depictions of the *paterfamilias* or *genius* of the family are commonly included in shrine paintings.[1] Statuettes like this example are relatively rare. The *genius* of the *paterfamilias* was treated like a family god, standing for the ancestral lineage of the family. The *paterfamilias*, as in this instance, is generally depicted sacrificing to the protecting gods of the household, and the image therefore also demonstrates the piety of the family members and their veneration for the *lares* and *penates*.

DATE: Roman.

BIBLIOGRAPHY: Mitten and Doeringer 1967, no. 243.

MSB

1 See, for example, the shrine from the House of the Vettii, VI.15.2, as well as cat. no. 37.

39 Statuette of a *Lar*

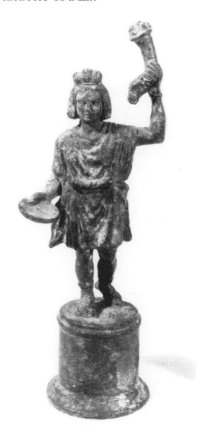

Bronze
H. 6³/₄; D. at base 1³/₄ in.
(17.0; 4.5 cm)
Provenance unknown, possibly Italy
Purchased by F. W. Kelsey
Kelsey Museum of Archaeology, acc. no. 29738
The completely intact figure is in good condition, with surface details well preserved and little or no visible wear. There are traces of a blue-white residue in the interior of the hollow base, a brownish incrustation in the folds of the tunic, and green corrosion on much of the exterior of the figurine.

The statuette depicts a *lar* standing on a circular base, with a banded rim and foot. The *lar* is positioned in almost contrapposto stance with his right foot in front of his left. In his left hand he holds a *rhyton* filled with fruit and in his right a *patera*, or libation bowl. He wears open-toed boots and a tunic with a shawl (perhaps a *chlamys*) tied around his waist. The *lar*'s hair is roughly chin length with vertical ringlets framing his face. A bun at the crown of the head is composed of three knots.

The *lares* were deities commonly worshipped within Roman houses and were thought to be the protectors of those living within, promoting their general safety and welfare. Family members dedicated gifts to them to celebrate rites of passage and made offerings of grain, fruit, honey, and wine.[1] This example has some atypical features. *Lar* figurines, especially those from Pompeii and the Campanian region, usually have short-cropped, curled hair that lies close to the head or sometimes curled hair of roughly shoulder length. The Kelsey *lar*, however, has a distinctive hairstyle not seen on other extant statuettes. Unusual as well is his stance. These figurines generally stand on tiptoe in a dancing pose, with their tunics flaring to either side and their heads inclining slightly downward to look at the sacrificial implements they hold. The shawl tied around the waist in this example, itself an unusual feature, approximates the "flare" seen on most *lares*, but the figurine itself stands motionless and has a strictly frontal pose.

Mitten argues that, in fact, there are two different types of *lar* statuettes: the "dancing type" described above and also a "standing type" more similar to the stance of the Kelsey *lar*.[2] It is possible that this second type is later in date and is Late Antique rather than Imperial.[3] The closest parallel to the Kelsey *lar* is found in a second–fourth-century AD statuette in Providence (RISD 62.061), an example that is similar in hairstyle and attribute and features a similar shawl tied around the waist. It is possible, based on this comparison, that the Kelsey *lar*, too, dates to the third or fourth century AD. It is also possible that this example is a modern reproduction of a *lar* figurine, as it conflates different aspects of both the "standing" and "dancing" *lar* types.

DATE: Second–fourth century AD or modern reproduction.

Unpublished.

MSB

1 See also ch. 7 by M. Swetnam-Burland in this volume; Orr 1978.
2 The "standing type," like the Kelsey *lar*, stands flat-footed, and there is no indication of motion. The type differs from the Kelsey example, however, in that the feet are placed equally under the figure, though one knee is slightly bent. The Kelsey

example seems to combine both types. Like the "dancing" type, one foot is placed in front of the other, but like the "standing" type, both feet are depicted as if standing on a flat surface. For discussion of the types, see Mitten 1975, 190.

3 Mitten 1975, 190–93. See below, however, for an example of this type from Pompeii dating to the first century AD.

40 Statuette of a *Lar*

Bronze
H. 2³/₄ in.
(7 cm)
Rome
Purchased by F. W. Kelsey, 1901
Kelsey Museum of Archaeology, acc. no. 1512
The statuette is in excellent condition, though cleaning and treatment for bronze disease in 1975 have removed its original patina. A deep hole bored into the center of the back is modern, probably the result of a support used for display. A second, shallower drill hole is located over the back of the left leg.

Like the *lar* discussed above (cat. no. 39), this one wears a tunic, high boots, and in addition a five-pointed crown. In his right hand he holds a *patera* scored with five dots and in his left a *rhyton*.

This *lar*, remarkable for its small size, is an example of the "standing type" discussed above. Its closest parallel was found in a vineyard in Pompeii.[1] The example from Pompeii is also 7 cm tall, holds a *patera* and *rhyton*, and belongs to the "standing" *lar* type. The two figurines differ only in the

treatment of their hair. Whereas the Kelsey figurine wears a crown, the Pompeian example exhibits the more typical short-cropped hairstyle. It is likely that these two statuettes were not intended to be displayed in shrines, as neither is attached to a base; instead, their small size suggests that they may have acted as talismans or amulets that the owner could carry.

DATE: First century AD.

Unpublished.

MSB

1 Jashemski 1979–93, 1:230. The *lar* figurine was found near a *triclinium* and outdoor dining area in the vineyard.

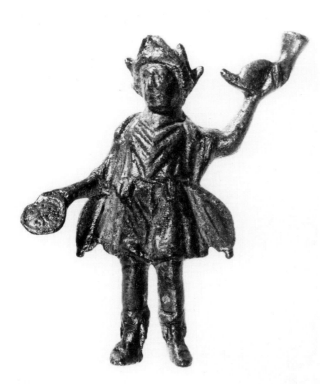

41 Bust of Isis

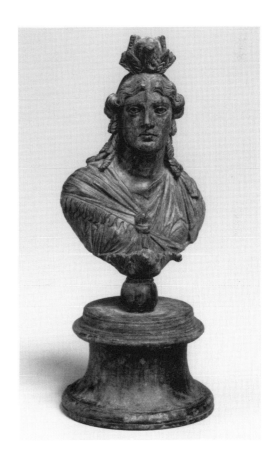

Bronze
H. 4¹/₂ in.
(11.4 cm)
Italy
Mount Holyoke College Museum of Art, Purchase with Nancy Everett Dwight Fund and the Society of Psi-Omega Fund in honor of Mary Gilmore Williams (Class of 1885)
Acc. no. 10.1965
The surface has a blue-green patina and is slightly worn. The top of the crown is missing.

The bust of Isis, rising from a three-leaf calyx, is affixed to a tiered cylindrical base. Both the bust and base are hollow cast. Isis wears a traditional headdress consisting of a globe and *uraeus* surrounded by ears of corn. The squarish face, with deeply set eyes, straight nose, thin lips, and prominent chin, is framed by wavy locks, which are parted at the center, rolled into sausage curls just above the ears, and gathered at the back with long curls falling on either side to the shoulders. Isis is portrayed in Graeco-Roman style, wearing a fringed mantle gathered at the center of her chest and fastened with a *nodus Isaicus*.

The use of bronze statuettes and busts as votive or domestic cult images is well attested in a number of periods and contexts.[1] There are examples of small marble and/or bronze images placed in groups within Roman household shrines.[2] It has been suggested that this piece may have been part of a shrine group, perhaps one that also included images of gods associated with Isis, such as Horus or Serapis.[3] At Pompeii, images of Isis have been found in a number of domestic *lararia*.[4] The temple of Isis in Pompeii attests to her prominence among the residents of the city.

DATE: Second century AD.

BIBLIOGRAPHY: Mentioned in *Art Journal* 1965, 25:1, 66; Mitten and Doeringer 1967, 278, cat. no. 270; Mount Holyoke College, Art Museum 1984, 52; Kleiner and Matheson 1996, 99–100, cat. no. 66.

CH

1 For a discussion of shrines, see ch. 7 by M. Swetnam-Burland in this volume.
2 See Mattusch 1996, 113–14, fig. 19.
3 See Mitten and Doeringer 1967, 278, cat. no. 271.
4 The House of Octavius Quartio is cited as evidence for worship of Isis in a domestic context at Pompeii because of its well-preserved niche painting depicting a seated female identified as Isis by the presence of a priest of Isis on the wall facing her. Furthermore, statuettes of an ibis (a bird sacred to Isis) and other Egyptian gods were also found, but what is particularly intriguing about the villa of Octavius Quartio is an opulent series of canals within the walled garden, which have led to speculation that it was used for imitating the ritual water ceremonies performed in the cult of Isis (Clarke 1991, 194–201).

42 Apis Bull

Bronze
H. 43 1/2; L. 40 1/3 in.
(17.1; 15.9 cm)
Scafati, Italy
The Detroit Institute of Arts, City of Detroit Purchase
Acc. no. 45.120
The statuette is in excellent condition. The surface is scratched and nicked in the region of the bull's head, rendering the attribute on the back of the head indistinct. Remnants of solder or another metallic alloy on the head of the bull suggest that there may once have been an attribute attached to the bull.

The bull walks to the right, with its right foreleg raised and head turned to face the viewer, a standard pose for bulls in Roman art, both as sacrificial animals and as deities.[1] The

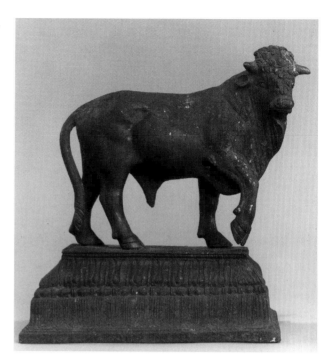

features of the bull are finely crafted, with great attention to detail. A curly forelock of hair runs from the crown of its head down to its nose. The ears lie flat against the neck. Musculature is suggested by dimpling in the surface of the bull's right rear leg and creases in the neck. The original base, a rectangular plinth, is decorated with acanthus leaves and architectural moldings.

The fragmentary attribute on the back of the bull's head suggests that the statuette most likely represents the Egyptian deity Apis, a god associated in the Egyptian period with Ptah and Osiris and in the Roman period with Serapis and Isis. The statuette was found in a shrine in a villa near Boscotrecase, near Pompeii, along with other items associated with Egyptian cults, including the silver crescent of Isis. In Pompeii and Campania, Egyptian deities were frequently incorporated into domestic worship along with the *lares* and *penates*, the traditional protectors of the household. Though there is no evidence that Egyptian or egyptianizing deities were venerated within the Villa of the Mysteries, by the Augustan period there was clearly an awareness of these divinities within the villa. Room 3, the *tablinum* near the vestibule to Room 5, has Third Style decoration with depictions of egyptianizing gods, including Osiris and Anubis.

DATE: First century AD.

BIBLIOGRAPHY: Sogliano 1899, 395, fig. 6; Furtwängler 1901, 37–45; Théatès 1908, 485, no. 5, ill.; Mitten and Doeringer 1967, no. 283; Kater-Sibbes and Vermaseren 1975, no. 306; Boulter 1979.

MSB

1 Mitten and Doeringer 1967, 289.

RITUAL AND FEMALE ADORNMENT

In the ancient Mediterranean world, adornment was often a component of religious rituals in which women participated. Women might, for example, bathe and bedeck the cult statues of goddesses as well as themselves for ritual purposes. The adornment of women was also important in everyday life. Adornment for the Roman woman frequently included anointment with perfumes, the donning of jewelry including armlets, bracelets, rings, necklaces, and earrings, and the application of facial cosmetics by a servant called the *ornatrix*.[1] Not least important was the dressing of a woman's hair, often an elaborate matter as evidenced by the complicated coiffures in marble portraits of Roman women. Not only did women wear a variety of hair ornaments, but the hair might also be curled and/or colored. Hairpieces were popular in certain periods.[2]

The jewelry in the exhibition is similar to that worn by the seated woman in the Villa of the Mysteries frieze, whose hair is being dressed by a standing female attendant (group G). Eros stands to the side of the pair, holding up a mirror in which appears the reflection of the female being adorned. This composition has been identified as the adornment of a young woman either before her initiation into the mysteries of Dionysus or before her wedding.[3]

Adornment that enhances a woman's seductive appeal is associated with the realm of Aphrodite/Venus and gave a woman some degree of manipulative power over men.[4] But a woman's appearance also reflected her social status and/or political associations:[5] an elaborate toilette was time-consuming and costly.[6] In the eyes of Roman society, a woman's beauty was considered a virtue.[7]

SK

1 La Rocco 1996, 160–61.
2 La Rocco 1996, 160–61.
3 For references to the copious scholarship on this image, see ch. 9 by J. M. Davis and ch. 10 by S. Kirk in this volume.
4 Davies 1996, 165; for cosmetics as deceptive, see La Rocco 1996, 161.
5 La Rocco 1996, 161.
6 Davies 1996, 165.
7 Davies 1996, 165.

43 Rectangular Mirror

Bronze (?)
Mirror: H. 5⅛; W. 1¾; D. ³/₁₆ in.
(13; 4.5; 0.4 cm)
Handle: Max. W. ⅓; Max. D. ⅓ in.
(0.9; 0.9 cm)
Italy

Bequest of Esther B. Van Deman, 1938
Kelsey Museum of Archaeology, acc. no. 6693
The reflective side of the mirror is somewhat corroded and the edges of the frame worn. There is a hairline fracture in the bottom left corner of the convex side of the mirror and its frame, and a patch of the handle's finish is missing. The mirror itself has a copper-color patina in contrast to the handle, which is a dull gray. The handle is widest at its center. It is composed of three tiers separated by flat disk-shaped elements.

The rectangular, slightly convex mirror is framed by a narrow border of thin, engraved lines that create a regular sawtooth pattern. This border is set apart from the reflective surface by an incised line, which the craftsman had to redo at the bottom of the mirror because the line drifted down into the border.

Representations of rectangular mirrors on South Italian pots indicate that mirrors of this shape originated in this region.[1] By the mid-first century AD, the rectangular mirror was one of the most common forms for Roman mirrors.[2] Indeed, the only two mirrors represented in the wall paintings in the Villa of the Mysteries are rectilinear in shape. The mirror located in the architectural scene above the so-called priestess in Room 4 is a rectangular compact, and the mirror held by the Cupid (group G, figure 25) in

the "bridal preparation" scene of the frieze in Room 5 is a square compact. Both mirrors are open to reflect figural images for the viewer.

DATE: Roman.

Unpublished.

BL

1 Lloyd-Morgan 1982, 41.
2 Lloyd-Morgan 1982, 40.

44 Mirror with an Engraved Image of the Dioscuri

Bronze
H. 9¹/₂; D. 4¹/₂; L. of handle 4³/₄ in.
(23.8; 11.6; 12.0 cm)
Rome (?)
Bequest of Esther B. Van Deman, 1938
Kelsey Museum of Archaeology, acc. no. 6714

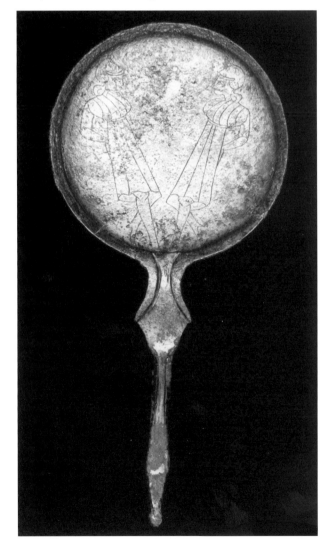

The condition of this mirror is generally good. There is some corrosion and patination on both sides and pitting on the upper portion of the reverse side.

The circular reflecting portion and the handle of this bronze mirror were cast as a single piece. Incised decoration appears on the reverse—or nonreflecting side—of the handle and around the edge of the convex reflecting side.

The decoration on the handle consists of a series of geometric, crisscrossing lines capped by a "stylized flame" motif[1] at the juncture of the mirror disk and handle on the reflecting side of the piece. The handle itself flares out in a diamond shape that then extends to a long, slender, slightly angled bar. This bar terminates in a rounded nub that, although now rather worn, seems, by analogy with other examples, to have originally portrayed an animal's head, perhaps that of a deer.

The reflecting side of the mirror disk is embellished simply with a border composed of a pair of engraved lines and, along the lip of the disk, a series of decorative tick marks.

The mirror's reverse features an engraving of two standing male figures who appear to be mirror images of each other. Centered between the two figures are, at eye level, a small circle and, in the center of the mirror disk, a small punctation. Each of the figures is poised with his "outside" arm—the right arm for the left-hand figure, the left arm for the figure on the right—on his hip, while his weight is thrown onto his "outside" leg. The men are depicted at such an angle that their "inner" arms are hidden from view, presumably behind the figures' backs. Each man stands with his unweighted leg bent toward the center of the scene. The bodies of both figures are shown in three-quarters view, while their heads are in profile, each looking toward the other. Both figures wear Phrygian caps over long hair and are clothed in identical belted tunics. Although the artisan's rendering of the men's anatomy and clothing is quite schematic, the quality of the engraving is generally high.

This mirror is one of a series of similar pieces that seem to have been stock Etruscan workshop productions.[2] The two men depicted on such mirrors are generally accepted to be the Dioscuri, or twin heroes Castor and Pollux, who figure in Greek and Roman, as well as Etruscan, mythology. Although twins, the two heroes were noted for a significant difference between them: Castor was mortal, while Pollux was divine. The two brothers ultimately arranged to share Pollux's immortality, dividing their time between the realm of men and that of the gods. It was perhaps this quality of the Dioscuri that made them attractive to mirror owners.[3] The Etruscans seem to have believed that the reflected image seen in a mirror was the viewer's soul; consequently, the relationship between the mortal viewer and her image—her immortal soul—was not unlike that of Castor to Pollux (shown here as mirror images). Indeed, the ability of a mirror to mediate between the mortal and immortal made mirrors an ideal grave good for deceased Etruscan women: the mirror as a toilet object was a testament to the woman's qualities—her beauty, her fertility—while alive, whereas its ability to hold the viewer's soul made it a desired possession in death and the afterlife.

A number of mirrors of this type have been found in secure, datable archaeological contexts. These contexts—invariably tombs—span the course of the third century BC.

The closest parallels to the Kelsey piece seem to belong to the middle of this century. It is thus likely the Kelsey mirror was also made c. 250 BC.[4]

DATE: c. 250 BC.

BIBLIOGRAPHY: *Research News, University of Michigan* 1972, 23(5):7 (conservation report); de Puma 1987, 15–16, fig. 1a–d.

EdeG

1 De Puma 1987, 15.
2 For a discussion of this series of mirrors, see Mansuelli 1946–47, 64; Rebuffat-Emmanuel 1973, 483–85; de Grummond 1982, 163–65.
3 De Grummond 1991, 11–31.
4 De Puma 1987, 16.

Rings and Their Significance

Jewelry played a prominent role in Roman society as an indicator of wealth, social status, and marital status. Pliny the Elder relates that the usual betrothal gift to a woman from the future bridegroom was an iron ring without a stone (*HN* 37.1–5). At some point before the late second century AD, it became customary for married women to wear a gold ring on the fourth finger of the left hand (Tert. *Apol.* 6) because it was believed that a vein led directly from this finger to the heart (Aul. Gell. *NA* 10.10).

In the frieze of the Villa of the Mysteries, five women wear rings of various types. These include the walking veiled woman (group A, figure 1), the woman holding a scroll (group A, figure 3), the woman carrying a tray (group A, figure 4), the seated veiled woman (group I, figure 29), and the companion of Liber (group D, figure 16). All five wear their rings on the fourth finger of their left hand, presumably to indicate their betrothed or married status. Only the companion of Liber wears a simple metal band—presumably of iron—and thus provides the only example on the frieze of the traditional betrothal gift. In contrast, the rings of the walking veiled woman, the woman holding the scroll, the woman carrying a tray, and the seated veiled woman are gold bands of varying sizes and shapes with inset stones, all suitable rings for married women.

Periodically in the early history of Rome, sumptuary laws, including the law of the Twelve Tables (450 BC) and the Lex Oppia (215 BC), regulated the use of jewelry. After the Augustan period, sumptuary laws became relatively uncommon, and throughout the imperial period the prominence, amount, and size of jewelry increased dramatically. The small size and simple design of four of the rings in this exhibition (cat. nos. 46–49) indicate that they were probably worn prior to or during the first century AD. The undistinguished craftsmanship and the use of bronze rather than gold for these same four rings also serve as a reminder that women of widely varied social status would wear rings. The fifth ring in the exhibition (cat. no. 45) is a signet ring, a type worn by both men and women. Wealthy Romans collected antique rings and especially the engraved gems that were originally fitted into them and served as signets.

GENERAL BIBLIOGRAPHY: Higgins 1980; Marshall 1907; Stout 1994.

BL

45 Gold Ring with Carnelian Gem

Gold and carnelian
Diam. ¹/₂ in.
(1.2 cm)
Cyprus
Lent by The Metropolitan Museum of Art
The Cesnola Collection, Purchased by Subscription, 1874–76
Acc. no. 74.51.4241
The rim of the gold ring setting is slightly chipped.

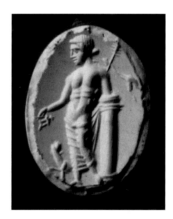

This oval carnelian gem, set in a gold ring, is carved with the image of Liber pouring wine from a kantharos into the mouth of his panther. The god holds a thyrsus in his left hand and leans against a pillar. He is wearing a mantle draped around his hips, and his hair is tied into a bun at the nape of his neck.

This depiction of Liber is similar to those found in shrine paintings from Pompeii.[1] In the shrine paintings, images of Liber act as the focal points of worship; they are images to which family members of all ages and genders make sacrifices and dedications in lieu of a cult statue. In this case, however, the image of Liber perhaps functions as an invocation of the god or as a personal emblem of the owner of the ring. Richter has argued that the figure of Liber in this pose is copied from a fourth-century Hellenistic statue type and that this ring provides evidence of the migration of the type in smaller objects and the decorative arts.[2] The type itself, however, is so common in a variety of media in the Roman period (bronze, marble, terracotta, painting, and engraved gems), and has so many variations, that it should not be thought of as a mere copy of a Greek original but rather as a quasi-canonical image of Liber that had been adapted to various purposes in the Roman period. For another example of this type, see also cat. no. 105, a modern replica of an ancient statuette.

DATE: First century BC–third century AD.

BIBLIOGRAPHY: Cesnola 1885–1903, 3:28.10; Richter 1920, 107–8, cat. no. 162, pl. 41; Richter 1956, cat. no. 318.

MSB

1 See also ch. 7 by M. Swetnam-Burland in this volume.
2 Richter 1956, 317.

46 Finger Ring

Bronze
Diam. ⁹/₁₆ in.
(1.5 cm)
Pozzuoli or vicinity, Italy
Purchased by J. G. Winter from Giuseppe De Criscio, 1922
Kelsey Museum of Archaeology, acc. no. 21543
The surface is corroded, pitted, and dull, with patches of a white, chalky-looking film. There is a patch of soil incrustation on the interior band.

This plain circular finger ring has a band of even thickness.

DATE: Roman.

Unpublished.

BL

Clockwise from bottom right: cat. nos. 46, 47, 49, 48.

47 Finger Ring

Bronze
Diam. ¹/₂ in.
(1.4 cm)
Pozzuoli or vicinity, Italy
Purchased by J. G. Winter from Giuseppe De Criscio, 1922
Kelsey Museum of Archaeology, acc. no. 21542
The surface is dark and pitted, with a patch of soil incrustation (?) on the outside. Spots of light green patina occur on the outside where the metal is especially corroded.

This plain circular finger ring has a band that is nearly round in section, although one side is thicker than the other.

DATE: Roman.

Unpublished.

BL

48 Finger Ring

Bronze
Diam. ²/₃ in.
(1.7 cm)
Rome (?)
Bequest of Esther B. Van Deman, 1938
Kelsey Museum of Archaeology, acc. no. 6662
The ring is in fair condition, with a dark, corroded surface.

This plain circular finger ring consists of a solid band, round in section and flattened on the top and bottom surfaces.

DATE: Roman.

Unpublished.

BL

49 Finger Ring

Bronze
Diam. ²/₃; W. ¹/₂ in.
(1.7; 1.4 cm)
Rome
Purchased from W. Dennison by L. Pollack, 1909
Kelsey Museum of Archaeology, acc. no. 1492
The exterior surface is dark and pitted, but corrosion is present in the interior circle of the band. Some soil is incrusted on the outer surface of the ring.

This ring is composed of a flat band that tapers so that the back is narrower than the front. The front consists of a raised rectangular bezel, where presumably a missing gem or glass piece was originally inset, although there is no sign of attachment point or other provision for securing a stone.

DATE: Roman.

Unpublished.

BL

❖

50 Bracelet or Armlet

Bronze
Diam. 3¹/₃ in.
(8.5 cm)
Vicinity of Rome (?)
Bequest of Esther B. Van Deman, 1938
Kelsey Museum of Archaeology, acc. no. 6647
The bracelet is in nearly perfect condition, with only small areas of greenish corrosion. The entire bracelet is preserved and retains its original shape.

The bracelet is composed of a single band of bronze with balled ends, formed into a circular-shaped coil. The exterior of the band is scored with four ridges, while the inside face is smooth. The ends of the coil are articulated with three slightly raised ridges.

The diameter of this bracelet is quite large, suggesting that it may have been worn as an armlet or perhaps even as an anklet.

Bracelets and anklets similar in form to this one are worn by some of the figures in the frieze from the Villa of the Mysteries: the Cupid, the *domina*, and even Liber himself.
DATE: Roman.

Unpublished.

MSB

51 Bracelet

Bronze
Diam. 2³/₄ in.
(7 cm)
Eastern Roman empire, probably Persia
Kelsey Museum of Archaeology, acc. no. 26747
The bracelet is in excellent condition, with evidence of green corrosion in the recesses of the coils and on the ducks at either end of the bracelet.

The bracelet is roughly oval in shape, with an opening at one end. Its shaft is composed of a four-stranded spiral, which terminates at either end with ducks, whose heads are turned back and resting upon their bodies.

The seated bride on the Villa of the Mysteries frieze wears a spiral bracelet.

DATE: Roman.

Unpublished.

MSB

52 Hairpin

Bronze
L. 3¹¹/₁₆; D. of head ³/₁₆; Max. D. of shaft ¹/₈ in.
(9.4; 0.4; 0.25 cm)
Rome
Purchased by F. W. Kelsey, 1901
Kelsey Museum of Archaeology, acc. no. 21459
The point of the pin is bent. Its head is incrusted. The pin has a dark green patina.

The head of the hairpin is decorated with a series of evenly spaced, protruding rings with concave spaces between them.

Unpublished.

JMD

Left: cat. no. 53; right: cat. no. 52.

54 Fragment of a Hair Comb

Bone, with traces of reddish-brown pigment
H. 7/8; L. 1 1/4 in.
(2.1; 2.9 cm)
Probably Pozzuoli or vicinity, Italy
Purchased from Giuseppe DeCriscio, 1923
Kelsey Museum of Archaeology, acc. no. 2755
The fragment is poorly preserved. All of the extant teeth are broken. There are a great deal of abrasion and many chips on the surface. A large piece is missing from one corner.

This ivory-colored comb once had two sets of teeth, one set thick, the other fine. The nine remaining larger teeth are of varying length, and there are traces of a few of the smaller teeth. In scale, the teeth are similar to those of a comb from Karanis in the Kelsey Museum (cat. no. 55). This comb from Pozzuoli was originally about the same size as cat. no. 55 and may have had polychrome decoration. Combs of this kind were common throughout the Roman world and would certainly have been used by the women of Campania.

DATE: Roman.

Unpublished.

SK

Left: cat. no. 54; right: cat. no. 55.

53 Hairpin

Bronze
L. 3 7/16; D. of head 3/16; D. of shaft 1/16 in.
(8.7; 0.5; 0.2 cm)
Rome
Purchased by F. W. Kelsey, 1901
Kelsey Museum of Archaeology, acc. no. 21460
The tip of the hairpin has broken off. It has a dark green patina and areas of incrustation.

This hairpin has a finial in the form of an amphora. The finial is flat at the end and round in cross-section.

Unpublished.

THESE PINS REPRESENT ONE TYPE of hair ornament that a Roman woman might have worn. An affluent woman would perhaps have had jewelry in gold or silver instead of bronze; not surprisingly, hairpins in bronze like these are more common, as are bone pins. The heads of these pins reflect the wide variety of motifs found on hairpin finials. Some of the more elaborate examples have animals and even tiny human figures; others are decorated with precious stones or enamel.[1]

JMD

1 For examples from the Vesuvian region, see d'Ambrosio and de Carolis 1997, 27–28, pl. I, nos. 1–4.

55 Hair Comb

Wood
H. 2 1/2; L. 3 in.
(5.6; 7.5 cm)
Karanis, Egypt, University of Michigan Excavations
Kelsey Museum of Archaeology, acc. no. 10010
The comb is very well preserved. A few of the teeth are chipped or broken, and there is some abrasion to the finish of the wood. There are small cracks throughout.

This dark brown wooden comb has two sets of teeth, one set finer than the other. It is finely carved and has a smooth surface. In comparison to many of the combs from Karanis, this one is relatively small and undecorated.

DATE: First century BC–fourth century AD.

Unpublished.

SK

56 Red-figure Pelike

Fired clay
H. 9¹/₈; Diam. rim 5¹¹/₁₆; Diam. body 5¹³/₁₆; Diam. foot 3¹/₂ in.
(23.3; 14.5; 14.8; 9.0 cm)
Southern Italy
From the collection of Martin D'Ooge,
 Gift of Mrs. Helen D'Ooge Daily, 1958
Kelsey Museum of Archaeology, acc. no. 29180
The rim has been broken and mended above the handle to the
right of side A. Eros's body has areas of incrustation and of loss of
the white pigment. There are surface losses on the handles and
neck as well as losses and chips on the rim. The surface of the
figures on side B is worn. There is a white incrustation in the in-
dentation above the foot, beneath the foot, and inside the vessel.
The pot was misfired so that much of the black background is
reddish with black outlines around the figures. An old collector's
label is attached below the handle at the left of side A.

The pelike has a wide flat rim that folds down and outward
at its edge. The vertical lip is decorated with an egg-and-
dot motif. The handles start under the rim and fall verti-
cally to the shoulder. The pot has a flat foot.
 Side A: A draped female figure with her hands wrapped

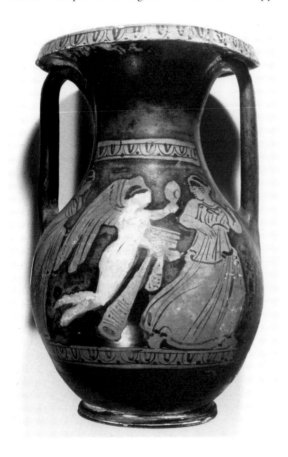

inside her garment stands at the left side of the scene facing
right. Her hair is held on top of her head with a band or
fillet. Eros occupies the center of the scene and faces right
also. He is flying, held aloft by his large wings. His body is
vertical, and his legs are bent back at the knee.[1] With his
right hand he holds up a mirror to the woman at the right
side of the scene. In his left hand he has a box with ribbons
or garlands hanging from it. The face of the woman at the
right is turned toward Eros and the mirror. Her body, how-
ever, is portrayed frontally, and from the position of her
legs it seems that she is turning away from Eros and step-
ping to her left.[2] Her right hand is held in front of her stom-
ach; her left arm is bent up at the elbow. The woman's hair is
bound up with a fillet. Her dress falls in three tiers and swirls
about her legs as she moves. The scene is bordered on the
top and bottom by bands of the egg-and-dot motif.
 Side B: Two draped figures face each other across a
waist-high altar. The left figure holds a tambourine; the
right figure pours a libation on the altar.[3]
 The Eros scene on this pelike juxtaposes figure types
that appear in two different episodes in the Villa of the
Mysteries frieze. The Eros on the vase provides an icono-
graphic parallel, albeit a more mature one, for the Eros
holding a mirror in the scene of the dressing of the bride.
Unlike the calm, seated bride in the Villa scene, however,
the woman on this pelike seems to run away from the mir-
ror. In her gesture of rejection she resembles the Villa's
fleeing maiden, who appears to recoil from the scenes on
the east wall of the frieze. The presence of these figures on
a South Italian vase that predates the Villa frieze by several
centuries reflects both the longevity and the pervasiveness
of this kind of imagery and indicates the freedom with
which the Villa's painters adapted older motifs to their spe-
cific purpose.

DATE: Fourth century BC.

Unpublished.

JMD

1 Flying Erotes in a similar pose appear on vases from Apulia and
 Campania. See Trendall and Cambitoglou 1978–82, pl. 31.5;
 Trendall 1967b, pl. 82.1, 5.
2 The turning woman is a common figure on South Italian vases.
 See, for example, Trendall and Cambitoglou 1978–82, pl. 23.3;
 Trendall 1967b, pl. 76.7.
3 For similar scenes on Campanian and Apulian vases, see Tren-
 dall and Cambitoglou 1978–82, pl. 85.5; Trendall 1967b, pl.
 199.5.

57 Antefix with Female Head

Fired clay
H. 6⁷/₈; W. 7; D. 5³/₈ in.
(16.7; 17.5; 15 cm)
Southern Italy
Kelsey Museum of Archaeology, acc. no. 69.7.1
The piece is largely intact. The tip of the nose is chipped; there is a
chip or flaw on the right side of the chin; and the half-cylinder
cover tile is broken irregularly approximately 11 cm from the back

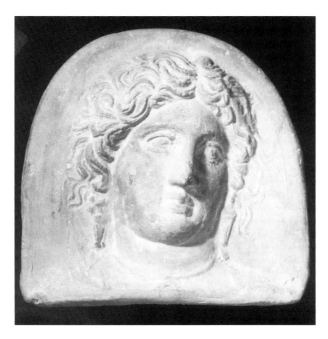

of the vertical plaque. It is molded of light red clay containing fine bits of mica and some black and white inclusions.[1] There is a black mark on the right cheek, and whitish incrustations cling to the grooves of the hair and facial features. The underside of the cover tile, which is also covered with a whitish incrustation, bears the number B.34.67, presumably from a former collection.

The arching edge of the antefix frames a female head, which is tilted downward and slightly turned to the woman's left. The square jaw and broad cheeks taper to a rather low, triangular forehead. The nose is long and straight and the lips full and slightly parted. The large, wide eyes set beneath a low brow have raised irises and pupils and prominent lids. The wavy hair is parted in the middle and drawn back over the ears. Stray locks escape on the left and right. The woman wears long cross-and-inverted-pyramid earrings of Tarentine type[2] and a necklace consisting of a simple

band and a crescent pendant. The somewhat indistinct folds of her garment form a square neckline.

Antefixes of this type were produced at Tarentum in Southern Italy and have also been found at the rural sanctuary of San Biagio near Metapontum.[3] Its image, probably of a goddess, illustrates the classical style in Southern Italy, which is reflected in many of the female faces on the Villa of the Mysteries frieze. Although not closely related in type to that of the bride being adorned on the Villa frieze, the head of the goddess on the antefix represents an ideal to which a South Italian woman, such as this bride, probably aspired. Both the bride and the goddess on the antefix display the kinds of jewelry with which Greek and Roman women in this region adorned themselves for ritual and other occasions. The act of adornment was, in fact, important in ancient Greek and Roman religious practice; it was common, for example, for women to bathe and/or dress female cult images.[4] Because South Italian visual images, such as vase paintings and votive figurines, often associated actual women with goddesses, it seems likely that a similar association would have occurred in the case of the image on the Kelsey antefix.[5]

Date: Early fourth century BC.

Unpublished.

EKG

1 See also the unpublished notes by K. K. Albertson on file in the Kelsey Museum.
2 See Higgins 1980, 128, pl. 25F and 162, pl. 48D.
3 For an example from Tarentum, see Pugliese Carratelli 1996, cat. no. 292 I, Taranto Museo Archeologico Nazionale 17554. For Metapontum, see Carter 1977, fig. 22.
4 Perhaps the best known example of this practice is the ceremony of dressing of the ancient statue of Athena on the Athenian Acropolis in a new peplos, which took place every four years at the Greater Panathenea. See Pomeroy 1975, 76. See also Kondoleon 1999, 330.
5 See ch. 10 by S. Kirk and cat. no. 7 in this volume.

Bacchic imagery is common on Roman sarcophagi, on funerary altars, and on many other items connected with burials.[1] The rise in popularity of Bacchic imagery on Roman sarcophagi mimics a rise in the cultic activity associated with Dionysus/Bacchus/Liber in Southern Italy and Rome. Bacchic organizations did in fact attend to the burials of their members,[2] and it seems that the mysteries of Bacchus/Liber provided for the initiate some assurance of an afterlife. It is uncertain just what the Roman initiate's conception encompassed,[3] although it was clearly perceived as an unpleasant experience. As Nilsson envisions the role of the Bacchic mysteries, "They calmed the fears and smoothed over the anxiety [regarding the afterlife], they promised the bliss of an eternal banquet."[4] Like other Roman mystery cults, the Bacchic mysteries may have "united post-humous salvation with the safekeeping of the initiate in this life."[5] If initiation in the mysteries of Bacchus was intended to provide a blissful and revelry-filled afterlife, this may have been reflected in the Bacchic imagery on sarcophagi. Images of Bacchus with the Seasons, for instance, may be perceived as symbolic of apotheosis and afterlife.[6] Similarly, images of Bacchus's triumphal return from India are often interpreted as a triumph over death—both by the god and presumably by the deceased.[7] The connection between the religious beliefs of the deceased and the imagery on the sarcophagus in which the believer is buried is supported by the portraits of the deceased that appear on many Bacchic sarcophagi, whether as bust portraits in roundels, as in the process of being apotheosized, as members of the Bacchic *thiasos* (cat. no. 58), or even as the god himself.[8]

SK

1　Kleiner 1992, 392; Strong 1988, 188. Matz (1968–75) provides a catalogue of figural types on Dionysiac sarcophagi.
2　Nilsson 1953, 187.
3　See Turcan 1996, 312.
4　Nilsson 1953, 195.
5　Turcan 1996, 312.
6　Kleiner (1992, 392): "The implication was that the deceased, a member of the Dionysiac mystery cult, would find renewed life in the hereafter."

7　Houser 1979, 13.
8　See McCann 1978, 118–21.

58 Sarcophagus with Bacchic Imagery

Marble
H. 16¹/₈; L. 72 in.
(41; 183 cm)
Italy
Purchase of the Museum Associates and Cummer Fund
Kelsey Museum of Archaeology, acc. no. 81.3.1
The sarcophagus is broken into four pieces. The back panel is missing and side panel only partially extant. There is no associated sarcophagus lid. The figural scenes are well preserved and free of extensive corrosion or weathering.

This full-size marble sarcophagus features sculpted decoration on its three surviving external faces. The main decorative scene, which runs the length of the front of the sarcophagus, includes, from left to right, a figure that is probably to be identified with Ariadne, leaning on the shoulder of her husband Bacchus, who holds a staff in his left hand and, in his right, a small vase, perhaps a kantharos for wine drinking. The couple is shown riding in a small, two-wheeled chariot pulled by two prancing centaurs. The first centaur is bearded and plays a lyre; the second is clean-shaven and blows into a double pipe. A *cista mystica*—a vessel of cultic significance—sits under the raised hoof of the second centaur, while a nude maenad stands beside the *cista* and thumps her tympanum, or drum. The gesture of her raised arm is mirrored by the arm of a dancing faun who is draped in an animal skin, while a female panther marches between these two central figures. To the right of this faun are two more fauns, who carry the plump Silenus on a makeshift hammock. A shepherd's staff, a tympanum, and a pair of castanets lie on the ground beneath the hammock. Another pair of fauns completes the scene: one faun holds a tympanum and a snake; the other is poised with his mantle in hand. A *cista mystica* sits between the two figures.

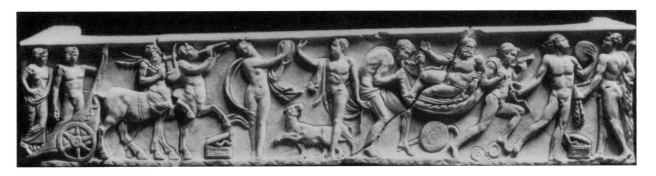

The panel on the left-hand end of the sarcophagus presents a faun who holds a tympanum and stands to the right of a pilaster. A *cista mystica* lies on the ground to the left of the pilaster, which is crowned by what appears to be a vase. The scene is framed by grape vines, although most of the vine on the left-hand side is missing, as the sarcophagus breaks off here. The panel on the right-hand end of the sarcophagus also features a faun, this one holding a thyrsus, or Bacchic staff, and standing over a *cista mystica*.

Scenes of Bacchic rituals and dancing were not uncommon on Roman sarcophagi. Such scenes may indicate specifically that the deceased was an initiate of a Bacchic cult, or they may simply allude more generally to a desire for the joyful afterlife that was associated with Bacchic religion. The distinctive facial features and the prominence of the dancing maenad at the center of the main panel of the sarcophagus suggest that this representation was intended as a portrait of the deceased. The Ariadne figure may perhaps bear portrait features as well,[1] as more than one image of the person being honored did sometimes appear in the same funerary scene. Regardless of whether one or both of these images was intended to portray the deceased, the presence of a portrait in a representation of Bacchic revelry—a depiction of the active participation of the deceased in this activity—attests to the personal sense of association with Bacchic religion that many Romans had. Furthermore, the prominence of female figures in this scene highlights the importance of the Bacchic cult to Roman women: the cult offered them revelrous relief from the social constraints that women felt in everyday life while also presenting them with the possibility of eternal bliss in the next life.

The reliefs are carved in a distinctive style and feature a number of stock figural types that appear on other sculpted sarcophagi of the Roman period. Although the Kelsey example perhaps most closely resembles pieces that have been attributed to a workshop active in the second quarter of the second century AD,[2] the hairstyle that the central maenad figure wears is one made popular by women of the Roman imperial family in the late second century AD.[3] Thus, it seems likely that the Kelsey sarcophagus was made in the second half of the second century AD.

DATE: Second half of the second century AD.

BIBLIOGRAPHY: *Bulletin, Museums of Art and Archaeology, The University of Michigan* 1983–84, 6:66, 69; Behen 1996, 209–10, cat. no. 166.

EdeG

1 Behen 1996, 210.
2 Matz (1968–75, 4:519). Individual sarcophagi most closely comparable in style to the Kelsey piece include a specimen now in the Munich Glyptotech (Matz 1968–75, 2:202–3, cat. no. 85) as well as one now in the Capitoline Museum in Rome (Koortbojian 1995, 65).
3 See the late Antonine-period bust of a woman in the Worcester (Mass.) Art Museum (Inan and Alföldi-Rosenbaum 1979, 339–40, cat. no. 339, pl. 248).

59 Inscribed Funerary Altar of Quintia Sabina

Marble
H. 28; W. 16½; L. 23¾ in.
(71.1; 41.9; 60.3 cm)
Rome
The Detroit Institute of Arts, Gift of Mrs. Standish Backus
Acc. no. 38.106

Scratches and small chips appear in the inscribed register, along the base of the front and right sides of the monument, and in the carved images on both side panels. The features of the figures at the bottom of the main panel are worn, and several elements of the scene are broken. There are some minor areas of incrustation on the piece. Metal dowels have been inserted in holes on the top, back, left, and right faces. The top of the monument has been fitted with a modern protective panel.

This small marble funerary altar is decorated on the front and side faces. The front panel features a framed register with the following text inscribed in well-formed block letters:

DIS
MANIBVS
QVINTIAE
S(uae) P(ecuniae) F(ecit)
SABINAE

To the blessed spirit of Quinta Sabina [who] set up [this monument] with her own money.

Above this register is a line of sculpted animal images interspersed with vegetal and other decorative motifs. At the far left is a column capital composed of acanthus leaves and birds (eagles?). Next is a ram's head, which in turn faces a bird, an eaglet or perhaps a swan. This bird, the central figure in this decorative zone, stands with its wings spread

and its neck bent to the left. To its right is a left-facing ram's head. The two rams and the bird are enclosed in a line of decorative bosses that cause the ensemble to resemble an Ionic column capital. A second column capital of acanthus leaves and birds completes this zone.

On either side of the inscribed register is a vertical row of garlands with pomegranates and pinecones, flanked to the outside by the columns that support the bird-and-acanthus capitals in the top register. The columns, carved with spiral flutes, extend from the bottom to the top of the altar and form its two front corners.

At the bottom of the front face, below the inscribed register, is a sculpted processional scene. At the left a faun stands in three-quarters view, his head turned toward the celebrants who precede him. He wears a loin cloth and carries a goatskin over his shoulders. He holds a *lagobolon*, or shepherd's staff, in his right hand. Before him, in a chariot pulled by two large panthers, is a male figure whose mass of unruly hair may support a wreath (of berries?). He carries a kantharos, or drinking vessel, and a staff. This figure is apparently Liber, the Roman god of wine, who often carries a kantharos and the thyrsus, a long staff topped by a pinecone. The two panthers harnessed to the chariot occupy the bulk of the center of this scene. The heads of a maenad and a satyr are visible above the backs of the felines. Hair pulled back, the maenad's head is turned slightly to her left, in the direction of the tympanum, or drum, that she holds in the air. The satyr is bearded and holds a *lagobolon* in his left hand. One of his hairy goat legs can be seen in the poorly differentiated jumble formed by the limbs of the panthers, the maenad, and the satyr. A faun closes the scene to the right. Leading the procession, he wears a loin cloth and, on his head, a wreath. His head is tilted upward as he plays a flute. Several of the figures in this scene have distorted or unnatural proportions, and the rendering of spatial relationships is not realistic.

Each of the side panels of the altar is embellished with a laurel tree below which sit two birds, ravens perhaps. A pillar decorated with a vegetal motif runs along the corner that each side panel shares with the back of the monument. The spirally fluted columns on the face of the altar are also visible along the front corners of both of the side panels. The back of the monument is undecorated.

Grave altars such as this were set up in ancient Italy to mark the location of burials and to offer the living a suitable place to pour libations to the dead. They likewise served to perpetuate the memory of the deceased. Many of the decorative motifs that appear on the altar of Quintia Sabina were common in Roman funerary art and probably carried symbolic meaning for the ancient Roman viewer.[1] Thus, for instance, birds often represented the soul of the deceased; garlands with fruit were to offer sustenance in the afterlife; and the *thiasos*, or Bacchic procession of the god Liber, was suggestive of a blissful hereafter. The figures of Liber and the maenad in the Detroit processional scene may bear portrait features[2] in order to increase the personal association of the deceased with the symbolic meaning of the depiction.

The altar of Quintia Sabina is from Rome. The form of the inscription[3] and the constellation of decorative motifs[4] on the altar indicate that the monument was probably made in the mid- to late first century AD.

DATE: Mid–late first century AD.

BIBLIOGRAPHY: Matz and von Duhn 1881–82, 3:191–92, no. 3924; *CIL* 6.25325; Altmann 1905, 160–61, no. 201; Bodel and Tracy 1997, 129.

EdeG

1 Prieur 1986, 149–86.
2 In W. Altmann's estimation these two figures are intended to be portraits. The level of preservation of the scene makes this assertion difficult to evaluate (Altmann 1905, 151).
3 Calabi Limentani 1991, 153–54.
4 Altmann 1905, 136 ff., 160–64; Prieur 1986, 155.

60 Head of Pan or a Satyr

Parian marble
H. 7^1/$_3$; W. 4^{13}/$_{16}$; D. 5^1/$_2$ in.
(18.7; 12.2; 14.1 cm)
Said to have been found at Porto d'Anzio, Italy, about 1910
The Detroit Institute of Arts, Founders Society Purchase
Acc. no. 49.520
This head is in good condition. The most significant break cuts off both the neck and the beard just below the chin, suggesting that the fragment was originally attached to a body. The right ear is broken, and other extremities are worn, including the tip of the nose and several locks of hair that protrude from the head.

The small marble head is probably broken from a full-length figure, perhaps one that formed a group with a nymph[1] or Venus. The extant male head has pointed ears, heavy-lidded and slanting eyes, full cheeks, dimples, a protruding lower jaw, and a broad, short nose. The sides of a

mustache are plastically rendered,[2] as is the partial beard that covers the jawbone but not the chin. Thick, shaggy hair falls in twisted locks over the forehead and neck. The hair on the forehead is bisected by a line to either side of which the locks fall over the top of the nose and blend into the arched eyebrows. Small horns project from the head at the hairline above each eye, and the tongue licks the upper lip, giving the head a lascivious, mischievous appearance.

The pointed ears indicate that the head represents either a satyr or a pan. Pans are half-man and half-goat creatures while satyrs originally were conceived of as part man and part horse; by the Hellenistic period, however, satyrs are more goatlike in appearance. The cult of Pan originated in Arcadia, where Pan was a god of shepherds, hunting, and fertility. During the fourth century BC, his cult spread throughout the Greek world, and from the Hellenistic period onward Pan was held to be responsible for sowing panic in enemies. Satyrs, on the other hand, are primarily recognized as mythical followers of Dionysus/Bacchus and are often represented as participating in Bacchic processions such as the one portrayed on the Detroit altar of Sabina in this exhibition (cat. no. 59). These two categories of mythical creatures are linked to each other by their respective pursuits of nymphs and their associations with the natural world. From a single head lacking its original context, it is difficult to distinguish between a pan and a satyr, and the Detroit head has been thought alternatively to represent one or the other. Because both pans and satyrs are associated with nymphs, the lasciviousness of the expression does not help in the identification.[3]

The exaggerated curls in the hair and beard as well as the intensity of the facial expression may have been inspired by the art of Attalid Pergamon, the baroque style of which was popular in Hellenistic and Roman times. The head itself is said to have been found at Porto d'Anzio, a popular location for Roman seaside villas in the late Republican and imperial periods, which included one of the emperor Nero. The associations of both satyrs and pans with the rustic countryside, caves, nymphs, and Bacchic pleasures made sculptures of them popular and appropriate adornments for gardens in Roman dwellings.

DATE: Second century BC or later.

BIBLIOGRAPHY: Detroit Institute of Arts 1950, 10 (ill.); *Detroit Institute of Arts Pictures on Exhibit* 1950, 12.5 (Feb.), 53; *Pallas* 1950, 14.4 (March 14), 38; *Bulletin of the Detroit Institute of* Arts 1951–52, 31(3–4): 66–67.

BL

1 *Bulletin of the Detroit Institute of Arts* 1951–52, 31(3–4):66–67.
2 It is possible that the rest of the mustache was originally rendered in paint.
3 At present the piece is thought to be a pan. According to the Detroit Institute of Arts records, this attribution was made by Cornelius Vermeule and Frank Brommer in 1958.

61 Lucanian Bell Krater with Satyrs

Attributed to the Pisticii Painter
Fired clay
H. 10¹/₂; W. 10¹⁵/₁₆ in.
(26.6; 27.7 cm)
Lucania, Italy
Purchased from the Marburg Collection, 1923
Kelsey Museum of Archaeology, acc. no. 2610
There are minor cracks in the glaze where the body meets the foot, as well as small pits and traces of incrustation on the foot, scattered scratches on the surface of the lip, and small bits of incrustation on the interior. Light brown incrustations mark the inner side of the right handle, and there are patchy remnants of white paint or incrustation under the lip. Incomplete firing mars the area around the handles.

The red clay is slightly paler than Attic and has a good glaze. Narrow bands of clay are reserved at the top and bottom of the rim. There is a ridge at the juncture of the body and the foot. A laurel wreath runs beneath the rim.

Side A: Two bearded and nude satyrs, with bushy tails and pointed ears, stand on a strip of meanders, which is interrupted at intervals by crossed squares. The figure at left, in profile, walks toward the right while playing a double flute. The figure at right also walks toward the right but turns his head to look at his companion, to whom he offers a drinking horn with his left hand. In his right hand he holds a thyrsus.

194

Side B: Two youths wearing himatia stand facing each other. The figure at left wears a band of laurel around his neck; the one at right holds a staff in his left hand.

In Attica and Southern Italy, volute kraters, kylix kraters, and bell kraters were principal vehicles for red-figured decoration.[1] Lucanian vases were the earliest of the red-figure style proper in Southern Italy.[2] A. Trendall attributes this vase to the Pisticii Painter, who was one of the first of the red-figure painters in Southern Italy. The motif of standing youths clad in himatia is one that commonly decorates the reverse sides of South Italian vase paintings (see, for example, cat. no. 36). The figural style and composite profile view of the satyr on the right of side A strongly recall Attic red-figure vases of the early fifth century BC.

The findspot of this particular vessel is unknown, but kraters are often found in grave contexts, presumably as offerings to the deceased. The primary function of kraters was for mixing wine. The decoration of side A with members of the Dionysiac entourage playing musical instruments and drinking underscores the vessel's symposiastic context. The relaxed atmosphere of frolicking satyrs on side A stands in marked contrast to the more sober portrayal of satyrs on the Villa of the Mysteries frieze, where two satyrs solemnly examine the contents of a bowl held by Silenus (group D).

DATE: 440–430 BC.

BIBLIOGRAPHY: University of Michigan Museum of Art 1965, IIIb; "Historical Background Contextualizes Exhibition on Music in Roman Egypt," *Kelsey Museum Newsletter* (Fall 1998) ill.

EXHIBITIONS: "Greece vs. Rome: The Search for the Classical Spirit," UMMA-MPP, 3/91–4/91; "Music in Roman Egypt," Kelsey Museum of Archaeology, Winter 1999.

BL

1 Rasmussen and Spivey 1991, 258.
2 The other regional styles of red-figure vase painting in Southern Italy and Sicily are Apulian, Campanian, Sicilian, and Paestan.

62 Askos

Bronze
H. 9; W. 4 1/2; L. 7 1/2 in.
(22.86; 11.43; 19.05 cm)
Pompeii
Field Museum of Natural History, acc. no. 24341
The entire surface of the askos is corroded and covered with incrustations.

The askos is set on a low foot. The globular body rises to a high curved neck, then flares out at front in a wide raised mouth.[1] Ridges on either side of the body extend downward from the rear edge of the rim, where two small goats sit separated by the thin, high curving handle; perched at the apex of the handle is a parrot with a long tail.[2] At its base, the handle separates into two sections, each joined to a decorative attachment in the form of a Silenus mask.[3]

The word *askos*, meaning "wineskin" in Greek, refers to

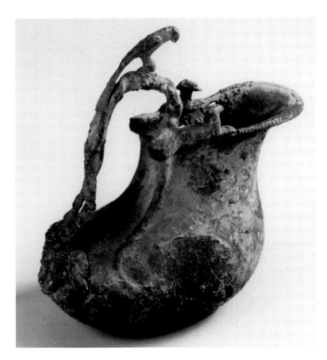

the resemblance the shape of the vessel had to wineskins.[4] Produced in both pottery and precious metals, askoi were vessels commonly used for pouring oil. In Campania, large numbers of bronze askoi have been found in funerary contexts. Oil flasks, such as lekythoi and askoi, were commonly buried with an individual after use in funerary rites.

The presence of the Silenus mask as the handle attachment on this piece (as on cat. nos. 66 and 67) is indicative of associations with Bacchus/Liber, whether used in daily life or placed in the grave.

DATE: Fourth century BC–first century AD.

Unpublished.

CH

1 The body shape of this askos is similar to that of an askos from Pompeii (Tassinari 1993, inv. no. 4088, pl. 56), and also to two askoi from Herculanum (Museo Archeologico Nazionale di Napoli, 1986–89, 1:178, nos. 43–44, Naples Museum 69166 and 69164).
2 For comparable goat figures lying on the rim of an askos, see Mitten and Doeringer 1967, 308, no. 309.
3 There are several parallels for handles decorated with parrots and Silenus mask handle attachment. See Tassinari 1993, inv. nos. 2551 and 14114, pl. 89.2; Pernice 1925, 14, fig. 18.
4 Robinson 1992, 105.

63 Lamp with Vines and Grape Clusters

Fired clay
L. 5 3/4; W. 4 1/2 in.
(14.8; 11.6 cm)
Rome
Purchased by F. W. Kelsey, 1893
Kelsey Museum of Archaeology, acc. no. 567

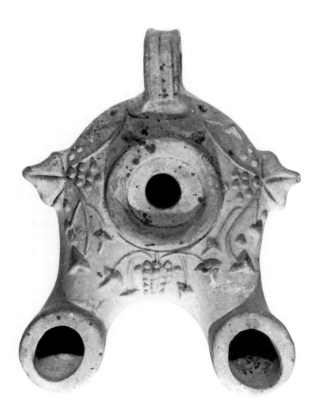

The lamp is in excellent condition, with some dark speckling on the upper surface.

This terracotta lamp has two raised nozzles with circular wick holes, a strap handle and a heel-shaped base, which lacks a signature. It is molded of buff-colored clay, somewhat mottled in appearance. The top of the lamp is decorated in relief with ivy vines and grape clusters arranged around the central discus. There are two leaf-shaped projections on either side of the lamp.

The lack of wear and the crispness of the relief impression may indicate that this is a modern reproduction rather than an ancient Roman lamp, but the shape conforms to that of lamps dating to c. 25 BC–AD 50.[1]

The status of this object as a possible "copy" raises questions concerning the nature of imitation, reproduction, and inspiration, which are of central interest to this exhibition. The ivy and grape motif on the lamp occurs on authentic Roman lamps and here demonstrates the widespread use of Bacchic imagery in a number of media. Such imagery, which is still associated with the ever-popular god of wine, is familiar to modern viewers; it lends an aura of authenticity to objects of uncertain date, such as this lamp.

DATE: Possibly a modern copy of a type from the late first century BC or early first century AD.

Unpublished.

SK

1 See Fitch and Goldman 1994, no. 275, fig. 35.

64 Lamp with Relief of a Dancing Satyr

Fired clay
Diam. spout to handle 4⁵/₁₆; Diam. of body 3⁵/₈; W. 1¹/₁₆ in.
(12.5; 9.2; 2.7 cm)
Rome
Kelsey Museum of Archaeology, acc. no. 658
The ring of the handle is broken, and there is a large, irregular hole in the center of the bottom 4.6 cm in diameter. The surface is worn.

The mold-made lamp, of a light buff clay, retains some traces of a red slip. The lamp is circular in shape, with a round nozzle.[1] The rim of the lamp has a double incision at its center and is impressed with a pattern of alternating grape clusters and leaves. The chest of the figure on the discus is frontal, but the legs are turned to the side, creating the impression of motion. The left leg is raised and bent at the knee, while the right leg, also bent, stands securely on the ground. The figure's raised arms grasp two unidentifiable objects. The head of the figure, though badly worn, appears to have horns. Given the presence of the grape motif on the rim and the movement of the figure, it seems likely that this lamp depicts a dancing satyr.

In size, shape, and decoration, the lamp is comparable to several British Museum lamp types, which reveal similarities in length and width, shoulder form, and decoration. Many of the lamps of this group (Type Q viii) in the British Museum are decorated with floral motifs, a feature that the Kelsey piece shares.[2] The Kelsey lamp's nozzle is rounded, while the nozzle type of the British Museum lamps is typically heart shaped. Such variations of nozzle type in this

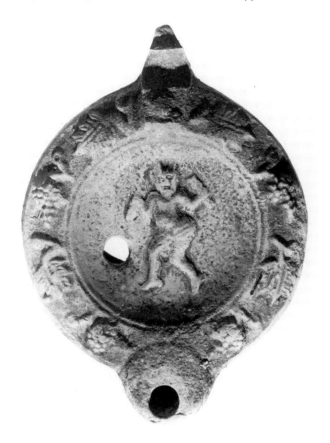

196

group, however, are common, suggesting a date between the late Antonine period and the middle of the third century AD.[3]

The satyr on the discus of the Kelsey lamp can be compared to those on two lamps in the collections of the British Museum (Q 2842 and Q 2843), both of which depict a figure dancing with two long, straight objects held in the hands.[4] This figure has been identified as a "stave dancer," probably a dwarf who acted as a comic entertainer. The Kelsey satyr differs in two important respects from the stave dancers. It lacks the phallus that hangs between the stave dancers' legs, and the Kelsey piece appears to have horns. While its iconography shares certain features with the stave dancer, the figure depicted on the Kelsey lamp is not mortal.

DATE: Late Antonine–mid-third century.

Unpublished.

DW

1 The nozzle conforms to Loeschcke Type K, while the shoulder can be compared to Loeschcke Type VIIIb (Bailey 1980, 246–48, 364).
2 British Museum lamps (Type Q viii), cat. nos. Q 1387, Q 1392, Q 1394 and Q 1397 (Bailey 1980, 364–69).
3 Bailey 1980, 364–69.
4 Bailey 1980, 364–69.

65 Double Herm with *Paniskos* and *Paniske*

Bronze
H. of herm 7½; H. of base 5 in.
(19.05; 12.70 cm)
Torre del Greco, near Pompeii, Italy
Los Angeles County Museum of Art,
 William Randolph Hearst Collection
Acc. no. 51.18.9
The herm has a green and blue patina. A rectangular opening in the torso reveals a hollow cast.[1] The eyes were originally articulated with metal nails.

One side of the herm depicts a bust of a youthful, smiling *paniskos* with pointed ears, clad in the pelt of a goat. In his bushy hair are nestled two long goat horns. The *paniske* on the other side of the herm is clad in a thin peplos. Her head is adorned with a wreath of ivy and berries, and her thick, wavy hair is parted in the center. A corkscrew curl falls over each of her shoulders.

The sharply defined features, incised irises, and precision of detail suggest that the herm is a Roman work rather than a product of a Hellenistic workshop.[2] The form of the herm, with its hollow interior and rectangular opening beneath the arm, recalls the double herms from the Nemi ships, one of a silenus and satyr and one of two maenads.[3] The long, slender Nemi herms, which functioned as elements of the ship's balustrade, can be dated to c. AD 25–50.[4]

By the Roman period, herms such as these often served a decorative purpose, either as ornaments for the garden or in interior spaces. They also served as architectural sup-

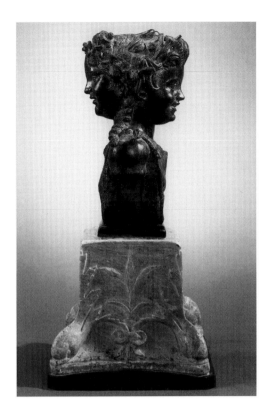

ports and were sometimes incorporated as decorative elements in metal objects such as candelabra or thymiateria. Most Roman herms were classicizing or archaizing in style. Either single or double-headed, they depicted a variety of personages, both divine and mortal.[5]

This herm of a Pan-boy and Pan-girl was probably once part of the decorative scheme of a Roman townhouse or villa in Campania, intended in that setting to elicit the pastoral ideal.[6] It evokes a mythological world of woodland creatures and Bacchic revelry and participates in a tradition of bucolic, rustic imagery such as that found in sacro-idyllic Roman landscape painting.[7] It also recalls the young satyr and satyress with goats depicted on the Villa of the Mysteries frieze (group C).

DATE: First century BC–first century AD.

BIBLIOGRAPHY: Castellani 1884, no. 277; Musée du Petit Palais 1897–1901, 1:17–18, no. 20, pl. 23; Burlington Fine Arts Club 1904, 63, no. D106, pl. 67, collection G. Salting; Mitten and Doeringer 1967, no. 294.

SK

1 Mitten and Doeringer 1967, no. 294.
2 Kozloff and Mitten 1988, 277; compare with a cast bronze bust of a *paniske* in the British Museum (GR 1814.7-4.750). See Barr-Sharrar 1987, 70, 108, pl. 44.
3 Ucelli 1950, 175 fig. 189, 220–21 figs. 241–43; see also Kozloff and Mitten 1988, 277, fig. 20.
4 Kozloff and Mitten 1988, 277, fig. 20.
5 For a summary of the function of herms and their history in the Greek world, see Mattusch 1994, 431–50.
6 See Frazer 1992, 49–61, esp. 51 ff.
7 See Bergmann 1992, 21–46.

197

66 Stamnos with Silenus Masks

Bronze
Approx. H. 17; W. at handles 17½ in.
(43.2; 44.5 cm)
Said to be from Pompeii
Field Museum of Natural History, acc. no. 24353
The surface of the stamnos has many small pits.

The stamnos has a flat, outward-curving lip on its concave neck. From its flat shoulder the body tapers to the vessel's foot. Just below the shoulder are two horizontal fluted handles that curve upward. Each handle is joined to the vessel by two teardrop-shaped attachments that are decorated in relief. These plates both have an undecorated border. Below the end of the handle is a pair of scrolls, each enclosing a half palmette. Beneath the scrolls, in the point of the attachment, the face of Silenus is represented. His broad face has wide-set eyes and a flat nose. The face is crowned by long, straight hair, parted above the center of the forehead, and by a pair of pointed ears. Silenus wears a long mustache and a beard that fills the point of the attachment.

Stamnoi were used for storing wine and, as such, were among the vessels and other utensils used for banqueting. Stamnoi and other vessels associated with feasting were a common element of Etruscan tomb assemblages.[1] Sometimes the stamnoi were used as cinerary urns.[2] The images of Silenus are doubly appropriate in this context. Through his association with wine Silenus is naturally a fitting subject for the decoration of wine containers. Secondly, like the god Liber, with whom he was closely connected, Silenus may also have been associated with death and the afterlife.

This stamnos is among the earliest of the objects with Bacchic imagery in this exhibition. The presence of Silenus

masks on it reflects the prominent place that Bacchic figures occupied in the beliefs of Italian cultures for several centuries prior to the creation of the Villa of the Mysteries frieze.

DATE: Late fifth–fourth century BC.

Unpublished.

JMD

1 For parallels from tomb contexts, see Haynes (1985, 77, 267, no. 59).
2 Mitten and Doeringer 1967, 196, no. 201.

67 Trefoil Oinochoe

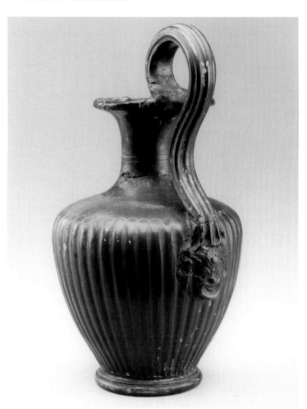

Fired clay with black glaze
H. 7 in.
(17.8 cm)
Etruria, Italy
The Detroit Institute of Arts, Gift of the Etruscan Foundation, Inc.
Acc. no. 61.135
The handle has been broken and repaired. There are many small areas of surface loss, especially on the handle and on the ribs of the body.

This small black-glazed oinochoe has a trefoil rim and a ribbed, undulating handle. Two incised horizontal lines decorate the middle of the concave neck. The nearly flat shoulder leads to an ovoid body. The body is decorated with parallel vertical ridges that extend from the shoulder to the foot. The ridges are connected at the top by a series

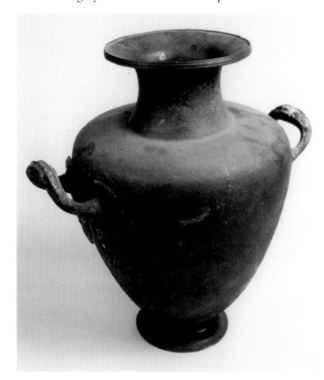

of impressed arcs. Just below the lower end of the handle is a mask of a satyr or Silenus. The stylized face on the mask has a beard, an open mouth, and wild curly hair.

This vase is one of many similar vessels of fourth- to third-century date that come from Etruscan sites.[1] The mask beneath the handle is a standard element on oinochoai of this type. Like the stamnos with the masks of Silenus beneath its handles (cat. no. 66), this oinochoe reveals the popularity of even small references to Bacchic figures on vessels intended for everyday use and for funerary assemblages. In comparison with the Villa of the Mysteries frieze, objects such as this oinochoe reveal the wide range of contexts and media in which such imagery was used. A small oinochoe of similar type is held by the woman who pours water over the hand of the seated matron on the north wall of the Villa of the Mysteries frieze.

DATE: Third century BC.

Unpublished.

JMD

1 For parallels, see Hayes 1984, 65–67, no. 111; Morel 1981, 371–73, ser. 5611, pls. 175–77.

68 Lucanian Bell Krater with Maenad and Satyrs

Attributed to the Amykos Painter
Fired clay
H. 12⁷/₁₆; D. 12³/₄ in.
(31.6; 32.5 cm)
Lucania, Italy
Arthur M. Sackler Museum, Harvard University Art Museums,
 Bequest of David M. Robinson
Acc. no. 1960.358
The light reddish clay is covered by black glaze, worn in areas.

A band of laurel leaves decorates the area below the rim. A meander with cross-squares encircles the vase below the figural scenes. On the obverse, a maenad wearing a chiton plays a double flute. She faces right, seated on a rock with her feet also resting on part of a rocky outcropping. Two bearded satyrs, identified by their pointed ears and tails, dance on either side of her. The satyr on the left carries a thyrsus with his left arm slightly behind him, his right arm stretched out in front of him, and his left leg raised and bent at the knee. The satyr at the right is rendered with a frontal face and torso in three-quarters view. He holds his right arm out toward the maenad. The reverse side, like cat.

nos. 31 and 61, is decorated with the figures of young men draped in himatia.[1] On this krater, three men stand in profile. The young man on the far left holds a staff and faces the other two, of which the one on the far right also holds a staff.

Trendall attributes this vase to the Amykos Painter, a follower of the Pisticii Painter (see cat. no. 61) and an important figure in his own right among early red-figure painters in Southern Italy.[2] As with cat. no. 61, this vessel has no definite provenance but was probably part of a funerary assemblage. Drinking vessels were a prominent part of the banqueting equipment provided for the dead for use in the afterworld.

DATE: Late fifth century BC.

BIBLIOGRAPHY: *CVA* USA 7, Robinson Collection 3:26, pl. 18.1; Hanfmann 1961, 21, no. 142; Trendall 1967b, 1:34, no. 120; Trendall 1974, 31, no. 131; Houser 1979, 40–42, no. 14.

CH

1 For a detailed discussion of the various types of draped young men, see Trendall 1967b, 1:11–12.
2 Trendall 1967b, 1:34, no. 120.

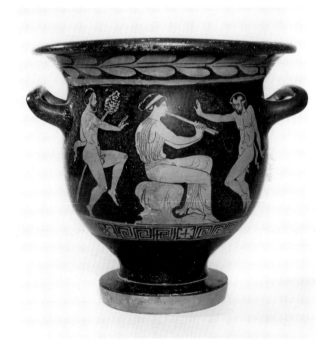

69 Villa of the Mysteries Mural Cycle in Twentieth-Century Watercolor

Maria Barosso, Rome, Italy
Watercolor
Commissioned by F. W. Kelsey, 1924
Painted 1925–27
Kelsey Museum of Archaeology, acc. no. 2000.2.1–7

The paintings of the murals in Room 5 of the Villa of the Mysteries by Maria Barosso have been examined and treated several times by conservators. The commentary on their condition provided below, however, is almost wholly taken from the report commissioned by the Kelsey Museum in 1986 by Laurie Mactavish and Genevieve Baird, which is the most recent report on file at the Kelsey Museum.[1] Currently, Brook Bowman, the Interim Conservator of the Kelsey Museum collections, has unrolled and relaxed the paintings, and, at the time of this writing, she is engaged in cleaning, repairing, and mounting the watercolors for exhibition. Her full report, however, will only be available after this catalogue goes to press.[2] Thus the descriptions provided below represent the state of conservation as of 1986, not 2000. The reader should assume that much of the damage noted by Mactavish and Baird will have been repaired by Brook Bowman by the time of the exhibition.

A description of the imagery of the Barosso watercolors would be redundant here, given that the paintings faithfully reproduce that of the Roman paintings in Pompeii.[3] Descriptions of the latter, therefore, apply to the watercolor representation. The nature of the commission and documentation of the project are discussed by Elizabeth de Grummond in chapter 12 of the present volume.[4]

The entire Roman figural frieze, along with its upper and lower borders, were represented by Barosso at five-sixths scale. A sample panel, portraying the seated bride and her attendants (group G) on the western end of the south wall, was painted at full scale (E1–3, below). The same panel was painted again at five-sixths scale (D1–3) to match the rest of the watercolor frieze. The letters and numbers used to designate each painting below are keyed to those indicated on the plan of the figural frieze (**fig. 000**), which are referenced throughout this catalogue.

1 "Examination Report on the Barosso Watercolors, Villa of the Mysteries, Pompeii," prepared for the Kelsey Museum of Archaeology, Ann Arbor, Michigan, by L. Mactavish and G. Baird, February 1986.
2 Her brief report on work in progress, B. Bowman, "Conserving the Barosso Watercolors," appeared in the *Kelsey Museum Newsletter* (Ann Arbor, Spring 2000) 4.
3 Barosso, however, did not represent all of the details of the frieze of Cupids in the upper register.
4 See ch. 12 and color plates 000–000 for further illustrations.

EKG/CH

A1–4 = North Wall, Groups A, B, and C/ Figures 1–11

A1. FIGURAL FRIEZE
H. 23¹/₂; L. 194¹/₂ in.
(59.69; 494.03 cm)
Painted in 1926
Kelsey Museum of Archaeology, acc. no. 2000.2.2a

The painting, which depicts the main, figural zone of the north wall of Room 5 in the Villa of the Mysteries, is composed of two joined pieces of paper keyed together 98¹/₂ in. from the right side. The pieces are joined on the verso by a

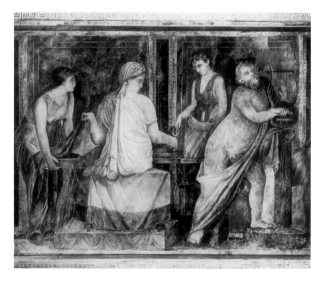

North wall figural frieze (left).

North wall figural frieze (center).

wide piece of heavy paper glued to the painting back with hide glue adhesive. The upper and lower edges of the painting are severely crumpled. The backing fabric has separated from these edges 3 in. into the painting. There are multiple tears associated with these crumples, especially in the lower left corner. Several $^1/_2$ in.-diameter circles are embossed on the painting front. A paper insert is located 40$^1/_2$–48 in. from the lower left edge; the insert is attached to the main body by a fabric-covered paper patch pasted onto the verso. Slight abrasion mars the painted surface along the bottom edge, and there is paper loss in the middle left edge. A crease in the paper occurs 15$^1/_2$ in. from the left side and another one at 22$^1/_2$–28 in. from the left edge and 27 in. down from the top. The two pieces of paper are backed with different fabrics: the paper on the right-hand side has a white canvas backing and the one on the left-hand side, a gray canvas. The seam in the gray canvas has imprinted a sympathetic crease all along the front of the paper. The painting is signed on the verso: "*Maria Barosso Roma Fecit Pompeii 1926.*"

A2. UPPER BORDER (ABOVE DOOR)
H. 23$^3/_8$; L. 35$^1/_2$ in.
(59.37; 90.17 cm)
Kelsey Museum of Archaeology, acc. no. 2000.2.2b

Written in pencil on the recto are the words "*Cornincia la parete lungo sopra la porta. DA AGGIUNGERE COL PEZZO A–B.*" Alignment instructions are written along the right side in pencil.

The left side is cut so as to key to another piece of the upper border. The back of the key has a paper residue where it was once joined with hide glue to its mate. Written on the verso: "*fregio della grande pittura della villa dei misteri. Appartiene all'Universita di Michigan pagato TUTTO.*"

A3. UPPER BORDER (FROM EDGE OF DOOR)
H. 23$^1/_2$; L. 194$^1/_2$ in.
(59.69; 494.03 cm)
Kelsey Museum of Archaeology, acc. no. 2000.2.2c

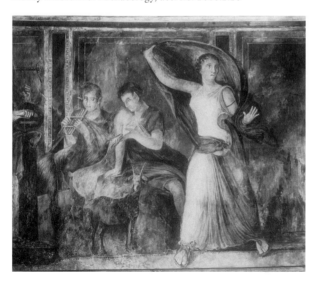

North wall figural frieze (right).

The piece is keyed on the right side to be joined to the aforementioned border (A2). Alignment instructions are written on the upper edge in pencil. Several $^1/_2$ in.-diameter circles are embossed along the paper's top edge. A crease is located 44$^3/_4$ in. from bottom left edge. Several vertical soft creases occur throughout the painting. The backing fabric is heavily stained and is marked with numerous paint splatters. Paper residue remains along the keyed edge verso from the time when the piece was joined to its mate.

A4. LOWER BORDER
H. 28$^1/_2$; L. 236 in.
(72.39; 599.44 cm)
Kelsey Museum of Archaeology, acc. no. 2000.2.2d

The painting is composed of two pieces keyed to each other 144 in. from the left edge. The pieces are joined together on the verso with a paper strip attached with hide glue. The upper right-hand corner is severely creased. Tears along the perimeter are associated with pinholes. Several 1 in.-diameter circles are embossed along the upper edge. There is a small amount of paper loss in the upper right-hand corner. Creases run along the lower right edge.

B1–3 = East Wall, Groups D and E/ Figures 12–20

B1. FIGURAL FRIEZE
H. 58; L. 166 in.
(147.32; 421.64 cm)
Painted in 1925
Kelsey Museum of Archaeology, acc. no. 2000.2.3a

The top edge of the painting is severely crumpled on the left side, and several small tears are associated with the crumpled area. Pinholes are throughout the painting, not only along the perimeter. A series of $^1/_2$ in.-diameter circles is embossed along the painting margins. Creases in the paper are located 69 in. from the left side 6–19 in. down from the top, and also 62$^1/_2$ in. from the right side 19$^1/_4$ in. down from the top. A thumbnail-shaped dent is located 23$^1/_2$ in. from the right edge and 24$^1/_2$ in. down from the top. There is abrasion and pigment loss along the right side and to the right of the central seated figure. The backing fabric has rust-colored mold or foxing stains along the bottom edge. The piece is signed on the front: "*dipinto da Maria Barosso di Roma a Pompeii 1925.*"

B2. UPPER BORDER
H. 24$^1/_8$; L. 164 in.
(61.28; 416.56 cm)
Kelsey Museum of Archaeology, acc. no. 2000.2.3b

There are tears long the perimeter associated with a pinhole and the crumpled edges. Several $^1/_2$ in.-diameter circles are embossed in the paper surface. Alignment instructions are written in pencil along the center bottom edge. There are scuff marks in the lower right area.

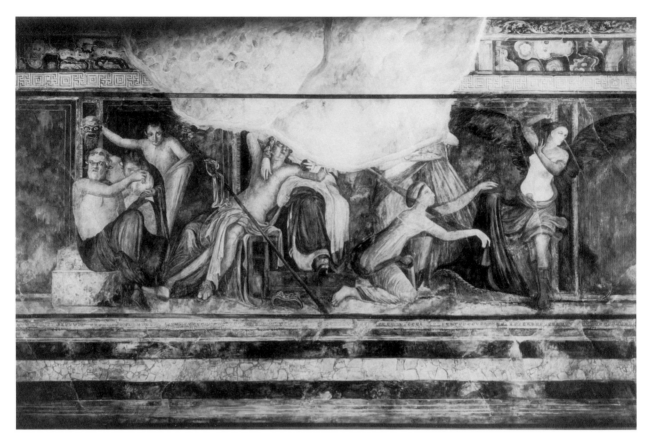

East wall of figural frieze

B3. LOWER BORDER
H. 29; L. 166¹/₄ in.
(73.66; 422.28 cm)
Kelsey Museum of Archaeology, acc. no.2000.2.3c

Small tears are associated with pinholes along the perimeter; others are located in the upper left corner and on the lower right side. A crease located at 50 in. from the left side extends 10 in. into the painting. A crease located at 42 in. from the right edge along the bottom extends into the painting 10 in. The backing fabric is extremely dirty and is covered with watercolor stains.

C1–3 = South Wall, Group F/ Figures 21–24

C1. FIGURAL FRIEZE (FLAGELLATION)
H. 58¹/₈; L. 71¹/₂ in.
(147.64; 181.61 cm)
Painted in 1925
Kelsey Museum of Archaeology, acc. no. 2000.2.4a
See color pl. II

The painting, which depicts a scene usually identified as a flagellation, is signed by the artist in the lower left corner. A dime-size tear in the upper right corner is located 7³/₄ in. from the right edge. The backing fabric is seamed vertically in two places. There are numerous areas where the backing fabric is no longer attached to the paper and loss of the backing fabric along the lower edge. There is an orange mold stain (est.) over the entire fabric.

C2. UPPER BORDER
H. 23³/₄; L. 71³/₄ in.
(60.33; 182.25 cm)
Kelsey Museum of Archaeology, acc. no. 2000.2.4b

There is a sharp crease along the left edge. Written on the verso in pencil: "*fregio sopra la scena della flagellasiona.*"

C3. LOWER BORDER
H. 28¹/₂; L. 71³/₄ in.
(72.39; 182.25 cm)
Kelsey Museum of Archaeology, acc. no. 2000.2.4c

There are small tears along the top edge and in the lower right corner and a crease 5¹/₄ in. from the top and 27¹/₂ in. from the right edge.

D1–3 = South Wall, Group G/ Figures 25–27

D1. FIGURAL FRIEZE (SEATED BRIDE)
H. 58³/₈; L. 67¹/₂ in.
(148.27; 171.45 cm)
Painted in 1926
Kelsey Museum of Archaeology, acc. no. 2000.2.5a
See color pl. III

The figural panel represents a seated woman dressing her hair with the help of a female attendant who stands behind her and a Cupid who stands to her right holding a mirror.

The panel is crumpled along the top edge, and several small tears along the top are associated with the crumples. Two small tears are located along the bottom edge. The fabric backing has separated from the paper along the top edge and the left side. There are several finger-shaped areas along the right side where the fabric is no longer attached to the paper. Adhesive stains occur throughout the fabric. The back is signed by the artist in pencil.

D2. UPPER BORDER
H. 23; L. 67⁵/₈ in.
(58.42; 171.77 cm)
Kelsey Museum of Archaeology, acc. no. 2000.2.5b

Small tears are associated with the crumpled edges. The white lead (est.) overpaint on fretwork is turning dull gray in places. The inscription in pencil on the verso reads: "*fregio sopra la luna [?] della toeletta.*"

D3. LOWER BORDER
H. 28³/₄; L. 67¹/₂ in.
(70.03; 171.45 cm)
Kelsey Museum of Archaeology, acc. no. 2000.2.5c

There are crumples along the lower edge. An inscription in pencil on the verso reads: "*sotto scena toeletta, soccolatura sotto la scena della vestizione.*"

E1–3 = South Wall, Group G/ Figures 25–27 (Full Scale)

E1. FIGURAL FRIEZE (SEATED BRIDE)
H. 58; L. 78 in.
(147.32; 198.12 cm)
Painted in 1925
Kelsey Museum of Archaeology, acc. no. 2000.2.7a

The scene is identical to the preceding bridal group, D1. E1, however, is represented at full scale as compared to D1 at five-sixths scale.

There are small tears associated with the crumpled upper, lower, and left side edges and losses to the paper along the left side, up to 1¹/₂ in. into the painting. Tears and crumples are associated with pinholes and with staples along the perimeter. There is cockling along the entire perimeter. A 1¹/₂-in. tear is located 23 in. from the lower left edge and 2¹/₄ in. from left corner. A T-shaped tear occurs in the upper left corner. The backing fabric has pulled away from the paper in the top corners, and some paper delamination is associated with this separation. A loss of adhesion of the fabric to the paper is notable throughout. There are paste stains over the entire back of the fabric.

E2. UPPER BORDER
H. 28; L. 78¹/₂ in.
(71.12; 199.39 cm)
Kelsey Museum of Archaeology, acc. no. 2000.2.7b

Small tears are associated with the crumpled edges. Some ¹/₂ in.-diameter circles are embossed into the paper surfaces. A series of three tears is located 42–51 in. from the right edge and up 3–6 in. from the bottom. There is a tear located 2–5 in. up from the bottom and 5–9 in. from the left side, and a U-shaped tear 8 in. from the bottom and 16–18¹/₂ in. over from the right edge. A dent is located 1¹/₂ in. from the left edge and 4¹/₂ in. from the top, and a crease 7¹/₂ in. from the bottom and 26–34 in. over from the right edge. The backing fabric has been removed except behind the area of the three tears (see above). A general delamination of the paper verso is associated with the removal of the fabric. There are numerous dents in the paper surface throughout the painting and a brown gummed paper residue along its edges.

E3. LOWER BORDER
H. 43¹/₄; L. 79¹/₄ in.
(109.86; 201.30 cm)
Kelsey Museum of Archaeology, acc. no. 2000.2.7c

Several small tears are associated with the crumpled edges along the left and lower edges. A large tear extending 44 in. into the artwork is located 17 in. up from the left edge. An L-shaped tear is located 3³/₄ in. up from the lower edge and 40³/₄ in. over from the right edge. The fabric backing has been removed. Starch adhesive residue covers the entire paper surface on the verso, and brown gummed paper residues adhere along the verso of the painting's top edge.

F1–3 = West Wall, Group H/ Figure 28

F1. FIGURAL FRIEZE (EROS)
H. 57³/₄; L. 33¹/₈ in.
(146.69; 84.14 cm
Painted in 1925
Kelsey Museum of Archaeology, acc. no. 2000.2.6a
See fig. 12.1

The painting represents Eros, or Cupid, who is leaning on his right arm and holding his bow in his left hand. There are tears associated with the crumpled edges.

F2. UPPER BORDER
H. 24¹/₂; L. 33¹/₈ in.
(62.23; 84.14 cm)
Kelsey Museum of Archaeology, acc. no. 2000.2.6b

An inscription in pencil on the verso reads: "*fregio sopra la figura dell'amorino.*" Rust-colored mold stains or foxing occur throughout the backing fabric.

F3. LOWER BORDER
H. 29; L. 34³/₄ in.
(73.66; 88.27 cm)
Kelsey Museum of Archaeology, acc. no. 2000.2.6c

There is a crease in the lower left corner. An inscription in pencil on the verso reads: "*soccolatura sotto l'amorino.*"

G1–3 = West Wall, Group I/ Figure 29

G1. FIGURAL FRIEZE (SEATED MATRON)
H. 56⁷/₈; L. 34⁵/₈ in.
(144.46; 87.95 cm)
Painted in 1926
Kelsey Museum of Archaeology, acc. no. 2000.2.1a
See frontispiece

The painting is signed "*Maria Barosso 1926*" in lower left corner and again on the back, "*Maria Barosso, MCMXXVI.*" There is a small tear in the lower right-hand corner. An inverted U-shaped tear, located 27–32 in. up from the lower edge and 8¹/₂–16 in. from the left side, has been repaired. To repair the tear, the original fabric backing was removed and replaced with a paper backing. Associated with the rebacking are areas of creases and air pockets where the papers warped because of the tear. The entire piece is extremely stiff and brittle.

G2. UPPER BORDER
H. 24; L. 34¹/₂ in.
(60.96; 87.63 cm)
Kelsey Museum of Archaeology, acc. no. 2000.2.1b

There are severe crumples along the upper and lower edges, a fold in the upper right corner, and several dents along the upper left corner. Several small tears are associated with pinholes along the perimeter. An interior tear is located 13¹/₂ in. up from the bottom edge on the left side. Creases and paper delamination occur 5¹/₂ in. from the upper edge and 13¹/₂–15 in. from the left side. An inscription in pencil on the verso reads: "*fregio sopra la figure isolata* (indecipherable) *seduta.*" There is an alignment instruction written along the bottom edge, verso, and rust-colored mold stains or foxing along the bottom half of the backing fabric.

G3. LOWER BORDER
H. 30¹/₂; L. 33¹/₈ in.
(77.47; 84.14 cm)
Kelsey Museum of Archaeology, acc. no. 2000.2.1c

Several small tears are associated with the severely crumpled upper and lower edges. A number of other tears are associated with the pinholes located along the bottom perimeter. There is a 1¹/₂ in. crease located 15¹/₂ in. down from the upper left edge. The white lead (est.) overpaint in the central portion is starting to turn dull gray. A 1 in.-diameter oil stain is located 6¹/₂ in. from the right corner. Alignment instructions are written in pencil on the upper right edge. A penciled inscription on the verso reads: "*Soccolatura sotto la donna seduta.*" The backing fabric is substantially soiled along the upper right edge. Several areas of watercolor paint are smeared over the entire back.

GREEK SOURCES: ATTICA, SOUTHERN ITALY, AND THE HELLENISTIC EAST

70 Attic Red-figure Hydria

In the manner of the Meidias Painter
Fired clay, with black and yellowish glaze, white paint
H. 14; Diam. 9³/₄ in.
(35.5; 24.7 cm)
Attica, Greece
Arthur M. Sackler Museum, Harvard University Art Museums,
 Bequest of David M. Robinson
Acc. no. 1960.347
The vase was broken and has been restored. There are some paint losses.

A bead-and-reel frieze encircles the lip, an egg-and-dart frieze the neck, and a meander-and-St.-Andrew's-cross frieze the body, which is painted with a figural scene. The figures are placed on varying groundlines, so that some figures appear to hover over others.[1] Dionysus is seated at the center, half-draped and holding a thyrsus. Eros flies overhead holding a necklace. To Dionysus's right is a vine of ivy that separates him from an approaching bushy-tailed satyr holding a thyrsus and wearing an ivy wreath. A woman in a chiton and himation is seated above, to the satyr's right. Dionysus's gaze is held by a woman on his right, who reaches her hand out to a panther reposing on the ground. Above her to the left a partly draped male figure wearing a diadem and holding a kerykeion sits above a stylized vegetal formation; below him is a chiton-clad seated woman whose hair is

bound in a bun. An Eros approaches the young man. Floral decoration in the form of palmettes, lotuses, and tendrils adorns the spaces above and below the handles and on the back of the vase.

The scene may be identified as Dionysus with his retinue, composed of both mythical figures (the satyr) and human ones (the young men and women who are probably members of the god's earthly cult). Similar compositions appear frequently in both Attic and South Italian vase painting. The woman approaching the panther is probably the wife of Dionysus, Ariadne, who is often depicted as Dionysus's female companion, or she may be a maenad. The presence of Erotes is notable: it may give the scene an erotic content, which would support the woman's identification as Ariadne and allude to the couple as a *hieros gamos*, a paradigmatic sacred marriage. Erotes do not belong to the realm of Dionysus but rather to that of Aphrodite. Their presence in this scene probably refers to the god's fertile and regenerative powers.

This kind of Attic imagery was well known in Italy, where not only Attic vases but their South Italian counterparts were prized. Such images comprise the corpus from which the Bacchic scenes in the Villa of the Mysteries frieze ultimately derive.

DATE: c. 400 BC.

BIBLIOGRAPHY: Hanfmann 1961, 18, no. 107; Beazley 1963, 1341, 2; Buitron 1972, 146–47, no. 80; Houser 1979, no. 15, figs. 15a–c; *CVA* USA 7, Robinson Collection 3:22, pl. 13.

SK

1 A characteristic of the Meidias Painter. See Houser 1979, no. 15.

71 Red-figure Oinochoe

Attributed to the Felton Painter
Fired clay
H. 8¹/₂; Diam. 6¹/₄; Diam. of foot 4¹/₂ in.
(21.0; 15.9; 11.5 cm)
Apulia, Italy
Lent by the Toledo Museum of Art
Purchased with funds from the Libbey Endowment,
 Gift of Edward Drummond Libbey
Acc. no. 67.136

The oinochoe is intact. There are some chips in the lower center of the scene and in the meander. In some areas the added white has been lost.[1] There are small areas of surface loss especially on the rim and the foot. Vertical streaks of black glaze are visible on the neck and feet of the dwarf and in the meander below him.[2]

The red-figure oinochoe has a trefoil mouth. The figured scene is bordered above by a band of egg-and-dot motif with ivy leaves above and below it, and below by a meander band interspersed with saltire squares. The figure at the left of the scene is a dwarf with an enlarged head who stands alone and looks out at the viewer. He wears a short cloak over his protruding stomach, and he raises it with his hands so that part of his phallus is visible. The cloak covers his

arms and head and obscures the lower part of his face. In his left hand he holds a white stick. To his left is a woman wearing a chiton. She is shown in profile to the right, standing with her weight on her left leg. Her hair is gathered at the nape of her neck. She holds her left hand at waist level with the palm up, and with her raised right hand she holds an oinochoe, from which she will pour into the phiale held by Dionysus. Dionysus occupies the center of the scene. He reclines, facing the standing woman, on an animal-skin couch and supports himself with his left arm on two embroidered pillows. A mantle is draped loosely around his waist and covers his legs. His right arm is extended toward the standing woman, and with it he holds a phiale. He inclines his head forward toward her. His hair is long and curly and is crowned by a wreath. Above Dionysus are a female mask and a tympanum, and below his couch is a tray of fruit. To Dionysus's left and facing away from him is a nude satyr, shown in profile to the right. He is in a dancing pose, supported by his bent left leg while the right leg, also bent, is lifted forward. His hair is bound in a fillet, and he holds another fillet across his hands, which he extends toward the figure at the extreme right of the scene. She is a dancing maenad who wears a sheer garment. The garment slips from her back as she turns away from the satyr. Her left arm, bent up at the elbow, is held behind her while she reaches out in front of her with the other arm. Above her tilted-back head is a branch with leaves.[3] The vase has been attributed to the Felton Painter by A. D. Trendall.[4]

The oddly dressed dwarf, probably a comic figure, wears a costume similar to those of actors in phlyax plays. These comedies, which parodied tragedies, the deeds of the gods, and everyday activities, appeared in Southern Italy and Sicily in the fourth and third centuries BC. Their popularity is attested by the frequency of the appearance of such

characters on vases from this region, and in particular on Apulian vases of the first half of the fourth century.[5] The presence of Dionysus on vases of this genre reflects his role not only as the god of wine and of the mysteries but also as patron of the theater. The multiple aspects of this god perhaps account for the numerous representations of him in various contexts, as demonstrated by this vase and other objects in the exhibition, in the art of ancient Italy.

The languid Dionysus loosely draped with a mantle calls to mind the similarly posed figure of Liber in the Villa of the Mysteries frieze. Although smaller in scale and different in detail, the figure on this vase represents one element of the repertoire of South Italian images of the god of wine on which the Villa's painters were free to draw as they shaped their own unique composition.

DATE: c. 375 BC.

BIBLIOGRAPHY: *CVA* USA 20, Toledo 2:pl. 95; Münzen und Medaillen A. G. 1967, *Auktion 34. Kunstwerke der Antike. 6. Mai 1967* (Basel) 96, pl. 63, no. 183; Trendall 1967a, 85, pl. 13b, no. 193; Riefstahl 1968a, 47; Hoffmann 1971, 135, figs. 112 a–c; Luckner 1972, 75, fig. 19; Schauenburg 1972, 318, pls. 131.2, 132.1–2; Trendall and Cambitoglou 1978–82, 1:172, no. 50; Mayo 1982, 101, no. 29; Dasen 1993, 241–42, 293, pl. 57.2.

JMD

1 *CVA* USA 20, Toledo 2:18.
2 *CVA* USA 20, Toledo 2:19.
3 *CVA* USA 20, Toledo 2:18–19.
4 Trendall 1967a, 85.
5 Trendall 1967a, 9.

72 Red-figure Volute Krater

Attributed to the Creusa Painter
Fired clay
H. at rim 20³/₁₆; Diam. of body 14⁹/₁₆; Diam. of foot 7¹/₁₆; W. including handles 17³/₄ in.
(51.3; 37.0; 17.9; 45.0 cm)
Lucanian
Lent by the Toledo Museum of Art
Purchased with funds from the Libbey Endowment,
 Gift of Edward Drummond Libbey
Acc. no. 81.110
The krater has been repaired from fragments. Some losses and chips along the cracks have been filled and repainted. Unfilled areas of loss remain on the right shoulder and hair of the woman with the kottabos stand and on the grapes and in the background above Pan.[1] There are small scattered dots of surface loss.

The red-figure volute krater has a figured scene on either side. The side of each volute is decorated with two rows of ivy leaves. The outside of the lip has an egg motif. Below the lip the neck has four bands of decoration on each side. At top is a band of large laurel leaves, next a row of short tongues, then a sinuous ivy vine, and fourth a row of palmettes. Around the shoulder of the vase and forming the upper border of the figured scenes is a band of vertical tongues. The lower border of each scene consists of a band of meanders, punctuated by saltire squares, that runs around

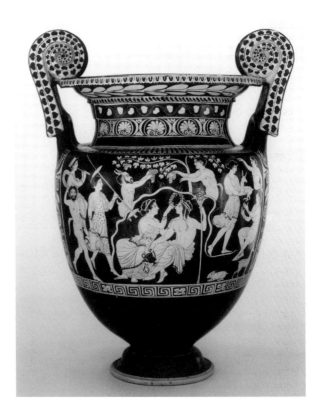

the entire body of the vase. The scenes are separated by a vertical border beneath each handle. The border is filled with two palmettes, one above the other, inside a vine motif. Each handle has two roots, around which the shoulder of the vase is decorated with a band of radiating tongues.

Side A: At the center of the scene Dionysus and a female companion, probably Ariadne, are shown seated in a cave, which is indicated by a wavy line. The goddess's legs are turned to her right, while she looks at the god over her left shoulder. She wears a sheer garment; her hair is bound in a fillet, and she wears a bracelet on each wrist. The goddess offers a wreath to the half-nude Dionysus with one hand and rests the other on his shoulder. The god holds a kantharos in his right hand and a thyrsus in his left. The cave is surrounded by Dionysiac figures. At the left side of the scene a satyr strides toward the cave. He carries on his left shoulder a maenad, fully clothed, who plays a double flute. Another maenad, who carries a kottabos stand in her left hand and a situla in her right, walks before them. Above the cave Pan, at left, and a satyr, at right, are picking grapes from a vine. At the right side of the panel is a scene framed by a raised groundline on which a satyr leans. Like Pan and the grape-gathering satyr, he is visible only from the waist up. Below him a standing maenad, shown in profile to the right, hands a fawn to another maenad seated on a rock. Beneath them are a rabbit and a second fawn.[2]

Side B: This side of the vase depicts two scenes, each with a man and a woman. At left, a woman, standing in profile to the right, holds out a phiale with her right hand to the youth before her. Above the phiale flies a bird. The youth, who wears boots and has a cloak fastened around his neck, is shown frontally but turns his head toward the woman. In his right hand he holds a hat; in his left he has a spear. A sword in a scabbard is worn around his neck and

under his left arm. To the right of these figures stands another couple. The woman, again in profile to the right and here heavily draped, offers a wreath to the youth. The young man, also nude except for his boots and cloak, rests his left hand and right knee against his shield; a spear held in his right hand leans on his shoulder. These two scenes may represent the same couple, showing first the departure and then the return of the youth.[3]

The vase has been attributed to the Creusa Painter by A. D. Trendall.[4]

The central scene of side A offers a parallel for the image of Liber and his consort in the Villa of the Mysteries frieze.[5] Although the basic idea of a depiction of the divine couple seated next to each other is the same, the two representations differ greatly in detail. In the Villa painting the goddess, placed at the center of the wall and raised above Liber, is clearly given a measure of prominence that she lacks on the krater, where the two are seated at the same level. Her elevation in the Villa may be connected to the focus on women in the surrounding initiation scenes: What better way to point out the special relationship between Liber and women than to emphasize his consort? The divine couple's companions also differ in the two images. On the krater, they are surrounded by satyrs and maenads. These figures also appear in the Villa, but there the couple is intimately connected with humans, both by the figures' proximity to the initiation scene to their left and by the network of gestures and glances that links all the figures in the frieze. These variations suggest the extent to which individual artists made use of familiar compositional types and adapted them to suit their own purposes.[6]

This krater was made in Lucania, a region in southwestern Italy. Its Dionysiac scenes reflect the importance and popularity of such imagery in this area, as throughout Southern Italy, in the late Classical and Hellenistic periods.

DATE: c. 400–380 BC.

BIBLIOGRAPHY: *CVA* USA 20, Toledo 2:pl. 91–93; Mayo 1982, 63–66, no. 6; Trendall 1983, 46, pl. 7; Trendall 1989, 56, fig. 72; Cambitoglou 1995, 429, fig. 520; Toledo Museum of Art 1995, 41; Sparkes 1996, 21, 24, fig. 1.16.

JMD

1 *CVA* USA 20, Toledo 2:16.
2 *CVA* USA 20, Toledo 2:16–17.
3 *CVA* USA 20, Toledo 2:17–18.
4 Mayo 1982, 66.
5 Liber's companion has been variously identified as Ariadne, Semele, and Venus. See ch. 11 by B. Longfellow in this volume.
6 For a more detailed investigation of parallels for the Villa frieze on South Italian vases, see ch. 10 by S. Kirk in this volume.

73 Polychrome Painted Lekanis

Fired clay, polychromy
H. including lid 22½ in.
(57 cm)
Probably Centuripe, Sicily

Indiana University Art Museum,
 Purchased in honor of Burton Y. Berry
Acc. no. 72.145.1
There are losses of the polychrome decoration and chips on the foot.

The conical body of the lekanis has two strap handles and is supported on a ringed foot. The base is painted with reddish-brown rays that terminate in off-white fans above which is painted a band of black scallops. A plastic beed-and-reel motif divides the painted decoration from a wide band of relief decoration stretching between the two handles. The band comprises gilded Erotes amidst gilded tendrils and pink and blue polychromed rosettes. In the center of the band is a gorgoneion with wavy hair and delicate features. The lid has figural decoration in creamy white with black details against a pink background. The conical lid is topped with a stem and bowl finial. All polychrome decoration was applied after the firing of the vase.[1]

This vase belongs to a group of more than one hundred vases from Sicily known as Centuripe ware.[2] Although most scholars believe these vases were fabricated in the town of Centuripe, their function and chronology have been difficult to assess because the majority of extant vases, such as this one, lack an archaeological provenance. Graves and sanctuaries are the most common recorded findspots, suggesting that Centuripe vases served as grave gifts or votive offerings. Attributions of date range from the third to first centuries BC, usually based on stylistic or technical similarities to other types of vase painting and/or Roman megalographic wall paintings, like the Villa of the Mysteries frieze.[3]

Centuripe vases exist in only a few shapes, of which the lekanis and the krater comprise the majority. The lids of many Centuripe vases are not detachable from their bodies, while other examples are fabricated from many separate

pieces.[4] The reverse sides of Centuripe vases are usually left undecorated, indicating that they were not intended to be seen in the round but were probably placed against walls or in niches. These factors, in addition to the fragility of the vases and their ephemeral polychrome decoration, suggest that they did not serve a utilitarian purpose.

The plastic gorgoneion on the rim of the Indiana vase is a common feature of Centuripe vases and may be apotropaic in nature, perhaps serving to protect the deceased (compare the Hadra-ware hydria in this exhibition, cat. no. 97). Plastic floral and vegetal decoration of the type that occurs here is also common and usually, as here, includes tiny Erotes. Such imagery may refer to the realm of Aphrodite and may be symbolic of regeneration and the afterlife.

The figural scene on the Indiana lekanis comprises two women in profile, flanking a waist-high table or an altar. Each woman extends an arm downward to the altar in a gesture of offering. A similar scene is found on the lid of a rose-ground lekanis in New York, on which four women in white and blue drapery, one of whom holds a tympanum, flank a fire altar.[5] Their gestures are almost identical to the figures on the Indiana vase. The women in both cases are engaged in some type of offering, the nature of which remains uncertain.[6]

Generally speaking, the painted figural scenes on Centuripe vases display a blend of nuptial and Bacchic imagery, which in connection with their sepulchral context suggests that the vases served a purpose similar to that of Attic loutrophoroi, vases that were often buried with unwed women.[7] The references to a variety of cultic spheres (Aphrodite, Dionysus) and rites of passage in a woman's life (marriage, death) recall the multivalent imagery of the Villa of the Mysteries painting cycle.

DATE: 300–100 BC.

BIBLIOGRAPHY: Indiana University Art Museum 1980.

SK

1 I am grateful to Adriana Calinescu, Curator of Ancient Art at the Indiana University Art Museum, for her assistance in describing the vase and its color scheme.
2 For more discussion of the figural scenes on Centuripe vases, see ch. 10 by S. Kirk in this volume. For further reading on Centuripe ware, see: Deussen 1973; Joly 1980; Libertini 1926; 1934; Pace 1915; Richter 1932; and Wintermeyer 1975.
3 Deussen (1971, 245–76) dates Centuripe ware between 304 and 230 BC based on a stylistic, evolutionary schema and the Roman conquest of Centuripe in 211 BC. His view is shared by most scholars (see n. 2), exceptions being Pollitt 1986 and Richter 1932, who propose a late second/early first century BC date.
4 See, for example, a krater in the Metropolitan Museum of Art (acc. no. 53.11.5) that has a nondetachable lid (Mayo 1982, no. 143) and a lekanis in the Virginia Museum of Fine Arts (acc. no. 78.84) that was made of five separate pieces (Mayo 1982, no. 144).
5 See Richter 1932.
6 Paul Deussen (1971, 135 ff.; 1973, 127) has speculated that the figures are engaged in a prenuptial offering of burnt hair. However, although offerings of locks of hair occurred in Greece, neither the visual nor the literary record attests to offerings of hair for burning in Greece or Magna Graecia, and it is thus unlikely to have been a custom unique to Sicily, as suggested by

Deussen (1971, 136; 1973, 129). Richter (1932, 48) declines to identify the scene specifically, noting that "We can only interpret the picture in a general way as the performance of a mystic rite."
7 The vases may have functioned as wedding gifts that later accompanied the bride to the grave. Apparently they did not serve as cinerary urns, for no cremated remains have been found inside them. See Holloway 1991, 163; Deussen 1973, 125; Trendall 1955, 165; Richter 1930, 200; Green 1982, 282; Arias 1962, 387.

74 Eros

Fired clay
H. 6⅞ in.
(17.5 cm)
Greece
The Detroit Institute of Arts, City of Detroit Purchase
Acc. no. 24.137
The figurine is in good condition, with a few superficial blemishes. The finish on the right elbow is scraped off, the left hand is broken at the base of the fingers, and the right wing may be reattached. There is an oval vent hole (2.3 × 2.0 cm) high on the back.

The youthful Eros stands with his weight on his right leg and his left leg relaxed. This contrapposto stance creates an S-curve through the body. He holds his right arm behind his body and his left arm out to his side and bent at the elbow. The figurine is naked except for a mantle, which

covers his left shoulder and pectoral and is fastened on his right shoulder with a brooch. The Eros originally held a rectilinear object in the palm of his hand that was pointed toward the viewer, and his face is turned to look at the object in his left hand. His wings are large relative to the size of the body and in the same position and grandiose style as the wings of the giant Alcyoneus on the Great Altar of Zeus at Pergamon of the mid-second century BC.

The delicate facial features and plump body of the Detroit Eros resemble those of the Cupid who holds a mirror for the Seated Bride on the Villa of the Mysteries frieze. The wings of the latter, however, are considerably smaller.

DATE: Second century BC.

BIBLIOGRAPHY: Motz 1984, cat. no. 42.

BL

75 Eros in the Guise of Harpocrates

Fired clay
H. 4 in.
(10.2 cm)
Greece
The Detroit Institute of Arts, City of Detroit Purchase
Acc. no. 24.139
The figurine is in good condition. White paint or gesso remains on the face and in patches across the surface. The back is pierced by a vent hole. The object once held in the left hand is now missing.

This winged Eros has childish proportions, with rounded stomach and pectorals, short, chubby legs and arms, and a round, cherubic yet solemn face with full cheeks. He holds an apple or pomegranate in his right hand and bends his left arm at the elbow to support a now-missing object once held in the palm of his left hand. The object was originally held upward and level with the head. The figurine wears a garment tied at both hips and covering the genital area. The statuette must have been attached (perhaps at the wings) to a larger sculptural group. The legs cannot support the body's weight; the right leg is bent and behind the left; the left foot is pointed downward as if about to alight and touch the earth with its toes.

This Eros wears a headdress of Harpocrates, the Egyptian child-god of fertility, with whom he was identified. The headdress consists of horns and a sun disk and purplish-blue appendages to either side, which are perhaps part of a wreath that once crowned the head. Two winged Erotes from Myrina, as with the Detroit piece, appear to fly down to earth and alight on one foot.[1] One in the Louvre (acc. no. MYR 86) dates to the first half of the first century BC. The other in the Boston Museum of Fine Arts (acc. no. 01.7693) dates to the mid-second century BC.[2]

Another Egyptian Harpocrates as the childish Eros from Myrina (Boston Museum of Fine Arts 00.322)[3] dates to the mid-first century BC. Its wings are similar in size, shape, and appearance to those of the Detroit Harpocrates. The Boston Eros also wears the headdress of Harpocrates, with the sun disk between horns and surrounded by a wreath. As

these figurines suggest, the portrayal of Harpocrates in the guise of Eros/Cupid was relatively common in the Graeco-Roman world. They provide a concrete example of the multivalency of religious imagery. This form of syncretism of Egyptian and Graeco-Roman gods is closely paralleled by the identification of the mother of Harpocrates, Isis, with Venus/Aphrodite. The cult of Isis spread throughout the Roman world (see cat. nos. 12–16 and 41) and was also popular in Pompeii, as evidenced by the Temple of Isis in the city.

DATE: Second–first century BC.

BIBLIOGRAPHY: Motz 1984, cat. no. 41.

BL

1 Higgins 1967, pl. 55A.
2 Higgins 1967, pl. 55B.
3 Higgins 1967, pl. 55D.

76 Two South Italian Erotes

Fired clay
H. of 38.35 A 4³/₈ in.
(11.1 cm)
H. of 38.35.B 4¹/₄ in.
(10.8 cm)
Graeco-Roman
The Detroit Institute of Arts, Gift of the Founders Society,
 Octavia W. Bates Fund
Acc. nos. 38.35.A and 38.35.B

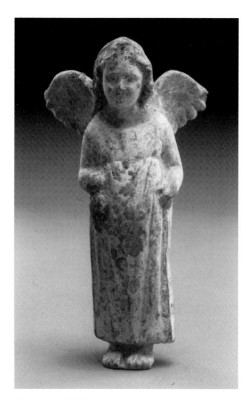

Both figurines are well preserved. There are small accretions on the bodies of each, the paint on the garments and hair is chipped, and dirt clings to recessed areas.

These free-standing youthful figurines have small, simple wings, white garments, reddish-brown shoulder-length hair, pink skin, and round-cheeked, small-nosed, and smiling cherubic faces. They stand with their backs swayed and their stomachs protruding forward. The wings were added to the bodies. Their right wings are practically identical in size, shape, decorative details, and placement, suggesting that they were made by means of a mold. Although the left wings also closely resemble each other in size, shape, and decorative details, they were attached separately to the two bodies at different angles, with the wing of the slightly taller figurine more vertical than the wing of the shorter figurine.

The shorter Eros wears a white chiton belted at the waist. It falls to the top of the ankles in stylized folds that mask the shape of the body beneath. The feet are bare and next to each other. The left hand of the Eros casually rests on his chiton at hip level, while his right hand holds a small pointed alabastron or grape cluster next to his side.

Instead of a chiton, the taller Eros wears a white mantle that completely envelops him from the chin to the top of the feet and conceals the shape of his body. The regular stylized drapery folds are only interrupted by the drapery's response to the placement of the arms. The right arm is held against the side in much the same manner as the shorter Eros, but with the arm and hand hidden beneath the folds of the mantle. The mantle is also wrapped around the left arm and hand, covering them entirely. The Eros holds his draped left hand to his chin, partly covering it. The drapery responds to this arm position with stylized

radiating folds. Like its partner, the feet of this Eros are bare and positioned next to each other.

The drapery of the slightly taller Eros and the way it both reveals movement and conceals the body is reminiscent of the Tanagra-type female figures, such those in this exhibition from the Detroit Institute of Arts (cat. nos. 77 and 78) and the Kelsey Museum of Archaeology (cat. no. 79). Erotes were a popular subject matter for Tanagra and Tanagra-style figurines.[1] Down to approximately 200 BC, naked and clothed Erotes with the chubby features and babyish proportions of children were popular. Then, from 200 to 130 BC, these childish Erotes were joined in popularity by youthful Erotes of the Tanagra style, such as these two South Italian Erotes.[2] Small terracottas such as these have been found in sanctuaries, tombs, and domestic spaces and could be used as toys for children or offerings to divinities or the dead.

These two youthful clothed Erotes from Southern Italy serve as a reminder that the use of the childish naked Erotes/Cupids in the frieze of the Villa of the Mysteries was a deliberate choice, as various naked and clothed prototypes were available at this time to the designer of the frieze.

DATE: Second century BC.

BIBLIOGRAPHY: for 38.35.B: "Family Art Game" DIA Advertising Supplement, *Detroit Free Press*, May 18, 1986, p. 8 (ill.).

BL

1 Tanagra figurines are figurines that were found in the cemeteries in the region of Tanagra, Boeotia. These were produced between 330 and 200 BC. The style continued to be adapted by workshops in other regions well into the first century BC, and any figurine produced in the style but not from Tanagra is considered a Tanagra-style figurine.
2 Higgins 1967, 113. See also the comments on this type of figurine by E. de Grummond in connection with cat. nos. 77–79.

Tanagra-style Figurines

These three figurines are of a type commonly known as Tanagra-style, named after a site in central Greece where hundreds, if not thousands, of comparable figurines have been found.

The subject matter of Tanagra-style statuettes is relatively limited, and most portray standing women or girls. Although some are clearly intended to portray deities, many present mortals, as both worshippers and participants in genre scenes. Indeed, as a group, the Tanagra-style figurines are noteworthy for their strikingly human aspect.

The figurines seem to have served a variety of purposes, functioning as votive objects, grave goods, and toys. Although the majority of known Tanagra-style statuettes were found with burials, examples have been uncovered in both sacred and domestic contexts.[1] Religious overtones are often evident—through subject matter as well as through deposition in graves and cult areas—but the secular appeal of these figurines is also apparent, and they may at times

have served, both in the home and in the tomb, as little more than comforting personal possessions.[2] A sculptural relief on a funerary stele from Athens offers evidence of use of such figurines as dolls.[3]

Although one of the most fruitful sites for the finding of Tanagra-style figurines has been Tanagra itself, statuettes of this type have been recovered from many other places in the Mediterranean area, most notably from other sites in Boeotia, from Myrina in Asia Minor, and from Athens, where the Tanagra style seems to have originated.[4] Similar figurines have also been found in quantity in the Greek-inhabited regions of Southern Italy, where they are particularly common in religious contexts.[5] Unfortunately, the prominent role of the international antiquities market in the more recent history of Tanagra figurines has led to the looting of thousands of these statuettes from their archaeological contexts; thus, the original provenance of many such statuettes is unknown. Stylistic analysis of Tanagra-type figurines can often help to identify a region of origin, although regional differences are often subtle. Furthermore, because the figurines were produced in small molds that were sometimes made from preexisting figurines and that could easily be transported from one workshop to another, defining the place of "origin" of a Tanagra-style figurine is not necessarily a meaningful exercise.

A further problem caused by the popularity of Tanagra figurines on the international art market is the flood of spurious Tanagra-style statuettes that were able to pass into museum collections as ancient originals. Indeed, the scale of production of forged Tanagra-style figurines has been so great that the modern industry itself has become an object of scholarly study.[6] The forgeries range from extremely clumsy to quite good copies produced using Boeotian clay in ancient molds or in molds made from genuine ancient figurines.[7] Less successful copies can often be identified on sight, but more sophisticated forgeries may elude stylistic assessment. Consequently, scientific analysis, usually in the form of thermoluminescence testing, may be necessary to determine the approximate age—ancient or modern—of the object in question.[8]

77 Woman with a Fan

Fired clay
H. 7³/₄ in.
(19.7 cm)
Tanagra, Greece
The Detroit Institute of Arts, City of Detroit Purchase
Acc. no. 24.138
This piece is well preserved and has no major breaks. A fairly heavy coat of dirt and other accretions cling to the surface, most notably along the woman's fan and drapery. The figurine was probably originally painted—a white slip may have covered the entire piece— although much of the paint has either faded or chipped away. Painted on the figurine is the number of a previous collection, HA 353. According to William Peck, Curator of Ancient Art at the Detroit Institute of Arts, HA stands for Herzog, Alfred, Duke of Saxony and son of Queen Victoria, Prince of Wales. Before entering Detroit's collection the piece was in the Museum of Antiquities in Gotte, Germany.

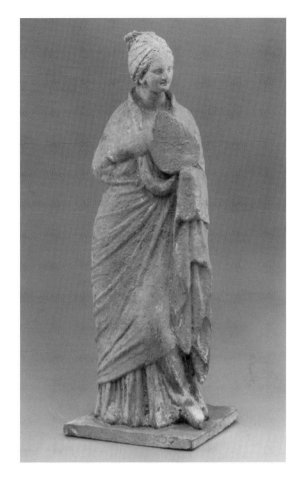

Fashioned from clay of a medium orange color, this figurine was cast in a mold, then embellished with hand-modeled and engraved features. The piece depicts a standing draped woman. When viewed from the side, the figurine has a particularly thick head, neck, and body. The woman's hair, partially covered by a bandana, is carefully parted in the middle and pulled down along the side of the head to gather in a loose spray of hair in the back. The figurine has a small, fleshy face, oval in shape, with a wide nose and triangular forehead. Globular earrings show just below the hair. The woman's face is slightly down-turned, as she glances to her left. Her full neck has subtly indicated rings of flesh. The woman's entire body, from the neck down, is enveloped in a Greek-style mantle-and-tunic ensemble. The slightly plump figure stands with her arms pulled against her chest, while her left hand, covered completely by the mantle, holds a spade-shaped fan. The folds of the himation, or mantle, radiate out from the woman's drawn arms and spread along her right, weight-bearing hip. A cascade of thick folds also hangs down from the figure's left hand. The woman's left leg is pitched forward, her knee bent as she shifts her weight to her right leg. The left foot appears just beneath the floor-length tunic or chiton, but the right is hidden. There is perhaps a hint of pink pigment on the left foot. The figurine stands on a small, square plinth.

On the back of the figurine in the middle of the upper torso is a square hole (2.5 × 2.0 cm), which would have served as an air vent for the piece while it was being fired. The figurine was apparently made in a single mold. The

back was probably molded by hand. The figurine stands on a solid slab of clay.

A number of features of this piece show the influence of the Greek sculptor Praxiteles, who was active in the second and third quarters of the fourth century BC. These Praxitelean features—common to many Tanagra-style figurines of the late fourth as well as third centuries BC—include the oval face, triangular forehead, and neck with marked rings of flesh.[9] The figurine's coiffeur, done in a style called the *lampadion* or "little torch" in antiquity, was current in the middle of the fourth century BC.[10] The *lampadion* hairstyle was also worn, however, by a number of women portrayed in Tanagra-style figurines of the third century BC.[11] The drapery of the present statuette—the mantle pulled taut over the hip, with a cascade of folds to the side and, underneath, a tunic with straight, heavy folds—is also comparable to that of figurines from the third century BC.[12] Indeed, since many features of the Detroit figurine are characteristic of that century, a date of the third century BC is likely for the piece.

DATE: Third century BC.

Unpublished.

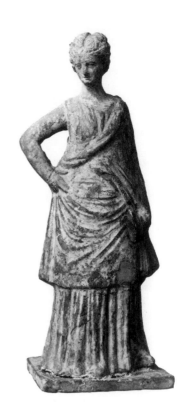

78 Woman with a Fan

Fired clay
H. 8¹/₂ in.
(21.6 cm)
Greece
The Detroit Institute of Arts, Gift of Walter Bachstitz
Acc. no. 30.410
Broken in several places, this figurine has been mended and attached anew to its plinth. Cracks and breakage are particularly evident on the right arm and hand, the left foot, and across the drapery. Chips of terracotta are missing from the midriff area and from the hem of the mantle. The object that the figure once held in her left hand has been partially broken off and is now missing. Traces of white pigment indicate that the piece was once painted, but little remains of this coloring. There are some incrustations, particularly on the neck and shoulders.

This terracotta figurine, pale orange in color, was formed in a mold, then elaborated by hand. The piece portrays a draped woman who stands with one arm akimbo as she glances down to her right. The woman's hair, parted in the middle, is pulled back into a loose, unruly knot. Her face is longer and trimmer than that of many Tanagra-style figurines and notably features a rectangular forehead. The woman has a slender neck and narrow shoulders, partially covered by a tightly wrapped Greek-style himation and sleeveless tunic. The figure's jutting right arm is bare, while her left, held close to the body, is hidden within her mantle. In her left hand, the woman grasps the base of a small object, probably a fan not unlike that held by the other Tanagra-style figurine now in Detroit (cat. no. 77). The lower portion of the mantle is draped across the stomach in a loose arc, while the underlying tunic reaches to the ground in straight, stiff folds. The woman's left foot breaks these folds

as it peeks out just below the hem of the tunic. The figurine rests on a small, square plinth.

A small oval vent hole (3.0 × 2.0 cm) has been left open on the back of the piece. The figurine was apparently made in a double mold, as the back as well as the front appears to have been molded. The back, however, features no decorative detail. The figure stands on a solid slab of clay, slightly trapezoidal in shape.

The woman's exposed arm is unusual, as is the shape of the face. Her stance, with one hand on the hip and the other held down to the side, is, however, common among Tanagra-style sculpture of the late fourth and early third centuries BC.[13]

DATE: Late fourth–early third century BC.

BIBLIOGRAPHY: *Detroit Institute of Arts Bulletin* 1931, 12(5), 51.

79 Standing Woman

Fired clay
H. 6¹/₄ in.
(15.4 cm)
Greece
Gift of Mrs. David Dennison
Kelsey Museum of Archaeology, acc. no. 77.3.1
The piece is well preserved and has no major breaks. A few small, recently made scratches occur in the white slip on the figurine's chest. The decorative slip is flaking in some places, and the blue pigment has faded. Dirt and other small accretions cling to the deeper folds of the woman's drapery.

Like the other Tanagra-style figurines presented here, this unusually small specimen portrays a standing woman dressed in heavy drapery. Made from a clay of a dark tan to pale brown color, the Kelsey figurine seems originally to have been brightly painted. The woman has thick, wavy, plastically rendered hair, which is pulled back into a low, double-lobed bun. Her face is oval in shape, with rounded cheeks and a sharp, pointed nose and chin. She wears Greek-style clothing: a himation draped over a floor-length, cream-colored chiton. The himation, which features a wide blue border, falls straight down over the left shoulder in a series of stiff, parallel folds that continue down to just below knee level. The himation is wrapped around and entirely covers the right arm, which the woman holds clutched against her chest. The left arm juts out akimbo and then is lost within the drapery. The pressure of the figure's right elbow against her hip creates in the drapery a pattern of radiating folds that spreads out from the hip, across the stomach, and down the legs. The radiating pattern is broken by the forward thrust of the left knee. The underlying tunic falls down to the base of the figurine in a series of deep, stylized folds. Wearing a pointed-toed shoe, the woman's left foot peeks out from under the garment. The foot is presumably intended to appear linked to the woman's bent left knee, but the two body parts are not well aligned. The woman stands on a small plinth that is rectangular in front and slightly curved along the back.

The piece appears to have been made in a double mold, as it is molded on all sides. Many of the superficial traits, such as the facial features and hair, have been added or enhanced by hand modeling and incision. The back of the

woman is schematically rendered, with little more than a suggestion of clothing and anatomical form. In the middle of the figurine's back is a medium-sized, round hole, intentionally cut to facilitate the firing of the ceramic object. The figurine itself is hollow, and the underside of the plinth on which the woman stands was left open.

The woman's pose recalls that of such mid- to late-fourth-century BC statuary as is thought to be represented by a Roman copy of a portrait of Sophocles, now in the Vatican Museums.[14] The stance, relatively common, first appeared among Tanagra-style figurines in the early third century BC and continued to be popular throughout that century.[15] The triangular forehead, oval face, and slightly contrapposto stance of the Kelsey figurine reflect tendencies of the Praxitilean sculptural style that were also current among manufacturers of Tanagra-style figurines in the late fourth and third centuries BC.[16] The attention to detail in the woman's unruly hair is most closely paralleled by the treatment of the hair on late fourth-century types,[17] although the deep cut of the Kelsey woman's part is closer to that of a third-century type.[18] The small size of the figurine is, however, noteworthy and perhaps an indication that the piece is a modern creation.

The Tanagra figurines that share stylistic traits with the Kelsey statuette span the third century BC, although there is a cluster of such comparanda in the first half of that century. Nonetheless, the relatively evolved composition of the piece shows a more mature style; thus, if not spurious, the figurine is perhaps datable to the middle of the third century BC.

DATE: Mid-third century BC.

Unpublished.

EdeG

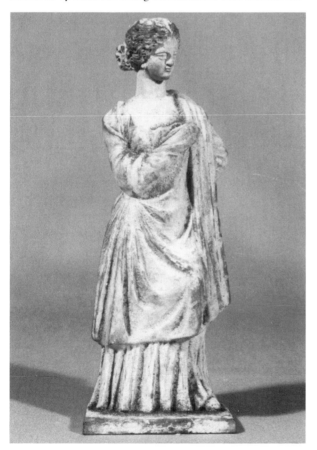

1 Higgins 1967, 118–19.
2 Higgins 1967, 65.
3 Ammerman 1990, 44.
4 For an overview of terracotta figurines from various parts of the ancient Mediterranean world, see Uhlenbrock 1990.
5 Rebecca M. Ammerman, personal communication to Elaine Gazda, May 2000. See also Bell 1990, 64–70.
6 See Higgins 1967, 163–78; Kriseleit and Zimmer 1994.
7 Higgins 1967, 170, 172.
8 See Goedicke 1994, 77–81.
9 Uhlenbrock 1990b, 50.
10 Higgins 1986, 123.
11 E.g., Higgins 1967, 130, fig. 155; Kriseleit and Zimmer 1994, cat. no. 16.
12 E.g., Kriseleit and Zimmer 1994, cat. no. 10.
13 Uhlenbrock 1990, cat. no. 41.
14 For a discussion of the Sophocles statue in relation to Tanagra-style figurines, see Zimmer 1994, 20.
15 The pose also continued to be popular in full-scale marble statuary well into the period of the Roman empire. The Roman versions are referred to as the "Large Herculaneum Woman" and "Small Herculaneum Woman" types. The classic study of such statuary is Bieber 1962, 111–34. For a more recent treatment, see Trimble 1999.
16 Uhlenbrock 1990b, 50.
17 Uhlenbrock 1990, cat. nos. 11–12.
18 Uhlenbrock 1990b, 51.

80 Fragment of a Gnathia-ware Pelike

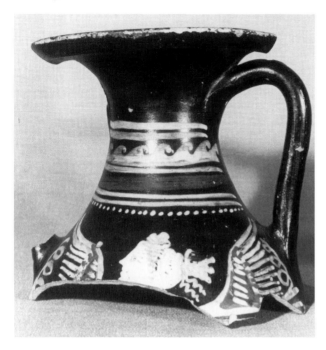

Fired clay
H. 4¹/₁₆; Diam. 4¹/₂ in.
(10.4; 10.9 cm)
Apulian, said to have been found in Pozzuoli or Cumae, Italy
Purchased from Giuseppe De Criscio, 1923
Kelsey Museum of Archaeology, acc. no. 2706
Half of the rim, the neck, one of the two handles, and the shoulder are preserved. Two fingerprints above and one below the rim are visible above the right wing of the figure. Below the fingerprints and on side B are several reddish (misfired?) spots. There are small chips and losses of the painted surface on the edge of the rim. Some paint loss has occurred on the handle and on side B. There is a pit above the figure's right wing.

The wide rim of the pelike turns outward and is almost flat. The rim is decorated with an incised line approximately 1.8 cm in from its edge. The handle, oval in cross-section, springs immediately below the rim and attaches at the shoulder.

Side A: On the neck between the handles is a series of decorative horizontal bands: two yellow lines, a row of waves in yellow, another yellow line, a wider red band, two yellow bands, and a row of yellow dots. At the center of this side is a winged woman whose head, in left profile, is even with the bottom of the handles. Her skin is white, and her eyebrow, eyelid, and pupil are yellow. Her yellow hair is pulled back to her crown in a white band with yellow lines on it; several corkscrew curls emerge from the band. The tip of a wing is visible on each side of the woman; the individual feathers are painted in yellow, red, and white. Her body is not preserved below the chin, and thus the base of the wings and their point of attachment are not visible. To the outside of each wing is a long yellow scroll.

Side B: A rosette consisting of a central dot surrounded by nine dots, all in yellow-orange, is at the center of the neck. Three short lines and five dots, in the same color, form a tendril centered beneath it.

Gnathia ware was produced in Apulia during the Hellenistic period. Typical of this pottery is painted decoration, particularly in white and yellow, applied after firing. A female head between two wings is a common decorative motif on Gnathian vases; however, the identity and significance of this figure have not been determined.[1] Whatever she may represent, the presence of such an image on these vases reflects the familiarity in Southern Italy of depictions of winged women that recall the one who appears on a much larger scale in the Villa of the Mysteries frieze.

DATE: 350–250 BC.

BIBLIOGRAPHY: *CVA* USA 3, University of Michigan 1:pl. 29.10a–b.

JMD

1 Green 1976, 8.

214

81 Praenestine *Cista*

Bronze
Total H. 11⁵/₈; H. of *cista* without lid or feet 6⁹/₁₆; Diam. of lid 6⁵/₈;
 Diam. of *cista* 6¹/₄ in.
(29.5; 16.7; 16.8; 15.9 cm)
Said to have been found near Pompeii[1]
Museum of Art, Rhode Island School of Design, Providence,
 Gift of Mrs. Gustav Radeke
Acc. no. 06.014
Green patina covers the surface of the *cista*. The feet and handle
group are attached to the body with modern bolts, while the lid
and bottom of the *cista* are reinforced with modern sheet metal.

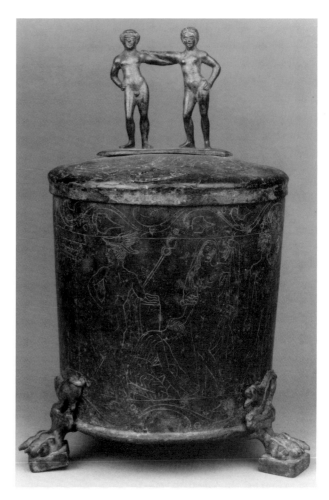

The body of this cylindrical *cista* consists of a large incised
figural frieze framed by two smaller bands of stylized ivy
decoration. Horizontal lines, which separate the three
decorative bands, were added after the figural frieze; they
do not bisect the figural elements that extend into the adja-
cent decorative zone. The incised lines were whitened to
make the composition stand out more clearly.

Tuscan columns divide the figural composition into two
scenes. One scene consists of a standing youth and a bearded
and balding older man seated on a rocky outcrop. Both
figures, of unknown identity, are heroically bare-chested
and unshod; the youth wears a pilos and *chlamys* and holds a
staff in his right hand, and the older man wears a cloth
around his midriff and holds a staff in his left hand. The
two men gaze introspectively into the distance.

The second scene consists of five women of unknown
identity and Mercury, who is identified by his winged cap
and caduceus. Nude, unshod, and standing with his back to
the women, Mercury unites the two scenes by gazing across
the column and toward the two men. The five young women
at his back are in various states of undress. Two, nude and
barefooted, are located to the extreme right of the scene
and face each other over a basin that is being filled by water
falling from a lion-headed spout. These women may be
preparing a bridal, initiatory, or funerary bath.[2] To the left
of them is a maenad watching the scene. She is nude, except
for her shoes and a cloth draped over her left forearm, and
holds a thyrsus in her left hand and a small rectangular
object in her right. A sheet of drapery to the far right com-
pletes the basin scene. The final two women are located
between Mercury and the basin scene. A nude woman,
apparently the focal point of the frieze, is removing her veil,
while a clothed woman with cropped hair unties the sandal
on her right foot.

The handle is composed of a satyr, with pointed ears,
and a nude woman, presumably a maenad. The three claw
feet are surmounted by lions crouching on Ionic capitals, an
attachment almost identical to those adorning *cistae* in the
City Art Museum of St. Louis (16:25)[3] and in the Walters
Art Gallery, Baltimore (54.132).[4] In all three examples, the

lions are attached so that they overlap the incised decora-
tion on the main body of the *cista*.

Often associated with women and found in graves, *cistae*
are thought to have held a variety of toiletry items, includ-
ing mirrors, combs, hair pins, and perfume flasks. Although
this particular *cista* may have been found near Pompeii, it is
most likely of Praenestine manufacture.[5] Over one hundred
elaborately engraved *cistae* such as this one were produced
in Praeneste from about the middle of the fourth through
the third centuries BC. Because the Etruscans controlled
the city during this period, the Praenestine *cistae* are consid-
ered to be Etruscan objects (Pliny *HN* 15.6.4; Strabo 5.4.3
and 10).

The themes portrayed on Praenestine *cistae* were prima-
rily inspired by Etruscan versions of Greek myths, with
Italic elements often included. It was common to render
two or more mythical episodes in a single frieze, and some-
times they were related to one another by formal analogies.

As O. Brendel has observed, "In these instances the myth has ceased to be a self-contained narrative; it points to a moral which transcends the contents of a single story. Thus paired for comparison and interpreted as meaningful counterparts, the mythical images assume an allegorical function, like poetic allusions, they can be grouped at will."[6] Toward the end of the fourth century, the imagery on Praenestine *cistae* tends to be quiet, inactive, and of uncertain purpose to the modern viewer. Mythical characters are represented but rarely any actions that create a cohesive story. It is unclear whether any specific meaning was intended.

The frieze on this *cista* qualifies as one of the obscure scenes, although various interpretations have been put forth. Hanfmann interpreted this scene as related to a wedding and suggested that the *cista* was a wedding gift.[7] Picard argued that it shows a young girl being readied for her journey to the underworld, and as such the *cista* is appropriate as a grave good.[8] Mitten suggests that the presence of the maenad with the thyrsus suggests that the women are preparing to take part in some kind of Dionysiac initiation and that the owner may have been an initiate into the Dionysian mysteries.[9]

The uncertainty surrounding the iconography and meaning of the scene is similar to that surrounding the great frieze in the Villa of the Mysteries. Both friezes include clothed and unclothed figures, shod and unshod figures, mortals and immortals. The participants are predominately women, suggesting that the activities are closely related to the female sphere of activity. Without any accompanying inscriptions, however, a single, concrete interpretation of either frieze is untenable.

DATE: Late fourth–mid-third century BC.

BIBLIOGRAPHY: Sambon 1905, 39, no. 256, pl. 9; S— 1919, 39–41; Hanfmann 1940, 17–19, fig. 15; Picard 1946–47, 210–18, pl. 2.1; Rhode Island School of Design, Museum of Art 1956, pl. 6.1; De Ruyt 1958, 100–101, pl. 34; Brown 1960, 162 (in list of *cista* feet with lions); Picard 1963, 1280, 1281 n. 3, 1354 n. 4, 1408 n. 1, 1413, 1434; Teitz 1967, 95, no. 86; ill. on 183; Mitten and Doeringer 1967, 206, no. 210, ill. on 207; Mitten 1975, 137–46, no. 38; Rhode Island School of Design, Museum of Art 1985, 116, no. 26.

EXHIBITIONS: Worcester Art Museum, Worcester, Massachusetts, *Masterpieces of Etruscan Art*, April 21–June 4, 1967; Fogg Art Museum, Cambridge, Massachusetts, *Master Bronzes from the Classical World*, December 4, 1967–January 23, 1968, traveled to City Art Museum, St. Louis, March 1–April 13, 1968, and Los Angeles County Museum of Art, Los Angeles, May 8–June 30, 1968.

BL

1 This findspot is disputed by Mitten 1975, 141.
2 Mitten 1975, 144.
3 Mitten and Doeringer 1967, cat. no. 206.
4 Mitten and Doeringer 1967, cat. no. 204.
5 It is also possible that the *cista* was manufactured in Praeneste and later brought to Pompeii as an heirloom. Late Republican inscriptional evidence from Pompeii suggests that a number of Praenestean families had settled there as early as c. 200 BC (Castrén 1975, 39).
6 Brendel 1995, 353–54.
7 Hanfmann 1940, 17–19, fig. 15.
8 Picard 1946–47, 210–18, pl. 2.1.
9 Mitten 1975, 144.

82 Mirror with Winged Female Figure

Bronze
H. 6³/₄; Diam. 4⁵/₈; L. handle 1¹/₈ in.
(15.0; 11.9; 2.9 cm)
Etruria, Italy
Gift of Mrs. David Dennison
Kelsey Museum of Archaeology, acc. no. 77.3.3
The condition is generally good. There are patches of patination and corrosion on both sides of the mirror. The handle is broken off. There are two small cracks at the base of the disk, near the handle.

This bronze mirror is composed of a circular reflecting surface and a handle, now broken, that were cast together as a single piece. The obverse, or reflecting surface, of the mirror is convex and features a beveled edge that terminates in a ticked lip. The mirror's concave reverse bears an engraved figural scene framed at the mirror's edge by a sharp, raised border, triangular in profile. The surviving portion of

the handle, which flairs out as it extends from the disk, presents a geometric motif on either side.

The figural scene on the mirror consists of a single winged female who, with her wings loosely extended, fills the entire tondo. Her head is shown in profile, while her body appears in a three-quarters view. The figure advances to the viewer's left, her left arm akimbo and her right arm outstretched. In her right hand, she holds between her thumb and index finger a small, round object. The figure wears a Phrygian cap and boots but is otherwise nude. Although the composition and details are quite schematic, the engraving of the scene is executed with skill.

This winged female falls within the range of a figural type that is common on Etruscan mirrors. Such figures are generally referred to as Lasas, after the Etruscan word that often labels them in inscriptions. Because, however, the attributes of Lasas seem to be quite variable, a Lasa can only be identified with certainty when accompanied by an inscription.[1] The changeable nature of these figures suggests that the term *Lasa* may refer to a type of divine being rather than a particular individual or deity. These may be nymphs, or perhaps some type of attendant spirit—a "guardian angel"—that was personalized to suit the individual owner of the mirror.

Although the Kelsey mirror lacks an identifying "Lasa" inscription, the figure's attributes are consistent with those of a nymph or of an attendant spirit. Unfortunately, the object in the figure's right hand—perhaps a ring?—is enigmatic and thus does not aid in the identification of the figure.

This example belongs to a relatively uniform series of "Lasa" mirrors, conventionally so called despite the absence of any identifying inscription.[2] The Lasa series as a whole has an industrial or rote quality about it, particularly when compared with other unique or more artistically complex Etruscan mirrors. These mirrors generally belong to the third century and perhaps the beginning of the second century BC. The present example was probably made in the second half of the third century BC.[3]

DATE: Second half of the third century BC.

BIBLIOGRAPHY: de Puma 1987, 16, figs. 2a–d.

EdeG

1 Rallo 1974; Sowder 1982, 114–15.
2 For an overview of the "Lasa" mirror type and relevant bibliography, see Rallo 1974) and de Grummond 1982, 163–65.
3 De Puma 1987, 16.

83 Cinerary Urn with Winged Dieties

Alabaster
H. 29; W. 10; L. 17 in.
(73.7; 25.4; 43.2 cm)
Etruria, Italy
The Detroit Institute of Arts, Founders Society Purchase
Acc. no. 23.139
There are numerous chips along the frame of the front panel, on the left end of the lid, and on the right side panel. The limbs of

several of the figures in the main sculpted scene are broken, as is part of the head of one figure. The facial features of the heads in the upper half of the main scene are worn, while on the lower half are several areas of incrustation. The left shoulder and back of the reclining man on the lid also bear heavy incrustation. The head of the figure on the lid has been broken and mended, and a chunk of alabaster is missing from the forehead. Three holes have been bored into the left end of the lid and one into the right end. The lid does not fit tightly to the urn and may not belong. Carved details on the panel on the left end of the urn are worn. The back left foot of the urn is broken.

This alabaster cinerary urn is composed of two separate pieces: the footed boxlike urn itself and a removable lid. The front and side panels of the urn are decorated with figural scenes carved in relief, while the lid features a three-dimensional sculpted image of a reclining figure. The back panel is undecorated.

The front relief panel depicts a battle scene with four warriors who appear in pairs on either side of a winged female deity. Facing the viewer, the central figure is seated, with her wings spread. She is dressed in a short tunic with thick girding and a crossed baldrick. She also wears knee-high boots. Her right arm, now missing, probably originally supported a torch. The warriors that flank her all wear long capes and have large, circular shields. The two sets of paired warriors each consist of a figure tensely poised for battle and, at his feet, a fallen soldier. The fallen figure on the left sits facing the center of the scene, as he leans on the shield in his right hand. He is nude beneath his cloak. The companion behind him stands with his body toward the viewer and his head turned in the direction of his foe on the opposite side of the winged figure. He wears a tunic under his cape and holds his shield in his right hand. In his left hand he brandishes a weapon, perhaps a sword. The pair to the right looks at first glance to be a mirror image of the left-hand group. In the second pair, however, the naked body of

the fallen warrior rests within the hollow of his shield, and the standing soldier holds his shield in his right hand rather than in a position that mirrors the gesture of his opponent. Furthermore, the standing figure on the right is outfitted with a Greek-style helmet. Like his opponent, however, he wears a tunic and seems to brandish a weapon. The scene is framed on either side by grooved pillarlike elements.

The panel on the left end of the urn features a female figure similar to the winged deity on the front relief. Also winged, the woman on the end panel likewise wears a short, girded tunic and high boots. Turned to the viewer's right, she is shown in profile with her left foot advanced and her right arm raised in the air. Her left arm is partially covered by drapery, while, in her left hand, she holds what appears to be a torch. The right end of the urn bears a figural scene as well. Here a winged man, also dressed in a belted tunic and high boots, sits with his right arm raised and his left arm dropped to his side. In his right hand he grasps a serpent and in his left, a hammer. Shown in profile, the figure faces the left end of the panel.

The figure depicted on the lid of the urn is a middle-aged male who, facing the viewer, lies on his right side. The man's body is disproportionately small with respect to his head in order that the body fit within the restricted space provided by the urn lid. Leaning with his left arm on two small cushions, the man is draped in a loose garment that covers his left arm, passes down his back, and crosses his lower body. His upper body is bare. A gathered roll of drapery accents the man's waist, while the drapery that passes over the man's lower body is characterized by tight, undulating linear folds. The man holds in his right hand a *patera*, or dish for pouring libations. With his left hand he fingers the garland around his neck. He also wears a laurel wreath on his head. His hair lies close to his head, in short, stylized locks. The squared face has prominent, heavy-lidded eyes, a small mouth, and a small, jutting chin. The man seems to gaze slightly upward, with a serene expression on his face.

This urn would have been used to hold the cremated remains of a deceased Etruscan, presumably an adult male not unlike the man depicted on the lid. The urn was probably placed in a subterranean tomb with the back side against a tomb wall. Tombs were often used for several generations, and consequently an urn such as this one would have been seen by the living on the occasion of funerals and other rituals for the dead.

The iconography that appears on this urn is common in Etruscan funerary art. The front panel depicts a scene from Greek mythology, the fatal battle between the brothers Eteocles and Polynices over the throne of the city of Thebes.

The winged figure who sits between the two fallen brothers is, however, a wholly Etruscan addition to the scene. This deity, easily recognizable in her distinctive clothing, is Vanth, a denizen of the Etruscan underworld who leads the dead to their final destination. The winged female figure on the left side panel is also Vanth,[1] while the male on the right panel is Vanth's frequent companion Charun. Charun is a character in Greek mythology—he is the ferryman to the Greek underworld—but he does not figure with great prominence in Greek funerary art.[2] Etruscan Charun, however, appears often in tomb paintings and on sculpted sarcophagi and cinerary urns. He usually carries a small hammer, which he uses to tap the dead on the shoulder to confirm that the deceased is indeed dead. These two demons of the underworld, Vanth and Charun, began to appear in Etruscan art in the fourth century BC; they experienced a particular popularity in the subsequent century, the period of Etruscan incorporation into the Roman state. The Vanth figure is especially interesting in the context of the present exhibition, as her attributes coincide with those of the winged demon in the frieze in the Villa of the Mysteries. Indeed, the presence of such a figure in the Pompeiian painting may offer evidence of Italian influence in a work often argued to be of Greek inspiration.[3]

This urn was probably made in the Etruscan city of Volterra, noted for its production of alabaster cinerary urns in the Hellenistic period.[4]

DATE: Fourth–first century BC.

Unpublished.

EdeG

1 The Etruscan conception of divinity was different from that of the Greeks, and many divine Etruscan figures occurred in twinned pairs or even in triplicate. Thus, the figure on the side panel need not be regarded as a different view of the same deity that appears in the main scene. That is to say, both deities are Vanth yet not necessarily the same Vanth. Two Vanth figures could just as easily appear in the same scene, as is often the case (e.g., on the urn of Arnth Velimnas: Brendel 1995, 421).
2 The name of the Greek ferryman is usually rendered Charon in English, while Charun is used in reference to the Etruscan demon.
3 See ch. 9 by J. M. Davis in this volume for a discussion of the artistic sources that may have influenced the production of the Pompeiian frieze.
4 For comparable urns and relevant bibliography, see Cristofani 1977 and Cateni 1986.

84 Fragment of an Arretine Bowl

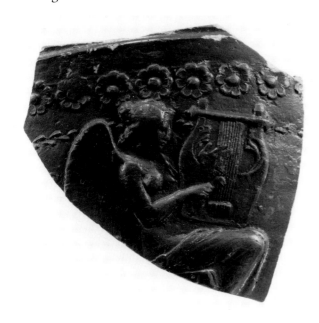

Fired clay
H. 2⁵/₈; W. 2¹¹/₁₆ in.
(6.7; 6.8 cm)
Italy
The Detroit Institute of Arts, Gift of Piero Tozzi
Acc. no. 50.162
The surface of this convex bowl fragment preserves a deep brownish-red gloss.

The mold-made bowl fragment is decorated in relief. At the top is a border of rosettes, each with eight rounded petals above a narrow leaf band. The preserved scene on the fragment contains the nearly complete figure of a winged female playing a kithera. The winged female is seated on a backless stool facing to the right. Her torso is nude, while the lower part of her body is sheathed by a garment, which is gathered into a knot at her hips and draped in folds over her legs. With her left hand, she holds a kithera, slightly tilted on her lap, and with her right hand a plectrum.

Arretine ware, also known as *terra sigillata*, was the principal type of ceramic fineware used throughout the Roman empire from the late first century BC to the early fourth century AD.[1] Intricate and detailed reliefs regularly decorated these vessels. Among the wide array of motifs and themes, erotic or Bacchic scenes were common. However, the most prevalent motifs in early Arretine ware are choirs of figures identified as *genii* or sirens.[2]

In Roman religion, the *genius* represented a complex concept of divinity through which an individual's power of generation was honored. Depictions of *genii* commonly occur in another form in household shrines, such as the *lararium* painting in the Field Museum (cat. no. 37) and a bronze *togatus* (cat. no. 38), which represent the *genius* of the *paterfamilias*.[3]

On Arretine vessels, a number of variations of such figures occur—winged and wingless, seated and standing. This example of a seated, winged *genius* playing a kithera has numerous parallels.[4] Among them is a fragment of a mold in the Metropolitan Museum of Art (acc. no. 19.192.20),[5] which depicts a kithera-playing *genius* confronting a *genius* playing a double flute much like that on cat. no. 84.

DATE: First century BC–first century AD.

Unpublished.

CH

1 Oswald and Pryce 1920, 4.
2 *CVA* USA 9, Metropolitan Museum of Art, New York 1:23.
3 The female counterpart for the male *genius* was called *juno*. The *juno* was the protector of women, marriage, and birth (Boyce 1937, 75, no. 349, pl. 19.2). See also ch. 7 by M. Swetnam-Burland in this volume.
4 See Brown 1968, 13, no. 25, pl. 9; Dragendorff and Watzinger (1948, pl. 2, no. 24). This piece is an example of "Musizierende Genien und Sirenen" Group V, type 3, as classified by Dragendorff and Watzinger (65–67).
5 *CVA* USA 9, Metropolitan Museum of Art, New York (1:23, acc. no. 19.192.20, pl. 29). See also Dragendorff and Watzinger 1948, 65–67, pl. 2, no. 24.

85 Fragment of an Arretine Bowl

Fired clay
H. 2¹/₂; W. 2⁵/₁₆ in.
(6.5; 5.6 cm)
Italy
The Detroit Institute of Arts, Gift of Piero Tozzi
Acc. no. 50.165
The convex fragment of a bowl is fairly well preserved. The deep brownish-red gloss is slightly mottled on the far upper left side.

This fragment is from a mold-made bowl with relief decoration. At the top is a portion of an ovolo border just above the main scene, in which a winged female figure playing a double flute is preserved.[1] This winged *genius* is seated on a backless stool facing to the left. The lower part of her semi-nude body is sheathed in a garment gathered into a knot at her hip and draped in folds over her legs. She plays a double flute with her arms extended out in front of her. In front of the figure and in the background, near her head, is the curling tendril of a grape

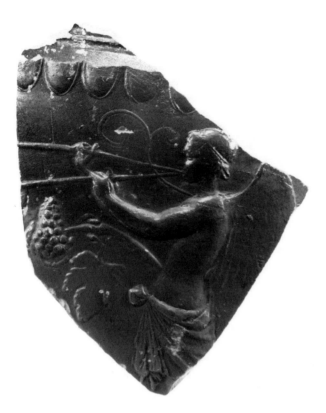

CVA USA 9, Metropolitan Museum of Art, New York (1:23, acc. no. 19.192.20, pl. 29).

3 Dragendorff and Watzinger 1948, 66. For an example of a complete scene of the "Birth of Dionysus," which includes a figure playing a double flute, see Vivani 1921, figs. 1–3, cited by Brown 1968, 11, no. 20.

86 Fragment of Cameo Glass

white on blue glass
H. 1⅛; W. 1¾ in. (?)
(2.86; 4.45 cm)
Italy
Lent by the Toledo Museum of Art,
 Gift of Edward Drummond Libbey
Acc. no. 23.1540
Broken on all sides, the fragment is weathered and slightly pitted all over. Brownish discoloration covers areas of the white glass. The details of the figure are worn and indistinct.

vine. At about waist level is a single large grape leaf in fairly shallow relief and, just to the right, a cluster of grapes in bolder relief.

Like cat. no. 84, this example of relief-decorated Arretine ware includes a seated winged *genius* playing an instrument, in this case a double flute. However, with the inclusion of the grape vine—an attribute ubiquitously associated with Bacchus/Liber—another popular Arretine motif is incorporated.

The winged *genii* on this Arretine fragment and on cat. no. 84[2] present intriguing possibilities for interpreting the winged female figure in connection with Bacchus/Liber in the Villa of the Mysteries frieze (group E, fig. 20). While perhaps not directly comparable to the Arretine examples, the winged figure may suggest another level of meaning. Individuals were not the only ones to possess a *genius*; families, households, cities, and even the Roman people as a whole had a *genius*. Some deities, including Bacchus/Liber, did as well. A number of scenes on Arretine vessels, including scenes of the birth of Bacchus/Liber, contain winged female *genii*.[3]

DATE: First century BC–first century AD.

Unpublished.

CH

1 See Brown 1968, 13, no. 28, pl. 9; Dragendorff and Watzinger 1948, pl. 2, no. 20.
2 Although not from the same vessel, possible associations with Bacchus/Liber are similarly posited for cat. no. 84 since kithera- and flute-playing winged figural types do occur together. See

The thin, convex fragment of a vessel preserves a group of two male figures. The relief decoration is in opaque white on a translucent blue background. The male figure on the right is depicted with his head in profile and a torso in three-quarters view. His hair is bound by a fillet, and he holds aloft a barely visible thyrsus. The male figure on the left is depicted frontally. Both are bearded and nude.

These two figures are identified as followers of Bacchus by the thyrsus, a staff topped by a pinecone. Scenes containing followers of Bacchus are ubiquitous on painted vases, such as cat. nos. 68 and 70, but are relatively rare on cameos. Glass does not often survive intact; moreover, glass cameos are among the rarest types of ancient glass.[1] Among the cameo vessels that *have* come down to us intact, several display Bacchic themes. These include a cameo amphora from Pompeii called the Blue Vase (Museo Archeologico Nazionale, Naples, inv. no. 13521) and the so-called Morgan Cup (J. Pierpont Morgan Collection, New York, CMG 52.1.93).[2] Smaller cameo gems, such as those displayed in the current exhibit (cat. nos. 85–87), show the array of Bacchic imagery produced on glass cameos, which were luxury items highly prized by their wealthy owners.

DATE: Fourth–first century BC.

BIBLIOGRAPHY: Sturgis 1894, 557, fig. 13.

CH

1 Toledo Museum of Art 1969, 21. The technique of producing cameo vessels is thought to have been developed in Alexandria no later than the first century BC. For a more extensive discussion on cameo techniques and other cameo vessels, see Whitehouse 1997.
2 Harden 1987, 75–78, cat. no. 33, and 80–82, cat. no. 35.

87 Rim Fragment of a Cameo Plaque with a Theater Mask

White on blue glass
L. 3⁵/₁₆; W. 1¹⁵/₁₆ in.
(8.4; 4.9 cm)
Alexandria or Italy
Lent by the Toledo Museum of Art,
 Gift of Edward Drummond Libbey
Acc. no. 23.1571

Although the right and left sides are broken, the upper edge remains intact. The fragment is weathered with minor pitting on the surface. The details of the cameo decoration are finely modeled.

This flat, triangular fragment of a cameo plaque preserves a tragic mask in relief. The relief decoration is in opaque white on a deep blue background. The mask has large eyes with drilled round pupils, arched brows, a flaring nose, and a large open mouth. The hair is swept back and held by a fillet that crosses the forehead. Clusters of grape leaves crown the head on each side. There is a tiny, partially broken rosette on the right edge of the fragment.

Masks were common components of Bacchic imagery. In this instance the grape leaf wreath marks the mask emphatically as Bacchic.[1] The use of masks was widespread in the art of Pompeii and Herculaneum. Numerous examples in different media are comparable to the Toledo cameo in facial expression and in the form of the eyes and mouth. Examples include, among others, a marble *oscillum* in the form of a theater mask (Museo Archeologico Nazionale, Naples, inv. no. 6611), a mosaic of two masks nestled within a bough of fruit and leaves (Museo Archeologico Nazionale, Naples, inv. no. 9994), and a Fourth Style wall painting of a

mask (Museo Archeologico Nazionale, Naples, inv. no. 9805).[2]

The range of media and number of examples in which this particular type of mask occurs in the area of Pompeii are a vivid indication of Bacchus's significance there. Whether such masks evoke merely an association of Bacchus with the theater or the more enigmatic meaning suggested by the mask held up by a Silenus (group D, figure 14) on the frieze in the Villa of the Mysteries, the ubiquitous presence of this type of imagery in Pompeii and elsewhere in the Roman world is noteworthy.

In the present day, the imagery of masks carries a new range of meanings and yet still evokes antiquity. Analogous to the contemporary works of art in the current exhibit, which are inspired by the Villa of the Mysteries frieze, is a large modern sculpture entitled *Tragic Mask*, which was inspired by this Toledo cameo fragment. Created by artists Anne and Patrick Poirier, *Tragic Mask* is located fittingly next to the Valentine Theatre in Toledo, Ohio.

DATE: First century AD.

BIBLIOGRAPHY: Sturgis 1894, 556, fig 12; Toledo Museum of Art 1961, "Ancient and Near Eastern Glass," *Toledo Museum of Art: Museum News* 4(2): back cover (color ill.); Toledo Museum of Art 1966, 9; Riefstahl 1968b, 18, fig. 6; Toledo Museum of Art 1969, 22.

CH

1 Masks, especially tragic masks, occur fairly commonly on cameos and other gems. See Tondo and Vanni 1990, 100–101, nos. 211–12.
2 The sources for these objects are the following two catalogues: Ward-Perkins and Claridge (1978, 1:140, no. 65 and 211, no. 309); Museo Archeologico Nazionale di Napoli (1986–89, 1:116–17, no. 3). For yet another mask of this type used as a decorative detail on a Second Style wall painting in Rome, see Carettoni 1983, 56–57, pl. O.

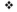

Gems and Cameos

The Latin word, *gemma*, used to describe such objects does not distinguish between gem and glass media[1] but rather includes both, as both were used for the same purposes: as amulets, personal seals, and items of adornment. Glass cameos were meant to approximate the look and function of gems and indeed were carved using the same techniques. Yet they lacked both the monetary and magical value of real gemstones and precious metals, which were thought in certain cases to have special properties that could treat illnesses. Gold, for example, was thought to ward off evil spells and charms, counteract poisons, cure blemishes, and to be efficacious worn as an amulet or applied as gold dust mixed with honey in a topical cream (Pliny *HN* 33.25.87).

Engraved cameos and rings were worn by both men and women in a range of sizes, shapes, colors, and decorative motifs. According to Pliny, concave or convex gems were less valuable than those with a planed surface, and those

with an elongated shape were the most valuable (*HN* 37.75.196). Carving itself could also enhance the value of a gem (Pliny *HN* 33.6.22). Accordingly, gemstones were carved with numerous kinds of designs, from portraits of the owners to erotic scenes, from inscribed prayers to religious imagery. Thus, the imagery on gemstones can not only reveal the beliefs or interests of the owners but also act as an invocation of the gods. The engraved gemstones and glass cameos in this exhibition depict Liber and his followers.

GENERAL BIBLIOGRAPHY: Boardman 1968; 1970; Stout 1994; Guiraud 1996.

MSB

1 Guiraud 1996, 7; Pliny *HN* 37.75.195.

88 Cameo Fragment

White on blue glass
H. 2; W. 1¹/₂ in.
(5; 3.81 cm)
Provenance unknown
Lent by the Toledo Museum of Art,
 Gift of Edward Drummond Libbey
Acc. no. 23.1673
The fragment of cameo glass is broken on the top, bottom, and left sides, with the white glass frame of the cameo preserved only on the right. There is a slight crack in the frame, about 1 cm from the bottom of the fragment.

The glass cameo is made from translucent cobalt blue glass, with a frame of opaque white glass. The cameo depicts a youth, possibly Antinous, in profile, with his shoulders and chest positioned frontally. The young man wears a Dionysiac crown composed of flat grape leaves and clusters of grapes, similar to that worn by the marble head of Silenus in the Kelsey Museum (cat. no. 93).

Glass cameos were produced by fusing together two

layers of colored glass. The artists then carved these layers in the same manner as precious gems. In this example, the high quality of the carving is evidenced by the attention to detail and the depth of the relief. The central figure is probably Antinous, the lover of the emperor Hadrian, identified by the characteristic pattern of curls framing his face.[1] Antinous died at a young age and was subsequently deified by Hadrian; he was venerated in many guises, assimilated to other deities. This cameo presents him in the guise of Liber or one of his followers, a popular way of representing Antinous, especially in his homeland of Bithynia in Asia Minor. The worship of Antinous in this guise is attested in many statue types,[2] but there is no other cameo in which he is presented as Liber.[3] It is possible that this glass cameo comes from Asia Minor or was somehow associated with an adherent of a cult that venerated Liber and Antinous. This cameo also illustrates the ways in which individuals identified with the gods they worshipped, sometimes even dressing up or playing the role of the gods in rituals.[4]

DATE: Hadrianic.

Unpublished.

MSB

1 See Clairmont 1966; Meyer 1991, pls. 146–47.
2 Meyer 1991, 83 ff.
3 There is, however, a blown glass vessel from Asia Minor that features a portrait of Antinous as Liber (Stern 1995, no. 506).
4 See also ch. 8 by E. de Grummond in this volume for a discussion of the so-called Bacchic Inscription in the Metropolitan Museum of Art and of this issue as it relates to the friezes from the Kelsey sarcophagus and the Villa of the Mysteries.

89 Cameo with Bacchic Group

White on purple glass
H. ⁷/₈; W. 1³/₁₆; D. ³/₁₆ in.
(2.3; 3.0; 0.4 cm)
Provenance unknown
Lent by The Metropolitan Museum of Art,
 Gift of J. Pierpont Morgan, 1917
Acc. no. 17.194.9
The white layer of fused glass is worn, with an iridescent cast that renders the surface detail somewhat indistinct.

The cameo depicts the god Liber reclining on a couch and holding a kantharos, facing a female figure to his right—a nymph, maenad, or perhaps Venus or Ariadne. Both figures are partially draped. To the right a pan or satyr is playing a *syrinx*.

The composition of the central figures bears some resemblance to that of the central group in the Villa of the Mysteries. Here, as there, the god is shown in a recumbent pose looking up at his companion. Similar iconography is also found on Attic and South Italian vases.[1] In this instance, little specific context for the interaction between the two figures is given, and it is impossible to identify with certainty the companion of the deity. Nonetheless, this cameo provides evidence of the adaptability of such imagery

to a variety of contexts, from wall painting to items of adornment. Glass cameos such as this one were also luxury items and may reflect the owner's interest in the cult of Liber.

DATE: First century BC–third century AD.

BIBLIOGRAPHY: Richter 1920, no. 321;1956, cat. no. 618; Hartmann 1979, 168, n. 6.

MSB

1 For a discussion of the iconography of Dionysus and his companions on Greek and South Italian vases, see ch. 10 by S. Kirk in this volume.

90 Cameo with Maenads and Satyr

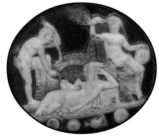

Sardonyx
H. 1⁵/₁₆; W. 1⁷/₁₆ in.
(3.3; 3.6 cm)
Provenance unknown
Lent by The Metropolitan Museum of Art, Fletcher Fund, 1925
Acc. no. 25.78.96
There are a few chips in the stone's white layer.

The cameo is roughly circular. The figures are carved in a white layer of the sardonyx; the background layer is a caramel color. At the center, in the foreground, a maenad reclines with her back to the viewer. She is nursing a young

panther. Her crossed legs are wrapped in a mantle that has slipped from the rest of her body, leaving her buttocks, torso, and arms bare. Her face is shown in profile to the left. The maenad raises her bent left arm above her head; with her right arm she supports herself on a basket. At left is a satyr who is nude except for a cloth draped across his left leg. He stands on his right leg, while his left, bent at the knee, rests on a rock. The satyr leans forward. In his extended right hand he holds the tail of the panther. His left arm is raised and curled around the side of his face so that his hand, which holds a shepherd's stick, is on top of his head. A wreath adorns his hair. Another maenad sits to the right of these figures. She is wrapped from the waist down in a mantle, the end of which she holds behind her with her raised right hand. She wears a wreath in her hair. A tympanum, supported by her left hand, rests on her left thigh. The space below the reclining maenad is occupied by a pair of cymbals, a krater, and a tympanum.[1]

The maenads and satyr depicted in this cameo are accompanied by a number of elements associated with the cult of Liber. The god is often represented with a panther as a reference to his Eastern origins.[2] The krater was a natural component of both Bacchic and everyday paraphernalia, as it was a vessel used for mixing water and wine. Musical instruments such as the ones shown here were played by the maenads and satyrs who followed in Liber's train.

The depiction of a Bacchic scene on this cameo, a small object worn as personal adornment, reveals in comparison with the much larger frieze in the Villa of the Mysteries the range of contexts and of media in which such themes appeared in the late Republic and early Empire. The wearing of images of this sort indicates both Liber's popularity among elite women and the personal nature of individuals' devotion to him. The owner of this cameo may have worn it as a sign of her association with the cult or as a protective talisman.

DATE: First century BC–first century AD.

BIBLIOGRAPHY: Richter 1956, 124–25, no. 619, pl. 68, with earlier bibliography.

JMD

1 Richter 1956, 124–25.
2 See, for example, cat. no. 105, a statuette of Liber playing with a panther.

91 Cameo with Dancing Maenad

White on blue glass
H. 1³/₈; W. 1¹/₈; D. ¹/₄ in.
(3.5; 2.7; 0.6 cm)
Provenance unknown
Lent by The Metropolitan Museum of Art,
 Gift of J. Pierpont Morgan, 1917
Acc. no. 17.194.10
The cameo is broken in half (now restored) and has a chip along the upper edge. The white layer of glass is chipped. A section of the maenad's drapery is missing on the left side of the cameo.
The cameo is made from two layers of fused glass, blue and white. It depicts a frenzied dancing maenad, with her head

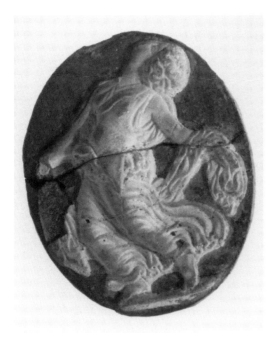

BIBLIOGRAPHY: Richter 1920, no. 322; 1956, cat. no. 620.

MSB

1 For an explanation of the Hauser types, see Touchette 1995, esp. pl. 1.
2 Touchette 1995, 56.
3 See ch. 8 by E. de Grummond in this volume.

❖

92 Head of Dionysus/Liber

Marble
H. 12¹³/₁₆; W. 10⁵/₈; D. 12⁵/₈ in.
(32.5; 27; 32 cm)
Provenance unknown, probably Italy
Kelsey Museum of Archaeology Cummer Fund and
 University of Michigan Museum of Art joint purchase, 1974
KM acc. no. 74.4.1, UMMA acc. no. 1976/2.1

The nose is broken at the bridge. A large fragment just below the lip, including the chin, was broken and reattached. The chin is scored on the left side by a deep gash. The right earlobe has been replaced with modern plaster. The left cheek is damaged just below the curling tendril of hair. A number of chips mar the surface of the face, particularly the upper and lower lip, the right eyebrow, across the forehead, and on the *mitra*, or fillet, just above the forehead. There is a metal pin set into the right side of the neck, possibly the result of an ancient attempt to repair the hair.[1] Above the *mitra* and on both sides of the head the frontal portion of an ivy wreath has been systematically removed. Sections of the wreath are preserved on the right rear of the head and, to a lesser extent, on the left rear as well. The top of the hair is also abraded, especially near the areas where the wreath was removed. A reddish pigment, or perhaps bole for attaching gold leaf,[2] is preserved on the left side of the head. The surface of the hair and marble appears more worn than that of

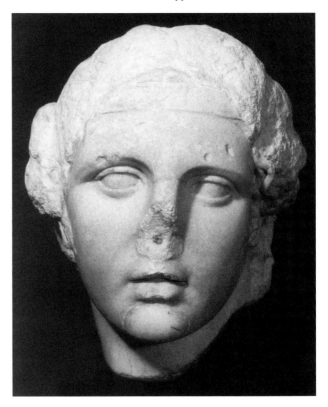

thrown back, her right arm behind her head, and her left arm holding a fold of drapery at her side.

The maenad corresponds most closely to Hauser type 25,[1] though it differs in small particulars, holding drapery in place of the haunch of the animal in her left hand. Hauser type 25 depicts the maenad with her head thrown back, her right arm lifted above her head, holding a knife in her right hand and the haunch from a sacrificial victim in her left. The maenad on the Detroit *oscillum* (cat. no. 104) is an excellent example of Hauser type 25. Touchette argues that the model upon which Hauser type 25 is based is exemplified by the base of a cult statue of Dionysus from the Acropolis in Athens, but she suggests that in the Roman world these basic types were varied to suit numerous different contexts. She suggests that Roman depictions of such maenads made reference to the religious context from which the type ultimately originated but that they gained new associations specific to their uses by the Romans. According to Touchette, use of the type should be considered not merely decorative but laden with associations that referred to the Roman version of the cult of Liber.[2] In this example, the type has been modified so that there are no sacrificial connotations. Rather, the dancing and rejoicing associated with the worship of Liber are emphasized.

This glass cameo, the glass cameo depicting a reclining Liber (cat. no. 89), and the *oscillum* (cat. no. 104) in this exhibition are examples of the ways in which imagery associated with the god and his retinue was deployed in different media to fit specific contexts. The *oscillum*, which would have been located in the peristyle of a villa or house, presents this type of dancing maenad in a garden context especially suited to celebrating the mythological and theatrical aspects of Liber, whereas this cameo presents the maenad in a context more closely linked with the owner, perhaps used to invoke the deity. Both may refer, as well, to the Roman ritual practices associated with the cult of Liber, in which women often enacted the role of maenad.[3]

DATE: First century BC–third century AD.

the face, which except for the chipped areas is smooth and rather polished. This polish is probably ancient but may also be the result of cleaning and modern restoration.[3]

The head is slightly over life size, and was once part of a larger (full body) composition. The arm originally lay on top of the head, with the hand resting lightly on the crown; traces remain of the little finger of the right hand. The facial features, especially the eyes and mouth, are deeply carved. They are softly modeled with little indication of bone structure or musculature. The hair is carved in loose, wavy ridges and is drawn off the face into a chignon at the nape of the neck. The fillet along the top of the forehead is probably a *mitra*, the headband worn by followers of Liber to ward off headaches caused by excessive drinking.[4] The turn of the head slightly to the left indicates that the pose of the full figure was not strictly frontal.

J. G. Pedley suggests that the Kelsey head is a Roman copy of Hadrianic date of an early Hellenistic adaptation of a fourth-century statue type.[5] Pedley notes a resemblance to fourth-century standing types of Apollo and Dionysus, especially the Apollo Lykeios and the Apollo Kitharoidos, and suggests that it could either have been a single composition or part of a group of statues.[6] Comparison with a torso of Dionysus from the Horti Lamiani in Rome suggests that the Kelsey head may also be reconstructed as a sitting or reclining type. The head of the torso in Rome is strikingly similar to the Kelsey head, with comparable hairstyle, wreath, and smoothed features. The Horti Lamiani head is turned to the left, and the right arm is held with the hand resting lightly on the crown; the nude torso is preserved to the top of the thighs, the angle of which with respect to the abdomen suggests that the figure is seated or reclining, probably draped with a *chlamys* over the thighs and lower legs. C. Häuber suggests that this pose is modified from that of standing types like the Apollo Lykeios and Apollo Kitharoidos mentioned above. She argues that in the Roman period this seated type was appropriate for figures of Dionysus and Apollo.[7] The figure of Liber in Room 5 in the Villa of the Mysteries frieze is an example of this type as well.

DATE: Hadrianic or early Antonine.

BIBLIOGRAPHY: Pedley 1978, 17–27.

MSB

1 Pedley 1978, 17.
2 Pedley 1978, 17.
3 Pedley 1978, 17.
4 Diod. Sic. 4.4.4
5 Pedley 1978, 21.
6 Pedley 1978, 21.
7 Häuber 1986, 95–97, figs. 65–66.

93 Head of Silenus

White marble
H. 10¼; W. 7½; D. 8⁵/₁₆ in.
(26.4; 19.1; 21.1 cm)
Provenance unknown
Kelsey Museum of Archaeology, acc. no. 1984.5.1

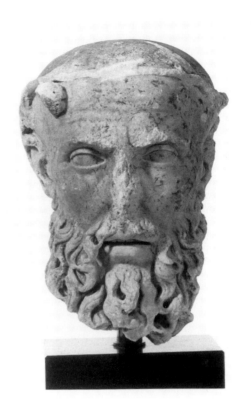

The head is broken diagonally at the neck. There are breaks above the center of the forehead and on the left forward portion of the skull, both cutting through the wreath. The nose is broken off almost completely. There is a significant amount of wear on the wreath, both on the leaves and berries and along the roping. The ears show signs of abrasion and chipping along the back edges; the right ear is broken along the rims. Both eyebrows are missing at the root of the nose, and the mustache is chipped. There are scattered chips on the hair. The white marble has a slightly yellow-ochre patina.

The piece depicts the head of an older, bald man with a furrowed brow, sunken cheeks, and a full, curly beard. The right side of the neck curves outward on the right side. The mustache is not as deeply cut as the drilled curls of the beard. The full lips are parted slightly, baring six teeth in the upper row. The drill hole of the right nostril remains, as does a small part of the outer edge of the right nostril. The man is crowned with a wreath of ivy leaves and berry clusters. There is a shallowly carved fringe of hair on the back of the head.

In frontal view, the top of the head appears significantly wider than the lower portion of the face, and from the side, the top of the skull is rather flattened, except for a slightly raised area above the forehead. These anomalies suggest either that there was some recarving of the head or that the head portrays the physiognomy of a particular individual.

The use of the drill to create sharp textual contrasts between locks of hair and flesh and the chisel to render individual strands of hair is common among male portraits and ideal sculptures of the Hadrianic through Severan periods. Like the Kelsey piece, the mustaches of these portraits are cut in small, rather shallow grooves. An Antonine or Severan date for the Kelsey head is suggested by the presence of bridges of marble between the locks of hair on the left side as well as the center of the beard.

The identity of the Kelsey head and its general date are supported by the iconography of Silenus on contemporary sarcophagi. Among the significant features of the Kelsey head are the wreath, the age and baldness of the subject, and the bared teeth, which also occur on numerous depictions of Silenus. A sarcophagus in the Fitzwilliam Museum in Cambridge, dating to the Hadrianic period, includes a Silenus with an open mouth that reveals the upper row of teeth.[1] Another from the Museo Nazionale in Naples (acc. no. 6776) depicts a younger Silenus whose thin face, with its relatively narrow nose, slightly sunken cheeks, and furrowed brow, is strikingly similar to that of the Kelsey sculpture.[2]

The wreath and the portraitlike aspect of the Kelsey head are closely paralleled in a sarcophagus from the Palais des Artes in Lyons, dated between AD 220 and 230.[3] Here a "Silenus" with a typical beard and bald head wears a wreath like that worn by the Kelsey head. Both wreaths have two protrusions, one at either temple, and a thin, wavering circle connecting the leaves. Further, although the ears of the Lyons Silenus are pointed, clearly marking the figure as mythological, the facial features seem to be individualized and were perhaps intended as a portrait.

A number of other sarcophagi provide further examples of men, identifiable by their portraitlike facial appearance, who are depicted with features characteristic of Silenus. These men have the pointed ears of Silenus, but other characteristics of their faces, such as thinness, a straight nose, and compactness of the beard, suggest that they are portraits with divine attributes.[4] The Kelsey piece may likewise represent a free-standing portrait or a bust that alludes to the iconography of Silenus.

In the Villa of the Mysteries frieze two Silenoi are depicted. Both are crowned with wreaths and have pointed ears. These two figures share many features with the Kelsey piece, but they reflect a more canonical Silenus type.

DATE: Late second–early third century AD.

Unpublished.

DW

1 Matz 1968-75, 2:no. 129, fig. 144,1.
2 Matz 1968–75, 2:no. 118, fig. 138,1.
3 Matz 1968-75, 2:no. 101, fig. 129,3.
4 Two examples of this are in the British Museum, acc. no. 2298 (AD 160–170), and the Lateran in Rome, acc. no. 10428 (AD 265–270). Matz 1968–75, 2:no. 88, fig. 110,2 and no. 139, fig. 160, 1.2, respectively.

94 Head of a Satyr

Marble
H. 9¹/₄; D. 6¹/₄ in.
(23.9; 16 cm)
Found in Rome in a modern context
Gift of the Melvin Brody Family, 1987
Kelsey Museum of Archaeology, acc. no. 87.10.1
There are a gouge in the brow above the left eye, a chip extending from the right brow to the center of the forehead, chips in the right brow, cheeks, and chin, and damage to the bottom lip. Smooth

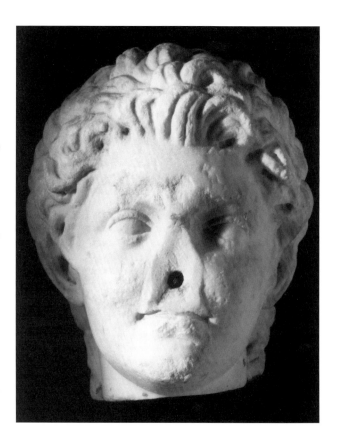

surfaces at the nose and upper lip and a drill hole in the center of the nose remain from a now-dismantled repair. The hair is abraded but bears traces of red paint. There are small dark spots of incrustation on the neck. An old attempt at restoration removed the tips of the ears. The back of the head had also been restored. The slightly concave, claw-chiseled surface preserves three iron pins—two at the center in a hollow c. 2 cm in diameter and one on the right side. A drill hole may have held a fourth pin. The restorations were removed in 1959.

Despite significant losses, the softly modeled fleshy face, tilted slightly to the right, effectively portrays a youthful subject. The face, with its prominent cheekbones and small chin, exhibits fine carving. The drill was used sparingly in the ears, locks of hair, and parted lips. The thick hair is composed of a series of tufts, which continue down the nape of the neck. A tuft on each side of the face curls downward over the cheekbone, mimicking the curve of the ears. The preserved, fleshy lower lip forms a bow-shaped curve. The eyes are set into thickly lidded sockets. A smooth neck extends a few centimeters below the chin.

The holes and iron pins indicate that the back of the head either was worked as a separate piece and attached or was altered at a later date for reuse (attached to a wall, for instance). The head was probably attached originally to a three-dimensional body or one in high relief.

Although the pointed tips of the ears were removed, their outline, preserved in the hair, identifies the head as that of a satyr. Artists often exploited the comic and lascivious nature of satyrs as trouble-causing companions of Bacchus whose lives are spent in drunken ecstasy in an

eternal, if often unsuccessful, quest for sexual gratification.[1]

This head may have belonged to a relief perhaps on a large-scale Bacchic sarcophagus or, more likely, to a free-standing figure or group composition. Hellenistic and Roman groups with satyrs include the *Invitation to the Dance* group and *Pan Pulling a Thorn from the Foot of a Satyr*. Several erotically charged *symplegmata* depict a satyr struggling with a hermaphrodite or a nymph.[2] The soft facial physiognomy of the Kelsey satyr, however, recalls in particular Roman adaptations of the *Resting Satyr*, a free-standing statue type of the second half of the fourth century BC attributed to Praxiteles.[3] The Kelsey satyr has the salient characteristics of the type: a slight turn of the head to the left, pointed ears, a cunning smile, hair in ruffled locks, and high cheekbones.[4] One can easily imagine this head attached to a relaxed, youthful body, leaning against a tree. Sculptures of Bacchic subjects such as this one, whether singly or in a group, were frequently placed in the gardens of Campanian and other Roman villas. This head recalls those of the young satyrs in the Villa of the Mysteries frieze.

DATE: Second century AD.

Unpublished.

SK

1 For general information on satyrs, see *OCD*[3] s.v. "satyrs"; for the habits and psychology of satyrs, see Houser 1979, 14. For a comprehensive survey of satyrs in Greek and Roman art and extensive bibliography, see *LIMC* s.v. "Silenoi"; see also Brommer 1937; Carpenter 1986; 1997; Hedreen 1994, 47–69; Lissarrague 1990.
2 *Pan Pulling a Thorn from the Foot of a Satyr:* see Pollitt 1986, fig. 143; *Invitation to the Dance:* see Pollitt 1986, fig. 139; *Struggling Hermaphrodite and Satyr:* see Pollitt 1986, fig. 140; *Struggling Nymph and Satyr:* Roman adaptation of a Greek original c. 100 BC, see Pollitt 1986, fig. 141.
3 Rome, Museo Capitolino, 739, *LIMC* s.v. "Silenoi," no. 213. See also Bartman 1992, 51–101, nos. 1–21, figs. 9, 16.
4 Tomei 1997, 137, no. 118.

95 Torso of a Young Satyr

White marble
H. 31; W. 10; W. at hips 15³/₅ in.
(78.7; 25.4; 39.7 cm)
Provenance unknown
Kelsey Museum of Archaeology, acc. no. 1976.1.1
The torso lacks the head, the right arm from just below the shoulder, the lower part, the left forearm from just above the wrist, the right leg from above the knee, the left leg from below the knee, and the genitalia. The stub of a marble strut remains on the right breast and an attachment point on the right hip. The nebris is incrusted along the broken lower edge. The back of the left thigh is pitted. There are scattered scratches and mottled ochre-colored stains over the surface of the figure, but much of the flesh surface has a silken polish. A small hole in the break of the left arm may indicate an ancient repair. Other signs of reworking appear at the genitalia and the underside of the nebris, which originally fell down along the left side of the figure. There was once a large strut, perhaps a tree trunk, on the left side that would have supported the leaning figure.[1]

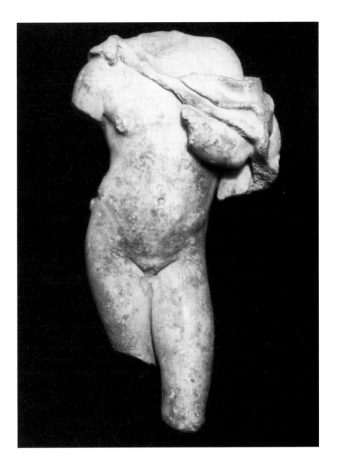

The sculpture depicts an almost naked youth, with slightly turned hips, resting his weight on his right leg. The left leg crosses in front of the right. The left arm is bent at the elbow and raised in front of the chest. Although the right arm is missing, the remains of a strut on the right breast indicate that this arm was also bent at the elbow and raised in front of the chest. An animal-skin nebris, tied in a knot over the right shoulder, falls diagonally across the chest and upper left arm. A small portion of the ear of the animal survives below the left elbow. The graceful curve of the body and the soft modeling suggest the youthfulness of the subject.

The posture of the Kelsey piece is nearly identical to that of a young satyr usually attributed to Lysippos, versions of which are numerous. Examples include those in the Louvre, the Vatican, and the Museo Nazionale Romano.[2] In these sculptures a youthful satyr lifts a flute to his mouth, with arms bent at nearly identical angles and the nebris knotted in a similar fashion over the right shoulder. According to the Elder Pliny (*HN* 34.64), Lysippos created such a statue of a satyr for Athens.

Satyrs, as creatures associated with the countryside and the wildness of nature, commonly appeared in the gardens of opulent Roman houses and villas. The owner of such a piece would have appreciated its resonance with nature and with life in the country. It is difficult to know to what extent such garden *ornamenta* had religious significance. A similar ambiguity of meaning surrounds the two young satyrs or pans on the north wall of the frieze in the Villa of the Mysteries (group C, figures 9 and 10). On the left side of the frieze, a male and female satyr are depicted. One plays the

double flute, as the Kelsey satyr once did, while the female suckles a young goat in a scene that evokes the rustic world associated with the gods Bacchus and Liber. The Kelsey piece would have encouraged a similar association.

DATE: Roman.

BIBLIOGRAPHY: Friedland 1992, 3.

DW

1 Friedland (1992, 3) discusses the alterations and missing parts of the statue.
2 Bieber 1961, 38, n. 35, fig. 86 (Louvre).

96 Relief Plaque with Bacchic Initiation Scene

Fired clay
H. 13¹/₈; W. 16¹/₄; D. ⁷/₈ in.
(33.3; 41.3; 2.2 cm)
Italy
Seattle Museum of Art, Norman and Amelia Davis
 Classical Collection
Acc. no. 67.39

The surface and edges of this object are somewhat worn and chipped, and a diagonal crack runs from the top center through the middle of the figural scene.

The top of this architectural plaque is decorated with a stylized floral motif repeated six times. The floral frieze sits on a curved ledge with two hatch marks under each of the stylized flowers. Below this is a scene of four figures standing on a groundline created by a small ledge that serves as the lower frame for the scene. At the far left is a stocky, bearded, goat-legged Silenus walking erect toward the other three figures and holding a liknon with a projecting phallus. The fact that he has just revealed the contents of the liknon is made evident by the cloth that hangs from his left hand, which also supports the weight of the liknon. He wears a chiton and a mantle tied around his waist. At the far right of the scene is a woman raising before her a tympanum decorated with a winged creature; she approaches the central two figures, who together form the focal point of the scene. The woman lifts up her head and gazes at the sky, possibly in a state of ecstasy; her garment slips off her left shoulder, both identifying her as a maenad and associating her with Venus and the realm of sexuality. At the center a figure in mid-stride walks toward the left and the revealed phallus. The gender of this figure is uncertain because the head is veiled. The body is bent sharply forward, and the head is

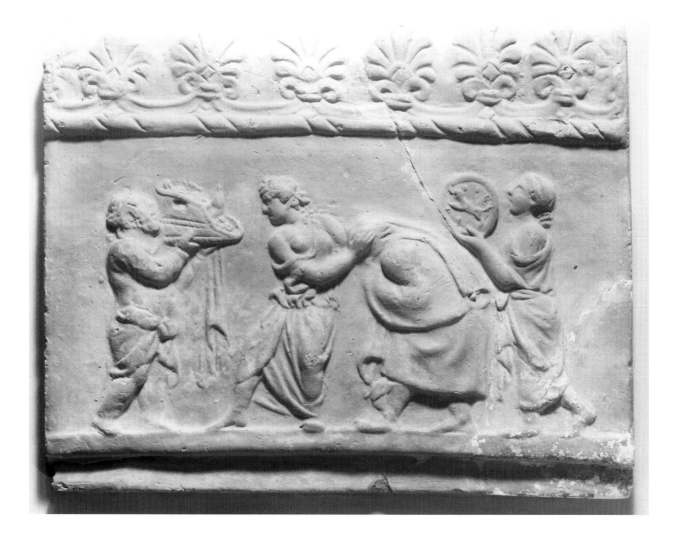

held by a woman who appears to be guiding the bent figure. This guide stands with her frontally placed left foot planted firmly on the ground and her right foot pointed toward the Silenus. She gazes intently at the revealed phallus. She twists her body backward to grasp the head of the initiate, presumably in an effort to stop her or him from approaching as well as to cover his or her face from the revelation. The woman's garment slips off her shoulders, exposing her right breast and indicating that she, too, is probably a maenad.

The veiled figure and maenads indicate that this is a scene of initiation, possibly into the Bacchic rites. Like the great frieze in the Villa of the Mysteries, the scene mixes mortals and immortals participating in the rites. Likewise, both scenes underscore the importance of veiling and unveiling in mystery rites: on the back wall of the painted frieze, an object is covered and possibly about to be unveiled; on the Seattle plaque, a phallus carried by the Silenus is unveiled while the initiate is veiled. The original context of the Seattle terracotta is unknown, but it may have been an architectural relief used either in a domestic context or in a sanctuary.

This plaque is remarkably similar to one in the Louvre.[1] Both plaques are adorned with floral ornaments that sit on a curved ledge. The floral patterns, however, are different from each other, and the curved ledge on the Louvre plaque has a pattern of three hatch marks that do not necessarily line up beneath each flower. The Louvre plaque consists of the same four figural types in the same relationships to one another as on the Seattle plaque, although the figures do differ in some details. For instance, on the Louvre plaque, the maenad or Bacchante approaching from the right plays a tympanum that is clearly decorated with the image of a goat rather than a winged creature. In addition, the stationary maenad on the Louvre plaque covers the eyes of a male initiate, whose head, unlike that of the initiate on the Seattle plaque, is uncovered. The clear portrayal of the male initiate on the Louvre plaque suggests that the initiate on the Seattle plaque may also be a man. Sauron argues that the scene on the Louvre plaque portrays the second phase of the Dionysiac mysteries initiation rites for men, a reading that perhaps applies to the Seattle plaque as well.[2]

DATE: Roman.

Unpublished.

BL

1 Sauron 1998, fig. 31.
2 Sauron 1998, 124.

❖

Greek Traditions of Monumental Painting

97 Ptolemaic Hadra-ware Hydria

Fired clay, with white slip and polychromy
H. 15^{15}/$_{16}$; Diam. 10^{15}/$_{16}$; Diam. of tondo 5^{1}/$_{2}$ in.
(40.5; 27.8; 13.9 cm)
Found before 1884 in Alexandria, Egypt
Lent by The Metropolitan Museum of Art, Purchase, 1890
Acc. no. 90.9.67 (formerly GR 690)
Although the white slip covering the body of the vase has suffered much flaking, the figural decoration is in good condition.

A polychrome painted tondo composed of three concentric circles appears on the belly of the vase. The outermost ring is of ochre hue, followed by a thick gold ring, which encircles the innermost ring of pale blue. Inside this last circle is a female head slightly to the right of center, with a thick neck, large brown eyes, and brown hair that stands on end in snakelike curls.

The head is rendered in three-quarters view and is strongly lit from the upper left. The succession of rings suggests the molded frame of a shield. The snaky hair identifies the head as a gorgoneion, the head of the gorgon Medusa portrayed here in the so-called "beautiful type" popular in Hellenistic and Roman art.[1] Indeed, owing to their apotropaic power, gorgoneia were a common and suitable decoration for shields.[2] As many Hadra hydriai functioned as cinerary urns,[3] a gorgoneion shield may have served to protect the deceased, whose remains were contained within.

Most Hadra vases are decorated with brownish glaze, but this vase is among the few that have polychrome decoration.[4] As in other vase paintings of this type, dramatic light and shadow create an illusion of three-dimensionality and space.[5] Indeed, Hadra vase paintings that depict everyday items are considered to be the first still lifes.[6] Their three-dimensional illusionism suggests a relationship between monumental wall painting and polychrome vase painting. Like Centuripe vase paintings (see, for example, cat. no. 73), Hadra vase paintings achieve effects of plasticity through *skiagraphia* ("shadow painting"), a technique developed in late-fifth-century Athens and used generally in Hellenistic wall painting.[7] These Greek paintings (Hadra vases included) considerably predate Romano-Campanian wall painting and were produced in different parts of the Mediterranean world. However, the similarities between them are striking and suggest the cross-temporal and pan-Mediterranean artistic milieu from which the Villa of the Mysteries frieze later emerged.

DATE: c. 300–200 BC.

BIBLIOGRAPHY: Merriam 1885, 19, pl. 1; Furtwängler 1905, 276, fig. 10; Pagenstecher 1912, 119, fig. 3; 1913, 49–50, fig. 55 a–b; Six 1914–15, 33–34, pl. 34a; Metropolitan Museum of Art 1917, 169–70, fig. 107; 1927, 206, fig. 142; Swindler 1929, 355, fig. 563; Scheurleer 1936, 147; Buschor 1940, 261, 264, fig. 282; Richter 1944, 19; 1953, 130, n. 74, pl. 110a; Rumpf 1953, 154; Brown 1957, 61, 64, n. 179, cat. no. 41, pl. 33; Buschor 1958, 35, pl. 53.3; Diehl 1964, 160, n. 10; Cook 1966, 9, n. 10; Nelson 1977, 122–23, fig. 70.

SK

1 See *LIMC* s.v. "Gorgo, gorgones" category 4, "Schöner Typus," no. 182 ff.
2 Brown 1957, 61; see *LIMC* s.v. "Gorgo, gorgones" for shields decorated with gorgoneia.
3 Cook 1960, 209; Pollitt 1986, 256.
4 Pollitt 1986, 257.
5 Pollitt 1986, 257; see also Brown 1957, 61, 64.
6 Pollitt 1986, 257.
7 See Pollitt 1986, 188 ff.; the paintings at Lefkadia, Kazanlak, and Vergina all demonstrate *skiagraphia*.

98 White-ground Pyxis

Fired clay
H. 4³⁄₄; Diam. 4¹⁄₂ in.
(12.1; 11.5 cm)
Attica, Greece
Lent by the Toledo Museum of Art
Purchased with funds from the Libbey Endowment,
 Gift of Edward Drummond Libbey
Acc. no. 63.29
The lid and pyxis are intact, except for minor chips at the base and on the interior.

The pyxis is covered with a flat lid with a domed knob. The lid is decorated with a red-figure wreath of olives and berries. The decoration on the pyxis is executed on a white-ground background with applied purple, black, and dilute

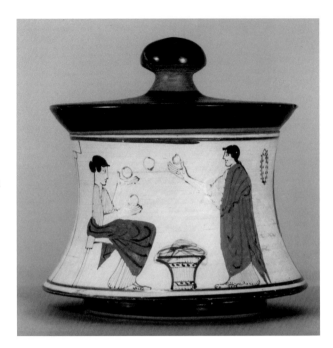

black paint, which appears brown to reddish-brown. J. Beazley attributes this Type A pyxis to the Painter of London D12.[1] Attic white-ground vessels such as this may indicate something of the appearance of contemporary large-scale wall paintings, which are now lost.

A group of five women are depicted in an uninterrupted frieze around the body of the pyxis. Starting to the right of a Doric column, which indicates that the scene takes place within an interior space, a woman seated on a *diphros* facing right juggles three apples; a basket of wool sits on the floor before her; her hair is worn up, unlike the other four women whose loose hair falls over their neck and shoulders. Standing and facing this first woman, a second woman holds an apple with her outstretched right hand; a wreath hangs on the wall behind her. Facing right, another woman with her arms tucked inside her himation sits on a *diphros*. In front of her, a pair of sandals hangs from the wall, one viewed frontally, the other from the side; a basket of wool sits on the floor. Also before her are two standing women—one holding an apple, the other a mirror. Between the two is a third *diphros*, shown frontally, with a large striped pillow on it.

This scene of domesticity, emphasized by the display of domestic objects such as furniture (i.e., the *diphroi*), wool baskets, a wreath, and hanging sandals, is common on Attic vases. The seated woman juggling apples, however, and the offering of apples by two other women is noteworthy. Classical Attic vases display a greater interest than ever before not only in depicting the lives of women but also in scenes of marriage preparation.[2] The inclusion of apples on the Toledo pyxis is appropriate since the apple is a love-token, often associated with Aphrodite, the goddess of love and marriage.[3]

Pyxides were containers used primarily by women for holding such objects as cosmetics and jewelry; however, they were also used as offerings at the graves of women. Their dual purpose is indicated on a number of Attic vases that show pyxides in both domestic and funeral scenes. Other vessels also associated with marriage and death are

Attic loutrophoroi and South Italian Centuripe vases, such as cat. no. 73, which could be used in both nuptial and funerary rites. The complex associations and sometimes ambiguous imagery on these types of vases may reflect the various uses to which they were put. Furthermore, such representations of women's activities prefigure later images like those on the Villa of the Mysteries frieze.

DATE: 470–460 BC.

BIBLIOGRAPHY: Beazley 1942, 2:963, no. 97 (39); *Apollo* supplement, London, June 1962, p. 1; *Auktion XXVI Basel* 1963, 79–80,

no. 149; Beazley 1963, 2:1675, no. 94 *bis;* Riefstahl 1968a, 45; 1971, 434; Luckner 1972, 86; *CVA* USA 17, Toledo 2:37–38, pls. 58, 60.1; Boardman 1989, no. 91.

CH

1 Beazley 1963, 1675, no. 94 *bis.*
2 Boardman 1989, 226.
3 See Gow 1950, 2:107, on 5.88.

❖

ROMAN WALL PAINTING: STYLES, MATERIALS, TECHNIQUES

Roman wall paintings are noted for their palette of rich and varied colors. The Villa of the Mysteries murals are no exception. A sense of the vivid colors and the character of the painted surface of the Villa of the Mysteries and other Roman murals can be gained from both the large and small fragments of Roman wall paintings included in this exhibition. The large fragments also illustrate the sequence of painting styles in use at Pompeii for over a century.

Known as the Four Pompeian Styles of painting, this classification system was devised by August Mau, based on the account of the Roman architect Vitruvius (*De Arch.* 7.5.1). The First Style became fashionable in Italy in the second century BC but continued to be used up to the time of the eruption of Vesuvius in AD 79. Called the Incrustation Style, this decorative system imitates blocks of exotic marble (cat. no. 99G). The Second Style, or Architectural Style, was introduced in the early first century BC. It imitated real architecture, often with an illusionism that appeared to open up the wall to the world beyond. The Third Style, also known as the Ornamental or Candelabra Style, emerged during the Augustan period in the later part of the first century BC. Here, the solid architectural components of the Second Style gave way to fantasy (cat. no. 101). Like the First Style, both the Second and Third Styles continued in use in Pompeii up to the time of the eruption.

In the Fourth Style, which was introduced during the reign of Nero, the wall was typically divided into horizontal and vertical sections by borders consisting of decorative architectural elements, grotesques, garlands, or embroidery patterns (cat. no. 99D). The remaining wall surface was decorated with panels depicting mythological characters and events, with floating figures (scenes without frames), or with architectural scenes (cat. no. 102).[1] Because the Fourth Style was most popular at the time of the eruption of Vesuvius, and because so many houses around the Bay of Naples required repair after the earthquake of 62, this style is the best represented of the four among surviving Campanian wall paintings.

Wall paintings could be made to suit a variety of budgets. For instance, the cost of the pigments used for Pompeian wall painting varied greatly. White and most reds were among the least expensive colors available. White pigment was usually derived from some form of calcium carbonate, obtained from chalk or a similar substance. The price range for white was broad; the cheapest whites cost very little, while the best quality Paraetonium white cost $8^{1}/_{3}$ denarii.[2] To put the cost of wall pigments into perspective, one measure of ordinary wine in first-century Pompeii cost 1 as, one pound of oil cost 4 asses, and fourteen pounds of wheat cost 30 asses.[3] There were 4 asses to 1 sestertius and 4 sestertii to 1 denarius.[4]

Red was a fairly common color in Pompeian paintings, and for the most part, the red that was used was an anhydrous ferric oxide, which occurs both in crystalline form as haematite and in earthy form as red ocher.[5] Vitruvius states that red ocher is plentiful, with the best sources being in Egypt, Spain, Lemnos, and Sinope in Pontus (*De Arch.* 7.7.2). According to Pliny, red ocher cost from eight asses to two denarii (*HN* 35.29–49). In extraordinary cases, like the great frieze at the Villa of the Mysteries, the common, inexpensive anhydrous ferric oxide was replaced by one of the most expensive and light-sensitive pigments available: cinnabar. The price of cinnabar was limited by law to 70 denarii. This pigment had to be protected from sunlight with a special application of heated wax and oil.[6]

Yellow is another color prevalent in several of the wall painting fragments in this exhibition, including cat. nos. 99C and 99G. The color consists of hydrated ferric oxide, which is derived from crystalline goethite or found in its earthy form as yellow ocher.[7] According to Pliny, the various types of yellow ocher are roughly equivalent to the cost of red ocher: yellow ocher cost between 6 asses to 2 denarii (*HN* 35.29–49).

Another color of interest is blue, which is more expensive than most yellows, reds, and whites. The typical blue used in ancient painting is blue frit, or Egyptian blue, which is an artificially produced pigment consisting of copper calcium silicate in a glassy matrix.[8] The tonal quality of the blue was controlled by the amount of grinding; paler shades such as those used on cat. no. 99B were obtained by finer grinding. According to Vitruvius, blue was first made in Alexandria, and then in the first century BC the banker Gaius Vestorius of Puteoli improved upon the technique (*De Arch.* 7.11). The better quality of his technique for making blue was recognized by painters and patrons alike and was reflected in increased prices: Vestoria blue cost 11 denarii, while Egyptian blue was only 8 denarii.

The plaster on the back of several of the fragments in the exhibition is a reminder of the nature of work in the fresco medium. The walls of Roman houses were made of mortared rubble faced with stone or brick and covered in layers of plaster. Before its application the plaster was mixed with a gritty substance to allow the airflow necessary for drying. The layers on these fragments reveal the different kinds of materials used for this purpose: pebbles or gravel for the courses closest to the wall, sand for ones in the middle, and marble dust, which made the plaster white, for the surface layer that was painted.[9] The paint was applied while the plaster was wet, with the result that only the amount of plaster the artist could paint before it dried was applied in a given session. As it dried, the paint bonded to the wall, and the images and decorative schemes could only be removed by either being chipped off or plastered over. The relative permanence of the medium most likely inspired the owners of such houses to choose their decorative schemes with care. Replacing them was both expensive and time-consuming.

BL/JMD

1 For an introduction to the Four Styles, see Ling 1991.
2 Ling 1991, 209.
3 Etienne 1992, 184.
4 Etienne 1992, 184.
5 Ling 1991, 207.
6 Ling 1991, 209.
7 Ling 1991, 209.
8 Ling 1991, 208.
9 Ling 1991, 199. For further discussion of the techniques used in Roman wall painting, see Ling 1991, 198–211.

99A Wall Painting Fragment

Painted plaster
H. 4¹⁵/₁₆; W. 5¹¹/₁₆; D. ³/₄ in.
(12.6; 14.5; 1.9 cm)
Rome
Purchased for the University of Michigan by C. L. Meader, 1898
Kelsey Museum of Archaeology, acc. no. 781

The pentagon-shaped fragment has uneven breaks on all five sides. Its painted surface is chipped along the left side of the top point. There are many small areas of lost pigment. Larger incrusted losses are present in the left arrowhead, at the bottom left corner, on the center roundel, and in the upper right corner. A horizontal line along which the gold pigments have been lost runs parallel to the lower edge of the fragment (the maroon background is visible beneath). The plaster on the back and sides has a pitted, incrusted surface.

The fragment has a maroon-colored background that darkens toward the bottom. At its top is a thin black horizontal line. Below this is a red horizontal band, outlined in black above and pink below. At the left a vertical stripe, also in red and outlined in black on the left, descends from the horizontal band. In the lower right part of the fragment a thin pink line parallels the angle of these two bands. Below the red horizontal line a decorative pattern is superimposed on these elements. The pattern consists of a roundel at the center of the fragment, flanked and supported by two ar-

rowheads. To the outside of each arrowhead is a palmette. These elements are painted in gold, with highlights added to suggest three-dimensional objects lit from the left: the left side of each is picked out in a lighter yellow, while the right edges, in shadow, are a darker tan.

The practice of creating a sense of three-dimensional space, as in the gold pattern on this fragment, was a development of the Second Pompeian Style. Similar treatment of a border motif appears, in fact, in the egg-and-dart bands that outline each of the pilasters in the Villa of the Mysteries frieze. Second Style painters applied these techniques not only to decorative elements but, more importantly, to whole walls, on which they created large-scale illusionistic architectural vistas. This taste for illusion decreased, but did not disappear altogether, during the Third Style; it was revived on a smaller scale in the Fourth.

DATE: c. 60 BC–first century AD.

Unpublished.

JMD

99B Wall Painting Fragment

Painted plaster
H. 5¹/₈; W. 4¹/₈; D. 1¹/₄ in.
(13.1; 10.5; 3.1 cm)
Pompeii
Gift of F. W. Kelsey, 1893
Kelsey Museum of Archaeology, acc. no. 309

The surface of this fragment is stained, and the paint is chipped so that the blue background shows through the white and red paint. Both the plaster and the white paint are flaking. A crack runs through the top of the fragment.

This triangular fragment is painted pale blue, with a narrow white stripe and a thicker dark red field. Both the white and red are painted over the blue, which serves as a background color.

This fragment was found by F. W. Kelsey at Pompeii either in an archaeological dump or in the fields outside the

excavations. The narrow white line between the red and blue color fields suggests that the fragment originally was part of a wall painting that could be classified as any one of August Mau's Second, Third, or Fourth Pompeian Styles. Each of the three colors used on this fragment is relatively standard in Pompeian wall paintings. The red and white are two of the least expensive colors that were available.

DATE: c. 80 BC–AD 79.

Unpublished.

BL

DATE: Second century BC–AD 79.

Unpublished.

BL

99C Wall Painting Fragment

Painted plaster
H. 2³/₄; W. 1³/₄; D. ¹/₂ in.
(7.0; 4.4; 1.3 cm)
Pompeii
Purchased from F. W. Kelsey, 1893
Kelsey Museum of Archaeology, acc. no. 93643
The edges are worn, and cracks are visible all over the surface. Some flaking of the plaster is evident but no flaking of the paint.

The fragment has a yellow background decorated with thin stripes and subtle gradations of various shades of yellow and reddish-orange. The textured surface suggests that this may possibly be an example of August Mau's First Pompeian Style, or, alternatively, a piece from a later wall whose dado is decorated with faux marble and other panels and friezes that imitate expensive or exotic stone. Examples of the latter can be found in the Second Style Villa of the Mysteries paintings and the Fourth Style rooms in the House of the Vettii, such as the Ixion and Pentheus rooms.

99D Wall Painting Fragment

Painted plaster
H. 4; W. 4³/₈; D. 1⁵/₁₆ in.
(10.2; 11.3; 2.8 cm)
Probably from Pompeii
Kelsey Museum of Archaeology, acc. no. 94577
The fragment has uneven breaks on all sides. Its back and sides are quite rough. There is a chip in the painted surface below the point on the right side. The black field to the right of the red band has many fine scratches. There are several areas of loss of yellow pigment in the decorative band. Some of these losses are incrusted; the black background shows through others.

The broken sides of this fragment clearly show four layers of the plaster and mortar of the wall beneath the painted surface. The paint was applied to a thin bed of white plaster. Behind this are two courses of tan, granular mortar. In the middle of the back a fourth layer consisting of a rough mortar mixed with small pebbles is preserved.

The background of the painted surface is black. The fragment is divided by a vertical red band, which is outlined on each side by a thin white line. To the left of this band part of a border pattern is preserved. Each unit of the pattern consists of two concentric circles with a dot at the center. The space between the two circles is filled with a series of curved, radiating strokes. The units are arranged vertically so that each one just touches the next. To the right of each juncture is a four-pointed star. On this fragment the right half and most of the bottom of one unit and the top half of the next are preserved. Both are painted yellow.

The yellow pattern on this fragment belongs to a group of decorative motifs of the Fourth Style commonly referred to as "embroidered borders."[1] These borders, which appear frequently at Pompeii, consist of a repeated geometric motif, usually in a single color. The border is perforated, as in this example, so that the background color of the wall is visible through the openings.

DATE: c. AD 50–79.

Unpublished.

JMD

1 For a classification and illustrations of embroidered borders, see Barbet 1981, 917–98; for similar circular motifs, see in particular 989, nos. 150–51.

99E Wall Painting Fragment with Swan

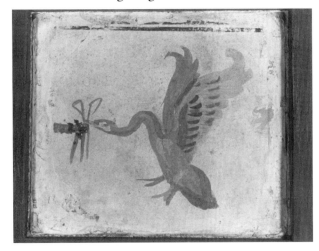

Painted plaster
H. 8¹¹/₁₆; W. 9¹/₄ in.
(20.5; 23.5 cm)
Vicinity of Puteoli, Italy
Purchased by F. W. Kelsey

Kelsey Museum of Archaeology, acc. no. 2729
The edges of the fragment are restored with modern plaster, and the fragment is set into a modern rectangular wooden frame. A few light stains or watermarks seem contemporary with the fragment's restoration, the largest located to the right of the swan. An indentation in the surface of the fresco was left by the edge of a flat implement, such as a *trulla*, during the original application of the plaster to the wall. A stray brush mark in the upper right corner was probably made during the execution of the red border lines.

The central motif of the fragment is a flying swan in profile with wings fully extended. Its neck and legs are outstretched and thrust forward in a moment of tension, and it holds a ribboned garland in its beak. The vivid colors give a sense of perspective and delineate the musculature; the contrast of light and dark colors on the light background creates the impression of feathers, and the use of a dark peach color to outline the edge of the wing suggests bone and muscle structure.

This fragment was rendered in *fresco secco*, a technique in which pigments, affixed by chemical additives, are added to the wall after the original plaster is dry. The stray brush mark mentioned above and a smear located under the swan's left wing suggest a hurried application of paint and hasty addition of detail. This apparent hastiness suggests that this section of the wall was not the painter's main focus, yet the swan is expertly executed with fluid lines.

This fragment probably comprised part of a Fourth Style mural composition, judging from its similarity to the garland-bearing swans found in *ala* "h" of the House of the Vettii in Pompeii, which like the Kelsey swan are set against a white ground, in profile with wings thrust forward. The swans in the House of the Vettii are located in the upper zone of the wall, which is filled with attenuated and perspectival architecture. The Kelsey swan's proximity to the red border suggests that it might have been in a similar position. The Kelsey swan should also be reconstructed as one of a pair, facing its mirror image holding the other end of the garland.

Swans are a common motif in Roman domestic decoration.[1] They first gained prominence in the Augustan period, when they appeared in the House of Augustus on the Palatine, and were incorporated into the decoration of other imperial villas, including the Villa of Livia at Primaporta and the Villa of Agrippa Postumus at Boscotrecase. Swans were associated with Venus and Apollo and were linked in Augustan propaganda to the golden age of abundance brought by Augustus's victories. In Campanian wall decoration after the period of Augustus, such as that found in the House of the Vettii, and probably also the Kelsey fragment, swans retained their divine associations, reminding viewers of a household's connections with Venus and Apollo.

DATE: First century AD.

Unpublished.

MSB

1 For comparanda, see Archer 1990; Castriota 1995; Clarke 1991; Ling 1991.

99F Wall Painting Fragment with a Kantharos

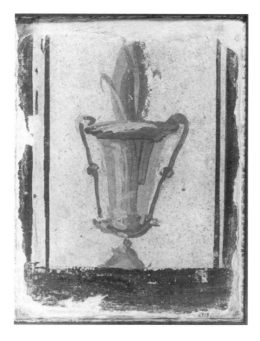

Painted plaster
H. 8¼; W. 6¾ in.
(21.0; 17.2 cm)
Probably Pozzuoli or vicinity, Italy
Purchased from Giuseppe De Criscio, 1923
Kelsey Museum of Archaeology, acc. no. 2719
The fragment is set into a modern rectangular wooden frame. The edges, particularly at the top, are restored with modern plaster. There is some flaking of the paint at the center on the right portion of the floral motif.

The fragment has a cream-colored background with a dark red border. At the right and left are thin vertical dark red lines. The central motif is a large kantharos (12 × 8.5 cm) painted illusionistically with broad brush strokes in golden yellow and brown. The long, thin handles of the kantharos extend from the base of the foot to just above the rim. Rising from the top of the kantharos is a stylized floral motif also painted in golden yellow and brown.

Wall painting fragments from a villa at Commugny, Switzerland, dated to the first half of the first century AD also depict a "column" of leaves and flowers rising up from a kantharos.[1] The kantharos and vegetation appear to be allusions to Bacchus/Liber. Such still-life paintings with ritual and mythological connotations, although seemingly discrete elements, were often part of larger decorative programs that created an atmosphere of cultic worship.[2]

DATE: Second century BC–first century AD.

Unpublished.

CH

1 Ling 1991, color pl. XVB.
2 Winkes (1982, 23, 26, fig. 25) makes a similar observation with reference to a still life from the Field Museum (no. 26650),

which shows several vessels with branches of vegetation leaning up against them.

99G First Style Wall Painting Fragment

Painted plaster
H. 7⅔; W. 4¾; D. ⅓–1 in.
(19.5; 12; 0.9–2.5 cm)
Italy
Bequest of Esther B. Van Deman, 1938
Kelsey Museum of Archaeology, acc. no. 29515B
The paint is faded and worn away in numerous places. There are a few pockmarks where the plaster shows through the paint.

The fragment is decorated with spatters of red-orange, maroon, blue, green, and white paint on a yellow ocher ground. The red-orange spatters were applied first, then the maroon, followed by the blue, the green, and the white. The intended effect of these spatters was to imitate the appearance of marble or another costly stone. Such mimicking of stone masonry is a hallmark of the First Pompeian Style. The First Style occurs in Pompeii as early as the second century BC. Faux marble panels continued to be incorporated into decorative wall schemes until the Late Empire. It is not possible to determine the precise date of this particular fragment.

DATE: Second century BC or later

Unpublished.

BL

99H Wall Painting Fragment

Painted plaster
H. 7⅛; W. 5⅓; D. 1¼ in.
(18.0; 13.5; 3.2 cm)
Pozzuoli or vicinity, Italy
Purchased from Giuseppe De Criscio, 1923
Kelsey Museum of Archaeology, acc. no. 93587
The colors are faded, and the surface has numerous scratches. The white pigment shows through all other colors, and the plaster shows through on two of the green leaves.

The white-ground fragment is roughly pentagonal in shape. The top corner is decorated in black, while the rest of the fragment has a creamy white background. The transition between these two background colors is made with a thin dark line just below the juncture of the black and white; there are traces of thin red lines in an unidentifiable pattern above and below the dark line. The left half of the fragment is decorated with a pale purple diamond with concave sides and elongated points. White paint outlines an inner diamond and a central circle. The right point is decorated with two dark green leaves. The right half of the fragment preserves light green, dark green, and light purple leaves along with flowers and brown stems.

Such decorative features often were used as borders around and among painted architecture, figural panels, and other central images in the Second, Third, and Fourth Pompeian Styles. Although white-ground paintings were more common in the Third and Fourth Styles than in the Second, it is not possible to determine which of these Pompeian styles this particular fragment originally formed a part of nor to determine its precise date.

DATE: Second century BC–fourth century AD.

Unpublished.

BL

100 Shrine Painting of Venus and Attendant

Painted plaster
H. 16¹⁵/₁₆; W. 16⁹/₁₆ in.
(43; 42 cm)
Villa of Publius Fannius Synistor, Boscoreale, Italy
Lent by The Metropolitan Museum of Art, Rogers Fund, 1903

Acc. no. 03.14.9
The painted surface is somewhat pocked, and a heavy incrustation covers the body of the seated woman, approximately half of the cornice molding, and the bottom half of one of the open doors that frames the scene.

This fragment consists of a framed central scene perched on a painted golden cornice. Resting her chin on her right hand, an older woman sits to the right in profile and gazes up at a younger woman standing at the left of the scene. Little is preserved of the seated woman beyond her head, which is covered by a red headdress. The younger woman holds a spear or staff with her right hand, crosses her left arm over her body, and gazes out of the painting toward her right. She wears a purple chiton and a headdress similar in color and appearance to that of the seated woman. A round cream-colored shield fills the space between the two women, the upper edge of which is still visible. Neither woman appears to be holding the shield. Half of each woman's body is in front of a dark, schematically rendered architectural feature, probably two pillars or columns. The light source falls from the upper right-hand corner of the scene. The mood of the scene is solemn.

The scene is enclosed in an illusionistically painted purplish-brown frame with open paneled shutters, approximately half of which are preserved. This framing device recalls the paintings displayed in the Greek world in public picture galleries, or *pinacothecae*, such as the one in the Classical Propylaia on the Athenian acropolis. The tradition of displaying portable paintings in wooden frames, or *pinakes*, in such galleries presumably continued into the Hellenistic period. The shutters allowed certain especially valuable paintings—as well as ones that might offend sensibilities—to be hidden from view and protected from the damaging effects of sunlight. The uncovering of a painting in the presence of a visitor added to the drama of its display. The inclusion of such *pinakes* in Pompeian Second Style wall paintings recalls this Greek tradition; indeed, such panel paintings have often been thought to be copies of famous paintings by Greek masters. By painting the shutters open

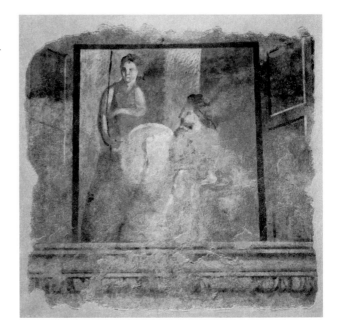

rather than closed, the artist suggests not only the magnanimity and wealth of the owner but also the high status of the visitor who is allowed to see the owner's most valuable paintings. This *pinax* from Boscoreale is among the earliest known representations of this type of painting in a Roman context.

Originally located above the entablature on the north wall of Room H of the Villa of Publius Fannius Synistor, this *pinax* is one of three that were each centered over one of the large images in the main horizontal zone of the wall. The scene below this particular painting is now lost, but according to Sogliano's excavation notes, it portrayed a youthful Dionysus with a thyrsus propped against his left leg as he reclined across the lap of a heavily draped female companion.[1] His right foot was bare, and his shoe lay abandoned in front of the stone block that held his companion. This image, then, was practically identical in composition to the central image of Dionysus (Liber) with a female companion on the east wall of the frieze in Room 5 at the Villa of the Mysteries. The Boscoreale composition suggests further that the same female companion may have been portrayed in both villas.

DATE: Mid-first century BC.

BIBLIOGRAPHY: Sambon 1903, 12; Studniczka 1923–24, 64 ff., fig. 14; Curtius 1929, fig. 77; Beyen 1938, 1:fig. 83; Lehmann 1953, 63 ff., 181–82, 188–89; Müller 1994, 117, pl. a.

BL

1 Lehmann 1953, 28.

101 Third Style Wall Painting Fragment

Painted plaster
H. 104; W. 20 in.
(264.2; 50.8 cm)
Italy
The Detroit Institute of Arts, Founders Society Purchase,
 Hill Memorial Fund
Acc. no. 70.649
There are some small areas of restoration in the upper zone. The edges are worn and irregular, and in various places the paint is chipping so that the yellow background shows through. The panel was pieced together from numerous fragments.

This painting fragment consists of a fantastic candelabrum embellished with calyces and other stylized floral motifs. Painted in pigments resembling silver and gold, the candelabrum rests on a groundline composed of two distinct bands of colors and is crowned by a round disk that serves as an attenuated capital. Approximately two-thirds of the way up the candelabrum, a thick gray horizontal band and a change in background color break the candelabrum into two distinct sections. At this point, the background changes from three vertical bands of yellow, black, and red to a single swatch of yellow, producing an abstract pattern probably meant to flatten out the wall and highlight the decorative nature of the architectural support.

The Detroit fragment exemplifies the Pompeian late Third Style of wall painting, in which large areas of the wall are painted in flat, decorative colors as a foil for decorative columns. In the Third Style, such attenuated candelabra typically were used to divide the wall between small, isolated scenes and figures floating in a vast expanse of monochrome color.

DATE: AD 14–54.

BIBLIOGRAPHY: Henshaw 1995, 118 (ill.); Cohn 1970, 58, fig. 93.

BL

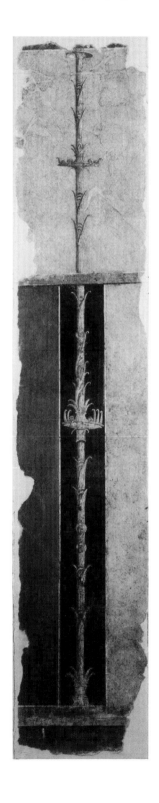

102 Wall Painting Fragment

Painted plaster
H. 57³/₁₆; W. 26 in.
(145.3; 66 cm)
Villa of the Treasure, Boscoreale, Italy
Gift of Edward E. Ayer, H. H. Porter, D. H. Burnham,
 and Charles Singer
Field Museum of Natural History, acc. no. 24656
The colors have faded, and there are numerous small abrasions
over the surface.

This Fourth Style wall painting fragment consists of the
lower section of the original wall scheme. The dado con-
tains a red square panel framed by thick black lines. In the
main zone of the wall, simple yellow, black, red, and green
pillared architectural members stand in front of a white
background. This architectural vista is viewed from below,
so that the viewer is able to see the rafters. The architecture
forms two distinct structures. A garland hangs from the
rafters of the broader, shorter building on the left. The
garland is attached to the ceiling by an ornament that prob-
ably represents a jar with round bottom and two handles.[1]
The hanging attachment for the garland is very similar to a
better-preserved example decorating another fragment in
the Field Museum (acc. no. 24659). The structure is sur-
mounted by an oblong faux marble panel decorated with a
floral motif, which de Cou identified as rosettes. In addi-
tion, the lower part of the frieze of the yellow building in
the lower story is ornamented with a leaf pattern suggesting
dentils.[2] At the point where the two buildings join, a spiral
acroterion emerges and reaches into the space beyond the
borders of the fragment.

This fragment comes from the Villa of the Treasure at
Boscoreale, a two-story working villa (*villa rustica*) located
less than two miles north of Pompeii. It was discovered in
1876 and excavated in 1894–96 and 1898 by Vincenzo De
Prisco.[3] This particular wall painting fragment most likely
came from Room N, which presumably was used as a din-
ing room (*triclinium*), judging from the remains of three
couches that were found in it.[4] The painting is very similar
in design and coloring to another fragment in the Field
Museum (acc. no. 24651),[5] except that the arrangement of
the building is reversed. The mirror images suggest that the
two panels originally decorated the same wall, flanking a
central scene.

This type of Fourth Style architectural decoration was
apparently common for wall paintings in Campanian *villae
rusticae*, as evidenced by the similar architectural fragments
found in the Field Museum,[6] the Boston Museum of Fine
Arts,[7] and the Rhode Island School of Design Museum of
Art,[8] all of which are associated with the villa in the Fondo
Bottaro excavated by Gennaro Matrone from 1899 to 1902.[9]
Like the Villa of the Mysteries, where Second and Third
Style paintings coexisted, the Fourth Style architectural
decorations in both the Fondo Bottaro villa and the Villa of
the Treasure at Boscoreale existed alongside paintings in
the Second and Third Pompeian Styles. A general sense of
the visual effects of concurrent styles in villa decoration can
be gained from the juxtaposition in this exhibition of this
Fourth Style fragment, a Second Style *pinax* from the con-
temporary and nearby Villa of Publius Fannius Synistor at
Boscoreale (cat. no. 100), and the contemporary Third

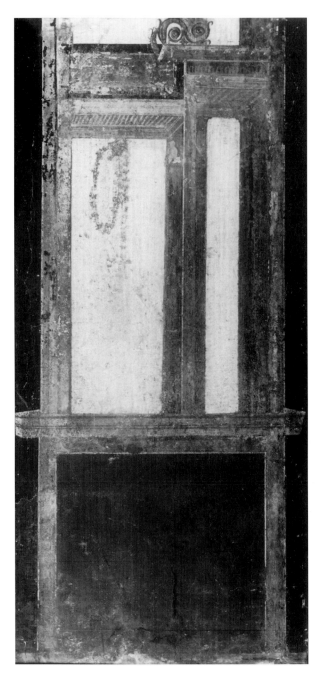

Style architectural panel from the Detroit Institute of Arts
(cat. no. 101).

DATE: c. AD 25–79.

BIBLIOGRAPHY: de Cou 1912, 160–61.

BL

1 De Cou 1912, 161.
2 De Cou 1912, 161.
3 De Cou 1912, 151. The villa received its name from the find of
 a male skeleton in one of the pits beneath the floor of the room
 with the wine presses (Room P). He held a pair of gold brace-
 lets and a gold neck chain. Nearby were the contents of his
 purse of approximately 1000 gold coins as well as 117 pieces of
 silverware. Most of this treasure is now in the Louvre.

4 Mau 1902, 363.
5 De Cou 1912, 161.
6 De Cou 1912.
7 Caskey 1938, 9–16.
8 Winkes 1982, nos. 1–4, 14–17.
9 Winkes 1982, 8.

103 Wall Painting Fragment, Seated Woman with a Lyre

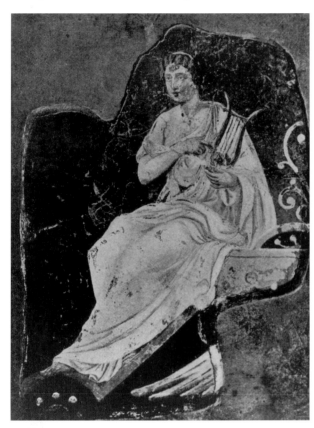

Painted plaster
Painting: H. 7³/₄; W. 5¹/₄ in.
(19.7; 13.4 cm)
Modern frame: H. 10¹/₈; W. 7³/₄ in.
(25.8; 19.7 cm)

Italy
Museum of Art, Rhode Island School of Design,
 Museum Appropriation Fund
Acc. no. 18.498
The surface of the fragment is scratched. The cracks and the lyre
have been retouched. Each side has an uneven edge.

The fragment has a red background. A seated woman occupies most of the piece, which was originally part of a larger composition. The woman, who is shown in three-quarters view turned to her right, wears a white chiton with a purple mantle over it. Her dark, wavy hair is held back by a fillet. She seems to be gazing off into space, and her eyes have a pensive expression. The woman's lyre rests against her left shoulder and is supported by her left hand. Her right arm, bared below the elbow, is bent across her chest. She gestures at the lyre with her right forefinger. The woman's left leg is bent slightly, and her bare foot rests on a round object at the bottom left corner of the fragment. Her right leg is more sharply bent, and the foot is not visible. The woman's seat is only partially preserved; part of a volute appears above it, and part of a wing is shown below. This object is probably a chariot drawn by griffins. The woman herself has been identified as Terpsichore, the muse of lyric poetry and dancing.[1]

This image of Terpsichore was probably originally part of a larger Fourth Style scene involving other figures. Her seated pose here calls to mind the seated postures of the life-size bride and *domina* figures in the Villa of the Mysteries frieze. These images all draw on a tradition of representing respectable women as seated and heavily draped that lasted throughout the Graeco-Roman period. The polished red background against which the figure is placed provides an idea of the visual effect produced, albeit on a much larger scale, by the Villa of the Mysteries murals.

DATE: AD 62–79.[2]

BIBLIOGRAPHY: Hincks 1919, 29–31; Winkes 1982, 59, no. 29.

JMD

1 Winkes 1982, 59.
2 The fragment's authenticity was verified in 1972 after it was
 examined at the Museum of Fine Arts, Boston. Winkes 1982, 59.

104 *Oscillum* with Satyr and Maenad

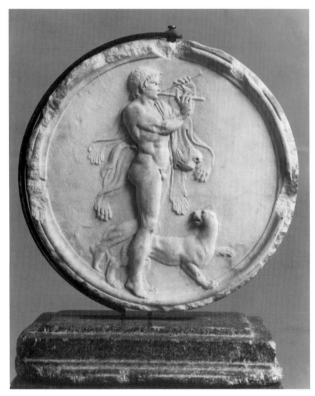

Marble
Diam. 16⁷/₈; W. 1³/₄ in.
(42.9; 4.4 cm)
Vicinity of Rome
The Detroit Institute of Arts, City of Detroit Purchase
Acc. no. 45.130
The overall condition of the *oscillum* is good. In 1960 it was broken into five pieces and has since been restored as a complete disk. The raised rims on both faces of the *oscillum* are chipped and worn, and the undecorated surfaces of the relief are in a rough and corroded state. The sculpted reliefs, however, are in nearly pristine condition, with the exception of a few chips on the forearm and hands of the satyr and a chip on the front paw of the panther.

The *oscillum*, an oscillating disk, is carved from a white marble, possibly of Greek origin. It is a tondo with Neo-Attic-style depictions of a satyr on one side and a maenad on the other, both participating in the ecstatic revels of Liber. The satyr[1] is playing a double flute, or *aulos*, held in both hands and supported by a strap around the base of his neck. He wears a panther skin draped loosely across his shoulders and is accompanied by a panther. The maenad wears a flowing cape and a chiton that has slipped off one shoulder and reveals her breasts. She holds a sacrificial knife

in her right arm. In her left hand, she holds the haunch of a goat or sheep.

Oscilla similar to this one were displayed in Roman houses, hung in the spaces between the columns of the peristyle, and may even have been placed in vineyards and fields. They are generally decorated on both sides and often bear scenes connected with Liber and his retinue: maenads, satyrs, dramatic masks, and musical instruments. Thus, the decoration on this example, as well as the Neo-Attic style of the relief carving, fits well the known corpus of Roman *oscilla*.

The authenticity of the Detroit *oscillum* has recently been challenged by R. Cohon based on certain features, which he regards as peculiar. These include: the depth of the cavity provided for attaching the *oscillum* to a metal hanging device,[2] the combination of decorative motifs, and the corrosion of the relief ground. But because Neo-Attic works were replicated in great numbers in antiquity and were also reproduced in the modern era when neoclassical imagery was in vogue, it is often very difficult to distinguish between ancient and modern works. For the purposes of this exhibition the ambiguity inherent in such objects is of interest in itself, for it mirrors the ongoing reassessment of the values assigned to an "original" work versus one inspired by an earlier model.

DATE: First century BC or later.

BIBLIOGRAPHY: *Bulletin of the Detroit Institute of Arts* 1946, 25(2): 24; *Bulletin of the Detroit Institute of Arts* 1946, 25(3): 63 (ill.); Cohon 1996, 239–46.

MSB

1 Cohon (1996, 239) identifies the satyr as Hauser type 23, and the maenad as Hauser type 25. For another depiction of a maenad of this type, see cat. no. 91.
2 The C-shaped metal frame on which the *oscillum* now pivots is modern.

105 Statuette of Liber

Bronze
Approx. H. 11¹/₂ in. (including base)
(29.2 cm)
Modern Italian; half-scale replica of a statuette from Pompeii
Collection Dr. Christine Verzar
The first finger of the right hand is missing. The statuette has a green patina that is most apparent in the hair, inside the right hand, around the genitals, along the left side, and on the animal's head of the nebris.

The nude youth is shown standing with his left foot slightly advanced. The musculature of his torso is softly modeled. His right arm is held out at waist level; his left hangs down

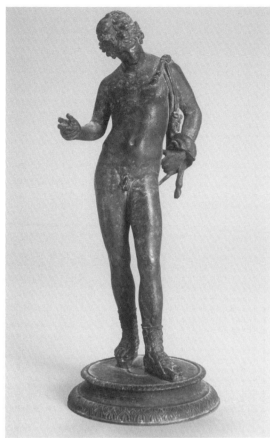

artistic reactions to the past bespeak the fascination that the ancient world and in particular the realm of the god Liber continue to hold for artist, collector, and scholar alike.

DATE: Early twentieth century.

Unpublished.

JMD

1 Museo Nazionale 5003. Museo Archeologico Nazionale di Napoli 1986–89, 1.2:no. 240. The replica was purchased by F. Verzár in Italy circa 1910.

106 Sarah Belchetz-Swenson

Rites IV, VI, VII, IX, XIV
Oil on canvas
5 of 14 paintings (*Rites I–XIV*, 1980–83)
H. 44; W. 34 in.
(111.8; 86.4 cm)
Collection of the artist
See fig. 13.3 for *Rites VI*

Rites IV

at his side. Over his left shoulder he wears a nebris, an animal-skin cloak, the lower end of which is wrapped around his wrist. His head, covered with thick curly hair, is inclined downward. He wears a pair of sandals that lace up to his ankles.

This bronze is a half-scale copy of a statuette of the late Hellenistic period found in House VII.12.21 at Pompeii and now in the Museo Nazionale Archeologico in Naples.[1] The Naples figure, which wears a crown of ivy, is thought to represent Liber playing with a now-lost panther at his feet. The base of the Verzar replica reproduces the restored base on the Naples statuette.

The reproduction of such images for modern collectors attests to the continuing popularity not just of classical art but specifically of characters from the Bacchic repertoire. Works of art like this statuette and the Barosso watercolors that attempt to imitate ancient creations precisely, if on a reduced scale, form only one of several strains of later responses to the visual heritage of the classical world. The eighteenth- and nineteenth-century books on display in the exhibition, for example, are illustrated with prints by artists who translated views of ancient ruins and of individual objects into the two-dimensional medium of the printed page. The twentieth-century paintings in the exhibition are different again: here the artists have not imitated or recreated ancient works but rather have drawn inspiration from them for the creation of new and modern images. Together these

241

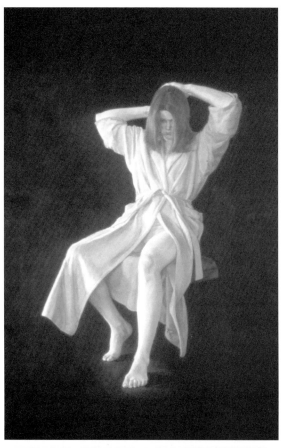

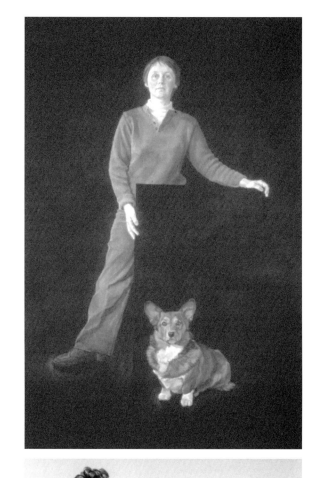

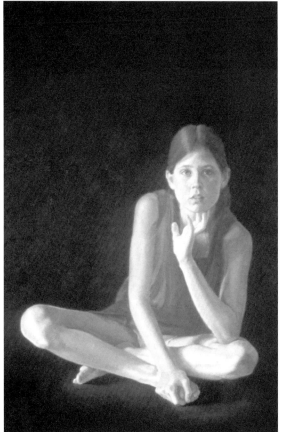

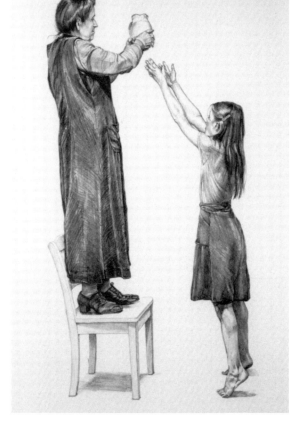

Top: Rites VII, *bottom:* Rites IX

Top: Rites XIV; *bottom:* Rites I, Opus II

Rites IV, Opus III

Rites I, Opus II
Rites II, Opus II
Lithographs
2 of 4 lithographs (1981)
H. 28; W. 22 in.
(71.1; 55.9 cm)
Collection of the artist
See fig. 13.4 for *Rites II, Opus II*

Rites IV, Opus III
Monoprint
1 of 4 monoprints (1984)
H. 18; W. c. 15 in.
(45.7; c. 38.1 cm)
Collection of the artist

Beginning in 1980, Belchetz-Swenson created a series of fourteen oil paintings, four lithographs, and four monoprints inspired by the fresco cycle in the Villa of the Mysteries. Each work contains one or two figures engaged in gestures that reflect both the present and the kind of "timeless gestures" that stirred her in the figures at Pompeii. Swenson's models include "a girl, a young woman, a mother, an older woman and myself as an artist-observer in our common enterprise" plus "my dog . . . to represent the mythical animal elements."[1] The full series of *Rites* has been exhibited five times: in 1984 at the Hood Museum of Art, Dartmouth College, Hanover, New Hampshire, and at Helen Day Art Center, Stowe, Vermont; in 1986 at Manhattanville College in Purchase, New York, and at Scripps College in

Claremont, California; and in 1997 at Westfield State College in Westfield, Massachusetts.

BIOGRAPHICAL DATA: Education: BA, Oberlin College, Oberlin, Ohio, 1960; Position: Independent artist, Williamsburg, Massachusetts.

SELECTED EXHIBITIONS AND PUBLICATIONS: *Rites*, Helen Day Art Center, Stowe, Vermont, 1984 (as part of two-person exhibition); Hood Museum of Art, Dartmouth College, Hanover, New Hampshire, 1984; Scripps College, Claremont, California, 1986 (exhibition brochure); Manhattanville College, Purchase, New York, 1986; Westfield State College, Westfield, Massachusetts, 1997; *Intimate Perspectives*, Artist Foundation Gallery, Boston, Massachusetts, 1991; *Self-Portraits*, group exhibition, Hart Gallery, Northampton, Massachusetts, 1997.

DK

1 Swenson 1986, 2.

107 Wes Christensen

Confabulation
Watercolor, pencil
1990
H. 7^1/$_8$; W. 5^1/$_8$ in.
(18.1; 13.0 cm)
Collection Martha and Darrel Anderson,
 Courtesy of Koplin Gallery, Los Angeles

Confabulation

Turnstile
Watercolor, pencil
1994
H. 9; W. 4³/₄ in.
(22.9; 12.1 cm)
Collection Janis Cline, Courtesy of Koplin Gallery, Los Angeles
See fig. 13.7

In the Second Style (RW)
Watercolor, pencil
1994
H. 4⁵/₈; W. 3 in.
(11.8; 7.6 cm)
Collection Gary Ruttenberg,
 Courtesy of Koplin Gallery, Los Angeles

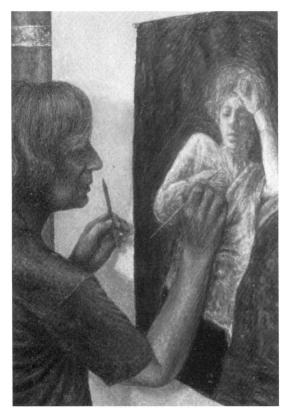

In the Second Style (RW)

Confabulation and *Turnstile* are each based on details in the figural frieze in the Villa of the Mysteries. They reflect the way in which Christensen draws on his fascination with the multivalent meaning in the ancient works as stimulus for reinventing and transforming the poses into allusive modern allegories. The small size and accumulation of precise detail in Christensen's work prompted the critic Michael Laurence to call these images "compressed narratives."[1] *In the Second Style (RW)* is a direct homage to Ruth Weisberg, in admiration of her work inspired by classical and other earlier art. Here she is completing one of her series showing a woman deep in trance or a state of inner inspiration. For a related work, see *Seer* (cat. no. 111) in this exhibition.

BIOGRAPHICAL DATA: Education: Spring University of the Seven Seas, Chapman College, 1967; BA, Comparative Literature, California State University at Long Beach, 1974; MA, Fine Arts,

California State University at San Francisco, 1979; Position: Instructor, Art Institute of Southern California, Laguna Beach, California.

SELECTED EXHIBITIONS AND PUBLICATIONS: Laurence 1988; Ackerman 1992; *Emulations: Quotations from the Source*, Riverside Art Museum, 1995; *Re-Masters/New Images from Old Sources*, Rancho Santiago College, Santa Ana, California, 1996; *Reconfigured Painting* (October), *Reconfigured Drawing* (November), Santa Monica College Art Gallery, 1997; *Allegorical Re/Visions* (catalogue), Los Angeles Municipal Art Gallery, Los Angeles, California, 1997–98; *Cabinet Pictures*, Koplin Gallery, Los Angeles, California, 1999; *Story Tellers*, Art Institute of Southern California, Laguna Beach, California, 1999; *Courting the Muse: Contemporary Pictures, Historical Influences*, California State Fullerton, 1999.

DK

1 Laurence 1988.

108 Patricia Olson

The Mysteries
Oil on board
3 of 7 triptychs (1996–99)
Collection of the artist

The Presentation
3 panels—total H. 60; W. 79 in.
(152.4; 200.7 cm)
See fig. 13.1

The Offering
3 panels—total H. 66; W. 73 in.
(167.6; 185.4 cm)

The Descent
3 panels—total H. 72; W. 71 in.
(182.9; 180.3 cm)
See color pl. IV

These three triptychs are part of a full cycle of paintings created by Olson as "a narrative sequence of life-sized panels that portray a woman at mid-life as she undertakes a ritual, inner journey to the center of the self."[1] The painter is the initiate, and the series is based on eight "scenes" in the figural mural in the Villa of the Mysteries. Olson was inspired to create this cycle by Nor Hall's book, *Those Women*, "which presents the ancient Roman murals in the villa of the Mysteries in Pompeii as a woman's midlife initiation."[2] The artist appears at work at her easel in the final triptych, *The Re-Visioning*, representing "the initiate making sense of her experience and attempting to communicate it through her artistic skills."[3] The cycle has been shown in its entirety at least twice, the first showing being for the artist's MFA exhibition at the Minneapolis College of Art and Design in 1998.

BIOGRAPHICAL DATA: Education: BA, Art, Macalester College, St. Paul, Minnesota, 1973; MFA, Visual Studies, Minneapolis College of Art and Design, Minneapolis, Minnesota, 1998; Position: Assistant Professor of Art, College of St. Catherine, St. Paul, Minnesota.

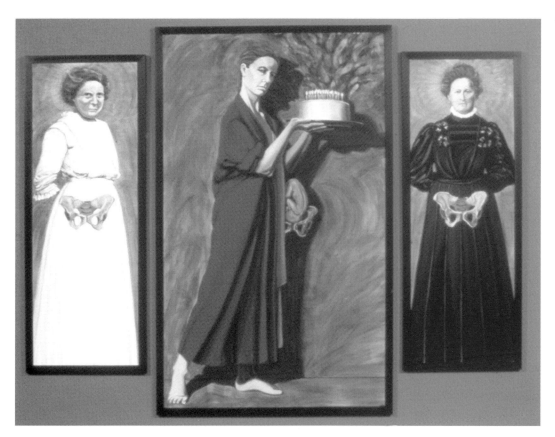

SELECTED EXHIBITIONS AND PUBLICATIONS: *Print's Best Logos and Symbols*, vol. 4, 1996; *The Mysteries*, Minneapolis College of Art and Design, Minneapolis, Minnesota, 1998; The College of St. Catherine, St. Paul, Minnesota (catalogue), 1999; *Re-imaging Woman: Body and Mind*, University of Wisconsin–River Falls, River Falls, Wisconsin, 1998; *The Song Inside Her*, MCAD Concourse Gallery, Minneapolis, Minnesota, 1999.

DK

1 Artist's Statement, unpublished.
2 Olson 1999, 6.
3 Olson 1999, 20.

109 Eleanor Rappe

Rothko in Pompeii: Seeing Red!
Mixed media: acrylic paint, plaster, papers
1 of 3 compositions in the series *Rothko in Pompeii* (1999–2000)
H. 24; W. 40 in.
(61; 101.6 cm)
Collection of the artist
See fig. 13.5

This work is part of a current series, *Rothko in Pompeii*, which is a dual salute to the artist's long fascination with the murals in the Villa of the Mysteries in Pompeii and her recent discovery that her undergraduate painting teacher, Mark Rothko, expressed a "deep affinity" for Pompeian wall murals after a visit to the site in 1959.[1] *Rothko in Pom-* *peii, Seeing Red!* not only expresses Rothko's appreciation for the sheets of color found on the ancient walls but draws on details from the figural frieze in the Villa of the Mysteries. These works are the latest to manifest Rappe's continued reference to classical antiquity. With Eleanore Bender, Rappe earlier created the "archaeological fiction," *Caerulea— Ruins and Restorations*. Currently she continues work on her solo multimedia project, *Plato's Studio: Fragments and Restorations*, which "questions the validity and nature of scholarship, the distinction between the true and the false, and the ways we accept or reject information."[2]

BIOGRAPHICAL DATA: Education: BA, Brooklyn College; MA, Indiana University; painting study, Akademie der Bildende Kunst, Vienna; postgraduate work, San Francisco State University, San Francisco, California; Position: Chairperson of Art Department, City College of San Francisco, San Francisco, California, until retirement in 1996; Docent at SITE, Santa Fe, New Mexico.

SELECTED EXHIBITIONS: *ARTIST/Book*, City College of San Francisco, San Francisco, California, 1996; *EDGES + & Interfaces*, American Print Alliance Invitational; Seneca Center, Morgantown, West Virginia; Praga Press Galleries, Carborough, Ontario; Centre Intercultural Strathearn, Montreal, Quebec; New World School of the Arts, Miami, Florida; University of Massachusetts, Boston, Massachusetts, 1996–98; *101 Cups–101 Artists*, Karan Ruhlen Gallery, Santa Fe, New Mexico, 1997–99; *New Mexico 2000*, Museum of Fine Art, Santa Fe, New Mexico, 1999.

DK

1 E-mail to Elaine Gazda, Oct. 31, 1999.
2 Brief Biographical Information, June 2000, unpublished.

110 Kat Tomka

Satyr
Mixed media: acrylic on linen, wood, metal
1999
H. 12; W. 5 in.
(30.5; 12.7 cm)
Collection of the artist
See fig. 13.6 for front view

Satyr, *rear view*

Satyr unites Kat Tomka's multiple training as metalsmith, sculptor, printmaker, and art historian. "As both artist and art historian, I look to history as an avenue towards highly personal-yet-universal themes."[1] This work is built upon two details from the figural fresco in the Villa of the Mysteries. The front of the small painted panel holds a reconfigured detail of the satyr looking into a bowl near the Silenus on the east wall of the Villa. The back of the same panel has a band with eyes inspired by those of the startled woman around the corner at the Villa from the satyr and bowl. The delicately crafted metal frame and antiqued bracket mark the artist's concern with rich detail.

BIOGRAPHICAL DATA: Education: BFA, Metalsmithing and Fibers, University of Wisconsin, Milwaukee, Wisconsin; MA, Art History, University of Wisconsin, Milwaukee, Wisconsin; MFA, Drawing and Painting, University of Wisconsin, Milwaukee, Wisconsin; Position: Professor of Painting and Drawing, University of Alaska Anchorage.

SELECTED EXHIBITIONS AND PUBLICATIONS: *Loud and Clear, Whispered and Hidden*, University Art Gallery, University of Wisconsin, 1992; *Noetic Images: Recent Work by Kat Tomka*, Dorothy Bradley Galleries, Milwaukee, Wisconsin, 1992; *Fiestas de Navidad*, installation, Walker's Point Center for the Arts, Milwaukee, Wisconsin, 1995; *Dias de los Muertos*, installation: *My Dress Hangs There*,

Walker's Point Center for the Arts, Milwaukee, Wisconsin, 1995; *Madonnas*, Walker's Point Center for the Arts, Milwaukee, Wisconsin, 1996; *Tactile Inventions*, Internos Gallery, Milwaukee, Wisconsin, 1996; *Fragments: New Work by Kat Tomka*, Ronald Gallery, Portland, Indiana, 1998; *Kat Tomka*, Bemis Center for Contemporary Arts, Omaha, Nebraska, 1999; *9th International Biennial Print and Drawing Exhibition*, Taipei Fine Arts Museum, Taipei, Republic of China, 1999; *National Vahki Exhibition* (catalogue), Mesa Arts Center, Mesa, Arizona, 1999; *The Homogeneity Tapes* (catalogue), The Ragdale Foundation, Chicago, Illinois, 2000.

DK

1 Artist's Statement, unpublished.

111 Ruth Weisberg

Initiation
Scroll, watercolor and graphic media
1997
H. 51 in.; W. 28 ft.
(129.5; 853.4 cm)
Courtesy of Jack Rutberg Fine Arts, Los Angeles
See fig. 13.2 for detail

Seer
Pencil, gesso, and watercolor
1994
H. 21¹⁄₈; W. 21¹⁄₈ in.
(53.7; 53.7 cm)
Courtesy of Jack Rutberg Fine Arts, Los Angeles

Initiation is one of two large scrolls based on the scenes in the figural frieze at the Villa of the Mysteries in Pompeii. The first, *Mysteries*, was a large black-and-white drawing, 45 in. high by 28 ft. long. *Initiation*, created the following year, is taller and filled with the subtle colors of watercolor and Prismacolor wash. These works, like many others during Weisberg's career, are inspired by the art of the past. "The two great mediators for me are classical and Renaissance art."[1] *Initiation* has been shown at least once before in *Allegorical Re/Visions* at the Los Angeles Municipal Art Gallery in 1997–98.

BIOGRAPHICAL DATA: Education: BS, Design, University of Michigan, Ann Arbor, Michigan, 1963; MFA, University of Michigan, Ann Arbor, Michigan, 1965; Laurea di Belle Arti, Academic di Belle Arti, Perugia, Italy, 1992; Position: Dean of Fine Arts, University of Southern California.

SELECTED EXHIBITIONS AND PUBLICATIONS: *Survey Exhibition 1966–1988* (catalogue), Slusser Gallery, University of Michigan, Ann Arbor, Michigan; Laguna Art Museum, Laguna Beach, California; College of Wooster, Wooster, Ohio; Hope College, Holland, Michigan, 1988; *Sisters and Brothers* (catalogue), installation, Fresno Art Museum, Fresno California, 1994; Gross Gallery, University of Arizona, 1995; Laband Art Gallery, Loyola Marymount University, Los Angeles, 1996; *Ruth Weisberg*, Platt Gallery, University of Judaism, Los Angeles, California, 1997; *Mysteries*, Doolin Gallery, Southern Methodist University, Dallas, Texas, 1997; *Singular Impressions: The Monotype in America* (catalogue), National Museum of American Art, Smithsonian, Washington,

Seer

D.C., 1997; *A Continuing Tradition*, The Judson Gallery, Los Angeles, California, 1997; *New Dialogues: Women Printmakers Invitational*, Trustman Art Gallery, Simmons College, Boston, Massachusetts; Wellesley College, Wellesley, Massachusetts, 1997; *Allegorical Re/Visions* (catalogue), Los Angeles Municipal Art Gallery, Garnsdall Los Angeles, California, 1997–98; *Presenca Femminile* (catalogue), Temple University Gallery, Rome, Italy, 1998; *Ruth Weisberg: Canto V: Whirlwind of Lovers* (catalogue), The Virginia Steele Scott Gallery, The Huntington Library, Art Collections and Botanical Gardens, San Marino, California, 1999–2000.

DK

1 Nygren 1999, 8.

Glossary

acanthus Plant of the genus *Acanthus* used as a decorative motif in sculpture, carving, etc.

aedile Roman magistrate charged with the supervision of public buildings, games, markets, etc.

ala (-ae) Recess on either side of the atrium

aryballos (-oi) Small oil or perfume flask

atrium (-a) First main room in a standard Roman dwelling where visitors were received; such rooms usually included a single central opening in the roof for capturing rainwater (compluvium) with a corresponding basin in the floor beneath (impluvium)

bucolic Pastoral

bucranium (-a) Decorative motif of an ox skull adorned with wreaths

Campania Region of west central Italy bounded by the river Liris, the Apenines, and the Sorrentine peninsula

cella (-ae) Central or subsidiary room in a temple; a room in a Roman dwelling

cenaculum (-a) Dining room; a top story, garret, or attic that was often rented out as lodgings

chiasmus An inversion of word order in two corresponding parallel phrases; in visual compositions, opposing directions

chiton (-iskos) Lightweight Greek garment made of two rectangular lengths of material that were sewn along the sides of the arms; often belted

chlamys Long or short cloak

cista (-ae) Box or chest; used to hold sacred objects during mystery rites; used by women to hold toiletry items

cista mystica *See* cista

Compitalia Festival of the *Lares Compitales*, which was held annually at the crossroads

dado Lower part of a wall when specially decorated and differentiated as a separate zone from the rest of the wall

domina (-ae) Female head of a household, mistress, owner

exedra (-ae) Semicircular or rectangular room or recess; in a Roman dwelling, it is an open rectangular or semicircular room usually located off the peristyle

faun Italic deity of fields and herds that became amalgamated with satyrs; represented as half man and half goat

Gorgoneion (-eia) Head of a Gorgon

hieros gamos Sacred marriage

himation Identical to the palium and palla; rectangular mantle worn by both men and women over the chiton or peplos

iconography Study of subject matter in the visual arts; study or description of visual representation

kantharos (-oi) Large drinking vessel with high vertical handles

kibotos Bowl, chest, coffer

klismos (-oi) Couch; a total of three couches would be arranged at the back and sides of a dining room

kottabos Sicilian game of throwing wine dregs into a metal basin

krater Bowl for mixing wine

kylix (-kes) Shallow drinking cup

laver Basin or bowl for water

liknon (-a) Winnowing fan, that is, a basket in which grain was placed after harvesting and from which it was thrown against the wind in order to winnow the grain from the chaff; an object sacred to Dionysus/Bacchus and carried at his festivals

Lupercalia Annual Roman festival held on February 15 on the Palatine Hill to promote fertility and avert evil

maenad Attendant of Dionysus/Bacchus; mortal woman who celebrated the orgiastic rites of Dionysus/ Bacchus; also known as a Bacchante

Magna Graecia The coastal region of Italy between Cumae and Tarentum that was colonized by the Greeks; usually excludes Sicily and Campania

manus Authority/control over the property and life of a minor or woman by the *paterfamilias*; literally means "hand"

materfamilias A matron; the mistress of a household

megalographia (-ae) Wall painting representing large-scale or life-size figures

metonomy Use of one word for another that it suggests; use of the part for the whole, the sign for the thing signified, the cause for the effect, etc.

mysteries Variety of cults, including those of Dionysus/ Bacchus, Isis, and Demeter and Kore, that focused on individual rather than civic well-being; an individual participant in a mystery cult attempts to transcend the everyday world through ecstasy, possession, madness, etc.

naiskos A small shrine

nymph Minor nature deity conceived of as a beautiful maiden dwelling in the mountains, forests, waters, etc. who was also a follower of Dionysus/Bacchus

nymphaeum (-a) Originally, a cave with running water dedicated to the nymphs; any natural or artificial fountain grotto, monumental public fountain, decorative fountain, or whole room dedicated to a fountain

oecus (-i) Reception room often used for dining and entertainment; Vitruvius (6.3.8–10) uses "oecus" and "triclinium" almost indiscriminately

orthostat Vertical panel, block, or slab usually at the base of a real or painted masonry wall

paniske (-es) Female counterpart of a pan or paniskus

paniskos (-e) Diminutive of Pan; a minor forest deity often represented as half man and half goat

Parentalia Annual Roman festival of ancestors lasting from February 13 to 21, in which all but the last day honored the family dead with private celebrations. The last day was a public ceremony. During the entire festival, temples were closed and no weddings were celebrated.

paterfamilias Male head of an extended Roman family

pediment Triangular space at the gabled end of a ridged roof

pelike (-es) Storage jar with two handles, a wide mouth, little or no neck, and a sagging belly; used for storing wine or water

peplos A Greek garment fastened at the shoulders, with the upper portion folded over at the waist to form an overblouse

peristyle Inner courtyard or garden surrounded by a colonnade

phiale Broad shallow bowl often used for libations; also known as a patera

phlyax play Comic play often popular in Southern Italy

pinacotheca (-ae) Picture gallery

pinax (-kes) Panel painting often protected by wooden shutters and displayed in a picture gallery; panel in other medium, usually decorated

pronaos Porch in front of the cella of a temple

pyxis (-ides) Cylindrical box with a lid used by women to hold jewelry, cosmetics, or other items

ressault Any projection from the plane of a wall

salutatio (-ones) Formal morning call paid by a client on his patron

satyr Minor woodland deity represented as half man and half horse and a youthful follower of Dionysus given to merriment and lasciviousness

schola (-ae) Circular, semicircular, etc., area with benches for the public; an area of this sort in which members of a guild, club, society, or fraternity met for recreation, ritual, etc.; the members meeting in such a place

silen Minor wood god represented as half man and half horse and a companion of Dionysus/Bacchus that is sometimes not distinguished from a satyr; when distinguished from satyrs, the silens are bearded, old, and frequently bald

Silenus Satyr who educated Dionysus/Bacchus

situla (-ae) Vessel for holding water

skyphoid pyxis Pyxis in the shape of a skyphos

skyphos (-oi) Drinking cup with two handles

sponsalia (-ae) Roman betrothal ceremony

taberna (-ae) Shop, stall for trade; inn

tablinum (-a) Main reception room of the Roman dwelling; the central room at the far end of an atrium or a room running between the atrium and the peristyle; originally the main bedroom and record room

tetrastyle Consisting of four columns

thiasos (-oi) Sacred band of a god; group of worshippers of a particular god or hero

tholos (-oi) Circular building

thymiaterion (-a) Incense burner

thyrsus (-i) Wand tipped with a fir cone, tuft of ivy, or vine leaves carried by devotees of Dionysus/Bacchus/Liber

toga virilis Plain white toga worn by male citizens upon reaching the age of maturity

tondo Circular painting or sculptured medallion; often decorates the interiors of kylixes

torcularium (-a) Wine or olive press; the room where the pressing takes place

triclinium (-a) Dining room; Vitruvius (6.3.8–10) uses "oecus" and "triclinium" almost interchangeably; in later Roman usage the principal reception room of a house

tympanum (-a) The vertical triangular or semicircular wall face of a pediment; a hand drum

Bibliography

Abbreviations in the text and bibliography conform to those listed in the *American Journal of Archaeology* 95 (1991) 4–16.

Ackerman, G. M. 1992. "Hercules, Ever at the Crossroads: Moral Dilemmas in the Paintings of Wes Christensen." *SULFUR 30, A Literary Bi-annual of the Whole Art* (Spring).

Adkins, L., and R. Adkins. 1996. *Dictionary of Roman Religion*. New York.

Aigner-Foresti, L. 1998. "Fufluns." In *Der neue Pauly. Enzyklopädie der Antike Altertum*, ed. H. Cancik and H. Schneider, 4:698. Stuttgart.

Alexander, C. 1933. "Abstract of the Articles on the Bacchic Inscription in the Metropolitan Museum." *AJA* 37:264–70.

Allison, P. 1992a. "Artefact Assemblages: Not 'the Pompeii Premise'." In *Papers of the Fourth Conference of Italian Archaeology*, ed. E. Herring, R. Whitehouse, and J. Wilkins, 49–56. London.

————. 1992b. "The Relationship between Wall-Decoration and Room-Type in Pompeian Houses: A Case Study of the Casa della Caccia Antica." *JRA* 5:235–49.

————. 1993. "How Do We Identify the Use of Space in Roman Housing?" In *Functional and Spatial Analysis of Wall Paintings: Proceedings of the Fifth International Congress on Ancient Wall Painting*, ed. E. M. Moormann, 1–8. *BABesch* suppl. 3. Leiden.

————. 1997. "Artifact Distribution and Spatial Function in Pompeian Houses." In *The Roman Family in Italy*, ed. B. Rawson and P. Weaver, 321–55. Oxford.

Altmann, W. 1905. *Die Römischen Grabaltäre der Kaiserzeit*. Berlin.

Ammerman, R. M. 1990. "The Religious Context of Hellenistic Terracotta Figurines." In *The Coroplast's Art: Greek Terracottas of the Hellenistic World*, ed. J. P. Uhlenbrock, 37–46. New Rochelle, NY.

Andersen, F. G. 1993. "Roman Figural Painting in the Hellenistic Age." In *Aspects of Hellenism in Italy: Towards a Cultural Unity?*, ed. P. G. Bilde, I. Nielsen, and M. Nielsen, 179–90. Acta Hyperborea 5. Copenhagen.

Anderson, R. D. 1976. *Catalogue of Egyptian Antiquities in the British Museum*. Vol. 3, *Musical Instruments*. London.

Andreae, B. 1975. "Rekonstruktion des grossen Oecus der Villa des P. Fannius Synistor in Boscoreale." In *Neue Forschungen in Pompeji und den anderen vom Vesuvausbruch 79 n. Chr. verschütteten Städten*, ed. B. Andreae and H. Kyrieleis, 71–92. Recklinghausen.

Andrén, A. 1940. *Architectural Terracottas from Etrusco-Italic Temples*. Lund.

Archer, W. 1990. "The Paintings in the Alae of the Casa dei Vettii and a Definition of the Fourth Pompeian Style." *AJA* 94:95–123.

Arias, P. E. 1962. *A History of 1000 Years of Greek Vase Painting*, trans. and rev. B. Shefton. New York.

Bailey, D. M. 1980. *A Catalogue of the Lamps in the British Museum*. Vol. 2, *Roman Lamps Made in Italy*. London.

Bakker, J. T. 1994. *Living and Working with the Gods: Studies of Evidence for Private Religion and Its Material Environment in the City of Ostia (100–500 AD)*. Dutch Monographs on Ancient History and Archaeology 12. Amsterdam.

Balsdon, J. P. V. D. 1983. Reprint. *Roman Women: Their History and Habits*. New York. Original edition, 1962.

Barbet, A. 1981. "Les Bordures ajourées dans le IVe style de Pompéi."*MEFRA* 98:917–98.

————. 1985. *La peinture murale romaine: Les styles décoratifs pompéiens*. Paris.

Baring, A., and J. Cashford. 1991. *The Myth of the Goddess: Evolution of an Image*. London.

Barnabei, F. 1901. *La villa pompeiana di P. Fannio Sinistore scoperta presso Boscoreale*. Rome.

Barosso, M. 1940a. "Edificio Romano sotto il Tempio di Venere e Roma." In *Atti del III Convegno Nazionale di Storia dell'Architettura Romana*. Rome.

————. 1940b. "Le Costruzioni sottostanti la Basilica Massenziana e la Velia." In *Atti del V Congresso Nazionale di Studi Romani*, 2:58–62.

Barrett, J. C. 1997. "Romanization: A Critical Comment." In *Dialogues in Roman Imperialism*, ed. D. Mattingly, 53–64. *JRA* suppl. 23. Portsmouth, RI.

Barr-Sharrar, B. 1987. *The Hellenistic and Early Imperial Decorative Bust*. Mainz.

Bartman, E. 1992. *Ancient Sculptural Copies in Miniature*. Columbia Studies in the Classical Tradition 19. Leiden.

Bartoloni, G. 1970. "Alcune terrecotte votive delle collezioni medicee ora al Museo archeologico di Firenze." *StEtr* 38:257–70.

Bastet, F. L. 1974. "Fabularum Dispositas Explicationes." *BABesch* 49:206–40.

Beard, M. 1980. "The Sexual Status of Vestal Virgins." *JRS* 70:12–27.

————. 1991. "Adopting an Approach II." In *Looking at Greek Vases*, ed. T. Rasmussen and N. Spivey, 12–35. Cambridge.

————. 1995. "Re-reading (Vestal) Virgins." In *Women in Antiquity: New Assessments*, ed. R. Hawley and B. Levick, 166–77. London.

————, J. Huskinson, and J. Reyonolds, eds. 1988. *Image and Mystery in the Roman World*. Gloucester.

————, J. A. North, and S. R. F. Price. 1998. *Religions of Rome*. 2 vols. Cambridge.

Beazley, J. D. 1942. *Attic Red-figure Vase-painters*. Oxford.

————. 1963. *Attic Red-figure Vase-painters*, 2nd ed. Oxford.

————. 1971. *Paralipomena, Additions to Attic Black-figure Vase Painters and to Attic Red-figure Vase Painters*, 2nd ed. Oxford.

Behen, M. J. 1996. "Sarcophagus Fragment with Bacchic Thiasus." In *I, Claudia: Women in Ancient Rome*, ed. D. E. E. Kleiner and S. B. Matheson, 209–10. New Haven.

Bell, H. 1948. "Popular Religion in Graeco-Roman Egypt." *JEA* 34:82–97.

Bell, M., III. 1990. "Hellentistic Terracottas of Southern Italy and Sicily." In *The Coroplast's Art: Greek Terracottas of the Hellenistic World*, ed. J. P. Uhlenbrock, 64–70. New Rochelle, NY.

Bendinelli, G. 1968. "Ultime considerazioni intorno alla villa pompeiana detta dei misteri." *Latomus* 27:823–31.

Benson, C. 1995. "Maenads." In *Pandora: Women in Classical Greece*, ed. E. D. Reeder, 381–83. Baltimore.

Benvenuto, B. 1994. *Concerning the Rites of Psychoanalysis, or, The Villa of the Mysteries*. Cambridge.

Berard, C. 1967. "Art alexandrin et mystères dionysiaques. Le vase bachique d'Avenches." *Pro Aventicum* 29:57–90.

Bergmann, B. 1992. "Exploring the Grove: Pastoral Space on Roman Walls." In *The Pastoral Landscape*, ed. J. Hunt, 21–48. Studies in the History of Art 36. Washington, DC.

———. 1995. "Greek Masterpieces and Roman Recreative Fictions." *HSCP* 97:79–120.

Berry, J. 1997. "Household Artifacts: Towards a Re-interpretation of Roman Domestic Space." In *Domestic Space in the Roman World: Pompeii and Beyond*, ed. R. Laurence and A. Wallace-Hadrill, 183–95. *JRA* suppl. 22. Portsmouth, RI.

Berti, F., ed. 1991. *Dionysos: Mito e mistero: Atti del Convegno internazionale, Comacchio, 3–5 novembre 1989*. Ferrara.

Beyen, H. G. 1938. *Die pompejanische Wanddekoration vom zweiten bis zum vierten Stil*, vol. 1. The Hague.

Bieber, M. 1917. "Die Herkunft des Tragischen Kostums." *JdI* 32:15–104.

———. 1928. "Der Mysteriensaal der Villa *Item*." *JdI* 43:298–330.

———. 1961. *The Sculpture of the Hellenistic Age*, rev. ed. New York.

———. 1962. "Copies of the Herculaneum Woman." *ProcPhilSoc* 106:111–34.

Bispham, E. H., G. J. Bradley, and J. W. J. Hawthorne. 2000. "Towards a Phenomenology of Samnite Fortified Centres." *Antiquity* 74 (Mar.): 23–24.

Boak, A. E., ed. 1933. *Karanis: The Temples, Coin Hoards, Botanical and Zoological Reports, Seasons 1924–31*. Ann Arbor.

Boardman, J. 1968. *Engraved Gems: The Ionides Collection*. London.

———. 1970. *Greek Gems and Finger Rings: Early Bronze Age to Late Classical*. London.

———. 1989. *Athenian Red Figure Vases: The Classical Period*. New York.

Bodel, J., and S. Tracy. 1997. *Greek and Latin Inscriptions in the USA: A Checklist*. New York.

Boëls-Janssen, N. 1993. *La vie religieuse des matrones dans la Rome archaïque*. CEFR 176. Rome.

Boethius, A. 1934. "Remarks on the Development of Domestic Architecture in Rome." *AJA* 24:158–70.

Bon, S. E., and R. Jones, eds. 1997. *Sequence and Space in Pompeii*. Oxbow Monograph 77. Oxford.

Bondanella, P. 1987. *The Eternal City: Roman Images in the Modern World*. Chapel Hill, NC.

Bonfante, L. 1993. "Fufluns Pacha: The Etruscan Dionysus." In *Masks of Dionysus*, ed. T. H. Carpenter and C. A. Faraone, 221–35. Ithaca.

Bonghi Jovino, M., ed. 1965. *Terrecotte votive: Catalogo del Museo Provinciale Campano*. Vol. 1, *Teste isolate e mezze-teste*. Florence.

Boucher, S. 1983. *Les bronzes figurés antiques*. Lyons.

Boulter, P. N. 1979. "A Bronze Bull in Cincinnati." In *Studies in Classical Art and Archaeology: A Tribute to Peter Heinrich von Blanckenhagen*, ed. G. Kopcke and M. B. Moore, 251–54. Locust Valley, NY.

Boyancé, P. 1960–61. "L'antre dans les mystères de Dionysos." *RendPontAcc* 33:107–27.

———. 1965–66. "Dionysos et Semele." *RendPontAcc* 38:79–104.

———. 1966a. "Dionysiaca, à propos d'une étude recent sur l'initiation dionysiaque." *REA* 68:30–60.

———. 1966b. "Ménè-Hékate à la Villa des Mystères." *RACrist* 42:57–71.

Boyce, G. K. 1937. *Corpus of the Lararia of Pompeii*. MAAR 14. Rome.

Bradway, K. 1982. *"Villa of Mysteries": Pompeian Initiation Rites of Women*. San Francisco.

Bruan, E., ed. 1989. *Italian Art in the 20th Century: Painting and Sculpture 1900–1988*. Munich.

Bremmer, J. N. 1984. "Greek Maenadism Reconsidered." *ZPE* 55:267–86.

———. 1994. *Greek Religion*. Oxford.

Brendel, O. J. 1979. *Prolegomena to the Study of Roman Art*. New Haven.

———. 1980. "The Great Frieze in the Villa of the Mysteries." In *The Visible Idea: Interpretations of Classical Art*, ed. O. J. Brendel, trans. M. Brendel, 90–138. Washington DC.

———. 1995. *Etruscan Art*, 2nd ed. New Haven.

Brilliant, R. 1979. *Pompeii AD 79: The Treasure of Rediscovery*. New York.

Brommer, F. 1937. *Satyroi*. Würzburg.

Broneer, O. 1930. *Terracotta Lamps*. Corinth 4.2. Cambridge, MA.

Brown, A. C. 1968. *Catalogue of Italian Terra-Sigillata in the Ashmolean Museum*. London.

Brown, B. R. 1957. *Ptolemaic Paintings and Mosaics*. Cambridge, MA.

Brown, W. L. 1960. *The Etruscan Lion*. Oxford.

Bruhl, A. 1953. *Liber Pater: Origine et expansion du culte dionysiaque à Rome et dans le monde romain*. BEFAR 175. Paris.

Bruno, V. J. 1993. "Mark Rothko and the Second Style: The Art of the Color-Field in Roman Murals." In *Eius Virtutis Studiosi: Classical and Postclassical Studies in Memory of Frank Edward Brown (1908–1988)*, ed. R. T. Scott and A. R. Scott, 235–55. Studies in the History of Art 43. Hanover and London.

Buitron, D. M. 1972. *Attic Vase Painting in New England Collections*. Cambridge, MA.

Burkert, W. 1985. *Greek Religion*, trans. J. Raffan. Cambridge, MA.

———. 1987. *Ancient Mystery Cults*. Cambridge, MA.

———. 1993. "Bacchic *Teletai* in the Hellenistic Age." In *Masks of Dionysus*, ed. T. H. Carpenter and C. A. Faraone, 259–75. Ithaca.

Burlington Fine Arts Club. 1904. *Exhibition of Ancient Greek Art*. London.

Buschor, E. 1940. *Griechische Vasen*. Munich.

Buschor, E. 1958. *Medusa Rondanini*. Stuttgart.

Cahn, H. A. 1970. *Art of Ancient Italy: Etruscans, Greeks and Romans: An Exhibition Organized in Cooperation with Munzen und Medaillen AG, Basle, Switzerland, April 4–29, 1970*. New York.

Calabi Limentani, I. 1991. *Epigrafia Latina*, 4th ed. Milan.

Calza, G. 1928. "Ostia." *NSc* 4:133–75.

Cambitoglou, A. 1995. "Lucani, Vasi." *EAA* suppl. 2.3:420–33.

Cannistraro, P. V. 1989. "Fascism and Culture in Italy, 1919–1945." In *Italian Art in the 20th Century: Painting and Sculpture 1900–1988*, ed. E. Braun, 147–54. Munich.

Cantarella, E. 1987. *Pandora's Daughters: The Role and Status of Women in Greek and Roman Antiquity*. Baltimore.

Carafa, P. 1997. "What Was Pompeii before 200 BC?" In *Sequence and Space in Pompeii*, ed. S. E. Bon and R. Jones, 13–31. Oxbow Monograph 77. Oxford.

Carpenter, T. H. 1986. *Dionysian Imagery in Archaic Greek Art*. Oxford.

———. 1993. "On the Beardless Dionysus." In *Masks of Dionysus*, ed. T. H. Carpenter and C. A. Faraone, 185–207. Ithaca.

———. 1997. *Dionysian Imagery in Fifth Century Athens*. Oxford.

———, and C. A. Faraone, eds. 1993. *Masks of Dionysus, Myth and Poetics*. Ithaca.

Carter, J. 1977. *Ancient Crossroads: The Rural Population of Classical Italy. Guide to an Archaeological Exhibition*. Austin, TX.

Carettoni, G. 1983. *Das Haus des Augustus auf dem Palatin*. Mainz.

Caskey, D. L. 1938. "Pompeian Frescoes." *Bulletin of the Museum of Fine Arts* 38:9–16.

Castellani, A. 1884. *Catalogue des objets d'art antiques . . . la vente aura lieu à Rome*. Paris.

Castriota, D. 1995. *The Ara Pacis Augustae and the Imagery of Abundance in Later Greek and Early Roman Imperial Art*. Princeton.

Castrén, P. 1975. *Ordo Populusque Pompeianus, Polity and Society in Roman Pompeii*. Rome.

Cateni, G., ed. 1986. *Urne volterrane*. Vol. 2, *Il Museo Guarnacci*, pt. 2. Pisa.

Cesnola, L. 1885–1903. *A Descriptive Atlas of the Cesnola Collection of Cypriote Antiquities in the Metropolitan Museum of Art, New York*. 6 vols. Boston.

Charles, M.-O. 1998. "Les cultes privés en Italie au 1er siècle de notre ère: L'exemple de Pompéi et d'Herculanum." Ph.D. diss., Ecole Pratique des Hautes Etudes.

Chevalier, J., and A. Gheerbrant. 1994. *A Dictionary of Symbols*, trans. J. Buchanan-Brown. Oxford.

Clairmont, C. 1966. *Die Bildnisse des Antinous. Ein Beitrag zur Porträtplastik unter Kaiser Hadrian*. Rome.

Clarke, J. R. 1985. "Relationships between Floor, Wall, and Ceiling Decoration at Rome and Ostia Antica: Some Case Studies." *BullAIEMA* 10:93–103.

———. 1991. *The Houses of Roman Italy, 100 B.C.–A.D. 250: Ritual, Space, and Decoration*. Berkeley.

Clinton, K. 1992. *Myth and Cult: The Iconography of the Eleusinian Mysteries: The Martin P. Nilsson Lectures on Greek Religion, Delivered 19–21 November 1990 at the Swedish Institute at Athens. SkrAth* 8°, 11. Stockholm.

Clinton, K. 1993. "The Sanctuary of Demeter and Kore at Eleusis." In *Greek Sanctuaries: New Approaches*, ed. N. Marinatos and R. Hägg, 110–23. London.

Cohen, A. 1997. *The Alexander Mosaic: Stories of Victory and Defeat*. Cambridge Studies in Classical Art and Iconography. Cambridge.

Cohon, R. 1996. "A Forged Masterpiece." *JRA* 9:239–46.

Coldstream, J. N. 1994. "Prospectors and Pioneers." In *The Archaeology of Greek Colonisation*, ed. G. R. Tsetskhladze and F. de Angelis, 47–59. Oxford.

Cole, S. G. 1980. "New Evidence for the Mysteries of Dionysos." *GRBS* 21:223–38.

———. 1991. "Dionysiac Mysteries in Phrygia in the Imperial Period." *EpigAnat* 17:41–50.

———. 1993. "Voices from beyond the Grave: Dionysus and the Dead." In *Masks of Dionysus*, ed. T. H. Carpenter and C. A. Faraone, 276–95. Ithaca.

———. 1994. "Demeter in the Ancient Greek City and Its Countryside." In *Placing the Gods: Sanctuaries and Sacred Space in Ancient Greece*, ed. S. E. Alcock and R. Osborne, 199–216. Oxford.

Comella, A., and G. Stefani. 1990. *Materiali votivi del santuario di Campetti a Veio: Scavi 1947 e 1969*. Rome.

Comparetti, D. 1921. *Le nozze di Bacco ed Arianna: Rappresentazione pittorica spettacolosa nel triclinio di una villa suburbana di Pompei*. Florence.

Conticello, B. 1987. *Pompei. Guida archeologica*. Novara.

Conway, R. 1967. Reprint. *The Italic Dialects*. 2 vols. Hildesheim. Original edition, Cambridge, 1897.

Cook, B. 1966. *Inscribed Hadra Vases in the Metropolitan Museum of Art*. New York.

Cook, R. M. 1960. *Greek Painted Pottery*. London.

Cooney, J. D. 1973. "Deluxe Toilet Objects." *BClevMus* 60:219–21.

Cowling, E., and J. Mundy. 1990. *On Classic Ground: Picasso, Léger, de Chirico and the New Classicism 1910–1930*. London.

Crawford, M. 1974. *Roman Republican Coinage*. London.

Cremonese, F. S. 1848. "Notizia di una tavola di bronzo con inscrizione sannitica ed altre antichita della stessa data scoperte nelle vicinanze di Agnone." *BdI* 10:145–51.

Crispolti, E. 1989. "Second Futurism." In *Italian Art in the 20th Century: Painting and Sculpture 1900–1988*, ed. E. Braun, 165–71. Munich.

Cristofani, M. 1967. "Ricerche sulle pitture della Tomba François di Vulci. I fregi decorativi." *DialArch* 1:186–219.

———, ed. 1977. *Urne volterrane*. Vol. 2, *Il Museo Guarnacci*, pt. 1. Florence.

———. 1985. *I bronzi degli Etruschi*. Novara.

Cummings, F. J., and C. H. Elam, eds. 1971. *The Detroit Institute of Arts Illustrated Handbook*. Detroit.

Cumont, F. 1933. "La grande inscription bachique du Metropolitan Museum." *AJA* 37:232–63.

Curtius, L. 1929. *Die Wandmalerei Pompejis*. Leipzig.

D'Agonisto, B. 1996. "The Impact of the Greek Colonies on the Indigenous Peoples of Campania." In *I Greci in Occidente*, ed. G. Pugliese Carratelli, 533–40. Milan.

D'Ambra, E. 1996. "The Calculus of Venus: Nude Portraits of Roman Matrons." In *Sexuality in Ancient Art*, ed. N. B. Kampen, 219–32. Cambridge.

D'Ambrosio, A., and E. De Carolis. 1997. *I Monili dall'Area Vesuviana*. Rome.

D'Arms, J. H. 1991. "Slaves at Roman Convivia." In *Dining in a Classical Context*, ed. W. J. Slater, 171–84. Ann Arbor.

Dasen, V. 1993. *Dwarfs in Ancient Egypt and Greece*. Oxford.

Davies, P. J. E. 1996. "Beauty as a Virtue." In *I, Claudia: Women in Ancient Rome*, ed. D. E. E. Kleiner and S. B. Matheson, 165. New Haven.

De Caro, S. 1997a. "L'Iseo di Pompei." In *Iside, il mito, il mistero, la magia*, ed. E. A. Arslan, 338–43. Milan.

———. 1997b. "Iside nei Campi Flegrei." In *Iside, il mito, il mistero, la magia*, ed. E. A. Arslan, 348–51. Milan.

De Cazanove, O. 1986. "Le thiase et son double: Images, statuts, fonctions du cortège divin de dionysos en Italie centrale." In *L'association dionysiaque dans les sociétés anciennes*, 177–97. CEFR 89. Rome.

———. 1987. "Exesto. L'incapacité sacrificielle des femmes à Rome." *Phoenix* 41:159–74.

De Cou, H. F. 1912. "Antiquities from Boscoreale in Field Museum of Natural History." *Field Museum of Natural History* 7.4:145–212.

De Grummond, N. T., ed. 1982. *A Guide to Etruscan Mirrors*. Tallahassee, FL.

———. 1991. "Etruscan Twins and Mirror Images: The Dioskouroi at the Door." *YaleBull*, 11–31.

De Petra, G. 1910. "Villa Romana Presso Pompei." *NSc*, 139–45.

De Puma, R. D. 1987. *Corpus Speculorum Etruscorum: U.S.A. 1: Midwestern Collections*. Ames, IA.

———. 1989. "Engraved Etruscan Mirrors: Questions of Authenticity." In *Secondo Congresso Internazionale Etrusco, Firenze 26 Maggio–2 Giugno 1985, Atti* 2:695–711.

De Ruyt, F. 1958. "Charun, l'âme et le griffon sur deux stamnoi étrusques." *ArchCl* 10:97–101.

Detroit Institute of Arts. 1950. "Museum Acquires Hellenistic Head of Satyr." *Art Digest* 24 (Jan. 15): 10.

Deussen, P. 1971. "The Polychromatic Ceramics of Centuripe." Ph.D. diss., Princeton University.

———. 1973. "The Nuptial Theme of Centuripe Vases." *OpRom* 9:125–33.

De Vos, M. 1980. *L'Egittomania in pitture e mosaici romano-campani della prima età imperiale*. Leiden.

———, and A. de Vos. 1997. *Dionysus, Hylas e Isis sui monti di Roma: Tre monumenti con decorazione parietale in Roma antica (Palatino, Quirinale, Oppio)*. Rome.

Diehl, E. 1964. *Die Hydria: Formgeschichte und Verwendung im Kult des Altertums*. Mainz.

Dixon, S. 1988. *The Roman Mother*. Norman, OK.

Donati, A., ed. 1998. *Romana Pictura: La pittura romana dalle origini all'età bizantina*. Milan.

Dragendorff, H., and C. Watzinger. 1948. *Arretinische Reliefkeramik mit Beschreibung der Sammlung in Tübingen*. Reutlingen.

Dumézil, G. 1970. *Archaic Roman Religion, with an Appendix on the Religion of the Etruscans*. Chicago.

Durand, J. L., and F. Frontisi-Ducroux. 1982. "Idoles, Figures, Images: Autour de Dionysos." *RA*, 83–108.

Dwyer, E. J. 1981. "Pompeian Oscilla Collections." *RM* 88:247–329.

Dwyer, E. J. 1982. *Pompeian Domestic Sculpture: A Study of Five Pompeian Houses and Their Contents*. Rome.

Edlund, I. E. M. 1987. *The Gods and the Place: Location and Function of Sanctuaries in the Countryside of Etruria and Magna Graecia (700–400 B.C.)*. SkrRom 4°, 43. Stockholm.

Einaudi, K. B.-S. 1983. "Esther Boise Van Deman: Un'archeologa americana." In *L'archeologia in Roma capitale tra sterro e scavo*, ed. G. Pisani Sartorio and L. Quilici, 41–47. Venice.

Ensoli, S. 1997. "I santuari isiaci a Roma e i contesti non cultuali: Religione pubblica, devozioni private e impiego ideologico del culto." In *Iside, il mito, il mistero, la magia*, ed. E. A. Arslan, 306–21. Milan.

Etienne, R. 1977. *La vie quotidienne à Pompéi*, 2nd ed. Paris.

———. 1992. *Pompeii: The Day a City Died*. New York.

Fitch, C. R., and N. W. Goldman. 1994. *Cosa: The Lamps*. MAAR 39. Ann Arbor.

Foss, P. W. 1997. "Watchful *Lares*: Roman Household Organization and the Rituals of Cooking and Eating." In *Domestic Space in the Roman World: Pompeii and Beyond*, ed. R. Laurence and A. Wallace-Hadrill, 196–218. JRA suppl. 22. Portsmouth, RI.

Foucher, L. 1981. "Le cult de Bacchus sous l'empire romain." *ANRW* 2.17.2: 684–702.

Frazer, A. 1992. "The Roman Villa and the Pastoral Ideal." In *The Pastoral Landscape*, ed. J. Hunt, 49–61. Studies in the History of Art 36. Washington, DC.

Frederiksen, M. 1984. *Campania*, ed. N. Purcell. London.

Friedland, E. 1992. "Satyr Playing the Flute." *Kelsey Museum Newsletter* (Spring), 3.

Frölich, T. 1991. *Lararien und Fassadenbilder in den Vesuv-städten*. RM-EH 32. Mainz.

Fulford, M., and A. Wallace-Hadrill. 1998. "Unpeeling Pompeii." *Antiquity* 72 (Mar.): 128–45.

Furtwängler, A. 1901. "Römische-ägyptische Bronzen." *BJb* 107:37–47.

———. 1905. *Neue Denkmäler antiker Kunst*. Vol. 3, *Antiken in den Museen von Amerika*. Munich.

Gagé, J. 1963. *Matronalia: Essai sur les dévotions et les organisations cultuelles des femmes dans l'ancienne Rome*. CollLatomus 60. Brussels.

Galestin, M. 1987. *Etruscan and Italic Bronze Statuettes*. Warfhuizen.

Galinsky, K. 1981. "Augustus' Legislation on Morals and Marriage." *Philologus* 125:126–44.

Gallo, P. 1997. "Luoghi di culto e santuari isiaci in Italia." In *Iside, il mito, il mistero, la magia*, ed. E. A. Arslan, 290–96. Milan.

Gatti, S. 1997. "La diffusione del culto di Iside: *Praeneste*." In *Iside, il mito, il mistero, la magia*, ed. E. A. Arslan, 332–34. Milan.

Gatti Lo Guzzo, L. 1978. *Il deposito votivo dell'Esquilino detto di Minerva Medica*. Florence.

Gazda, E. K., ed. 1978. *Guardians of the Nile: Sculptures from Karanis in the Fayoum (c. 250 B.C.–A.D. 450)*. Ann Arbor.

———, ed. 1983a. *In Pursuit of Antiquity: Thomas Spencer Jerome and the Bay of Naples (1899–1914)*. Ann Arbor.

———, ed. 1983b. *Karanis: An Egyptian Town in Roman Times*. Ann Arbor.

Gazda, E.K. 1995. "Roman Sculpture and the Ethos of Emulation: Reconsidering Repetition." *HSCP* 97:121–56.

Gerhard, E., ed. 1840–97. *Etruskische Spiegel.* 5 vols. Berlin.

Gernet, L. 1981. "Dionysos and Dionysiac Religion: Inherited Elements and Original Traits." In *The Anthropology of Ancient Greece*, ed. L. Gernet, 48–70. Baltimore.

Geyer, A. 1977a. *Das Problem des Realitätsbezuges in der dionysischen Bildkunst der Kaiserzeit.* Beiträge zur Archäologie 10. Würzburg.

———. 1977b. "Roman und Mysterienritual: Zum Problem eines Bezugs zum dionysischen Mysterienritual im Roman des Longos." *WürzJbb* 3:179–96.

Giovino, M. 1992. "Oh Mighty Isis." *Kelsey Museum Newsletter* (Fall), 3.

Goedicke, C. 1994. "Echtheitsprüfung an Tanagrafiguren nach der Thermolumineszenzmethode." In *Bürgerwelten, Hellenistische Tonfiguren und Nachschöpfungen im 19. Jh.*, ed. I. Kriseleit and G. Zimmer, 77–81. Mainz.

Gorgon, R. 1979. "The Real and the Imaginary: Production and Religion in the Greco-Roman World." *Art History* 2:5–34.

Gow, A. S. F. 1950. *Theocritus.* 2 vols. Cambridge.

Grahame, M. 1997. "Public and Private in the Roman House: Investigating the Social Order of the *Casa del Fauno.*" In *Domestic Space in the Roman World: Pompeii and Beyond*, ed. R. Laurence and A. Wallace-Hadrill, 137–64. *JRA* suppl. 22. Portsmouth, RI.

Grant, M., and W. Forman. 1971. *Cities of Vesuvius: Pompeii and Herculaneum.* London.

Green, J. R. 1976. *Gnathia Pottery in the Akademisches Kunstmuseum Bonn.* Mainz.

———. 1982. "Centuripe." In *The Art of South Italy: Vases from Magna Graecia*, ed. M. E. Mayo, 282. Richmond, VA.

Grieco, G. 1979. "La grande frise de la Villa des Mystères et l'initiation dionysiaque." *PP* 34:417–41.

Griffith, D. R. 1989. "Pelops and Sicily: The Myth of Pindar 01.I." *JHS* 109:171–73.

Gruen, E. S. 1990. *Studies in Greek Culture and Roman Policy.* Cincinnati Classical Studies new ser., 7. Leiden.

———. 1990a. "The Advent of the Magna Mater." In *Studies in Greek Culture and Roman Policy*, ed. E. S. Gruen, 5–33. Cincinnati Classical Studies new ser., 7. Leiden.

———. 1990b. "The Bacchanalian Affair." In *Studies in Greek Culture and Roman Policy*, ed. E. S. Gruen, 34–78. Cincinnati Classical Studies new ser., 7. Leiden.

Guiraud, H. 1996. *Intailles et cameés romaines.* Paris.

Guzzo, P. G. 1997. "Ritrovamenti in contesti non cultuali: Pompei." In *Iside, il mito, il mistero, la magia*, ed. E. A. Arslan, 344–47. Milan.

Haeckl, A. E., and K. C. Spelman, eds. 1977. *The Gods of Egypt in the Greco-Roman Period.* Ann Arbor.

Hall, N. 1988. *Those Women.* Dallas.

———. 1999. "Woman Lost and Woman Found: Images of an Ancient Passage." In *The Mysteries: Patricia Olson, 18 September–27 October, 1999, The Catherine G. Murphy Gallery, The College of St. Catherine, St. Paul, Minnesota*, 2–5. St. Paul, MN.

Hallett, J. P. 1984. *Fathers and Daughters in Roman Society.* Princeton.

Hanfmann, G. M. A. 1940. "The Etruscans and Their Art." *Bulletin of the Museum of Art, Rhode Island School of Design* 28.1:17–19.

———. 1961. *The David Moore Robinson Bequest of Classical Art and Antiquities: A Special Exhibition.* Cambridge, MA.

Harden, D. B. 1987. *The Glass of the Caesars.* Milan.

Harding, M. E. 1972. *Woman's Mysteries, Ancient and Modern: A Psychological Interpretation of the Feminine Principle as Portrayed in Myth, Story, and Dreams.* New York.

Hartmann, J. B. 1979. *Antike Motive bei Thorvaldsen. Studien zur Antikenrezeption des Klassizismus.* Tübingen.

Hartt, F., and D. G. Wilkins. 1994. *History of Italian Renaissance Art: Painting, Sculpture, Architecture*, 4th ed. New York.

Hartwig, P. 1910. *Wiener Neue Freie Presse*, no. 16436 (May 27).

Haüber, C. 1986. "Torso di Dioniso." In *Le tranquille dimore degli dei: La residenza imperiale degli horti Lamiani*, ed. M. Cima and E. La Rocca, 95–97. Venice.

Häusle, H. 1980. *Das Denkmal als Garant des Nachruhms. Beiträge zur Geschichte und Thematik eines Motivs in lateinischen Inschriften.* Zetemata 75. Munich.

Hayes, J. W. 1984. *Greek and Italian Black-gloss Wares and Related Wares in the Royal Ontario Museum: A Catalogue.* Toronto.

Haynes, S. 1985. *Etruscan Bronzes.* London.

Hedreen, G. 1994. "Silens, Nymphs and Maenads in Late Sixth-century Red-figure Attic Vase-painting." *JHS* 114:47–69.

Henderson, J. 1996. "Footnote: Representation in the Villa of the Mysteries." In *Art and Text in Roman Culture*, ed. J. Elsner, 234–76. Cambridge.

Henrichs, A. 1978. "Greek Maenadism from Olympias to Messalina." *HSCP* 82:121–60.

———. 1979. "Greek and Roman Glimpses of Dionysos." In *Dionysos and His Circle: Ancient through Modern*, ed. C. Houser, 1–11. Cambridge, MA.

———. 1982. "Changing Dionysiac Identities." In *Jewish and Christian Self-definition. Vol. 3, Self-definition in the Greco-Roman World*, ed. B. F. Meyer and E. P. Sanders, 137–60, 213–36. London.

———. 1993. "'He Has a God in Him': Human and Divine in the Modern Perception of Dionysus." In *Masks of Dionysus*, ed. T. H. Carpenter and C. A. Faraone, 13–43. Ithaca.

Henshaw, J. P., ed. 1995. *The Detroit Institute of Arts: A Visitors' Guide.* Detroit.

Herbig, R. 1958. *Neue Beobachtungen am Fries der Mysterien-Villa in Pompeji. Ein Beitrag zur römischen Wandmalerei in Campanien.* Deutsche Beiträge zur Altertumswissenschaft 10. Baden-Baden.

Heyob, S. K. 1975. *The Cult of Isis among Women in the Graeco-Roman World.* EPRO 51. Leiden.

Hiers, M. E. 1998. "In the Eye of the Beholder: A Study of the Iconography of Bronze Mirrors from Magna Graecia." Senior honors thesis, Dartmouth College.

Higgins, R. A. 1954–59. *Catalogue of the Terracottas in the Department of Greek and Roman Antiquities, the British Museum.* 3 vols. London.

———. 1967. *Greek Terracottas.* London.

Higgins, R. A. 1976. "Terracottas." In *Roman Crafts*, ed. D. Strong and D. Brown, 104–9. New York.

———. 1980. *Greek and Roman Jewellery*, 2nd ed. Berkeley.

———. 1986. *Tanagra and the Figurines*. Princeton.

Hillier, B., and J. Hanson. 1984. *The Social Logic of Space*. Cambridge.

Hincks, H. S. 1919. "Pompeian Wall-Painting." *Bulletin of the Rhode Island School of Design* 7.3: 9–31.

Hinz, V. 1998. *Der Kult von Demeter und Kore auf Sizilien und in der Magna Graecia*. Palilia 4. Wiesbaden.

Hoffmann, H. 1971. *Collecting Greek Antiquities*. New York.

Hoffman, R. J. 1989. "Ritual License and the Cult of Dionysos." *Athenaeum* 67:91–115.

Holloway, R. R. 1991. *The Archaeology of Ancient Sicily*. London.

Hooper, W. D., and H. B. Ash, trans. 1934. *Marcus Porcius Cato: On Agriculture. Marcus Terentius Varro: On Agriculture*. The Loeb Classical Library. London.

Horn, H. G. 1972. *Mysteriensymbolik auf dem Kölner Dionysosmosaik*. Bonn.

Houser, C. 1979. *Dionysos and His Circle: Ancient through Modern*. Cambridge, MA.

Houtzager, J. 1963. *De grote wandschildering in de Villa dei Misteri bij Pompeii en haar verhouding tot de monumenten der vroegere kunst*. Leiden.

Huskinson, J. 1996. *Roman Children's Sarcophagi: Their Decoration and Its Social Significance*. Oxford.

Inan, J., and E. Alföldi-Rosenbaum. 1979. *Römische und frühbyzantische Porträtplastik aus der Türkei*. Mainz.

Indiana University Art Museum. 1980. *Guide to the Collections: Highlights from the Indiana University Art Museum*. Bloomington, IN.

Jahannowsky, W., et al. 1986. *Le Ville romane dell'età imperiale*. Itinerari turistico culturali in Campania 3. Naples.

Jameson, M. 1993. "The Asexuality of Dionysus." In *Masks of Dionysus*, ed. T. H. Carpenter and C. A. Faraone, 44–64. Ithaca.

Jashemski, W. M. F., and S. A. Jashemski. 1979–93. *The Gardens of Pompeii: Herculaneum and the Villas Destroyed by Vesuvius*. 2 vols. New Rochelle, NY.

Joly, E. 1980. "Teorie Vecchie e Nuove sulla Ceramica Policroma." In *Miscellanea di Studi Classici in Onore di Eugenio Manni*, 4:1241–54. Rome.

Jones, C. P. 1991. "Dinner Theater." In *Dining in a Classical Context*, ed. W. J. Slater, 185–98. Ann Arbor.

Kampen, N., and B. A. Bergmann. 1996. *Sexuality in Ancient Art: Near East, Egypt, Greece, and Italy*. Cambridge Studies in New Art History and Criticism. Cambridge.

Kater-Sibbes, G. J. F., and M. J. Vermaseren. 1975. *Apis*. Vol. 2, *Monuments from outside Egypt*. EPRO 48. Leiden.

Kerényi, C. 1976. *Dionysos: Archetypal Image of Indestructible Life*, trans. R. Manheim. Princeton.

Keuls, E. C. 1984. "Male-Female Interaction in Fifth-century Dionysiac Ritual as Shown in Attic Vase Painting." *ZPE* 55:287–97.

Khan, S. 1999. "Midlife in the Villa of the Mysteries." *Power Trips: The Travel Guide to Mother Earth's Sacred Places* 10 (Dec./Jan.): 10–13.

Kleiner, D. E. E. 1992. *Roman Sculpture*. Yale Publications in the History of Art. New Haven.

———. 1996. "Imperial Women as Patrons of the Arts in the Early Empire." In *I Claudia: Women in Ancient Rome*, ed. D. E. E. Kleiner and S. B. Matheson, 28–41. New Haven.

———, and S. B. Matheson, eds. 1996. *I, Claudia: Women in Ancient Rome*. New Haven.

———, and S. B. Matheson, eds. 2000. *I, Claudia II: Women in Ancient Rome*. New Haven.

Klossowski, P. 1990. *Diana at Her Bath: The Women of Rome*, trans. S. Sartarelli and S. Hawkes. The Eridanos Library 19. Boston.

Koch, G., and H. Sichtermann. 1982. *Römische Sarkophage*. HdA. Munich.

Kockel, V. 1986. "Archäologische Funde und Forschungen in den Vesuvstädten II." *AA*, 443–569.

Koloski-Ostrow, A. O., and C. L. Lyons, eds. 1997. *Naked Truths: Women, Sexuality, and Gender in Classical Art and Archaeology*. London.

Kondoleon, C. 1995. *Domestic and Divine: Roman Mosaics in the House of Dionysos*. Ithaca.

———. 1999. "Timing Spectacles: Roman Domestic Art and Performance." In *The Art of Ancient Spectacle*, ed. B. Bergmann and C. Kondoleon, 321–41. Studies in the History of Art 56. Washington DC.

Koortbojian, M. 1995. *Myth, Meaning, and Memory on Roman Sarcophagi*. Berkeley.

Kozloff, A. P., and D. G. Mitten. 1988. *The Gods Delight: The Human Figure in Classical Bronze*. Bloomington, IN.

Kraemer, R. S. 1979. "Ecstasy and Possession: The Attraction of Women to the Cult of Dionysos." *HThR* 72:55–80.

———. 1983. "Women in the Religions of the Greco-Roman World." *Religious Studies Review* 9:127–39.

———. 1988. *Maenads, Martyrs, Matrons, Monastics: Sourcebook on Women's Religions in the Greco-Roman World*. Philadelphia.

Kriseleit, I., and G. Zimmer, eds. 1994. *Bürgerwelten, Hellenistische Tonfiguren und Nachschöpfungen im 19. Jh.* Mainz.

Kuttner, A. 1999. "Hellenistic Images of Spectacle, from Alexander to Augustus." In *The Art of Ancient Spectacle*, ed. B. Bergmann and C. Kondoleon, 97–123. Studies in the History of Art 56. Washington, DC.

La Follette, L. 1994. "The Costume of the Roman Bride." In *The World of Roman Costume*, ed. L. Sebesta and L. Bonfante, 54–64. Madison, WI.

La Rocca, E. R. 1996. "Powder and Politics: Roman Women and the Art of Beauty." In *I Claudia: Women in Ancient Rome*, ed. D. E. E. Kleiner and S. B. Matheson, 160–61. New Haven.

Laurence, M. 1988. "Wes Christensen: Compressed Narratives." *Visions Magazine* 2.3.

Laurence, R. 1994. *Roman Pompeii: Space and Society*. London.

———, and A. Wallace-Hadrill, eds. 1997. *Domestic Space in the Roman World: Pompeii and Beyond*. JRA suppl. 22. Portsmouth, RI.

Leach, E. 1988. *The Rhetoric of Space: Literary and Artistic Representations of Landscape in Republican and Augustan Rome*. Princeton.

———. 1997. "Oecus on Ibycus: Investigating the Vocabulary of the Roman House." In *Sequence and Space in Pompeii*, ed. S. E. Bon and R. Jones, 50–71. Oxford.

Lehmann, K. 1962. "Ignorance and Search in the Villa of the Mysteries." *JRS* 52:62–68.

Lehmann, P. W. 1953. *Roman Wall Paintings from Boscoreale in the Metropolitan Museum of Art*. Archaeological Institute of America Monographs on Archaeology and Fine Arts 5. Cambridge, MA.

Leipin, N., P. Denis, J. R. Guy, and A. D. Trendall. 1984. *Glimpses of Excellence: A Selection of Greek Vases and Bronzes from the Elie Borowski Collection*. Toronto.

Libertini, G. 1926. *Centuripe*. Catania.

———. 1934. *Nuove ceramiche dipinte di Centuripe*. Rome.

Lincoln, B. 1979. "The Rape of Persephone: A Greek Scenario of Women's Initiation." *HThR* 72:221–35.

Lindner, M. 1996. "The Vestal Virgins and Their Imperial Patrons: Sculptures and Inscriptions from the Atrium Vestae in the Roman Forum." Ph.D. diss., University of Michigan.

Ling, R. 1991. *Roman Painting*. Cambridge.

Lissarrague, F. 1990. "Why Satyrs Are Good to Represent." In *Nothing to Do with Dionysos*, ed. J. Winkler and F. Zeitlin, 228–36. Princeton.

———. 1998. "Intrusions au gynécée." In *Les mystères du gynécée*, ed. P. Veyne, 157–98. Paris.

Little, A. 1963a. "A Series of Notes in Four Parts on Campanian Megalography. A. The Composition of the Villa Item Painting." *AJA* 67:191–94.

———. 1963b. "A Series of Notes in Four Parts on Campanian Megalography. B. Numerical Grouping at the Villa Item and the Balance of Opposites." *AJA* 67:291–94.

———. 1964a. "A Series of Notes in Four Parts on Campanian Megalography. C. The Boscoreale Cycle." *AJA* 68:62–66.

———. 1964b. "A Series of Notes in Four Parts on Campanian Megalography. D. The Homeric House Cycle and the Herculaneum Megalography." *AJA* 68:390–95.

———. 1972. *A Roman Bridal Drama in the Villa of the Mysteries*. Kennebunk, ME.

Lloyd-Morgan, G. 1982. "The Roman Mirror and Its Origins." In *A Guide to Etruscan Mirrors*, ed. N. T. de Grummond, 39–48. Tallahassee, FL.

Loeschcke, S. 1919. *Lampen aus Vindonissa*. Zürich.

Luckner, K. 1972. "Greek Vases: Shapes and Uses." *The Toledo Museum of Art. Museum News* 15.3:63–86.

Macchioro, V. 1920. *Zagreus: Studi sull'Orfismo*. Bari.

MacKendrick, P. 1960. *The Mute Stones Speak*. New York.

Maiuri, A. 1931. *La villa dei misteri*. Rome.

———. 1947. *La villa dei misteri*, 2nd ed. Rome.

———. 1948. "Note e commenti al dipinto della Villa dei Misteri." *PP* 3:185–211.

———. 1953. *Roman Painting*. Lausanne.

———. 1957. *Pompeii: The New Excavations, the "Villa dei Misteri," the Antiquarium*, trans. V. Priestly. Itinerari dei musei e monumenti d'Italia 3, 9th ed. Rome.

———. 1960. *La villa dei misteri*, 3rd ed. Rome.

———. 1970. *Pompeii, i nuovi scavi e la villa dei misteri, l'Antiquarium*. Itinerari dei musei e monumenti d'Italia 3, 14th ed. Rome. Original edition, 1931.

Manniche, L. 1991. *Music and Musicians in Ancient Egypt*. London.

Mansuelli, G. A. 1946–47. "Gli specchi figurati etruschi." *StEtr* 19:9–137.

———. 1979. "The Etruscan City." In *Italy before the Romans*, ed. D. Ridgway and F. R. Ridgway, 353–71. London.

Margarucci Italiani, B. M. 1978. "Maria Barosso: Archeologa e pittrice di Roma." In *Donne di ieri a Roma e nel Lazio*, 315–46. Lunario Romano 7. Rome.

Marshall, F. H. 1907. *Catalogue of the Finger Rings, Greek, Etruscan, and Roman in the Departments of Antiquities, British Museum*. London.

Matt, L. von. 1961. *Grossgriechenland*. Wurzburg.

Mattusch, C. C. 1994. "Bronze Herm of Dionysos." In *Das Wrack: Der antike Schiffsfund von Mahdia*, ed. G. H. Salies, 431–50. Cologne.

———. 1996. *The Fire of Hephaistos: Large Classical Bronzes from North American Collections*. Cambridge, MA.

Matz, F. 1963. *Dionysiake telete. Archäologische Untersuchungen zum Dionysoskult in hellenistischer und römischer Zeit. AbhMainz* 15. Wiesbaden.

———. 1968–75. *Die dionysischen Sarkophage*. 4 vols. *ASR* 4. Berlin.

Matz, F., and F. von Duhn. 1881–82. *Antike Bildwerke in Rom*. 3 vols. Leipzig.

Mau, A. 1902. *Pompeii: Its Life and Art*, trans. F. Kelsey, 2nd ed. New York.

Mayo, M. E., ed. 1982. *The Art of South Italy: Vases from Magna Graecia*. Richmond, VA.

McCann, A. M. 1978. *Roman Sarcophagi in the Metropolitan Museum of Art*. New York.

McKay, A. G. 1975. *Houses, Villas, and Palaces in the Roman World*. Aspects of Greek and Roman Life. Ithaca.

Méautis, G. 1945. "La Composition de la Peinture de la 'Villa des Mystères' à Pompéi." *MusHelv* 2:259–62.

Merkelbach, R. 1988. *Die Hirten des Dionysos. Die Dionysos-Mysterien der römischen Kaiserzeit und der bukolische Roman des Longus*. Stuttgart.

Merriam, A. C. 1885. "Inscribed Sepulchral Vases from Alexandria." *AJA* 1:18–33.

Metropolitan Museum of Art. 1917. *Handbook of the Classical Collection*. New York.

———. 1927. *Handbook of the Classical Collection*, new ed. New York.

Metzger, B. M. 1984. "A Classified Bibliography of the Graeco-Roman Mystery Religions 1924–1973 with a Supplement 1974–1977." *ANRW* 2.17.3:1259–1423.

Metzger, H. 1995. "Le Dionysos des images eleusiniennes du IVe siècle." *RA*, 3–22.

Meyer, H. 1991. *Antinoos. Die archäologischen Denkmäler unter Einbeziehung des numismatischen und epigraphischen Materials sowie der literarischen Nachrichten: Ein Beitrag zur Kunst- und Kulturgeschichte der hadrianisch-fruhantoninischen Zeit*. Munich.

Meyer, M. W. 1987. *The Ancient Mysteries: A Sourcebook: Sacred Texts of the Mystery Religions of the Ancient Mediterranean World.* San Francisco.

———, and P. Mirecki, eds. 1995. *Ancient Magic and Ritual Power.* New York.

Miller, F. J., trans. 1921. *Ovid* Metamorphoses. Vol. 1, bks. 1–8, 2nd ed. The Loeb Classical Library. London.

Miller, R. L. 1983. "The Terracotta Votives from Medma: Cult and Coroplastic Craft in Magna Graecia." Ph.D. diss., University of Michigan.

Mitten, D. G. 1975. *Catalogue of the Classical Collection.* Vol. 2, *Classical Bronzes.* Providence.

———, and S. F. Doeringer. 1967. *Master Bronzes from the Classical World.* Mainz.

Montagu, J. 1994. *The Expression of the Passions: The Origin and Influence of Charles Le Brun's* Conférence sur l'expression générale et particulière. New Haven.

Moormann, E. M., ed. 1993. *Functional and Spatial Analysis of Wall Painting: Proceedings of the Fifth International Congress on Ancient Wall Painting, Amsterdam, 8–12 September 1992. BABesch* suppl. 3. Leiden.

Morel, J.-P. 1981. *Céramique campanienne: Les formes. BEFAR* 244. Rome.

Motz, T. 1984. *Image and Artifact: Ancient Art from the Detroit Institute of Arts.* Detroit.

Mount Holyoke College, Art Museum. 1984. *Handbook of the Collection.* South Hadley, MA.

Mudie Cooke, P. B. 1913. "The Paintings of the Villa Item at Pompeii." *JRS* 3:157–74.

Müller, F. G. J. M. 1994. *The Wall Paintings from the Oecus of the Villa of Publius Fannius Synistor in Boscoreale.* Iconological Studies in Roman Art 2. Amsterdam.

Musée du Petit Palais. 1897–1901. *Collection Auguste Dutuit, bronzes antiques.* Paris.

Museo Archeologico Nazionale di Napoli. 1986–89. *Le collezioni del Museo Nazionale di Napoli.* 2 vols. Rome.

Nelson, L. G. 1977. "The Rendering of Landscape in Greek and South Italian Vase-Painting." Ph.D. diss., SUNY–Binghamton.

Nilsson, M. P. 1953. "The Bacchic Mysteries of the Roman Age." *HThR* 46:175–202.

———. 1957. *The Dionysiac Mysteries of the Hellenistic and Roman Age. SkrAth* 8°, 5. Lund.

North, J. A. 1976. "Conservatism and Change in Roman Religion." *BSR* 31:1–12.

———. 1979. "Religious Toleration in Republican Rome." *PCPS* 205:85–103.

Nygren, E. J. 1999. "Ruth Weisberg's *Canto V: A Whirlwind of Lovers.*" In *Ruth Weisburg: Canto V: A Whirlwind of Lovers, The Virginia Steele Scott Gallery, The Huntington Library Art Collections and Botanical Gardens, San Marino California, November 17, 1999–January 30, 2000,* 7–18. San Marino, CA.

Oakley, J., and R. Sinos. 1993. *The Wedding in Ancient Athens.* Madison, WI.

Obbink, D. 1993. "Dionysus Poured Out: Ancient and Modern Theories of Sacrifice and Cultural Formation." In *Masks of Dionysus,* ed. T. H. Carpenter and C. A. Faraone, 65–89. Ithaca.

Oldfather, C. H., trans. 1935. *Diodorus of Sicily.* Vol. 2, bks. 2 (continued).35–4.58. The Loeb Classical Library. London.

Olson, P. 1999. "The Mysteries." In *The Mysteries: Patricia Olson, 18 September–27 October, 1999, The Catherine G. Murphy Gallery, The College of St. Catherine, St. Paul, Minnesota,* 6–21. St. Paul, MN.

Orr, D. G. 1972. "Roman Domestic Religion: A Study of the Roman Household Deities and Their Shrines at Pompeii and Herculaneum." Ph.D. diss., University of Maryland.

———. 1978. "Roman Domestic Religion: The Evidence of Household Shrines." *ANRW* 2.16.2:1557–91.

———. 1980. "Roman Domestic Religion: The Archaeology of Roman Popular Art." In *5000 Years of Popular Culture: Popular Culture before Printing,* ed. F. E. H. Schroeder. Bowling Green, OH.

———. 1988. "Learning from Lararia: Notes on the Household Shrines in Pompeii." In *Studia Pompeiana & Classica in Honor of Wilhelmina F. Jashemski,* ed. R. I. Curtis. New Rochelle, NY.

Oswald, F., and T. D. Pryce. 1920. *An Introduction to the Study of Terra Sigillata.* London.

Otto, W. F. 1981. Reprint. *Dionysus, Myth and Cult,* trans. R. B. Palmer. Dunquin series 14. Dallas. Original edition, Bloomington, IN, 1965.

Owens, C. 1984. "The Allegorical Impulse: Towards a Theory of Postmodernism." In *Art after Modernism: Rethinking Representation,* ed. B. Wallis, 203–35. New York.

Pace, B. 1915. "Ceramiche ellenistiche siceliote." *Ausonia* 8:27–34.

Pagenstecher, R. 1912. "Grabgemälde aus Gnathia." *RM* 27:101–23.

———. 1913. *Die Gefäße in Stein und Ton, Knockenschnitzereien* 2.3. Leipzig.

Pailler, J.-M. 1984. "Lieu sacré et lien associatif dans le dionysisme romain de la République." In *L'association dionysiaque dans les sociétés anciennes,* 261–73. *CEFR* 89. Rome.

———. 1988. *Bacchanalia: La répression de 186 av. J.-C. à Rome et en Italie: Vestiges, images, tradition. BEFAR* 270. Rome.

Pairault, J.-M. 1987. "En quel sens parler de la romanisation du culte de Dionysos en Etrurie?" *MEFRA* 99:573–94.

Pallottino, M. 1975. *The Etruscans,* trans. J. Cremona, ed. D. Ridgway, 2nd ed. Bloomington, IN.

Paoletta, E. 1989. *Svelato il mistero della Pompeiana Villa dei Misteri: Un altro grande successo della microarcheologia e della panarcheologia: il dramma di Ottavia e il trionfo di Poppea nella trama di Aniceto e nelle pitture di Glicone attraverso un filo di Arianna epigrafico e una scabrosa sequenza di epigrafi e figurazioni minori.* Naples(?).

Pappalardo, U. 1982a. "Il fregio con eroti fra girali nella 'salla dei misteri' a Pompei." *JdI* 97:251–80.

———. 1982b. "Nuove osservazioni sul fregio della 'Villa dei Misteri' a Pompei." In *La regione sotterrata del Vesuvio: Studi e prospettive,* 599–634. Naples.

Pedley, J. G. 1978. "A *Dionysos* in Ann Arbor." *Bulletin of the University of Michigan Museums of Art and Archaeology* 1:17–27.

Pedley, J. G. 1990. *Paestum: Greeks and Romans in Southern Italy*. London.

———. 1993. *The Sanctuary of Santa Venera at Paestum*. Rome.

———. 1998. "Problems in Provenance and Patronage: A Group of Late Hellenistic Statuettes from Paestum." In *Regional Schools in Hellenistic Sculpture*, ed. O. Palagia and W. Coulson, 199–208. Oxford.

Pernice, E. 1925. *Die Hellenistische Kunst in Pompeji*. Vol. 4, *Gefasse und Gerate aus Bronze*. Berlin.

Peterson, R. M. 1919. *The Cults of Campania*. Rome.

Pfuhl, E. 1923. *Malerei und Zeichnung der Griechen*. 3 vols. Munich.

Picard, C. 1946–47. "De la stèle d'Ameinocleia à la ciste 'prenestine' G. Radeke." *REG* 59–60:210–18.

———. 1963. *Manuel d'archéologie grecque*. Vol. 4.2, *La sculpture, période classique-IVe siècle*. Paris.

Pollitt, J. J. 1974. *The Ancient View of Greek Art: Criticism, History, and Terminology*. New Haven.

———. 1986. *Art in the Hellenistic Age*. Cambridge.

Pomeroy, S. B. 1975. *Goddesses, Whores, Wives, and Slaves: Women in Classical Antiquity*. New York.

Pottier, E. 1915. "Les Fresques de la Villa du Fondo Gargiulo." *RA* 5:321–47.

Prieur, J. 1986. *La mort dans l'antiquité romaine*. Rennes.

Pugliese Carratelli, G., ed. 1996. *The Greek World: Art and Civilization in Magna Graecia and Sicily*, trans. A. Ellis et al. New York.

———, and O. Elia. 1979. "Il santuario dionisiaco di Pompei." *PP* 34:442–81.

Rackham, H., trans. 1942. *Pliny*: Natural History. Vol. 2, bks. 3–7. The Loeb Classical Library. London.

Rallo, A. 1974. *Lasa: Iconografia e esegesi*. Florence.

Rasmussen, T., and N. Spivey, eds. 1991. *Looking at Greek Vases*. Cambridge.

Rebuffat-Emmanuel, D. 1973. *Le miroir étrusque d'après la Collection du Cabinet des Médailles*. CEFR 20. Rome.

Reilly, J. 1989. "Many Brides: 'Mistress and Maid' on Athenian Lekythoi." *Hesperia* 58:411–44.

Reis, P. 1991. "The Villa of the Mysteries: Initiation into Woman's Midlife Passage." *Continuum* 1.3:64–91.

Rhode Island School of Design, Museum of Art. 1956. *Treasures in the Museum of Art*. Providence, RI.

———. 1985. *A Handbook of the Museum of Art*. Providence, RI.

Richards, J. E., and T. Wilfong. 1995. *Preserving Eternity: Modern Goals, Ancient Intentions. Egyptian Funerary Artifacts in the Kelsey Museum of Archaeology*. Ann Arbor.

Richardson, E. H. 1982. "Covered Mirrors: Bronze." In *A Guide to Etruscan Mirrors*, ed. N. T. de Grummond, 14–21. Tallahassee, FL.

———. 1983. *Etruscan Votive Bronzes: Geometric, Orientalizing, Archaic*. 2 vols. Mainz.

Richardson, L. 1988. *Pompeii: An Architectural History*. Baltimore.

———. 1992. *A New Topographical Dictionary of Ancient Rome*. Baltimore.

Richter, G. M. 1920. *Catalogue of Engraved Gems in the Classical Style*. New York.

———. 1930. "Polychrome Vases from Centuripe in the Metropolitan Museum." *MMS* 2:187–205.

Richter, G. M. 1932. "A Polychrome Vase from Centuripe." *MMS* 4:45–54.

———. 1944. *Greek Painting*. New York.

———. 1953. *Handbook of the Greek Collection of the Metropolitan Museum of Art*. Cambridge, MA.

———. 1956. *Catalogue of Engraved Gems: Greek, Etruscan and Roman*. Rome.

Riefstahl, R. M. 1968a. "Greek Vases." *The Toledo Museum of Art. Museum News* 11.2:27–50.

———. 1968b. "The Complexities of Ancient Glass." In *The Toledo Museum of Art*, 16–25. Toledo, OH. Originally published in *Apollo* n.s. 86 (Dec. 1967): 428–37.

Robertson, M. 1959. *Greek Painting*. Geneva.

Robinson, F. W. 1948. "A Cast and Engraved Bronze Mirror." *Bulletin of the Detroit Institute of Arts* 27:67–68.

Robinson, M. 1992. *The Art of Vase-Painting in Classical Athens*. Cambridge.

Root, M. C. 1984–85. "An Apulian Volute Krater by the Gioia del Colle Painter: Aspects of Context, Attribution, and Iconography." *Bulletin of the University of Michigan Museums of Art and Archaeology* 7:1–25.

Rossbach, O. 1911. "Szenen des Pantominos auf den Wandbildern der Villa Gargiulo." *BPW* 31:503–4.

Rumpf, A. 1953. *Malerei und Zeichnung der klassischen Antike*. HdA 6.4.1. Munich.

S___, L. A. 1919. "A Praenestine Cista." *Bulletin of the Museum of Art, Rhode Island School of Design* 7.4:39–41.

Sage, E. T., trans. 1936. *Livy*. Vol. 11, bks. 38–39. The Loeb Classical Library. London.

Salmon, E. T. 1967. *Samnium and the Samnites*. Cambridge.

Sambon, A. 1903. *Les fresques de Boscoreale*. Paris.

———. 1905. *Catalogue des objects d'art antique, succession de Mme. E. Warneck*. Paris.

Sarup, M. 1993. *An Introductory Guide to Post-Structuralism and Postmodernism*. Athens, GA.

Sassatelli, G. 1992. *La Citta Etrusca di Marzabotto*. Bologna.

Sauron, G. M. 1984. "Nature et signification de la mégalographie dionysiaque de Pompéi." *CRAI* 198:151–76.

———. 1998. *La grande fresque de la villa des Mystères à Pompéi: Mémoires d'une dévote de Dionysos*. Paris.

Saxon, C. 1986 "A Classicist's View." In *Sarah Swenson: Rites. Lang Gallery, Scripps College, Claremont, California, August 31–October 20, 1986*, 3–4. Claremont, CA.

Scafuro, A. C. 1989. "Livy's Comic Narrative of the Bacchanalia." *Helios* 16:119–42.

Schauenburg, K. 1972. "Der besorgte Marsyas." *RM* 79:317–22.

Schefold, K. 1952. *Pompejanische Malerei. Sinn und Ideengeschichte*. Basel.

———. 1957. *Die Wände Pompejis. Topographisches Verzeichnis der Bildmotive*. Berlin.

Scheid, J. 1984. "Le thiase du Metropolitan Museum (*IGUR* I, 160)." In *L'association dionysiaque dans les sociétés anciennes*, 275–90. CEFR 89. Rome.

———. 1992. "The Religious Roles of Roman Women." In *A History of Women in the West*. Vol. 1, *From Ancient Goddess to Christian Saints*, ed. G. Duby and M. Perrot, 377–408. Cambridge, MA.

———. 1994. "Claudia, la vestale." In *Roma al feminile*, ed. A. Fraschetti, 3–19. Rome.

Scheurleer, C. W. L. 1936. *Grieksche Ceramiek*. Rotterdam.

Schilling, R. 1954. *La religion romaine de Vénus depuis les origines jusqu'au temps d'Auguste*. BEFAR 178. Paris.

Shier, L. A. 1978. *Terracotta Lamps from Karanis, Egypt: Excavations of the University of Michigan*. Kelsey Museum of Archaeology Studies 3. Ann Arbor.

Schmidt, M. 1982. "Some Remarks on the Subjects of South Italian Vases." In *The Art of South Italy: Vases from Magna Graecia*, ed. M. E. Mayo, 23–36. Richmond, VA.

———. 1996. "Southern Italian and Sicilian Vases." In *The Greek World: Art and Civilization in Magna Graecia and Sicily*, ed. G. Pugliese Carratelli, 443–56. New York.

Schur, W. 1926. "Liber Pater." In *Paulys Real-Encyclopaedie der classischen Altertumswissenschaft. Neue Bearbeitung*, ed. G. Wissowa, 13:68–75. Stuttgart.

Schwarzmaier, A. 1997. *Griechische Klappspiegel. Untersuchungen zu Typologie und Stil*. Berlin.

Scullard, H. H. 1981. *Festivals and Ceremonies of the Roman Republic*. London.

Seaford, R. 1981. "The Mysteries of Dionysos at Pompeii." In *Pegasus: Classical Essays from the University of Exeter*, ed. H. W. Stubbs, 52–68. Exeter.

———. 1987. "The Tragic Wedding." *JHS* 107:106–30.

Sear, F. 1977. *Roman Wall and Vault Mosaics*. RM-EH 23. Berlin.

Segal, C. 1990. "Dionysos and the Gold Tablets of Pelinna." *GRBS* 31:411–19.

Sfameni Gasparro, G. 1985. *Soteriology and Mystic Aspects in the Cult of Cybele and Attis*. EPRO 103. Leiden.

Shapiro, H. A., C. A. Picón, and G. D. Scott, eds. 1995. *Greek Vases in the San Antonio Museum of Art*. San Antonio, TX.

Simon, E. 1961. "Zum Fries der Mysterienvilla bei Pompeji." *JdI* 76:111–72.

Six, J. 1914–15. "Vasen der Sammlung Six zu Amsterdam und des Metropolitan Museum of Art zu New York." *AntDenk* 3.3:33–34.

Skov, G. E. 1975. "The Priestess of Demeter and Kore and Her Role in the Initiation of Women at the Festival of the Haloa at Eleusis." *Temenos* 11:136–47.

Smith, H. R. W. 1976. *Funerary Symbolism in Apulian Vase-Painting*, ed. J. K. Anderson. University of California Publications: Classical Studies 12. Berkeley.

Smithers, S. 1992–93. "Seven Campanian Terracotta Votive Heads in the Kelsey Museum." *Bulletin of the University of Michigan Museums of Art and Archaeology* 10:48–64.

Sogliano, A. 1899. "Scafati—Avanzi di antica villa dell'agro pompeiano." *NSc* 24:392–96.

Sourvinou-Inwood, C. 1978 "Persephone and Aphrodite at Locri: A Model for Personality Definitions in Greek Religion." *JHS* 98:101–21.

Sowder, C. L. 1982. "Etruscan Mythological Figures." In *A Guide to Etruscan Mirrors*, ed. N. T. de Grummond, 100–128. Tallahassee, FL.

Spaeth, B. S. 1996. *The Roman Goddess Ceres*. Austin, TX.

Sparkes, B. A. 1991. *Greek Pottery: An Introduction*. Manchester.

———. 1996. *The Red and the Black: Studies in Greek Pottery*. London.

Spivey, N. 1997. *Etruscan Art*. London.

Stern, E. M. 1995. *Roman Mold-blown Glass: The First through Sixth Centuries*. Rome.

Stewart, A. 1980. "A Fourth-century Bronze Mirror Case in Dunedin." *AntK* 23:24–34.

Stout, A. 1994. "Jewelry as Symbol of Status in the Roman Empire." In *The World of Roman Costume*, ed. L. Sebesta and L. Bonfante, 77–100. Madison, WI.

Strocka, V. M. 1984. *Casa del Principe di Napoli (VI 15, 7.8)*. Häuser in Pompeji 1. Tübingen.

Strong, D. 1988. *Roman Art*, prepared for press by J. C. M. Toynbee, 2nd ed., rev. R. Ling. The Pelican History of Art. Harmondsworth.

Studniczka, F. 1923–24. "Imagines Illustrium." *JdI* 38–39:57–128.

Sturgis, R. 1894. "The Coleman Collection of Antique Glass." *The Century Illustrated Monthly Magazine*, n.s. 26 (May–Oct.): 556–57.

Swenson, S. 1986. "A Painter's Mystery." In *Sarah Swenson: Rites. Lang Gallery, Scripps College, Claremont, California, August 31–October 20, 1986*, 2. Claremont, CA.

Swindler, M. H. 1929. *Ancient Painting, From the Earliest Times to the Period of Christian Art*. New Haven.

Tassinari, S. 1993. *Il vasellame bronzeo di Pompei*. 2 vols. Rome.

Tea, E. 1932. *Giacomo Boni nella vita del suo tempo*. 2 vols. Milan.

Teitz, R. S. 1967. *Masterpieces of Etruscan Art*. Worcester, MA.

Théatès, O. 1908. "Les artistes animaliers." *Revue d'art* (Paris) 5:485.

Thomas, T. K. 1990. *Dangerous Archaeology: Francis Willey Kelsey and Armenia (1919–1920)*. Ann Arbor.

Tocco Sciarelli, G., ed. 1983. *BAIA: Il ninfeo imperiale sommerso di Punta Epitaffio*. Naples.

Toledo Museum of Art. 1966. *A Guide to the Collections*. Toledo.

———. 1969. *Art in Glass: A Guide to the Glass Collections*. Toledo.

———. 1995. *Toledo Treasures: Selections from the Toledo Museum of Art*. New York.

Tomei, M. A. 1997. *Museo Palatino*. Rome.

Tondo, L., and F. M. Vanni. 1990. *Le gemme dei Medici e dei Lorena nel Museo Archeologico di Firenze*. Florence.

Touchette, L. 1995. *The Dancing Maenad Reliefs: Continuity and Change in Roman Copies*. BICS suppl. 62. London.

Toynbee, J. M. C. 1929. "The Villa Item and a Bride's Ordeal." *JRS* 19:67–87.

Tran, V. T. T. 1964. *Essai sur le culte d'Isis à Pompéi*. Paris.

———. 1973. *Isis lactans. Corpus des monuments gréco-romains d'Isis allaitant Harpocrate*. EPRO 37. Leiden.

Treggiari, S. 1991. *Roman Marriage: Iusti Coniuges from the Time of Cicero to the Time of Ulpian*. Oxford.

———. 1996. "Women in Roman Society." In *I Claudia: Women in Ancient Rome*, ed. D. E. E. Kleiner and S. B. Matheson, 116–25. New Haven.

Trendall, A. D. 1955. "A New Polychrome Vase from Centuripe." *Metropolitan Museum of Art Bulletin* 8:161–66.

———. 1967a. *Phlyax Vases*, 2nd ed. BICS suppl. 19. London.

Trendall, A. D. 1967b. *Red-figured Vases of Lucania, Campania and Sicily*. 2 vols. Oxford.

———. 1974. *Early South Italian Vase-Painting*. Mainz.

———. 1982. "Vase Painting in South Italy and Sicily." In *The Art of South Italy: Vases from Magna Graecia*, ed. M. E. Mayo, 15–21. Richmond, VA.

———. 1983. *The Red-figured Vases of Lucania, Campania and Sicily: Third Supplement*. BICS suppl. 41. London.

———. 1987. *The Red-figured Vases of Paestum*. Rome.

———. 1989. *The Red-figured Vases of South Italy and Sicily: A Handbook*. London.

———, and A. Cambitoglou. 1978–82. *The Red-figured Vases of Apulia*. 3 vols. Oxford.

Trimble, J. F. 1999. "The Aesthetics of Sameness: A Contextual Analysis of the Large and Small Herculaneum Woman Statue Types in the Roman Empire." Ph.D. diss., University of Michigan.

Turcan, R. 1963. "Le roman initiatique. A propos d'un livre récent." *RHR* 163:149–99.

———. 1965. "Du nouveau sur l'initiation dionysiaque." *Latomus* 24:101–19.

———. 1966. *Les sarcophages romains à représentations dionysiaques: Essai de chronologie et d'histoire religieuse*. Paris.

———. 1969. "La démone ailée de la Villa Item." In *Hommages à Marcel Renard*, ed. J. Bibauw and M. Renard, 3:586–609. *CollLatomus* 101–3. Brussels.

———. 1982. "Pour en finir avec la femme fouettée." *RA*, 291–302.

———. 1995. *L'art romain dans l'histoire: Six siècles d'expressions de la romanité*. Paris.

———. 1996. *The Cults of the Roman Empire*, trans. A. Nevill. Oxford.

Turner, V. W. 1969. *The Ritual Process: Structure and Antistructure*. Lewis Henry Morgan Lectures 1966. Chicago.

Tybout, R. A. 1993. "Malerei und Raumfunktion im zweiten Stil." In *Functional and Spatial Analysis of Wall Painting: Proceedings of the Fifth International Congress on Ancient Wall Painting*, ed. E. M. Moormann, 38–50. BABesch suppl. 3. Leiden.

Tzannes, M.-C. 1997. "Kraters, Libations and Dionysiac Imagery in South Italian Red-figure." In *Greek Offerings*, ed. O. Palagia, 145–58. Oxford.

Ucelli, G. 1950. *Le navi di Nemi*. Rome.

Uhlenbrock, J. P., ed. 1990. *The Coroplast's Art: Greek Terracottas of the Hellenistic World*. New Rochelle, NY.

———. 1990a. "The Coroplast and His Craft." In *The Coroplast's Art: Greek Terracottas of the Hellenistic World*, ed. J. P. Uhlenbrock, 15–21. New Rochelle, NY.

———. 1990b. "The Hellenistic Terracottas of Athens and the Tanagra Style." In *The Coroplast's Art: Greek Terracottas of the Hellenistic World*, ed. J. P. Uhlenbrock, 48–53. New Rochelle, NY.

University of Michigan Museum of Art. 1965. *Reflections, the Image of Man*. Ann Arbor.

Vagnetti, L. 1971. *Il Deposito votivo di campetti a Veio (Materiale degli scavi 1937–1938)*. Florence.

Van de Grift, J. H. 1985. "Dionysiaca: Bacchic Imagery in Roman Luxury Art of the Late Republic and Early Empire." Ph.D. diss., Columbia University.

Van der Meer, L. B. 1995. *Interpretatio etrusca: Greek Myths on Etruscan Mirrors*. Amsterdam.

Van Gennep, A. 1960. *The Rites of Passage*, trans. M. B. Vizedom and G. L. Caffee. Chicago.

Vermaseren, M. J. 1977. *Cybele and Attis: The Myth and the Cult*. London.

———, and P. Simone. 1976. *Liber in deum. L'apoteosi di un iniziato dionisiaco*. EPRO 53. Leiden.

Veyne, P. 1998. "La fresque dite des Mystères à Pompéi." In *Les mystères du gynécée*, ed. P. Veyne, 13–153. Paris.

Vidman, L. 1969. *Sylloge inscriptionum religionis Isiacae et Sarapiacae*. Berolini.

Vivani, U., ed. 1921. *I vasi aretini*. Arezzo.

Vogliano, A. 1933. "La grande iscrizione bacchica del Metropolitan Museum." *AJA* 37:215–31.

Von Rohden, H., and H. Winnefeld. 1911. *Architektonische römische Tonreliefs der Kaiserzeit*. Die Antiken Terrakotten im Auftrag des archäologischen Instituts des deutschen Reichs 4. Berlin.

Walker, S. 1985. *Memorials to the Roman Dead*. London.

Wallace-Hadrill, A. 1994. *Houses and Society in Pompeii and Herculaneum*. Princeton.

———. 1996. "Engendering the Roman House." In *I, Claudia: Women in Ancient Rome*, ed. D. E. E. Kleiner and S. B. Matheson, 104–16. New Haven.

Ward-Perkins, J., and A. Claridge. 1978. *Pompeii A.D. 79: Essay and Catalogue*. 2 vols. New York.

West, M. L. 1992. *Ancient Greek Music*. Oxford.

Whitehouse, D. 1997. *Roman Glass in the Corning Museum of Glass*, vol. 1. Corning, NY.

Wiegandt, H. 1998. *Charms of the Past—Engraved Gems: A Private Collection of Ancient, Medieval and Modern Intaglii and Camei*. Marburg.

Wild, R. A. 1981. *Water in the Cultic Worship of Isis and Serapis*. Leiden.

Wiles, D. 1991. *The Masks of Menander: Sign and Meaning in Greek and Roman Performance*. Cambridge.

Wilfong, T. 1997. *Women and Gender in Ancient Egypt from Prehistory to Late Antiquity*. Ann Arbor.

Wilkinson, R. H. 1992. *Reading Egyptian Art: A Hieroglyphic Guide to Ancient Egyptian Painting and Sculpture*. London.

Williams, G. 1996. "Representations of Roman Women in Literature." In *I, Claudia: Women in Ancient Rome*, ed. D. E. E. Kleiner and S. B. Matheson, 126–38. New Haven.

Winkes, R. 1982. *Roman Paintings and Mosaics*. Providence, RI.

Winckelmann, J. J. 1968. *History of Ancient Art*, trans. A. Gode. 2 vols. New York.

Winter, F. 1912. "Die Wandgemälde der Villa Item bei Pompeji." *Kunst und Künstler* 10:548–55.

Wintermeyer, U. 1975. "Die polychrome Reliefkeramik aus Centuripe." *JdI* 90:136–241.

Wissowa, G. 1912. *Religion und Kultus der Römer*. Munich.

Wittkower, R. 1977. "Interpretation of Visual Symbols." In *Allegory and the Migration of Symbols*, 173–87. London.

Wood, S. 2000. "Mortals, Empresses, and Earth Goddesses: Demeter and Persephone in Public and Private Apotheosis." In *I, Claudia II: Women in Ancient Rome*, ed. D. E. E. Kleiner and S. B. Matheson, 77–100. New Haven.

Woolf, G. 1998. *Becoming Roman: The Origins of Provincial Civilization in Gaul*. Cambridge.

Worsfold, T. C. 1934. *The History of the Vestal Virgins of Rome*. London.

Wrede, H. 1981. *Consecratio in formam deorum. Vergöttlichte Privatpersonen in der römischen Kaiserzeit*. Mainz.

York, M. 1986. *The Roman Festival Calendar of Numa Pompilius*. New York.

Zaidman, L. B. 1992. "Pandora's Daughters and Rituals in Grecian Cities." In *A History of Women in the West*, ed. G. Duby and M. Perrot, 338–76. Cambridge, MA.

Zanker, P. 1988. *The Power of Images in the Age of Augustus*, trans. A. Shapiro. Ann Arbor.

Zanker, P. 1998. *Pompeii: Public and Private Life*, trans. D. L. Schneider. Cambridge, MA.

Zeitlin, F. I. 1982. "Cultic Models of the Female: Rites of Dionysus and Demeter." *Arethusa* 15:129–57.

Zevi, F., ed. 1984. *Pompei 79: Raccolta di studi per il decimonono centenario dell'eruzione vesuviana*. Naples.

Zimmer, G. 1994. "Frauen aus Tanagra." In *Bürgerwelten, hellenistische Tonfiguren und Nachschöpfungen im 19. Jh.*, ed. I. Kriseleit and G. Zimmer, 19–28. Mainz.

Zuntz, G. 1963. "On the Dionysiac Fresco in the Villa dei Misteri at Pompeii." *ProcBritAc* 49:177–202.

———. 1971. *Persephone: Three Essays on Religion and Thought in Magna Graecia*. Oxford.

Photographic Credits

Photographs for the catalogue have for the most part been supplied by the owners of the works reproduced. Exceptions and additional credits are listed below by catalogue number.

All photographs have been used either with permission or under fair use. If any copyright holder is concerned about unauthorized use, please contact Elaine K. Gazda in care of the Kelsey Museum of Archaeology, University of Michigan, Ann Arbor, MI 48109-1390.

Arthur M. Sackler Museum, Harvard University Art Museums:
 cat. nos. 35, 68, 70 (Photographic Services: President and Fellows of Harvard College, Harvard University)
Detroit Institute of Arts:
 cat. no. 4 (Photograph Copyright 1998 DIA); cat. nos. 42, 84, 101 (Photograph Copyright 1988 DIA); cat. nos. 59, 67, 74–78, 83 (Photograph Copyright 2000 DIA); cat. no. 60 (Photograph Copyright 1981 DIA); cat. no. 85 (Photograph Copyright 1989 DIA); cat. no. 104 (Photograph Copyright 1993 DIA)
© Ernst Wasmuth Verlag, Tübingen/Germany:
 fig. 11.2
Everson Museum of Art, Syracuse, New York:
 cat. no. 7 (Photography: Andrew Emmerich Gallery, by permission)
The Field Museum, Chicago:
 cat. nos. 62, 66 (Photography by Diane Alexander White)
Indiana University Art Museum:
 cat. no. 73 (Photography by Michael Cavanagh and Kevin Montague)
© Istituto Poligrafico e Zecca dello Stato, Rome:
 figs. 11.8, 11.9, 11.10, 11.11
Museum of Art, Rhode Island School of Design:
 cat. no. 81 (Photography by Del Bogart)
Seattle Art Museum:
 cat. no. 96 (Photo Credit: Paul Macapia)
Toledo Museum of Art:
 cat. nos. 86, 87 (Photography: C. Hammer, by permission)
University of Michigan Museum of Art
 cat. nos. 9, 10, 105; frontispiece; color pls. II, III (Photography by Patrick Young)